Major Voices.
18th Century Women Playwrights

Major Voices
18TH CENTURY WOMEN PLAYWRIGHTS

SELECTED WITH INTRODUCTIONS BY
Michael Caines

The Toby Press

The Toby Press
Toby Press Edition 2004

The Toby Press LLC
POB 8531, New Milford, CT. 06676-8531, USA
& POB 2455, London WIA 5WY, England
www.tobypress.com

Introductions copyright © Michael Caines 2004

ISBN 1 59264 058 3, *paperback*
ISBN 1 59264 059 1, *hardcover*

A CIP catalogue record for this title is
available from the British Library

Cover illustration by Barry Moser

Typeset in Garamond by Jerusalem Typesetting

Printed and bound in the United States
by Thomson-Shore Inc., Michigan

Contents

Introduction

In the eighteenth century, a woman who wrote plays was a phenomenon. Very few female playwrights had plays performed in the early years of the Restoration, and several more were busy in the age of Queen Anne, including Mary Pix, Catharine Trotter and Susannah Centlivre. Leaving aside the issue of anonymous works, it seems that the London stage, by 1750, saw about eighty plays written by women. Just over a quarter of this output, however, came from a single hand, that of Aphra Behn, who was the most prolific playwright of her time after the Poet Laureate John Dryden. Behn's most popular plays continued to be performed after her death in 1689, as was Thomas Southerne's 1695 adaptation of her famous novella *Oroonoko* (1688). After Behn, the second most frequently staged female playwright of the eighteenth century was Susannah Centlivre (of whose nineteen plays only two farces had not been acted by the time of her death in 1723). Of those eighty plays, then, two writers account for approximately forty—half the number performed in the capital of the English theatrical world. To put this in a broader context, female playwrights account for roughly seven per cent of work produced for the stage

between 1660 and 1800. Such figures may be vague, but they at least begin to show the phenomenon to scale; to most people, the female playwright must have seemed decidedly abnormal.

Towards the end of the eighteenth century, a select few female playwrights attained a prominence that is comparable with the "boom" one hundred years earlier. One of the able and lucky few, Elizabeth Inchbald, became "virtually the playwright in residence at Covent Garden in the winter and at the Haymarket in the summer,"[1] with (again) twenty-odd productions to her name. She is among the seven writers featured in Ellen Donkin's *Getting into the Act: Women Playwrights in London, 1776–1829* who together constitute a quarter of the total number of those women whose plays were produced in London in the last quarter of the century. In this statistical light, Inchbald and company look to be just what Donkin says they are: "designated survivors" within a "tightly controlled" patriarchal system, "a system that worked with remarkable efficiency to keep women voiceless, propertyless, and acquiescent."[2] What Germaine Greer says about female poets in general before the twentieth century applies equally to female playwrights during the eighteenth:

> When an unschooled, almost unlettered female begins
> to express herself in verse, she delivers herself up to
> the best and the worst of which the masculine literary
> establishment is capable. She may be humored, she
> may excite genuine wonder and admiration, she will
> certainly be exploited.[3]

This anthology constitutes not simply a reckoning of rarely heard dramatic voices that happen to belong to women, but a tragicomic subplot in the history of dramatic literature. Even selectively attending

1. Annibel Jenkins, *I'll Tell You What: The Life of Elizabeth Inchbald* (Lexington: Kentucky University Press, 2003), p. 11.
2. Ellen Donkin, *Getting into the Act: Women Playwrights in London, 1776–1829* (London: Routledge, 1995), pp. 2–3.
3. Germaine Greer, *Slip-Shod Sibyls: Recognition, Rejection and the Women Poet* (London: Viking, 1995), p. xi.

to that subplot enriches our understanding of the past. That is why plays by Eliza Haywood and Fanny Burney—one a flop, the other unperformed—are included here alongside plays that found commercial success and critical acceptance by Susannah Centlivre, Hannah Cowley and Elizabeth Inchbald. While the plays of Haywood and Burney can be studied and enjoyed as drama, they also complement the authors' better known non-dramatic works. In the same way, *Lovers' Vows* by Inchbald can be read for the sake of its unabashed, glorious melodrama as well as for a better understanding of *Mansfield Park*. These voices are not major in a straightforward canonical sense, to be heard for that reason alone—but they have merits, such as stage-worthiness, wit, intelligence, and historical interest, that make it seem extraordinary that they have been, by and large, ignored.

Moreover, it would be inaccurate to represent eighteenth-century theatrical activity in England as limited exclusively to the Theatres Royal of London or to public theatres in general. A great deal of this activity was going on in private, for instance, not least in the country communities, large and small, in which people made their own entertainment. "Closet drama," sometimes treated as a diminutive term, thrived in all the ways that practically and commercially limited theatre could not. If anything, the women who wrote for private (perhaps religious or instructive) performance belonged to an older tradition than their public (and explicitly secular) counterparts. It is no coincidence that both play-acting and play-writing were staple pastimes in the childhood homes of two outstanding novelists, Fanny Burney and Jane Austen—hence the inclusion here of an appendix about Austen's experiences in theatrical culture, as theatergoer, critic and playwright.

"There is a line…which female gentleness should not step beyond," ruled the sixty-second issue of *Critical Review* in 1786, and beyond it lay the predominantly male sphere of literature. Nonetheless, by the 1750s, Samuel Johnson could refer to "a generation of Amazons of the pen,"[4] and, by the 1790s, Maria Edgeworth could imagine a gentleman saying that:

4. In *The Adventurer*, 1753.

ix

> Women of literature are much more numerous of late than they were a few years ago. They make a class in society, they fill the public eye, and have acquired a degree of consequence and an appropriate character.

To which the gentleman's friend replies:

> A literary lady is no longer a sight; the spectacle is now too common to attract curiosity; the species of animal is too well known even to admit of much exaggeration in the description of its appearance. [5]

Participants in the late eighteenth-century debate on women's education took for granted that a young lady's choice of reading (let alone writing) matter could have a profound influence on the vulnerable female mind. The royal princesses themselves, who had known Fanny Burney from her stint as a Keeper of the Robes to their mother, were prevented from reading Burney's *Camilla* (1796), "till it was sanctioned by a Bishop's recommendation."[6] Sheridan, for a fictional example, gives comical vent given to the anxiety about deluded, romantic female reading in the guise of Lydia Languish in *The Rivals* (1775), while Charlotte Lennox did much the same with Arabella, the heroine of *The Female Quixote* (1752). Anxiety about fiction's delusive influence also gripped the anonymous author of *Some Considerations about the Danger of Going to Plays* (1704), in which the theatre is held responsible for "a sad degenerate Age,"[7] and it would be so even if it could be cleared of the charges of viciousness and profanity:

> this would not make it a place to be greatly frequented by those that desire to keep their minds in a suitable frame. No one would choose to converse always with

5. "Letter from a Gentleman to a Friend, upon the Birth of a Daughter" in *Letters for Literary Ladies*, 1795.

6. Burney, in a letter to one of her sisters, June 18, 1795.

7. Anonymous, *Some Considerations about the Danger of Going to Plays* (London: M. Wotton, 1704), p. 15.

fiction and show, that cared to preserve something Real within…we can't but observe the admirers of scenes to have something romantic in all that they do. [8]

What combination could be more perilous, therefore, than innocent young women and bawdy old plays? Even the fairly moderate Erasmus Darwin recommends only those plays, in his *Plan for the Conduct of Female Education* (1797), as are "entertaining and inoffensive, and may be read by young ladies without injury to their morals, or much outrage to their feelings." "There are many plays," he continues,

> which are better seen as exhibited on the stage, than as read in the closet; because the objectionable passages are generally omitted in the representation. But whether young ladies should be taught to act plays themselves, as is done at some boy's schools, is a matter of doubt. The danger consists in this, lest the acquisition of bolder action, and a more elevated voice, should annihilate that retiring modesty, and blushing embarrassment, to which young ladies owe one of their most powerful external charms.

One hundred years earlier, the same concerns had troubled a certain non-juring clergyman called Jeremy Collier, whose epochal pamphlet called *A Short View of the Immorality and Profaneness of the English Stage* (1698) warned, among other things, of the obscenity of contemporary plays. They were liable to be "very affrontive" to "any lady of reputation"; "modesty is the distinguishing virtue of that sex and serves both for ornament and defense." Nonetheless, between Collier's *Short View* and Darwin's *Plan*, a number of women were not only reading but writing plays, not only endangering their ornamental modesty, but casting it willingly aside.

Neither Darwin nor Collier object to dramatic literature per se (note Darwin's references to the contrasting conduct of male

8. Op. cit., p. 5.

education and the acceptable omission of "objectionable passages" in the professional theatre). The former recommends it cautiously, on an educational basis that the latter might have approved, under the heading of "Polite Literature." According to Darwin, the works of Joseph Addison, James Thompson, Richard Cumberland, and Richard Brinsley Sheridan could yield moral instruction in much the same way that Samuel Richardson's novels could be boiled down to *Moral and Instructive Sentiments [...] contained in [...] Pamela, Clarissa and Sir Charles Grandison* (1755). Under the watchful gaze of a "judicious monitor," says Darwin, drama can make itself useful:

> If young ladies act plays amongst themselves only, or without admitting more than two or three of their friends or parents; or if they repeat chosen scenes of plays, or speeches only, much of the above objection ceases, and some advantages may result to their attitudes or enunciation.[9]

Jane Austen's novel *Mansfield Park* (1814) seems to confirm the perils of play-acting for modest young ladies. When Sir Thomas Bertram, the master of Mansfield Park, leaves his English country estate in order to oversee business in his plantation in Antigua, his children and their guests decide to amuse themselves by staging a notoriously immodest play: *Lovers' Vows*, Inchbald's adaptation of *Die Kinde der Liebe* by Kotzebue. Tony Tanner, one of the novel's modern editors, dismisses the play as "a rather trivial sentimental melodrama"[10] and pays accordingly grudging attention. The play means more to Austen's amateur actors than that judgment suggests, although not necessarily for literary reasons. The casting process alone fulfils a flirtatious function, with Henry Crawford arbitrating between the two Bertram girls as they compete for the role that involves greater intimacy with him, while his sister Mary coaxes Edmund into playing Anhalt, the clergy-

9. *Plan*, section 14, "Polite Literature," p. 32. For complete references, see Further Reading.
10. Note to Tony Tanner's 1966 Penguin edition of the novel, p. 460. For complete references, see Further Reading

man whom her character, Amelia, loves. Furthermore, in the absence of Sir Thomas, the play becomes the focus of other kinds of extravagance. A carpenter is brought in to do the expensive job of building the stage, while Tom Bertram invites considerably more than the initially mooted "two or three of their friends or parents." The excitement and the excess of the theatricals is reflected in the passionate play itself. Maria Bertram, who is engaged to Mr. Rushworth, flirts with Henry by "needlessly often"[11] rehearsing their main scene together. "Female gentleness" is on its way out: "There," says Mary Crawford, pointedly addressing the novel's heroine, Fanny Price, and thinking of her scenes with Edmund, "look at *that* speech, and *that*, and *that*. How am I ever to look him in the face and say such things?"[12] Sir Thomas returns just in time to prevent the performance and to save Fanny from being bullied into acting. He duly castigates Mrs. Norris for neglecting her duties as a surrogate monitor and not "watching the behaviour, or guarding the happiness of his daughters." Indeed, she had thrown herself into "contriving and directing the general little matters of the company."[13] Order may be restored, Austen seems to say, but *Lovers' Vows* and the thrills of unrestrained amateur theatricals are not so soon forgotten.

It is worth mentioning this episode if only to suggest that, if to read or to act in such plays was potentially hazardous, how much worse was it for a woman to *write* them? A respectable young lady like Fanny Burney—the recipient of the letter from Samuel Crisp, quoted below—was hardly expected to publish a novel, let alone submit a play for professional production:

> Well—I have been ruminating a good deal on the obstacles and difficulties I mentioned in my last, that lie directly across YOUR path (as a prude): in the walk of comedy…I will never allow you to sacrifice a *grain* of female delicacy, for all the wit of Congreve and Vanbrugh put together.

11. Jane Austen, *Mansfield Park*, p. 184.
12. Op. cit., p. 188. Inchbald herself claimed to have softened the "indelicately blunt" original in her Preface.
13. Op. cit., p. 183.

Crisp, dubbed her "second Daddy" by Burney, received the reassurance that she would "a thousand Times rather forfeit my character as a *Writer*, than risk ridicule or censure as a *Female*"; absolute literary liberty would be unthinkable for her as long as she had a "*Grain* of female delicacy" left. She had, after all, only just gained the character of a writer after the anonymous publication of her first novel, *Evelina, or The History of a Young Lady's Entrance into the World* (1778). The book's brilliant dialogue and comedy persuaded peers as eminent as Samuel Johnson, Arthur Murphy, Richard Brinsley Sheridan, Sir Joshua Reynolds and Hester Thrale that here was a precocious young talent who could produce—was all but destined to produce—something equally brilliant for the stage.

Burney proved them right with *The Witlings*. Or rather, that was how it seemed at first, when Burney's father, the musicologist and composer Doctor Charles Burney, read the play to an audience of family and friends (no larger, perhaps, than the initially intended audience for *Lovers' Vows* in *Mansfield Park*). One sister wept at the sentimental scenes, while another wept tears of laughter at the comedy. *The Witlings* has also impressed modern readers, who have described it as "brilliantly devised" and "Burney's best sustained imaginative work."[14] Yet Crisp and Dr. Burney refused to let it fall into theatrical hands. Sheridan, as proprietor of the Theatre Royal in Drury Lane, was in an obvious position to see it staged, and had expressed, according to Burney, his eagerness to do so. He would never read it.

The reason for this suppression seems to lie with *The Witlings* itself and Burney's creation of Lady Smatter and her literary salon, the "Esprit Club." Mrs. Thrale insinuates as much when she claims to "like [the play] very well for my own part," although she suspects that Burney had her in mind as an object of her satire; in fact, she thinks that "none of the scribbling Ladies have a Right to admire its

14. Respectively, Margaret Doody, *Frances Burney: The Life in the Works* (New Brunswick: Rutgers University Press, 1988), p. 91, and Katharine M. Rogers, *Feminism in Eighteenth-Century England.* (Urbana: University of Illinois Press, 1982), p. 26.

general tendency."[15] In her view, Burney's "confidential friend Mr. Crisp [had] advised her against bringing it on, for fear of displeasing the female wits—a formidable body, and called by those who ridicule them the *Blue Stocking Club*," and, in particular, Lady Smatter bore too striking a resemblance to the most prominent of the Bluestockings, Elizabeth Montagu. Montagu was well known as a patron of the arts and hostess to a wide circle of literati at her London home in Portland Square. It was a circle to which *Evelina* gave Burney access, and she would have known about Montagu through others' eyes; both Thrale and Johnson (who mockingly dubbed Montagu the "Queen of the Blues") thought the learned lady's *Essay on the Writings and Genius of Shakespeare* (1769) to be unreadable. Moreover, Montagu was a rich, childless widow who made her nephew, Matthew Prior, a dependent heir. In these respects, she seems a very likely model for Burney's Lady Smatter, a vain and pretentious older woman who threatens to disinherit her nephew if he marries against her wishes and beneath her financial expectations.

Very probably Dr. Burney thought such a likeness too scandalously good to be seen in public. General satire was unladylike enough, but specific satire on powerful individuals was tantamount to a declaration of literary war. The Burneys could easily imagine Montagu and her friends boycotting the theatre, and encourage others to follow suit. They could see to it that Dr. Burney's music-teaching career suffered, or they could sully Fanny's reputation. Although she pleaded that the resemblance was unintentional (while also denying that she had read *Les Femmes Savantes*, the 1672 comedy by Molière that sets a clear precedent for *The Witlings*),[16] and offered to rewrite the play without the offending material, it was condemned to sink "down among the dead men." Lady Smatter herself would return in

15. Hester Thrale, ed. Katherine C. Balderston, *Thraliana* (Oxford: Clarendon Press, 1942), vol. i, p. 381.
16. Maria Edgeworth, *Letters for Literary Ladies*: "Molière has pointed out with all the force of comic ridicule, in the *Femmes Savantes*, that a lady who aspires to the sublime delights of philosophy and poetry, must forego the simple pleasures, and will despise the duties of domestic life."

less controversial form, along with a couple of other characters from *The Witlings*, in a later comedy, *The Woman-Hater*, also unproduced.

Burney was not the only playwright with potential to be stopped at the gender barrier, but, as it happens, *Evelina* itself offers an exact counterpart to Crisp's dichotomy between indelicate wit and anti-theatrical prudery. The eponymous heroine, a provincial girl keen to "*Londonize*" herself, becomes repeatedly embroiled in potentially humiliating situations, not least of which is a trip to the theatre:

> The play was *Love for Love*, and though it is fraught
> with wit and entertainment, I hope I shall never see it
> represented again; for it is so extremely indelicate, to
> use the softest word I can...

Love for Love, Congreve's comedy of 1695, was bound to offend refined Georgian taste,[17] although it was revived often enough. In *Evelina*, etiquette seems to dictate that the ladies' condemnation of its indecency should actually be left to the men, after Mrs. Mirvan says little more than that "there are objections to it, which I should be glad to see removed." "I could have ventured to answer for the ladies," says Lord Orville, "since I am sure this is not a play that can be honored with their approbation." In particular, it is Captain Mirvan's reply that anticipates the presuppositions, if not the tone, of Crisp's letter:

> "What, I suppose it is not sentimental enough!" cried
> the Captain, "or else it's too good for them; for I'll
> maintain it's one of the best comedies in the language,
> and has more wit in one scene, than there is in all the
> new plays put together."

Manly wit, it would seem, outweighs all things effeminate, from the fashionable novelty and sentimentalism scoffed at by Captain

17. Congreve also features among the risqué authors whose works are owned by Elizabeth Inchbald, in a hostile caricature of her as a gin-inspired hack.

Mirvan, to the "prudery" and "delicacy" prized by Burney and Crisp. The *Love for Love* incident in *Evelina* also casts the public critic as a kind of chivalrous ventriloquist, and the heroine's distress as private. Congreve would not have found this new, let alone Burney. It is worth noting, however, that the word "prudery" was itself new to the English language at the beginning of the eighteenth century, when Susannah Centlivre wrote the first play in this volume, *A Bold Stroke for a Wife*, in 1718. Prudery came from France, via *The Tatler* and *The Female Tatler*, with the latter using it in a thoroughly pejorative sense. According to "Arabella," a prude is

> a woman who places her virtue in having wit enough to keep a man from prying into her faults, and modest enough to hinder him climbing into her bed-chamber. She simpers before company, as if butter would not melt in her mouth… [18]

In other ways, the misogynist streak in anti-theatrical criticism was little changed since the days of the modest "Orinda" (as Aphra Behn's contemporary Katharine Phillips was styled) and the lascivious "Astraea" (Behn herself)—two names often uncritically connected as polar opposites. Delariviere Manley awarded them joint honors in her commendation of "the Author of *Agnes de Castro*," Catharine Trotter, whom she casts as their heir:

> Orinda and the fair Astraea gone,
> Not one was found to fill the vacant throne:
> Aspiring Man had quite regained the sway,
> Again had taught us humbly to obey;
> Till you (Nature's third start, in favour of our kind)
> With stronger arms, their empire have disjoined,

18. The *Female Tatler* (no 71, December 16, 1709). Mrs. Prim takes note of the neologism in *A Bold Stroke for a Wife*, Act 2, scene 2.

And snatcht a laurel which they thought their prize,
Thus conqu'ror with your wit as with your eyes.[19]

According to Behn's preface to *The Lucky Chance* (1687), when her enemies "can no other way prevail with the Town, they charge it with the old never-failing scandal—that 'tis not fit for the ladies." The vicarious criticism reveals a certain inequality: "Had I a day or two's time, I would sum up all your beloved plays, and all the things in them that are past with such silence by, because written by men; such masculine strokes in me, must not be allowed."[20] Furthermore, as Marcie Frank points out, Behn implies that "those women (if there be any such)," who are so finely tuned to "that sort of conversation" that they can take offence at her plays, can only be the "figments of a male imagination with a predilection for obscenity."[21]

The cynical ploy, if that is what it is that Behn exposes, looks a poor thing next to Lord Orville's vicarious yet kindly intended disapprobation of *Love for Love*. It surfaces again in Collier's *Short View of the Immorality and Profaneness of the English Stage*.[22] Collier found modern plays smutty, blasphemous and debauched, and believed he was not alone in this. "Do women leave all the regards to decency and conscience behind them when they come to the playhouse?" he asked. "To treat the ladies with such stuff is no better than taking their money to abuse them."

In such a cultural climate, the tribe of Behn—those women who openly wrote for the indecorous motive of making a living—could well expect the hypocritical disdain of their male peers. Behn herself had not only insulted the women in the audience; she was not fit to write precisely because she was a woman. This was the view,

19. Quoted in Marcie Frank's *Gender, Theatre, and the Origins of Criticism: From Dryden to Manley* (Cambridge: Cambridge University Press, 2003), p. 103.
20. A criticism echoed in *The Adventures of Rivella* (1714) by Delariviere Manley: "If she had been a man, she had been without fault: but…what is not a crime in men is scandalous and unpardonable in women."
21. Frank, *Gender, Theatre, and the Origins of Criticism*, p. 99.
22. "The business of plays," Collier proclaims "is to recommend virtue and discountenance vice…. This design has been oddly pursued by the English stage."

at least, of the "long, lithe, phlegmatic, white, ill-favoured, wretched fop" in the pit at the opening night of *The Dutch Lover* (1673), as the playwright scathingly recollected:

> this thing, I tell you, opening that which serves it for a mouth, out issued such a noise as this to those that sat about it, that they were to expect a woeful play, God damn him, for it was a woman's.[23]

Among the more blatantly misogynistic condemnations of Behn was Robert Gould's notorious couplets on her as one of the female "hackney writers" whose poetical and sexual debasement were aspects of the same willingness to trade on themselves: "For *punk* and *poetess* agree so pat, / You cannot well be *this* and not be *that*."[24] But, as Derek Hughes has argued, this remark should not be read as anything more than the spiteful misogyny of a poetaster willing to disparage the dead. Furthermore, Behn may seem "marginal and threatened" as a lone woman among professional men, but Gould reminds us that she is "only the third professional dramatist to emerge since 1660."[25] The whole *business* of writing plays and the status of the playwright of both sexes are in transition, in which context, Gould's couplet recalls the stereotyping of actresses as whores. Perhaps not a little jealous of a more successful writer, he claims her as his scapegoat, by implication, the exclusive masculinity of writing.

As Chagrin, one of the interlocutors in *A Comparison between the Two Stages* (1702) asks, "What a pox have the women to do with the Muses?" "I grant you the poets call the Nine Muses by the name of women, but why so? Not because the sex had anything to do with poetry, but because in that sex they're much fitter for prostitution." Like Gould, Chagrin goes on to make the case for authorship as inherently, because etymologically, masculine:

23. From the play's preface of 1673.
24. Robert Gould, *The Poetess: A Satyr* (1707), p. 3–4.
25. Derek Hughes, "The Masked Woman Revealed: Or, the Prostitute and the Playwright in Aphra Behn Criticism," *Woman's Writing* (2000), vol. 7, no. 2, p. 156.

> I hate these petticoat-authors; 'tis false grammar, there's no feminine for the Latin word, 'tis entirely of the masculine gender, and the language won't bear such a thing as a she-author.[26]

For women who wrote in the face of such hostility, one apologetic way into marketable legitimacy, was to present the literary part of her brain as somehow masculine, desexualized, or anonymous. Eliza Haywood's *Female Spectator* ran a letter in 1744, purporting to be written by the distressed "Distrario", and taking to task theatre managers and the Lord Chamberlain's "Licensing-Office" for killing off new writing.[27] In response, Haywood observed that a powerful prejudice existed in favour of established writers and against unknown names, and recommended an anonymous submission process: "every one might send his play without ever being known from what hand it came, till it had been approved and was ordered to be acted." Although it should be remembered that the value placed on authorship was far from constant, and writers of both sexes found good reason to take shelter in anonymity, from Centlivre at one end of the century to Burney at the other. It is hard not to imagine that Distrario is itself the pseudonym of Eliza Haywood, the former playwright whose career in the theater closed as the Lord Chamberlain acquired new powers of censorship. Even complaining about plays was safer as a man.

From reading plays, to acting, writing, and finally making a viable career out of them: the author's sex was not always the subject of outright condemnation, but something that could be turned to good commercial advantage if correctly advertised. The author's sex made the perfect shorthand plea for indulgence, as an obvious, often formulaic marketing tool. The prologue to Hannah Cowley's first comedy, *The Runaway* (1776), makes recourse to this tactic with its very first couplet: "Oh list! A tale it is, not very common, / Our poet of tonight in faith's a—woman!" By then, the device was over a cen-

26. Anonymous, *A Comparison between the Two Stages* (1702), pp. 25–26.
27. *The Female Spectator*, Vol. 2, Bk. 8, pp. 69–89, December 4, 1744. Robert Walpole's Licensing Act of 1737 had made censorship law and regulated the proliferation of theatres.

tury old: "I'm hither come, but what d'ye think to say? / A woman's pen presents you with a play."[28] The system of repression described by Ellen Donkin in *Getting into the Act* relied on a concomitant idealization of women writers.[29]

In such a system, the female exception proved the male rule, exemplifying, as she did, womanhood that was sainted if not superhuman. And the veneration of this female exception depends on the elevated language of the patriarchal literary canon—indeed, often draws on the authority of a singular male great, such as Shakespeare or Dryden—and tends to shy away from the theatre itself.[30] Hence Elizabeth Inchbald's elevation to the status of "The Muse" or "The Tenth Muse" in a literary periodical called *The World* (1787–90).[31] (Germaine Greer remarked that "The tenth muse is always one like the phoenix and she always displaces all other claimants to the title; she is the exception that proves the rule that women have no talent.") Hence Elizabeth Montagu and her fellow Bluestockings, including the young Hannah More—who made her name with a tragedy, *Percy* (1777), and later disowned the theater—depicted as a Chagrin might have accepted, as the nine Muses of classical mythology.[32] Hence also John Duncombe's *Feminiad* (1754), with its high praise for virtuous, retiring women poets and its condemnation of the "bold, unblushing"

28. Frances Boothby, *Marcelia: Or, The Treacherous Friend* (1670).
29. Cf. Brigid Brophy, TLS, July 26, 1985: "To segregate women in a reference book of their own is offensive to egalitarians, the more so when the women are writers." The point is a sound one, even if it implies that egalitarians are not capable of owning more than one reference book. Brophy also describes George Ballard's *Memoirs of Several Ladies of Great Britain* (1752) as "a decent example of the eighteenth-century ardour for curio-hunting that was the protozoic form of so many disciplines and sciences." The same ardour is present in *The Belle's Stratagem*, with Lady Frances Touchwood's virtuoso father, or in Periwinkle in *A Bold Stroke for a Wife*.
30. The tribute to John Dryden called *The Nine Muses* (1700), with contributions from Centlivre, Delariviere Manley and Mary Pix, comes to mind. See also Hannah More's lines about Elizabeth Montagu and Shakespeare, quoted below.
31. Interviewed in *Early Modern Literary Studies* (January 2001), vol. 6, no. 3
32. An engraving featured in *The Ladies' Pocket Book* in 1778, that includes three other women besides More who wrote plays: Frances Sheridan, Charlotte Lennox and Elizabeth Griffith. To varying degrees, all four women were celebrated more as prose-writers than playwrights.

commercialism of writers like "modern Manley, Centlivre and Behn": "The modest Muse a veil with pity throws / O'er Vice's friends and Virtue's female foes." Finally, there is the teenage Hannah More, who justifies her *Search after Happiness: A Pastoral Drama*, which was performed by boarding-school girls for an exclusively female audience in the 1760s,[33] by calling on an essentially non-dramatic tradition:

> ...in our chaster times, 'tis no offence,
> When female virtue joins with female sense,
> When moral CARTER breathes the strain divine,
> And AIKIN's life flows faultless as her line;
> When all accomplished MONTAGU can spread
> Fresh gathered laurels round her Shakespeare's head;
> When wit and worth in polished BROOKE unite,
> And fair MACAULAY claims a LIVY's right.

Slightly different from the elevation of the female writer to the status of Muse, but no less restrictive, was the idea that "good women's poetry came from a tamed, domesticated body."[34] Although this is a less exclusive image than that of the Muse, it is ultimately a political stance nonetheless. The obedient wife's "contribution to the state was vital, as vital, indeed, as that of men":

> The confines of the home were the boundaries of her kingdom. This was where she exercised a gentle and improving sway over her husband and forged the next generation, breast-feeding and brainwashing her children into patriotic virtue. Women who neglected their families for the outside world...endangered the polity and violated their own natures.[35]

33. It was published 1773.
34. Jane Spencer, "Imagining the Woman Poet: Creative Female Bodies" in *Women and Poetry, 1660–1750*, edited by Sarah Prescott and David E. Shuttleton (New York: Palgrave Macmillan, 2003), p. 117.
35. Linda Colley, *Britons: Forging the Nation, 1707–1837* (Yale: Yale University Press, 1992), p. 239.

The scenario of neglect is substantially the same as that which Sheridan envisions in his epilogue to More's second tragedy, *The Fatal Falsehood* (1779). No wonder More would turn away from the theatre in disgust, after the death of her beloved David Garrick. Here was directly disrespectful treatment from the leading playwright of the day, a man not noted, during his years as Garrick's successor as manager of Drury Lane, for his generous attitude towards new writers, including women:

> A scene she now projects, and now a dish,
> Here's Act the First—and here—remove with fish.
> Now while this eye in a fine frenzy rolls,
> That soberly, casts up a bill for coals;
> Black pins and daggers in one leaf she sticks,
> And tears and thread, and bowls and thimbles mix.

Unlike More, Hannah Cowley was forthright in her admiration for her untamed predecessors, Behn and Centlivre. She rewrote *The Lucky Chance* (1686) by Behn as the controversial *School for Greybeards* (1786), and turned *The Stolen Heiress* (1702) by Centlivre into the farcical *Who's the Dupe?* (1779). She paid a conspicuous tribute to the latter's *A Bold Stroke for a Wife* with the title *A Bold Stroke for a Husband* (1783), just as she would acknowledge a male influence—George Farquhar, the author of *The Beaux' Stratagem* (1707)—with *The Belle's Stratagem* (1780). In the prologue to *The Runaway*, Cowley compensates for the trespass of her literary loyalties by eschewing the unnatural rigor of an archaic continental classicism:

> A woman, too, untutored in the school,
> Nor Aristotle knows, nor scarce a rule
> By which fine writers fabricated plays,
> From sage Menander's, to these modern days;
> …She ne'er has sought Apollo's classic fire,
> Or Muse invoked, or heard th' Aönian Lyre…

This humility before the patriarchal Parnassus leads naturally into a

plea for gallant indulgence from the audience. Cowley, it is said, is unfazed at the prospect of a theatre full of "squeaking catcalls, hisses, groans, / 'Off-off's, and critics' dread condemning moans":

> "I'm undismayed," she cried, "for critic men
> Will smile on folly from a woman's pen."
> Then, 'tis the ladies' cause! Why, I'm secure—
> Let him who hisses no soft nymph endure,
> May he who frowns be frowned on by his goddess,
> From pearls and Brussels-point to maids in bodice.[36]

The play itself is merely "rural, playful—harmless 'tis at least; / Not over-stocked with repartee or wit, / Though, here and there, perchance there is a hit." In this situation, manly "wit" is not disallowed but reborn in a domestic setting, one which Cowley could genuinely validate as a dutiful wife and mother who would later dedicate a comedy, *More Ways than One* (1783), to her husband, then working in India:

> Her Comic Muse—a little blue-eyed maid,
> With cheeks which innocence and health displayed,
> In lieu of Phoebus—but a romping boy,
> Whose taste is trap-ball, and a kite his joy;
> Her nursery, the study where she thought,
> Framed fable, incident, surprise and plot.
> …Our painter watched the lines which Nature drew,
> Her fancy glowed and coloured them for you;
> A mother's eye through each soft scene pervades,
> Her children rose before her flattered view,
> Hope spread the canvas, whilst her wishes drew!

As Betsy Bolton has argued, Cowley and Inchbald were adept at making "political stands *in the act of disavowing politics*" [emphasis added]:

36. In this line, "pearls and Brussels-point" indicates those rich ladies who sat in the boxes, while their lowlier counterparts, the "maids in bodice," sat in the gallery.

"the female dramatist participates in politics through an overdone performance of innocent restraint."[37] This performance depended on apparatus such as prologues and dedications (*The Belle's Stratagem* is dedicated to that exemplar of the political matron herself, Queen Charlotte) as much as, if not more than, the text itself.

A related alignment of physical and imaginative fecundity can be found in a poem by a female playwright who lacked the social connections and status that helped Cowley to get her plays staged.[38] The gifted and all too short-lived poet Mary Leapor (1722–46) expressed her disappointment at the rejection of her tragedy, *The Unhappy Father*, in a poem called "Upon her Play being returned to her, stained with Claret":

> WELCOME, dear wanderer, once more!
> Thrice welcome to thy native cell!
> Within this peaceful humble door
> Let thou and I contented dwell!
>
> But say, O whither hast thou ranged?
> Why dost thou blush a crimson hue?
> Thy fair complexion's greatly changed:
> Why, I can scarce believe 'tis you.
>
> Then tell, my son, O tell me, where
> Didst thou contract this sottish dye?
> You kept ill company, I fear,
> When distant from your parent's eye.
>
> Was it for this, O graceless child!

37. Betsy Bolton, *Women, Nationalism and the Romantic Stage: Theatre and Politics in Britain, 1780–1800* (Cambridge: Cambridge University Press, 2001), p. 234.
38. In particular, Cowley had an aristocratic patron, a bookseller for a father and a husband willing to review his wife's plays. She was also an experienced theater-goer based in London when she wrote *The Runaway*. Leapor's father was poor and she herself went into service as a kitchen maid, albeit it one who was much favored and looked after by the family she served.

Was it for this you learned to spell?
Thy face and credit both are spoiled:
Go drown thyself in yonder well.

I wonder how thy time was spent:
No news, alas, hast thou to bring?
Hast thou not climbed the Monument?
Nor seen the lions, nor the King?

But now I'll keep you here secure:
No more you view the smoky sky;
The Court was never made, I'm sure,
For idiots like thee and I.

Few rejection slips can have been so inspiring. Leapor casts herself as rural peasant, complete with humble abode and a pastoral world-view. Perhaps there is something more than rueful playfulness, though, in the depiction of her play as the prodigal son returning in disgrace from the big, bad city and the poetess as disappointed mother. In the imagery of an earlier poem, "To a Gentleman with a Manuscript Play," Leapor's play had figured as a *daughter* going into service. With its sexual metamorphosis, "face," "credit" and education ("Was it for this *you* learned to spell?") take a masculine turn, while the mother haunts the "native cell," deprived of news, experience, city smoke, and courtly sophistication. (The tourist's expectations of the metropolis in the penultimate stanza turn up again in the first scene of *The Belle's Stratagem*, in which the urbane Courtall bemoans the newfangled fashion consciousness of his country cousins.) Between the "dear wanderer" and the "peaceful humble door," the business of literature is suggestively "sexed up." It inverts the convention in which "poetic authorship was grounded in a hierarchical heterosexual relation," with "the poet's masculinity" acting "through his writing on the female beloved and the implicit femininity of the text he produced."[39]

39. Spencer, "Imagining the Woman Poet," p. 99. An exchange between the Dangles in Act 1, scene 1 of *The Critic* by Sheridan, in which Mrs. Dangle berates her

Nonetheless, the explicitly masculine manuscript sallies forth into the world at the price of picturesque exile for its creator.[40]

John Gay, Alexander Pope and John Arbuthnot's burlesque of 1717, *Three Hours after Marriage*, closes with an incident that comically anticipates Leapor's poem, as well as the prologue to *The Runaway*, when it presents women's writings and bastard births as equally perverse forms of female procreativity. The play's "scribbling woman," Phoebe Clinket, innocently creates uproar among her male interlocutors when she refers in a letter to her ludicrous tragedy, *The Universal Deluge, or the Tragedy of Deucalion and Pyrrha*, as her "child" or "offspring". Unaware of her poetic meaning, the men assume that she is talking about an unintended pregnancy, when she makes matters worse by saying:

> I am not in the least mortified with the incident. I know it has happened to many of the most famous daughters of Apollo; and to myself several times…. I have had one returned upon my hands every winter for these five years past.[41]

Clinket soon clarifies that she is in fact referring to the "offspring of my brain," but not before the aghast men have heard her

husband, offers a comic version of this paradigm: "And what have you to do with the theatre, Mr. Dangle? Why should you affect the character of a critic?…haven't you made yourself the jest of all your acquaintance by your interference in matters where you have no business?"

40. Susanne Kord writes of another poem by Leapor in *Women Peasant Poets in Eighteenth-Century England, Scotland and Germany* (Rochester, NY: Camden House, 2003) that: "the poet's themes and genres, the entire process of writing, can be vitally influenced by her predetermined reception. Publication…is viewed as an act of giving in to this influence, a conclusion that parallels the speaker's determination in 'Upon Her Play Being Returned To Her, Stained with Claret' to refuse to resubmit the play for production and instead have it disappear in the drawer."

41. Clinket has been identified with Centlivre, by Brean S. Hammond in *Professional Imaginative Writing in England, 1670–1740* (Oxford: Clarendon Press, 1997), pp. 203–204, but could also be a joke at the expense of Anne Finch, Countess of Winchelsea.

proud self-defense. Doctor Fossil has already diagnosed her composi-
tional compulsion as a female malady, not unlike the splenetic "fit"
Pope describes in *The Rape of the Lock* (and close, too, to Sheridan's
attitude in the epilogue to *The Fatal Falsehood*):

> ...alas, the poor girl has a providence of the pineal gland,
> which has occasioned a rupture in her understanding.
> I took her into my house to regulate my economy; but
> instead of puddings, she makes pastorals; or when she
> should be raising paste, is raising some ghost in a new
> tragedy.[42]

Once more, it seems to the triumvirate of male satirists bad enough
that who women who read cannot be regulated, let alone women
who write.[43]

Notably, during the middle years of the century, when Leapor
was writing, very few new plays by women reached the stage at all, in
spite of the rise of the literary Amazons acknowledged by Johnson.
Between Centlivre's death and Cowley's debut, those women who did
see their plays produced often enjoyed some prior and primary con-
nection with the theatre establishment. Such a connection authorized
these women to tread where someone like the genteel Fanny Burney
could not: that is, behind the scenes where, fairly unusually for the
period, men and women mixed freely and necessarily in a professional
capacity. They included Charlotte Charke (actress and daughter of
the actor-manager Colley Cibber), Frances Sheridan (wife of the
actor-manager Thomas and mother of Richard Brinsley), Elizabeth
Griffith (actress and daughter of a manager) and Garrick's leading

42. Cf. *The Rape of the Lock* (1712), Canto 4, in which Pope hails the goddess Spleen
as the "Parent of vapours and of female wit, / Who give th' *hysteric* or *poetic*
fit, / On various tempers act by various ways, / Make some take physic, others
scribble plays."

43. Cf. Edgeworth's "Letter from a Gentleman to a Friend, upon the Birth of a
Daughter": "I should not expect that my house affairs would be with haste
dispatched by a Desdemona, weeping over some unvarnished tale, or petrified
with some history of horrors, at the very time when she should be ordering
dinner, or paying the butcher's bill."

comedienne, Kitty Clive.[44] Phoebe Clinket stands for the outsider, the female Distrario—then again, *Three Hours after Marriage* was itself a scandalous failure and hardly the work of veterans.

The question arises, does all this heady discourse about the nature of genre and gender, society and artistic freedom, affect the contents and quality of the plays themselves? Plays, after all, differ from other literary forms, such as novels or poems, in their collaborative and performative nature, the disappearance of the author behind an array of masks, the changeable and temporary nature of performance itself, and the influence and interference of their spectators. Perhaps the patriotism of Leonora, the princess in Centlivre's unsuccessful tragedy *The Cruel Gift* (1716), sounds strikingly like the author's own Whig politics—

> The man, though never so meanly born in blood,
> That, next his soul, prefers his country's good;
> Who more than interest does his honor prize,
> And scorns by secret treachery to rise;
> That can the base and gilded bribe disdain,
> Prevent reflections on his prince's fame,
> And point out glorious virtues for his reign:
> That man should be a monarch's chiefest care,
> And none but such should royal favours wear.

—but this is far from being a unique or gender-specific passage, for either its point of view or its poetics. In the same way, although Centlivre is as keen to make fun of Quakers as she is to celebrate soldiers, often in the same play for the same reason, that this was a

44. See Cami Agan, "Catherine Clive's Media Relations: The Stage as Media and the Page as Performance," in *Eighteenth-Century Women* volume 3 (2003), pp. 47–76. Clive shows her tactical shrewdness by sending herself up in *The Rehearsal; or, Bayes in Petticoats*, taking her tone rather than content from Buckingham's burlesque of 1671 for a benefit performance in 1750. She played Mrs. Hazard, a female author whose burletta is thwarted because its star—one "Kitty Clive"—cannot attend rehearsal because she is too busy organising her benefit. In a further irony, "Mrs. Hazard," played by Kitty Clive, then takes over "Kitty Clive"'s part.

popular hallmark of hers speaks of the prejudices of her age more than it does for her own experience as a woman writer. The playwright and scholar Kendall, in her selection of early eighteenth-century plays by women, writes that "it is generally possible to distinguish a woman's play of the era from a man's without an author's name;" both in "female characterization" and "theme"[45] these were plays that could surprise and delight both men and women who, if this is true, would have seen nothing like the relationship between women in Mary Pix's tragedy *Queen Catherine* (1698) or Centlivre's *The Wonder* (1719) before. This certainly could apply to later plays, too, like *The Belle's Stratagem* by Cowley. Then again, turn to *A Bold Stroke for a Wife*, and you have an almost entirely passive heroine, powerless to escape her situation until a man rescues her. We should read these plays armed against our own expectations as well as those of other ages.

A Bold Stroke for a Wife (1718)

By the time the last play in this anthology was written, the first was eighty years old. Nonetheless, *A Bold Stroke for a Wife* remained a firm stage favorite throughout the age of Cowley and Inchbald, as did other plays by Centlivre, such as *The Busy Body* and *The Wonder: A Woman Keeps a Secret*. *A Bold Stroke for a Wife*, though, is quintessential Centlivre in its patriotic emphasis,[46] intrigue plot and humors comedy.

 A Bold Stroke for a Wife has a single and original plot: the campaign of Colonel Fainwell to win the hand of a young heiress in marriage. The heiress, Anne Lovely, has already promised herself to the Colonel when the play starts, on the condition, that is, that he can extricate her from the captivity imposed on her by her late, misanthropic father. He has given her four obstinate and contradic-

45. Kendall, ed. *Love and Thunder: Plays by Women in the Age of Queen Anne* (London: Methuen, 1988), pp. 10–11.
46. One of Centlivre's first plays set the tone for the rest of her career in its subtitle: *The Beau's Duel: or, A Soldier for the Ladies* (1702).

tory guardians—an old beau, a virtuoso, a stockbroker and a Quaker. Each would propose a husband for Anne of their own kind, whom the others are therefore bound to reject. The soldier must live up to his name and "feign well," playing the ideal husband as defined by each guardian in turn, and thus earning their consent to marry Anne. He has two friends—Freeman, a merchant, and Sackbut, landlord of the tavern where they meet—who turn out to be invaluable sources of disguise and information. Fainwell begins with the beau, Sir Philip Modelove, dazzling him with a display of fine clothes and French fashion, and easily securing his written agreement. The other guardians are harder to please, and the Colonel becomes increasingly unsure of his capacity to fool them. "I wish he had been an old soldier," he says of the stockbroker, Tradelove, "that I might have attacked him in my own way, heard him fight over all the battles of the Civil War—but for trade, by Jupiter, I shall never do it." The "hardest task" of all is to play the Quaker in order to impress Obadiah Prim: "Of all the counterfeits performed by man, / The soldier makes the simplest Puritan." Before the Quaker and the stockbroker, though, Fainwell has to deal with the virtuoso, Mr. Periwinkle, in the most pantomimic scene in the play.

For Centlivre, the guardians represent four laughable corners of society that are each, to differing degrees, unpatriotic. If the Colonel is her typically soldierly hero and loyal servant of the Crown, then they are all aspects of virtually treasonous self-interest: "avarice, impertinence, hypocrisy and pride." None of them shows especial affection or loyalty to their own country. Sir Philip disdains everything English for everything French,[47] while Tradelove admires the financial sophistication of the Dutch Republic, and shows a misplaced pride when he says "one merchant is of more service to a nation than fifty coxcombs. The Dutch know the trading interest to be of more benefit to the state than the landed." Periwinkle cannot wait to for his uncle to die so that he can inherit a fortune and spend the rest of his life on a global treasure hunt. Even Obadiah Prim has an overseas connection, with the staunchly Quaker territory of Pennsylvania.

47. Cf. Doricourt's tastefully divided loyalties in *The Belle's Stratagem*.

Freeman, Sackbut and the Colonel, meanwhile, are related not only by allegiance in their plot against these four, but also in a simple economic way, with Freeman the importer, Sackbut the immediate supplier, and the Colonel the drinker, of wine. Success with the lady, says the Colonel, will lead to more business for Sackbut. (The guardians, by contrast, obstruct Fainwell by obstructing one another.) It is a more mercantile than military hierarchy, and the Colonel's technique is likewise more smooth than shock tactics.[48] At the end of the play, when he reveals his true identity and assures the guardians of his military credentials: he has "headed a regiment of the bravest fellows that ever pushed bayonet in the throat of a Frenchman." Even so, the possible use of that prowess against his fellow Englishmen is never more than briefly implicit. Instead, Centlivre concentrates on a delightfully fleet-footed comedy of intrigue, farcical at some points and gripping at others, when it looks like the Colonel's plan is going awry.

At the same time, the play glances at the parallels between feigning well and fighting well, acting, courting, soldiering and trading and other social performances, parallels that might be drawn out in a modern production. An example of this is the lively scene Centlivre sets in the heart of the City, seemingly drawing on a close knowledge of London's stocks and shares mania in the years before the unprecedented financial disaster of the South Sea Bubble. Tradelove yearns to trick a certain speculator just as the Colonel seeks to trick him, with Freeman's help. Great sums of money hang on a little inside information about affairs of state, and, as quickly as Tradelove thinks he has made a fortune, he has lost it. It must have made uncomfortable viewing in later years, when it was obvious with hindsight how neatly this scenario of greed and gullibility anticipated the spectacular catastrophe of 1720.

48. Brean S. Hammond, "Is There a Whig Cannon?: The Case of Susannah Centlivre," in *Women's Writing* (2000), Vol. 7, No. 3, p. 386: "Fainwell gains his ambition less through the deception devices of Restoration theatre (although he does resort to them) than through an ability to be liked: to oil the social wheels by playing back to the guardians a self-image of which they narcissistically approve. This is an eminently Addisonian way of being in the world. 'Exchange and civilisation of the passions', social consensus, is the play's desired end."

A Wife To Be Let

One of the things that might irk readers of *A Bold Stroke for a Wife* is its recurrent references to the heroine, Anne Lovely, merely as a moveable property to be exchanged among men—as a "city worth taking" or a "thirty-thousand-pounder." At the end of the play, the Colonel claims her as "this beautiful tenement" after he has fooled the last of her guardians into signing her away. In her comedy of 1724, *A Wife To Be Let*, Eliza Haywood toys with the same imagery. The play's setting—the provincial town of Salisbury—and its cast—including a soldier, a beau, witty women and country oafs—also show the influence of (Centlivre's friend) George Farquhar, whose final two comedies, *The Recruiting Officer* (1706) and *The Beaux' Stratagem* (1707) display all these features. There is also an extended military metaphor in the lovers' repartee, in the guise of skirmishes, sieges, fortification, storming the town.

As its title announces, however, *A Wife To Be Let* reduces the idea of a man's wife as his property to an absurdity. Mr. Graspall, who speaks the same doting yet manipulative language to his young wife as Centlivre's old misers (in *The Busy Body*, among others), thinks avariciously of hiring her out to her admirer, Sir Harry Beaumont, whom she has virtuously and repeatedly repulsed. (The name recalls Farquhar's archetypal easy-going pleasure-seeker, Sir Harry Wildair, who appears in *The Constant Couple* of 1699 and the 1701 sequel named after him.) His wife, argues Graspall, is of no more use to him than his sword; both are merely decorative to him and, for the right price, both may be borrowed—although, in this respect, Sir Harry is not as carefree as he seems.

In the play's parallel plot, more conventionally mercenary matches for Marilla and her cousin Celemena look likely to go ahead in spite of the undesirability of their respective husbands-to-be, Toywell and Sneaksby. The heroes of the play, Courtly and (another soldier) Captain Gaylove behave much as their counterparts might have done in a comedy by Wycherley or Etherege, and seek to undermine these matches by making Toywell believe that Marilla is impoverished,

thus exposing his "mercenary base nature," and effectively disinheriting Sneaksby by finding his rich aunt a husband.

Unlike *A Bold Stroke for a Wife*, Haywood's comedy ties itself in narrative knots as it switches between the title-plot, about the unscrupulous miser and his virtuous wife, and the loosely related events at the houses nearby. It takes a while to get into its stride, and most of the characters are stock-types. Once the action is under way, however, Haywood comes to life with the characterization of the buffoons Sneaksby and Toywell, the wily double act of the servants Shamble and Dogood, and the miserly Mr. Graspall. Like Penelope Aubin and Mary Davys, Haywood might be seen as a novelist who deviated into drama briefly, even mistakenly. She nevertheless shows a promise in this comic play that her tragedies do not hold out, and would have to wait until *The Opera of Operas* (1733), her spirited, co-written version of Fielding's burlesque *Tom Thumb*, to be seen again. Furthermore, as Toni Bowers and Stephanie Harzewski have written, the play

> unmistakably bears the Haywood stamp: indeed, it has almost more characters, subplots, and action than one might expect even from Haywood. And it engages themes that would occupy the author for her entire career: greed, appearance vs. reality, courtship games, married chastity vs. extra- or pre-marital passion, assignments and exchanges of power between the sexes.[49]

The Witlings

Although not overtly patriotic, Fanny Burney's satire on would-be literary ladies and other monsters of her own sex in *The Witlings* is somewhat reminiscent of Centlivre's outright vilification of Quakers, fops and stockbrokers in *A Bold Stroke for a Wife*. And whether or

49. *The Age of Johnson* 13 (2002), p. 481.

not it refers to specific contemporaries, the comedy contributes to a genre to which women are supposed to be relatively inconspicuous contributors: ruthless satire. It has the same jaunty yet acerbic tone as Byron's "literary eclogue" called "The Blues," in which Sir Richard Bluebottle complains of the company that his wife's learned leanings attract, a "numerous, humorous, backbiting crew/ Of scribblers, wits, lecturers, white, black, and blue,/ …No pleasure! no leisure! no thought for my pains,/ But to hear a vile jargon which addles my brains;/ A smatter and chatter, glean'd out of reviews,/ By the rag, tag, and bobtail, of those they call 'BLUES'…." Significantly, Burney embodies her satirical energies in a male character, Censor, who quotes from Pope's *Essay on Criticism* (1711):

> A little learning is a dangerous thing;
> Drink deep, or taste not the Pierian spring:
> There shallow droughts intoxicate the brain,
> And drinking largely sobers us again.

Censor's targets are mainly women. Besides Lady Smatter, who pretender to the kind of literary knowledge that Censor commands with ease, there is Mrs. Sapient, who quotes nothing but her own facile truisms, and Mrs. Voluble, an unstoppable, unscrupulous gossip. In addition, the play's heroine might be read as a melodrama queen, with her ludicrously heightened sensibility and sensitivity to slight. Still, the men do not escape ridicule, with the over-cautious, pedantic Mr. Codger, his son, the ever-hasty Jack, and, completing the sentimental couple, Cecilia's fiancé Beaufort. In their different ways, Burney's humorous types are all wrong-headed, shallow-drinkers, as perilously incompatible a group as Anne Lovely's guardians.

The Witlings takes place over a single protracted day, its length an indication of Burney's enthusiasm for painting as full a scene as possible. It begins with a wonderful, convincing scene set in a milliner's shop, with Mrs. Wheedle overseeing her employees, Mrs. Voluble gossiping, customers and coachmen coming and going. The contrast with the prosaic exposition that opens *A Wife To Be Let* could not be greater. Even when Beaufort enters, dragging Censor with him, it is

a false start, for Beaufort has only come in order to meet his fiancée, Cecilia, and she fails to appear. Instead, the men encounter Mrs. Sapient, who gives them an ominous taste of her mediocre intellect, and mentions the Esprit Club, the private literary club of which she, Lady Smatter and Mr. Dabler are the main members.

It is explained further in Act 2, which is set in Lady Smatter's house. The other members of the Club are introduced: Mr. Codger; Mr. Dabler, the vain and superficial poet; and Lady Smatter herself. Disaster looms when Jack rushes in with word of Cecilia's bankruptcy. Smatter promptly forbids her nephew Beaufort from marrying a "beggar" and offends the distraught Cecilia into leaving the house. The rest of the play sees Censor attempt to save the lovers from ruin, and expose the assorted witlings as frauds in the process.

In its underlying threat of financial downfall, either by disinheritance or bankruptcy, *The Witlings* echoes *A Bold Stroke for a Wife* and *A Wife To Be Let*. In the latter play, Toywell deliberately infuriates his fiancée in order to provoke her into breaking off their engagement because he believes her to be ruined, just like Cecilia. In the former, the risky business of the stock market reflects the hero's own adventure in pursuit of wealth as well as contemporary circumstances. Fear of this kind of financial crash, both before and after the wake of the South Sea Bubble, marks a distinctively eighteenth-century twist on the Restoration comic formula. How Stipend, Cecilia's banker, has fouled up is never made clear, but it would be misrepresenting the play to dismiss this merely as a plot device, secondary to the main business of satirizing the witlings themselves. After all, moral, intellectual and financial bankruptcy are equally at stake.

The satire on the witlings and the state of Cecilia's finances are also linked by the motif of events or information being deferred, interrupted, incomplete or exaggerated. Just as Censor can't stop Cecilia getting emotionally carried away in Act 3 when Beaufort fails to come to her rescue, Codger cannot help but offend the rest of the Esprit Club because they do not have the patience to endure his speeches. Nobody waits for the rumor of Stipend's ruin to be verified; nobody listens to one another in the Esprit Club. They refuse to take more than "A little learning" at a time.

The play could be seen principally as a brilliantly shaggy dog story, a mock-melodrama, a storm in a teacup, were it not for the crucial part the bankruptcy plot plays in exposing the false basis on which the marriage of Cecilia and Beaufort was proceeding, with the lovers utterly dependent on the approval of their moneyed elders. Lady Smatter's insensitive proclamation of the importance of Literature with a capital "L" over material well being, let alone wealth, is exposed as a fatuous status symbol, a luxury item. While Centlivre's Colonel claims a victory for "liberty of choice" at the end of *A Bold Stroke for a Wife*, Beaufort concludes *The Witlings* in praise of "self-dependence", thus answering his own earlier question: "Oh misery of dependence! The heaviest toil, the hardest labour, fatigue the most intense—what are they compared to the corroding servility of discontented dependence?":[50]

> …self-dependence is the first of all earthly blessings… those who rely solely on others for support and protection are not only liable to the common vicissitudes of human life, but exposed to the partial caprices and infirmities of human nature.

At the very end of the play (and the day) comes the news, allowed to pass without comment, that Cecilia's finances are not so badly dented as was immediately reported. The news seems too good to be true, a last-minute reprieve for the sake of the comic structure of the piece, but it also deftly emphasizes the absurdity of the whole affair and shows Burney on her best ironic behaviour.

The Belle's Stratagem

In spite of the efficacy of Burney's protectors, which ensured that *The Witlings* was not staged, Richard Brinsley Sheridan , manager of

50. Act 3, scene 1.

Drury Lane, did find himself with a palpable hit on his hands in 1780, and it was one written by a woman: *The Belle's Stratagem* by Hannah Cowley, one of the great plays of the period. Cowley's comedy thoroughly deserves the place in the classical repertoire that it held long into the nineteenth century, alongside its fellow "laughing comedies" by Goldsmith and Sheridan. Goldsmith had considered the same title for *She Stoops To Conquer* (1773), and it is easy to see the two plays as complementary. Both feature a heroine who disguises herself as a "low" character in order to win the love of a man who is ostensibly, but unromantically, hers already. While one is set entirely in the country, mostly and farcically in a single house, the other is decidedly metropolitan. Cowley's play takes a grand tour of London life, complete with morning visits, celebrity journalism, an auction-house, conversation "over a bottle," and a spectacular masquerade, pursuing its twin plots through anonymous, pleasure-seeking crowds.

One plot, as in *A Wife To Be Let*, concerns an arranged marriage. Nobody opposes it, and, in this instance, the fathers have agreed on the details well in advance. The bride and groom, who have not met since childhood, just have to like each other; but when Doricourt returns from the Grand Tour as the toast of the town to be re-introduced to Letitia Hardy, he can summon little feeling beyond polite indifference. Letitia, correctly interpreting this muted reaction, promises herself that she will "touch his heart, or never be his wife." An encounter with her in her first disguise, as a clumsy country girl, inspires in Doricourt a passionate horror of the predestined marriage, heightened further by her appearance at a masquerade as an ultra-sophisticated mask who enthralls him but he is bound not to pursue.

In the secondary plot, a marriage has already taken place. It has transformed Sir George Touchwood from a gregarious socialite into a jealous killjoy. He speaks from experience when he speaks of fashionable society as "universal masquerade" in Act 2, a "mere chaos," in which "all distinction of rank is lost." He uses the foppish Flutter as an "illustration," the epitome of the modern man who, from his appearance, could be almost anybody—"a privy counsellor or a mercer, a lawyer or a grocer's apprentice." In Sir George's eyes, Lon-

don is not the place for a beautiful and naïve young wife like Lady Frances Touchwood, and he cannot wait to whisk her away into the safety of the countryside. London fights back, however, in the form of Mrs. Racket, who co-opts Lady Frances into her daily round of activities, and, more dangerously, of the rakish Courtall, who wagers with their mutual friend Saville that he can "prevail on her" at the masquerade, "only to taste the fresh air, I mean." To Courtall, Lady Frances's reproach to his flirtations, that she is married, is simply a "good hint."

In the end, it is not Sir George who saves Lady Frances from Courtall, but Saville, the former admirer who gives up any pretense of courting her, citing his inferior rank and fortune: "I had not the arrogance to look so high." In this respect, he is Courtall's antithesis, an essentially conservative riposte to the promiscuous pleasure-seeker. He also bears a family resemblance to the preposterously decent (and eponymous) hero of Samuel Richardson's highly influential novel *Sir Charles Grandison* (1753–54), whose rescue of the heroine, Harriet Byron, is one of (too) many good deeds. Saville saves Lady Frances from Courtall, but he can only do this by adopting the tactics of the masquerade itself, in which distinctions of rank are lost, and then delivering her safely to her husband. Doricourt, meanwhile, is effectively seduced by the disguised Letitia and his own feigned attempt at madness, to escape marriage, completely fails. Cowley may be looking down and laughing at the affected servants, the "puffers" employed to hype an auction, the gossipmongers, masqueraders and ladies in search of a husband, but she knows that they are essential to her theme; *The Belle's Stratagem* is a joyous comedy.

Lovers' Vows

The drama of August von Kotzebue (1761–1819) had a brief but bright burst of popularity in England during the late 1790s. Often tense and well-constructed, adaptations of Kotzebue's plays included *Pizarro* (1799) by Sheridan, *La Peyrouse* (1797), staged as a pantomime in the

same year, and *The Stranger* (1798) by Benjamin Thompson. Around the same time, Thomas Harris, the manager of Covent Garden, asked Elizabeth Inchbald to adapt *Kind der Liebe* (1796). *Lovers' Vows* was an immediate success, making a remarkable initial run of forty-five performances. Although the taste for Kotzebue is long gone, Inchbald's version of one of his plays lives on in curious form, as a crucial component in Jane Austen's novel *Mansfield Park*. This preservation in literary amber also seems significant as an emblem of the changing relationship between the page and the stage, and between the distinguishing qualities of both forms.

The story of *Lovers' Vows* is a simple one: a family is reunited. Agatha, reduced to illness and poverty, encounters her son Frederick, a soldier home on leave, and is forced to confess to him her unfortunate history. A nobleman seduced and then abandoned her; the birth of their illegitimate child, Frederick himself, disgraced her further. She has made her own way, but now she is too ill to work, and Frederick goes off to beg on her behalf. In desperation, he tries to rob a nobleman whom the audience knows to be his father, Baron Wildenhaim. The Baron has returned to his German estate from France and is, strangely enough, desperate to find his long-lost Agatha, whom he has long searched for in vain. He has brought with him a priest called Anhalt, tutor to his daughter Amelia, and a suitor for her too, as unsuitable a man in his way as Toywell or Sneaksby in *A Wife To Be Let*. Count Cassel has money and rank on his side, but little else. Needless to say, he is not much competition for the man whom Amelia loves, her tutor Anhalt. Like Sir George and Lady Francis Touchwood, who defy the dictates of fashionable society, and dare to be seen in public as loving husband and wife, the Baron comes round to valuing love over birth and fortune.

Lovers' Vows is therefore a story too good to be true, full of convenient coincidences and populated by basically good, forgivable characters. It is the nearest thing in this selection of plays to the modern Hollywood tearjerker, and comes complete with a final tableau in which Anhalt raises his arms gratefully to Heaven as the family comes together with nothing more to say. Sentiments gush forth all the more strongly in *Lovers' Vows* for being long restrained. Anhalt

denies his love for Amelia, for example, not least because he is her social inferior, as Saville is Lady Frances's. Inchbald's humor and pace make the play a much less banal experience than this outline might imply, but finally, as one modern reader has put it, "If *Lovers' Vows* has been granted immortality, it is courtesy of Jane Austen":

> One token of the play's success was that Austen should have assumed knowledge of the plot on the part of her readers, and one worthwhile reason for reading the work is that such a knowledge helps to sharpen the irony in her novel.[51]

While it is hard to miss in the history of control and repression in the story of female writers in the eighteenth century, this is not the only way that story can be told. The seemingly perennial theme of town versus country—fast living in the metropolis versus the stable, rural community and its stable, rural values—is another example of a perennial theme that some of these plays give an idiosyncratic twist. It is not surprising that this dichotomy colors *A Wife To Be Let* and *The Belle's Stratagem*, even though the two plays are separated by sixty years, given its ubiquity in English literature. Likewise, something of Sir Philip Modelove's French fashion consciousness resurfaces in Doricourt's continental sophistication. The sentimental strain of the dialogues between Mrs. Graspall and Sir Harry Beaumont returns in those of Cecilia and Beaufort, Sir George and Lady Touchwood, and Anhalt and Amelia.

More particular to the plays gathered here is the theme of patriarchal power and lovers' evasions of it. *A Bold Stroke for a Wife* starts with the nihilistic dictates of Anne Lovely's father (it is hard to imagine that "Mr. Lovely" was very suitably named), while Marilla's promise to her late father that she will marry Toywell is at the root of one subplot in *A Wife To Be Let*. Variations appear in *The Belle's Stratagem*. Gossip about Lady Frances tells us that she was formerly

51. Paul Jarman, review of *Five Romantic Plays, 1768–1821*, edited by Paul Baines and Edward Burns (Oxford: Oxford University Press, 2001) in the TLS, April 27, 2001, p. 21.

cooped up in Shropshire like one of her father's "curiosities" (an echo of Anne Lovely's fate were Periwinkle to get his way), while Mr. Hardy reminisces sentimentally about Doricourt's late father and the agreement they made on their children's behalf. In contrast to these dead paternal hands is the benevolent father figure who features in several of these plays, who wants the best for his daughter(s) and heartily admits to mistakes like misjudging character. Such a philanthropic spirit finds absurd expression in "Sir Charles Grandison," Jane Austen's gleeful, carefree take on Richardson's fat novel about an unbelievably good man.

Such paternal figures perhaps relate to the conflict of love and pragmatism that sees a miser treating his wife as a property for hire and being punished for it, while Anne Lovely tempers her passion for Colonel Fainwell with similar advice to Censor's to Beaufort:

> Is not security from want the basis of all happiness? And
> if you undermine that, do you not lose all possibility of
> enjoyment? Will the presence of Cecilia soften the hard-
> ships of penury? Will her smiles teach you to forget the
> pangs of famine? Will her society make you insensible
> to the severities of an houseless winter?

On the other hand, Doricourt is prepared to abandon a fortune in order to escape what seems like the marriage of his nightmares, and Frederick is prepared to risk death for the sake of a precious few coins. These financial tribulations have dramatic consequences, in the negotiation of a price on love and happiness (Beaufort's romantic willingness to impoverish himself for the sake of Cecilia), the exposure of gold-diggers (like Toywell) and the hard lesson of what Burney calls "the dire guidance of necessity." If such issues return again and again in these plays, it is an indication of their continuity, regardless of authorial gender, yet each has attractive, even unique, qualities. Such literary merits guarantee that the reader who turns to them out of an interest in eighteenth-century history, literature or women's studies, or in search stage-worthy drama, will not be disappointed.

A Note on the Texts

Ｎone of the published plays has especially fraught textual histories (although see the appendix on Jane Austen for a brief account of the manuscript of "Sir Charles Grandison"). A collation of copies of *Lovers' Vows*, for example, in its second, fifth and eleventh editions revealed nothing more than minor emendations. *The Belle's Stratagem*, for another, was twice pirated in Dublin in 1781, the year before Thomas Cadell printed the authorized edition in London, but the omissions are fairly minor. More programmatic are the amendments Cowley made for the three-volume *Works* published at the end of her life 1813, but these have been eschewed in favour of the livelier originals.

A Bold Stroke for a Wife, *The Belle's Stratagem* and *Lovers' Vows* were all reprinted frequently in the eighteenth century, and have featured in modern editions at one time or another. In each case, new texts have been compared with old (or, in the case of *The Witlings* and "Sir Charles Grandison," with the manuscripts or facsimiles). Spelling has been modernized, and the majority of extraneous capital letters and idiosyncratic punctuation excised, as in quotations given in the introduction. Some silent corrections have been made in the interest of clarity.

Select Chronology

This chronology concentrates on the lives and works of the female playwrights represented in this anthology, in the context of literary and theatrical culture and eighteenth-century history. See the bibliography for some suggestions about where to find detailed narrative accounts of the period.

1669 Susannah Centlivre born?

1693 Eliza Haywood born?

1698 Jeremy Collier, *A Short View of the Immorality and Profaneness of the English Stage.*

1700 Centlivre, *The Perjured Husband*; Mary Pix, *The Beau Defeated*; Catherine Trotter, *Love at a Loss*; William Congreve, *The Way of the World.* Death of John Dryden. A collection of tributes, *The Nine Muses*, appears, with contributions from Centlivre, Delarivière Manley and Mary Pix.

1701 Trotter, *The Unhappy Penitent*; Pix, *The Czar of Muscovy* and

The Double Distress. Act of Settlement. War of the Spanish Succession begins.

1702 Centlivre, *The Stolen Heiress* and *The Beau's Duel*; *Daily Courant*, London's first daily newspaper, begins publishing in March. Death of King William III and accession of Queen Anne. War of the Spanish Succession.

1703 Centlivre, *Love's Contrivance*; Pix, *The Different Widows*; Nicholas Rowe, *The Fair Penitent.*

1704 The English capture Gibraltar; Marlborough defeats the French at Blenheim. Jonathan Swift, *A Tale of a Tub* and *The Battle of the Books.*

1705 Centlivre, *The Basset Table*, and *The Gamester*; Pix, *The Conquest of Spain.* Haymarket Theatre opens.

1706 Centlivre, *Love at a Venture* and *The Platonick Lady*; Manley, *Almyna*; Trotter, *The Revolution of Sweden*; Pix, *The Adventures in Madrid.*

1707 George Farquhar, *The Beaux' Stratagem.* Union of England and Scotland.

1709 Centlivre, *The Busy Body* and *The Man's Bewitched*; Richard Steele, *The Tatler* (till 1711).

1710 Centlivre, *Mar-Plot*, the sequel to *The Busybody*, and *A Bickerstaff's Burying.*

1711 Joseph Addison and Steele, *The Spectator* (till 1712); Alexander Pope, *An Essay on Criticism.* Mrs. Salmon's waxworks open in Fleet Street.

1712 Centlivre, *The Perplexed Lovers.*

1713 Addison, *Cato.* End of the War of the Spanish Succession.

1714 Centlivre, *The Wonder: A Woman Keeps a Secret.* Death of Queen Anne and accession of George I.

1715	Centlivre, *The Gotham Election* and *A Wife Well Managed.* The Jacobite Rebellion. Death of Louis xiv. Steele becomes Governor of Drury Lane and John Rich becomes manager of Lincoln's Inn Fields.
1716	Centlivre, *The Cruel Gift*; Mary Davys, *The Northern Heiress.*
1717	Manley, *Lucius, the First Christian King of Britain.*
1718	Centlivre, *A Bold Stroke for a Wife.* War with Spain declared
1719	Daniel Defoe, *Robinson Crusoe.*
1720	South Sea Bubble. Little Theatre in the Haymarket opens. Steele starts a periodical called *The Theatre.*
1721	Haywood, *The Fair Captive.* Walpole becomes "Prime Minister."
1722	Centlivre, *The Artifice*; Steele, *The Conscious Lovers.*
1723	Haywood, *A Wife To Be Let.* Centlivre dies.
1726	Swift, *Gulliver's Travels.*
1727	Death of George i and accession of George ii.
1728	John Gay, *The Beggar's Opera*; Pope, *The Dunciad.*
1729	Haywood, *Frederick, Duke of Brunswick-Lunenburgh.* Thomas Odell opens the Goodman's Fields Theatre in Stepney.
1730	Penelope Aubin, *The Humors of the Masqueraders*; Marivaux, *Le Jeu de l'amour et du le hasard*, a comedy translated by Lady Mary Wortley Montagu, within the next few years, as *Simplicity*; Henry Fielding, *Tom Thumb* and *The Author's Farce* (lampooning Haywood as "Mrs. Novel"); James Thomson, *The Seasons.*
1731	George Lillo, *The London Merchant.* Edward Cave founds the *Gentleman's Magazine.*

1750 Catharine Clive, *The Rehearsal: or, Bays in Petticoats.*

1751 Charlotte Lennox, *The Female Quixote.*

1752 Fanny Burney born.

1753 Lennox, *Shakespeare Illustrated*; Richardson, *Sir Charles Grandison.* Elizabeth Inchbald born.

1755 Charke, *A Narrative of the Life of Mrs. Charlotte Charke*; Johnson's *Dictionary of the English Language.*

1756 Haywood dies. Frances Brooke, *Virginia*; John Home, *Douglas.* Seven Years War begins.

1757 Edmund Burke, *A Philosophical Enquiry into the Origin of our Ideas of the Sublime and Beautiful*; Richard and Elizabeth Griffith, *A Series of Genuine Letters between Henry and Frances.*

1760 Laurence Sterne, *Tristram Shandy*; Death of George II; his grandson succeeds as George III. Theresa Cornelys opens her assembly rooms at Carlisle House.

1761 John Beard becomes manager of Covent Garden.

1762 William Almack founds his dining club.

1763 Frances Sheridan, *The Discovery* and *The Dupe.* Treaty of Paris ends the Seven Years' War with France.

1764 Horace Walpole, *The Castle of Otranto.*

1765 Griffith, *The Platonic Wife.*

1766 Garrick and George Colman the Elder, *The Clandestine Marriage*; Griffith, *The Double Mistake.*

1768 Sterne, *A Sentimental Journey through France and Italy.* Royal Academy of Arts founded with Sir Joshua Reynolds as its first President.

1769 *The Sister* by Lennox lasts one night at Covent Garden;

Montagu, *Essay on the Writings and Genius of Shakespeare*;
Griffith and Garrick, *The School for Rakes*.

1771 Henry Mackenzie, *The Man of Feeling*.

1772 Mansfield Decision undermines slavery on British soil. The
Pantheon assembly rooms open in Oxford Street.

1773 Oliver Goldsmith, *She Stoops To Conquer*. Boston Tea Party.

1775 Lennox, *Old City Manners*; Richard Brinsley Sheridan, *The
Rivals* and *The Duenna*; Griffith, *The Morality of Shakespeare's
Drama Illustrated*. Jane Austen born. War with the American
colonies begins. Sarah Siddons makes her London debut.

1776 Cowley, *The Runaway*; Edward Gibbon, *Decline and Fall
of the Roman Empire*; Charles Burney, *General History of
Music*. Garrick retires with a performance of *The Wonder*
by Centlivre. American Declaration of Independence.

1777 Hannah More, *Percy*; Sheridan, *The School for Scandal*;
Brooke's novel *The Excursion*, about a heroine in London
seeking success as a writer, criticizes Garrick for not sup-
porting new work; Adam Smith, *The Wealth of Nations*.

1778 Burney, *Evelina*.

1779 Cowley, *Countess Raimond* and *Who's the Dupe?*; More, *The
Fatal Falsehood*; Griffith, *The Times*; Burney, *The Witlings*.

1780 · Cowley, *The Belle's Stratagem*; Lee, *The Chapter of Accidents*.
Gordon Riots in London.

1781 Brooke, *The Siege of Sinope*.

1782 Cowley, *Which Is the Man?*; Burney, *Cecilia*. End of the
American War of Independence. Surrey Theatre opens on
Blackfriars Road.

1783 Cowley, *A Bold Stroke for a Husband* and *More Ways than
One*; Brooke, *Rosina*. Peace of Versailles ends war between
Britain and France in North America.

1784 Johnson dies.

1785 Inchbald, *I'll Tell You What.*

1786 Cowley, *A School for Greybeards.*

1787 Inchbald, *Such Things Are, The Midnight Hour* and *All on a Summer's Day.*

1788 Cowley, *The Fate of Sparta*; Inchbald, *Animal Magnetism* and *The Child of Nature*; Brooke, *Marion.* Trial of Warren Hastings, governor of India. First Regency Crisis, as George III succumbs temporarily to insanity.

1789 Inchbald, *The Married Man.* French Revolution begins with the formation of the National Assembly in June, the storming of the Bastille in July, and the *Declaration of the Rights of Man and Citizen* in August.

1790 Burney works on three verse tragedies, *Hubert De Vere, The Siege of Pevensey* and *Elberta.*

1791 Inchbald, *Next Door Neighbours* and her first novel, *A Simple Story.* Amelia Opie's *Adelaide* is privately produced in Norwich.

1792 Mary Wollstonecraft, *A Vindication of the Rights of Women.*

1793 Griffith dies. Louis XVI executed; war is declared against France.

1795 Burney's *Edwy and Elgiva* lasts one night at Drury Lane. Cowley, *The Town before You*; Matthew Lewis, *The Monk*; Maria Edgeworth, *Letters for Literary Ladies.*

1796 Inchbald's second novel, *Nature and Art*; Burney, *Camilla.*

1797 Inchbald, *Wives as They Were, and Maids as They Are,* and *Lovers' Vows*; Baillie, first volume of *Plays on the Passions*; Lewis, *The Castle Spectre*; William Wordsworth and Samuel Taylor Coleridge, *Lyrical Ballads.* Nelson wins the Battle of the Nile.

1799 Charlotte Smith, *What Is She?*. Burney's comedy *Love and Fashion* is cancelled in rehearsal.

1800 Burney, *A Busy Day* and *The Woman-Hater*; Charles Dibdin, *A Complete History of the Stage*; Approximate date of Austen's completion of "Sir Charles Grandison."

1809 Cowley dies.

1814 Austen, *Mansfield Park*; Burney, *The Wanderer*.

1817 Austen dies.

1821 Inchbald dies.

1840 Burney dies.

Susannah Centlivre:
(?1669–1723)

S usannah Centlivre did not lead a dull life. The various contradictory accounts published during and after that life agree on this point at least (although that is far from proving it to be true). Giles Jacob's Poetical Register of 1719 makes her the daughter of a Mr. Freeman who died while she was very young, while John Mottley claims that her stepmother drove her to leave home. In *The British Theatre* (1750), William Rufus Chetwood, a retired prompter, records that she then became a strolling player. Mottley, in his *Compleat List of All the English Dramatic Poets* published with Thomas Whincop's *Scanderberg* (1747), claims that she wore men's clothes and lived with Anthony Hammond in Cambridge as a student for several months. She may have been born as early as 1667, or as late as 1677. Accounts of her life often fall back on the likely birth-date of 1669.

It is easy to believe Jacob when he says that she was educated "by her own industry and application" and "was inclined to Poetry when very young." By 1706, she was an actress. This was when Joseph Centlivre, principal cook (or "Yeoman of the Mouth") in Queen Anne's household, first saw her, when she played the breeches role of Alexander the Great in a performance of *The Rival Queens* by

Nathaniel Lee at Windsor Castle. They were married in 1707. Yeoman Centlivre was possibly her second or third husband. She had already published several plays under the name "Susannah Carroll" after her marriage to a soldier who "succeeded in her affections" (as Mottley put it; "A soldier is her darling character," runs one epilogue), and become a friend of Mary Pix, Nicholas Rowe, Richard Steele, Colley Cibber, and George Farquhar.

In apocryphal terms, then, Centlivre recalls the pioneering professional playwright whose pseudonym, "Astraea", she borrowed in published correspondence with "Celadon" (Abel Boyer): Aphra Behn. *The Female Tatler* took a more literary view when it "rejoiced to see the inimitable Mrs. Behn so nearly revived in Mrs. Centlivre." The two writers also matched one another in their profound devotion to the monarch, albeit on different sides of the Glorious Revolution of 1688, and for speaking up in defense of their right to write—for money and for the stage.

Over the course of the long eighteenth century, in terms of plays produced and retained in the repertoire, Centlivre far excelled Behn. In total, she wrote some nineteen plays, together with some tub-thumping, patriotic poetry, but her popularity rests on four outstanding comedies: *The Gamester* (1705), *The Busy Body* (1709), *The Wonder: A Woman Keeps a Secret* (1714) and *A Bold Stroke for a Wife* (1718). From the start, these were plays that appealed to actors, who regularly chose them for their benefit nights, and to audiences, who relished their vivid characters and fast-moving, often intricate, plots. Before 1800, *The Wonder* alone was performed at least 250 times (over a fifth of this total with David Garrick as Don Felix, including his farewell performance at Drury Lane), and *The Busy Body* 475 times. In November 1779, *A Bold Stroke for a Wife* played at Drury Lane one night, and was followed by *The Wonder* at Covent Garden the next. In 1800, Sheridan, forced to cancel a performance of *The School for Scandal*, could replace it with *A Bold Stroke* at a day's notice as a trusty standby. For the best part of two centuries, only one dramatist could touch Susannah Centlivre for the frequency with which his plays were revived: William Shakespeare. And this is to discount adaptations (like *The Ghost*, a two-act farce based on the last act or

so of *The Man's Bewitched*, 1709), influence (Goldsmith, for one, took a case of mistaken identity from the same play), and plagiarism. The anonymous editor of Centlivre's collected works of 1761 thought it scandalous that she was not memorialized, as Shakespeare was, in Poets' Corner in Westminster Abbey.

Such enduring success did not seem very likely before *The Gamester*. Centlivre's early plays made comparatively little impact on the early eighteenth-century theatre. From the failure of her first play at Drury Lane onwards, a tragicomedy called *The Perjured Husband* (1700), her literary career could easily have succumbed to the same obscurity that marks her early life. Prejudice against women writing for the stage certainly affected her (see Introduction), as it did all her contemporary "female wits", such as Delarivière Manley, Mary Pix, and Catharine Trotter. They made easy targets. Even a leading actor, Robert Wilkes, could dismiss *The Busy Body* in rehearsal as "a silly thing wrote by a woman, that the players had no opinion of." (His response to the resounding success of the play on its first night is unrecorded.) Centlivre did not attach her name to *The Beau's Duel* (1702), *The Stolen Heiress* (1702), *Love's Contrivance* (1703) or, in spite of its success, *The Gamester*. In her dedication of *The Platonick Lady* (1706) to "all the generous encouragers of female ingenuity," she complained that

> A play secretly introduced to the [play]house, whilst the author remains unknown, is approved by everybody: the actors cry it up, and are in expectation of a great run; the bookseller of a second edition, and the scribbler of a sixth night. But if by chance, the plot's discovered and the brat found fatherless, immediately it flags in the opinion of those that extolled it before, and the bookseller falls his price, with this reason only, *It is a woman's.*

Were women meddling in matters "out of their sphere" when they wrote for the stage? "I say, no," she answered, "for since the poet is born, why not a woman as well as a man?"

On the other hand, Mottley could say, by the time of her death in December 1723, that Centlivre "could show (which I believe few other poets could who depended on their pen) a great many jewels and pieces of plate, which were the product of her labour." The accumulation of this material wealth anticipates the prudence of Elizabeth Inchbald rather than the impoverishment of Aphra Behn. Indeed, it would be Inchbald's time before female playwrights were restored to the commercial and artistic prominence that some of them had enjoyed in Centlivre's.

A Bold Stroke for a Wife

DRAMATIS PERSONAE

MEN

SIR PHILIP MODELOVE	*an old beau*
PERIWINKLE	*a kind of silly virtuoso*
TRADELOVE	*a change-broker*
OBADIAH PRIM	*a Quaker*
COLONEL FAINWELL	*in love with* MRS. LOVELY
FREEMAN	*his friend, a merchant*
SIMON PURE	*a Quaking preacher*
MR. SACKBUT	*a tavern-keeper*

WOMEN

MRS. LOVELY	*a fortune of thirty thousand pound*
MRS. PRIM	*wife to* PRIM *the hosier*
BETTY	*servant to* MRS. LOVELY

FOOTMEN, DRAWERS, *etc*

The scene is London.

To His Grace, Philip, Duke and Marquis of Wharton, &c.

My Lord,

It has ever been the custom of poets to shelter productions of this nature under the patronage of the brightest men of their time; and 'tis observed that the Muses always met the kindest reception from persons of the greatest merit. The world will do me justice as to the choice of my patron, but will, I fear, blame my rash attempt, in daring to address Your Grace, and offer at a work too difficult for our ablest pens, *viz.* an encomium on Your Grace. I have no plea against such just reflections but the disadvantage of education and the privilege of my sex.

If Your Grace discovers a genius so surprising in this dawn of life, what must your riper years produce? Your Grace has already been distinguished in a most peculiar manner, being the first young nobleman that ever was admitted into a House of Peers before he reached the age of one-and-twenty. But Your Grace's judgement and eloquence soon convinced that august assembly that the excelling gifts of nature ought not to be consigned to time. We hope the example which Ireland has set will shortly be followed by an English House of Lords, and Your Grace made a Member of that body to which you will be so conspicuous an ornament.

Your good sense and real love for your country taught Your Grace to persevere in the principles of your glorious ancestors, by adhering to the Defender of our Religion and Laws; and the penetrating wisdom of Your Royal Master saw you merited your honors e'er he conferred them. It is one of the greatest glories of a monarch to distinguish where to bestow his favours; and the world must do ours justice, by owning Your Grace's titles most deservedly worn.

It is with the greatest pleasure imaginable the friends of liberty see you pursuing the steps of your noble father. Your courteous, affable temper, free from pride and ostentation, makes your name adored in the country, and enables Your Grace to carry what point you please. The late Lord Wharton will be still remembered by every lover of his country, which never felt a greater shock than what his

death occasioned. Their grief had been inconsolable if Heaven, out of its wonted beneficence to this favourite isle, had not transmitted all his shining qualities to you, and, phoenix-like, raised up one patriot out of the ashes of another.

That Your Grace has a high esteem for learning particularly appears by the large progress you have made therein, and your love for the Muses shows a sweetness of temper and generous humanity peculiar to the greatness of your soul, for such virtues reign not in the breast of every man of quality.

Defer no longer then, my Lord, to charm the world with the beauty of your numbers, and show the poet as you have done the orator. Convince our unthinking Britons by what vile arts France lost her liberty, and teach 'em to avoid their own misfortunes as well as to weep over Henry IV, who (if it were possible for him to know) would forgive the bold assassin's hand for the honor of having his fall celebrated by Your Grace's pen.

To be distinguished by persons of Your Grace's character is not only the highest ambition but the greatest reputation to an author, and it is not the least of my vanities to have it known to the public I had Your Grace's leave to prefix your name to this comedy.

I wish I were capable to clothe the following scenes in such a dress as might be worthy to appear before Your Grace, and draw your attention as much as Your Grace's admirable qualifications do that of all mankind; but the Muses, like most females, are least liberal to their own sex.

All I dare say in favour of this piece is that the plot is entirely new, and the incidents wholly owing to my own invention, not borrowed from our own or translated from the works of any foreign poet; so that they have at least the charm of novelty to recommend 'em. If they are so lucky in some leisure hour to give Your Grace the least diversion, they will answer the utmost ambition of, my Lord,

> Your Grace's most obedient,
> Most devoted, and
> Most humble servant,
> Susannah Centlivre

PROLOGUE

Tonight we come upon a bold design,
To try to please without one borrowed line;
Our plot is new, and regularly clear,
And not one single tittle from *Moleire*;
O'er buried poets we with caution tread,
And parish sextons leave to rob the dead.
For you, bright British fair, in hopes to charm ye,
We bring tonight a lover from the army.
You know the soldiers have the strangest arts,
Such a proportion of prevailing parts,
You'd think that they rid post to women's hearts.
I wonder whence they draw their bold pretense;
We do not choose them sure for our defense.
That plea is both impolitic and wrong,
And only suits such dames as want a tongue.
Is it their eloquence and fine address?
The softness of their language?—Nothing less.
Is it their courage, that they bravely dare
To storm the sex at once? —Egad, 'tis there:
They act by us as in the rough campaign,
Unmindful of repulses, charge again;
They mine and countermine, resolved to win,
And, if a breach is made—they will come in.
You'll think, by what we have of soldiers said,
Our female wit was in the service bred,
But she is to the hardy toil a stranger,
She loves the cloth indeed, but hates the danger.
Yet to this circle of the brave and gay,
She bid me for her good intentions say
She hopes you'll not reduce her to half-pay.
As for our play, 'tis English humor all;
Then will you let our manufacture fall?
Would you the honor of our nation raise,
Keep English credit up, and English plays.

ACT I, SCENE I

A tavern. COLONEL FAINWELL *and* FREEMAN *over a bottle.*

FREEMAN: Come, Colonel, His Majesty's health. You are as melancholy as if you were in love; I wish some of the beauties at Bath ha'n't snapped your heart.

COLONEL: Why, faith, Freeman, there is something in't. I have seen a lady at Bath who has kindled such a flame in me that all the waters there can't quench.

FREEMAN: Women, like some poisonous animals, carry their antidote about 'em. Is she not to be had, Colonel?

COLONEL: That's a difficult question to answer; however, I resolve to try. Perhaps you may be able to serve me; you merchants know one another. The lady told me herself she was under the charge of four persons.

FREEMAN: Odso! 'Tis Mrs. Anne Lovely.

COLONEL: The same. Do you know her?

FREEMAN: Know her! Aye—Faith, Colonel, your condition is more desperate than you imagine; why, she is the talk and pity of the whole town, and it is the opinion of the learned that she must die a maid.

COLONEL: Say you so? That's somewhat odd, in this charitable city. She's a woman, I hope.

FREEMAN: For aught I know, but it had been as well for her had nature made her any other part of the Creation. The man which keeps this house served her father; he is a very honest fellow and may be of use to you. We'll send for him to take a glass with us; he'll give you the whole history, and 'tis worth your hearing.

COLONEL: But may one trust him?

FREEMAN: With your life. I have obligations enough upon him to make him do anything: I serve him with wine. [*Knocks*]

COLONEL: Nay, I know him pretty well myself; I once used to frequent a club that was kept here.

Enter DRAWER.

DRAWER: Gentlemen, d'you call?

FREEMAN: Aye, send up your master.

DRAWER: Yes, sir. [*Exit*]

COLONEL: Do you know any of this lady's guardians, Freeman?

FREEMAN: Yes, I know two of them very well.

COLONEL: What are they?

Enter SACKBUT.

FREEMAN: Here comes one will give you an account of them all. Mr. Sackbut, we sent you to take a glass with us. 'Tis a maxim among the friends of the bottle that as long as the master is in company one may be sure of good wine.

SACKBUT: Sir, you shall be sure to have as good wine as you send in. Colonel, your most humble servant; you are welcome to town.

COLONEL: I thank you, Mr. Sackbut.

SACKBUT: I am as glad to see you as I should a hundred tun of French claret custom-free. My service to you, sir. [*Drinks*] You don't look so merry as you used to do. Are you not well, Colonel?

FREEMAN: He has got a woman in his head, landlord. Can you help him?

SACKBUT: If 'tis in my power, I shan't scruple to serve my friend.

COLONEL: 'Tis one perquisite of your calling.

SACKBUT: Aye, at t'other end of the town, where you officers use, women are good forcers of trade. A well-customed house, a handsome bar-keeper, with clean, obliging drawers, soon gets the master an estate; but our citizens seldom do anything but cheat within the walls. But as to the lady, Colonel: point you at particulars, or have you a good champagne stomach? Are you in full pay or reduced, Colonel?

COLONEL: Reduced, reduced, landlord.

FREEMAN: To the miserable condition of a lover!

SACKBUT: Pish! That's preferable to half pay; a woman's resolution may break before the peace. Push her home, Colonel, there's no parleying with that sex.

COLONEL: Were the lady her own mistress, I have some reasons to believe I should soon command in chief.

FREEMAN: You know Mrs. Lovely, Mr. Sackbut.

SACKBUT: Know her! Aye, poor Nancy; I have carried her to school many a frosty morning. Alas! If she's the woman, I pity you, Colonel. Her father, my old master, was the most whimsical, out-of-the-way tempered man I ever heard of, as you will guess by his last will and testament. This was his only child; I have heard him wish her dead a thousand times.

COLONEL: Why so?

SACKBUT: He hated posterity, you must know, and wished the world were to expire with himself. He used to swear if she had been a boy, he would have qualified him for the opera.

FREEMAN: 'Tis a very unnatural resolution in a father.

SACKBUT: He died worth thirty thousand pounds, which he left to this daughter, provided she married with the consent of her guardians. But, that she might be sure never to do so, he left her in the care of four men as opposite to each other as light and darkness. Each has his quarterly rule, and three months in a year she is obliged to be subject to each of their humors, and they are pretty different, I assure you. She is just come from Bath.

COLONEL: 'Twas there I saw her.

SACKBUT: Aye, sir, the last quarter was her beau-guardian's. She appears in all public places during his reign.

COLONEL: She visited a lady who boarded in the same house with me. I liked her person, and found an opportunity to tell her so. She replied, she had no objection to mine, but if I could not reconcile contradictions, I must not think of her, for that she was condemned to the caprice of four persons who never yet agreed in any one thing, and she was obliged to please them all.

SACKBUT: 'Tis most true, sir; I'll give you a short description of the men and leave you to judge of the poor lady's condition. One is a kind of a virtuoso, a silly, half-witted fellow, but positive and surly; fond of nothing but what is antique and foreign,

and wears his clothes of the fashion of the last century; dotes upon travellers and believes Sir John Mandeville more than the Bible.

COLONEL: That must be a rare old fellow!

SACKBUT: Another is a change-broker; a fellow that will out-lie the devil for the advantage of stock and cheat his father that got him in a bargain. He is a great stickler for trade and hates everything that wears a sword.

FREEMAN: He is a great admirer of the Dutch management, and swears they understand trade better than any nation under the sun.

SACKBUT: The third is an old beau that has May in his fancy and dress but December in his face and his heels. He admires nothing but new fashions, and those must be French; loves operas, balls, masquerades, and is always the most tawdry of the whole company on a Birthday.

COLONEL: These are pretty opposite to one another, truly! And the fourth, what is he, landlord?

SACKBUT: A very rigid Quaker, whose quarter begun this day. I saw Mrs. Lovely go in not above two hours ago; Sir Philip set her down. What think you now, Colonel, is not the poor lady to be pitied?

COLONEL: Aye, and rescued too, landlord.

FREEMAN: In my opinion, that's impossible.

COLONEL: There is nothing impossible to a lover. What would not a man attempt for a fine woman and thirty thousand pounds? Besides, my honor is at stake; I promised to deliver her, and she bade me win her and take her.

SACKBUT: That's fair, faith.

FREEMAN: If it depended upon knight-errantry, I should not doubt your setting free the damsel, but to have avarice, impertinence, hypocrisy, and pride at once to deal with requires more cunning than generally attends a man of honor.

COLONEL: My fancy tells me I shall come off with glory; I resolve to try, however. Do you know all the guardians, Mr. Sackbut?

SACKBUT: Very well, sir, they all use my house.

COLONEL: And will you assist me, if occasion be?

SACKBUT: In everything I can, Colonel.

FREEMAN: I'll answer for him; and whatever I can serve you in, you may depend on. I know Mr. Periwinkle and Mr. Tradelove; the latter has a very great opinion of my interest abroad. I happened to have a letter from a correspondent two hours before the news arrived of the French King's death. I communicated it to him, upon which he bought up all the stock he could, and, what with that and some wagers he laid, he told me, he had got to the tune of five hundred pounds, so that I am much in his good graces.

COLONEL: I don't know but you may be of service to me, Freeman.

FREEMAN: If I can, command me, Colonel.

COLONEL: Is it not possible to find a suit of clothes ready-made at some of these sale shops, fit to rig out a beau, think you, Mr. Sackbut?

SACKBUT: Oh, hang 'em. No, Colonel, they keep nothing ready-made that a gentleman would be seen in. But I can fit you with a suit of clothes, if you'd make a figure—velvet and gold brocade—they were pawned to me a by a French count, who had been stripped at play and wanted money to carry him home; he promised to send for them, but I have heard nothing from him.

FREEMAN: He has not fed upon frogs long enough yet to recover his loss, ha, ha!

COLONEL: Ha, ha! Well, those clothes will do, Mr. Sackbut—though we must have three or four fellows in tawdry liveries; those can be procured, I hope.

FREEMAN: Egad, I have a brother come from the West Indies that can match you, and, for expedition sake, you shall have his servants. There's a black, a tawny-moor and a Frenchman; they don't speak one word of English, so can make no mistake.

COLONEL: Excellent. Egad, I shall look like an Indian prince. First, I'll attack my beau-guardian. Where lives he?

SACKBUT: Faith, somewhere about St. James's, though to say in what street, I cannot; but any chairman will tell you where Sir Philip Modelove lives.

FREEMAN: Oh! You'll find him in the Park at eleven every day—at least, I never passed through at that hour without seeing him there. But what do you intend?

COLONEL: To address him in his own way, and find what he designs to do with the lady.

FREEMAN: And what then?

COLONEL: Nay, that I can't tell, but I shall take my measures accordingly.

SACKBUT: Well 'tis a mad undertaking, in my mind; but here's to your success, Colonel. [*Drinks*]

COLONEL: 'Tis something out of the way, I confess; but Fortune may chance to smile, and I succeed. Come, landlord, let me see those clothes. Freeman, I shall expect you'll leave word with Mr. Sackbut where one may find you upon occasion; and send my equipage of India immediately, do you hear?

FREEMAN: Immediately. [*Exit*]

COLONEL: Bold was the man who ventured first to sea,
But the first vent'ring lovers bolder were:
The path of love's a dark and dangerous way,
Without a landmark, or one friendly star,
And he that runs the risk deserves the fair. [*Exit*]

ACT I, SCENE II

PRIM'*s house. Enter* MRS. LOVELY *and her maid* BETTY.

BETTY: Bless me, madam! Why do you fret and tease yourself so? This is giving them the advantage with a witness.

LOVELY: Must I be condemned all my life to the preposterous humors of other people and pointed at by every boy in town? Oh! I could tear my flesh and curse the hour I was born. Is it not monstrously ridiculous that they should desire to impose their Quaking dress upon me at these years? When I was a child, no matter what they made me wear, but now—

BETTY: I would resolve against it, madam; I'd see 'em hanged before I'd put on the pinched cap again.

LOVELY: Then I must never expect one moment's ease; she has rung such a peal in my ears already that I shan't have the right use of them this month. What can I do?

BETTY: What can you not do, if you will but give your mind to it? Marry, madam.

LOVELY: What! And have my fortune go to build churches and hospitals?

BETTY: Why, let it go. If the Colonel loves you, as he pretends, he'll marry you without a fortune, madam; and I assure you, a Colonel's lady is no despicable thing. A Colonel's post will maintain you like a gentlewoman, madam.

LOVELY: So you would advise me to give up my own fortune and throw myself upon the Colonel's?

BETTY: I would advise you to make yourself easy, madam.

LOVELY: That's not the way, I am sure. No, no, girl, there are certain ingredients to be mingled with matrimony without which I may as well change for the worse as for the better. When the woman has fortune enough to make the man happy, if he has either honor or good manners, he'll make her easy. Love makes but a slovenly figure in that house where poverty keeps the door.

BETTY: And so you resolve to die a maid, do you, madam?

LOVELY: Or have it in my power to make the man I love master of my fortune.

BETTY: Then you don't like the Colonel so well as I thought you did, madam, or you would not take such a resolution.

LOVELY: It is because I do like him, Betty, that I take such a resolution.

BETTY: Why, do you expect, madam, the Colonel can work miracles? Is it possible for him to marry you with the consent of all your guardians?

LOVELY: Or he must not marry me at all, and so I told him; and he did not seem displeased with the news. He promised to set me free, and I, on that condition, promised to make him master of that freedom.

BETTY: Well! I have read of enchanted castles, ladies delivered from the chains of magic, giants killed, and monsters overcome, so

that I shall be the less surprised if the Colonel should conjure you out of the power of your guardians. If he does, I am sure he deserves your fortune.

LOVELY: And shall have it, girl, if it were ten times as much. For I'll ingenuously confess to thee, that I do like the Colonel above all men I ever saw. There's something so *jantée* in a soldier, a kind of *je ne sais quoi* air that makes 'em more agreeable than the rest of mankind. They command regard, as who should say "we are your defenders, we preserve your beauties from the insults of rude, unpolished foes," and ought to be preferred before those lazy, indolent mortals who, by dropping into their father's estate, set up their coaches and think to rattle themselves into our affections.

BETTY: Nay, madam, I confess that the army has engrossed all the prettiest fellows. A laced coat and feather have irresistible charms.

LOVELY: But the Colonel has all the beauties of the mind as well as person. Oh all ye powers that favour happy lovers, grant he may be mine! Thou God of Love, if thou be'st aught but name, assist my Fainwell.

Point all thy darts to aid my love's design,
And make his plots as prevalent as thine.

ACT II, SCENE I

The park. Enter the COLONEL *finely dressed, three footman after him.*

COLONEL: So, now if I can but meet this beau. Egad, methinks I cut a smart figure, and have as much of the tawdry air as any Italian count or French marquis of 'em all. Sure I shall know this knight again.—Ha! Yonder he sits, making love to a mask, i'faith. I'll walk up the Mall, and come down by him. [*Exit*]

Scene draws and discovers SIR PHILIP *upon a bench with a* WOMAN, *masked.*

SIR PHILIP: Well, but, my dear, are you really constant to your keeper?

WOMAN: Yes, really, sir.—Hey day! Who comes yonder? He cuts a mighty figure.

SIR PHILIP: Ha! A stranger, by his equipage keeping so close at his heels. He has the appearance of a man of quality. Positively French by his dancing air.

WOMAN: He crosses, as if he meant to sit down here.

SIR PHILIP: He has a mind to make love to thee, child.

Enter COLONEL *and seats himself upon the bench by* SIR PHILIP.

WOMAN: It will be to no purpose if he does.

SIR PHILIP: Are you resolved to be cruel then?

COLONEL: You must be very cruel, indeed, if you can deny anything to so fine a gentleman, madam. [*Takes out his watch*]

WOMAN: I never mind the outside of a man.

COLONEL: And I'm afraid thou art no judge of the inside.

SIR PHILIP: I am, positively, of your mind, sir. For creatures of her function seldom penetrate beyond the pocket.

WOMAN: [*Aside*] Creatures of your composition have, indeed, generally more in their pockets than in their heads.

SIR PHILIP: Pray what says your watch? Mine is down. [*Pulling out his watch*]

COLONEL: I want thirty-six minutes of twelve, sir. [*Puts up his watch and takes out his snuffbox*]

SIR PHILIP: May I presume, sir?

COLONEL: Sir, you honor me. [*Presenting the box*]

SIR PHILIP: [*Aside*] He speaks good English, though he must be a foreigner. [*To him*] This snuff is extremely good and the box prodigious fine; the work is French, I presume, sir.

COLONEL: I bought it in Paris, sir. I do think the workmanship pretty neat.

SIR PHILIP: Neat, 'tis exquisitely fine, sir. Pray, sir, if I may take the liberty of inquiring, what country is so happy to claim the birth of the finest gentleman in the universe? France, I presume.

COLONEL: Then you don't think me an Englishman?

SIR PHILIP: No, upon my soul, don't I.

COLONEL: I am sorry for't.

SIR PHILIP: Impossible you should wish to be an Englishman. Pardon me, sir, this island could not produce a person of such alertness.

COLONEL: As this mirror shows you, sir. [*Puts up a pocket-glass to* SIR PHILIP*'s face*]

WOMAN: [*Aside*] Coxcombs, I'm sick to hear 'em praise one another. One seldom gets anything by such animals, not even a dinner, unless one can dine upon soup and celery. [*Exit*]

SIR PHILIP: Oh Ged, sir!—Will you leave us, madam? Ha, ha!

COLONEL: She fears 'twill be only losing time to stay here, ha, ha. I know not how to distinguish you, sir, but your mien and address speak you Right Honorable.

SIR PHILIP: Thus great souls judge of others by themselves. I am only adorned with knighthood, that's all, I assure you, sir; my name is Sir Philip Modelove.

COLONEL: Of French extraction?

SIR PHILIP: My father was French.

COLONEL: One may plainly perceive it. There is a certain gaiety peculiar to my nation (for I will own myself a Frenchman), which distinguishes us everywhere. A person of your figure would be a vast addition to a coronet.

SIR PHILIP: I must own, I had the offer of a barony about five years ago, but I abhorred the fatigue which must have attended it. I could never yet bring myself to join with either party.

COLONEL: You are perfectly in the right, Sir Philip. A fine person should not embark himself in the slovenly concern of politics; dress and pleasure are objects proper for the soul of a fine gentleman.

SIR PHILIP: And love—

COLONEL: Oh! That's included under the article of pleasure.

SIR PHILIP: *Parbleu, il est un homme d'esprit.*—I must embrace you. [*Rises and embraces*] Your sentiments are so agreeable to mine that we appear to have but one soul, for our ideas and conceptions are the same.

COLONEL: [*Aside*] I should be sorry for that. [*To him*] You do me too much honor, Sir Philip.

SIR PHILIP: Your vivacity and *jantée* mien assured me at first sight there was nothing of this foggy island in your composition. May I crave your name, sir?

COLONEL: My name is La Fainwell, sir, at your service.

SIR PHILIP: The La Fainwells are French, I know, though the name is become very numerous in Great Britain of late years. I was sure you was French the moment I laid my eyes upon you; I could not come into the supposition of your being an Englishman. This island produces few such ornaments.

COLONEL: Pardon me, Sir Philip, this island has two things superior to all nations under the sun.

SIR PHILIP: Aye! What are they?

COLONEL: The ladies and the laws.

SIR PHILIP: The laws indeed do claim a preference of other nations, but by my soul there are fine women everywhere. I must own I have felt their power in all countries.

COLONEL: There are some finished beauties, I confess, in France, Italy, Germany, nay, even in Holland, *mais sont bien rares*. But *les belles Anglaises*! Oh, Sir Philip, where find we such women! Such symmetry of shape! Such elegancy of dress! Such regularity of features! Such sweetness of temper! Such commanding eyes! And such bewitching smiles?

SIR PHILIP: Ah! *Parbleu, vous êtes attrapér.*

COLONEL: *Non, je vous assure, chevalier*—but I declare there is no amusement so agreeable to my *goût* as the conversation of a fine woman. I could never be prevailed upon to enter into what the vulgar calls the pleasure of the bottle.

SIR PHILIP: My own taste, *positivement*. A ball or a masquerade is certainly preferable to all the productions of the vineyard.

COLONEL: Infinitely! I hope the people of quality in England will support that branch of pleasure which was imported with their peace and since naturalized by the ingenious Mr. Heidegger.

SIR PHILIP: The ladies assure me it will become part of the constitution, upon which I subscribed an hundred guineas. It will

be of great service to the public, at least to the Company of Surgeons and the City in general.

COLONEL: Ha, ha, it may help to ennoble the blood of the City. Are you married, Sir Philip?

SIR PHILIP: No, nor do I believe I ever shall enter into that honorable state; I have an absolute tender for the whole sex.

COLONEL: [*Aside*] That's more than they have for you I dare swear.

SIR PHILIP: And I have the honor to be very well with the ladies, I can assure you, sir, and I won't affront a million of fine women to make one happy.

COLONEL: Nay, marriage is really reducing a man's taste to a kind of half-pleasure, but then it carries the blessing of peace along with it; one goes to sleep without fear and wakes without pain.

SIR PHILIP: There is something of that in't; a wife is a very good dish for an English stomach, but gross feeding for nicer palates, ha, ha, ha!

COLONEL: I find I was very much mistaken—I imagined you had been married to that young lady which I saw in the chariot with you this morning in Gracechurch Street.

SIR PHILIP: Who, Nancy Lovely? I am a piece of a guardian to that lady, you must know; her father, I thank him, joined me with three of the most preposterous old fellows that, upon my soul, I'm in pain for the poor girl. She must certainly lead apes, as the saying is, ha, ha.

COLONEL: That's pity. Sir Philip, if the lady would give me leave, I would endeavour to avert that curse.

SIR PHILIP: As to the lady, she'd gladly be rid of us at any rate, I believe, but here's the mischief: he who marries Miss Lovely, must have the consent of us all four, or not a penny of her portion. For my part, I shall never approve of any but a man of figure, and the rest are not only averse to cleanliness, but have each a peculiar taste to gratify. For my part, I declare, I would prefer you to all men I ever saw—

COLONEL: And I her to all women—

SIR PHILIP: I assure you, Mr. Fainwell, I am for marrying her, for I hate the trouble of a guardian, especially among such wretches,

but resolve never to agree to the choice of any one of them, and I fancy they'll be even with me, for they never came into any proposal of mine yet.

COLONEL: I wish I had your leave to try them, Sir Philip.

SIR PHILIP: With all my soul, sir, I can refuse a person of your appearance nothing.

COLONEL: Sir, I am infinitely obliged to you.

SIR PHILIP: But do you really like matrimony?

COLONEL: I believe I could with that lady, sir.

SIR PHILIP: The only point in which we differ—but you are master of so many qualifications that I can excuse one fault, for I must think it a fault in a fine gentleman; and that you are such, I'll give it under my hand.

COLONEL: I wish you'd give me your consent to marry Mrs. Lovely under your hand, Sir Philip.

SIR PHILIP: I'll do't, if you'll step into St. James's Coffee-house, where we may have pen and ink. Though I can't foresee what advantage my consent will be to you without you could find a way to get the rest of the guardians'. But I'll introduce you, however; she is now at a Quaker's, where I carried her this morning, when you saw us in Gracechurch Street. I assure you she has an odd *ragoût* of guardians, as you will find when you hear the characters, which I'll endeavour to give you as we go along.—Hey! Pierre, Jacques, Renault—where are you all, scoundrels? Order the chariot to St. James's Coffee-house.

COLONEL: *Le noir, le brun, le blanc—mortbleu, où sont ces coquins-là? Allons, monsieur le chevalier.*

SIR PHILIP: Ah! *Pardonnez moi, monsieur.*

COLONEL: Not one step, upon my soul, Sir Philip.

SIR PHILIP: The best-bred man in Europe, positively.

Exeunt.

ACT II, SCENE II

OBADIAH PRIM*'s house. Enter* MRS. LOVELY *followed by* MRS. PRIM.

MRS. PRIM: Then thou wilt not obey me; and thou dost really think those fal-lals becometh thee?

LOVELY: I do, indeed.

MRS. PRIM: Now will I be judged by all sober people, if I don't look more like a modest woman than thou dost Anne.

LOVELY: More like a hypocrite, you mean, Mrs. Prim.

MRS. PRIM: Ah! Anne, Anne, that wicked Philip Modelove will undo thee. Satan so fills thy heart with pride during the three months of his guardianship, that thou becomest a stumbling block to the upright.

LOVELY: Pray, who are they? Are the pinched cap and formal hood the emblems of sanctity? Does your virtue consist in your dress, Mrs. Prim?

MRS. PRIM: It doth not consist in cut hair, spotted face and bare necks. Oh, the wickedness of this generation! The primitive women knew not the abomination of hooped petticoats.

LOVELY: No, nor the abomination of cant neither. Don't tell me, Mrs. Prim, don't. I know you have as much pride, vanity, self-conceit, and ambition among you, couched under that formal habit and sanctified countenance, as the proudest of us all; but the world begins to see your prudery.

MRS. PRIM: Prudery! What! Do they invent new words as well as new fashions? Ah! Poor, fantastic age, I pity thee. Poor deluded Anne, which does thou think most resemblest the saint and which the sinner, thy dress or mine? Thy naked bosom allureth the eye of the bystander, encourageth the frailty of human nature, and corrupteth the soul with evil longings.

LOVELY: And pray who corrupted your son Tobias with evil longings? You maid Tabitha wore a handkerchief, and yet he made the saint a sinner.

MRS. PRIM: Well, well, spit thy malice. I confess Satan did buffet my son Tobias and my servant Tabitha; the evil spirit was at that

27

time too strong and they both became subject to its work-
ings—not from any outward provocation, but from an inward
call. He was not tainted with the rottenness of the fashions,
nor did his eyes take in the drunkenness of beauty.

LOVELY: No! That's plain to be seen.

MRS. PRIM: Tabitha is one of the faithful, he fell not with a stranger.

LOVELY: So! Then you hold wenching no crime, provided it be within
the pale of your own tribe. You are an excellent casuist, truly.

Enter OBADIAH PRIM.

PRIM: Not stripped of thy vanity yet, Anne? Why dost not thou make
her put it off, Sarah?

MRS. PRIM: She will not do it.

PRIM: Verily, thy naked breasts troubleth my outward man; I pray
thee hide 'em, Anne; put on a handkerchief, Anne Lovely.

LOVELY: I hate handkerchiefs when 'tis not cold weather, Mr. Prim.

MRS. PRIM: I have seen thee wear a handkerchief; nay, and a mask
to boot, in the middle of July.

LOVELY: Aye, to keep the sun from scorching me.

PRIM: If thou couldst not bear the sunbeams, how dost thou think
man should bear thy beams? Those breasts inflame desire; let
them be hid, I say.

LOVELY: Let me be quiet, I say. Must I be tormented thus forever?
Sure no woman's condition ever equalled mine; foppery, folly,
avarice, and hypocrisy are by turns my constant companions,
and I must vary shapes as often as a player. I cannot think my
father meant this tyranny! No; you usurp an authority which
he never intended you should take.

PRIM: Hark thee, dost thou call good counsel tyranny? Do I or my
wife tyrannize when we desire thee in all love to put off thy
tempting attire and veil thy provokers to sin?

LOVELY: Deliver me, good Heaven! Or I shall go distracted. [*Walks
about*]

MRS. PRIM: So! Now thy pinners are tossed and thy breasts pulled
up; verily they were seen enough before. Fie upon the filthy
tailor who made them stays.

LOVELY: I wish I were in my grave! Kill me rather than treat me thus.

PRIM: Kill thee! Ha, ha! Thou think'st thou art acting some lewd play, sure—kill thee! Art thou prepared for death, Anne Lovely? No, no, thou wouldst rather have a husband, Anne. Thou wantest a gilt coach with six lazy fellows behind to flaunt it in the ring of vanity among the princes and rulers of the land, who pamper themselves with the fatness thereof; but I will take care that none shall squander away thy father's estate. Thou shalt marry none such, Anne.

LOVELY: Would you marry me to one of your own canting sect?

PRIM: Yea, verily, none else shall ever get my consent, I do assure thee, Anne.

LOVELY: And I do assure thee, Obadiah, that I will as soon turn papist and die in a convent.

MRS. PRIM: Oh wickedness!

LOVELY: Oh stupidity!

PRIM: Oh blindness of heart!

LOVELY: [*Aside to* PRIM] Thou blinder of the world, don't provoke me, lest I betray your sanctity and leave your wife judge of your purity. What were the emotions of your spirit when you squeezed Mary by the hand last night in the pantry, when she told you, you bussed so filthily? Ah! You had no aversion to naked bosoms when you begged her to show you a little, little, little bit of her delicious bubby. Don't you remember those words, Mr. Prim?

MRS. PRIM: What does she say, Obadiah?

PRIM: She talketh unintelligibly, Sarah. [*Aside*] Which way did she hear this? This should not have reached the ears of the wicked ones; verily, it troubleth me.

Enter SERVANT.

SERVANT: Philip Modelove, whom they call Sir Philip, is below, and such another with him; shall I send them up?

PRIM: Yea. [*Exit* SERVANT]

Enter SIR PHILIP *and* COLONEL.

29

SIR PHILIP: How dost thou do, Friend Prim. Odso! My she-Friend here too! What, you are documenting Miss Nancy, reading her a lecture upon the pinched coif, I warrant ye.

MRS. PRIM: I was sure thou never readest her any lecture that was good.—My flesh riseth so at these wicked ones that prudence adviseth me to withdraw from their sight. [*Exit* MRS. PRIM]

COLONEL: [*Aside*] Oh! That I could find means to speak to her! How charming she appears! I wish I could get this letter into her hand.

SIR PHILIP: Well, Miss Cocky, I hope thou hast got the better of them.

LOVELY: The difficulties of my life are not to be surmounted, Sir Philip. [*Aside*] I hate the impertinence of him as much as the stupidity of the other.

PRIM: Verily, Philip, thou wilt spoil this maiden.

SIR PHILIP: I find we still differ in opinion; but that we may none of us spoil her, prithee, Prim, let us consent to marry her. I have sent for our brother guardians to meet me here about that very thing. Madam, will you give me leave to recommend a husband to you? Here's a gentleman which, in my mind, you can have no objection to. [*Presents the* COLONEL *to her; she looks another way.*]

LOVELY: [*Aside*] Heaven deliver me from the formal and the fantastic fool.

COLONEL: A fine woman, a fine horse and fine equipage are the finest things in the universe. And if I am so happy to possess you, madam, I shall become the envy of mankind, as much as you outshine your whole sex. [*As he takes her hand to kiss it, he endeavours to put a letter into it. She lets it drop;* PRIM *takes it up.*]

LOVELY: [*Turning from him*] I have no ambition to appear conspicuously ridiculous, sir.

COLONEL: So fall the hopes of Fainwell.

LOVELY: [*Aside*] Ha! Fainwell! 'Tis he! What have I done? Prim has the letter and all will be discovered.

PRIM: Friend, I know not thy name, so cannot call thee by it, but thou seest thy letter is unwelcome to the maiden. She will not read it.

LOVELY: Nor shall you. [*Snatches the letter*] I'll tear it in a thousand pieces and scatter it, as I will the hopes of all those that any of you shall recommend to me. [*Tears the letter*]

SIR PHILIP: Ha! Right woman, faith!

COLONEL: [*Aside*] Excellent woman.

PRIM: Friend, thy garb favoureth too much of the vanity of the age for my approbation. Nothing that resembleth Philip Modelove shall I love, mark that; therefore, Friend Philip, bring no more of thy own apes under my roof.

SIR PHILIP: I am so entirely a stranger to the monsters of thy breed that I shall bring none of them, I am sure.

COLONEL: [*Aside*] I am likely to have a pretty task by that time I have gone through them all; but she's a city worth taking and egad I'll carry on the siege. If I can but blow up the outworks, I fancy I am pretty secure of the town.

Enter SERVANT.

SERVANT: [*To* SIR PHILIP] Toby Periwinkle and Thomas Tradelove demandeth to see thee.

SIR PHILIP: Bid them come up.

LOVELY: Deliver me from such an inundation of noise and nonsense. [*Aside*] Oh Fainwell! Whatever thy contrivance is, prosper it Heaven; but oh, I fear thou never canst redeem me. [*Exit*]

SIR PHILIP: *Sic transit gloria mundi.*

Enter MR. PERIWINKLE *and* TRADELOVE.

SIR PHILIP: [*Aside to the* COLONEL] These are my brother guardians, Mr. Fainwell; prithee observe the creatures.

TRADELOVE: Well, Sir Philip, I obey your summons.

PERIWINKLE: Pray, what have you to offer for the good of Mrs. Lovely, Sir Philip?

SIR PHILIP: First, I desire to know what you intend to do with that

lady. Must she be sent to the Indies for a venture, or live to be an old maid and then entered amongst your curiosities and shown for a monster, Mr. Periwinkle?

COLONEL: [*Aside*] Humph, curiosities! That must be the virtuoso.

PERIWINKLE: Why, what would you do with her?

SIR PHILIP: I would recommend this gentleman to her for a husband, sir—a person whom I have picked out form the whole race of mankind.

PRIM: I would advise thee to shuffle him again with the rest of mankind, for I like him not.

COLONEL: Pray, sir, without offence to your formality, what may be your objections?

PRIM: Thy person; thy manners; thy dress; thy acquaintance; thy everything, Friend.

SIR PHILIP: You are most particularly obliging, Friend, ha, ha.

TRADELOVE: What business do you follow, pray, sir?

COLONEL: [*Aside*] Humph, by that question he must be the broker. [*To* TRADELOVE] Business, sir! The business of a gentleman.

TRADELOVE: That is as much to say, you dress fine, feed high, lie with every woman you like, and pay your surgeon's bills better than your tailor's or your butcher's.

COLONEL: The court is much obliged to you, sir, for your character of a gentleman.

TRADELOVE: The court, sir! What would the court do without us citizens?

SIR PHILIP: Without your wives and daughters, you mean, Mr. Tradelove?

PERIWINKLE: Have you ever travelled, sir?

COLONEL: [*Aside*] That question must not be answered now. [*To* PERIWINKLE] In books I have, sir.

PERIWINKLE: In books? That's a fine traveler indeed!—Sir Philip, when you present a person I like, he shall have my consent to marry Mrs. Lovely—till when, your servant. [*Exit*]

COLONEL: [*Aside*] I'll make you like me before I have done with you, or I am mistaken.

TRADELOVE: And when you can convince me that a beau is more use-

ful to my country than a merchant, you shall have mine—till then, you must excuse me. [*Exit*]

COLONEL: [*Aside*] So much for trade. I'll fit you too.

SIR PHILIP: In my opinion, this is very inhumane treatment as to the lady, Mr. Prim.

PRIM: Thy opinion and mine happens to differ as much as our occupations, Friend; business requireth my presence and folly thine, and so I must bid thee farewell. [*Exit*]

SIR PHILIP: Here's breeding for you, Mr. Fainwell! Gad take me, I'd give half my estate to see these rascals bit.

COLONEL: [*Aside*] I hope to bite you all, if my plots hit.

Exeunt.

ACT III

The tavern. SACKBUT *and the* COLONEL *in an Egyptian dress.*

SACKBUT: A lucky beginning, Colonel—you have got the old beau's consent.

COLONEL: Aye, he's a reasonable creature, but the other three will require some pains. Shall I pass upon him, think you? Egad, in my mind, I look as antique as if I had been preserved in the ark.

SACKBUT: Pass upon him! Aye, aye, as roundly as white wine dashed with sack does for mountain and sherry, if you have but assurance enough.

COLONEL: I have no apprehension from that quarter; assurance is the cockade of a soldier.

SACKBUT: Aye, but the assurance of a soldier differs much from that of a traveler. Can you lie with a good grace?

COLONEL: As heartily, when my mistress is the prize, as I would meet the foe when my country called and King commanded, so don't you fear that part. If he don't know me again, I'm safe. I hope he'll come.

SACKBUT: I wish all my debts would come as sure. I told him you

had been a great traveler, had many valuable curiosities, and was a person of a most singular taste; he seemed transported and begged me to keep you till he came.

COLONEL: Aye, aye, he need not fear my running away. Let's have a bottle of sack, landlord, our ancestors drank sack.

SACKBUT: You shall have it.

COLONEL: And whereabouts is the trapdoor you mentioned?

SACKBUT: There's the conveyance, sir. [*Exit*]

COLONEL: Now if I should cheat all these roguish guardians and carry off my mistress in triumph, it would be what the French call a *grand coup d'éclat*. Odso! Here comes Periwinkle. Ah! Deuce take this beard! Pray Jupiter it does not give me the slip and spoil all.

Enter SACKBUT *with wine and* PERIWINKLE *following.*

SACKBUT: Sir, this gentleman, hearing you have been a great traveller and a person of fine speculation, begs leave to take a glass with you. He is a man of curious taste himself.

COLONEL: The gentleman has it in his face and garb. Sir, you are welcome.

PERIWINKLE: Sir, I honor a traveller and men of your inquiring disposition. The oddness of your habit pleases me extremely; 'tis very antique, and for that I like it.

COLONEL: It is very antique, sir. This habit once belonged to the famous Claudius Ptolemeus, who lived in the year a hundred and thirty five.

SACKBUT: [*Aside*] If he keeps up to the sample, he shall lie with the devil for a bean-stack and win it every straw.

PERIWINKLE: A hundred and thirty-five! Why, that's prodigious now. Well, certainly 'tis the finest thing in the world to be a traveller.

COLONEL: For my part, I value none of the modern fashions of a fig-leaf.

PERIWINKLE: No more do I, sir; I had rather be the jest of a fool than his favourite. I am laughed at here for my singularity. This

coat, you must know, sir, was formerly worn by that ingenious and very learned person, John Tradescant.

COLONEL: John Tradescant! Let me embrace you, sir. John Tradescant was my uncle, by mother-side, and I thank you for the honor you do his memory. He was a very curious man indeed.

PERIWINKLE: Your uncle, sir! Nay then, 'tis no wonder that your taste is so refined; why, you have it in your blood. My humble service to you, sir, to the immortal memory of John Tradescant, your never-to-be-forgotten uncle. [*Drinks*]

COLONEL: Give me a glass, landlord.

PERIWINKLE: I find you are primitive even in your wine. Canary was the drink of our wise forefathers; 'tis balsamic and saves the charge of apothecaries' cordials. Oh! That I had lived in your uncle's days! Or rather, that he were now alive. Oh! How proud he'd be of such a nephew!

SACKBUT: [*Aside*] Oh pox! That would have spoiled the jest.

PERIWINKLE: A person of your curiosity must have collected many rarities.

COLONEL: I have some, sir, which are not yet come ashore, as an Egyptian's idol.

PERIWINKLE: Pray, what might that be?

COLONEL: It is, sir, a kind of an ape, which they formerly worshipped in that country. I took it from the breast of a female mummy.

PERIWINKLE: Ha, ha! Our women retain part of their idolatry to this day, for many an ape lies on a lady's breast, ha, ha—

SACKBUT: [*Aside*] A smart old thief.

COLONEL: Two tusks of an hippopotamus, two pair of Chinese nut-crackers, and one Egyptian mummy.

PERIWINKLE: Pray, sir, have you never a crocodile?

COLONEL: Humph! The boatswain brought one with design to show it, but touching at Rotterdam and hearing it was no rarity in England, he sold it to a Dutch poet.

SACKBUT: The devil's in that nation, it rivals us in everything.

PERIWINKLE: I should have been very glad to have seen a living crocodile.

COLONEL: My genius led me to things more worthy of my regard. Sir, I have seen the utmost limits of this globular world. I have seen the sun rise and set, know in what degree of heat he is at noon to the breadth of a hair, and what quantity of combustibles he burns in a day, how much of it turns to ashes and how much to cinders.

PERIWINKLE: To cinders? You amaze me, sir; I never heard that the sun consumed anything. Descartes tells us—

COLONEL: Descartes, with the rest of his brethren both ancient and modern, knew nothing of the matter. I tell you, sir, that nature admits an annual decay, though imperceptible to vulgar eyes. Sometimes his rays destroy below, sometimes above. You have heard of blazing comets, I suppose?

PERIWINKLE: Yes, yes, I remember to have seen one, and our astrologers tell us of another which shall happen very quickly.

COLONEL: Those comets are little islands bordering on the sun, which at certain times are set on fire by that luminous body's moving over them perpendicular, which will one day occasion a general conflagration.

SACKBUT: [*Aside*] One need not scruple the Colonel's capacity, faith.

PERIWINKLE: This is marvellous strange! These cinders are what I never read of in any of our learned dissertations.

COLONEL: [*Aside*] I don't know how the devil you should.

SACKBUT: [*Aside*] He has it at his fingers' ends; one would swear he had learned to lie at school, he does it so cleverly.

PERIWINKLE: Well, you travellers see strange things! Pray, sir, have you any of those cinders?

COLONEL: I have, among my other curiosities.

PERIWINKLE: Oh, what have I lost for want of travelling! Pray, what have you else?

COLONEL: Several things worth your attention. I have a muff made of the feathers of those geese that saved the Roman Capitol.

PERIWINKLE: Is't possible?

SACKBUT: [*Aside*] Yes, if you are such a goose to believe him.

COLONEL: I have an Indian leaf, which, open, will cover an acre of

land, yet folds up into so little a compass, you may put it into your snuffbox.

SACKBUT: [*Aside*] Humph! That's a thunderer.

PERIWINKLE: Amazing!

COLONEL: Ah! Mine is but a little one. I have seen some of them that would cover one of the Caribbean islands.

PERIWINKLE: Well, if I don't travel before I die, I shan't rest in my grave. Pray, what do the Indians with them?

COLONEL: Sir, they use them in their wars for tents, the old women for riding hoods, the young for fans and umbrellas.

SACKBUT: [*Aside*] He has a fruitful invention.

PERIWINKLE: I admire our East India Company imports none of them; they would certainly find their account in them.

COLONEL: [*Aside*] Right, if they could find the leaves. [*To* PERIWINKLE] Look ye, sir, do you see this little vial?

PERIWINKLE: Pray you, what is it?

COLONEL: This is called *poluflosboio*.

PERIWINKLE: *Poluflosboio*! It has a rumbling sound.

COLONEL: Right, sir, it proceeds from a rumbling nature. This water was part of those waves which bore Cleopatra's vessel when she sailed to meet Anthony.

PERIWINKLE: Well, of all that ever travelled, none had a taste like you.

COLONEL: But here's the wonder of the world. This, sir, is called *zona* or *moros musphonon*; the virtues of this is inestimable.

PERIWINKLE: *Moros musphonon*! What in the name of wisdom can that be? To me it seems a plain belt.

COLONEL: This girdle has carried me all the world over.

PERIWINKLE: You have carried it, you mean.

COLONEL: I mean as I say, sir. Whenever I am girdled with this, I am invisible; and, by turning this little screw, can be in the court of the Great Mogul, the Grand Seignior, and King George in as little time as your cook can poach an egg.

PERIWINKLE: You must pardon me, sir, I can't believe it.

COLONEL: If my landlord pleases, he shall try the experiment immediately.

SACKBUT: I thank you kindly, sir, but I have no inclination to ride post to the devil.

COLONEL: No, no, you shan't stir a foot; I'll only make you invisible.

SACKBUT: But if you could not make me visible again?

PERIWINKLE: Come, try it upon me, sir, I am not afraid of the devil nor all his tricks. 'Zbud, I'll stand 'em all.

COLONEL: There, sir, I put it on. Come, landlord, you and I must face the east. [*They turn about*] Is it on, sir?

PERIWINKLE: 'Tis on. [*They turn about again*]

SACKBUT: Heaven protect me! Where is he?

PERIWINKLE: Why, here, just where I was.

SACKBUT: Where, where, in the name of virtue? Ah, poor Mr. Periwinkle! Egad, look to't, you had best, sir, and let him be seen again, or I shall have you burnt for a wizard.

COLONEL: Have patience, good landlord.

PERIWINKLE: But really, don't you see me now?

SACKBUT: No more than I see my grandmother that died forty years ago.

PERIWINKLE: Are you sure you don't lie? Methinks I stand just where I did and see you as plain as I did before.

SACKBUT: Ah! I wish I could see you once again.

COLONEL: Take off the girdle, sir. [*He takes it off.*]

SACKBUT: Ah, sir, I am glad to see you with all my heart. [*Embraces him*]

PERIWINKLE: This is very odd; certainly there must be some trick in't. Pray, sir, will you do me the favour to put it on yourself?

COLONEL: With all my heart.

PERIWINKLE: But first I'll secure the door.

COLONEL: You know how to turn the screw, Mr. Sackbut?

SACKBUT: Yes, yes. Come, Mr. Periwinkle, we must turn full east.

They turn; the COLONEL *sinks down a trapdoor.*

COLONEL: 'Tis done; now turn.

They turn.

PERIWINKLE: Ha! Mercy upon me! My flesh creeps upon my bones. This must be a conjuror, Mr. Sackbut.

SACKBUT: He is the devil, I think.

PERIWINKLE: Oh! Mr. Sackbut, why do you name the devil when perhaps he may be at your elbow?

SACKBUT: At my elbow! Marry, Heaven forbid.

COLONEL: [*Below*] Are you satisfied, sir?

PERIWINKLE: Yes, sir, yes. How hollow his voice sounds!

SACKBUT: Yours seemed just the same. Faith, I wish this girdle were mine, I'd sell wine no more. Hark ye, Mr. Periwinkle, [*Takes him aside till the* COLONEL *rises again*] if he would sell this girdle, you might travel with great expedition.

COLONEL: But it is not to be parted with for money.

PERIWINKLE: I am sorry for't, sir, because I think it the greatest curiosity I ever heard of.

COLONEL: By the advice of a learned physiognomist in Grand Cairo, who consulted the lines in my face, I returned to England, where, he told me, I should find a rarity in the keeping of four men, which I was born to possess for the benefit of mankind, and the first of the four that gave me his consent, I should present him with this girdle. Till I have found this jewel, I shall not part with the girdle.

PERIWINKLE: What can that rarity be? Did he not name it to you?

COLONEL: Yes, sir; he called it a chaste, beautiful, unaffected woman.

PERIWINKLE: Pish! Women are no rarities. I never had any great taste that way. I married, indeed, to please a father, and I got a girl to please my wife; but she and the child (thank Heaven) died together. Women are the very gewgaws of the Creation, playthings for boys, which, when they write man, they ought to throw aside.

SACKBUT: [*Aside*] A fine lecture to be read to a circle of ladies!

PERIWINKLE: What woman is there, dressed in all the pride and foppery of the times, can boast of such a foretop as the cockatoo?

COLONEL: [*Aside*] I must humor him. [To PERIWINKLE] Such a skin as the lizard?

PERIWINKLE: Such a shining breast as the hummingbird?

COLONEL: Such a shape as the antelope?

PERIWINKLE: Or, in all the artful mixture of their various dresses, have they half the beauty of one box of butterflies?

COLONEL: No, that must be allowed. For my part, if it were not for the benefit of mankind, I'd have nothing to do with them, for they are as indifferent to me as a sparrow or a flesh-fly.

PERIWINKLE: Pray, sir, what benefit is the world to reap from this lady?

COLONEL: Why, sir, she is to bear me a son, who shall restore the art of embalming and the old Roman manner of burying their dead, and, for the benefit of posterity, he is to discover the longitude, so long sought for in vain.

PERIWINKLE: Od! These are very valuable things, Mr. Sackbut.

SACKBUT: [*Aside*] He hits it off admirably and t'other swallows it like sack and sugar. [*To* PERIWINKLE] Certainly this lady must be your ward, Mr. Periwinkle, by her being under the care of four persons.

PERIWINKLE: By the description it should. [*Aside*] Egad, if I could get that girdle, I'd ride with the sun and make th'tour of the whole world in four-and-twenty hours. [*To* COLONEL] And are you to give that girdle to the first of the four guardians that shall give his consent to marry that lady, say you, sir?

COLONEL: I am so ordered, when I can find him.

PERIWINKLE: I fancy I know the very woman: her name is Anne Lovely.

COLONEL: Excellent! He said, indeed, that the first letter of her name was *L*.

PERIWINKLE: Did he really? Well, that's prodigiously amazing, that a person in Grand Cairo should know anything of my ward.

COLONEL: Your ward?

PERIWINKLE: To be plain with you, sir, I am one of those four guardians.

COLONEL: Are you indeed, sir? I am transported to find the man who is to possess this *moros musphonon* is a person of so curious a taste. Here is a writing drawn up by that famous Egyptian,

which, if you will please to sign, you must turn your face full north, and the girdle is yours.

PERIWINKLE: If I live till this boy is born, I'll be embalmed and sent to the Royal Society when I die.

COLONEL: That you shall most certainly.

Enter DRAWER.

DRAWER: Here's Mr. Staytape the tailor, inquires for you, Colonel.

SACKBUT: Who do you speak to, you son of a whore?

PERIWINKLE: [*Aside*] Ha! Colonel!

COLONEL: [*Aside*] Confound the blundering dog!

DRAWER: Why, to Colonel—

SACKBUT: Get you out, you rascal. [*Kicks him out and exits after him*]

DRAWER: [*As he exits*] What the devil is the matter?

COLONEL: [*Aside*] This dog has ruined my scheme, I see by Periwinkle's looks.

PERIWINKLE: [*Aside*] How finely I should have been choused.—Colonel, you'll pardon me that I did not give you your title before; it was pure ignorance, faith it was. Pray—hem, hem—pray, Colonel, what post had this learned Egyptian in your regiment?

COLONEL: [*Aside*] A pox of your sneer. [*To* PERIWINKLE] I don't understand you, sir.

PERIWINKLE: No? That's strange! I understand you, Colonel. An Egyptian of Grand Cairo! Ha, ha, ha! I am sorry such a well-invented tale should do you no more service. We old fellows can see as far into a millstone as him that picks it. I am not to be tricked out of my trust, mark that.

COLONEL: [*Aside*] The devil! I must carry it off; I wish I were fairly out. [*To* PERIWINKLE] Look ye, sir, you may make what jest you please, but the stars will obeyed, sir, and, depend upon it, I shall have the lady and you none of the girdle. [*Aside*] Now for Freeman's part of the plot. [*Exit*]

PERIWINKLE: The stars, ha, ha! No star has favoured you, it seems.

The girdle! Ha, ha, ha, none of your legerdemain tricks can pass upon me. Why, what a pack of trumpery has this rogue picked up! His *pagod, poluflosboios,* his *zonas, moros musphonon,* and the devil knows what. But I'll take care—Ha! Gone? Aye, 'twas time to sneak off.—Soho! The house! [*Enter* SACKBUT] Where is this trickster? Send for a constable, I'll have this rascal before the Lord Mayor; I'll Grand Cairo him, with a pox to him. I believe you had a hand in putting this imposture upon me, Sackbut.

SACKBUT: Who, I, Mr. Periwinkle? I scorn it. I perceived he was a cheat and left the room on purpose to send for a constable to apprehend him, and endeavoured to stop him when he went out; but the rogue made but one step from the stairs to the door, called a coach, leapt into it, and drove away like the devil, as Mr. Freeman can witness, who is at the bar and desires to speak with you. He is this minute come to town.

PERIWINKLE: Send him in. [*Exit* SACKBUT] What a scheme this rogue had laid! How I should have been laughed at, had it succeeded! [*Enter* FREEMAN *booted and spurred*] Mr. Freeman, your dress commands your welcome to town. What will you drink? I had like to have been imposed upon here by the veriest rascal—

FREEMAN: I am sorry to hear it. The dog flew for't—he had not 'scaped me if I had been aware of him; Sackbut struck at him, but missed his blow, or he had done his business for him.

PERIWINKLE: I believe you never heard of such a contrivance, Mr. Freeman, as this fellow had found out.

FREEMAN: Mr. Sackbut has told me the whole story, Mr. Periwinkle, but now I have something to tell you of much more importance to yourself. I happened to lie one night at Coventry, and knowing your uncle, Sir Toby Periwinkle, I paid him a visit and to my great surprise found him dying.

PERIWINKLE: Dying!

FREEMAN: Dying, in all appearance; the servants weeping, the room in darkness. The apothecary, shaking his head, told me the doctors had given him over, and then there is small hopes, you know.

PERIWINKLE: I hope he has made his will. He always told me he would make me his heir.

FREEMAN: I have heard you say as much and therefore resolved to give you notice. I should think it would not be amiss if you went down tomorrow morning.

PERIWINKLE: It is a long journey, and the roads very bad.

FREEMAN: But he has a great estate, and the land very good. Think upon that.

PERIWINKLE: Why, that's true, as you say; I'll think upon it. In the meantime, I give you many thanks for your civility, Mr. Freeman, and should be glad of your company to dine with me.

FREEMAN: I am obliged to be at Jonathan's Coffee-house at two, and it is now half-an-hour after one; if I dispatch my business, I'll wait on you; I know your hour.

PERIWINKLE: You shall be very welcome, Mr. Freeman; and so, your humble servant. [*Exit*]

Re-enter COLONEL *and* SACKBUT.

FREEMAN: Ha, ha, ha! I have done your business, Colonel; he has swallowed the bait.

COLONEL: I overheard all, though I am a little in the dark. I am to personate a highwayman, I suppose. That's a project I am not fond of; for though I may fright him out of his consent, he may fright me out of my life when he discovers me, as he certainly must in the end.

FREEMAN: No, no, I have a plot for you without danger, but first we must manage Tradelove. Has the tailor brought your clothes?

SACKBUT: Yes, pox take the thief.

COLONEL: Pox take your drawer for a jolt-headed rogue.

FREEMAN: Well, well, no matter, I warrant we have him yet. But now you must put on the Dutch merchant.

COLONEL: The deuce of this trading plot. I wish he had been an old soldier, that I might have attacked him in my own way, heard him fight over all the battles of the Civil War—but for trade, by Jupiter, I shall never do it.

SACKBUT: Never fear, Colonel, Mr. Freeman will instruct you.

FREEMAN: You'll see what others do, the coffee-house will instruct you.

COLONEL: I must venture, however. But I have a farther plot in my head upon Tradelove, which you must assist me in, Freeman; you are in credit with him, I heard you say.

FREEMAN: I am, and will scruple nothing to serve you, Colonel.

COLONEL: Come along then. Now for the Dutchman. Honest Ptolemy, by your leave,

Now must bob wig and business come in play,

And a fair thirty-thousand-pounder leads the way.

ACT IV, SCENE I

Jonathan's Coffee-house in Exchange Alley. Crowd of people with rolls of paper and parchment in their hands; a bar, and COFFEE-BOYS *waiting. Enter* TRADELOVE *and* STOCKJOBBERS *with rolls of paper and parchment.*

FIRST STOCKJOBBER: South Sea at seven-eighths! Who buys?

SECOND STOCKJOBBER: South Sea bonds due at Michaelmas 1718. Class lottery tickets.

THIRD STOCKJOBBER: East India bonds?

FOURTH STOCKJOBBER: What, all sellers and no buyers? Gentlemen, I'll buy a thousand pound for Tuesday next at three-fourths.

FIRST COFFEE-BOY: Fresh coffee, gentlemen, fresh coffee?

TRADELOVE: Hark ye, Gabriel, you'll pay the difference of that stock we transacted for t'other day.

GABRIEL: Aye, Mr. Tradelove, here's a note for the money upon the Sword Blade Company. [*Gives him a note*]

COFFEE-BOY: Bohea tea, gentlemen?

Enter a MAN.

MAN: Is Mr. Smuggle here?

FIRST COFFEE-BOY: Mr. Smuggle's not here, sir, you'll find him at the books.

SECOND STOCKJOBBER: Ho! Here come two sparks from the other end of the town. What news bring they?

Enter two GENTLEMEN.

TRADELOVE: I would fain bite that spark in the brown coat; he comes very often into the Alley, but never employs a broker.

Enter COLONEL *and* FREEMAN.

SECOND STOCKJOBBER: Who does anything in the Civil List lottery? Or cacao? Zounds, where are all the Jews this afternoon? Are you a bull or a bear today, Abraham?

THIRD STOCKJOBBER: A bull, faith, but I have a good put for next week.

TRADELOVE: Mr. Freeman, your servant! Who is that gentleman?

FREEMAN: A Dutch merchant, just come to England. But hark ye, Mr. Tradelove, I have a piece of news will get you as much as the French king's death did, if you are expeditious.

TRADELOVE: Say you so, sir! Pray, what is it?

FREEMAN: [*Showing him a letter*] Read there, I received it just now from one that belongs to the Emperor's minister.

TRADELOVE: [*Reads*] "Sir, As I have many obligations to you, I cannot miss any opportunity to show my gratitude. This moment my lord has received a private express that the Spaniards have raised their siege from before Cagliari. If this prove any advantage to you, it will answer both the ends and wishes of, sir, your most obliged humble servant, Henricus Dusseldorp. Postscript: in two or three hours, the news will be public." [*Aside to* FREEMAN] May one depend upon this, Mr. Freeman?

FREEMAN: You may. I never knew this person send me a false piece of news in my life.

TRADELOVE: Sir, I am much obliged to you. Egad, 'tis rare news.— Who sells South Sea for next week?

STOCKJOBBERS: [*All together*] I sell; I, I, I, I, I sell.

FIRST STOCKJOBBER: I'll sell five thousand pounds for next week at five-eighths.

SECOND STOCKJOBBER: I'll sell ten thousand at five-eighths for the same time.

TRADELOVE: Nay, nay, hold, hold, not all together, gentlemen, I'll be no bull, I'll buy no more than I can take. Will you sell ten thousand pound at a half for any day next week, except Sunday?

FIRST STOCKJOBBER: I'll sell it you, Mr. Tradelove.

FREEMAN *whispers to one of the* GENTLEMEN.

GENTLEMAN: [*Aloud*] The Spaniards raised the siege of Cagliari! I don't believe one word of it.

SECOND GENTLEMAN: Raised the siege! As much as you have raised the Monument.

FREEMAN: 'Tis raised, I assure you, sir.

SECOND GENTLEMAN: What will you lay on't?

FREEMAN: What you please.

FIRST GENTLEMAN: Why, I have a brother upon the spot in the Emperor's service; I am certain if there were any such thing, I should have had a letter.

A STOCKJOBBER: How's this? The siege of Cagliari raised? I wish it may true, 'twill make business stir and stocks rise.

FIRST STOCKJOBBER: Tradelove's a cunning fat bear; if this news proves true, I shall repent I sold him the five thousand pounds.—Pray, sir, what assurance have you that the siege is raised?

FREEMAN: There is come an express to the Emperor's minister.

SECOND STOCKJOBBER: I'll know that presently. [*Exit*]

FIRST GENTLEMAN: Let it come where it will, I'll hold you fifty pounds 'tis false.

FREEMAN: 'Tis done.

SECOND GENTLEMAN: I'll lay you a brace of hundreds upon the same.

FREEMAN: I'll take you.

FOURTH STOCKJOBBER: Egad, I'll hold twenty pieces 'tis not raised, sir.

FREEMAN: Done with you too.

TRADELOVE: I'll lay any man a brace of thousands the siege is raised.

FREEMAN: [*Aside to* TRADELOVE] The Dutch merchant is your man to take in.

TRADELOVE: Does not he know the news?

FREEMAN: [*To* TRADELOVE] Not a syllable; if he did, he would bet a hundred thousand pound as soon as one penny; he's plaguy rich, and a mighty man at wagers.

TRADELOVE: Say you so.—Egad, I'll bite him if possible. [*To* COLONEL] Are you from Holland, sir?

COLONEL: Ya, mynheer.

TRADELOVE: Had you the news before you came away?

COLONEL: Wat believe you, mynheer?

TRADELOVE: What do I believe? Why, I believe that the Spaniards have actually raised the siege of Cagliari.

COLONEL: Wat duyvels niews is dat? 'Tis niet waer, mynheer,—'tis no true, sir.

TRADELOVE: 'Tis so true, mynheer, that I'll lay you two thousand pounds upon it. [*To* FREEMAN] You are sure the letter may be depended upon, Mr. Freeman?

FREEMAN: [*Aside to* TRADELOVE] Do you think I would venture my money if I were not sure of the truth of it?

COLONEL: Two duysend pond, mynheer, 'tis gedaen—dis gentleman sal hold de gelt. [*Gives* FREEMAN *money*]

TRADELOVE: With all my heart—this binds the wager. You have certainly lost, mynheer, the siege is raised indeed.

COLONEL: Ik gelove't niet, Mynheer Freeman, ik sal ye dubbled houden, if you please.

FREEMAN: I am let into the secret, therefore won't win your money.

TRADELOVE: Ha, ha, ha! I have snapped the Dutchman, faith, ha, ha! This is no ill day's work.—Pray, may I crave your name, mynheer?

COLONEL: Myn naem, mynheer! Myn naem is Jan Van Timtamtire-lireletta Heer Van Fainwell.

TRADELOVE: Zounds, 'tis a damned long name, I shall never remember it: Mynheer Van Tim, Tim, Tim—What the devil is it?

FREEMAN: Oh! Never heed, I know the gentleman and will pass my word for twice the sum.

TRADELOVE: That's enough.

COLONEL: [*Aside*] You'll hear of me sooner than you'll wish, old gentleman, I fancy. [*Aside to* FREEMAN] You'll come to Sackbut's, Freeman? [*Exit*]

FREEMAN: [*Aside to the* COLONEL] Immediately.

FIRST MAN: Humphrey Hump here?

SECOND COFFEE-BOY: Mr. Humphrey Hump is not here; you'll find him upon the Dutch walk.

TRADELOVE: Mr. Freeman, I give you many thanks for your kindness.

FREEMAN: [*Aside*] I fear you'll repent when you know all.

TRADELOVE: Will you dine with me?

FREEMAN: I am engaged at Sackbut's; adieu. [*Exit*]

TRADELOVE: Sir, your humble servant. Now I'll see what I can do upon Change with my news. [*Exit*]

ACT IV, SCENE II

The tavern. Enter FREEMAN *and* COLONEL.

FREEMAN: Ha, ha, ha! The old fellow swallowed the bait as greedily as a gudgeon.

COLONEL: I have him, faith, ha, ha, ha. His two thousand pound's secure—if he would keep his money, he must part with the lady, ha, ha. What came of your two friends? They performed their part very well; you should have brought 'em to take a glass with us.

FREEMAN: No matter, we'll drink a bottle together another time. I did not care to bring them hither. There's no necessity to trust them with the main secret, you know, Colonel.

COLONEL: Nay, that's right, Freeman.

Enter SACKBUT.

SACKBUT: Joy, joy, Colonel, the luckiest accident in the world!

COLONEL: What say'st thou?

SACKBUT: This letter does your business.

COLONEL: [*Reads*] "To Obadiah Prim, hosier, near the building called the Monument, in London."

FREEMAN: A letter to Prim; how came you by it?

SACKBUT: Looking over the letters our post-woman brought, as I always do, to see what letters are directed to my house (for she can't read, you must know), I spied this to Prim, so paid for't among the rest. I have given the old jade a pint of wine on purpose to delay time, till you see if the letter will be of any service; then I'll seal it up again and tell her I took it by mistake. I have read it and fancy you'll like the project—read, read, Colonel.

COLONEL: [*Reads*] "Friend Prim, There is arrived from Pennsylvania one Simon Pure, a leader of the faithful, who hath sojourned with us eleven days and hath been of great comfort to the brethren. He intendeth for the quarterly meeting in London; I have recommended him to thy house; I pray thee intreat him kindly and let thy wife cherish him, for he's of weakly constitution. He will depart from us the third day; which is all from thy Friend in the faith, Aminidab Holdfast."

Ha, ha! Excellent! I understand you, landlord, I am to personate this Simon Pure, am I not?

SACKBUT: Don't you like the hint?

COLONEL: Admirably well!

FREEMAN: 'Tis the best contrivance in the world, if the right Simon gets not there before you.

COLONEL: No, no, the Quakers never ride post; he can't be here before tomorrow at soonest. Do you send and buy me a Quaker's dress, Mr. Sackbut; and suppose, Freeman, you should wait at the Bristol coach, that if you see any such person, you might contrive to give me notice.

FREEMAN: I will.—The country dress and boots, are they ready?

SACKBUT: Yes, yes, everything, sir.

FREEMAN: Bring 'em in then. [*Exit* SACKBUT] Thou must dispatch Periwinkle first. Remember his uncle, Sir Toby Periwinkle, is

an old bachelor of seventy-five; that he has seven hundred a year, most in abbey land; that he was once in love with your mother, and shrewdly suspected by some to be your father; that you have been thirty years his steward, and ten years his gentleman—remember to improve these hints.

COLONEL: Never fear, let me alone for that—but what's the steward's name?

FREEMAN: His name is Pillage.

COLONEL: Enough. [*Enter* SACKBUT *with clothes*] Now for the country put. [*Dresses*]

FREEMAN: Egad, landlord, thou deservest to have the first night's lodging with the lady for thy fidelity. What say you, Colonel, shall we settle a club here, you'll make one?

COLONEL: Make one? I'll bring a set of honest officers that will spend their money as freely to their King's health as they would their blood in his service.

SACKBUT: I thank you, Colonel. [*Bell rings*] Here, here. [*Exit* SACK-BUT]

COLONEL: So now for my boots. [*Puts on boots*] Shall I find you here, Freeman, when I come back?

FREEMAN: Yes, or I'll leave word with Sackbut where he may send for me. Have you the writings? The will, and everything?

COLONEL: All, all!

Enter SACKBUT.

SACKBUT: Zounds! Mr. Freeman! Yonder is Tradelove in the damnedest passion in the world. He swears you are in the house—he says you told him you was to dine here.

FREEMAN: I did so. Ha, ha, ha! He has found himself bit already.

COLONEL: The devil! He must not see me in this dress.

SACKBUT: I told him I expected you here, but you were not come yet.

FREEMAN: Very well.—Make you haste out, Colonel, and let me alone to deal with him. Where is he?

SACKBUT: In the King's Head?

COLONEL: You remember what I told you?

FREEMAN: Aye, aye, very well.—Landlord, let him know I am come in.—And now, Mr. Pillage, success attend you.

Exit SACKBUT.

COLONEL: Mr. Proteus, rather.
From changing shape and imitating Jove,
I draw the happy omens of my love.
I'm not the first young brother of the blade
Who made his fortune in a masquerade. [*Exit* COLONEL]

Enter TRADELOVE.

FREEMAN: Zounds! Mr. Tradelove, we're bit it seems.

TRADELOVE: Bit do you call it, Mr. Freeman, I am ruined. Pox on your news.

FREEMAN: Pox on the rascal that sent it me.

TRADELOVE: Sent it you! Why, Gabriel Skinflint has been at the minister's and spoke with him, and he has assured him 'tis every syllable false; he received no such express.

FREEMAN: I know it. I this minute parted with my friend, who protested he never sent me any such letter. Some roguish stockjobber has done it on purpose to make me lose my money, that's certain. I wish I knew who he was, I'd make him repent it—I have lost three hundred pounds by it.

TRADELOVE: What signifies your three hundred pounds to what I have lost? There's two thousand pounds to that Dutchman with the cursed long name, besides the stock I bought. The devil! I could tear my flesh. I must never show my face upon Change more, for, by my soul, I can't pay it.

FREEMAN: I am heartily sorry for't! What can I serve you in? Shall I speak to the Dutch merchant and try to get you time for the payment?

TRADELOVE: Time! Adsheart! I shall never be able to look up again.

FREEMAN: I am very much concerned that I was the occasion and wish I could be an instrument of retrieving your misfortune; for my own, I value it not.—Adso! A thought comes into my head that, well improved, may be of service.

TRADELOVE: Ah! There's no thought can be of any service to me, without paying the money or running away.

FREEMAN: How do you know? What do you think of my proposing Mrs. Lovely to him? He is a single man, and I heard him say he had a mind to marry an English woman. Nay, more than that, he said somebody told him you had a pretty ward. He wished you had bet her instead of your money.

TRADELOVE: Aye, but he'd be hanged before he'd take her instead of the money; the Dutch are too covetous for that. Besides, he did not know that there were three more of us, I suppose.

FREEMAN: So much the better; you may venture to give him your consent, if he'll but forgive you the wager. It is not your business to tell him that your consent will signify nothing.

TRADELOVE: That's right, as you say, but will he do it, think you?

FREEMAN: I can't tell that, but I'll try what I can do with him. He has promised me to meet me here an hour hence; I'll feel his pulse and let you know. If I find it feasible, I'll send for you. If not, you are at liberty to take what measures you please.

TRADELOVE: You must extol her beauty, double her portion, and tell him I have the entire disposal of her and that she can't marry without my consent and that I am a covetous rogue and will never part with her without a valuable consideration.

FREEMAN: Aye, aye, let me alone for a lie at a pinch.

TRADELOVE: Egad, if you can bring this to bear, Mr. Freeman, I'll make you whole again; I'll pay the three hundred pounds you lost, with all my soul.

FREEMAN: Well, I'll use my best endeavours. Where will you be?

TRADELOVE: At home. Pray Heaven you prosper. If I were but the sole trustee now, I should not fear it. Who the devil would be a guardian,
If when cash runs low, our coffers t'enlarge,
We can't, like other stocks, transfer our charge? [*Exit*]

FREEMAN: Ha, ha, ha! He has it. [*Exit*]

ACT IV, SCENE III

PERIWINKLE'S *house. Enter* PERIWINKLE *on one side and* FOOTMAN *on the other.*

FOOTMAN: A gentleman from Coventry inquires for you, sir.

PERIWINKLE: From my uncle, I warrant you, bring him up. [*Exit* FOOTMAN] This will save me the trouble, as well as the expenses of a journey.

Enter COLONEL.

COLONEL: Is your name Periwinkle, sir?

PERIWINKLE: It is, sir.

COLONEL: I am sorry for the message I bring. My old master, whom I served these forty years, claims the sorrow due from a faithful servant to an indulgent master. [*Weeps*]

PERIWINKLE: By this I understand, sir, my uncle, Sir Toby Periwinkle, is dead.

COLONEL: He is, sir, and he has left you heir to seven hundred a year in as good abbey land as ever paid Peter's pence to Rome. I wish you long to enjoy it, but my tears will flow when I think of my benefactor. [*Weeps*] Ah! He was a good man—he has not left many of his fellows—the poor laments him sorely.

PERIWINKLE: I pray, sir, what office bore you?

COLONEL: I was his steward, sir.

PERIWINKLE: I have heard him mention you with much respect; your name is—

COLONEL: Pillage, sir.

PERIWINKLE: Aye, Pillage! I do remember he called you Pillage. Pray, Mr. Pillage, when did my uncle die?

COLONEL: Monday last, at four in the morning. About two he signed this will and gave it into my hands and strictly charged me to leave Coventry the moment he expired and deliver it to you with what speed I could. I have obeyed him, sir, and there is the will. [*Gives it to* PERIWINKLE]

PERIWINKLE: 'Tis very well, I'll lodge it in the Commons.

COLONEL: There are two things which he forgot to insert, but charged

me to tell you that he desired you'd perform them as readily as if you had found them written in his will, which is to remove his corpse and bury him by his father in St. Paul, Covent Garden, and to give all his servants mourning.

PERIWINKLE: [*Aside*] That will be a considerable charge; a pox of all modern fashions. [*To him*] Well! It shall be done, Mr. Pillage. I will agree with one of death's fashion-mongers, called an undertaker, to go down and bring up the body.

COLONEL: I hope, sir, I shall have the honor to serve you in the same station I did your worthy uncle; I have not many years to stay behind him and would gladly spend them in the family where I was brought up. [*Weeps*] He was a kind and tender master to me.

PERIWINKLE: Pray don't grieve, Mr. Pillage; you shall hold your place and everything else which you held under my uncle. You make me weep to see you so concerned. [*Weeps*] He lived to a good old age—and we are all mortal.

COLONEL: We are so, sir, and therefore I must beg you to sign this lease. You'll find Sir Toby has ta'en particular notice of it in his will. I could not get it time enough from the lawyer, or he had signed it before he died. [*Gives him a paper*]

PERIWINKLE: A lease for what?

COLONEL: I rented a hundred a year of Sir Toby upon lease, which lease expires at Lady Day next, and I desire to renew it for twenty years—that's all, sir.

PERIWINKLE: Let me see. [*Looks over the lease*]

COLONEL: [*Aside*] Matters go swimmingly, if nothing intervene.

PERIWINKLE: Very well. Let's see what he says in his will about it. [*Lays the lease upon the table and looks on the will*]

COLONEL: [*Aside*] He's very wary, yet I fancy I shall be too cunning for him.

PERIWINKLE: Ho, here it is. "—The farm lying—now in possession of Samuel Pillage—suffer him to renew his lease—at the same rent."—Very well, Mr. Pillage, I see my uncle does mention it, and I'll perform his will. Give me the lease. [COLONEL *gives it*

him; he looks upon it and lays it upon the table.] Pray you, step
to the door and call for a pen and ink, Mr. Pillage.

COLONEL: I have pen and ink in my pocket, sir. [*Pulls out an inkhorn*]
I never go without that.

PERIWINKLE: I think it belongs to your profession. [*He looks upon
the pen while the* COLONEL *changes the lease and lays down the
contract*] I doubt this is but a sorry pen, though it may serve
to write my name. [*Writes*]

COLONEL: [*Aside*] Little does he think what he signs.

PERIWINKLE: There is your lease, Mr. Pillage. [*Gives him the paper*]
Now I must desire you to make what haste you can down to
Coventry and take care of everything, and I'll send down the
undertaker for the body; do you attend it up, and whatever
charge you are at, I will repay you.

COLONEL: [*Aside*] You have paid me already, I thank you, sir.

PERIWINKLE: Will you dine with me?

COLONEL: I would rather not; there are some of my neighbours which
I met as I came along, who leaves the town this afternoon, they
told me, and I should be glad of their company down.

PERIWINKLE: Well, well, I won't retain you.

COLONEL: [*Aside*] I don't care how soon I am out.

PERIWINKLE: I will give orders about mourning.

COLONEL: [*Aside*] You will have cause to mourn, when you know
your estate imaginary only.
You'll find your hopes and cares alike are vain,
In spite of all the caution you have ta'en,
Fortune rewards the faithful lover's pain. [*Exit*]

PERIWINKLE: Seven hundred a year! I wish he had died seventeen
years ago. What a valuable collection of rarities might I have
had by this time? I might have travelled over the known parts
of the globe and made my own closet rival the Vatican at Rome.
Odso, I have a good mind to begin my travels now—let me
see—I am but sixty! My father, grandfather and great-grandfa-
ther reached ninety-odd; I have almost forty years good. Let me
consider! What will seven hundred a year amount to—in—aye!

in thirty years, I'll say but thirty—thirty times seven, is seven times thirty—that is—just twenty-one thousand pound—'tis a great deal of money—I may very well reserve sixteen hundred of it for a collection of such rarities as will make my name famous to posterity. I would not die like other mortals, forgotten in a year or two, as my uncle will be. No.

With nature's curious works I'll raise my fame,

That men, till doomsday, may repeat my name. [*Exit*]

ACT IV, SCENE IV

A tavern. FREEMAN *and* TRADELOVE *over a bottle.*

TRADELOVE: Come, Mr. Freeman, here's Mynheer Jan Van Tim, Tam, Tam—I shall never think of that Dutchman's name.

FREEMAN: Mynheer Jan Van Timtamtirelireletta Heer Van Fainwell.

TRADELOVE: Aye, Heer Van Fainwell, I never heard such a confounded name in life—here's his health, I say. [*Drinks*]

FREEMAN: With all my heart.

TRADELOVE: Faith, I never expected to have found so generous a thing in a Dutchman.

FREEMAN: Oh, he has nothing of the Hollander in his temper—except an antipathy to monarchy. As soon as I told him your circumstances, he replied he would not be the ruin of any man for the world and immediately made this proposal himself. Let him take what time he will for the payment, said he, or if he'll give me his ward, I'll forgive him the debt.

TRADELOVE: Well, Mr. Freeman, I can but thank you. Egad, you have made a man of me again, and if ever I lay a wager more, may I rot in a gaol.

FREEMAN: I assure you, Mr. Tradelove, I was very much concerned because I was the occasion—though very innocently, I protest.

TRADELOVE: I dare swear you was, Mr. Freeman.

Enter a FIDDLER.

FIDDLER: Please to have a lesson of music or a song, gentlemen?

FREEMAN: A song, aye, with all our hearts. Have you ever a merry one?

FIDDLER: Yes, sir, my wife and I can give you a merry dialogue.

Here is the song.

TRADELOVE: 'Tis very pretty, faith.

FREEMAN: There's something for you to drink, friend; go, lose no time.

FIDDLER: I thank you, sir. [*Exit*]

Enter DRAWER *and* COLONEL, *dressed for the Dutch merchant.*

COLONEL: Hah, Mynheer Tradelove. Ik ben sorry voor your troubles, maer Ik sal you easie maeken, Ik wil de gelt nier hebben.

TRADELOVE: I shall forever acknowledge the obligation, sir.

FREEMAN: But you understand upon what condition, Mr. Tradelove: Mrs. Lovely.

COLONEL: Ya, de juffrow sal al te regt setten, mynheer.

TRADELOVE: With all my heart, mynheer, you shall have my consent to marry her freely.

FREEMAN: Well then, as I am a party concerned between you, Mynheer Jan Van Timtamtirelireletta Heer Van Fainwell shall give you a discharge of your wager under his own hand, and you shall give him your consent to marry Mrs. Lovely under yours. That is the way to avoid all manner of disputes hereafter.

COLONEL: Ya, waeragtig.

TRADELOVE: Aye, aye, so it is, Mr. Freeman, I'll give it under mine this minute. [*Sits down to write*]

COLONEL: And so sal Ik. [*Sits down to write*]

FREEMAN: So, ho, the house. [*Enter* DRAWER] Bid your master come up. [*Exit* DRAWER]. [*Aside*] I'll see there be witnesses enough to the bargain.

Enter SACKBUT.

SACKBUT: Do you call, gentlemen?

FREEMAN: Aye, Mr. Sackbut, we shall want your hand here.

TRADELOVE: There, mynheer, there's my consent as amply as you can desire, but you must insert your own name, for I know not how to spell it; I have left a blank for it. [*Gives the* COLONEL *a paper*]

COLONEL: Ya, Ik sal dat well doen.

FREEMAN: Now, Mr. Sackbut, you and I will witness it. [*They write*]

COLONEL: Daer, Mynheer Tradelove, is your discharge. [*Gives him a paper*]

TRADELOVE: Be pleased to witness this receipt too, gentlemen.

FREEMAN *and* SACKBUT *put their hands.*

FREEMAN: Aye, aye, that we will.

COLONEL: Well, mynheer, ye most meer doen, ye most myn voorspraek to de juffrow syn.

FREEMAN: He means you must recommend him to the lady.

TRADELOVE: That I will, and to the rest of my brother guardians.

COLONEL: Wat, voor den duyvel, heb you meer guardians?

TRADELOVE: Only three, mynheer.

COLONEL: Wat dondner heb ye myn betrocken, mynheer? Had Ik that gewoeten, Ik soude eaven met you geweest syn.

SACKBUT: But Mr. Tradelove is the principal, and he can do a great deal with the rest, sir.

FREEMAN: And he shall use his interest I promise you, mynheer.

TRADELOVE: I will say all that ever I can think on to recommend you, mynheer, and if you please, I'll introduce you to the lady.

COLONEL: Well, dat is waer. Maer ye must first spreken of myn to de juffrow and to de oudere gentlemen.

FREEMAN: Aye, that's the best way, and then I and the Heer Van Fainwell will meet you there.

TRADELOVE: I will go this moment, upon honor. Your most obedient humble servant. [*Aside*] My speaking will do you little good, mynheer, ha, ha. We have bit you, faith, ha, ha.
My debt's discharged, and for the man,

He's my consent—to get her if he can. [*Exit*]

COLONEL: Ha, ha, ha, this was a masterpiece of contrivance, Freeman.

FREEMAN: He hugs himself with his supposed good fortune and little thinks the luck's of our side, but come, pursue the fickle goddess while she's in the mood. Now for the Quaker.

COLONEL: That's the hardest task.

 Of all the counterfeits performed by man,

 A soldier makes the simplest Puritan. [*Exit*]

ACT V

PRIM's *house. Enter* MRS. PRIM *and* MRS. LOVELY *in Quaker's dress, meeting.*

MRS. PRIM: So, now I like thee, Anne. Art thou not better without thy monstrous hoop coat and patches? If Heaven should make thee so many black spots upon thy face, would it not fright thee, Anne?

LOVELY: If it should turn your inside outward and show all the spots of your hypocrisy, 'twould fright me worse.

MRS. PRIM: My hypocrisy! I scorn thy words, Anne. I lay no baits.

LOVELY: If you did, you'd catch no fish.

MRS. PRIM: Well, well, make thy jests, but I'd have thee to know, Anne, that I could have catched as many fish (as thou call'st them) in my time, as ever thou didst with all thy fool-traps about thee. If admirers be thy aim, thou wilt have more of them in this dress than thy other. The men, take my word for't, are most desirous to see what we are most careful to conceal.

LOVELY: Is that the reason for your formality, Mrs. Prim? Truth will out. I ever thought, indeed, there was more design than godliness in the pinched cap.

MRS. PRIM: Go, thou art corrupted with reading lewd plays and filthy romances, good for nothing but to lead youth into the high road of fornication. Ah! I wish thou art not already too familiar with the wicked ones.

LOVELY: Too familiar with the wicked ones! Pray, no more of those freedoms, madam. I am familiar with none so wicked as yourself. How dare you talk thus to me! You, you, you unworthy woman, you. [*Bursts into tears*]

Enter TRADELOVE.

TRADELOVE: What, in tears, Nancy? What have you done to her, Mrs. Prim, to make her weep?

LOVELY: Done to me! I admire I keep my senses among you. But I will rid myself of your tyranny, if there be either law or justice to be had; I'll force you to give me up my liberty.

MRS. PRIM: Thou hast more need to weep for thy sins, Anne—yea, for thy manifold sins.

LOVELY: Don't think that I'll be still the fool which you have made me. No, I'll wear what I please, go when and where I please, and keep what company I think fit and not what you shall direct—I will.

TRADELOVE: For my part, I do think all this very reasonable, Mrs. Lovely—'tis fit you should have your liberty, and for that purpose I am come.

Enter MR. PERIWINKLE *and* OBADIAH PRIM, *with a letter in his hand.*

PERIWINKLE: I have bought some black stockings of your husband, Mrs. Prim, but he tells me the glover's trade belongs to you; therefore, I pray you look me out five or six dozen mourning gloves, such as are given at funerals, and send them to my house.

PRIM: My friend Periwinkle has got a good windfall today—seven hundred a year.

MRS. PRIM: I wish thee joy of it, neighbour.

TRADELOVE: What, is Sir Toby dead then?

PERIWINKLE: He is!—You'll take care, Mrs. Prim?

MRS. PRIM: Yea, I will, neighbour.

PRIM: This letter recommendeth a speaker, 'tis from Aminidab Holdfast of Bristol. Peradventure, he will be here this night;

therefore, Sarah, do thou take care for his reception. [*Gives her the letter*]

MRS. PRIM: I will obey thee. [*Exit*]

PRIM: What art thou in the dumps for, Anne?

TRADELOVE: We must marry her, Mr. Prim.

PRIM: Why truly, if we could find a husband worth having, I should be as glad to see her married as thou wouldst, neighbour.

PERIWINKLE: Well said, there are but few worth having.

TRADELOVE: I can recommend you a man now that I think you can none of you have an objection to!

Enter SIR PHILIP MODELOVE.

PERIWINKLE: You recommend! Nay, whenever she marries, I'll recommend the husband.

SIR PHILIP: What, must it be a whale or a rhinoceros, Mr. Periwinkle? Ha, ha, ha! Mr. Tradelove, I have a bill upon you [*gives him a paper*] and have been seeking for you all over the town.

TRADELOVE: I'll accept it, Sir Philip, and pay it when due.

PERIWINKLE: He shall be none of the fops at your end of the town, with full perukes and empty skulls, nor yet none of your trading gentry, who puzzle the heralds to find arms for their coaches. No, he shall be a man famous for travels, solidity and curiosity, one who has searched into the profundity of nature. When Heaven shall direct such a one, he shall have my consent, because it may turn to the benefit of mankind.

LOVELY: The benefit of mankind! What, would you anatomize me?

SIR PHILIP: Aye, aye, madam, he would dissect you.

TRADELOVE: Or pore over you through a microscope to see how your blood circulates from the crown of your head to the sole of your foot, ha, ha! But I have a husband for you, a man that knows how to improve your fortune, one that trades to the four corners of the globe.

LOVELY: And would send me for a venture perhaps.

TRADELOVE: One that will dress you in all the pride of Europe, Asia, Africa, and America—a Dutch merchant, my girl!

SIR PHILIP: A Dutchman! Ha, ha, there's a husband for a fine lady—

Ya, juffrow, will you met myn slapen? Ha, ha! He'll learn you to talk the language of the hogs, madam, ha, ha.

TRADELOVE: He'll learn you that one merchant is of more service to a nation than fifty coxcombs. The Dutch know the trading interest to be of more benefit to the state than the landed.

SIR PHILIP: But what is either interest to a lady?

TRADELOVE: 'Tis the merchant makes the belle. How would the ladies sparkle in the box without the merchant? The Indian diamonds! The French brocade! The Italian fan! The Flanders lace! The fine Dutch holland! How would they vent their scandal over their tea-tables? And where would you beaus have champagne to toast your mistresses, were it not for the merchant?

PRIM: Verily, neighbour Tradelove, thou dost waste thy breath about nothing. All that thou hast said tendeth only to debauch youth and fill their heads with the pride and luxury of this world. The merchant is a very great friend to Satan and sendeth as many to his dominions as the Pope.

PERIWINKLE: Right, I say knowledge makes the man.

PRIM: Yea, but not thy kind of knowledge—it is the knowledge of Truth. Search thou for the light within and not for baubles, Friend.

LOVELY: Ah, study your country's good, Mr. Periwinkle, and not her insects. Rid you of your homebred monsters before you fetch any from abroad. I dare swear you have maggots enough in your own brain to stock all the virtuosos in Europe with butterflies.

SIR PHILIP: By my soul, Miss Nancy's a wit.

PRIM: That is more than she can say by thee, Friend. Look ye, it is in vain to talk; when I meet a man worthy of her, she shall have my leave to marry him.

LOVELY: Provided he be one of the faithful. [*Aside*] Was there ever such a swarm of caterpillars to blast the hopes of a young woman! [*Aloud*] Know this, that you contend in vain: I'll have no husband of your choosing, nor shall you lord it over me

long. I'll try the power of an English senate. Orphans have
been redressed and wills set aside, and none did ever deserve
their pity more. [*Aside*] Oh Fainwell! Where are thy promises
to free me from these vermin? Alas! The task was more difficult
than he imagined!
A harder task than what the poets tell
Of yore, the fair Andromeda befell;
She but one monster feared, I've four to fear,
And see no Perseus, no deliv'rer near. [*Exit*]

Enter SERVANT *and whispers to* PRIM.

SERVANT: One Simon Pure inquireth for thee.
PERIWINKLE: The woman is mad. [*Exit*]
SIR PHILIP: So are you all, in my opinion. [*Exit*]
PRIM: Friend Tradelove, business requireth my presence.
TRADELOVE: Oh, I shan't trouble you. [*Aside*] Pox take him for an
unmannerly dog. However, I have kept my word with my
Dutchman, and will introduce him too for all you. [*Exit*]

Enter COLONEL *in a Quaker's habit.*

PRIM: Friend Pure, thou art welcome. How is it with Friend Holdfast
and all Friends in Bristol? Timothy Littlewit, John Slenderbrain
and Christopher Keepfaith?
COLONEL: [*Aside*] A goodly company! [*To him*] They are all in health,
I thank thee for them.
PRIM: Friend Holdfast writes me word that thou camest lately from
Pennsylvania. How do all Friends there?
COLONEL: [*Aside*] What the devil shall I say? I know just as much of
Pennsylvania as I do of Bristol.
PRIM: Do they thrive?
COLONEL: Yea, Friend, the blessing of their good works fall upon
them.

Enter MRS. PRIM *and* MRS. LOVELY.

PRIM: Sarah, know our Friend Pure.

MRS. PRIM: Thou art welcome.

He salutes her.

COLONEL: [*Aside*] Here comes the sum of all my wishes. How charming she appears, even in that disguise.

PRIM: Why dost thou consider the maiden so intentively, Friend?

COLONEL: I will tell thee. About four days ago I saw a vision—this very maiden, but in vain attire, standing on a precipice—and heard a voice, which called me by my name and bade me put forth my hand and save her from the pit. I did so, and methought the damsel grew to my side.

MRS. PRIM: What can that portend?

PRIM: The damsel's conversion, I am persuaded.

LOVELY: [*Aside*] That's false, I'm sure.

PRIM: Wilt thou use the means, Friend Pure?

COLONEL: Means! What means? Is she not thy daughter and already one of the faithful?

MRS. PRIM: No, alas! She's one of the ungodly.

PRIM: Pray thee, mind what this good man will say unto thee; he will teach thee the way that thou shouldst walk, Anne.

LOVELY: I know my way without his instructions. I hoped to have been quiet, when once I had put on your odious formality here.

COLONEL: Then thou wearest it out of compulsion, not choice, Friend?

LOVELY: Thou art in the right of it, Friend.

MRS. PRIM: Art not thou ashamed to mimic the good man? Ah! Thou art a stubborn girl.

COLONEL: Mind her not; she hurteth not me. If thou wilt leave her alone with me, I will discuss some few points with her that may, perchance, soften her stubbornness and melt her into compliance.

PRIM: Content, I pray thee put it home to her. Come, Sarah, let us leave the good man with her.

LOVELY: [*Catching hold of* PRIM; *he breaks loose and exists with* MRS. PRIM] What do you mean—to leave me with this old enthu-

siastical canter? Don't think, because I complied with your formality, to impose your ridiculous doctrine upon me.

COLONEL: I pray thee, young woman, moderate thy passion.

LOVELY: I pray thee, walk after thy leader. You will but lose your labour upon me. [*Aside*] These wretches will certainly make me mad.

COLONEL: I am of another opinion; the spirit telleth me that I shall convert thee, Anne.

LOVELY: 'Tis a lying spirit; don't believe it.

COLONEL: Say'st thou so? Why then, thou shalt convert me, my angel. [*Catching her in his arms*]

LOVELY: [*Shrieks*] Ah! Monster, hold off, or I'll tear thy eyes out.

COLONEL: Hush! For Heaven's sake—dost thou know me? I am Fainwell.

LOVELY: Fainwell! [*Enter old* PRIM]. [*Aside*] Oh, I'm undone, Prim here. I wish with all my soul I had been dumb.

PRIM: What is the matter? Why didst thou shriek out, Anne?

LOVELY: Shriek out! I'll shriek and shriek again, cry murder, thieves, or anything to drown the noise of that eternal babbler, if you leave me with him any longer.

PRIM: Was that all? Fie, fie, Anne.

COLONEL: No matter, I'll bring down her stomach, I'll warrant thee—leave us, I pray thee.

PRIM: Fare thee well. [*Exit*]

COLONEL: [*Embraces her*] My charming, lovely woman.

LOVELY: What means thou by this disguise, Fainwell?

COLONEL: To set thee free, if thou wilt perform thy promise.

LOVELY: Make me mistress of my fortune and make thy own conditions.

COLONEL: This night shall answer all thy wishes. See here, I have the consent of three of thy guardians already and doubt not but Prim shall make the fourth.

PRIM *listening.*

PRIM: [*Aside*] I would gladly hear what argument the good man useth to bend her.

LOVELY: Thy words give me new life, methinks.

PRIM: What do I hear?

LOVELY: Thou best of men, Heaven meant to bless me sure, when first I saw thee.

PRIM: He hath mollified her. Oh wonderful conversion!

COLONEL: Ha! Prim listening. [*Aside*] No more, my love, we are observed; seem to be edified and give 'em hopes that thou wilt turn Quaker, and leave the rest to me. [*Aloud*] I am glad to find that thou art touched with what I said unto thee, Anne. Another time I will explain the other article to thee; in the meanwhile, be thou dutiful to our Friend Prim.

LOVELY: I shall obey thee in everything.

Enter old PRIM.

PRIM: Oh what a prodigious change is here! Thou hast wrought a miracle, Friend! Anne, how dost thou like the doctrine he hath preached?

LOVELY: So well, that I could talk to him forever, methinks. I am ashamed of my former folly and ask your pardon, Mr. Prim.

COLONEL: Enough, enough that thou art sorry; he is no pope, Anne.

PRIM: Verily, thou dost rejoice me exceedingly, Friend. Will it please thee to walk into the next room and refresh thyself? Come, take the maiden by the hand.

COLONEL: We will follow thee.

Enter SERVANT.

SERVANT: There is another Simon Pure inquireth for thee, master.

COLONEL: [*Aside*] The devil there is.

PRIM: Another Simon Pure? I do not know him. Is he any relation of thine?

COLONEL: No, Friend, I know him not. [*Aside*] Pox take him, I wish he were in Pennsylvania again, with all my blood.

LOVELY: [*Aside*] What shall I do?

PRIM: Bring him up.

COLONEL: [*Aside*] Humph! Then one of us must go down, that's certain. Now Impudence assist me.

Enter SIMON PURE.

PRIM: What is thy will with me, Friend?

SIMON PURE: Didst thou not receive a letter from Aminidab Holdfast of Bristol concerning one Simon Pure?

PRIM: Yea, and Simon Pure is already here, Friend.

COLONEL: [*Aside*] And Simon Pure will stay here, Friend, if possible.

SIMON PURE: That's an untruth, for I am he.

COLONEL: Take thou heed, Friend, what thou dost say; I do affirm that I am Simon Pure.

SIMON PURE: Thy name may be Pure, Friend but not that Pure.

COLONEL: Yea, that Pure which my good Friend Aminidab Holdfast wrote to my Friend Prim about, the same Simon Pure that came from Pennsylvania and sojourned in Bristol eleven days. Thou wouldst not take my name from me, wouldst thou? [*Aside*] Till I have done with it.

SIMON PURE: Thy name! I am astonished.

COLONEL: At what? At thy own assurance? [*Going up to him;* SIMON PURE *starts back.*]

SIMON PURE: Avaunt, Sathan, approach me not; I defy thee and all thy works.

LOVELY: [*Aside*] Oh, he'll outcant him. Undone, undone forever.

COLONEL: Hark thee, Friend, thy sham will not take. Don't exert thy voice; thou art too well acquainted with Sathan to start at him, thou wicked reprobate. What can thy design be here?

Enter SERVANT *and gives* PRIM *a letter.*

PRIM: One of these must be a counterfeit, but which I cannot say.

COLONEL: [*Aside*] What can that letter be?

SIMON PURE: Thou must be the devil, Friend, that's certain, for no human power can stock so great a falsehood.

PRIM: This letter sayeth that thou art better acquainted with that

prince of darkness than any here. Read that, I pray thee, Simon. [*Gives it the* COLONEL]

COLONEL: [*Aside*] 'Tis Freeman's hand. [*Reads*] "There is a design formed to rob your house this night and cut your throat, and for that purpose there is a man disguised like a Quaker, who is to pass for one Simon Pure. The gang whereof I am one, though now resolved to rob no more, has been at Bristol. One of them came up in the coach with the Quaker, whose name he hath taken, and from what he gathered from him, formed that design, and did not doubt but he should impose so far upon you as to make you turn out the real Simon Pure and keep him with you. Adieu." [*Aside*] Excellent well!

PRIM: [*To* SIMON PURE] Dost thou hear this?

SIMON PURE: Yea, but it moveth me not; that, doubtless, is the impostor. [*Pointing at the* COLONEL]

COLONEL: Ah! Thou wicked one—now I consider thy face I remember thou didst come up in the leathern convenience with me—thou hadst a black bob wig on, and a brown camblet coat with brass buttons. Canst thou deny it, ha?

SIMON PURE: Yea, I can, and with a safe conscience too, Friend.

PRIM: Verily, Friend, thou art the most impudent villain I ever saw.

LOVELY: [*Aside*] Nay then, I'll have a fling too. [*Aloud*] I remember the face of this fellow at Bath. Aye, this is he that picked my Lady Raffle's pocket upon the Grove. Don't you remember that the mob pumped you, Friend? This is the most notorious rogue.

SIMON PURE: What doth provoke thee to seek my life? Thou wilt not hang me, wilt thou, wrongfully?

PRIM: She will do thee no hurt, nor thou shalt do me none; therefore, get thee about thy business, Friend, and leave thy wicked course of life, or thou may'st not come off so favourably everywhere.

COLONEL: Go, Friend, I would advise thee, and tempt thy fate no more.

SIMON PURE: Yea, I will go, but it shall be to thy confusion; for I shall clear myself. I will return with some proofs that shall convince thee, Obadiah, that thou art highly imposed upon. [*Exit*]

COLONEL: [*Aside*] Then here will be no staying for me, that's certain. What the devil shall I do?

PRIM: What monstrous works of iniquity are there in this world, Simon!

COLONEL: Yea, the age is full of vice. [*Aside*] Z'death, I am so confounded, I know not what to say.

PRIM: Thou art disordered, Friend—art thou not well?

COLONEL: My spirit is greatly troubled, and something telleth me, that though I have wrought a good work in converting this maiden, this tender maiden, yet my labour will be in vain; for the evil spirit fighteth against her, and I see, yea I see with the eyes of my inward man, that Sathan will rebuffet her again, whenever I withdraw myself from her, and she will, yea this very damsel will return again to that abomination from whence I have retrieved her, as if it were, yea, as if it were out of the jaws of the Fiend—hum—

PRIM: Good lack! Thinkest thou so?

LOVELY: [*Aside*] I must second him. [*Aloud*] What meaneth this struggling within me? I feel the spirit resisting the vanities of this world, but the flesh is rebellious, yea the flesh—I greatly fear the flesh and the weakness thereof—hum—

PRIM: The maid is inspired.

COLONEL: Behold, her light begins to shine forth. [*Aside*] Excellent woman!

LOVELY: This good man hath spoken comfort unto me, yea comfort, I say; because the words which he hath breathed into my outward ears are gone through and fixed in mine heart, yea verily in mine heart, I say—and I feel the spirit doth love him exceedingly, hum—

COLONEL: [*Aside*] She acts it to the life.

PRIM: Prodigious! The damsel is filled with the spirit, Sarah!

Enter MRS. PRIM.

MRS. PRIM: I am greatly rejoiced to see such a change in our beloved Anne. I came to tell thee that supper stayeth for thee.

COLONEL: I am not disposed for thy food—my spirit longeth for

more delicious meat. Fain would I redeem this maiden from the tribe of sinners and break thoswhat e cords asunder wherewith she is bound—hum—

LOVELY: Something whispers in my ears, methinks, that I must be subject to the will of this good man and from him only must hope for consolation—hum—it also telleth me that I am a chosen vessel to raise up seed to the faithful and that thou must consent that we two be one flesh according to the Word—hum—

PRIM: What a Revelation is here? This is certainly part of thy vision, Friend, this is the maiden's growing to thy side. Ah! With what willingness should I give thee my consent, could I give thee her fortune too, but thou wilt never get the consent of the wicked ones.

COLONEL: [*Aside*] I wish I was as sure of yours.

PRIM: My soul rejoiceth, yea, it rejoiceth, I say, to find the spirit within thee. For lo, it moveth thee with natural agitation—yea, with natural agitation, I say again, and stirreth up the seeds of thy virgin inclination towards this good man—yea, it stirreth, as one may say—yea verily, I say it stirreth up thy inclination—yea, as one would stir a pudding.

LOVELY: I see, I see! The spirit guiding of thy hand, good Obadiah Prim, and now behold thou art signing thy consent, and now I see myself within thy arms, my Friend and Brother, yea, I am become bone of thy bone and flesh of thy flesh. [*Embraces him*] Hum—

COLONEL: [*Aside*] Admirably performed. [*Aloud*] And I will take thee in all spiritual love for an helpmeet, yea, for the wife of my bosom—and now, methinks—I feel a longing—yea, a longing, I say, for the consummation of thy love, hum—yea, I do long exceedingly.

LOVELY: And verily, verily my spirit feeleth the same longing.

MRS. PRIM: The spirit hath greatly moved them both. Friend Prim, thou must consent; there is no resisting of the spirit.

PRIM: Yea, the light within showeth me that I shall fight a good

fight—and wrestle through those reprobate fiends, thy other guardians—yea, I perceive the spirit will hedge thee into the flock of the righteous—Thou art a chosen Lamb—yea, a chosen Lamb, and I will not push thee back—no, I will not, I say—no, thou shall leap-a, and frisk-a, and skip-a, and bound, and bound, I say—yea, bound within the fold of the righteous—yea, even within thy fold, my Brother. Fetch me the pen and ink, Sarah—and my hand shall confess its obedience to the spirit. [*Exit* MRS. PRIM]

COLONEL: [*Aside*] I wish it were over.

Enter MRS. PRIM *with pen and ink.*

LOVELY: [*Aside*] I tremble lest this Quaking rogue should return and spoil all.

PRIM: Here, Friend, do thou write what the spirit prompteth, and I will sign it.

COLONEL *sits down and writes.*

MRS. PRIM: Verily, Anne, it greatly rejoiceth me, to see thee reformed from that original wickedness wherein I found thee.

LOVELY: I do believe thou art, and I thank thee.

COLONEL: [*Reads*] "This is to certify all whom it may concern, that I do freely give up all my right and title in Anne Lovely to Simon Pure, and my full consent that she shall become his wife according to the form of marriage. Witness my hand."

PRIM: That is enough—give me the pen. [*Signs it*]

Enter BETTY *running to* MRS. LOVELY.

BETTY: Oh! Madam, madam, here's the Quaking man again; he has brought a coachman and two or three more.

LOVELY: [*Aside to* COLONEL] Ruined past redemption.

COLONEL: [*Aside to her*] No, no, one minute sooner had spoiled all, but now—[*Going to* PRIM *hastily*] Here is company coming, Friend, give me the paper.

PRIM: Here it is, Simon, and I wish thee happy with the maiden.

LOVELY: 'Tis done, and now devil do thy worst.

Enter SIMON PURE *and* COACHMAN, *etc.*

SIMON PURE: Look thee, Friend, I have brought these people to satisfy thee that I am not that impostor which thou didst take me for. This is the man which did drive the leathern conveniency that brought me from Bristol, and this is—

COLONEL: Look ye, Friend, to save the Court the trouble of examining the witnesses, I plead guilty, ha, ha!

PRIM: How's this? Is not thy name Pure, then?

COLONEL: No really, sir, I only made bold with this gentleman's name, but I here give it up safe and sound. It has done the business which I had occasion for, and now I intend to wear my own, which shall be at his service upon the same occasion at any time, ha, ha, ha!

SIMON PURE: Oh! The wickedness of this age.

COACHMAN: Then you have no farther need of us, sir. [*Exit*]

COLONEL: No, honest man, you may go about your business.

PRIM: I am struck dumb with thy impudence, Anne; thou hast deceived me and perchance undone thyself.

MRS. PRIM: Thou art a dissembling baggage, and shame will overtake thee. [*Exit*]

SIMON PURE: I am grieved to see thy wife so much troubled; I will follow and console her. [*Exit*]

Enter SERVANT.

SERVANT: Thy brother guardians inquireth for thee; there is another man with them.

LOVELY: [*To* COLONEL] Who can that other man be?

COLONEL: 'Tis one Freeman, a friend of mine, whom I ordered to bring the rest of thy guardians here.

Enter SIR PHILIP, TRADELOVE, PERIWINKLE, *and* FREEMAN.

FREEMAN: [*To* COLONEL] Is all safe? Did my letter do you service?

COLONEL: [*Aside to* FREEMAN] All! All's safe; ample service.

SIR PHILIP: Miss Nancy, how dost do, child?

LOVELY: Don't call me Miss, Friend Philip, my name is Anne, thou knowest.

SIR PHILIP: What, is the girl metamorphosed?

LOVELY: I wish thou wert so metamorphosed. Ah! Philip, throw off that gaudy attire and wear the clothes becoming of thy age.

PRIM: [*Aside*] I am ashamed to see these men.

SIR PHILIP: My age! The woman is possessed.

COLONEL: No, thou art possessed rather, Friend.

TRADELOVE: Hark ye, Mrs. Lovely, one word with you. [*Takes hold of her hand*]

COLONEL: This maiden is my wife, thanks to Friend Prim, and thou hast to business with her. [*Takes her from him*]

TRADELOVE: His wife! Hark ye, Mr. Freeman—

PERIWINKLE: Why, you have made a very fine piece of work of it, Mr. Prim.

SIR PHILIP: Married to a Quaker! Thou art a fine fellow to be left guardian to an orphan, truly—there's a husband for a young lady!

COLONEL: When I have put on my beau clothes, Sir Philip, you'll like me better.

SIR PHILIP: Thou wilt make a very scurvy beau, Friend.

COLONEL: I believe I can prove it under your hand that you thought me a very fine gentleman in the park today, about thirty-six minutes after eleven. Will you take a pinch, Sir Philip—out of the finest snuffbox you ever saw? [*Offers him snuff*]

SIR PHILIP: Ha, ha, ha! I am overjoyed, faith I am, if thou be'st that gentleman. I own I did give my consent to the gentleman I brought here today, but if this is he I can't be positive.

PRIM: Canst thou not? Now I think thou art a fine fellow to be left to an orphan. Thou shallow-brained shuttlecock, he may be a pickpocket for aught thou dost know.

PERIWINKLE: You would have been two rare fellows to have been trusted with the sole management of her fortune, would ye not, think ye? But Mr. Tradelove and myself shall take care of her portion.

TRADELOVE: Aye, aye, so we will. Did not you tell me the Dutch merchant desired me to meet him here, Mr. Freeman?

FREEMAN: I did so, and I am sure he will be here, if you have a little patience.

COLONEL: What, is Mr. Tradelove impatient? Nay then, ik ben gereet veor you, heb ye Jan Van Timtamtirelireletta Heer Van Fainwell vergeeten?

TRADELOVE: Oh! Pox of the name! What, have you tricked me too, Mr. Freeman?

COLONEL: Tricked, Mr. Tradelove! Did I not give you two thousand pound for your consent fairly? And now do you tell a gentleman that he has tricked you?

PERIWINKLE: So, so, you are a pretty guardian, faith, sell your charge. What, did you look upon her as part of your stock?

PRIM: Ha, ha, ha! I am glad thy knavery is found out however. I confess the maiden overreached me, and no sinister end at all.

PERIWINKLE: Aye, aye, one thing or another overreached you all, but I'll take care he shall never finger a penny of her money, I warrant you. Overreached, quoth'a? Why, I might have been overreached too, if I had had no more wit. I don't know but this very fellow may be him that was directed to me from Grand Cairo today. Ha, ha, ha.

COLONEL: The very same, sir.

PERIWINKLE: Are you so, sir, but your trick would not pass upon me.

COLONEL: No, as you say, at that time it did not, that was not my lucky hour, but hark ye, sir, I must let you into one secret—you may keep honest John Tradescant's coat on, for your uncle, Sir Toby Periwinkle, is not dead—so the charge of mourning will be saved, ha, ha! Don't you remember Mr. Pillage, your uncle's steward, ha, ha, ha?

PERIWINKLE: Not dead! I begin to fear I am tricked too.

COLONEL: Don't you remember the signing of a lease, Mr. Periwinkle?

PERIWINKLE: Well, and what signifies that lease, if my uncle is not dead? Ha! I am sure it was a lease I signed.

COLONEL: Aye, but it was a lease for life, sir, and of this beautiful tenement, I thank you. [*Taking hold of* MRS. LOVELY]

ALL: Ha, ha, ha, neighbour's fare!

FREEMAN: So then, I find you are all tricked, ha, ha!

PERIWINKLE: I am certain I read as plain a lease as ever I read in my life.

COLONEL: You read a lease I grant you, but you signed this contract. [*Showing a paper*]

PERIWINKLE: How durst you put this trick upon me, Mr. Freeman, did not you tell me my uncle was dying?

FREEMAN: And would tell you twice as much to serve my friend, ha, ha.

SIR PHILIP: What, the learned, famous Mr. Periwinkle choused too? Ha, ha, ha! I shall die with laughing, ha, ha, ha.

PRIM: It had been well if her father had left her to wiser heads than thine and mine, Friend, ha, ha.

TRADELOVE: Well, since you have outwitted us all, pray you, what and who are you, sir?

SIR PHILIP: Sir, the gentleman is a fine gentleman. I am glad you have got a person, madam, who understands dress and good breeding. I was resolved she should have a husband of my choosing.

PRIM: I am sorry the maiden is fallen into such hands.

TRADELOVE: A beau! Nay then, she is finely helped up.

LOVELY: Why, beaus are great encouragers of trade, sir, ha, ha!

COLONEL: Look ye, gentlemen, I am the person who can give the best account of myself, and I must beg Sir Philip's pardon, when I tell him that I have as much aversion to what he calls dress and breeding as I have to the enemies of my religion. I have had the honor to serve his Majesty and headed a regiment of the bravest fellows that ever pushed bayonet in the throat of a Frenchman, and notwithstanding the fortune this lady brings me, whenever my country wants my aid, this sword and arm are at her service.

And now, my fair, if you'll but deign to smile, I meet a recompense for all my toil:

Love and religion ne'er admit restraint,
Force makes many a sinner, not one saint;
Still free as air the active mind does rove,
And searches proper objects for its love,
But that once fixed, 'tis past the power of art
To chase the dear ideas from the heart:
'Tis liberty of choice that sweetens life,
Makes the glad husband and the happy wife.

Exeunt.

EPILOGUE

What new strange ways our modern beaus devise!
What trials of love-skill to gain the prize!
The heathen gods, who never mattered rapes,
Scarce wore such strange variety of shapes:
The devil take their odious barren skulls,
To court in form of snakes and filthy bulls.
Old Jove once nicked it, I am told,
In a whole lapful of true standard gold;
How must his godship then fair Daëne warm?
In trucking ware for ware there is no harm,
Well, after all—that money has a charm:
But now indeed that stale invention's past;
Besides, you know, that guineas fall so fast,
Poor nymph must come to pocket-piece at last.
Old Harry's face or good Queen Bess's ruff—
Not that I'd take 'em—may do well enough.
No, my ambitious spirit's far above
Those little tricks of mercenary love.
That man be mine who, like the Colonel here,
Can top his character in every sphere,
Who can a thousand ways employ his wit,
Out-promise statesmen and out-cheat a cit,
Beyond the colours of a trav'ler paint,
And cant and ogle too—beyond a saint.
The last disguise most pleased me, I confess;
There's something tempting in the preaching dress,
And pleased me more than once a dame of note,
Who loved her husband in his footman's coat.
To see one eye in wanton motions played,
Th'other to the Heavenly regions strayed,
As if it for its fellow's frailties prayed.
But yet I hope, for all that I have said,
To find my spouse a man of war in bed.

FINIS

77

Notes on *A Bold Stroke for a Wife*

DRAMATIS PERSONAE

Virtuoso—An amateur scientist or collector of curiosities and antiquities.

Change-broker—An exchange-broker, a financial go-between in the stock market.

Quaker—A member of the religious movement that emerged in the mid-seventeenth century through the preaching of George Fox (1624–91). The Society of Friends, as the Quakers called themselves, was a consistent target of Centlivre's satire.

DEDICATION

Philip, Duke and Marquis of Wharton—Philip was the son of an Earl, Thomas Wharton, who had died in 1715. Thomas had been a prominent member of the Whig group known as the "Junto"; Philip's claim to fame seems to have been defecating in a parish pulpit to show his contempt of the Church of England. His mother, Anne Wharton,

was a poet and the author of *Love's Martyr, or Wit above Crowns*, a tragedy that allegorized the Exclusion Crisis.

Henry iv and *the bold assassin's hand*—Henri iv, also known as Henri of Navarre, was the first Bourbon King of France. He was assassinated in Paris in 1610 by a Roman Catholic fanatic.

PROLOGUE

Moleire—Conveniently rhyming version of "Molière" (1622–73), the most influential French comic dramatist of the seventeenth century.

Rid post—Rode hard and fast.

Half-pay—A bitterly despised hazard of the military life. See Act 1, scene 1.

ACT I, SCENE I

Bath—This is a hint of the character of Sir Philip, who is properly introduced in another fashionable place, St. James's Park, in Act 2. Bath was a relatively small spa town in 1700, but very popular as a summer resort even before it flourished in the age of Richard "Beau" Nash. This speech also implies a time of year for the play, with the end of Sir Philip's "quarter", the summer season, and Anne Lovely about to enter the austere autumn world of the Prims.

Within the walls—the boundaries of the City of London itself, as defined by the fortifications built by the Romans in the second century AD. The City lies to the east of the fashionable haunts—St. James's Park and Pall Mall—mentioned later in the play, and includes Gracechurch Street, where Obadiah Prim lives, and Jonathan's Coffee-house, where Tradelove works.

Good champagne stomach—A "champaign" is a field of battle, although the military metaphor perhaps merges here with a general sense of exhilaration, the "thrill of the chase."

Full or reduced pay—After the Peace of Utrecht brought the War of the Spanish Succession in 1713, the government saved money by reducing the pay of its officers.

He would have qualified him for the opera—The conventions of Italian opera required *castrati*, i.e. male sopranos.

Sir John Mandeville—The supposed author of an influential, fabulous fourteenth-century travel book. "Mandeville" reports many things from the Middle and Far East as incredible as the Colonel's inventions.

Dutch management—The Dutch republic had thrived in many ways in the seventeenth century, and was renowned in England for its mercantile prosperity.

Birthday—The monarch's birthday was cause for national celebration and dressing up.

The French King's death—Louis xiv "the Sun King" had died in September 1715, ending the longest reign in European history (seventy-two years), during which France had become the continent's supreme power, culturally and politically. See Act 4, scene 1.

Tawny-moor—A dark-skinned foreigner, especially a North African.

St. James's—The fashionable area near Westminster, including the Park and the Palace.

ACT I, SCENE II

Quaking dress and *pinched cap*—A plain, distinctive and unrevealing style, including the pleated or "pinched" cap for women.

Jantée—Dashing.

ACT II, SCENE I

Mask and *keeper*—"Mask" could stand for the woman wearing one, and insinuates that she is a prostitute or a "kept" woman.

Mall—Pall Mall, a fashionable alley and notorious pick-up spot, laid out in 1661 and named after a croquet-like game.

Either party—Tory (supporters of the old Stuart dynasty) or Whig (supporters of the House of Hanover).

Parbleu, il est un homme d'esprit.—Good Lord, he is a man of wit. Cf. the "Esprit Club" in *The Witlings*.

Mais sont bien rares—But they are very rare.

Les belles anglaises—The English beauties.

Parbleu, vous êtes attrapé.—Good Lord, you are caught.

Non, je vous assure, chevalier.—No, I assure you, knight.

Mr. Heidegger—John James Heidegger, the so-called "Swiss Count," was an opera impresario and the manager of the Haymarket Theatre, where he instigated the fashionable "Midnight Masquerades" in 1717.

I have the honor to be very well with the ladies, I can assure you, sir, and I won't affront a million of fine women to make one happy.—Cf. Count Cassel in *Lovers' Vows*, Act 4, scene 2: "when a man is young and rich, has travelled, and is no personal object of disapprobation, to have made vows but to one woman, is an absolute slight upon the rest of the sex."

Gracechurch Street—Well "within the walls," this street is near the oldest Quaker meeting house in London.

She must certainly lead apes, as the saying is—The saying is that old maids lead apes in hell, that is, that Anne Lovely has no chance of marrying with guardians like these and she will die an old maid. The phrase is of unclear origin. Cf. *Much Ado about Nothing*, Act 2, scene 1, in which Beatrice opts to "lead . . . apes into hell" rather than marry.

St. James's Coffee-house—A gathering place for the leading Whigs, including Addison and Steele.

Ragoût—Mixture.

Le noir, le brun, le blanc—mortbleu, où sont ces coquins-là? Allons, monsieur le chevalier.—The black, the brown, the white—zounds, where are these rascals? Come, sir knight.

ACT II, SCENE II

Fal-lals—Finery.

Prudery—This was indeed a new word in the early 1800s, of French origin. See Introduction.

Philip Modelove whom they call Sir Philip—This illustrates the Quakers' rejection of honorific titles.

Sic transit gloria mundi—Thus passes the glory of the world.

Must she…live to be an old maid and then entered amongst your curiosities and shown for a monster, Mr. Periwinkle?—A virtuoso like Periwinkle would be an avid collector of curious artifacts; seventeenth-century "cabinets of curiosities" were in themselves peculiar hybrids of high-minded museum and freak-show. Centlivre had turned the tables in *The Basset Table* (1705), with Valeria, a "philosophical girl"—that is, a female virtuoso. Doctor Fossil in *Three Hours after Marriage* (1717) by Pope, Gay and Arbuthnot welcomes his young bride into his house as "thou best of my curiosities." See also the note on the Royal Society below.

ACT III

Pass upon him! Aye, aye, as roundly as white wine dashed with sack does for mountain and sherry—Cf. Sackbut's counterpart in Act I of *Lovers' Vows*, who passes off one wine for another.

Grand coup d'éclat—A spectacular feat.

Claudius Ptolemeus—Also known as Ptolemy, who lived in second century AD, as the Colonel says, in Alexandria. He was famous as

an astronomer, mathematician and geographer, whose system of astronomy survived until Copernicus.

John Tradescant—There were two seventeenth-century John Tradescants renowned as travelers and gardeners, father (c. 1570–1638) and son (1608–62).

Canary—A sweet wine from the Canary Islands, "balsamic" in the sense of having medicinal properties.

The Devil's in that nation, it rivals us in everything.—A view that Periwinkle shares with Travelove.

Descartes—René Descartes (1596–1650), the French mathematician and philosopher, wrote about the sun in *The World*, an unfinished treatise. Isaac Newton attacked his astronomical theories.

Those geese that saved the Roman Capitol—The invading Gauls were detected as they crept closer to the walls of the city by geese, whose honking alerted the guards.

Poluflosboio, zona and *moros musphonon*—All instances of the Colonel's somewhat fanciful Greek. The first refers to the loud roaring or "rumbling" of the sea. The second suggests something like a girdle or belt, and the third "idiot's mousetrap."

Those waves which bore Cleopatra's vessel when she sailed to meet Antony—Enobarbus describes this occasion in Shakespeare's *Antony and Cleopatra*, Act 2, scene 2, when "The barge she sat in, like a burnished throne" moves through water "amorous" of the stroke of the oars.

I got a girl to please my wife; but she and the child (thank Heaven) died together.—Periwinkle's attitude to women recalls that of Anne Lovely's father.

Gewgaws—A showy or worthless (play)thing or person.

Longitude—Finding the longitude was topical, since £20,000 was on offer, by an Act of Parliament, to the person who could devise an accurate way of calculating a ship's longitudinal position at sea (that

is, its distance east or west from a standard meridian). Inaccurate measurements could spell disaster; it was an avowed aim of the Royal Society (see below) to find the longitude.

Royal Society—The Royal Society of London for the Improving of Natural Knowledge, founded in 1662, was soon recognized as an easy target for satire on scientists—in, for example, *The Virtuoso* (1676) by Thomas Shadwell—as well a leading forum for intellectual debate.

Choused—Cheated or swindled.

See…into a millstone—Proverbial for acuteness.

Soho—This call for attention was originally a huntsman's cry to direct the dogs.

Pagod—An Oriental idol.

Coventry—A city in the Midlands, about three days' travel from London.

Jonathan's Coffee-house—One of the epicenters of the financial world in eighteenth-century London, this was in Exchange Alley, near the Royal Exchange.

Civil War—The conflict between King Charles 1 and Parliament, 1642–49, in which the latter had the decisive force in the form of the New Model Army.

Bob-wig—A simple wig with the ends curled up.

ACT IV, SCENE I

South Sea at seven-eighths—It was conventional at the time to give the price of stock by the last fraction; the stock itself, in the South Sea Company, would have been highly valuable at the time. The Company was founded in 1711, nominally to trade with South America, but really to take on some of the vast national debt. Its collapse, a defining financial disaster, came in 1720, the infamous "South Sea Bubble."

Michaelmas 1718—Like Lady Day (see the note on Act 4, scene 3, below), the Feast of Saint Michael (September 29) traditionally marked one quarter of the business year.

Class lottery tickets—Starting in 1694, the government had tried to ease its financial difficulties through a series of lotteries, in this case, with a system of prizes divided into "classes." Tickets could be bought and sold like any other stock.

East India bonds—England's veteran trading company, the East India Company was chartered in 1600 to trade with the Far East.

Sword Blade Company—Originally chartered in 1691 to produce French blades in England, the company became a rival to the Bank of England and the East India Company as a financial power in the City.

Bohea tea—China tea of the finest quality (it now refers to tea of the lowest quality).

Sparks—Fops.

Civil List lottery—The first Civil List, Parliament's annual allowance to the monarch, was for £700,000 to William III in 1697. The average for his reign was considerably lower than this would suggest, however, and he left substantial debts. By 1720, it was necessary for George I to sell royal charters to two insurance companies—the London Assurance and the Royal Exchange Insurance Companies—in order to pay off royal debts of £600,000.

Cacao—The tropical seed from which cocoa and chocolate are produced.

Bull or a bear—A bull bought stock in order to sell it later at a higher price; a bear sells at a set price, anticipating that the market will fall and a loss can thus be avoided.

Cagliari—The capital of Sardinia. The Spanish had invaded in 1717.

Emperor—Charles VI, Emperor of Austria from 1711 to 1740.

Monument—The column in Fish Street Hill, designed by Sir Christopher Wren and Robert Hooke, and erected to commemorate the Great Fire of London of 1666. It was finished in 1677.

The Dutch walk—A meeting-place in the courtyard of the Royal Exchange.

ACT IV, SCENE II

Gudgeon—Literally, a small fish; figuratively, a dupe.

Pennsylvania—Charles II had signed the Charter of Pennsylvania in 1681, making it over to William Penn, a highly placed Quaker, as a safe haven for the Society of Friends. It thrived under a largely Quaker leadership that endured into the mid-eighteenth century.

Aminidab—Like Obadiah, this was a Quaker name.

Abbey land—Land that belonged to the monastic orders before they were dissolved by Henry VIII in the early sixteenth century.

Mr. Proteus—Like the Colonel, the mythological Proteus was a shape-shifter.

Jove—The Roman king of the gods.

Brother of the blade—Conventional Restoration phrase for a soldier or gallant.

ACT IV, SCENE III

Lady Day—The Feast of the Annunciation, March 25, was commonly known as Lady Day. It was often appointed as a date for the collection of quarterly rents and dues.

ACT IV, SCENE IV

Antipathy to monarchy—Holland was a republic.

ACT V

Peruke—A full head of hair or a wig made to imitate one.

Brocade and *holland*—Brocade is a rich, embroidered fabric; holland is smooth linen.

Andromeda and *Perseus*—In Greek myth, Perseus saved Andromeda from death by beheading a sea-monster, and married her.

Enthusiastical—Displaying a specifically religious fervor.

Simon Pure—The "real Simon Pure" is a phrase that entered the language.

Camblet coat—A coat made from a light material.

The Grove—This refers to the Orange Grove, named after William of Orange (William iii).

Shuttlecock—That is, light and easily batted back and forth.

EPILOGUE

Epilogue—The Epilogue is written by George Sewell (d. 1726), a physician and hack writer who wrote for the Tories up to circa 1715, and then for the Whigs.

To court in form of snakes and filthy bulls—Both disguises used by Zeus in his amorous pursuits of mortal women.

Old Jove once nicked it… / In a whole lapful of true Standard Gold—The allusion is to the legend of Danaë (or, in this instance, "Daëne"), who was visited in her prison by Zeus in the form of a shower of gold. Their son, incidentally, was Perseus (see above).

Old Harry's face or good Queen Bess's ruff—Both monarchs, Henry v and Elizabeth i, were popular icons, not least as they appeared in profile on coins.

Eliza Haywood:
(?1693–1756)

U nlike Susannah Centlivre, Elizabeth Inchbald or Hannah Cowley, Eliza Haywood was not primarily a playwright and secondarily a poet or novelist. Indeed, her repertoire of literary roles was extensive, and it included poet and translator, publisher and distributor, pornographer and periodical-writer, political commentator in *The Adventures of Eovaii* (1736), and hapless muse for a scurrilous section of Pope's *Dunciad*. Her mature works of fiction, *The History of Miss Betsy Thoughtless* (1751) and *The History of Jemmy and Jessamy* (1753), are regarded as significant contributions to the history of the novel. Haywood's early essays in drama therefore come a long way down a long list of works.

Two things that Haywood does have in common with Centlivre and Aphra Behn are an enigmatic past and a supposedly disreputable personal life. She is thought to have been the daughter of a London tradesman named Fowler; the year of her birth is unproven. Her marriage is equally obscure, although it seems likely that she and the older clergyman she married were highly unsuited and unhappy together. Pope alludes to the rumors of an illegitimate child in the 1728 *Dunciad*, in which Haywood appears as "yon Juno of magnificent

size, / With cow-like udders, and with ox-like eyes [...] Two babes of love close clinging to her waist." Whatever the truth of the matter, the *Post Boy* announced in 1721 that "Elizabeth Haywood, wife of the Reverend Mr. Valentine Haywood, eloped from her husband on Saturday the 26th of November last past, and went away without his knowledge and consent":

> This is to give notice to all persons in general, that if any one shall trust her either with money or goods, or if she shall contract debts of any kind whatsoever, the said Mr. Haywood will not pay the same.

Before 1723, when *A Wife To Be Let* was first performed, Haywood had already made a notorious name for herself as a purveyor of sensational prose romances. The first of these was *Love in Excess* (two parts appeared in 1719 and a third in 1720), which quickly went through several editions, and was rapidly followed by more of the same: *The British Recluse*, *The Injured Husband* (both 1722), *Lasselia* (1723), and so on. These were then collected in a three-volume *Works* in 1723, which was augmented the following year by a fourth volume. The pace was set for a prolific output that Haywood kept up until her death in 1756, thus earning herself all the disdain that high-minded men could muster for a mere hack. Swift, in a letter to the Countess of Suffolk in 1731, calls her a "stupid, infamous, scribbling woman," and sounds a familiarly ugly note when, elsewhere, he catches something of her caricature in the "the nymph Corinna" who is,

> At twelve, a wit and a coquette,
> Marries for love, half whore, half wife;
> Cuckolds, elopes, and runs in debt;
> Turns auth'ress, and is Curll's for life.

This chimes not only with Haywood's low literary reputation and inferred passionate nature, but also the *Dunciad*, in which Curll is one of two publishers competing for her affections as the prize in a pissing contest. Pope, for good measure, footnoted his portrait of her

as belonging to the tribe of "shameless scribblers" who "in libellous memoirs and novels, reveal the faults or misfortunes of both sexes, to the ruin of public fame or disturbance of private happiness."

Haywood's acting career predates her career as a published writer, and possibly began in Dublin around 1715, when she is known to have played Chloe in Shadwell's version of *Timon of Athens* at the Smock Alley Theatre. She continued to act professionally in London well into the 1730s, without writing for the stage as often as she perhaps had opportunity to. Her first acknowledged dramatic work was an extensive revision of *The Fair Captive*, a tragedy written by a Captain Hurst. It was poorly received, but Haywood excused herself on the basis that she was just the script's doctor. It was followed by *A Wife To Be Let* and *Frederick, Duke of Brunswick-Lunenburgh*, another tragedy, which ran for only two nights at Lincoln's Inn Fields in 1729. Commercially, her most successful work was *The Opera of Operas*, written with William Hatchett (with whom, it was said, she lived "on terms of friendship") and based on the 1730 burlesque by Henry Fielding. It had a good run of thirteen performances in the summer of 1733, at the Little Haymarket Theatre, before being "deferr'd…on account of the excessive heat of the weather." It was resumed later that season and again in the winter—but perhaps its popularity had more to do with Thomas Arne's music than the co-written libretto.

Haywood may also have been responsible for an unsuccessful revision of the anonymous Elizabethan play *Arden of Faversham* in 1736, but it is more likely that this is the confused result of her being advertised in the cast list as "the Author". It is a description that could merely be a symptom of her continuing "novelty" value as a known novelist *and* actress. The two reputations inevitably seep into one another. Fielding, for instance, lampooned her as "Mrs. Novel" in *The Author's Farce* (1730), thrusting her into a sensational romantic scenario, in which she "die[s] for love" by dying "in childbed." "If we may judge by her writings," said the *Daily Post* when she took over the role of the eponymous wife, Mrs. Graspall, in *A Wife To Be Let*, "on the occasion of the indisposition of one of the actresses," "we may reasonably expect she will bid fair to entertain the Town very agreeable."

Haywood's actual death gave the *Whitehall Evening Post* the opportunity to recast her as a "celebrated authoress of some of the best moral and entertaining pieces that have been published for these many years." No plays are mentioned among the various "living monuments to her merit." Later, in *The Progress of Romance* (1785), Clara Reeve would say that Haywood had "the singular good fortune to recover a lost reputation." Not much can be said for the tragedies, it is true, but it is disappointing that Haywood did not develop the dramatic style of *A Wife To Be Let*. The bitter account of trying to get a play staged offered by "Distrario" in *The Female Spectator* may indicate why she did not. Haywood's comedy remains a teasing indication of how, with the energies she poured into her "known novels" (see the Prologue), she might have had a greater influence than she did on the direction of sentimental comedy, as she did on the novel.

A Wife To Be Let

DRAMATIS PERSONAE

MEN

FAIRMAN
MR. GRASPALL
SIR HARRY BEAUMONT
CAPTAIN GAYLOVE
COURTLY
TOYWELL
SNEAKSBY
SHAMBLE
TIM

WOMEN

WIDOW STATELY Aunt to Sneaksby
MRS. GRASPALL Fairman's daughter
CELEMENA Fairman's niece
MARILLA
AMADEA
DOGOOD

The scene is Salisbury.

PROLOGUE

The Tragic Muse, to merit wished applause,
From fancied misery real caution draws;
Her flaming strokes display some purple crime,
The passions feel, and the soul swells sublime.
The Comic all this pomp of woe declines,
Softens her light, and rather smiles than shines;
She but your known familiar follies shows,
Prudes, misers, cullies, fops, coquettes, and beaus.
With her, as at some poor man's feast, you meet
Where what the guests contribute make the treat.
Critics! Be dumb tonight—no skill display;
A dangerous woman-poet wrote the play,
One who not fears your fury, though prevailing,
More than your match in everything but railing.
Give her fair quarter, and whene'er she tries ye,
Safe in superior spirit, she defies ye.
Measure her force by her known novels, writ
With manly vigour and with woman's wit.
Then tremble and depend, if ye beset her,
She who can talk so well may act yet better.
Learn from the opening scene, ye blooming fair,
Rightly to know your worth, and match with care;
When a fool tempts ye, arm your hearts with pride,
And think th'ungenerous born to be denied.
But to the worthy and the wise be kind;
Their Cupid is not, like the vulgar's, blind.
Justly they weigh your charms, and sweetly pay
Your soft submission with permitted sway.

ACT I

Enter CAPTAIN GAYLOVE, COURTLY *and* SHAMBLE.

COURTLY: I little thought when I went out to take the air this morning to be so agreeably surprised with the sight of my old companion and friend. But I hope no misfortune of yours has occasioned me this happiness which, I confess, would be much more complete but for that doubt.

GAYLOVE: While Fortune has a being, we must all expect to find vicissitudes, but nothing of my own affairs can take me up so much as to make me forgetful of my friends. May I yet wish you joy? Art married? Or do you still set Hymen at defiance?

COURTLY: No, Charles, I am not yet so happy.

GAYLOVE: Happy! Is it possible you can term the loss of liberty a happiness? You, who of all mankind seemed most averse to it?

COURTLY: My eyes at last are opened, Charles, and I now court those bonds as a blessing which I once looked upon as galling fetters.

GAYLOVE: Poor Ned; I pity thy change. But pray, who is the lady whose charms have wrought so wonderful a transformation?

COURTLY: I will not go about to describe her because I am certain you'll look on her real character as an extravagant encomium, but she is the niece of Mr. Fairman, whom you have often seen with me in London.

GAYLOVE: If I remember the man, he's of a downright sincere temper, affable and obliging, but I believe he loves money.

COURTLY: You read his character. His brother was a positive, hasty old gentleman, and considered money as the source of all happiness; left an only daughter whom, on his death-bed, he obliged to swear she should marry the man he proposed to her, one who is, without exception, the greatest fop in nature, but has £3,000 a year, which was an irresistible motive to him. You cannot but have seen him either at London or Bath; his name is Toywell.

GAYLOVE: Oh, I know him perfectly.

COURTLY: This wretch, who has no sense of what is truly valuable,

and esteems Marilla only for her fortune, makes me despair of happiness; for she seems so religiously bent to keep her vow that all my applications hitherto have been ineffectual to obtain anything more from her than a bare complaisance. But prithee, dear Charles, give me leave to be impertinent and enquire what drove you to Salisbury?

GAYLOVE: Why faith, Ned, you know in what manner I used to live, the consequence of which was a certain equipage of people called duns, whose daily attendance was no way pleasing to me. In short, my creditors having no patience, my father no compassion and I no money, I was obliged to leave London in complaisance to my tradesmen, fearing I should put them to the expense of providing a lodging for one who thought himself too far engaged to 'em already. Therefore, selling my Company in the Guards, I bought in one of these regiments. But prithee, Ned, give me some little idea how you spend your time here.

COURTLY: As they do in most country towns—the men in hunting, hawking and drinking, the women in cookery, pickling and preserving—not but there are some more elegant among us, to whom I shall make it my business to introduce you.

GAYLOVE: I shall think myself infinitely obliged to you.

COURTLY: Of the number of those I last mentioned is Sir Harry Beaumont, who, though he chooses to live retired in this country at present, where he has a vast estate, has been a very great traveller, and from all the different courts where he has been, brought with him everything worth the wearing of a fine gentleman. In short, I know nothing of his character that a man of the strictest honor would not be proud of. Then, for his wit and conversation, 'tis such as I'm sure you'll be infinitely charmed with.

GAYLOVE: The description you give of him is no more than what he merits. I knew him about a year ago, he then made his addresses to a relation of mine; I never heard what occasioned their breaking off. I thought him a most accomplished gentleman, and I am glad to hear his late accession to his uncle's title and

estate has not taken from him that easy gaiety and freedom of behaviour which is one of the greatest charms of conversation, and without which the brightest wit wants relish.

COURTLY: You shall anon renew your acquaintance with him; he has engaged me to dine with him today. Your company will add to the pleasure of the entertainment, and in the afternoon I will carry you to visit some ladies.

GAYLOVE: May I ask you who they are?

COURTLY: I believe you never saw either of 'em. One is my mistress; the other is daughter to Mr. Fairman, whose name is Celemena. She is speedily to be married to a very blockhead, one Sneaksby. She is a woman of a world of life and spirit in her conversation, and has as much wit as her intended husband wants it. I am certain you will be pleased with her acquaintance.

GAYLOVE: I were stupid else, if she be what you represent. But, Ned, I have heard of a mighty fine woman you have here, since my coming into these parts, one who bears the bell from all the rest. I think they call her Mrs. Graspall.

COURTLY: She is extremely handsome indeed and virtuous, they say, but I never visit there. She is married to the most covetous, miserable wretch that ever was. He denies her the privilege of any company, not out of jealousy, but for fear she should be at any expense in entertaining 'em.

GAYLOVE: And how does she endure a restraint so disagreeable to her youth and beauty?

COURTLY: With a resignation which is surprising to all who know her. But come, we'll take a little walk, and then to dinner.

GAYLOVE: With all my heart.

Exeunt GAYLOVE *and* COURTLY. *Enter* DOGOOD, *who pulls* SHAMBLE *back.*

DOGOOD: 'Tis he for certain! Hark ye! Hark ye! Squire Sancho, you have followed your Don Quixote long enough to take upon you the protection of a distressed damsel without any infringement, I hope, on the hardy knight, your master.

SHAMBLE: Faith, lady, I know you not and, if you have commands

for me, I shall be more at leisure and in better humor after dinner.

DOGOOD: Well, I find the proverb's false which says custom is a second nature, or the want of a dinner would not put the accustomed Mr. Shamble out of humor.

SHAMBLE: Ha! By my veracity, *Jenny*!

DOGOOD: Ay, by my maidenhead (as terrible an oath), the very same; but I wonder thou could'st forget me in so short a time.

SHAMBLE: Why, how was it possible to know thee thus metamorphosed, fine lace pinners transmogrified into a round-eared coif and a high-crowned hat, a gold watch into a pin-cushion, and a tweezer into a scissor-case? Prithee, on what design art thou thus equipped?

DOGOOD: Why, faith, Shamble, I found trading in public grew somewhat slippery, and now deal all in private.

SHAMBLE: What, kept?

DOGOOD: Not for the purpose you mean. In short, being weary of the life I lead in London, I resolved to take up and live retired. I found means to be recommended to the service of one of the richest widows in this country, with whom I now live as a housekeeper—not but I have a great deal of spare time for the service of my friends.

SHAMBLE: Ha! Sayest thou so? Why then, methinks 'tis greatly in thy power to oblige my master. Thy assistance may be needful in a place where he has so little acquaintance. The company of a kind she would not be unwelcome to a man of his constitution, and as his affairs stand at present, a rich widow or heiress would be an excellent cordial to his sinking fortune.

DOGOOD: Oh, I thought you would be glad to own me! Why, my mistress is a widow and exceeding rich; but, deuce on't, her age and affectation will never down with thy queasy-stomached master.

SHAMBLE: Prithee what, who is she?

DOGOOD: The relic of a country mercer who, dying, left her an immense sum of money besides a good estate he had purchased in land. She has no child, but a foolish nephew is looked upon

as heir. He is speedily to be married to a young lady of a great fortune and a celebrated beauty. I could wish thy master were in his place, but that's impossible to be effected.

SHAMBLE: But has this old lady of yours no suitors?

DOGOOD: Yes, enow, but she is all for a title. A man of her own station she looks upon as unworthy of her. As soon as this marriage is over, she designs to go to London, and lay out her whole estate, rather than want a bargain of knight's flesh.

SHAMBLE: I have a thought come into my head, which may prove a lucky one. Dost thou not think if I were equipped accordingly, I might pass for a knight?

DOGOOD: A knight, ha, ha, ha!

SHAMBLE: Why, I have seen as bad a face in a gilded chariot.

DOGOOD: That's true; and now I think on't, 'tis not the man but the title that must charm her. I don't know but with my management such a thing might be possible.

SHAMBLE: If it could, £500 are thine out of her money, besides a premium better than any jointure I can make her.

DOGOOD: Oh Goodman Promiser! As if I were not acquainted with your abilities! Make but the money secure to me and I'll give you a discharge from all other demands.

SHAMBLE: Well, but hark ye, I suppose with your change of habit you have also shifted your name. By what must I call you now?

DOGOOD: Dogood, at your service.

SHAMBLE: A very good name, and I hope prophetic to us both; but come, shall we step into some house and consult about this affair?

DOGOOD: Aye, I have an acquaintance just by.

Exeunt. Enter MRS. GRASPALL *and* AMADEA *in boy's clothes.*

WIFE: [*Aside*] Very unaccountable! That neither at home or abroad, I can one moment get rid of this little troublesome impertinent. [*To* AMADEA] Have you any business this way, sir?

AMADEA: No other, madam, than to wait on you. Now the camp's so near, 'tis unsafe for ladies to walk alone.

WIFE: I am much obliged to you but I apprehend no danger. I can-

not harbour so ill an opinion of the gentlemen of the army as to imagine any of them would offer an affront to a woman who, I hope, looks not to deserve it. And as for the meaner sort (thanks to the good discipline they are under), they are obliged to follow the example of their leaders.

AMADEA: Were it so, which yet I can't allow, there is another danger not less imminent, though perhaps more pleasing than what I have mentioned. A certain gentleman who lives not far off, and very much frequents this walk, carries a kind of spell in his eyes and tongue, which has been fatal to many of your sex.

WIFE: Aye; pray who is that?

AMADEA: I fancy, madam, after what I've said, 'tis needless to repeat his name—however, for your satisfaction—

WIFE: [*Aside*] My satisfaction! What means he?

AMADEA: [*Aside*] Ha! She blushes; then my suspicions are too just. [*To* WIFE] Yes, madam, since you take pleasure in the sound, Sir Harry Beaumont.

WIFE: Was ever such an insolence! I, take pleasure in the sound? What is Sir Harry Beaumont to me or I to him?

AMADEA: Nay, if you are angry, madam—

WIFE: Have I not reason? What act of mine has ever justified this rudeness? But I guess by whom you are set on, and if it were not more love of myself than my husband, I would be revenged even in the way he fears.

AMADEA: Nay, now I understand you not, but if you think your husband—

WIFE: Yes, I know you would not dare, unless authorised by him, to treat me in this manner. Ungrateful man! Have I submitted to the hard, uncoveted condition of his wife, to be at last suspected of dishonor? Oh! To what fate are wretched women born! Condemned to slavery, though conscious of superior merit, and bound to obey the severe dictates of a very fool, whene'er the name of husband gives 'em force.

AMADEA: Transport not thus yourself with causeless rage, but listen patiently while I confess I am alone the offender. Your virtue appears fair, your conduct blameless, to the fond eyes of your

admiring husband. But the judging world, which takes delight in finding something to condemn, watch all your actions, and, as I so freely have begun, I will take the liberty still to remind you, that the frequent visits of Sir Harry Beaumont are most pernicious to your character.

WIFE: 'Tis well; then this is your surmise.

AMADEA: If mine, why not others?

WIFE: No, bold adviser, my reputation is too well established. No malice ever attempted to sully my unblemished fame, till thou, for what base end I know not, hast presumed to tax me; but I despise whatever thou canst say and, secure in my own innocence, defy thy malice.

AMADEA: But one word more. If to receive the addresses of a man whose utmost wit can find no form to make 'em look like honorable, and varnish o'er the vile design they are made for—if this, I say, be not a fault to virtue, I have done.

WIFE: Oh Heavens!

AMADEA: If you are free from this, then I confess my accusation false—but if charmed with flattery, your sex's bait to ruin, you still encourage the deceiver's hopes, you wrong yourself, not I. I leave you to reflect on what I've said and, as you want not sense, entreat you to exert it on an occasion which requires it all. Think 'tis your good genius warns through my lips. Immortal honor, fame and peace attend to crown the glorious conquest; eternal infamy, disgrace and—those worse racks—the stings of conscience watch to seize your soul, if you persist to listen to the undoing vows of faithless Beaumont. Madam, farewell, and rest assured, whatever my thoughts are, my tongue, but to yourself, shall on this theme be dumb forever. [*Exit*]

WIFE: His words, methinks, have opened all my heart, and filled it with a horror till now a stranger to me. Oh virtue! If I in aught had swerved from thy strict precepts, I should not wonder at these starts and tremblings; but as I have held, and still will hold, my honor dearer than my life, why am I thus alarmed? Why, armed with innocence, did I not hear unmoved the audacious monitor? Oh 'tis too true, I've been to blame! Though

resolute never to yield to what the tempter sues for, I have perhaps with too attentive ears listened to his persuasions, and 'tis a crime to virtue ev'n but to hear what loose desires suggest. Were I unmarried, could I with honor receive Sir Harry's love, how happy were my lot! For sure, of all mankind, he is most formed to charm and bless a woman's fondest, softest wishes. But as I am, though hard my fate, I must be blind and deaf to all his worth, and place my sole felicity in duty.—

Enter TOYWELL.

That creature here!

TOYWELL: [*Aside*] She's here and alone; now will I accost her with such phrases, as she shall not be able to withstand. [*To* WIFE] Stay, madam, fly not your adoring slave who long has languished for this opportunity to tell you that he dies for you.

WIFE: What means the wretch? Are you mad, sir?

TOYWELL: If love be madness, I have wondrous cause, for from the first moment I beheld that field of beauty, I have done nothing but wish and languish, burn and bleed, with passion and desire.

WIFE: Hold, sir; if you really are in your senses, let me tell you, you are guilty of an assurance which you will not find me easy to forgive.

TOYWELL: [*Aside*] No matter for that, I know she's pleased with it. [*To* WIFE] Ah, madam! As the inimitable Otway says, "Who can behold such beauty, and be silent?"

WIFE: Wretched animal! If I did not think that all advice was lost upon you, I would give you this friendly caution—to know to whom you speak.

TOYWELL: [*Aside*] Ha! Perhaps I've been too grave; 'gad, I'll try another way. [*To* WIFE] Why, faith, madam, I believe I know you, and I am sure I know myself. There stand you, Mrs. Susanna Graspall, without exception, the most agreeable woman breathing, married to an old, decrepit, miserly curmudgeon who debars you from all the pleasures of life. And here am I, Jack Toywell, in free possession of full three thousand pounds

a year, with youth, vigour and some other tolerable qualifications, ready with my person and fortune to make you happy in all those enjoyments your husband's age and avarice denies. [*Aside*] Gad, I am mighty florid today.

WIFE: Since you disoblige me to be more serious than I thought at first your ridiculous addresses merited, I must tell you that you are an impudent fop, that I despise and loath you, and if you dare to trouble me again with such impertinent discourses, my husband shall be acquainted with the character you give of him.

TOYWELL: Come, madam, egad I like you ne'er the worse for this dissembled coldness. It whets the edge of appetite and gives a double relish to those raptures you yielding will bestow.

WIFE: Nay, if you grow rude—

TOYWELL: No rudeness, madam, but what you will one day pardon. A lover must begin with humble distant sighs, but when the ice is broke and he has once ventured to say he loves, then he proceeds by swift degrees to greater freedoms—your hand, your lips—[*Offers to kiss her*]

WIFE: Impudent villain! [*Boxes his ears*] But here's company—if ever thou dar'st affront me thus again—

Enter BEAUMONT.

BEAUMONT: Ha! So free!

TOYWELL: Sir Harry Beaumont—dear Sir Harry, I am your most obsequious humble servant.

BEAUMONT: Yours, yours, Mr. Toywell—a good day to you, madam, I see you are taking the benefit of the fresh air this morning. I doubt not but you have been agreeably entertained in the conversation of so polite a gentleman as Mr. Toywell.

WIFE: I shall not envy you that happiness, Sir Harry, therefore leave you to enjoy it—your servant! Oh the difference of men! [*Exit*]

BEAUMONT: Madam, your most humble. Methinks, Mr. Toywell, the lady seems displeased; what have you done to her?

TOYWELL: Oh Sir Harry, you and I know the world too well, to think

a woman's anger, in some cases, worth regarding. I dare swear it has escaped the observation of neither of us that they are frequently most pleased when least they seem to be so.

BEAUMONT: What! Then you have been making love.

TOYWELL: Why, faith, she is looked upon as one of the finest women in the county, and, having had of late a pretty deal of idle time on my hands, I took it into my head to make her some offers, which, I believe, when she has considered on, she'll scarce refuse.

BEAUMONT: [*Aside*] Conceited coxcomb! [*To* TOYWELL] But she has the reputation of a virtuous woman.

TOYWELL: Virtuous! So they are all till they are tried; and I don't remember to have heard that before me, any man of figure has attacked her.

BEAUMONT: [*Aside*] Intolerable fop! [*To* TOYWELL] A man truly deserving of a lady's favour, Mr. Toywell, seldom discloses his design on the woman he admires, but to herself. For anything you know, Mrs. Graspall may have been proof against the most elegant addresses.

TOYWELL: 'Twas then for want of a right method in applying them. For my part, I never yet had the mortification to engage with any woman silly enough to hold out above three summons.

BEAUMONT: You are a happy man indeed, but methinks 'tis a little odd you dare venture to make an attempt of this nature so near your marriage; for I hear your wedding with the fair Marilla is to be accomplished in a day or two. Suppose she should hear of it?

TOYWELL: Psha! 'Tis so long ago since we were contracted that for a great while we have regarded each other with an absolute indifference. I liked her well enough indeed at first, but the certainty that she must one day be my wife has set her in the self-same view as she would have appeared after seven years' possession. But now I think on't, I promised her uncle to dine with 'em today. Prithee, Sir Harry, go along with me, I shall be so dull else.

BEAUMONT: I would willingly accompany you, Mr. Toywell, to such

agreeable conversation, if I were not engaged at home with some friends, who I believe by this time expect me.

TOYWELL: Phoo, pox—well then I must take my leave. 'Tis pretty near one, and they dine consumed early. Sir Harry, your servant. [*Exit*]

BEAUMONT: Your servant, sir.—Fool! Heavens, how strange a creature is a lover!—I am ashamed to think the rivalship of such a wretch can give me pain, and yet it does, which proves, more strongly than I e'er knew before, the violence of my passion. Yes, I find I love to such a height that if unlicensed enjoyment be a crime, 'tis here excused by the necessity—but be it as it will, would I promise it myself at any rate—but hope is not so vain. Yet she has heard my suit, and still continues to admit my visits, confesses an esteem, and, if so, 'tis the first step to love. A constant assiduity, in time, perhaps may loosen the strict bonds of galling duty and make the charmer mine.

Ne'er let the lover of his wish despair,
Whose vows of passion reach th'attentive fair;
Though bent to follow virtue, 'tis her fate
At last to yield, if once capitulate.

ACT II, SCENE I

Enter CELEMENA *and* MARILLA.

CELEMENA: Prithee, good cousin, take a friend's advice, and cast off this obstinate humor of marrying the man who slights you, and slighting the man who loves you. Toywell has indeed a great estate, but Courtly knows how to use what he has handsomely, and is withal very easy in his circumstances. Can anything that has not taken an entire leave of her understanding persist in a resolution of throwing herself away in this manner?

MARILLA: Allowing all that you have said, the religious observances I owe to the vow I made my dying father leaves me no choice.

CELEMENA: If the dead could tell what we living are doing, I am apt to believe the old gentleman would quit his grave a while to

forbid the banns, and save his daughter from so visible a ruin. Besides, the vow you made was forced, and consequently not binding. Heavens! It provokes me to see you act so contrary to reason, nay, to your own inclination too; for I am sure you love Courtly.

MARILLA: How came you so well acquainted with my thoughts, good cousin?

CELEMENA: Prithee, none of your airs! I know you have sense enough to distinguish a man of parts from a fool.

Enter SERVANT.

SERVANT: Ladies, Mr. Courtly and a strange gentleman desire to know if you are at leisure.

CELEMENA: Show 'em up. [*Exit* SERVANT] Now let me see you use him as you used to do, and I protest I'll disclaim kindred with you.

MARILLA: You will—but I fancy I shall put it to the venture.

CELEMENA: I wonder who he has brought with him.

Enter COURTLY *and* GAYLOVE.

COURTLY: Ladies, I hope you will pardon my introducing a gentleman whose conversation will hereafter make his own apology. This, Captain, is Mr. Fairman's daughter; this, his niece.

CELEMENA: We are too well acquainted with Mr. Courtly's delicacy not to afford a ready welcome to any whom he calls friend. Such entertainment, sir, as furnishes a homely country cottage, you may expect.

GAYLOVE: He must be covetous indeed could form a wish beyond what here is to be found.

CELEMENA: [*Aside*] This fellow has something in him prodigiously [*To* COURTLY] agreeable; I can't help liking him.—Well, Mr. Courtly, I have been labouring for you, you must now e'en speak for yourself.

COURTLY: If all that can betoken a sincere and ardent passion could influence the fair Marilla to pity what I feel, she would not thus cruelly resolve to make my rival happy.

MARILLA: If you have any value for my quiet, you will forbear to urge a suit which, were my inclination otherwise, is not in my power to grant, and consider me not as mistress of myself.

COURTLY: Should the man you purpose to bless not know the value of the treasure you bestow, I do assure you, madam, 'twould give me an uneasiness almost equal to the loss of you.

MARILLA: That's generous indeed, but—

COURTLY: Yet give me leave—[*To* CELEMENA] Your pardon, madam! [*They walk apart*]

CELEMENA: Oh sir, you will have it, if your friend will as willingly forgive your leaving him to the conversation of a raw country girl.

GAYLOVE: Now have I a great mind to tell you the pleasure he does me, but fear of disobliging stops my mouth:

> But Echo shall so oft repeat your name,
> You'll learn my sufferings and reward my flame.

As my passion is more than common, my style, madam, ought to be no less than heroic.

CELEMENA: But had I an inclination to give ear to it, you have more modesty, I hope, than to make love at first sight. But now I think on't, perhaps you may imagine that the apprehension of the fine things may be saying yonder makes me wish I were capable of inspiring the same. However, to show you I have vanity enough to believe I've made a conquest, when I have found the bark of every tree carved with the cruel Celemena's name, and you have sighed away some seven years—

GAYLOVE: I find, madam, you're likely to be pretty reasonable.

CELEMENA: When cooing doves the shady cypress shun,
> And hide their heads to find their plaints outdone;
> When sympathizing grief o'erspreads the plains,
> And shepherds mourn your fate in rural strains;
> When my disdain's the theme of every song,
> And Celemena hangs on every tongue—

GAYLOVE: For Heaven's sake, madam! Have you no compassion?

CELEMENA: When "cruel nymph" through hills and valleys flies,
> And distant Echo "cruel nymph" replies—

GAYLOVE: Dear madam, come to a conclusion.

CELEMENA: I have done, and here give you permission to spend the following seven years in the same manner. Then come to me again, and I perhaps may allow you my hand to—kiss.

GAYLOVE: Truly, madam, I can't but say your demands are extremely moderate. But can't you as well suppose all this past? I have loved you very passionately these seven minutes, and, according to modern calculation, they appear so many ages.

CELEMENA: No, I can't suppose one word on't, nor can I admit of your modern calculations. 'Tis impossible the man can love me who would hesitate on starving, hanging or drowning on my account—much less in passing a few years in so sublime a despair, as I have enjoined you—

GAYLOVE: But, madam—

CELEMENA: A word more and I'll not allow of you as a servant till you have killed lions and made monsters tame.

GAYLOVE: There's no talking to her; she will be too hard for me. Oh! Here comes a relief.

Enter FAIRMAN *and* TOYWELL.

TOYWELL: So, ladies and gentlemen, wit and beauty are inseparable here, and, let me blood, I am so pleasant myself, I am like a fish out of water in dull company.

FAIRMAN: [*Aside*] O'my conscience, this nephew of mine that is to be grows every day a greater fop than ever.—Your servant, gentlemen. Daughter, pray invite this good company to your wedding. I expect Squire Sneaksby tonight, and tomorrow shall make you one.

CELEMENA: [*Aside*] Heaven forbid. [*To* FAIRMAN] 'Tis very sudden, sir.

FAIRMAN: His aunt, child, the Widow Stately, is a fickle woman; if she happen to marry again, or should change her mind, there is not such another match in the county. You don't consider she is to settle the best part of her estate on him, and the fortune I'll give you will set you on a foot with the nobility.

MARILLA: [*Aside to* CELEMENA] Now, Celemena, 'twill be my turn to

wonder how you can submit to be the wife of a fool. [*To* FAIR-MAN] But, uncle, this Sneaksby is accounted exceeding silly.

FAIRMAN: He is good-natured, niece, and rich—two things a young woman ought to prefer to a full head and light purse.

TOYWELL: Nay, sir, you would not marry my coz to a fool. Why, sir, she'll never enjoy a happy minute with a fool—

FAIRMAN: Hum! Then you think a fool can never make a good husband?

TOYWELL: Certainly.

FAIRMAN: Ha! Then if you have any value for the fair sex, show it by laying aside all thoughts of marrying.

TOYWELL: The old gentleman is mighty testy, methinks.

FAIRMAN: Well, Celemena, I expect your compliance.

CELEMENA: Sir, my duty obliges me not to dispute with your commands. [*Aside*] But I may find some way to evade 'em.

FAIRMAN: That's my good girl, and tomorrow thou shalt have my blessing in a bag of ten thousand pounds. But come, I have some business with you. Your servant, all. [*Exeunt* FAIRMAN *and* CELEMENA]

TOYWELL: Marilla.

MARILLA: Sir!

TOYWELL: Prithee, my dear, e'en let our wedding be tomorrow.

MARILLA: Sir, you know my obedience to my father submits my will to yours.

TOYWELL: Tomorrow then, if you please; 'twill save expenses.

COURTLY: [*Aside*] Heaven! That she can bear this usage! [*To* MARILLA] Dear madam, have some compassion for yourself, if you have none for me.

GAYLOVE: Pardon a stranger's freedom, madam, if I say not only my concern for my friend but also the sincere esteem your character has filled me with makes me wish you could avoid this marriage.

MARILLA: I thank you, sir, but, alas, you speak the charms of liberty to a galley-slave.

GAYLOVE: But suppose some lucky means should offer, would you then bless my friend?

MARILLA: There is not a possibility, unless the dead could be restored to life, and give me back my vow—but if there were, I'd promise nothing.

COURTLY: I do not ask it. May your fate be happy; my own I leave to your dispose.

MARILLA: 'Tis kindly said—and I, perhaps, should not be found ungrateful. But I'll order tea; you'll follow?

COURTLY: Immediately, madam. [*Exit* MARILLA]. [*Aside to* GAYLOVE] I fancy, Charles, this is a good time for our design.

GAYLOVE: [*Aside to* COURTLY] Aye, aye, let me alone. [*Aloud*] Poor lady, I pity her.

COURTLY: So do I, for he had all her fortune in his hands. But I am strangely surprised; he was reckoned one of the most substantial men in London. I fear his breaking will involve more than Marilla in his ruin.

TOYWELL: Ha! What's that? Pray, sir, who is the gentleman you speak of?

GAYLOVE: Mr. Trusty, sir, a banker in Lombard Street.

TOYWELL: Ha! Mr. Trusty!

GAYLOVE: Yes, sir; a statute was taken out against him two days before I left London. But you seem concerned, sir; I hope it will prove of no prejudice to you.

TOYWELL: Me! Hum! No, sir, I had no dealings with him, but I know the best part, if not all, of Marilla's fortune was lodged in his hands. [*Aside*] I must find some way to break with her. This was lucky news; a day more, and it had been as unfortunate.—Gentlemen, your servant. [*Exit*]

GAYLOVE: Come, cheer up, Ned, who knows how this may work.

COURTLY: His mercenary base nature gives me some hopes.

GAYLOVE: If we could as easily contrive some stratagem to defer Celemena's wedding; for I confess I feel something here that will give me disquiet to see her married to another.

COURTLY: How! Charles, I thought you were proof against love and matrimony.

GAYLOVE: Why, will you allow nobody to repent of their mistakes but yourself? Celemena has wit, beauty and good nature, and

I heard her father express himself very prettily to her; £10,000 would make a convert of one more reprobate than your humble servant.

COURTLY: 'Tis a received article indeed—but let's in, the ladies wait.

GAYLOVE: *Allons.*

Exeunt.

ACT II, SCENE II

MRS. GRASPALL *discovered reading at a toilette.*

WIFE: How small a relief can books afford us when the mind's perplexed! The subject that our thoughts are bent upon forms characters more capital and swelling than any these useless pages can produce, and 'tis no matter on what theme the author treats; we read it our own way, and see but with our passion's eyes. Beaumont is here in every line—Beaumont in all the volume—I'll look no more on't. These optics too are traitors, and conspire with fancy to undo me. To what shall I have recourse?

Enter BEAUMONT.

BEAUMONT: The door happening to be open and nobody in the way, I presumed to enter without ceremony.

WIFE: Ha! Catched in this confusion of my soul! When all my thoughts were unprepared and hurried! Unlucky accident!

BEAUMONT: You are disordered, madam. I hope my presence has not offended.

WIFE: Sir Harry, you can be guilty of but one offence; forbear to talk of love, and you shall ever be most welcome here.

BEAUMONT: Oh severe injunction! You know this is the only command I could refuse to obey you in, and yet, unkind and cruel, you rate the price of my admittance at an impossibility. The language of my eyes you have long since understood and

pardoned; why then is it greater guilt when told you by my tongue?

WIFE: The crime in both is equal, and since with innocence I can admit of neither, have resolved—

BEAUMONT: On what?

WIFE: Never to look on you or hear you more.

BEAUMONT: What have I done to merit such a sentence?

WIFE: [*Aside*] How shall I answer him or how disguise the real reason of my change of temper, for much I fear he will not think it hate? [*To* BEAUMONT] That I no sooner did forbid your visits was because I hoped you would endeavour to overcome a passion which, I think, I never erred so far by any word or actions to encourage, and wished I might with honor have preserved your friendship.

BEAUMONT: Are love and friendship then at such a distance they ne'er can meet? Oh, would you but rightly weigh their likeness, you'd find the scale so even, you'd think them twins. Friendship is love refined, and love is friendship of a warmer soil. There's such a sympathy between 'em, the breast that harbours one can never be a stranger to the other.

WIFE: I must not harken to such sophistry—Hark! I think I hear somebody coming, and have reason to believe that of late I have had spies upon my actions. Step into the closet while I see who 'tis. [*Exit* BEAUMONT]

Enter TOYWELL.

Toywell! What means this intrusion? Did I not bid you trouble me no more? Or if I had not, were there no servants in the way to keep down such impertinents?

TOYWELL: No, faith, madam, all your people are in the middle of the street yonder, crowding about a peddler's pack and choosing knick-knacks; and so, madam, passage being free, I took an opportunity to, to, to—come in, madam.

WIFE: Very well; but I shall call 'em to guard it better, and show you down a nearer way than you came up, unless you leave me immediately.

TOYWELL: I don't think you have so little understanding. Besides, I am come to make a new proposal. I have heard some news, which will certainly disappoint Marilla in her hopes of marrying me; I can now settle a whole heart upon you.

WIFE: Peace, thou despicable fop! If you fancy this gallantry—as 'tis possible you may be weak enough—I pity your simplicity. But if your designs are as base as your impudent persisting in this behaviour intimates, once more I tell you I have virtue to arm me against the assaults of your whole sex, and value enough for my husband to let him know the favour you would do him. [*Calling offstage*] Who's there?

TOYWELL: Nay, madam, if I part with you so, you may justly suspect my want of parts. Women often pardon actions when they will not words; a little compulsion gives 'em an excuse. Come, come, you will not be always cruel.

WIFE: Unhand me, villain—help—

TOYWELL: Nay, nay, I can stop your mouth—[*As they struggle, she falls against the closet door, which opens and discovers* BEAUMONT] 'Sdeath, Sir Harry Beaumont! Why, who the devil thought to find you here? I beg ten thousand pardons, if I have been the cause of your imprisonment. [*Aside*] Let me blood, I must banter him a little; he dares not resent it, for fear I should tell.

WIFE: Oh! I'm undone—my reputation's ruined! For Heaven's sake, Sir Harry, how came you there?

TOYWELL: I suppose, madam, Sir Harry offered this as a piece of gallantry, but I hope your goodness will pardon him for all the vain attempts he may make on a virtue so impregnable as yours, ha, ha, ha!

BEAUMONT: Give over your ridiculous mirth or—

TOYWELL: Fie, fie, Sir Harry, that's no proper weapon to be used in a lady's chamber. But, Sir Harry, you forget the lady desired you to tell her how you came hither.

BEAUMONT: Madam, I heartily beg your pardon for the surprise I have occasioned you, but having some business with Mr. Graspall, and, finding nobody at home, I took the freedom

to step into the closet, which I knew to be well furnished with books. Designing no more than to amuse myself till he came home, I happened to meet with one which so agreeably entertained me that, till the opening of the door, I had forgot where I was.

TOYWELL: Hum! Mr. Graspall has indeed an admirable collection—but age has somewhat impaired his eyesight, poor man! I believe he seldom reads; and I must own 'tis a great conveniency for a gentleman who has not books of his own to have the liberty of so fine a library.

BEAUMONT: Sir, I wish you either could or would explain yourself. But if you harbour a thought to the prejudice of this lady's character, could I discover it, I'd make such an example of you as should be a terror to all talkative coxcombs.

TOYWELL: Who, I, Sir Harry?

WIFE: [*Aside*] The aspersions of this fool are intolerable! Though my innocence should make me despise his malice, and my character not fear it, yet those of his own stamp may believe the mean reflections he may cast on me.

TOYWELL: You see, madam, what inconveniencies attend ill nature; when you are kind, I'll—

WIFE: Peace, screech owl! [*Exit*]

BEAUMONT: Come, sir, the lady is now gone; and since I am the unhappy cause of her uneasiness, it lies upon me to vindicate her reputation. A fool's most dangerous weapon is his tongue, and I find there is no way to stop yours but by cutting it out. Draw, sir.

TOYWELL: [*Aside*] I don't like his looks; 'gad, I wish I had not been so witty. [*To* BEAUMONT] Draw, Sir Harry! Why, I hope you are not in earnest! What, draw on your friend for a little harmless raillery? If you have no more value for me, I'll show you I love you better.

BEAUMONT: That shan't do, sir.

TOYWELL: Why, Sir Harry, I was but in jest as I hope to live. I vow to Gad I believe the lady as chaste as the moon, and her virtue

as conspicuous as the stars in the firmament. Draw, quoth'a! What, draw upon my friend, Sir Harry Beaumont! All the world shan't make me draw upon my friend.

BEAUMONT: Hark ye, sir, your cowardice shan't screen you another time. If ever I hear a word injurious of this lady, assure yourself I shall justify her honor with my life. [*Exit*]

TOYWELL: Pox! Who would have thought he had loved fighting so well? I'm glad I'm well off though; I'll trouble myself no more about her. There are as fine women to be had without venturing one's life for 'em. Now if I could but find some plausible pretence to break with Marilla, I should be the most easy man in the world, for

When her fortune's gone, the loveliest woman
In this wise age is a fit wife for no man.

ACT III, SCENE I

Enter CAPTAIN GAYLOVE, COURTLY *laughing, and* SHAMBLE *very fine.*

GAYLOVE: Ha, ha, ha! How saucy the rogue looks!

COURTLY: Why, he tells you his grandeur must charm the widow.

SHAMBLE: Ha, ha! I have quite forgot my dancing for want of practice—[*In an affected tone*] but business, state-affairs, intrigues and one hurry or another takes up all my time—ha, ha! Pray, gentlemen, stand by. Do you know who I am? Won't this do, sir? [*Dancing in an awkward manner*]

COURTLY: Rarely!

GAYLOVE: Excellent! If he can but keep up to his character.

SHAMBLE: Oh, sir! There is no one thing in the world so soon learnt as the forgetting what one really is in the appearance of another. Humility is a lesson few study with much pleasure, and all, at some times, are truant from. Then why may not I, Sir Tristram Shamtown, forget I have been your honor's pimp and serving-man?

COURTLY: Sir Tristram.

GAYLOVE: Aye, that name was of my inventing. But pray, good Sir Tristram, don't so far forget yourself as to neglect the main chance. Take care to put the widow off settling any part of her estate on her nephew.

SHAMBLE: No, no, sir, never doubt it. I shall retain that principle of honor, to serve my friends, when in so doing I doubly serve myself. If I marry the widow, depend upon it, not a foot of the estate shall be parted with. In that, I go a great way in breaking off the designed match between her nephew and Celemena.

COURTLY: A great way—all in all! For I am satisfied Mr. Fairman will never sacrifice his daughter to such a fool as Sneaksby without a certainty of the widow's land for her jointure.

GAYLOVE: Well, faith, I have a strong opinion we shall succeed. Prithee, Shamble, tell honest Jenny—Mrs. Dogood I think you call her now—that if she has not quite forgot past kindnesses, she must lend her assistance in this affair. And, to refresh her memory, let her know 500 pieces more are at her service the moment Sneaksby quits his pretensions to Celemena.

SHAMBLE: I'll warrant you, sir—but 'tis about the time she ordered me to come.

GAYLOVE: Come, shall we walk? Mr. Fairman, you know, was so obliging to desire we'd pass the evening there.

COURTLY: With all my heart—though it is feeding me with the fare of Tantalus. I ought to shun the sight of what I must desire and yet am hopeless of enjoying.

GAYLOVE: Never despair, our design on Toywell may have more effect than you imagine. Farewell, Shamble, good luck attend thee. If anything happens, I shall be here or at Mr. Fairman's.

Exeunt GAYLOVE *and* COURTLY.

SHAMBLE: I have a good stock of impudence, and that often carries the day.
And they went to a widow's house,
And she was dancing naked,
And all the tunes the piper played
Was take it, widow, take it. [*Exit*]

ACT III, SCENE II

Enter SNEAKSBY *and* TIM.

SNEAKSBY: Come, Tim, let's go close together; I can't abide to be out when it grows towards dark, now here be all these soldiers come down. They are plaguy mischievous, they say—

TIM: Aye, sir, my mother used to tell me terrible stories of 'em.

SNEAKSBY: 'Twasn't well done of aunt, so 'twasn't, to turn one out as soon as ever one come. She might have made one eat a bit of somewhat first, methinks. What did I care if I did not see my mistress till tomorrow? We ain't to be married tonight.

TIM: Mayhap, sir, she thought 'twould not look respectful enough.

SNEAKSBY: What did I care? I have paid respect to her long enough, I think; besides, is not she a-going to be my wife, and as long as we know one another's mind, what signifies making such a to-do about it?

TIM: Why, sir, you told me you had never asked her the question yet.

SNEAKSBY: What then? Aunt has, and father-in-law that must be, and that's as well. Oh, here he comes.

Enter FAIRMAN.

Your servant, father-in-law.

FAIRMAN: Mr. Sneaksby, your servant. How happens it your aunt is not with you? I expected her.

SNEAKSBY: Why, aunt gives her service, but she has some great visitor to come tonight belike, for all the house is stuck with candles, and she is woundy fine.

FAIRMAN: An humble servant, it may be.

SNEAKSBY: Mayhap so, I never ask questions.

FAIRMAN: [*Aside*] I wish I had the writings sealed though.

SNEAKSBY: 'Tis nothing to me; you know she has promised me the estate.

FAIRMAN: [*Aside*] If she should marry, I much question whether she'll keep her word; I must be satisfied. [*To* SNEAKSBY] But come, sir, let's go in. My daughter expects you.

SNEAKSBY: Aye, father-in-law, but I wish you'd let me have a bit of somewhat first, for Tim and I are plaguy hungry, and aunt would not let us stay to eat a bit.

FAIRMAN: You shall command anything my house affords. [*Exit*]

ACT III, SCENE III

Enter DOGOOD *and* SHAMBLE.

DOGOOD: Well, now I think 'tis almost impossible our plot should fail. The widow is half distracted in love with you before she sees you.

SHAMBLE: My person cannot but secure the conquest.

DOGOOD: You would have laughed if you had seen how greedily she swallowed the bait—but you must be sure to strut and look big, and not lose an inch of your grandeur.

SHAMBLE: Oh you need not fear; none look so proud and scornful as your new-made gentry.

DOGOOD: I have told her I waited on a sister of yours in London; that you have a good estate in possession and another in reversion; that you are of a most ancient family.

SHAMBLE: And my name is—

DOGOOD: Sir Tristram Shamtown—of Shamtown Hall. But I hear her coming; step into the next room and you shall hear a little of her humor.

Exit SHAMBLE. *Enter* WIDOW.

WIDOW: And did Sir Tristram tell you he'd be sure to come?

DOGOOD: I warrant you, madam, he'll not fail; for, though I say it, he had always a great respect for me.

WIDOW: I long to see him—how do I look, Dogood?

DOGOOD: Perfectly amiable, madam.

WIDOW: I think I am bloated today. [*Pulls out a pocket-glass*] Here, pull this riband a little more to my face—so, there, 'tis well enough now. Well, I don't like myself, 'tis impossible a man of his quality should take a fancy to me.

DOGOOD: 'Tis rather impossible he should not, madam. But hark, somebody knocks—'tis he for certain.

WIDOW: Well, I vow I believe something will come of this, for I never had such a palpitation since the day I first saw Mr. Stately.

Enter SERVANT.

SERVANT: A gentleman enquires for Mrs. Dogood. He told me his name, but 'tis so hard a one, I have forgot it.

WIDOW: It must be he! This blockhead is used to nothing but the vulgar, but if he continues with me, he must improve his understanding.

DOGOOD: Desire the gentleman to walk up.

WIDOW: And do you hear, loggerhead, be sure you pay him a great deal of respect. [*Exit* SERVANT] I leave thee to receive him. I'll step into the next room and settle myself a little, and then return as if I did not know anybody was here.

DOGOOD: Very well, madam, and in the meantime, I'll be giving him a character.

WIDOW: That's my good wench—and I'll reward thee. [*Exit*]

DOGOOD: They say good actions reward themselves, but if my project goes on as luckily as it begins, I am like to have rewards from all sides.

Enter SHAMBLE.

So you have nothing to do, you see, but to summon the governor; the fort's ready to surrender.

SHAMBLE: Egad, and I like the situation of it extremely, it seems to want no fortification.

DOGOOD: You see but the outworks; there's a magazine within of plate and jewels and old broad-pieces that have not seen the sun these forty years, enough to set the whole country in a blaze. But I hear her coming—now to your part.

SHAMBLE: Aye, aye. And your lady is so fine a woman you say, Mrs. Dogood?

Enter WIDOW.

DOGOOD: She's here, Sir Tristram.

WIDOW: Dogood! Bless me! I did not know you had anybody with you—

DOGOOD: A gentleman you have often heard me talk of, Sir Tristram Shamtown, madam.

WIDOW: Oh Heavens! Sir Tristram Shamtown! I am ashamed to be caught thus in my dishabille—and the house, oh gad, the house is not fit for anybody to come into, much more a gentleman of Sir Tristram Shamtown's quality.

SHAMBLE: Madam, 'tis impossible that anything can be more elegant than the economy of everything about you. I was perfectly charmed with your house till the appearance of your ladyship made me forget all but you.

WIDOW: Oh Sir Tristram!

SHAMBLE: Oh madam!

WIDOW: You are such a courtier—

SHAMBLE: You are such a beauty—

WIDOW: So full of gallantry—

SHAMBLE: So full of charms—

WIDOW: Nay, Sir Tristram—

SHAMBLE: So all over engaging that it would puzzle a logician to define your brightness.

WIDOW: This is too much, Sir Tristram.

SHAMBLE: Madam, everybody that has eyes must admire you—what a shape! Pray, Mrs. Dogood, did you ever see so exact a symmetry of body?

WIDOW: Oh fie, Sir Tristram! You make me blush to death—

SHAMBLE: What a foot! Mrs. Dogood, pray look at your lady's foot! There's a foot proportioned to the body; the body suited to the grandeur of the face; and the air of the face bespeaks the grandeur of the soul—

WIDOW: I vow, Sir Tristram, you quite confound me, but you men of quality are so used to raillery—

SHAMBLE: How, madam! Another such a word would make me curse my stars, grow mad and die. Is there any need to say I adore you after having seen you?

WIDOW: Alas, Sir Tristram, I have nothing in me worth the regard of a man of your quality.

SHAMBLE: Ah, madam, you cannot be ignorant of the power of your charms, and but say this because you think me undeserving of your favour.

WIDOW: I protest you wrong me, sir. Sir Tristram Shamtown cannot but know any woman would be proud of his addresses.

SHAMBLE: If you receive 'em, madam, let all your sex besides think as they please. Mrs. Dogood, you know I cannot flatter; help me to convince your lady of the sincerity of my passion, for my stock of speeches is almost exhausted.

DOGOOD: What do you think of him, madam?

WIDOW: Oh charming! But dost thou think he really admires me so much as he says?

DOGOOD: I never saw a man so much transported.

WIDOW: What a difference between a man of quality and the vulgar! Mr. Stately never courted me in this manner.

SHAMBLE: Speak, madam, what must I do to prove myself your beauty's slave? Will nothing but my death suffice?

WIDOW: Oh Heaven forbid, Sir Tristram! I would not do so much injustice to the world, whose chief ornament you are.

SHAMBLE: Your goodness is equal to your beauty.

WIDOW: Will you favour me so far, Sir Tristram, as to take part of a collation, just what the house affords?

SHAMBLE: A salad with your ladyship is preferable to ortelans in any other company.

WIDOW: Dogood, lead the way, and see if everything is read.

DOGOOD: Yes, madam. [*Exit*]

WIDOW: Sir Tristram!

SHAMBLE: Exquisite hand!

WIDOW: Nay, Sir Tristram!

SHAMBLE: Madam, I obey. [*Exeunt*]

ACT III, SCENE IV

Enter CELEMENA, MARILLA.

MARILLA: Sure never any two were so nearly allied in their misfortunes as ourselves. Was there ever such a wretch in humankind as Sneaksby?

CELEMENA: Never, unless it be Mr. Toywell; but if I had no more to fear from the resentment of a living father than you have from a dead one, I should not think my condition very deplorable.

MARILLA: You talk strangely; were mine alive, I might hope by prayers and tears to move him, or that the sight of Toywell's indifference might change his mind, but as he's past the knowledge of all this and has my vow, nothing remains for me but patience in my sufferings.

CELEMENA: Well, I find there's no persuading you, but, for my part, I'm resolved—

MARILLA: On what?

CELEMENA: Never to be wife to Sneaksby.

MARILLA: But how will you avoid it?

CELEMENA: [*Sighs*] Nay, that I can't tell.

MARILLA: Here comes one may inform you, for if I know anything of the language of the eyes, you understand one another's already.

CELEMENA: Psha!

MARILLA: Farewell, I'll be no interruption.

Enter GAYLOVE.

CELEMENA: Why, Marilla, Marilla!

GAYLOVE: Whither in such haste, madam?

MARILLA: Your pardon, Captain; I have business. [*Exit*]

GAYLOVE: Have you told her our design on Toywell?

CELEMENA: No, nor I would not have you. I know not but she may be whimsically nice enough to disapprove the means, though she would bless the effect.

GAYLOVE: 'Tis not impossible; but methinks, madam, you stand here prodigiously indolent and *degagé*. In fancy you forget

tomorrow is your wedding day. What, no preparations? Spouse that must be is arrived, I see, but I think at present he seems more inclinable to pay his addresses to a good supper than a mistress. As I came through the hall just now, I saw him lay about him like a man of mettle at a piece of cold roast beef and a tankard of ale.

CELEMENA: 'Tis ungenerous in you, Captain, to insult.

GAYLOVE: Who, I, madam? I protest the farthest from it in the world. Why, I thought you had been infinitely pleased with the match, and that no discourse could have been so agreeable as that which mentioned Mr. Sneaksby. And without doubt the squire will make you prodigiously happy in a husband—

CELEMENA: Well, Captain, well.

GAYLOVE: If your ready compliance with your father's commands had not assured me 'twas your own desire, I had a project in my head which would certainly have left you at your liberty.

CELEMENA: For Heaven's sake, what?

GAYLOVE: No, madam, no; far be it from me to separate hearts so strictly joined. Marry, madam, the lovely beloved youth, Enjoy th'unenvied title of his wife, While I at distance languish out my life.

CELEMENA: I hate your raillery when one has a mind to be serious. But tell me what you mean and I'll forgive it.

GAYLOVE: That won't do, madam; I have you in my power now and you can't blame me if I follow your own example in making use of it.

CELEMENA: Deuce take you! Well, but what must I do to bribe you then?

GAYLOVE: Why, faith, madam, no less than cancelling all the injunctions you laid me under this morning; that you will immediately, on the breaking off of this match, put me in possession of the same title your father designs to give Sneaksby.

CELEMENA: Oh the impudent demand! So to escape one slavery, I must throw myself into another, which, for ought I know, may be as bad.

GAYLOVE: Nay, if you think so—[*Going*]

CELEMENA: Stay! Have you no conscience?

GAYLOVE: You hear the price, madam.

CELEMENA: I thought a lock of my hair or my picture had been a reward, the greatest your ambition could have asked for the highest obligation.

GAYLOVE: No, no, madam, knight-errantry has been a long time out of fashion. I shan't bate an ace of what I told you—but see, here comes your doom, if you persist in obstinacy.

CELEMENA: Cursed, teasing, charming devil.

Enter FAIRMAN *and* SNEAKSBY.

SNEAKSBY: I hope, father-in-law that must be, you have told her everything, for I hate a great many words. An she were a man now, I should know what to say to her, but mayhap she mayn't like my way.

FAIRMAN: Well, well; she knows your mind.

SNEAKSBY: Why, that's well enough. Your servant, mistress.

CELEMENA: Your servant, sir.

FAIRMAN: Captain, if you please, we'll walk into the next room.

GAYLOVE: I wait upon you, sir. You'll remember the conditions, madam.

Exeunt FAIRMAN *and* GAYLOVE.

CELEMENA: Hang you. [*To* SNEAKSBY] Won't you please to sit, sir?

SNEAKSBY: No, I thank you, I'd as lief stand. [*Aside*] What must I say now? I wonder what made 'em go away?

CELEMENA: [*Aside*] I hope he has not courage enough to be impertinent.

SNEAKSBY: I suppose, Mrs. Celemena, you know that aunt and your father think it convenient our wedding should be tomorrow.

CELEMENA: 'Tis so designed, sir, I hear.

SNEAKSBY: Nay, as the saying is, as long as 'tis to be, the sooner 'tis over the better. For my part, I have nothing to say against it; have you?

CELEMENA: Not that I know of, sir.

SNEAKSBY: Why then, I may go to the company again, mayn't I?

CELEMENA: With all my heart, sir.

SNEAKSBY: Nay, do you go first; I ain't so unmannerly neither.

CELEMENA: [*Aside*] Oh intolerable! Heaven grant the Captain be in earnest or I shall lose my senses.

Exeunt.

ACT III, SCENE V

Enter GRASPALL *and* WIFE.

GRASPALL: You know, spouse, the duty of a husband is to love and provide for his wife; and, in return, the wife is obliged to obey the commands and study the interest of her husband.

WIFE: I don't know that I have given any occasion for this recital of a wife's duty.

GRASPALL: Far me it from me to accuse thee. I mention obedience to a husband, not that I believe thee to have erred in it, but that it being fresh in thy memory, thou might'st not boggle at anything which tends to the enriching of thy husband.

WIFE: To what purpose can this harangue be made? Sir, let me know what you expect from me and I shall answer with a ready compliance.

GRASPALL: Indeed, thou'rt very good, and thou would'st not scruple anything for thy old lovey, ha, Pudsy?

WIFE: I hope you can command me nothing I can make a scruple of obeying you in, but why all these precautions?

GRASPALL: Well, well, I ha' done—I ha' done. But remember that obedience to a husband ought to be the *primum mobile* in a woman. Here, Pudsy, read this.

WIFE: Heavens! A letter from Sir Harry!

GRASPALL: Read, Pudsy, it's prettily turned. Come, I'll read it for thee. [*Reads*] "Madam, What I feel in the contemplation of your cruelty this morning is not to be expressed. I beg you will be at least so just as to let me know to what I owe so great a misfortune. Your everlasting admirer, Beaumont."

Now, Pudsy, you shall see if I had not a tender regard for your youth and a just consideration of my own age. I fitted him with a letter in your name.

WIFE: I am undone! Oh sir, I beg you on my knees, whatever appearances may be against me, you will not think me guilty of dishonor, for on my soul—

GRASPALL: Rise, prithee, I am not jealous. Hear what I writ to him. I have the copy—oh, here 'tis.

WIFE: What will this come to?

GRASPALL: Now, Pudsy, you shall hear. [*Reads*] "Sir, The satisfaction you require of me shall be made you, if you will give yourself the trouble to meet me in the little field behind our garden at four a-clock this afternoon. Your humble servant, Susanna Graspall."

WIFE: And did you send him this impudent letter in my name?

GRASPALL: Have patience, condemn me when you have reason, Pudsy.

WIFE: I know not what to think.

GRASPALL: The appointed hour and the lover came together, whom I accosted with "Sir Harry, your humble servant" and so forth.

WIFE: Heavens, how I tremble!

GRASPALL: "And then it seems," said I, "by this letter, which accidentally fell into my hands, that you have some affairs to negotiate with my wife. Now she, being under covert-baron, can transact nothing without my leave; for which reason, and believing my age and experience might enable me to treat more effectually with you, I answered your letter. Nay, Sir Harry," said I, "don't blush" (for he did look cursedly confused, that he did); "a sword and a wife," said I, "are both useless to me; and as I wear one for the ornament of my dress, so I married the other as a grace to my house—"

WIFE: Where will this end?

GRASPALL: "Now, Sir Harry," says I, "whoever has the use of my sword, it's but reasonable he pay for the furbishing. And, if you really have so violent a passion for my wife as your letter intimates, pay the money down she has expended me in

clothes, and allow me some consideration for the pity I have of your sufferings, and I here give you free ingress, egress and regress." I was some time before I could persuade him that I was in earnest.

WIFE: In earnest, sir!

GRASPALL: Aye, Pudsy. For a good while I could not make him believe I really designed him the favour of paying me £2,000, the price I set, for giving him the liberty to—visit thee now and then, that's all. But I convinced him at last, and he immediately sent the sum proposed to my house in a strongbox, with condition only of keeping the key till you set your hand to the covenant. Now, Pudsy, if thou hast any love for thy old hubby, never let such a sum depart the house by a foolish denial. If thou dost, it is as bad as robbing me, for whatever I have in my custody, I always look upon as my own.

WIFE: Is it possible you can have so mean a spirit? Or do you believe, if you have so sordid and grovelling a soul, that I can, regardless of my fame and lost to virtue, yield to such a detested bargain?

GRASPALL: Dear, dear Pudsy, don't be too hasty in resolving; consider, will fame ever get thee £2,000? Remember, Pudsy! Two thousand pounds! When I think what a sum it is, I sweat at the apprehension of virtue.

WIFE: And would you be a cuckold?

GRASPALL: Two thousand pounds, Pudsy—

WIFE: Despised and pointed at?

GRASPALL: Two thousand pounds.

WIFE: Become the public scorn, and all for gain, a little trifling trash?

GRASPALL: A little, dost thou call it? I wish thy virtue has not flown into thy head and turned thy brain. Why, what dost thou value thy virtue at?

WIFE: The world cannot repair the loss of it.

GRASPALL: Ah! To be sure, thou art a little touched, but don't think that I'll be fooled out of the strongbox. If you are mad, I am not, and you had best consent quietly to what I desire, or I shall make you. 'Sbud, I've been too humble—

WIFE: No husband's power extends to force the execution of unlawful commands. But sure you cannot be so dead to shame, to wish it seriously?

GRASPALL: Seriously! Why, there 'tis now. Don't I tell you that £2,000 are in a strongbox, and that I have that box in keeping, and that there is nothing hinders me from being master of it, but your refusing to perform articles?

WIFE: Monstrous stupidity! Not to be believed!

GRASPALL: But you'll believe it, I hope, when you find Sir Harry tells you the same thing; I have appointed him to come this night. I'll give you half an hour to consider on't, but would advise you not to be a fool—nor think to make me so. [*Exit*]

WIFE: Thou mak'st thyself a wretched, wicked fool! Was ever anything like this?

Enter AMADEA.

AMADEA: Start not, madam; I have overheard all and know not whether my admiration of your virtue or amazement at your husband's base intention most takes up my thoughts.

WIFE: Exposed to him—Heavens! This story will be the jest of the whole country! Whatever are my husband's faults, is not your business to examine, and 'twas unmannerly to listen to our private conference.

AMADEA: I doubt not of your pardon for this, and many other actions which have seemed impertinent, when you shall know my reasons for curiosity, which now, fully convinced of your virtue and confident of your good nature and compassion, I shall make no scruple of revealing. I am a woman, madam.

WIFE: A woman!

AMADEA: My name is Amadea, descended from a family I need not blush to own, blessed with a fortune equal to my birth, and bred in expectation of the fairest hopes. Sir Harry Beaumont once was not ashamed to own to all who knew him he thought me worthy of the tenderest passion.

WIFE: A woman! And Sir Harry Beaumont's mistress—

AMADEA: His wife, if vows can make me so. Therefore, in such a

circumstance, you cannot wonder I took all opportunities to dive into the secret of his coming hither. You shall hereafter be informed of all the particulars of my story, but the time allowed you for consideration is so short I must defer it, and only beg you (for in your power alone it is) to help a wretched woman, and save me from eternal ruin and despair.

WIFE: Alas! What can I do?

AMADEA: Seem to consent to what your husband asks and leave the rest to me.

WIFE: How will that serve you?

AMADEA: You shall know anon. In the meantime, I conjure you to dissemble a compliance; your virtue shall not suffer by your charity to me.

WIFE: Well, you shall persuade me.

AMADEA: Heav'n will reward the generous aid you lend,
And the soft wishes of my soul befriend,
Since, true to virtue, my endeavours aim
Only the dear false rover to reclaim.

ACT IV, SCENE I

Enter DOGOOD, SHAMBLE *and* WIDOW.

WIDOW: Indeed, Sir Tristram, this offer of your sister for my nephew convinces me the most of anything of your affection. I wish there were a way for me to get off with Mr. Fairman.

SHAMBLE: Madam, the passion I have for you makes me study your interest, which I think you ought to prefer to ceremony. My sister's fortune, which is £5,000 more than Mr. Fairman proffers with his daughter, is in her own hands, and I'll undertake she shall be content with only her own money settled on her.

WIDOW: That is obliging, indeed. I was certainly bewitched when I agreed to Mr. Fairman's proposal—but alas! I did not think of marrying then, nor am I sure I shall yet.

SHAMBLE: How, madam! Not sure of marrying? You have undone

my quiet—drove me to despair, and without you retract those cruel words, you shall very soon see the fatal consequence.

WIDOW: Nay, Sir Tristram, I only said—

SHAMBLE: Oh you have ruined me! Farewell, board-wages and laced liveries! Farewell, all joy, all peace of mind, all happiness! Welcome, ye solitary groves and baleful yew, ye purling streams and cooing doves! Behold the unhappy Shamtown, oppressed with grief and sunk with sad despair, joins in your moan! The cruel Stately scorns my passion.

WIDOW: Sir Tristram, won't you hear me?

SHAMBLE: Oh! Can I bear a doubt of that happiness I so ardently desire, and yet live? No, no, death will soon ease me of these pains—I will rip up this faithful breast, and show my panting heart.

WIDOW: Sir Tristram, I did not say that—

SHAMBLE: Was it for this you gave me hopes? Did you raise me up but to make my fall the greater?

WIDOW: Why, Sir Tristram! Lard, I think he's run mad indeed. What shall I say to him, Dogood?

DOGOOD: Tell him you'll marry him this minute! Say anything.

WIDOW: Then, Sir Tristram, to show you—

SHAMBLE: What unhappy destiny drove me here or first fixed my eyes on that lovely cruel woman? Oh that I could forget I ever saw you!

WIDOW: Why, Sir Tristram, to convince you that I am not cruel, send for a parson and make me my Lady Shamtown.

SHAMBLE: Ha! Do you mock my grief? Nay, then death must be my portion. [*Offers to fall on his sword*]

DOGOOD: Ah!

WIDOW: Ah! For goodness sake, Sir Tristram, I am in earnest, I vow and swear—I will marry you this minute, if you please.

SHAMBLE: Can it be possible? But I'll not believe I am so happy.

WIDOW: Then follow me, and put it to the proof. [*Exit*]

DOGOOD: You'd make a rare actor.

SHAMBLE: Send for a parson, lest some unlucky accident should prevent us—I'm quite out of breath. [*Exeunt*]

ACT IV, SCENE II

Enter CELEMENA *and* GAYLOVE.

GAYLOVE: Well, madam, what think you of my plots? You see, as near as your cousin Marilla thought herself to Hymen, my contrivance is in a fair way to make her lose sight of him.

CELEMENA: I can't but say you are like to be successful enough, and I should be very apt to employ you in the same business, if you were not so exorbitant in your demands.

GAYLOVE: Good workmen, madam, will have good prices. I would fain do your business once for all. If I should be compassionate enough to hew off this rub in your way for little or nothing, who knows but another may start up? No, no, let me see you at your journey's end, lodge you safe in matrimony, and I'll trust to your management afterwards.

CELEMENA: You are very confident of your own abilities, I find. But suppose you should be mistaken? Many a woman has been glad of a fool after matrimony that she would have despised before.

GAYLOVE: That's because then she has a husband too wise.

Enter COURTLY.

COURTLY: Dear Gaylove, I am infinitely obliged to thee. Toywell is grown so insolent to Marilla, that if she should still persist in her resolution of marrying him, I think 'twould cure my passion.

CELEMENA: 'Twas almost come to a downright quarrel when we left 'em.

COURTLY: Nothing to what is now. Here they come, pray observe 'em.

Enter MARILLA *and* TOYWELL.

MARILLA: I wish, Mr. Toywell, you'd forbear your visits, unless you could behave youself with more good manners. You play the husband too soon.

TOYWELL: And to deal plainly with you, madam, I think you play the wife too soon.

MARILLA: If I never give you leave to call me by that title, your usage would almost excuse my breach of vow.

TOYWELL: Why really, madam, I believe, of all womankind, your charms have the least effect on me, and I don't think 'twould be the death of me, if you should refuse me that blessing of calling you my wife. If that's your desire, pray let me know it, probably I may have tenderness enough for you to give up my pretensions on very easy terms.

MARILLA: Say on what? Say on any. Leave me but a competency for bread and take the rest of my fortune.

TOYWELL: [*Aside*] Which is little enough, if she knew all. [*To* MARILLA] Look ye, madam, though you are so cruel as to tax me with indifference, to show you how vast a regard I have for your ease, I will forego all the happiness I proposed in the possession of so much beauty, and now swear from my soul, in the presence of these witnesses, that upon no account will I, John Toywell, ever be the husband of you, Marilla Fairman.

MARILLA: I thank you, and with joy receive my liberty.

COURTLY: Now, madam, may I not hope—?

MARILLA: The usage I have received from him is sufficient to make me hate all men. [*Exit*]

COURTLY: Yes, madam. [*Exit*]

GAYLOVE: Why, are you in earnest, Mr. Toywell? Really quitted your pretensions?

TOYWELL: Really! Aye, Captain. 'Twould have been carrying the jest too far to have married her without a portion. There stands one, and a good agreeable woman—egad, I think I'll make love to her.

GAYLOVE: But you know she's to be married to Sneaksby.

TOYWELL: It's no matter for that. Do you think she'd be such a fool to refuse me for him?

GAYLOVE: But you have affronted her cousin; don't you believe she'll resent it?

TOYWELL: Psha! I'll tell her 'twas for her sake.

GAYLOVE: Nay, you may try. Madam, here's a gentleman is fallen desperately in love with you on the sudden—

CELEMENA: Who? What do you mean?

GAYLOVE: That he must explain.

TOYWELL: Madam, I long have adored you; 'tis impossible to tell you with how much ardour; that your glass must inform you, because nothing else can give you any just idea of your perfections.

CELEMENA: The fool's distracted, sure, or is it your contrivance too?

GAYLOVE: No, faith, madam, 'tis all his own—

TOYWELL: Till this happy moment, madam, I was not at my own disposal, but was obliged to smother all the transports of my soul when I beheld you—

GAYLOVE: Hold, Mr. Toywell—take care—here's a rival approaching, trebly armed with mead, cider and metheglin.

TOYWELL: What, Sneaskby drunk! Oh the putt!

Enter SNEAKSBY *drunk.*

SNEAKSBY: Adod! Father-in-law keeps good liquor; but 'tis plaguy heady—who's here? Oh mistress! Wife that must be, here, tie my neckcloth—

CELEMENA: Oh hideous! Really, sir, I don't know how.

SNEAKSBY: Not know how! You are very fit for a wife indeed! Mayhap you'll never learn.

CELEMENA: 'Tis possible.

TOYWELL: Oh the brute, how he smells! Sure, madam, you cannot consent to bury your youth and beauty in the arms of that wretch?

CELEMENA: Whatever he is, I prefer him to a fop. Mr. Sneaksby, you are not apt to be jealous, I hope; Mr. Toywell is making love to me. How do you approve it?

SNEAKSBY: Making love to you—ugh!

TOYWELL: Well, sir, and what then, sir? What if I do, sir? [*Aside*] Egad, I may bully him.

GAYLOVE: I don't know but these two coxcombs might afford some diversion if we had time to work 'em to any pitch.

SNEAKSBY: Ugh—why then, mayhap, you may make me a cuckold—

TOYWELL: And what then, sir?

SNEAKSBY: Ha! Ugh! What then, sir—why then, mayhap I may break your sconce, I'll tell you but that.

TOYWELL: How, sir! [*Aside*] Gad, I'll charm her with my courage. [*To* SNEAKSBY] Do you see this, sir? [*Draws*]

SNEAKSBY: Why, mistress, do you stand there and see your husband that is to be—murdered? [*Using* CELEMENA *as shield*] But he shall kill you first, I'll tell you but that.

GAYLOVE: Oh sir! He'll do you no hurt. Come, put up, Mr. Toywell, put up.

SNEAKSBY: Nay, you shan't stir.

CELEMENA: Out, filthy creature!

SNEAKSBY: What's the matter—ugh—

CELEMENA: Oh insufferable! Captain, help me.

GAYLOVE: Ha, ha, ha—come, Mr. Toywell, you see your antagonist is not *se defendendo*. 'Twill be generous to lend your arm to help him in.

CELEMENA: Oh, I am poisoned! [*Exit*]

TOYWELL: In complaisance to you, Captain—faugh! How he stinks.

SNEAKSBY: Ugh! What are you doing—murder, murder! Where are you carrying me? Murder!

Enter SERVANTS.

FIRST SERVANT: Murder! What's the matter?

GAYLOVE: Why, your young master that is to be, as he says, is a little overtaken, that's all.

FIRST SERVANT: Oh, the squire's drunk.

SNEAKSBY: Murder, murder!

GAYLOVE: There; there lug him in. [*Exeunt*]

ACT IV, SCENE III

Enter BEAUMONT *and* GRASPALL.

BEAUMONT: Well, my kind solicitor, what hopes? Shall we enjoy our mistress or not? Here's the key, old Mammon, gives you admittance to your yellow beauties. Methinks thy looks foretell success, and say your wife gives ear to reason.

GRASPALL: Ah, Sir Harry, what pains have I taken!

BEAUMONT: But to what purpose, my old Plutus? What's the success? Is she still cruel? And must I send for the box?

GRASPALL: When the box goes, your suit ends, good Sir Harry. Ev'n Jove had been repulsed, if a good shower of gold had not introduced him. My reasons had, I hope, some effect, and I left her—

BEAUMONT: How, my dear Graspall?

GRASPALL: Like the sea after a storm; though the winds are laid, there yet remains some swell which must have time to settle. But the key, Sir Harry.

BEAUMONT: Nay, I must have some assurance that I don't part with such a sum for nothing. The minute your wife consents—

GRASPALL: Consents! 'Sbud, she had as good meet a hungry lion as pronounce the first letter of a denial. I'll have the letters N. O. struck out of the alphabet, except to poor rogues that come for money, and there self-preservation makes it lawful.

BEAUMONT: Farewell. [*Exit*]

GRASPALL: I'm in the house if you want help. Since I can't persuade him out of the key, I'll force the box; let him take the same method, if he pleases, with his mistress. Bless me! That Sir Harry, esteemed a man of wit, can part with such a sum for such a bauble as a woman! [*Exit*]

ACT IV, SCENE IV

Enter MRS. GRASPALL *and* BEAUMONT.

WIFE: And is it possible then, Sir Harry, that you can have joined

with my husband in an attempt at once so ridiculous and base? But though your gold has had this influence on his sordid nature, know I despise the man who dares believe 'twill bribe me out of my honor.

BEAUMONT: Far be it from me, madam, ever to have harboured such a thought; and as the proposal was made by your husband, 'tis he alone you should condemn.

WIFE: But you agreed to't.

BEAUMONT: If I had not, you might have believed I had thought so small a sum more valuable than your favour.

WIFE: You have taken a very wrong method to obtain it. But as for him, base, mean-spirited and sordid as he is, he is my husband still, nor will I wrong him, though by his own consent.

BEAUMONT: Can you have so much value for a man, who, tasteless of your charms and ignorant of the treasure he is master of, would barter it for trash? If no compassion for my sufferings would move you, methinks the injury he does you should prompt you to revenge.

WIFE: What you call revenging injuries is being accessory to 'em.

BEAUMONT: Your husband has transferred his right to me; and, if deaf to arguments, has giv'n me power to seize—

WIFE: Which if you dare attempt—

BEAUMONT: Be not frightened, madam; I never gave you cause to think I'd be a villain. Honor has always been the guide of my actions, and 'tis that now whispers me, no epithets so vile as that of ravisher.

WIFE: And does it not inform you too, you ought not to ask of me what honor forbids me to grant? You look confounded. Oh, Sir Harry! How forcible is truth, though ne'er so plainly uttered! Not all your learning, wit or artifice can form an answer in contradiction to this short demand.

BEAUMONT: Madam, I will not answer on this theme because I know that all the arguments I could bring would, to a woman of your temper, appear too weak to convince you that all those conversations which the world calls criminal are not also really dishonorable in themselves. Nay, I will own to you that I could

wish there were a possibility for me to love you less, unless my passion could appear in a more noble light.

WIFE: 'Tis generously confessed; but why will you then persist to urge a suit your reason does condemn?

BEAUMONT: Ah, lovely creature, you may as well ask madmen why they rave; but do not mistake me. When I say I wish I loved you less, 'tis not because my reason tells me 'tis a fault, but because it is not in my power to give you so convincing a proof as I would do of my sincere affection. The flame I feel for you is in itself so pure, I grieve it should appear in any likeness with those unconstant fires which base desires create. I tremble when I approach you, and though I'd forfeit life to touch that hand, so fearful am I to offend, I dare not ask it. Consider, madam, and justly weigh the difference between us. Did Toywell treat you thus?

WIFE: That wretch's impudence was owing to his folly. If I look into your designs, they are the same, and you, but with more art, would ruin me.

BEAUMONT: By Heav'n, I would not. Your reputation should be sacred and unblasted. The dear, the happy secret safe lodged within my soul should take no air nor let in the least room for a conjecture. Then for your fears, those little fears which all your sex are prone to, and which the inconstancy of ours too frequently gives cause for, I'd follow you, as now, with sighs and prayers, and ardent vows of everlasting passion.

WIFE: Then you'll allow that constancy's the only test of true affection.

BEAUMONT: Most sure it is, the only certain one.

WIFE: How am I then secure of yours till I have purchased the experiment at a rate too dear? I must resign my honor, my virtue and my peace of mind, before I can promise myself the least assurance I have not done all this for an ungrateful man.

BEAUMONT: There are a thousand marks by which you may distinguish which passions will be lasting, and which not, and if repeated vows and imprecations can have force—

WIFE: No, Sir Harry; I know with how much ease you men absolve yourselves the breach of vows in an affair of this nature. But, since you have confessed that constancy's the only proof of true affection, answer me: did you ne'er love before?

BEAUMONT: Suppose I did; if I hereafter shall love none but you, the former errors of my fancy may be forgiven.

WIFE: But tell me if you did and, I conjure you, speak with the same sincerity as you would answer Heaven.

BEAUMONT: [*Aside*] What can she mean? [*To* WIFE] Few men, madam, I believe, who have travelled so far as I have done, had such variety of conversations (some of which perhaps have not been over-nice) and seen such numbers of fine women, can boast an entire continency. I do not deny but I have met temptations in my way, which youth and inadvertency, at some unguarded hours, have yielded to.

WIFE: I speak not of those slight and transient passions, but of a flame which bore the show of honorable. Did you not—answer without equivocation—did you not, neglecting all the rest, never address one favourite fair?

BEAUMONT: [*Aside*] Ha! But whate'er she aims at, I scorn the baseness of a lie. [*To* WIFE] Yes, madam; I confess I once before, and ne'er but once, knew what it was to love. But why this question, and with such earnestness?

WIFE: You shall be told. Pray who was she?

BEAUMONT: She was a woman, madam, whose deserts might well excuse my passion; but why this enquiry?

WIFE: But one thing more, and you shall know. Since so beloved and so deserving, why are you disunited? Grew she unkind?

BEAUMONT: I am so confounded, I know not what to say. Oh Amadea! Now thy image rises to my view and brings my broken vows to my remembrance.

WIFE: What say you, sir? Did she prove false? Or is she dead?

BEAUMONT: Neither, madam—but, pray no more. This talk is foreign to the kind end your husband brought me for.

WIFE: Stand off, perfidious man! By your own mouth, you are

condemned; since, as yourself confess, constancy's the only proof of love and honor, how can you be justified by either? You own you loved where both desert and kindness joined to engage, yet, full of your sex's falsehood and ingratitude, that conquest gained, you offer to another your prostituted heart, and think a little idle flattery can win me to accept your violated faith.

BEAUMONT: [*Aside*] I have lost her by my plainness. [*To* WIFE] What you speak of, madam, happened a long time ago; we now are separated. Forgive what is past. Your beauty, as it justifies my change, will also be your own security for my future constancy.

WIFE: I'll hear no more—nor is it my business to judge either your past or present actions. Come forth, Amadea.

BEAUMONT: Amadea!

Enter AMADEA *in her own clothes.*

WIFE: If you can obtain a pardon here, mine will not be long withheld.

BEAUMONT: 'Tis she indeed!

AMADEA: Turn not away confused. I shall believe you never knew the force of love, if you can doubt my readiness to pardon. You wrong me more by this unkind delay to meet my stretched-out arms than e'er you did in your addresses there.

BEAUMONT: Can there be so much generosity in nature?

AMADEA: Come, Sir Harry, look on me, and as you just now said, forget what's past. By Heaven! Your future kindness will more than expiate all you have done, or would have done, to wrong me.

BEAUMONT: Excellent woman! May I then believe thee? Can it be possible that thou (who, I perceive, art well acquainted with my crime) can'st wish to pardon it, and again receive me to that soft breast, that lovely mansion of eternal truth?

AMADEA: I now am fully recompensed.

BEAUMONT: Thou prodigy of goodness! To find thou hast left London, thy father, friends, relations and acquaintance—to meet thee

here—here in this scene of guilty wishes, so strangely, so unexpected, fills me at once with shame, with joy and wonder.

AMADEA: Could London, my father's house, or the society of any friends, bring comfort to me when I saw not you? 'Twas enough to know that Beaumont was in Salisbury to wing the feet of Amadea hither. Besides, you may remember the news of your uncle's death took you away so suddenly, I scarce had time for one short adieu. You writ to me indeed, and made me hope a quick return; but in a little time (though I'm unwilling to mention past unkindnesses) you left off even that distant conversation. I writ and writ again, but had no answer. At first I thought my letters had miscarried, but long expectance at last grew weary, and I resolved to know the truth of what I then began to fear, and, to that end, left London in disguise.

BEAUMONT: In disguise!

AMADEA: I dressed me in a suit of my brother's clothes, which, happening to be out of town, he had left behind him, and came down here in the stage-coach. At the inn where I alighted I met Mr. Graspall, who, hearing me enquire for lodgings, made me an offer of a chamber in his house, where I have been ever since, and by that means had an opportunity of finding out that secret which now you are so good to acknowledge as a fault.

BEAUMONT: And ever shall. Nor will this lady think me unmannerly, when I declare I ought to have been blind to every charm but yours.

WIFE: Sir Harry, I rejoice in your conversion, and I hope you are too sincerely touched with a sense of your late errors to repeat 'em.

BEAUMONT: Oh never! This unexampled tenderness and generosity has charmed my very soul—nor will we ever be divided more, but as by solemn vows we have long since been one, my chaplain tomorrow shall ratify the contract.

WIFE: I heartily congratulate the happiness of you both. But, notwithstanding the real pleasure it gives me to see everything so well answer the end I proposed by this meeting, I cannot find

in my heart to forgive my husband's base design upon me, and have thought of a way to be revenged, if you'll vouchsafe me your assistance.

BEAUMONT: I dare answer you may command us both.

WIFE: This lady must put on her men's clothes once more.

AMADEA: Most willingly; they have been fortunate to me.

WIFE: Within I'll tell you my design. Please to walk—

BEAUMONT: We'll follow, madam.

> Ye false-named pleasures of my youth, farewell;
> They charmed my sense, but you subdue my soul.
> Though fixed to you alone, I've pow'r to change,
> While o'er each beauty of your form I range.
> Nor to those only need I be confined,
> But, changing still, enjoy the beauteous mind.

ACT V, SCENE I

Enter GRASPALL *and* WIFE.

WIFE: Nay, you won't be so ungrateful to deny me so small a request when I have broke through all objections to oblige you.

GRASPALL: I would deny thee nothing, Pudsy; but thou dost not consider what an inconvenience, as well as expense, this will be.

WIFE: Inconvenience! Where can be the inconvenience of having a few friends to be merry with you?

GRASPALL: A few! Why, thou hast named half the country, I think— but prithee, let me hear them over again.

WIFE: Why, in the first place, Sir Harry Beaumont. You won't grudge him a dinner out of his £2,000, sure?

GRASPALL: If he is not satisfied with the meal you have given him, he should e'en fast till Doomsday for me. But go on.

WIFE: Mr. Courtly. He is Sir Harry's intimate, and 'twill be rude to leave him out.

GRASPALL: Well! Who else?

WIFE: The Widow Stately. She is our next neighbour, you know, and must be invited.

GRASPALL: So—to the rest.

WIFE: Mr. Fairman, his niece and daughter, and their two lovers, Squire Sneaksby and Mr. Toywell; and, if you find any company at their house, as they seldom are without, they must be asked.

GRASPALL: Very well! And these you call a few, besides a retinue of servants at the heels of 'em, of more than twice double the number—a pack of romping, tearing, hungry hounds, that will eat me out of house and home, though I had laid in for a siege. 'Sdeath, how can you be so inconsiderate?

WIFE: Well, I'll never ask you anything again; but remember, that if ever you make any more bargains for me, your unkindness has given me a very good pretence to refuse making 'em good.

GRASPALL: Ha! Let me consider. [*Aside*] She'll be spiteful enough, that's certain, and who knows, but among these blades I may find a fool as willing to part with his money as Sir Harry? I have a good mind to let her have her will for once. [*To* WIFE] Well, Pudsy, suppose I should oblige thee in this, thou wilt never be refractory hereafter, wilt thou?

WIFE: Not when 'tis for your interest, Tony.

GRASPALL: I shall never ask anything of thee, Pudsy, that is not for the interest of us both.

WIFE: But since you have consented to have this company here today, 'tis time they were invited.

GRASPALL: Well, I'll go—but, Pudsy, dear Pudsy, prithee bate me the severity of one article.

WIFE: What's that?

GRASPALL: Give me leave to desire they would not bring their footmen with 'em.

WIFE: Fie! You would not make yourself so ridiculous.

GRASPALL: Well, for once—[*Going*]

WIFE: Stay, Tony! I protest I had like to have been guilty of a piece of ill manners I should never have forgiven myself.

GRASPALL: What now?

WIFE: I am told there's a baronet lately come down, I can't think of his name, but he's at the Widow Stately's. You must be sure to entreat the favour of his good company.

GRASPALL: The devil!

WIFE: You must not omit him by any means.

GRASPALL: No, no. Was ever man thus plagued?

WIFE: Well, go about it then, while I prepare for their reception. Be sure not to forget.

GRASPALL: No, no, no. [*Aside*] If I stay much longer, she'll remember as many more. [*Exit*]

WIFE: I'll fit you for your bargain, sir. [*Exit*]

ACT V, SCENE II

Enter GAYLOVE *and* CELEMENA.

CELEMENA: 'Tis now no time for dissimulation, Captain; I freely own nothing is so terrible to me as the thoughts of being Sneaksby's wife. Therefore, if in earnest you can find any way to disappoint my father in his design of marrying me to that idiot, I give you leave to hope I may one day have the opinion of you, you wish.

GAYLOVE: That is not sufficient, madam; I must have an immediate security for your performance of articles before I undertake anything.

CELEMENA: Why, I hope you have not seriously the confidence to think of gaining me so soon. Do you think it reasonable that a woman who believes herself in some measure agreeable should lose the pleasure of seeing her lover tremble at her approach, and by his sighs and melancholy betray the passion he has for her to all who know him? Admire all she says, and cry up all she does, and threaten to poison, stab, or drown himself to pacify her, whenever she happens to be in the humor of giving pain?

GAYLOVE: But, madam, I believe Squire Sneaksby never read romances and will perhaps think it an unreasonable request, should you desire him either to poison, stab, or drown himself. Therefore, madam, since all these preludiums, one way or other, must

be cut off, you had e'en as good venture on me, and imagine that, if there was time for it, I would willingly come into all these methods to obtain you.

CELEMENA: But do you consider what you ask? Though my father proffers Sneaksby £10,000 to take his daughter off his hands, I question whether he may be in the same humor when Gaylove has me.

GAYLOVE: It is you, not your fortune, that I am ambitious of. My commission will keep us from want, if your father gives you nothing; and when mine dies, his estate, for the greater part, is entailed on me; and, without being romantic, I shall think it but a poor purchase for my Celemena.

CELEMENA: Well, let me consider. [*Aside*] Here's a coach and six with my father's commands, and £10,000 to back it. On the other hand, 16s. a day and the title of a Captain's lady, with a reasonable suspicion of being turned out of doors with never a groat. But then, on this side, I've a fool; on that, a man not disagreeable, and of allowed sense. One marries me upon compact, the other generously runs the risk of a fortune. [*To* GAYLOVE] Well, Gaylove, I think you carry the day; I'll lay aside the woman for once. Here's my hand.

GAYLOVE: My future carriage shall show my gratitude for the blessing, and—

CELEMENA: Come, no raptures. You are a man of honor, and I expect you'll keep your promise. I can't bear this coxcomb's impertinence; prithee, banter him a little, while I retire to think on what I've done. [*Exit*]

Enter TOYWELL.

TOYWELL: Oh Captain Gaylove! Are you here? You have served me finely!

GAYLOVE: As how, good sir?

TOYWELL: Why, did not you tell me that Mr. Trusty the banker was broke? And I saw a letter from him just now which says he's in as good a condition as ever.

GAYLOVE: Is he so? Faith, I'm glad on't.

TOYWELL: Oh, but you have ruined me! I have lost Marilla by it.

GAYLOVE: Why, what's Marilla to Trusty?

TOYWELL: Why, he has her fortune in his hands—and if he had failed, she had been no wife for me. So, upon what you have told me, I broke off, and released her from all ties.

GAYLOVE: Why 'tis none of my fault. Did I advise you to't?

TOYWELL: No; for that matter, 'twas all my own doing. But I'll go and throw myself at her feet, and if she has any compassion—

GAYLOVE: You may spare yourself the pains, for to my certain knowledge, there's a terrible ill-natured fellow, with a sword like a scythe, pretends a right to her—[*Sings*] With whom you cannot grapple,

For at one sup,

He'd eat you up,

As boys do eat an apple.

TOYWELL: Gad's curse! So I am to lose my mistress for an old song?

GAYLOVE: His name is Courtly; do you know such a man?

TOYWELL: Courtly! Faugh, I've a better estate than he has.

GAYLOVE: But he understands a sword better than you do. Come, take my advice, and be merry, and when you see Courtly, wish him joy with an air of indifference, for they are, by this time, married. Seem pleased with what you can't help, for, to my knowledge, you'll get little by resentment.

TOYWELL: Psha! I don't care this pinch of snuff, and since she's gone—let her go.

GAYLOVE: Aye, this becomes you; it shows you are a man above disappointment. But here they come. Now let me see you bear your misfortunes like a man untouched by 'em.

TOYWELL: You shall see me accost her with the unconcern of a tired keeper.

Enter COURTLY, CELEMENA *and* MARILLA.

MARILLA: Your importunity, Mr. Courtly, incenses me as much as

Mr. Toywell's indifference; and if you think to tease me into a compliance, you shall find yourself deceived.

GAYLOVE: How's this?

TOYWELL: Ha! I find things are not so bad as I thought.

COURTLY: Heaven is not displeased with prayers and adorations. 'Tis with the most awful distance I pursue you, the tenderest passion and sincerest vows.

MARILLA: Perhaps I'm fixed never to marry, and, if so, shall no more endeavour to force my inclinations than you to govern yours.

TOYWELL: Oh! Madam, can you forgive my rashness, occasioned by the violence of my passion, for a belief I was not so well in your esteem as I desired to be?

GAYLOVE: What a devil! Have you a mind to have your throat cut?

MARILLA: Oh! Mr. Toywell, do you repent? Then I'll soon put an end to Mr. Courtly's importunities.

TOYWELL: Ah, madam! How shall I requite your goodness?

MARILLA: Hold, sir! Thank me when I deserve it. Mr. Courtly, you have given me daily uneasiness, haunting me from place to place, scarce leaving me a moment, and endeavouring by your constancy to merit me; answer me, guilty or not?

COURTLY: Guilty, madam.

MARILLA: You, Mr. Toywell, on the contrary—

TOYWELL: Aye, madam?

MARILLA: Always shunned the places I frequented, never discovered your passion by either words or actions, or hoped by assiduity to gain me.

TOYWELL: Not I, madam, upon my soul. I carried myself so, that no man on earth would ever have thought I had valued you in the least, not I. I had more sense. Poor Courtly, how he looks! He's finely fobbed.

GAYLOVE: What will this come to?

MARILLA: Know then, that I resolve to give myself to him who most deserves me.

GAYLOVE: That's easily distinguished, madam—

TOYWELL: Aye, Captain, so 'tis. Faith, I pity Courtly, but the lady must follow her inclinations, ha, ha, ha!

GAYLOVE: 'Sdeath, leave your impertinence! Prithee, how came you and I so familiar?

TOYWELL: Lord, you are as crusty as a sickly miser to a depending heir. Come, madam, I want that poor gentleman should be put out of suspense.

COURTLY: Sir!

MARILLA: Nay, no quarrelling. Mr. Courtly, from this time forwards, I desire you will lay aside all hopes and fears, for I now discharge you as my servant.

CELEMENA: Why, cousin, are you mad?

MARILLA: Have patience. I give you now my hand, with it my heart, and make you now my master.

COURTLY: Health to the sick is not more welcome; I receive you as the greatest blessing Heaven had in store.

TOYWELL: Fire and brimstone!

GAYLOVE: You are out of suspense now, sir.

CELEMENA: Joy to you, Marilla, I'll be bound you've made a worthy choice, and done justice.

GAYLOVE: I wanted but this to make me completely happy.

TOYWELL: Sure, madam, you are not in earnest?

GAYLOVE: You are only fobbed, sir.

Enter FAIRMAN, *dragging in* SNEAKSBY.

FAIRMAN: An impudent villain! To make a brothel of my house!

SNEAKSBY: How did I know 'twas your house, when I was so drunk, I did not know myself? Beside, you need not make such a to-do about it; I did no harm as I know of.

GAYLOVE: What's the matter, sir, that your intended son-in-law is in this condition?

FAIRMAN: No, no, Captain, I'll have no such drunken, lewd wretches in my family. Sending just now to look for him, to know what was the reason his aunt did not come to seal the writings, where do you think he was found, but in the cockloft,

where it seems he had lain all night with the wench that feeds the poultry?

CELEMENA: A blessed husband you had chose for me truly, sir!

FAIRMAN: I was wrong indeed, in believing thou could'st be happy with such an idiot—and rejoice I have made this discovery before it was too late!

SNEAKSBY: Marry, what care I? I can have a wife, I warrant you; but aunt shall know how you have used me—mayhap she may tell you your own.

GAYLOVE: Here's another fobbed too. Come, cheer up, man, you see you have a companion in tribulation.

FAIRMAN: Pray leave my house, and tell your aunt there's no occasion for the writings now.

GAYLOVE: I believe you may spare yourself that trouble, sir, for I expect her here every moment with her new husband.

FAIRMAN: Husband! Why, is she married?

GAYLOVE: Yes, faith, and to one who, I'll engage, will take care not a foot of her estate shall descend to this gentleman.

FAIRMAN: I'm glad on't, though this news yesterday would have been a very great disappointment to me.

Enter GRASPALL.

Ha! Who have we here? A stranger indeed! Mr. Graspall!

GRASPALL: Aye, truly, Mr. Fairman, I don't often visit, but my Pudsy has taken a fancy to be mighty merry today, and I love to humor her. So, if you, your niece and daughter, and all this good company, will take a dinner with her, ye shall have a hearty welcome. As for the rest of her entertainment, let her answer. I never trouble myself with those things.

FAIRMAN: Miracles are not ceased, I find!

GRASPALL: What say you, sir, will you do us the favour? [*Aside*] I hope he is engaged.

FAIRMAN: Sir, 'tis a favour you so seldom ask that I believe nobody will refuse it you. Gentlemen, Captain, you hear the invitation—can you go?

COURTLY: Oh, by all means, sir.

GAYLOVE: I'll wait upon you, sir.

TOYWELL: Am I in the number of your guests, sir?

GRASPALL: Aye, aye, all of you, if there were a hundred. I shall expect you soon. Your servant, [*Aside*] and I wish the first dish may choke you. [*Exit*]

FAIRMAN: There must be something extraordinary has happened to occasion this fit of generosity—let us go.

If that which is most rare is counted best,

We cannot want it in a miser's feast. [*Exeunt*]

ACT V, SCENE III

Enter BEAUMONT *and* GRASPALL.

BEAUMONT: Aye, now I like you, Mr. Graspall; this is done like a man who knows how to use his fortune. I look on hospitality to be the most pleasurable of any virtue, and when you have once tried it, I don't doubt but the whole country will very often find the effects of it.

GRASPALL: You'll find yourself exceedingly out in your politics, if you do think so, that I can tell you.

BEAUMONT: Once or twice a week at least, I suppose, one may expect to find good company here.

GRASPALL: [*Aside*] 'Sdeath! He wants to take out his £2,000 in board, I believe. [*To* BEAUMONT] As often as I can, Sir Harry, but alas! I am infirm and crazy—very crazy—and sometimes can't bear the sight of a fire, or the smell of dressing meat for a quarter of a year together.

BEAUMONT: Poor man! But you need not incommode yourself with that. A cold collation with three or four dozen of Champagne and Burgundy will serve well enough. Your friends will excuse the rest on account of your indisposition.

GRASPALL: [*Aside*] They shall when I give it 'em. [*To* BEAUMONT] But, Sir Harry, I can't endure a noise.

BEAUMONT: As for that, you have a large house here, and may easily

retire into some remote part of it, where you won't be disturbed. Your guests will be contented to spare you, provided you leave your wife and the fiddles to entertain 'em.

GRASPALL: That would be fine indeed. [*Aside*] 'Sbud! I'll sell my house and live in Wales among the mountains where nobody will attempt to come near me for fear of breaking their necks.

BEAUMONT: I think you look ill now; I am afraid you won't be able to let us have your company today. If you find yourself out of order, pray don't hazard growing worse by an over-complaisance. I'll answer for it, nobody will take it ill if you shut up yourself all day.

GRASPALL: [*Aside*] The devil I will. [*To* BEAUMONT] No, no, Sir Harry, I am mighty well, mighty well as can be, and so all my good friends shall find. Here they come.

Enter GAYLOVE, COURTLY, TOYWELL, FAIRMAN, MARILLA, *and* CELEMENA.

You are welcome, sirs, heartily welcome all.

FAIRMAN: Sir, we thank you.

COURTLY: We are all obliged to you. Sir Harry, your most humble servant.

BEAUMONT: Yours, sir. Ladies, yours—but where's your wife, Mr. Graspall? Your fair visitors will think themselves unwelcome while she is absent.

GRASPALL: I'll go and see for her.

BEAUMONT: I'll save you the trouble, if you please, sir; you know I am free here. [*Exit*]

GRASPALL: [*Aside*] Aye, and so should they all be on the same conditions.—Come, gentlemen, Mrs. Celemena, Mrs. Marilla, pray sit down. You'll excuse me, I don't love much ceremony, but pray be merry.

FAIRMAN: Wine, sir, gives a life to conversation; after dinner, when the cheerful glass goes round, you may expect we shall be heartily merry.

WIFE: [*Within*] Murder! Murder!

FAIRMAN: Ha! What's this?

COURTLY: Murder cried!

FAIRMAN: Your wife's voice.

> *Enter* BEAUMONT *and* AMADEA *fighting,* MRS. GRASPALL *following.*

BEAUMONT: Villain! To abuse so worthy a man! But from my arm thou shalt receive the just reward of thy treachery.

AMADEA: I fear you not.

WIFE: Part 'em, part 'em.

COURTLY: What's the matter, Sir Harry?

BEAUMONT: Base villain! And thou, ungrateful woman!

WIFE: Oh! Sir Harry, you will not be so barbarous to expose me?

GRASPALL: Why? What's the meaning of all this?

BEAUMONT: Not expose you, madam! Yes, to the whole world—you that could wrong so kind, so tender a husband.

GRASPALL: Ha! How's this?

BEAUMONT: So good, so true a friend, so worthy a man, and one so infinitely fond of you, shall receive no pity, no regard from me. You must know, gentlemen, that going to seek this lady, for whom till now I had the greatest respect, I found her in the embraces of that young gallant. They started when they saw me, and, though my sword was in a moment ready to revenge my injured friend, his was not tardy in defence. But though you have prevented me at present, I shall find a time to make the villain smart.

COURTLY: I'm amazed.

FAIRMAN: She that was esteemed so virtuous!

TOYWELL: They are all so till caught.

GRASPALL: And hast thou done this? Hast thou made a cuckold of thy old hubby? Ah, cockatrice!

WIFE: I see surprise in every face, and know my reputation has been hitherto so fair, that I believe some here scarce credit what they hear, but I disdain to be a hypocrite nor will deny the truth. This lovely youth, this darling of my soul, has indeed received whatever favours he could entreat or love prompt me to grant.

CELEMENA: Monstrous impudence!

MARILLA: I never heard the like.

GRASPALL: And do you own it then? Have you no shame?

WIFE: You taught me to despise all sense of shame when, laughing at that notion which the world calls virtue, you forced me—contrary to my nature, to my inclinations, to the principles my youth was bred to observe—to yield myself a prey to your insatiate avarice and his base desires.

FAIRMAN: How!

WIFE: Did you not sell me? Let me out to hire, and forced my trembling virtue to obey? Did I not kneel and weep and beg? But you had received the price you set me at, and I must yield or be turned out a beggar.

FAIRMAN: What! Let his wife for hire!

COURTLY: Agree for money to his own dishonor!

TOYWELL: Egad, if I had known that, I'd have been a customer. Prithee, what dost thou demand, old Lucre? Ha?

GRASPALL: Fop! Fool! Oh that I were dead!

WIFE: Since you have taught me, I'll now experience that charm mankind's so fond of: variety; I'll give a loose to each unbounded appetite, range though all degrees of men, nor shall you dare to contradict my pleasures.

GRASPALL: Pray kill me! Will nobody kill me?

GAYLOVE: Why truly, sir, as the case stands, I think 'tis the greatest kindness can be done you.

WIFE: But do not imagine you shall ever reap any advantage from my crimes. I have broke open your closet, and the £2,000 Sir Harry paid you for seducing me I have bestowed on this dear man.

GRASPALL: Oh! Oh! The money gone too!

WIFE: You shall find what 'tis to have a vicious wife. Do you not now repent what you have done, and wish I could resume my virtue, though it should cost you twice as much as you received for my renouncing it?

GRASPALL: I do indeed, I see my error now 'tis too late. Oh damned, damned avarice!

WIFE: You would not tempt me then, were it again to do?

GRASPALL: No.

WIFE: Not for the greatest consideration?

GRASPALL: Not for the universe! But do not plague me, I shall not live to endure it long.

WIFE: Stay, sir, your sorrow moves me; if I may believe your penitence sincere, I can return to your embraces a true, a faithful and a virtuous wife.

GRASPALL: What new invention to distract me more?

BEAUMONT: She tells you truth by Heaven. That seeming gentleman with whom I fought, and who you think has injured you, has not the power. Appear, my love, without disguise. See, sir, a woman and my wife.

ALL: How!

GAYLOVE: Amadea!

AMADEA: The same, dear cousin, much happier than when you saw me last, by the addition of Sir Harry's love confirmed.

GAYLOVE: I wish you joy.

GRASPALL: May I believe my eyes?

BEAUMONT: They do not deceive you, sir. This plot was laid on purpose to cure you, if 'twas possible, of that covetous, sordid disposition which has ever been the blot of your character, and a little also to revenge the contempt you seemed to have of so good a wife when you were willing to chaffer her for gold.

COURTLY: 'Twas handsomely contrived.

CELEMENA: I am glad to find she has brought herself off, for I protest I trembled for her two minutes ago.

BEAUMONT: Come, sir, if you have any consideration of honor and the eternal infamy and disgrace she has preserved you from, you will admire her virtues and entreat her pardon.

GRASPALL: Pudsy, dear Pudsy, can'st thou forgive me?

WIFE: Rise, sir, this is not a posture for a husband. I formed this design only to make you worthy of that name, and shall ever make it my study to prove myself a most obedient wife.

FAIRMAN: This is a happy conclusion indeed; but here's more company, Mr. Graspall.

Enter WIDOW, DOGOOD *and* SHAMBLE.

WIDOW: Your servant, gentlemen, your servant, ladies; I beg pardon

for my long absence—but, but—a—I could not rise today, I think.

GAYLOVE: Sir Tristram played his part then pretty well last night, I find.

FAIRMAN: Joy, madam, you have stole a wedding, I hear.

WIDOW: People of quality never talk of these affairs till they are accomplished, Mr. Fairman. Sir Tristram here was so pressing.

COURTLY: [*Aside*] And your ladyship so easy.

GRASPALL: Sir Tristram! Why, are you all mad? Why, this is Jonathan Shamble! Sure I know Jonathan Shamble; he was footman to a nephew of mine about four or five years ago, when I was last in London.

ALL: Ha, ha, ha! A footman!

GAYLOVE: Well, well, Mr. Graspall, he's a man of an estate now, and 'twill be unmannerly to rip up pedigrees.

WIDOW: I am not cheated, sure—what's the meaning of all this?

SHAMBLE: Why, faith, my dear wife, since the truth must out, I only borrowed my quality to make myself agreeable to you—

WIDOW: Villain! Rogue! I'll tear you to pieces.

SHAMBLE: Hold, hold, good Lady Passion, have mercy on my clothes, for they are none of my own.

GAYLOVE: Patience, madam, patience! Boxing does not become a woman of quality.

WIDOW: A footman! A footman! But I'll have him hanged, he's a cheat, he has married me in a false name; but you shan't think to carry it so. I was not born yesterday; I'll go to a lawyer immediately.

GAYLOVE: Hark ye, hark ye, madam, your anger will do you but little service. He has wedded you, bedded you and got your writings, and if you consider calmly on the matter, you'll find nothing can be done in this affair for your satisfaction. You had better therefore quietly forgive the imposition, and, as you have a good estate, turn part of it into ready money and e'en buy him a title. Such things are done every day in London, and when once you have made a gentleman of him, everybody won't know by what means he came to be one.

WIDOW: Why, that's true, indeed.

GAYLOVE: You'll find it your best way.

WIDOW: Well, since there's no help, I'll sell all I have and away to London.

GAYLOVE: You may be happy enough. I dare swear he'll make you a good husband.

WIDOW: That's all I have to hope.

GAYLOVE: Well, I think I have been very busy in endeavouring to settle the happiness of others. 'Tis high time now to consider my own, which lies only in your power, sir, to bestow.

FAIRMAN: Sir, Mr. Courtly has just now acquainted me with the kindness you have for my daughter. I know your father, and I approve of your character. Therefore, if she is of the same opinion (for I will never go about to force her inclinations more), she is yours, with the same fortune I designed to give the squire. What say you, Celemena?

CELEMENA: I should have endeavoured to obey you, sir, ev'n where my nature was most reluctant, but in this, I confess, you've chosen with my eyes.

FAIRMAN: Why, then bless you both. I think poor Mr. Toywell is the only unhappy man among us.

TOYWELL: Faith, sir, I am positively easy: I'll e'en trip to Bath this season, and I don't doubt but I shall there find an opportunity with some kind damsel to repay my loss in Marilla.

BEAUMONT: How simply politic is foolish man!
How poor, how vain, our deepest laid designs,
To the all-seeing eye of Providence!
Like those weak webs by Aesop's spider wrought,
To stop the swift-winged swallow in her flight,
Who, with contempt surveys her fruitless pains,
Her folly pities, and her rage disdains,
Baffles her wiles, breaks through the tender snare,
And, uncontrolled, divides the yielding air.

EPILOGUE

Spoken by the author.
We women, who by nature love to tease ye,
Will have it that the newest things best please ye;
Sure then, tonight, our Graspall claims compassion,
For ne'er, since bridal antlers were in fashion,
Heard ye of one who, to a beauty married,
Would fain have been a cuckold, and miscarried.
This man's of novelty, a proof most ample!
Had ye but grace to copy out th'example;
Each well complied with by his kinder fair one,
Would own that Graspall's fate's a new and rare one.
Well, we have shown ye av'rice to the life:
A rich old miser, melting down his wife,
Not into soft desires, and amorous puling,
He—sober thinker!—was for no such fooling.
Though many a sparkling jewel graced his honey,
He thought no gem about her worth that money;
Two thousand pounds, he judged, would soften satyr,
And weight against the heavy'st horns in nature.
Strange bargain! But, since husband wished to strike it,
What whim could work with madam—not to like it!
'Twas this: she shunned, when 'twas her husband's tasking,
What her own bounty would have given for asking.
Women, however stirring in their way,
Are ne'er too active when they move t'obey;
They rather would (if I can understand 'em)
Not *do* at all than *do* as *spouse* commands 'em.
But to be grave. The heroine of our play
Gains glory by a hard and dangerous way.
Beloved, her lover pleads; she fears no spy,
Her husband favours, and her pulse beats high.
Warm glows his hope; her wishes catch the fire,
Mutual their flame, yet virtue quells desire.
Safe th'untempted may defy love's call;

Eliza Haywood

Why should the unencountered fear to fall?
Virtue must pass through fire to prove its weight,
And equal danger make the triumph great.

<div align="center">FINIS</div>

Notes on *A Wife To Be Let*

PROLOGUE

Prudes and cullies—See note on "prudery" in *A Bold Stroke for a Wife*. A cully is a dupe or a simpleton.

Her known novels—By this time, Haywood's "known novels" included *Love in Excess* (1719), a translation of *Ten Letters from a Young Lady of Quality* (1720) by Edme Bursault and *The British Recluse* (1722).

Sway—Rule.

ACT I

Set Hymen at defiance—To defy (the god of) matrimony.

Encomium—A eulogy, a form of high praise.

Complaisance—Deference, easy-going courtesy.

A certain equipage of people called duns—i.e. creditors, so persistent in their pursuit of Gaylove that they resemble a retinue ("equipage").

Cf. *The Witlings*, in which the insensitive Mrs. Wheedle duns the hypersensitive Cecilia in Act 5.

Selling my Company in the Guards—It is an officer's commission that is sold here, not the Company itself.

Bears the bell—Wins first prize.

Squire Sancho and *Don Quixote*—Dogood is comparing Shamble and his master to the rustic servant and the chivalrously delusional knight of Cervantes's masterpiece, *Don Quixote* (1605 and 1615).

Mercer—Cloth-merchant.

I would be revenged even in the way he fears—That is, by cuckolding him.

As the inimitable Otway says, "Who can behold such beauty, and be silent?"—This appears to be more Toywell than Otway.

Gad, I am mighty florid today.—In *The Country Wife* (1675) by Wycherley, an equally "impudent" and "intolerable" fop, Sparkish, makes a similar boast: "Gad, I am witty, I think, considering I was married today."

Seven years' possession—Toywell imagines a married man's indifference to take the same period as Celemena demands of a loyal admirer in the next scene. With repetition, the number becomes shorthand for a considerable or necessary period.

Capitulate—Another military term.

ACT II SCENE I

Forbid the banns—Banns are the declaration of a forthcoming marriage, read in church on three Sundays.

Echo—Echo was cursed by Juno to speak only "mimic sounds," and pined away for love of the vain Narcissus: "She can't begin, but waits for the rebound, / To catch his voice, and to return the sound"

(Addison's 1717 translation of Book 3 of Ovid's *Metamorphosis*). Gaylove and Celemena are bantering in the high-flown style of pastoral romance, hence "The bark of every tree carved with the cruel Celemena's name."

Let me blood—Another echo of a well-known stage fop: Cibber's Sir Novelty Fashion, a.k.a. Lord Foppington, is given to crying out "Stap me vitals!"

Mr. Trusty, a banker in Lombard Street—As in *A Bold Stroke for a Wife* and *The Witlings*, this is news that plays on the fear of financial disaster emanating from the City, Lombard Street being at its heart.

ACT III, SCENE I

Sir Tristram Shamtown—A dashingly cod-Irish name, with an element of Shamble's own "Sham" suggesting trickery, like "Fainwell."

The fare of Tantalus—That is, tormented with the proximity and the image of something desirable. Tantalus was a king of Phrygia condemned to stand in water that receded whenever he tried to drink it, and beneath branches that withdrew whenever he tried to pick their fruit.

ACT III, SCENE III

None look so proud and scornful as your new-made gentry—Shamble may be thinking specifically of those who bought their titles rather than inheriting them; he was only gentrified two scenes earlier.

Man of his quality—The widow, true to Dogood's description of her, is transfixed by Sir Tristram's rank, his "quality," rather than quality in a modern sense.

This blockhead is used to nothing but the vulgar—Cf. Mr. Hardcastle's "awkward" country servants in *She Stoops To Conquer*, and the Widow Headless's "blundering rascals" in *The Artifice* by Centlivre, who "come trotting up to my nose, with a 'Dud you want me, forsooth?'"

Dishabille—The widow claims she has been caught unawares in her informal dress.

Ortelans—A small European bunting regarded at the time as something of a gastronomic delicacy.

ACT III, SCENE IV

Degagé—Unconcerned or relaxed, used here ironically.

An—If.

Lief—Willingly or gladly.

ACT III, SCENE V

Harangue—A remonstrative address.

Primum mobile—Literally, "first mover"; in Ptolemaic astronomy, the outermost sphere in the galaxy, exerting a primary influence over the others.

Under covert-baron—Married.

Furbishing—Polishing or cleaning up.

A little trifling trash—Sir Harry shares her low opinion of the bargain that he enters into, referring to her husband's love of "trash" in Act 4, scene 4.

His wife, if vows can make me so.—Amadea is as conscientious about her vows as Toywell is not. Together, they anticipate the disparity of views that dictates the action of *Lovers' Vows*.

ACT IV, SCENE I

Board-wages and laced liveries—The wages for food and uniform clothes allowed to servants. Shamble's burlesque of grand passion also touches on the language of pastoral romance lightly deployed in Act 2, scene 1, between Gaylove and Celemena.

ACT IV, SCENE II

Mead, cider and metheglin—Old-fashioned, unsophisticated and alcoholic drinks. Mead was made with fermented honey and water, and metheglin was spiced mead.

Put—Cf. the "country put," or bumpkin, in *A Bold Stroke for a Wife*, Act 4, scene 2.

These two coxcombs might afford some diversion if we had time to work 'em to any pitch.—Reminiscent of *Twelfth Night*, in which Sir Andrew Aguecheek and Viola, disguised as Cesario, are maneuvered into a cowards' duel. The notion also recalls an early Centlivre play, *The Beau's Duel* (1702).

Sconce—Head.

Se defendendo—Able to defend himself.

ACT IV, SCENE III

Mammon and *Plutus*—Both proverbial names for a covetous person. Sir Harry also calls Graspall "Old Lucre," in Act 5, scene 3.

Ev'n Jove had been repulsed, if a good shower of gold had not introduced him.—See note to the Epilogue of *A Bold Stroke for a Wife*.

ACT IV, SCENE IV

Imprecations—pleas.

ACT V, SCENE I

Fit—Be revenged on.

ACT V, SCENE II

Performance of articles—Gaylove's phrase for the wedding vows has a military ring and a bawdy undertone.

Upon compact—Obliged by pre-agreement.

Fobbed—Cheated, deceived.

ACT V, SCENE III

Alas! I am infirm and crazy—Cf. the feigned madness that fails Doricourt in Act 5 of *The Belle's Stratagem*.

Cockatrice—Originally the name of a mythical and dangerous reptile, the word was figuratively applied to a prostitute or whore.

Those weak webs by Aesop's spider wrought,/ To stop the swift-winged swallow in her flight—In *The Fables of Aesop* (1673–5) by John Ogilby, there is an illustration by Wenceslaus Hollar of a swallow trailing a spider on a thread as it flies.

EPILOGUE

Bridal antlers—As a cuckold, Graspall has horns.

Fanny Burney:
(1752–1840)

At least one biographer does not mourn the loss of the novel Fanny Burney might have written while she was otherwise occupied in the role of Second Keeper of the Robes to Queen Charlotte from 1786 to 1791. "On the other hand," says Hester Davenport in *Faithful Handmaid: Fanny Burney at the Court of King George III*,

> had Fanny turned to writing comedies in those years (as opposed to therapeutic tragedies) then, with her ear for dialogue and using her talent for creating distinctive character-types, she might have established herself as the leading woman dramatist of the eighteenth century.... if Fanny had begun to write such comedies in the late 1780s, and these had been the apprentice pieces from which she learned stagecraft, then her seclusion at court must be seen as a loss. It is, however, a very big *if*.

Unfortunately for English drama, Fanny's father, the musicologist and composer Charles Burney, saw the royal appointment as a great honor and a coup for the family. He and Samuel Crisp had already

suppressed one play of hers, *The Witlings* (see Introduction), with a "hissing, groaning, catcalling epistle." (Fanny suspected Crisp of persuading her father, who was "ever easy to be worked upon," against her.) Perhaps this was for the best. Contrary to Davenport, Kate Chisholm judges in *Fanny Burney: Her Life* that "none of these plays shows Fanny at her best, and it would be difficult to argue that, if she had been allowed to stage them, she would have established herself as a dramatist." Thomas Macaulay had thought much the same, and approved Crisp's intervention in his *Edinburgh Review* essay about her in 1843.

In spite of the repeated encouragement of theatrical and literary folk, only one of Burney's plays was staged in her lifetime, and carelessly at that. (There was also the slim consolation of an epilogue written for a friend, the actress Jane Barsanti, and spoken in Dublin in 1777.) After *The Witlings*, she submitted both a comedy (*Love and Fashion*) and a tragedy (*Hubert de Vere*) for production in London. The latter was withdrawn, however, and replaced with another blank-verse tragedy, *Edwy and Elgiva*, which lasted a single night at Drury Lane in 1795. Burney had been unable to revise the play, "an almost spontaneous work," which went into rehearsal after the birth of her son Alex in December 1794 and the severe fever she subsequently suffered. And although Fanny, her brother Charles who acted as go-between, and the actors were all aware of the play's defects, nobody warned her to rewrite it. Dr. Burney had also read it with indifference. Predictably, the play sunk under the humiliating weight of its "leaden lines" (as Davenport calls them) and the actors' failure to learn them. Writing novels would certainly be easier than writing plays while Burney was, in Chisholm's words, "tied to her son." Yet Burney continued to write plays including *A Busy Day, or, An Arrival from India* and *The Woman-Hater* until at least the turn of the century.

Burney was born in King's Lynn in Norfolk in 1752, and her family moved to a house in Poland Street, London, when she was eight. Her mother, Esther Sleepe Burney, died soon after, and, not much later, Crisp became a regular and familiar figure in the household (David Garrick, too, was a close friend of her father and Fanny's idol). The family was further enlarged by the remarriage of Dr. Burney

in 1767 to Elizabeth Allen, with whom Fanny would have a difficult relationship. In the same year, she made a bonfire of her childhood writings, including plays and a novel, *The History of Caroline Eve-lyn*—she had learned to read late, but made up for it quickly—and began to keep a diary. Ten years later, her first novel, *Evelina*, was an acclaimed sensation, and she was initiated into London literary life, not least through the protective Johnson and Thrale. It was at this point that she met Mrs. Elizabeth Montagu, the possible inspiration for Lady Smatter in *The Witlings*.

The 1780s brought difficulties other than the royal appointment. Those "therapeutic tragedies" followed the deaths of Johnson (1784) and Crisp (1783), and the remarriage of another close acquaintance, Hester Thrale, to Gabriel Piozzi, an event that led Burney to end their acquaintance. After a long illness, she retired from the Queen's service with an annual pension of £100. The second half of her life was no less eventful than the first, but it took place under very different circumstances. As a writer, she moved from the youthful vigor of *Evelina* to the poorly received convolutions of *The Wanderer*, and the somewhat didactic, pompous style of the *Brief Reflections relative to the Emigrant French Clergy.*

This publication, her first in eleven years, appeared in 1793, the year when, at the age of forty-one, she married Alexandre d'Arblay, an Adjutant-General in exile from revolutionary France. Their son Alex was born the following year. Struggling for money, the family moved out of London and subsequently to Paris, where d'Arblay had his military career and family estate to pursue. It was in Paris in 1811 that Fanny underwent the tortuous ordeal of a mastectomy without anaesthetic. She was in Brussels during the Battle of Waterloo in 1815, highly aware that her own fate depended on that of the *"tiny Tiger,"* Napoleon. After that, she returned to England for good, settling in Bath with d'Arblay and returning to London after his death. She outlived her sisters and Hester Piozzi (with whom she was reconciled in 1817), as well as her son. Her final publication was the *Memoirs of Doctor Burney*, which appeared in 1832, when she was seventy-nine years old. When she died in 1840, she was buried in Bath with her husband and son.

Unlike Susannah Centlivre and Eliza Haywood, Burney herself offers ample evidence for her everyday life and state of mind. The many references to her false-starting career as a playwright in her diaries and letters offer more room in which to maneuver "big if" speculations than all the references to the composition, publication and reception of her novels combined. On these increasingly bulky novels, however—*Evelina* (1778), *Cecilia* (1782), *Camilla* (1796) and *The Wanderer* (1814)—rested Burney's contemporary fame and some vital financial gain. During the nineteenth century, it was her voluminous and often colorful journals and letters that earned most attention. They tell us much about life at the court of a (temporarily) mad king, George III, about luminaries such as Garrick, Johnson, Sheridan, Sir Joshua Reynolds and Mrs. Thrale, and about a bustling middle-class family home in the late eighteenth century. For these reasons, not to mention the impression that they convey of Burney consciously playing (herself) to imaginary galleries, these autobiographical writings are central to her oeuvre. They have been reprinted several times to varying degrees of completeness. Her plays were meanwhile ignored. Modern readings, productions (notably of *A Busy Day* in Bristol in the 1990s and London's West End in 2000, directed by Jonathan Church) and fresh critical attention (Barbara Darby's *Frances Burney, Dramatist*, for one good example) have shown this to be an egregious oversight.

The Witlings

DRAMATIS PERSONAE

MEN

BEAUFORT	
CENSOR	
DABLER	
JACK	*half-brother to* BEAUFORT
CODGER	*father to* JACK, *and father-in-law to* BEAUFORT
BOB	*son to* MRS. VOLUBLE

FOOTMEN, SERVANTS *and* MESSENGERS

WOMEN

LADY SMATTER	*aunt to* BEAUFORT
CECILIA	
MRS. SAPIENT	
MRS. VOLUBLE	
MRS. WHEEDLE	*a milliner*
MISS JENNY	*her apprentice*
BETTY	*maid to* MRS. VOLUBLE
MISS SALLY	
MISS POLLY	
A YOUNG WOMAN	

The scene is London.

ACT I

A milliner's shop. A counter is spread with caps, ribbons, fans and bandboxes. MISS JENNY *and several young women at work. Enter* MRS. WHEEDLE.

MRS. WHEEDLE: So, young ladies! Pray, what have you done today? [*She examines their work*] Has anybody been in yet?

MISS JENNY: No, ma'am, nobody to signify; only some people a-foot.

MRS. WHEEDLE: Why, Miss Sally, who is this cap for?

MISS SALLY: Lady Mary Megrim, ma'am.

MRS. WHEEDLE: Lady Mary Megrim, child? Lord, she'll no more wear it than I shall! Why, how have you done the lappets? They'll never set while it's a cap. One would think you had never worked in a Christian land before. Pray, Miss Jenny, set about a cap for Lady Mary yourself.

MISS JENNY: Ma'am, I can't; I'm working for Miss Stanley.

MRS. WHEEDLE: Oh aye, for the wedding.

MISS SALLY: Am I to go on with this cap, ma'am?

MRS. WHEEDLE: Yes, to be sure, and let it be sent with the other things to Mrs. Apeall in the Minories. It will do well enough for the City.

Enter a FOOTMAN.

FOOTMAN: Is Lady Whirligig's cloak ready?

MRS. WHEEDLE: Not quite, sir, but I'll send it in five minutes.

FOOTMAN: My lady wants it immediately; it was bespoke a week ago, and my lady says you promised to let her have it last Friday.

MRS. WHEEDLE: Sir, it's just done, and I'll take care to let her ladyship have it directly.

Exit FOOTMAN.

MISS JENNY: I don't think it's cut out yet.

MRS. WHEEDLE: I know it i'n't. Miss Sally, you shall set about it when you've done that cap. Why, Miss Polly, for goodness' sake, what are you doing?

MISS POLLY: Making a tippet, ma'am, for Miss Lollop.

MRS. WHEEDLE: Miss Lollop would as soon wear a halter! 'Twill be fit for nothing but the window, and there the Miss Notables who work for themselves may look at it for a pattern.

Enter a YOUNG WOMAN.

YOUNG WOMAN: If you please, ma'am, I should be glad to look at some ribbons.

MRS. WHEEDLE: We'll show you some presently.

Enter MRS. VOLUBLE.

MRS. VOLUBLE: Mrs. Wheedle, how do you do? I'm vastly glad to see you. I hope all the young ladies are well. Miss Jenny, my dear, you look pale; I hope you ain't in love, child? Miss Sally, your servant. I saw your uncle the other day, and he's very well, and so are all the children, except, indeed, poor Tommy, and they're afraid he's going to have the whooping cough. I don't think I know that other young lady. Oh Lord, yes I do—it's Miss Polly Dyson! I beg your pardon, my dear, but I declare I did not recollect you at first.

MRS. WHEEDLE: Won't you take a chair, Mrs. Voluble?

MRS. VOLUBLE: Why, yes, thank you, ma'am; but there are so many pretty things to look at in your shop, that one does not know which way to turn oneself. I declare it's the greatest treat in the world to me to spend an hour or two here in a morning. One sees so many fine things, and so many fine folks—Lord, who are all these sweet things for?

MRS. WHEEDLE: Miss Stanley, ma'am, a young lady just going to be married.

MRS. VOLUBLE: Miss Stanley? Why, I can tell you all about her. Mr. Dabler, who lives in my house, makes verses upon her.

MISS JENNY: Dear me! Is that gentleman who dresses so smart a poet?

MRS. VOLUBLE: A poet? Yes, my dear, he's one of the first wits of the age. He can make verses as fast as I can talk.

MISS JENNY: Dear me! Why, he's quite a fine gentleman. I thought poets were always as poor as Job.

MRS. VOLUBLE: Why, so they are, my dear, in common. Your *real* poet is all rags and atoms, but Mr. Dabler is quite another thing. He's what you may call a poet of fashion. He studies sometimes by the hour together. Oh, he's quite one of the great geniuses, I assure you! I listened at his door once, when he was at it—for he talks so loud when he's by himself, that we can hear him quite downstairs—but I could make nothing out, only a heap of words all in a chime, as one may say. Mean, lean, Dean, wean—Lord, I can't remember half of them! At first when he came, I used to run in his room and ask what was the matter, but he told me I must not mind him, for it was only the *fit* was on him, I think he called it, and so—

YOUNG WOMAN: I wish somebody would show me some ribbons. I have waited this half-hour.

MRS. WHEEDLE: Oh aye, I forgot; do show this young gentlewoman some ribbons. [*In a low voice*] Take last year's. [*To the* YOUNG WOMAN] You shall see some just out of the loom.

MRS. VOLUBLE: Well, but, Mrs. Wheedle, I was going to tell you about Miss Stanley. You must know she's a young lady with a fortune all in her own hands, for she's just come of age, and she's got neither papa nor mama, and so—

Enter a FOOTMAN.

FOOTMAN: Lady Bab Vertigo desires Mrs. Wheedle will come to the coach door. [*Exit*]

MRS. WHEEDLE *goes out.*

MRS. VOLUBLE: [*Turning herself to* MISS JENNY] And so, Miss Jenny, as I was saying, this young lady came to spend the winter in town with Lady Smatter, and so she fell in love with my lady's nephew, Mr. Beaufort, and Mr. Beaufort fell in live with her, and so—

Re-enter MRS. WHEEDLE.

MRS. WHEEDLE: Miss Jenny, take Lady Bab the new trimming.

MRS. VOLUBLE: [*Turning to* MISS SALLY] And so, Miss Sally, the

match is all agreed upon, and they are to be married next week, and so, as soon as the ceremony is over—

MRS. WHEEDLE: Miss Sally, put away those ribbons.

MRS. VOLUBLE: [*Turning to* MISS POLLY] And so, Miss Polly, as soon as the ceremony's over, the bride and bridegroom—

CENSOR: [*Offstage*] No, faith, not I! Do you think I want to study the fashion of a lady's topknot?

BEAUFORT: [*Offstage*] Nay, prithee, Censor, in compassion to me—

Enter BEAUFORT *and* CENSOR *struggling.*

CENSOR: Why, how now, Beaufort? Is not a man's person his own property? Do you conclude that, because you take the liberty to expose your own to a ridiculous and unmanly situation, you may use the same freedom with your friend's?

BEAUFORT: Faugh! Prithee, don't be so churlish. Pray, ma'am, [*Advancing to* MRS. WHEEDLE] has Miss Stanley been here this morning?

MRS. WHEEDLE: No, sir, but I expect her every moment.

BEAUFORT: Then, if you'll give me leave, I'll wait till she comes.

CENSOR: Do as you list, but, for my part, I am gone.

BEAUFORT: How! Will you not stay with me?

CENSOR: No, sir. I'm a very stupid fellow; I take no manner of delight in tapes and ribbons. I leave you therefore to the unmolested contemplation of this valuable collection of dainties, and I doubt not but you will be equally charmed and edified by the various curiosities you will behold, and the sagacious observations you will hear. Sir, I heartily wish you well entertained. [*Going*]

BEAUFORT: [*Holding him*] Have you no bowels, man?

CENSOR: Yes, for *myself,* and therefore it is I leave you.

BEAUFORT: You shan't go, I swear!

CENSOR: With what weapons will you stay me? Will you tie me to your finger with a piece of ribbon, like a lady's sparrow? Or will you enthral me in a net of Brussel's lace? Will you raise a fortification of caps? Or barricade me with furbelows? Will you fire at me a broadside of pompoons? Or will you stop my retreat with a fan?

MISS JENNY: Dear, how odd the gentleman talks!

MRS. WHEEDLE: I wonder they don't ask to look at something.

MRS. VOLUBLE: I fancy I know who they are. [*Whispers*]

BEAUFORT: Are you not as able to bear the place as I am? If you had any grace, you would blush to be thus outdone in forbearance.

CENSOR: But, my good friend, do you not consider that there is some little difference in our situations? I, for which I bless my stars, am a *free* man, and therefore may be allowed to have an opinion of my own, to act with consistency, and to be guided by the light of reason. You, for which I most heartily pity you, are a lover, and, consequently, can have no pretensions to similar privileges. With you, therefore, the practice of patience, the toleration of impertinence and the study of nonsense, are become duties indispensable; and where can you find more ample occasion to display these acquirements, than in this region of foppery, extravagance and folly?

BEAUFORT: Ought you not, in justice, to acknowledge some obligation to me for introducing you to a place which abounds in such copious materials to gratify your splenetic humor?

CENSOR: Obligation? What, for showing me new scenes of the absurdities of my fellow creatures?

BEAUFORT: Yes, since those new scenes give fresh occasion to exert that spirit of railing which makes the whole happiness of your life.

CENSOR: Do you imagine, then, that, like Spenser's Strife, I *seek* occasion? Have I not eyes? And can I open them without becoming a spectator of dissipation, idleness, luxury and disorder? Have I not ears? And can I use them without becoming an auditor of malevolence, envy, futility and detraction? Oh Beaufort, take me where I can *avoid* occasion of railing, and then, indeed, I will confess my obligation to you!

MRS. VOLUBLE: [*Whispering to* MRS. WHEEDLE] It's the youngest that's the bridegroom that is to be; but I'm pretty sure I know the other too, for he comes to see Mr. Dabler. I'll speak to him. [*Advances to* CENSOR] Sir, your humble servant.

CENSOR: Madam!

MRS. VOLUBLE: I beg your pardon, sir, but I think I've had the pleasure of seeing you at my house, sir, when you've called upon Mr. Dabler.

CENSOR: Mr. Dabler? Oh yes, I recollect. [*Aside to* BEAUFORT] Why, Beaufort, what do you mean? Did you bring me hither to be food to this magpie?

BEAUFORT: [*Aside to* CENSOR] Not I, upon my honor; I never saw the woman before. Who is she?

CENSOR: A fool, a prating, intolerable fool. Dabler lodges at her house, and whoever passes through her hall to visit him, she claims for her acquaintance. She will consume more words in an hour than ten men will in a year. She is infected with a rage for talking, yet has nothing to say, which is a disease of all others the most pernicious to her fellow creatures, since the method she takes for her own relief proves their bane. Her tongue is as restless as scandal, and, like that, feeds upon nothing yet attacks and tortures everything; and it vies, in rapidity of motion, with the circulation of the blood in a frog's foot.

MISS JENNY: [*To* MRS. VOLUBLE] I think the gentleman's very proud, ma'am, to answer you so short.

MRS. VOLUBLE: Oh but he won't get off so, I can tell him! I'll speak to him again. [*To* CENSOR] Poor Mr. Dabler, sir, has been troubled with a very bad headache lately. I tell him he studies too much, but he says he can't help it. However, I think it's a friend's part to advise him against it, for a little caution can do no harm, you know, sir, if it does no good, and Mr. Dabler's such a worthy, agreeable gentleman, and so much the scholar, 'twould be a thousand pities he should come to any ill. Pray, sir, do you think he'll ever make a match of it with Mrs. Sapient? She's ready enough, we all know, and, to be sure, for the matter of that, she's no chicken. Pray, sir, how old do you reckon she may be?

CENSOR: Really, madam, I have no talents for calculating the age of a lady. [*Aside to* BEAUFORT] What a torrent of impertinence! Upon my honor, Beaufort, if you don't draw this woman off, I shall decamp.

BEAUFORT: I cannot imagine what detains Cecilia; however, I will do anything rather than wait with such gossips by myself. [*To* MRS. VOLUBLE] I hope, ma'am, we don't keep you standing?

MRS. VOLUBLE: Oh no, sir, I was quite tired of sitting. [*Aside to* MISS JENNY] What a polite young gentleman, Miss Jenny! I'm sure he deserves to marry a fortune. I'll speak to him about the 'Sprit Party; he'll be quite surprised to find how much I know of the matter.—I think, sir, your name's Mr. Beaufort?

BEAUFORT: At your service, ma'am.

MRS. VOLUBLE: I was pretty sure it was you, sir, for I happened to be at my window one morning when you called in a coach, and Mr. Dabler was out—that is, between friends, he was only at his studies, but he said he was out, and so that's all one. So you gave in a card, and drove off. I hope, sir, your good aunt, my Lady Smatter, is well? For though I have not that pleasure of knowing her ladyship myself, I know them that do. I suppose you two gentlemen are always of the 'Sprit Party at my lady's house?

CENSOR: 'Sprit Party? Prithee, Beaufort, what's that?

BEAUFORT: Oh, the most fantastic absurdity under Heaven. My good aunt has established a kind of club at her house, professedly for the discussion of literary subjects, and the set who compose it are about as well qualified for the purpose as so many dirty cabin boys would be to find out the longitude. To a very little reading, they join less understanding and no judgement, yet they decide upon books and authors with the most confirmed confidence in their abilities for the task. And this club they have had the modesty to nominate the Esprit Party.

CENSOR: Nay, when you have me Lady Smatter is President, you need add nothing more to convince me of its futility. Faith, Beaufort, were you my enemy instead of my friend, I should scarce forbear commiserating your situation in being dependent upon that woman. I hardly know a more insufferable being for having unfortunately just "tasted the Pierian spring," she has acquired that "little knowledge," so dangerous to shallow

understandings, which serves no other purpose than to stimulate a display of ignorance.

MRS. VOLUBLE: I always know, sir, when there's going to be a 'Sprit Party, for Mr. Dabler shuts himself up to study. Pray, sir, did you ever see his monody on the birth of Miss Dandle's lapdog?

CENSOR: A monody on a birth?

MRS. VOLUBLE: Yes, sir, a monody or elegy, I don't know exactly which you call it, but I think it's one of the prettiest things he ever wrote. There he tells us—oh dear, is not that Mrs. Sapient's coach? I'm pretty sure I know the cipher.

CENSOR: Mrs. Sapient? Nay, Beaufort, if *she* is coming hither—

BEAUFORT: Patience, man; she is one of the set, and will divert you.

CENSOR: You are mistaken; such consummate folly only makes me melancholy. She is more weak and superficial even than Lady Smatter, yet she has the same facility in giving herself credit for wisdom, and there is a degree of assurance in her conceit that is equally wonderful and disgusting. For, as Lady Smatter, from the shallowness of her knowledge, upon all subjects forms a *wrong* judgement, Mrs. Sapient, from extreme weakness of parts, is incapable of forming any, but, to compensate for that deficiency, she retails all the opinions she hears, and confidently utters them as her own. Yet, in the most notorious of her plagiarisms, she affects a scrupulous modesty, and apologises for troubling the company with her poor opinion!

BEAUFORT: She is indeed immeasurably wearisome.

CENSOR: When she utters a truth self-evident as that the sun shines at noon day, she speaks it as a discovery resulting from her own peculiar penetration and sagacity.

BEAUFORT: Silence! She is here.

Enter MRS. SAPIENT.

MRS. SAPIENT: Oh Mrs. Wheedle, how could you disappoint me so of my short apron? I believe you make it a rule never to keep

The Witlings

to your time, and I declare, for *my* part, I know nothing so provoking as people's promising more than they perform.

MRS. WHEEDLE: Indeed, ma'am, I beg ten thousand pardons, but really, ma'am, we've been so hurried, that upon my word, ma'am—but you shall certainly have it this afternoon. Will you give me leave to show you any caps, ma'am? I have some exceeding pretty ones just finished.

MRS. SAPIENT: [*Looking at the caps*] Oh for Heaven's sake, don't show me such flaunting things, for, in *my* opinion, nothing can be really elegant that is tawdry.

MRS. WHEEDLE: But here, ma'am, is one I'm sure you'll like. It's in the immediate taste—only look at it, ma'am! What can be prettier?

MRS. SAPIENT: Why, yes, this is well enough, only I'm afraid it's too young for me. Don't you think it is?

MRS. WHEEDLE: Too young? Dear ma'am, no, I'm sure it will become you of all things; only try it. [*Holds it over her head*] Oh ma'am, you can't think how charmingly you look in it! And it sets so sweetly! I never saw anything so becoming in my life.

MRS. SAPIENT: Is it? Well, I think I'll have it, if you are sure it is not too young for me. You must know, I am mightily for people's consulting their time of life in their choice of clothes, and, in *my* opinion, there is a wide difference between fifteen and fifty.

CENSOR: [*To* BEAUFORT] She'll certainly tell us next that, in *her* opinion, a man who has but one eye would look rather better if he had another!

MRS. WHEEDLE: Oh I'm sure, ma'am, you'll be quite in love with this cap, when you see how well you look in it. Shall I show you some of our new ribbons, ma'am?

MRS. SAPIENT: Oh I know now, you want to tempt me, but *I* always say the best way to escape temptation is to run away from it. However, as I am here—

MRS. VOLUBLE: Had not you better sit down, ma'am? [*Offering a chair*]

MRS. SAPIENT: Oh Mrs. Voluble, is it you? How do you do? Lord,

186

I don't like any of these ribbons. Pray, how does Mr. Dabler do?

MRS. VOLUBLE: Very well, thank you, ma'am; that is, not *very* well, but *pretty* well considering, for, to be sure, ma'am, so much study's very bad for the health. It's pity he don't take more care of himself, and so I often tell him, but your great wits never mind what little folk say, if they talk never so well, and I'm sure I've sometimes talked to him by the hour together about it, for I'd never spare my words to serve a friend. However, it's all to no purpose, for he says he has a kind of *fury*, I think he calls it, upon him, that makes him write whether he will or not. And, to be sure, he does write most charmingly! And he has such a collection of miniscrips! Lord, I question if a pastry cook or a cheese-monger could use them in a year! For he says he never destroyed a line he ever wrote in his life. All that he don't like, he tells me, he keeps by him for his postimus works, as he calls them, and I've some notion he intends soon to print them.

MRS. WHEEDLE: Do, ma'am, pray let me put this cloak up for you, and I'll make you a hat for it immediately.

MRS. SAPIENT: Well, then, take a great care how you put in the ribbon, for you know I won't keep it if it does not please me. Mr. Beaufort! Lord bless me, how long have you been here? Oh Heavens! Is that Mr. Censor? I can scarce believe my eyes! Mr. Censor in a milliner's shop! Well, this does indeed justify an observation I have often made, that the greatest geniuses sometimes do the oddest things.

CENSOR: Your surprise, madam, at seeing me here today will bear no comparison to what I must myself experience, should you ever see me here again.

MRS. SAPIENT: Oh I know well how much you must despise all this sort of business, and, I assure you, I am equally averse to it myself. Indeed, I often think what pity it is so much time should be given to mere show—for what are we the better tomorrow for what we have worn today? No time, in *my* opinion, turns to so little account as that which we spend in dress.

CENSOR: [*Aside to* BEAUFORT] Did you ever hear such an impudent falsehood?

MRS. SAPIENT: For *my* part, I always wear just what the milliner and mantua-maker please to send me, for I have a kind of maxim upon this subject which has some weight with *me*—though I don't know if anybody else ever suggested it—but it is, that the real value of a person springs from the *mind*, not from the outside appearance. So I never trouble myself to look at anything till the moment I put it on. Be sure [*Turning quick to the milliners*] you take care how you trim the hat! I shan't wear it else.

CENSOR: Prithee, Beaufort, how long will you give a man to decide which is greatest, her folly or her conceit?

MRS. SAPIENT: Gentlemen, good morning. Mrs. Voluble, you may give my compliments to Mr. Dabler. Mrs. Wheedle, pray send the things in time, for, to *me*, nothing is more disagreeable than to be disappointed.

As she is going out, JACK *enters abruptly, and brushes past her.*

Oh Heavens!

JACK: Lord, ma'am, I beg you a thousand pardons! I did not see you, I declare. I hope I did not hurt you?

MRS. SAPIENT: No, sir, no, but you a little alarmed me, and really an alarm, when one does not know how to account for it, gives one a rather odd sensation—at least *I* find it so.

JACK: Upon my word, ma'am, I'm very sorry—I'm sure if I'd seen you—but I was in such monstrous haste, I had no time to look about me.

MRS. SAPIENT: Oh sir, 'tis of no consequence; yet allow me to observe that, in *my* opinion, too much haste generally defeats its own purpose. Sir, good morning. [*Exit*]

BEAUFORT: Why, Jack, won't you see her to her coach?

JACK: Oh aye, true, I must! [*Follows her*]

CENSOR: This brother of yours, Beaufort, is a most ingenious youth.

BEAUFORT: He has foibles which you, I am sure, will not spare, but he means well and is extremely good-natured.

CENSOR: Nay, but I am serious, for without ingenuity no man, I think, could continue to be always in a hurry, who is never employed.

Re-enter JACK.

JACK: Plague take it, brother, how unlucky it was that you made me go after her! In running up to her, my deuced spurs caught hold of some of her falaldrums, and in my haste to disengage myself, I tore off half her trimming. She went off in a very ill humor, telling me that, in *her* opinion, a disagreeable accident was very—very—very disagreeable, I think, or something to that purpose.

BEAUFORT: But, for Heaven's sake, Jack, what is the occasion of all this furious haste?

JACK: Why, Lord, you know I'm always in a hurry. I've no notion of dreaming away life. How the deuce is anything to be done without a little spirit?

BEAUFORT: Faugh, prithee, Jack, give up this idle humor.

JACK: Idle? Nay, brother, call me what else you please, but you can never charge me with idleness.

BEAUFORT: Why, with all your boasted activity, I question if there is a man in England who would be more embarrassed how to give any account of his time.

JACK: Well, well, I can't stay now to discourse upon these matters. I have too many things to *do*, to stand here talking.

BEAUFORT: Nay, don't go till you tell us what you have to do this morning.

JACK: Why, more things than either of you would do in a month, but I can't stop now to tell you any of them, for I have three friends waiting for me in Hyde Park, and twenty places to call at in my way. [*Going*]

MRS. WHEEDLE: [*Following him*] Sir, would you not choose to look at some ruffles?

JACK: Oh aye—have you anything new? What do you call these?

MRS. WHEEDLE: Oh pray, sir, take care! They are so delicate they'll hardly bear to be touched.

JACK: I don't like them at all! Show me some others.

MRS. WHEEDLE: Why, sir, only see! You have quite spoilt this pair.

JACK: Have I? Well, then, you must put them up for me. But pray, have you got no better?

MRS. WHEEDLE: I'll look some directly, sir—but, dear sir, pray don't put your switch upon the caps! I hope you'll excuse me, sir, but the set is all in all in these little tasty things.

CENSOR: And pray, Jack, are all your hurries equally important and necessary as those of this morning?

JACK: Lord, you grave fellows, who plod on from day to day without any notion of life and spirit, spend half your lives in asking people questions they don't know how to answer.

CENSOR: And we might consume the other half to as little purpose, if we waited to find out questions which such people *do* know how to answer.

JACK: Severe, very severe, that! However, I have not time now for repartee, but I shall give you a Rowland for your Oliver when we meet again. [*Going*]

MRS. WHEEDLE: Sir, I've got the ruffles—won't you look at them?

JACK: Oh, the ruffles! Well, I'm glad you've found them, but I can't stay to look at them now. Keep them in the way against I call again. [*Exit*]

MRS. WHEEDLE: Miss Jenny, put these ruffles up again. That gentleman never knows his own mind.

MISS JENNY: I'm sure he's tumbled and tossed the things about like mad.

CENSOR: 'Tis to be much regretted, Beaufort, that such a youth as this was not an elder brother.

BEAUFORT: Why so?

CENSOR: Because the next heir might so easily get rid him; for, if he was knocked down, I believe he would think it loss of time to get up again, and if he were pushed into a river, I question if he would not be drowned ere he could persuade himself to swim long enough in the same direction to save himself.

BEAUFORT: He is young, and I hope this ridiculous humor will wear away.

CENSOR: But how came *you* so wholly to escape its infection? I find not in you any portion of this inordinate desire of action to which all power of thinking must be sacrificed.

BEAUFORT: Why, we are but half-brothers, and our educations were as different as our fathers, for my mother's second husband was no more like her first, than am "I to Hercules"—though Jack, indeed, has no resemblance even to his own father.

CENSOR: Resemblance? An hare and tortoise are not more different, for Jack is always running without knowing what he pursues, and his father is always pondering without knowing what he thinks of.

BEAUFORT: The truth is, Mr. Codger's humor of perpetual deliberation so early sickened his son that the fear of inheriting any share of it made him rush into the opposite extreme, and determine to avoid the censure of inactive meditation by executing every plan he could form at the very moment of projection.

CENSOR: And pray, sir—if such a question will not endanger a challenge—what think you, by this time, of the punctuality of your mistress?

BEAUFORT: Why, to own the truth, I fear I must have made some mistake.

CENSOR: Bravo, Beaufort! Ever doubt your own senses in preference to suspecting your mistress of negligence or caprice.

BEAUFORT: She is much too noble-minded, too just in her sentiments, and too uniform in her conduct, to be guilty of either.

CENSOR: Bravissimo, Beaufort! I commend your patience, and, this time twelvemonth, I'll ask you how it wears! In the meantime, however, I would not upon any account interrupt your contemplations either upon her excellencies or your own mistakes, but, as I expect no advantage from the one, you must excuse my any longer suffering from the other, and, ere you again entangle me in such a wilderness of frippery, I shall take the liberty more closely to investigate the accuracy of your appointments. [*Exit*]

BEAUFORT: My situation begins to grow as ridiculous as it is disagreeable. Surely Cecilia cannot have forgotten me?

MRS. VOLUBLE: [*Advancing to him*] To be sure, sir, it's vastly incommodious to be kept waiting so, but, sir, if I might put in a word, I think—

Enter JACK *running.*

JACK: Brother, I quite forgot to tell you Miss Stanley's message.

BEAUFORT: Message! What message?

JACK: I declare I had got half way to Hyde Park, before I ever thought of it.

BEAUFORT: Upon my honor, Jack, this is too much!

JACK: Why, I ran back the moment I recollected it, and what could I do more? I would not even stop to tell Will Scamper what was the matter, so he has been calling and bawling after me all the way I came. I gave him the slip when I got to the shop—but I'll just step and see if he's in the street. [*Going*]

BEAUFORT: Jack, you'll provoke me to more anger than you are prepared for! What was the message? Tell me quickly!

JACK: Oh aye, true! Why, she said she could not come.

BEAUFORT: Not come? But *why*? I'm sure she told you *why*?

JACK: Oh yes, she told me a long story about it—but I've forgot what it was.

BEAUFORT: [*Warmly*] Recollect, then!

JACK: Why, so I will. Oh, it was all your aunt Smatter's fault. Somebody came in with the Ranelagh Songs, so she stayed at home to study them, and Miss Stanley bid me say she was very sorry, but she could not come by herself.

JACK: And why might I not have been told this sooner?

JACK: Why, she desired me to come and tell you of it an hour or two ago, but I had so many places to stop at by the way, I could not possibly get here sooner; and when I came, my head was so full of my own appointments that I never once thought of her message. However, I must run back to Will Scamper or he'll think me crazy.

BEAUFORT: Hear me, Jack! If you do not take pains to correct this absurd rage to attempt everything while you execute nothing,

you will render yourself as contemptible to the world as you are useless or mischievous to your family. [*Exit*]

JACK: What a passion he's in! I've a good mind to run to Miss Stanley and beg her to intercede for me. [*Going*]

MRS. WHEEDLE: Sir, won't you please to look at the ruffles?

JACK: Oh aye, true. Where are they?

MRS. WHEEDLE: Here, sir. Miss Jenny, give me those ruffles again.

JACK: Oh if they ain't ready, I can't stay. [*Exit*]

MRS. VOLUBLE: Well, Mrs. Wheedle, I'm sure you've a pleasant life of it here, in seeing so much of the world. I'd a great mind to have spoke to that young gentleman, for I'm pretty sure I've seen him before, though I can't tell where. But he was in such a violent hurry, I could not get in a word. He's a fine, lively gentleman, to be sure. But now, Mrs. Wheedle, when will you come and drink a snug dish of tea with me? You and Miss Jenny, and any of the young ladies that can be spared? I'm sure if you can *all* come—

Enter BOB.

BOB: I ask pardon, ladies and gentlemen, but pray, is my mother here?

MRS. VOLUBLE: What's that to you, sirrah? Who gave you leave to follow me? Get home, directly, you dirty figure, you! Go, go, I say!

BOB: Why, Lord, mother, you've been out all the morning, and never told Betty what was for dinner!

MRS. VOLUBLE: Why, you great, tall, greedy, gormondising, lubberly cub, you, what signifies whether you have any dinner or no? Go, get away, you idle, good for nothing, dirty, greasy, hulking, tormenting—

She drives him off, and the scene closes.

ACT II

A drawing room at LADY SMATTER'S. LADY SMATTER *and* CECILIA.

LADY SMATTER: Yes, yes, this song is certainly Mr. Dabler's; I am not to be deceived in his style. What say you, my dear Miss Stanley, don't you think I have found him out?

CECILIA: Indeed, I am too little acquainted with his poems to be able to judge.

LADY SMATTER: Your indifference surprises me! For my part, I am never at rest till I have discovered the authors of every thing that comes out; and, indeed, I commonly hit upon them in a moment. I declare I sometimes wonder at myself, when I think how lucky I am in my guesses.

CECILIA: Your ladyship devotes so much time to these researches that it would be strange if they were unsuccessful.

LADY SMATTER: Yes, I do indeed devote my time to them; I own it without blushing, for how, as a certain author says, can time be better employed than in cultivating intellectual accomplishments? And I am often surprised, my dear Miss Stanley, that a young lady of your good sense should not be more warmly engaged in the same pursuit.

CECILIA: My pursuits, whatever they may be, are too unimportant to deserve being made public.

LADY SMATTER: Well, to be sure, we are born with sentiments of our own, as I read in a book I can't just now recollect the name of, so I ought not to wonder that yours and mine do not coincide; for, I declare, if my pursuits were not made public, I should not have any at all. For where can be the pleasure of reading books, and studying authors, if one is not to have the credit of talking of them?

CECILIA: Your ladyship's desire of celebrity is too well known for your motives to be doubted.

LADY SMATTER: Well, but, my dear Miss Stanley, I have been thinking for some time past of your becoming a member of our Esprit Party. Shall I put up your name?

CECILIA: By no means; my ambition aspires not at an honor for which I feel myself so little qualified.

LADY SMATTER: Nay, but you are too modest. You can't suppose how much you may profit by coming among us. I'll tell you some of our regulations. The principal persons of our party are Authors and Critics. The Authors always bring us something new of their own, and the Critics regale us with manuscript notes upon something old.

CECILIA: And in what class is your ladyship?

LADY SMATTER: Oh, I am among the Critics. I love criticism passionately, though it is really laborious work, for it obliges one to read with a vast deal of attention. I declare I am sometimes so immensely fatigued with the toil of studying for faults and objections that I am ready to fling all my books behind the fire.

CECILIA: And what authors have you chiefly criticised?

LADY SMATTER: Pope and Shakespeare. I have found more errors in those than in any other.

CECILIA: I hope, however, for the sake of readers less fastidious, your ladyship has also left them some beauties.

LADY SMATTER: Oh yes, I have not cut them up regularly through. Indeed, I have not yet read above half their works, so how they will fare as I go on, I can't determine. Oh, here's Beaufort.

Enter BEAUFORT.

BEAUFORT: Your ladyship's most obedient.

CECILIA: Mr. Beaufort, I am quite ashamed to see you! Yet the disappointment I occasioned you was as involuntary on my part as it could possibly be disagreeable on yours. Your brother, I hope, prevented your waiting long?

BEAUFORT: That you meant he should is sufficient reparation for my loss of time; but what must be the disappointment that an apology from you would not soften?

LADY SMATTER: [*Reading*] "Oh lovely, charming, beauteous maid"—I wish this song was not so difficult to get by heart, but I am always beginning one line for another. After all, study is a most

fatiguing thing! Oh how little does the world suspect, when we are figuring in all the brilliancy of conversation, the private hardships and secret labours of a *belle esprit*!

Enter a SERVANT.

SERVANT: Mr. Codger, my lady.

Enter MR. CODGER.

LADY SMATTER: Mr. Codger, your servant. I hope I see you well?

CODGER: Your ladyship's most humble. Not so well, indeed, as I could wish, yet perhaps better than I deserve to be.

LADY SMATTER: How is my friend Jack?

CODGER: I can't directly say, madam. I have not seen him these two hours, and poor Jack is but a harem-scarem young man. Many things may have happened to him in the space of two hours.

LADY SMATTER: And what, my good sir, can you apprehend?

CODGER: To enumerate all the casualties I apprehend might perhaps be tedious; I will therefore only mention the heads. In the first place, he may be thrown from his horse; in the second place, he may be run over while on foot; in the third place—

LADY SMATTER: Oh pray, *place* him no more in situations so horrible. Have you heard lately from our friends in the north?

CODGER: Not very lately, madam. The last letter I received was dated the sixteenth of February, and that, you know, madam, was five weeks last Thursday.

LADY SMATTER: I hope you had good news?

CODGER: Why, madam, yes; at least, none bad. My sister Deborah acquainted me with many curious little pieces of history that have happened in her neighbourhood. Would it be agreeable to your ladyship to hear them?

LADY SMATTER: Oh no, I would not take up so much of your time.

CODGER: I cannot, madam, employ my time more agreeably. Let me see—in the first place—no, that was not first—let me recollect!

BEAUFORT: Pray, sir, was any mention made of Tom?

CODGER: Yes, but don't be impatient; I shall speak of him in his turn.

BEAUFORT: I beg your pardon, sir, but I enquired from hearing he was not well.

CODGER: I shall explain whence that report arose in a few minutes. In the meantime, I must beg you not to interrupt me, for I am trying to arrange a chain of anecdotes for the satisfaction of Lady Smatter.

LADY SMATTER: Bless me, Mr. Codger, I did not mean to give you so much trouble.

CODGER: It will be no trouble in the world, if your ladyship will, for a while, forbear speaking to me, though the loss upon the occasion will be all mine. [*He retires to the side scene*]

LADY SMATTER: [*Aside*] What a formal old fogrum the man grows!— Beaufort, have you seen this song?

BEAUFORT: I believe not, madam.

LADY SMATTER: Oh, it's the prettiest thing! But I don't think you have a true taste for poetry. I never observed you to be enraptured, lost in ecstasy, or hurried, as it were, out of yourself, when I have been reading to you. But *my* enthusiasm for poetry may, perhaps, carry me too far. Come now, my dear Miss Stanley, be sincere with me; don't you think I indulge this propensity too much?

CECILIA: I should be sorry to have your ladyship suppose me quite insensible to the elegance of literary pursuits, though I neither claim any title nor profess any ability to judge of them.

LADY SMATTER: Oh, you'll do very well in a few years. But, as you observe, I own I think there is something rather elegant in a taste for these sort of amusements. Otherwise, indeed, I should not have taken so much pains to acquire it, for, to confess the truth, I had from nature quite an aversion to reading. I remember the time when the very sight of a book was disgustful to me!

CODGER: [*Coming forward*] I believe, madam, I can now satisfy your enquiries.

LADY SMATTER: What enquiries?

CODGER: Those your ladyship made in relation to my letter from
our friends in Yorkshire. In the first place, my sister Deborah
writes me word that the new barn which, you may remember,
was begun last summer, is pretty nearly finished. And here,
in my pocketbook, I have gotten the dimensions of it. It is
fifteen feet by—

LADY SMATTER: Oh for Heaven's sake, Mr. Codger, don't trouble
yourself to be so circumstantial.

CODGER: The trouble, madam, is inconsiderable, or, if it were oth-
erwise, for the information of your ladyship, I would most
readily go through with it. It is fifteen feet by thirty. And
pray, does your ladyship remember the old dog-kennel at the
parsonage house?

LADY SMATTER: No, sir, I never look at dog-kennels.

CODGER: Well, madam, my sister Deborah writes me word—

Enter SERVANT.

SERVANT: Mr. Dabler, my lady.

Enter MR. DABLER.

LADY SMATTER: Mr. Dabler, you are the man in the world I most
wished to see.

DABLER: Your ladyship is beneficence itself!

LADY SMATTER: A visit from you, Mr. Dabler, is the greatest of
favours, since your time is not only precious to yourself but
to the world.

DABLER: It is indeed precious to myself, madam, when I devote it
to the service of your ladyship. Miss Stanley, may I hope you
are as well as you look? If so, you health must indeed be in a
state of perfection; if not, never before did sickness wear so
fair a mask.

LADY SMATTER: 'Tis a thousand pities, Mr. Dabler, to throw away such
poetical thoughts and imagery in common conversation.

DABLER: Why, ma'am, the truth is, something a little out of the usual
path is expected from a man whom the world has been pleased
to style a poet—though I protest I never knew why!

LADY SMATTER: How true is it that modesty, as Pope or Swift, I forget which, has it, is the constant attendant upon merit!

DABLER: If merit, madam, were but the constant attendant upon modesty then indeed I might hope to attain no little share! Faith, I'll set that down. [*He takes out his tablets*]

CODGER: And so, madam, my sister Deborah writes me word—

LADY SMATTER: Oh dear, Mr. Codger, I merely wanted to know if all our friends were well.

CODGER: Nay, if your ladyship does not want to hear about the dog-kennel—

LADY SMATTER: Not in the least! I hate kennels and dogs too.

CODGER: As you please, madam! [*Aside*] She has given me the trouble of ten minutes' recollection, and now she won't hear me!

LADY SMATTER: Mr. Dabler, I believe I've had the pleasure of seeing something of yours this morning.

DABLER: Of mine? You alarm me beyond measure!

LADY SMATTER: Nay, nay, 'tis in print, so don't be frightened.

DABLER: Your ladyship relieves me; but, really, people are so little delicate in taking copies of my foolish manuscripts, that I protest I go into no house without fear of meeting something of my own. But what may it be?

LADY SMATTER: Why, I'll repeat it.
"O sweetest, softest, gentlest maid—"

DABLER: No, ma'am, no—you mistake—
"O lovely, beauteous, charming maid—" Is it not so?

LADY SMATTER: Yes, yes, that's it. Oh what a vile memory is mine! After all my studying, to make such a mistake! I declare I forget as fast as I learn. I shall begin to fancy myself a wit by and by.

DABLER: Then will your ladyship for the *first* time be the *last* to learn something. [*Aside*] 'Gad, I'll put that into an epigram!

LADY SMATTER: I was reading the other day, that the memory of a poet should be short, that his works may be original.

DABLER: Heavens, madam, where did you meet with that?

LADY SMATTER: I can't exactly say, but either in Pope or Swift.

DABLER: Oh curse it, how unlucky!

LADY SMATTER: Why so?

DABLER: Why, madam, 'tis my own thought! I've just finished an epigram upon that very subject! I protest I shall grow more and more sick of books every day, for I can never look into any, but I'm sure of popping upon something of my own.

LADY SMATTER: Well, but, dear sir, pray let's hear your epigram.

DABLER: Why—if your ladyship insists upon it—

[*Reads*] "Ye gentle gods, oh hear me plead,
And kindly grant this little loan:
Make me forget whate'er I read,
That what I write may be my own."

LADY SMATTER: Oh charming! Very clever, indeed.

BEAUFORT: But pray, sir, if such is your wish, why should you read at all?

DABLER: Why, sir, one must read; one's reputation requires it, for it would be cruelly confusing to be asked after such or such an author, and never to have looked into him, especially to a person who passes for having some little knowledge in these matters.

BEAUFORT: [*Aside*] What a shallow coxcomb!

LADY SMATTER: You must positively let me have a copy of that epigram, Mr. Dabler. Don't you think it charming, Mr. Codger?

CODGER: Madam, I never take anything in at first hearing. If Mr. Dabler will let me have it in my own hand, I will give your ladyship my opinion of it, after I have read it over two or three times.

DABLER: Sir, it is much at your service, but I must insist upon it that you don't get it by heart.

CODGER: Bless me, sir, I should not do that in half a year! I have no turn for such sort of things.

LADY SMATTER: I know not in what Mr. Dabler most excels—epigrams, sonnets, odes or elegies.

DABLER: Dear madam, mere nonsense! But I believe your ladyship forgets my little lampoons?

LADY SMATTER: Oh no, that I never can! There you are indeed perfect.

DABLER: Your ladyship far overrates my poor abilities. My writings are mere trifles, and I believe the world would be never the worse if they were all committed to the flames.

BEAUFORT: [*Aside*] I would I could try the experiment!

LADY SMATTER: Your talents are really universal.

DABLER: Oh ma'am, you quite overpower me! But now you are pleased to mention the word *universal*, did your ladyship ever meet with my little attempt in the epic way?

LADY SMATTER: Oh no, you sly creature! But I shall now suspect you of everything.

DABLER: Your ladyship is but too partial. I have indeed some little facility in stringing rhymes, but I should suppose there's nothing very extraordinary in that. Everybody, I believe, has some little talent. Mine happens to be for poetry, but it's all a chance! Nobody can choose for himself, and really, to be candid, I don't know if some other things are not of equal consequence.

LADY SMATTER: There, Mr. Dabler, I must indeed differ from you! What in the universe can be put in competition with poetry?

DABLER: Your ladyship's enthusiasm for the fine arts—

Enter a SERVANT.

SERVANT: Mrs. Sapient, madam.

LADY SMATTER: Lord, how tiresome! She'll talk us to death!

Enter MRS. SAPIENT.

Dear Mrs. Sapient, this is vastly good of you!

DABLER: Your arrival, madam, is particularly critical at this time, for we are engaged in a literary controversy, and to whom can we so properly apply to enlighten our doubts by the sunbeams of her counsel, as to Mrs. Sapient?

LADY SMATTER: What a sweet speech! [*Aside*] I wonder how he could make it to that stupid woman!

MRS. SAPIENT: You do me too much honor, sir. But what is the

subject I have been so unfortunate as to interrupt? For though
I shall be ashamed to offer my sentiments before such a com-
pany as this, I yet have rather a peculiar way of thinking upon
this subject.

DABLER: As how, ma'am?

MRS. SAPIENT: Why, sir, it seems to *me* that a proper degree of cour-
age is preferable to a superfluous excess of modesty.

DABLER: Excellent! Extremely right, madam. The present question is
upon poetry. We were considering whether, impartially speak-
ing, some other things are not of equal importance?

MRS. SAPIENT: I am unwilling, sir, to decide upon so delicate a point.
Yet, were I to offer my humble opinion, it would be that though
to *me* nothing is more delightful than poetry, I yet fancy there
may be other things of greater utility in common life.

DABLER: Pray, Mr. Codger, what is your opinion?

CODGER: Sir, I am so intently employed in considering this epigram,
that I cannot just now maturely weigh your question; and
indeed, sir, to acknowledge the truth, I could have excused
your interrupting me.

DABLER: Sir, you do my foolish epigram much honor. [*Aside*] That
man has twice the sense one would suppose from his look. I'll
show him my new sonnet.

MRS. SAPIENT: How much was I surprised, Mr. Beaufort, at seeing
Mr. Censor this morning in a milliner's shop!

CECILIA: I rejoice to hear you had such a companion; and yet perhaps
I ought rather to regret it, since the sting of his raillery might
but inflame your disappointment and vexation.

BEAUFORT: The sting of a professed satirist only proves poisonous to
fresh subjects. Those who have often felt it are merely tickled
by the wound.

DABLER: [*Aside*] How the deuce shall I introduce the sonnet? [*To the
company*] Pray, ladies and gentlemen, you who so often visit
the Muses, is there anything new in the poetical way?

LADY SMATTER: Who, Mr. Dabler, can so properly answer that ques-
tion as you—you, to whom all their haunts are open?

DABLER: Oh dear, ma'am, such compositions as mine are the merest

baubles in the world! I dare say there are people who would even be ashamed to set their names to them.

BEAUFORT: [*Aside*] I hope there is but one person who would not!

MRS. SAPIENT: How much more amiable in *my* eyes is genius when joined with diffidence than with conceit!

CODGER: [*Returning with the epigram*] Sir, I give you my thanks, and I think, sir, your wish is somewhat uncommon.

DABLER: I am much pleased, sir, that you approve of it. [*Aside*] This man does not want understanding, with all his formality. He'll be prodigiously struck with my sonnet.

MRS. SAPIENT: What, is that something new of Mr. Dabler's? Surely, sir, you must write night and day.

DABLER: Oh dear, no, ma'am, for I compose with a facility that is really surprising. Yet, sometimes, to be sure, I have been pretty hard worked. In the charade season, I protest I hardly slept a wink! I spent whole days in looking over dictionaries of words of double meaning, and really I made some not amiss. But 'twas too easy. I soon grew sick of it, yet I never quite gave it up till, accidentally, I heard a housemaid say to a scullion, "My first, is yourself; my second, holds a good cheer; and my third, is my own office"—and 'gad, the word was *scrub-bing*!

CODGER: With respect, sir, to that point concerning which you consulted me, I am inclined to think—

DABLER: Sir!

CODGER: You were speaking to me, sir, respecting the utility of poetry. I am inclined to think—

DABLER: Oh, apropos, now I think of it, I have a little sonnet here that is quite pat to the subject, and—

CODGER: What subject, good sir?

DABLER: What subject?—Why—this subject, you know.

CODGER: As yet, sir, we are talking of no subject; I was going—

DABLER: Well, but—ha, ha! It puts me so in mind of this little sonnet we speaking of, that—

CODGER: But, sir, you have not heard what I was going to say.

DABLER: True, sir, true. I'll put the poem away for the present—unless, indeed, you very much wish to see it?

The Witlings

CODGER: Another time will do as well, sir. I don't rightly comprehend what I read before company.

DABLER: Dear sir, such trifles as these are hardly worth your serious study. However, if you'll promise not to take a copy, I think I'll venture to trust you with the manuscript—but you must be sure not to show it a single soul, and, pray, take great care of it.

CODGER: Good sir, I don't mean to take it at all.

DABLER: Sir!

CODGER: I have no time for reading, and I hold that these sort of things only turn one's head from matters of more importance.

DABLER: Oh very well, sir—if you don't want to see it—[Aside] What a tasteless old dolt! Curse me if I shall hardly be civil to him when I meet him next!

CODGER: Notwithstanding which, sir, if I should find an odd hour or two in the course of the winter, I will let you know, and you may send it to me.

DABLER: Dear sir, you do me a vast favour! [Aside] The fellow's a perfect driveller!

LADY SMATTER: I declare, Mr. Codger, had we known you were indifferent to the charms of poetry, we should never have admitted you of our party.

CODGER: Madam, I was only moved to enter it in order to oblige your ladyship, but I shall hardly attend it above once more—or twice at the utmost.

Enter JACK.

JACK: [*To* LADY SMATTER] Ma'am, your servant. Where's Miss Stanley? I'm so out of breath I can hardly speak. Miss Stanley, I'm come on purpose to tell you some news.

CECILIA: It ought to be of some importance by your haste.

BEAUFORT: Not a whit the more for that! His haste indicates nothing, for it accompanies him in everything.

JACK: Nay, if you won't hear me at once, I'm gone!

CODGER: And pray, son Jack, whither may you be going?

JACK: Lord, sir, to an hundred places at least. I shall be all over the town in less than half an hour.

CODGER: Nevertheless it is well known, you have no manner of business over any part of it. I am much afraid, son Jack, you will be a blockhead all your life.

LADY SMATTER: For shame, Mr. Codger! Jack, you were voted into our Esprit Party last meeting, and if you come tonight, you will be admitted.

JACK: I'll come with the greatest pleasure, ma'am, if I can but get away from Will Scamper, but we are upon a frolic tonight, so it's ten to one if I can make off.

MRS. SAPIENT: If I might take the liberty, sir, to offer *my* advice upon this occasion, I should say that useful friends were more improving than frivolous companions, for, in *my* opinion, it is pity to waste time.

JACK: Why, ma'am, that's just my way of thinking! I like to be always getting forward, always doing something. Why, I am going now as far as Fleet Street, to a print shop, where I left Tom Whiffle. I met him in my way from Cornhill, and promised to be back with him in half an hour.

BEAUFORT: Cornhill? You said you were going to Hyde Park.

JACK: Yes, but I met Kit Filligree, and he hauled me into the City. But, now you put me in mind of it, I believe I had best run there first, and see who's waiting.

BEAUFORT: But what, in the meantime, is to become of Tom Whiffle?

JACK: Oh hang him, he can wait.

CODGER: In truth, son Jack, you scandalise me! I have even apprehensions for your head; you appear to me to be *non compos mentis*.

BEAUFORT: 'Tis pity, Jack, you cannot change situations with a running footman.

JACK: Aye, aye, good folks, I know you all love to cut me up, so pray amuse yourselves your own way—only don't expect me to stay and hear you. [*Going*]

CODGER: Son Jack, return. Pray answer me to the following question.

JACK: Dear sir, pray be quick, for I'm in a horrid hurry.

CODGER: A little more patience, son, would become you better. You should consider that you are but a boy, and that I am your father.

JACK: Yes, sir, I do. Was that all, sir?

CODGER: All? Why, I have said nothing.

JACK: Very true, sir.

CODGER: You ought also to keep it constantly in your head that I am not merely older but wiser than yourself.

JACK: Yes, sir. [*Aside*] Demme, though, if I believe that!

CODGER: You would do well, also, to remember, that such haste to quit my presence looks as if you took no pleasure in my company.

JACK: It does so, sir. [*Aside*] Plague take it, I shan't get away this age.

CODGER: Son Jack, I insist upon your minding what I say.

JACK: I will, sir. [*Going*]

CODGER: Why are you running away without hearing my question?

JACK: [*Aside*] O dem it, I shall never get off! [*To* CODGER] Pray, sir, what is it?

CODGER: Don't speak so quick, Jack, there's no understanding a word you say. One would think you supposed I was going to take the trouble of asking a question that was not of sufficient importance to deserve an answer.

JACK: True, sir, but do pray be so good as to make haste.

CODGER: Son, once again, don't put yourself in such a fury. You hurry so, you have almost made me forget what I wanted to ask you. Let me see—oh, now I recollect. Pray, do you know if the fish was sent home before you came out?

JACK: Lord, no, sir, I know nothing of the matter! [*Aside*] How plaguey tiresome! To keep me all this time for such a question as that.

CODGER: Son Jack, you know nothing! I am concerned to say it, but you know nothing!

LADY SMATTER: Don't judge him hastily. Mr. Dabler, you seem lost in thought.

DABLER: Do I, ma'am? I protest I did not know it.

LADY SMATTER: Oh you are a sly creature! Planning some poem, I dare say.

JACK: I'll e'en take French leave. [*Going*]

CECILIA: [*Following him*] You are destined to be tormented this morning, for I cannot suffer you to escape till we come to an explanation. You said you had news for me.

JACK: Oh aye, true; I'll tell you what it was. While I was upon 'Change this morning—but hold, I believe I'd best tell Lady Smatter first.

CECILIA: Why so?

JACK: Because perhaps you'll be frightened.

CECILIA: Frightened? At what?

JACK: Why, it's very bad news.

CECILIA: Good God, what can this mean?

BEAUFORT: Nothing, I dare be sworn.

JACK: Very well, brother! I wish you may think it nothing when you've heard it.

CECILIA: Don't keep me in suspense, I beseech you.

BEAUFORT: Jack, what is it you mean by alarming Miss Stanley thus?

JACK: Plague take it, I wish I had not spoke at all! I shall have him fly into another passion!

CECILIA: Why will you not explain yourself?

JACK: Why, ma'am, if you please, I'll call on you in the afternoon.

CECILIA: No, no, you do but increase my apprehensions by this delay.

BEAUFORT: Upon my honor, Jack, this is insufferable!

JACK: Why, Lord, brother, don't be so angry.

LADY SMATTER: Nay, now Jack, you are really provoking.

MRS. SAPIENT: Why, yes, I must needs own I am myself of opinion that it is rather disagreeable to wait long for bad news.

CODGER: In truth, Jack, you are no better than a booby.

JACK: Well, if you will have it, you will! But I tell you beforehand you won't like it. You know Stipend the banker?

CECILIA: Good Heaven, know him? Yes—what of him?

JACK: Why—now, upon my word, I'd rather not speak.

CECILIA: You sicken me with apprehension!

JACK: Well—had you much money in his hands?

CECILIA: Everything I am worth in the world!

JACK: Had you, faith?

CECILIA: You terrify me to death! What would you say?

BEAUFORT: No matter what—Jack, I could murder you!

JACK: There, now, I said how it would be! Now would not anybody suppose the man broke through my fault?

CECILIA: Broke? Oh Heaven, I am ruined!

BEAUFORT: No, my dearest Cecilia, your safety is wrapped in mine, and, to my heart's last sigh, they shall be inseparable.

LADY SMATTER: Broke? What can this mean?

MRS. SAPIENT: Broke? Who is broke? I am quite alarmed.

CODGER: In truth, this has the appearance of a serious business.

CECILIA: Mr. Beaufort, let me pass; I can stand this no longer.

BEAUFORT: Allow me to conduct you to your own room. This torrent will else overpower you. Jack, wait till I return. [*He leads* CECILIA *out*]

JACK: No, no, brother, you'll excuse me there! I've stayed too long already. [*Going*]

LADY SMATTER: Hold, Jack. I have ten thousand questions to ask you. Explain to me what all this means. It is of the utmost consequence I should know immediately.

MRS. SAPIENT: I too am greatly terrified. I know not but I may be myself concerned in this transaction, and really the thought of losing one's money is extremely serious, for, as far as *I* have seen of the world, there's no living without it.

CODGER: In truth, son Jack, you have put us all into tribulation.

MRS. SAPIENT: What, sir, did you say was the banker's name?

JACK: [*Aside*] Lord, how they worry me! [*To* LADY SMATTER.] Stipend, ma'am.

MRS. SAPIENT: Stipend? I protest he has concerns with half my

acquaintance! Lady Smatter, I am utmost consternation at this intelligence. I think one hears some bad news or other every day. Half the people one knows are ruined! I wish your ladyship good morning. Upon my word, in *my* opinion, a bankruptcy is no pleasant thing! [*Exit*]

LADY SMATTER: Pray, Jack, satisfy me more clearly how this affair stands. Tell me all you know of it.

JACK: [*Aside*] Lord, I shan't get away till midnight! [*To* LADY SMATTER] Why, ma'am, the man's broke, that's all.

LADY SMATTER: But *how*? Is there no prospect his affairs may be made up?

JACK: None; they say upon 'Change there won't be a shilling in the pound.

LADY SMATTER: What an unexpected blow! Poor Miss Stanley!

DABLER: 'Tis a shocking circumstance indeed. [*Aside*] I think it will make a pretty good elegy, though!

LADY SMATTER: I can't think what the poor girl will do! For here is an end of our marrying her!

DABLER: 'Tis very hard upon her indeed. [*Aside*] 'Twill be the most pathetic thing I ever wrote! [*To* LADY SMATTER] Ma'am, your ladyship's most obedient. [*Aside*] I'll to work while the subject is warm—nobody will read it with dry eyes! [*Exit*]

LADY SMATTER: I have the greatest regard in the world for Miss Stanley—nobody can esteem her more—but I can't think of letting Beaufort marry without money.

CODGER: Pray, madam, how came Miss Stanley to have such very large concerns with Mr. Stipend?

LADY SMATTER: Why, he was not only her banker but her guardian, and her whole fortune was in his hands. She is a pretty sort of girl; I am really grieved for her.

JACK: Lord, here's my brother! I wish I could make off.

Re-enter BEAUFORT.

BEAUFORT: Stay, sir! One word, and you will be most welcome to go. Whence had you the intelligence you so humanely communicated to Miss Stanley?

JACK: I had it upon 'Change. Everybody was talking of it.

BEAUFORT: Enough. I have no desire to detain you any longer.

JACK: Why now, brother, perhaps you think I am not sorry for Miss Stanley, because of my coming in such a hurry? But I do assure you it was out of mere good nature, for I made a point of running all the way, for fear she should hear it from a stranger.

BEAUFORT: I desire you will leave me. My mind is occupied with other matters than attending to your defence.

JACK: Very well, brother. Plague take it, I wish I had gone to Hyde Park at once! [*Exit*]

CODGER: In truth, son Beaufort, I must confess Jack has been somewhat abrupt; but nevertheless, I must hint to you that, when I am by, I think you might as well refer the due reproof to be given by me. Jack is not everybody's son, although he be mine.

BEAUFORT: I am sorry I have offended you, sir, but—

CODGER: Madam, as your house seems in some little perturbation, I hope you will excuse the shortness of my visit if I take leave now. Your ladyship's most humble servant. Jack is a good lad at the bottom, although he be somewhat wanting in solidity. [*Exit*]

BEAUFORT: At length, thank Heaven, the house is cleared. Oh madam, will you not go to Miss Stanley? I have left her in an agony of mind which I had no ability to mitigate.

LADY SMATTER: Poor thing! I am really in great pain for her.

BEAUFORT: Your ladyship alone has power to soothe her, a power which, I hope, you will instantly exert.

LADY SMATTER: I will go to her presently, or send for her here.

BEAUFORT: Surely your ladyship will go to *her*? At such a time as this, the smallest failure in respect—

LADY SMATTER: As to that, Beaufort—but I am thinking what the poor girl had best do. I really don't know what to advise.

BEAUFORT: If I may be honored with your powerful intercession, I hope to prevail with her to be mine immediately.

LADY SMATTER: Faugh, faugh, don't talk so idly.

BEAUFORT: Madam!

LADY SMATTER: Be quiet a few minutes, and let me consider what can be done.

BEAUFORT: But whilst we are both absent, what may not the sweet sufferer imagine?

LADY SMATTER: Suppose we get her into the country? Yet I know not what she can do when she is there. She can't live on green trees.

BEAUFORT: What does your ladyship mean?

LADY SMATTER: Nothing is so difficult as disposing of a poor girl of fashion.

BEAUFORT: Madam!

LADY SMATTER: She has been brought up to nothing. If she can make a cap, 'tis as much as she can do—and in such a case, when a girl is reduced to a penny, what is to be done?

BEAUFORT: Good Heaven, madam, will Miss Stanley ever be reduced to a penny, while I live in affluence?

LADY SMATTER: Beaufort—to cut the matter short, you must give her up.

BEAUFORT: Give her up?

LADY SMATTER: Certainly. You can never suppose I shall consent to your marrying a girl who has lost all her fortune? While the match seemed suitable to your expectations, and to my intentions towards you, I readily countenanced it, but now, it is quite a different thing. All is changed, and—

BEAUFORT: No, madam, no, all is not changed, for the heart of Beaufort is unalterable! I loved Miss Stanley in prosperity; in adversity, I adore her! I solicited her favour when she was surrounded by my rivals, and I will still supplicate it, though she should be deserted by all the world besides. Her distress shall increase my tenderness, her poverty shall redouble my respect, and her misfortunes shall render her more dear to me than ever!

LADY SMATTER: Beaufort, you offend me extremely. I have as high notions of sentiment and delicacy as you can have, for the study of the fine arts, as Pope justly says, greatly enlarges the mind; but for all that, if you would still have me regard you as a son,

you must pay me the obedience due to a mother, and never suppose I adopted you to marry you to a beggar.

BEAUFORT: A beggar?—Indignation chokes me!—I must leave you, madam. The submission I pay you as a nephew, and the obedience I owe you as an adopted son, will else both give way to feelings I know not how to stifle! [*Exit*]

LADY SMATTER: This is really an unfortunate affair. I am quite distressed how to act, for the eyes of all the world will be upon me! I will see the girl, however, and give her a hint about Beaufort.—William! [*Enter a* SERVANT] Tell Miss Stanley I beg to speak to her. [*Exit* SERVANT] I protest I wish she was fairly out of the house! I never cordially liked her. She has not a grain of taste, and her compliments are so cold, one has no pleasure in receiving them. She is a most insipid thing! I shan't be sorry to have done with her.

Enter CECILIA.

Miss Stanley, my dear, your servant.

CECILIA: Oh, madam!

LADY SMATTER: Take courage, don't be so downcast; a noble mind, as I was reading the other day, is always superior to misfortune.

CECILIA: Alas, madam, in the first moments of sorrow and disappointment, philosophy and rhetoric offer their aid in vain! Affliction may indeed be alleviated but it must first be felt.

LADY SMATTER: I did not expect, Miss Stanley, you would have disputed this point with *me*. I thought, after so long studying matters of this sort, I might be allowed to be a better judge than a young person who has not studied them at all.

CECILIA: Good Heaven, madam, are you offended?

LADY SMATTER: Whether I am or not, we'll not talk of it now. It would be illiberal to take offence at a person in distress.

CECILIA: Madam!

LADY SMATTER: Do you think Jack may have been misinformed?

CECILIA: Alas, no! I have just received this melancholy confirmation of his intelligence. [*Gives* LADY SMATTER *a letter*]

LADY SMATTER: Upon my word, 'tis a sad thing! A sad stroke upon

my word! However, you have good friends, and such as, I dare say, will take care of you.

CECILIA: Take care of me, madam?

LADY SMATTER: Yes, my dear, *I* will for one. And you should consider how much harder such a blow would have been to many other poor girls, who have not your resources.

CECILIA: My resources? I don't understand you.

LADY SMATTER: Nay, my dear, I only mean to comfort you, and to assure you of continued regard, and if you can think of anything in which I can serve you, I am quite at your command. Nobody can wish you better. My house too shall always be open to you. I should scorn to desert you because you are in distress. A mind, indeed, cultivated and informed, as Shakespeare has it, will ever be above a mean action.

CECILIA: I am quite confounded!

LADY SMATTER: In short, my dear, you will find *me* quite at your disposal, and as much your friend as in the sunshine of your prosperity, but as to Beaufort—

CECILIA: Hold, madam! I now begin to understand your ladyship perfectly.

LADY SMATTER: Don't be hasty, my dear. I say as to Beaufort, he is but a young man, and young men, you know, are mighty apt to be rash; but when they have no independence, and are of no profession, they should be very cautious how they disoblige their friends. Besides, it always happens that, when they are drawn in to their own ruin, they involve—

CECILIA: No more, I beseech you, madam! I know not how to brook such terms, or to endure such indignity. I shall leave your ladyship's house instantly, nor, while any other will receive me, shall I re-enter it! Pardon me, madam, but I am yet young in the school of adversity, and my spirit is not yet tamed down to that abject submission to unmerited mortifications which time and long suffering can alone render supportable.

LADY SMATTER: You quite surprise me, my dear! I can't imagine what you mean. However, when you mind is more composed, I beg you will follow me to my own room. Till then, I will leave

you to your meditations, for, as Swift has well said, 'tis vain to reason with a person in a passion. [*Exit*]

CECILIA: Follow you? No, no, I will converse with you no more. Cruel, unfeeling woman! I will quit your inhospitable roof; I will seek shelter—alas where? Without fortune, destitute of friends, ruined in circumstances, yet proud of heart—where can the poor Cecilia seek shelter, peace or protection? Oh Beaufort! 'Tis thine alone to console me; thy sympathy shall soften my calamities, and thy fidelity shall instruct me to support them. Yet fly I must! Insult ought not to be borne, and those who twice risk, the third time deserve it.

ACT III, SCENE I

A dressing room at LADY SMATTER's. *Enter* LADY SMATTER, *followed by* BEAUFORT.

BEAUFORT: Madam, you distract me! 'Tis impossible her intentions should be unknown to you. Tell me, I beseech you, whither she is gone, what are her designs, and why she deigned not to acquaint me with her resolution.

LADY SMATTER: Why will you, Beaufort, eternally forget that it is the duty of every wise man, as Swift has admirably said, to keep his passions to himself?

BEAUFORT: She must have been *driven* to this step; it could never have occurred to her without provocation. Relieve me then, madam, from a suspense insupportable, and tell me at least to what asylum she has flown?

LADY SMATTER: Beaufort, you make me blush for you! Who would suppose that a scholar, a man of cultivated talents, could behave so childishly? Do you remember what Pope has said upon this subject?

BEAUFORT: This is past endurance! No, madam, no! At such a time as this, his very name is disgustful to me.

LADY SMATTER: How! Did I hear right? The name of Pope disgust-ful?

BEAUFORT: Yes, madam. Pope, Swift, Shakespeare himself, and every other name you can mention but that of Cecilia Stanley, is hateful to my ear, and detestable to my remembrance.

LADY SMATTER: I am thunderstruck! This is downright blasphemy.

BEAUFORT: Good Heaven, madam, is this a time to talk of books and authors? However, if your ladyship is cruelly determined to give me no satisfaction, I must endeavour to procure intelligence elsewhere.

LADY SMATTER: I protest to you she went away without speaking to me. She sent for a chair and did not even let the servants hear whither she ordered it.

BEAUFORT: Perhaps, then, she left a letter for you? Oh I am sure she did! Her delicacy, her just sense of propriety would never suffer her to quit your ladyship's house with an abruptness so unaccountable.

LADY SMATTER: Well, well, whether she write or not is nothing to the purpose. She has acted a very prudent part in going away, and, once again I repeat, you must give her up.

BEAUFORT: No, madam, never! Never while life is lent me will I give up the tie that renders it most dear to me.

LADY SMATTER: Well, sir, I have only this to say: one must be given up, she or me. The decision is in your own hands.

BEAUFORT: Deign then, madam, to hear my final answer, and to hear it, if possible, with lenity. That your favour, upon every account, is valuable to me, there can be no occasion to assert, and I have endeavoured to prove my sense of the goodness you have so long shown me, by all the gratitude I have been able to manifest. You have a claim undoubted to my utmost respect and humblest deference, but there is yet another claim upon me, a sacred, irresistible claim: honor! And this were I to forego, not all your ladyship's most unbounded liberality and munificence would prove adequate reparation for so dreadful, so atrocious a sacrifice!

Enter a SERVANT.

SERVANT: Mr. Censor, my lady.

LADY SMATTER: Beg him to walk upstairs. I will put this affair into his hands. [*Aside*] He is a sour, morose, ill-tempered wretch, and will give Beaufort no quarter.

Enter CENSOR.

Mr. Censor, I am very glad to see you.

CENSOR: I thank your ladyship. Where is Miss Stanley?

LADY SMATTER: Why, not at home. Oh Mr. Censor, we have the saddest thing to tell you! We are all in the greatest affliction. Poor Miss Stanley has met with the cruellest misfortune you can conceive.

CENSOR: I have heard the whole affair.

LADY SMATTER: I am vastly glad you came, for I want to have a little rational consultation with you. Alas, Mr. Censor, what an unexpected stroke! You can't imagine how unhappy it makes me.

CENSOR: Possibly not, for my imagination is no reveller; it seldom deviates from the bounds of probability.

LADY SMATTER: Surely you don't doubt me?

CENSOR: No, madam, not in the least!

LADY SMATTER: I am happy to hear you say so.

CENSOR: [*Aside*] You have but little reason if you understood me. [*To* LADY SMATTER] When does your ladyship expect Miss Stanley's return?

LADY SMATTER: Why, really, I can't say exactly, for she left the house in a sort of hurry. I would fain have dissuaded her, but all my rhetoric was ineffectual. Shakespeare himself would have pleaded in vain! To say the truth, her temper is none of the most flexible; however, poor thing, great allowance ought to be made for her unhappy situation, for, as the poet has it, misfortune renders everybody unamiable.

CENSOR: What poet?

LADY SMATTER: Bless me, don't you know? Well, I shall now grow proud indeed if I can boast of making a quotation that is new to the learned Mr. Censor. My present author, sir, is Swift.

CENSOR: Swift? You have, then, some private edition of his works?

216

LADY SMATTER: Well, well, I won't be positive as to Swift. Perhaps it was Pope. 'Tis impracticable for anybody that reads so much as I do to be always exact as to an author. Why now, how many volumes do you think I can run through in one year's reading?

CENSOR: More than would require seven years to digest.

LADY SMATTER: Faugh, faugh, but I study besides, and, when I am preparing a criticism, I sometimes give a whole day to poring over only one line. However, let us, for the present, quit these abstruse points, and, as Parnell says, "e'en talk a little like folks of this world."

CENSOR: Parnell? You have, then, made a discovery with which you should oblige the public, for that line passes for Prior's.

LADY SMATTER: Prior? Oh, very true, so it is. Bless me, into what errors does extensive reading lead us! But to business—this poor girl must, some way or other, be provided for, and my opinion is she had best return to her friends in the country. London is a dangerous place for girls who have no fortune. Suppose you go to her, and reason with her upon the subject?

BEAUFORT: You *do* know her direction, then?

LADY SMATTER: No matter; I will not have *you* go to her, whoever does. Would you believe it, Mr. Censor, this unthinking young man would actually marry the girl without a penny? However, it behoves me to prevent him, if only for example's sake. That, indeed, is the chief motive which governs me, for such is my "fatal pre-eminence," as Addison calls it, that, should I give way, my name will be quoted for a licence to indiscreet marriages for ages yet to come.

CENSOR: I hope, madam, the gratitude of the world will be adequate to the obligations it owes you.

LADY SMATTER: Well, Mr. Censor, I will commit the affair to your management. This paper will tell you where Miss Stanley is to be met with, and pray tell the poor thing she may always depend upon my protection, and that I feel for her most extremely. But, above all things, let her know she must think no more of Beaufort, for why should the poor girl be fed with

false hopes? It would be barbarous to trifle with her expectations. I declare I should hate myself were I capable of such cruelty. Tell her so, Mr. Censor, and tell her—

BEAUFORT: Oh madam, forebear! Heavens, what a message for Miss Stanley! Dishonor not yourself by sending it. Is she not the same Miss Stanley who was so lately respected, caressed and admired? Whose esteem you sought? Whose favour you solicited? Whose alliance you coveted? Can a few moments have obliterated all remembrance of her merit? Shall *we* be treacherous because *she* is unfortunate? Must *we* lose our integrity because *she* has lost her fortune? Oh madam, reflect, while it is yet time, that the judgement of the world at large is always impartial, and let us not, by withholding protection from her, draw universal contempt and reproach upon ourselves!

LADY SMATTER: Beaufort, you offend me extremely. Do you suppose I have laboured so long at the fine arts, and studied so deeply the intricacies of Literature, to be taught at last the right rule of conduct by my nephew? Oh, Mr. Censor, how well has Shakespeare said rash and inconsiderate is youth! But I must waive a further discussion of this point at present, as I have some notes to prepare for our Esprit Party of tonight. But remember, Beaufort, that if you make any attempt to see or write to Miss Stanley, I will disown and disinherit you. Mr. Censor, you will enforce this doctrine, and pray tell him, it was a maxim with Pope—or Swift, I am not sure which—that resolution, in a cultivated mind, is unchangeable. [*Exit*]

BEAUFORT: By Heaven, Censor, with all your apathy and misanthropy, I had believed you incapable of listening to such inhumanity without concern.

CENSOR: Know you not, Beaufort, that though we can all see the surface of a river, its depth is only to be fathomed by experiment? Had my concern been shallow, it might have babbled without impediment, but, as it was strong and violent, I restrained it, lest a torrent of indignation should have overflowed your future hopes, and laid waste my future influence.

BEAUFORT: Show me, I beseech you, the paper, that I may hasten to

the lovely, injured writer, and endeavour, by my fidelity and sympathy, to make her forget my connections.

CENSOR: Not so fast, Beaufort. When a man has to deal with a lover, he must think a little of himself, for he may be sure the *inamorato* will think only of his mistress.

BEAUFORT: Surely you do not mean to refuse me her direction?

CENSOR: Indeed I do, unless you can instruct me how to sustain the assault that will follow my surrendering it.

BEAUFORT: Why will you trifle with me thus? What to you is the resentment of Lady Smatter?

CENSOR: How gloriously inconsistent is the conduct of a professed lover! While to his mistress he is tame submission and abject servility, to the rest of the world he is commanding, selfish and obstinate. Everything is to give way to him, no convenience is to be consulted, no objections are to be attended to in opposition to his wishes. It seems as if he thought it the sole business of the rest of mankind to study his single interest, in order, perhaps, to recompense him for pretending to his mistress that he has no will but hers.

BEAUFORT: Show me the address, then rail at your leisure.

CENSOR: You think nothing, then, of the disgrace I must incur with this literary phenomenon if I disregard her injunctions? Will she not exclude me forever from the purlieus of Parnassus? Stun me with the names of authors she has never read, and pester me with flimsy sentences which she has the assurance to call quotations?

BEAUFORT: Well, well, well!

CENSOR: Will she not tell me that Pope brands a breach of trust as dishonorable? That Shakespeare stigmatises the meanness of treachery? And recollect having read in Swift that fortitude is one of the cardinal virtues?

BEAUFORT: Stuff and folly! Does it matter what she says? The paper! The direction!

CENSOR: Heavens, that a woman whose utmost natural capacity will hardly enable her to understand the *History of Tom Thumb*, and whose comprehensive faculties would be absolutely baffled by

the *Lives of the Seven Champions of Christendom*, should dare blaspheme the names of our noblest poets with words that convey no ideas, and sentences of which the sound listens in vain for sense! Oh, she is insufferable!

BEAUFORT: How unseasonable a discussion! Yet you seem to be more irritated at her folly about books than at her want of feeling to the sweetest of her sex.

CENSOR: True, but the reason is obvious. Folly torments because it gives present disturbance; as to want of feeling, 'tis a thing of course. The moment I heard that Miss Stanley had lost her fortune, I was certain of all that would follow.

BEAUFORT: Can you then see such treachery without rage or emotion?

CENSOR: No, not without *emotion*, for base actions always excite contempt, but *rage* must be stimulated by surprise. No man is much moved by events that merely answer his expectations.

BEAUFORT: Censor, will you give me the direction? I have neither time nor patience for further uninteresting discussions. If you are determined to refuse it, say so. I have other resources, and I have a spirit resolute to essay them all.

CENSOR: It is no news to me, Beaufort, that a man may find more ways than one to ruin himself; yet, whatever pleasure may attend putting them in practice, I believe it seldom happens, when he is irreparably undone, that he piques himself upon his success.

BEAUFORT: I will trouble you no longer—your servant. [*Going*]

CENSOR: Hold, Beaufort! Forget, for a few moments, the lover, and listen to me, not with passion but understanding. Miss Stanley, you find, has now no dependence but upon you—you have none but upon Lady Smatter—what follows?

BEAUFORT: Distraction, I believe—I have nothing else before me!

CENSOR: If, instantly and wildly, you oppose her in the first heat of her determination, you will have served a ten years' apprenticeship to her caprices without any other payment than the pleasure of having endured them. She will regard your disobedience as rebellion to her judgement and resent it with acrimony.

BEAUFORT: Oh misery of dependence! The heaviest toil, the hardest labour, fatigue the most intense—what are they compared to the corroding servility of discontented dependence?

CENSOR: Nothing, I grant, is so painful to endure, but nothing is so difficult to shake off; and therefore, as you are now situated, there is but one thing in the world can excuse your seeking Miss Stanley.

BEAUFORT: Whatever it may be, I shall agree to it with transport. Name it.

CENSOR: Insanity.

BEAUFORT: Censor, at such a time as this, raillery is unpardonable.

CENSOR: Attend to me, then, in sober sadness. You must give up all thoughts of quitting this house, till the ferocity of your learned aunt is abated.

BEAUFORT: Impossible!

CENSOR: Nay, prithee, Beaufort, act not as a lunatic while you disclaim insanity. I will go to Miss Stanley myself, and bring you an account of her situation.

BEAUFORT: Would you have me, then, submit to this tyrant?

CENSOR: Would I have a farmer, after sowing a field, not wait to reap the harvest?

BEAUFORT: I will endeavour, then, to yield to your counsel. But remember, Censor, my yielding is not merely reluctant: it must also be transitory. For if I do not speedily find the good effects of my self-denial, I will boldly and firmly give up forever all hopes of precarious advantage, for the certain, the greater, the nobler blessing of claiming my lovely Cecilia—though at the hazard of ruin and destruction!

CENSOR: And do you, Beaufort, remember in turn, that had I believed you capable of a different conduct, I had never ranked you as my friend.

BEAUFORT: Oh Censor, how soothing to my anxiety is your hard-earned but most flattering approbation! Hasten, then, to the sweet sufferer. Tell her my heart bleeds at her unmerited distresses. Tell her that, with her fugitive self, peace and happiness both flew this mansion. Tell her that when we meet—

CENSOR: All these messages may be given, but not till then, believe me! Do you suppose I can find no better topic for conversation than making soft speeches by proxy?

BEAUFORT: Tell her, at least, how much—

CENSOR: My good friend, I am not ignorant that lovers, fops, fine ladies and chambermaids have all charters for talking nonsense. It is, therefore, a part of their business, and they deem it indispensable, but I never yet heard of any order of men so unfortunate as to be under a necessity of listening to them. [*Exit*]

BEAUFORT: Dear, injured Cecilia! Why cannot I be myself the bearer of the faith I have plighted thee, prostrate myself at thy feet, mitigate thy sorrows, and share or redress thy wrongs? Even while I submit to captivity, I disdain the chains that bind me—but alas, I rattle them in vain! Oh happy those who to their own industry owe their subsistence, and to their own fatigue and hardships their succeeding rest and rewarding affluence! Now indeed do I feel the weight of bondage, since it teaches me to envy even the toiling husbandman and laborious mechanic.

ACT III, SCENE II

The scene changes to an apartment at MRS. VOLUBLE'*s;* DABLER *is discovered writing.*

DABLER: "The pensive maid, with saddest sorrow sad"—no, hang it, that won't do! "Saddest sad" will never do. With—with—with "mildest"—ay, that's it!—"The pensive maid with mildest sorrow sad"—I should like, now, to hear a man mend that line! I shall never get another equal to it. Let's see—sad, bad, lad, dad—curse it, there's never a rhyme will do! Where's the art of poetry? Oh here—now we shall have it. Add—hold, that will do at once—[*Reads*] "with mildest sorrow sad, shed crystal tears and sigh to sigh did add." Admirable! Admirable, by all that's good! Now let's try the first stanza. [*Reads*] "Ye gentle nymphs, whose hearts are prone to love,

Ah hear my song, and ah! my song approve;
And ye, ye glorious, mighty sons of fame,
Ye mighty warriors—"
How's this, two "mightys"? Hang it, that won't do! Let's see—ye
"glorious" warriors—no, there's "glorious" before—oh curse it,
now I've got it all to do over again! Just as I thought I had
finished it! Ye "fighting"—no—ye "towering," no—ye—ye—
ye—I have it, by Apollo!

Enter BETTY.

BETTY: Sir, here's a person below who—
DABLER: [*Starting up in a rage*] Now curse me if this is not too much!
What do you mean by interrupting me at my studies? How
often have I given orders not to be disturbed?
BETTY: I'm sure, sir, I thought there was no harm in just telling
you—
DABLER: Tell me nothing! Get out of the room directly! And take
care you never break in upon me again—no, not if the house
be on fire! Go, I say!
BETTY: Yes, sir. [*Aside*] Lord, how masters and misisses do love scold-
ing! [*Exit*]
DABLER: What a provoking intrusion! Just as I had worked myself into
the true spirit of poetry! I shan't recover my ideas this half-hour.
'Tis a most barbarous thing that a man's retirement cannot be
sacred. [*Sits down to write*] Ye "fighting"—no, that was not
it—ye—ye—ye—oh curse it, [*Stamping*] if I have not forgot
all I was going to say! That unfeeling, impenetrable fool has lost
me more ideas than would have made a fresh man's reputation.
I'd rather have given 100 guineas than have seen her. I protest,
I was upon the point of making as good a poem as any in the
language—my numbers flowed—my thoughts were ready—my
words glided—but now, all is gone! All gone and evaporated!
[*Claps his hand on his forehead*] Here's nothing left! Nothing
in the world! What shall I do to compose myself? Suppose I
read? Why, where the deuce are all the things gone? [*Looking
over his papers*] Oh, here. I wonder how my epigram will read

today. I think I'll show it to Censor; he has seen nothing like it of late. I'll pass it off for some dead poet's, or he'll never do it justice—let's see, suppose Pope? No, it's too smart for Pope. Pope never wrote anything like it! Well then, suppose—

Enter MRS. VOLUBLE.

Oh curse it, another interruption!

MRS. VOLUBLE: I hope, sir, I don't disturb you? I'm sure I would not disturb you for the world, for I know nothing's so troublesome, and I know you gentlemen writers dislike it of all things, but I only just wanted to know if the windows were shut, for fear of the rain, for I asked Betty if she had been in to see about them, but she said—

DABLER: They'll do very well, pray leave them alone. I am extremely busy. [*Aside*] I must leave these lodgings, I see!

MRS. VOLUBLE: Oh sir, I would not stay upon any account, but only sometimes there are such sudden showers, that if the windows are left open, half one's things may be spoilt, before one knows anything of the matter. And if so much as a paper of yours was to be damaged, I should never forgive myself, for I'd rather all the poets in the world should be burnt in one great bonfire than lose so much as the most miniken bit of your writing, though no bigger than my nail.

DABLER: My dear Mrs. Voluble, you are very obliging. [*Aside*] She's mighty good sort of woman—I've a great mind to read her that song—no, this will be better. [*To* MRS. VOLUBLE] Mrs. Voluble, do you think you can keep a secret?

MRS. VOLUBLE: Oh dear sir, I'll defy anybody to excel me in that! I am more particular scrupulous about secrets than anybody.

DABLER: Well then, I'll read you a little thing I've just been composing, and you shall tell me your opinion of it. [*Reads*] "ON A YOUNG LADY BLINDED BY LIGHTNING.

"Fair Cloris, now deprived of sight,
To error ow'd her fate uneven;
Her eyes were so refulgent bright
The blundering lightning thought them Heaven."

What do you think of it, Mrs. Voluble?

MRS. VOLUBLE: Oh I think it the prettiest, most moving thing I ever heard in my life.

DABLER: Do you indeed? Pray sit down, Mrs. Voluble, I protest I never observed you were standing.

MRS. VOLUBLE: Dear sir, you're vastly polite. [*Seats herself*]

DABLER: So you really think it's pretty good, do you?

MRS. VOLUBLE: Oh dear yes, sir; I never heard anything I liked so well in my life. It's prodigious fine, indeed!

DABLER: Pray, don't sit so near the door, Mrs. Voluble; I'm afraid you will take cold. [*Aside*] 'Tis amazing to me where this woman picked up so much taste!

MRS. VOLUBLE: But I hope, sir, my being here is of no hindrance to you, because, if it is, I'm sure—

DABLER: No, Mrs. Voluble, [*Looking at his watch*] I am obliged to go out myself now. I leave my room in your charge. Let care be taken that no human being enters it in my absence, and don't let one of my papers be touched or moved upon any account.

MRS. VOLUBLE: Sir, I shall lock the door, and put the key in my pocket. Nobody shall so much as know there's a paper in the house. [*Exit DABLER*] I believe it's almost a week since I've had a good rummage of them myself. Let's see, is not this 'Sprit Night? Yes; and he won't come home till very late, so I think I may as well give them a fair look over at once. [*Seats herself at the table*] Well now, how nice and snug this is! What's here? [*Takes up a paper*]

Enter BOB.

BOB: Mother, here's Miss Jenny, the milliner-maker.

MRS. VOLUBLE: Is there? Ask her to come up.

BOB: Lord, mother, why, you would not have her come into Mr. Dabler's room? Why, if he—

MRS. VOLUBLE: What's that to you? Do you suppose I don't know what I'm about? You're never easy but when you're a-talking—always prate, prate, prate, about something or other. Go and ask her to come up, I say.

BOB: Lord, one can't speak a word! [*Exit*]

MRS. VOLUBLE: Have done, will you? Mutter, mutter, mutter. It will be a prodigious treat to Miss Jenny to come into this room.

Enter MISS JENNY.

Miss Jenny, how do do, my dear? This is very obliging of you. Do you know whose room you are in?

MISS JENNY: No, ma'am.

MRS. VOLUBLE: Mr. Dabler's own room, I assure you! And here's all his papers; these are what he calls his miniscrips.

MISS JENNY: Well, what a heap of them!

MRS. VOLUBLE: And he's got five or six boxes brimful besides.

MISS JENNY: Dear me! Well, I could not do so much if I was to have the Indies!

MRS. VOLUBLE: Now, if you'll promise not to tell a living soul a word of the matter, I'll read you some of them; but be sure now, you don't tell.

MISS JENNY: Dear no, I would not for ever so much.

MRS. VOLUBLE: Well, then, let's see—what's this? [*Takes up a paper*] "Elegy on the slaughter of a lamb."

MISS JENNY: Oh pray let's have that.

MRS. VOLUBLE: I'll put it aside, and look out some more. "A dialogue between a tear and a sigh"—"Verses on a young lady's fainting away"—

MISS JENNY: That must be pretty indeed! I dare say it will make us cry.

MRS. VOLUBLE: "An epitaph on a fly killed by a spider," "An—"

Enter BOB.

BOB: Mother, here's a young gentlewoman wants you.

MRS. VOLUBLE: A young gentlewoman? Who can it be?

BOB: I never see her before. She's a deal smarter than Miss Jenny.

MISS JENNY: I'm sure I'd have come more dressed, if I'd known of seeing anybody.

MRS. VOLUBLE: Well, I can't imagine who it is. I'm sure I'm in a sad pickle. Ask her into the parlour.

MISS JENNY: Dear ma'am, you'd better by half see her here. All the fine folks have their company upstairs, for I see a deal of the quality by carrying things home.

MRS. VOLUBLE: Well then, ask her to come up.

BOB: But suppose Mr. Dabler—

MRS. VOLUBLE: Mind your own business, sir, and don't think to teach me. Go and ask her up this minute.

BOB: I'm going, ain't I? [*Exit*]

MRS. VOLUBLE: I do verily believe that boy has no equal for prating; I never saw the like of him. His tongue's always a-running.

Re-enter BOB, *followed by* CECILIA.

BOB: Mother, here's the young gentlewoman.

CECILIA: I presume, ma'am, you are Mrs. Voluble?

MRS. VOLUBLE: Yes, ma'am.

CECILIA: I hope you will excuse this intrusion, and I must beg the favour of a few minutes private conversation with you.

MRS. VOLUBLE: To be sure, ma'am. Bobby, get the lady a chair. I hope, ma'am, you'll excuse Bobby's coming in before you. He's a sad, rude boy for manners.

BOB: Why, the young gentlewoman bid me herself; 'twas no fault of mine.

MRS. VOLUBLE: Be quiet, will you? Jabber, jabber, jabber! There's no making you hold your tongue a minute. Pray, ma'am, do sit down.

CECILIA: I thank you, I had rather stand. I have but a few words to say to you, and will not detain you five minutes.

MISS JENNY: Suppose Master Bobby and I go downstairs till the lady has done? [*Apart to* MRS. VOLUBLE] Why, Lord, Mrs. Voluble, I know who that lady is as well as I know you! Why, it's Miss Stanley, that we've been making such a heap of things for.

MRS. VOLUBLE: Why, you don't say so! What, the bride?

MISS JENNY: Yes.

MRS. VOLUBLE: Well, I protest I thought I'd seen her somewhere before. [*To* CECILIA] Ma'am, I'm quite ashamed of not recollecting you sooner, but I hope your goodness will excuse it. I

hope, ma'am, the good lady your aunt is well? That is, your aunt that is to be?

CECILIA: If you mean Lady Smatter, I believe she is well.

MRS. VOLUBLE: I'm sure, ma'am, I've the greatest respect in the world for her ladyship, though I have not the pleasure to know her; but I hear all about her from Mrs. Hobbins—to be sure, ma'am, you know Mrs. Hobbins, my lady's housekeeper?

CECILIA: Certainly. It was by her direction I came hither.

MRS. VOLUBLE: That was very obliging of her, I'm sure, and I take your coming as a very particular favour. I hope, ma'am, all the rest of the family's well? And Mrs. Simper, my lady's woman? But I beg pardon for my ill manners, ma'am, for, to be sure, I ought first to have asked for Mr. Beaufort. I hope he's well, ma'am?

CECILIA: I—I don't know—I believe—I fancy he is.

MRS. VOLUBLE: Well, he's a most agreeable gentleman indeed, ma'am, and I think—

CECILIA: If it is inconvenient for me to speak to you now—

MRS. VOLUBLE: Not at all, ma'am; Miss Jenny and Bobby can as well divert themselves in the parlour.

MISS JENNY: Dear me, yes, I'll go directly.

BOB: And I'll go and sit in the kitchen and look at the clock and when it's five minutes, I'll tell Miss Jenny.

MISS JENNY: Come then, Master Bobby. [*Aside*] She's very melancholic, I think, for a young lady just going to be married. [*Exit with* BOB]

CECILIA: The motive which has induced me to give you this trouble, Mrs. Voluble—

MRS. VOLUBLE: Dear ma'am, pray don't talk of trouble, for I'm sure I think it none. I take it quite as a favour to receive a visit from such a young lady as you. But pray, ma'am, sit down; I'm quite ashamed to see you standing. It's enough to tire you to death.

CECILIA: It is not of the least consequence. A very unexpected and unhappy event has obliged me most abruptly to quit the house of Lady Smatter, and if—

MRS. VOLUBLE: Dear ma'am, you surprise me! But I hope you have not parted upon account of any disagreement?

CECILIA: I must beg you to hear me. I have at present insuperable objections to visiting any of my friends; and Mrs. Hobbins, who advised me to apply to you, said she believed you would be able to recommend me to some place where I can be properly accommodated till my affairs are settled.

MRS. VOLUBLE: To be sure, ma'am, I can. But pray, ma'am, may I make bold to ask the reason of your parting?

CECILIA: I am not at present at liberty to tell it. Do you recollect any place that—

MRS. VOLUBLE: Oh dear, yes, ma'am, I know many. Let's see—there's one in King Street—and there's one in Charles Street—and there's another in—Lord, I dare say I know an hundred! Only I shall be very cautious of what I recommend, for it is not every place will do for such a lady as you. But pray, ma'am, where may Mr. Beaufort be? I hope he has no hand in this affair?

CECILIA: Pray ask me no questions!

MRS. VOLUBLE: I'm sure, ma'am, I don't mean to be troublesome; and, as to asking questions, I make a point not to do it, for I think that curiosity is the most impertinent thing in the world. I suppose, ma'am, he knows of your being here?

CECILIA: No, no—he knows nothing about me.

MRS. VOLUBLE: Well, that's quite surprising, upon my word! To be sure, poor gentleman, it must give him a deal of concern, that's but natural, and besides—

CECILIA: Can you name no place to me, Mrs. Voluble, that you think will be eligible?

MRS. VOLUBLE: Yes, sure I can, ma'am. I know a lady in the very next street, who has very genteel apartments, that will come to about five or six guineas a week, for, to be sure, a young lady of your fortune would not choose to give less.

CECILIA: Alas!

MRS. VOLUBLE: Dear ma'am, don't vex so. I dare say my lady will think better of it. Besides, it's for her interest, for though, to be sure, Mr. Beaufort will have a fine income, yet young ladies of

forty thousand pounds fortune ain't to be met with every day,
and the folks say, ma'am, that yours will be full that.

CECILIA: I must entreat you, Mrs. Voluble, not to speak of my affairs
at present. My mind is greatly disordered, and I cannot bear
the subject.

MRS. VOLUBLE: Dear ma'am, I won't say another word. To be sure,
nothing's so improper as talking of private affairs. It's a thing
I never do, for really—

Enter MISS JENNY *and* BOB.

MISS JENNY: May we come in?

MRS. VOLUBLE: Lord, no; why, I ha'n't heard one single thing yet.

BOB: It's a great deal past the five minutes. I've been looking at the
clock all the time.

MISS JENNY: Well, then, shall we go again?

CECILIA: No, it is not necessary. Mrs. Voluble, you can be so good
as to answer my question, without troubling anybody to leave
the room.

MISS JENNY: Then we'll keep at this side, and we shan't hear what
you say. [MISS JENNY *and* BOB *walk aside*]

MRS. VOLUBLE: What think you, ma'am, of that place I men-
tioned?

CECILIA: I mean to be quite private, and should wish for a situation
less expensive.

MRS. VOLUBLE: Why, sure, ma'am, you would not think of giving
less than five guineas a week? That's just nothing out of such
a fortune as yours.

CECILIA: Talk to me no more of my fortune, I beseech you. I have
none! I have lost it all!

MRS. VOLUBLE: Dear ma'am, why, you put me quite in a cold sweat!
Lost all your fortune?

CECILIA: I know not what I say! I can talk no longer—pray, excuse
my incoherence—and if you can allow me to remain here for
half an hour, I may, in that time perhaps hear from my friends,
and know better how to guide myself.

MRS. VOLUBLE: Yes, sure, ma'am, I shall be quite proud of your

company. But I hope, ma'am, you was not in earnest about losing fortune?

CECILIA: Let nothing I have said be mentioned, I beseech you. Converse with your friends as if I was not here, and suffer me to recover my composure in silence. [*Walks away*]. [*Aside*] Oh Beaufort, my only hope and refuge! I hasten to my support, ere my spirits wholly sink under the pressure of distressful suspense.

MRS. VOLUBLE: Well, this is quite what I call a *nigma*! Miss Jenny, my dear, come here; I'll tell you how it is. Do you know she's come away from Lady Smatter's?

MISS JENNY: Dear me!

MRS. VOLUBLE: Yes; and what's worse, she says she's lost all her fortune.

MISS JENNY: Lost all her fortune? Lack a daisy! Why, then who's to pay for all our things? Why, we've got such a heap as will come to a matter of I don't know how much.

MRS. VOLUBLE: Well, to be sure, it's a sad thing, but you're to know I don't much believe it, for she said it in a sort of a pet, and my notion is she has been falling out with her sweetheart, and if so maybe her head's a little touched. Them things often happens in the quarrels of lovers.

Enter BETTY.

BETTY: Ma'am, here's a gentleman wants the young lady.

CECILIA: [*Starting*] 'Tis surely Beaufort! Beg him to walk upstairs. Mrs. Voluble, will you excuse this liberty?

MRS. VOLUBLE: Yes, sure, ma'am.

CECILIA: [*Aside*] Dear, constant Beaufort! How grateful to my heart is this generous alacrity!

MRS. VOLUBLE: [*Aside to* MISS JENNY] I dare say this is her sweetheart.

MISS JENNY: Dear me, how nice! We shall hear all they say!

Enter CENSOR.

CECILIA: Mr. Censor! Good Heaven!

CENSOR: Miss Stanley, I will not say I rejoice, for, in truth, in this place I grieve to see you.

MRS. VOLUBLE: Pray, sir, won't you sit down?

CENSOR: I thank you, madam, I had rather stand. Miss Stanley, I must beg the honor of speaking to you alone.

MRS. VOLUBLE: Oh sir, if you like it, I'm sure we'll go.

CENSOR: Aye, pray do.

MRS. VOLUBLE: [*Aside to* MISS JENNY] This gentleman is by no means what I call a polite person. [*To* CENSOR] Sir, I hope you'll put the young lady in better spirits. She has been very low indeed since she came, and, sir, if you should want for anything, I beg—

CENSOR: Do, good madam, be quick. I am in haste.

MRS. VOLUBLE: We're going directly, sir. Come, Miss Jenny. Bobby, you great oaf, what do you stand gaping there for? Why don't you go?

BOB: Why, you would not have me go faster than I can, would you? [*Exit*]

MRS. VOLUBLE: I would have you hold your tongue, Mr. Prate-a-pace! Always wrangling and wrangling. Come, Miss Jenny! [*Exit*]

MISS JENNY: I don't see why we might not as well have stayed here. [*Exit*]

CECILIA: By what means, sir, have you discovered me? Have you been at Lady Smatter's? Does anybody there know where I am, except her ladyship?

CENSOR: First, let me ask you what possible allurement could draw you under this roof? Did you mean, by the volubility of folly, to overpower the sadness of recollection? Did you imagine that nonsense has the same oblivious quality as the waters of Lethe, and flatter yourself that, by swallowing large draughts, you should annihilate all remembrance of your misfortunes?

CECILIA: No, no! I came hither by the dire guidance of necessity. I wish to absent myself from my friends till the real state of my affairs is better known to me. I have sent my servant into the City, whence I expect speedy intelligence. Lady Smatter's

housekeeper assured me that the character of this woman was unblemished, and I was interested in no other enquiry. But tell me, I beseech you, whence you had your information of the calamity that has befallen me? And who directed you hither? And whether my letter has been shown or concealed? And what I am to infer from *your* being the first to seek me?

CENSOR: Pray, go on!

CECILIA: Sir!

CENSOR: Nay, if you ask forty more questions without waiting for an answer, I have messages that will more than keep pace with your enquiries; therefore ask on, and spare not!

CECILIA: [*Disconcerted*] No, sir, I have done!

CENSOR: How! Have I then discovered the art of silencing a lover? Hasten to me, ye wearied guardians of pining youth, I will tell ye a secret precious to ye as repose! Fly hither, ye sad and solemn confidants of the lovelorn tribe, for I can point out relief to exhausted patience!

CECILIA: Spare this raillery, I beseech you, and keep me not in suspense as to the motive of your visit.

CENSOR: My first motive is the desire of seeing, my second of serving you—if, indeed, the ill usage you have experienced from one banker will not intimidate you from trusting another.

CECILIA: How am I to understand you?

CENSOR: As an honest man! Or, in other words, as a man to whose friendship distressed innocence has a claim indisputable.

CECILIA: You amaze me!

CENSOR: It must be some time ere your affairs can be settled, and the loss of wealth will speedily, and roughly make you know its value. Consider me, therefore, as your banker, and draw upon me without reserve. Your present situation will teach you many lessons you are ill prepared to learn, but experience is an unfeeling master, whose severity is neither to be baffled by youth, nor softened by innocence. Suppose we open our account today? This may serve for a beginning. [*Presenting a paper*] I will call again tomorrow for fresh orders. [*Going*]

CECILIA: Stay, stay, Mr. Censor! Amazement has indeed silenced me, but it must not make me forget myself. Take back, I entreat you, this paper—

CENSOR: Probably you suspect my motives? And, if you do, I am the last man whom your doubts will offend. They are authorised by the baseness of mankind, and, in fact, suspicion, in worldly transactions, is but another word for common sense.

CECILIA: Is it then possible you can think so ill of all others, and yet be so generous, so benevolent, yourself?

CENSOR: Will any man follow an example he abhors to look at? Will you, for instance, because you see most women less handsome than yourself, ape deformity in order to resemble them?

CECILIA: Oh how little are you known, and how unjustly are you judged! For my own part, I even regarded you as my enemy, and imagined that, if you thought of me at all, it was with ill will.

CENSOR: In truth, madam, my character will rather increase than diminish your surprise as you become more acquainted with it. You will, indeed, find me an odd fellow; a fellow who can wish you well without loving you, and without any sinister view, be active in your service; a fellow, in short, unmoved by beauty yet susceptible of pity, invulnerable to love yet zealous in the cause of distress. If you accept my good offices, I shall ever after be your debtor for the esteem your acceptance will manifest. If you reject them, I shall but conclude you have the same indignant apprehensions of the depravity of your fellow creatures that I harbour in my own breast.

CECILIA: If hitherto I have escaped misanthropy, think you, sir, an action such as this will teach it me? No; I am charmed with your generous offer, and shall henceforward know better how to value you, but I must beg you to take back this paper. [*Returns it*] I have at present no occasion for assistance, and I hope—but tell me, for uncertainty is torture, have you or have you not been at Lady Smatter's?

CENSOR: I have, and I come hither loaded with as many messages as ever abigail was charged with for the milliner of a fantastic bride. The little sense, however, comprised in their many words,

is briefly this: Lady Smatter offers you her protection—which is commonly the first step towards the insolence of avowed superiority—and Beaufort—

CECILIA: Beaufort? Good Heaven! Did Mr. Beaufort know whither you were coming?

CENSOR: He did, and charged with as many vows, supplications, promises, and tender nonsenses, as if he took my memory for some empty habitation that his fancy might furnish at its pleasure. He commissioned me—

CECILIA: [*Weeps*] Oh Heaven!

CENSOR: Why, how now? He commissioned me, I say—

CECILIA: Oh faithless Beaufort! Lost, lost Cecilia!

CENSOR: To sue for him—kneel for him—

CECILIA: Leave me, leave me, Mr. Censor! I can hear no more.

CENSOR: Nay, prithee, madam, listen to his message.

CECILIA: No, sir, never! At such a time as this, a message is an insult! He must know I was easily to be found or he would not have sent it, and, knowing that, whose was it to have sought me? Go, go, hasten to your friend. Tell him I heard all that it became me to hear, and that I will save both him and myself the disgrace of a further explanation. Tell him, in short, that I renounce him forever!

CENSOR: Faith, madam, this is all beyond my comprehension.

CECILIA: To desert me at such a time as this! To know my abode, yet fail to seek it! To suffer my wounded heart, bleeding in all the anguish of recent calamity, to doubt his faith and suspect his tenderness!

CENSOR: I am so totally unacquainted with the laws and maxims necessary to be observed by fine ladies, that it would ill become me to prescribe the limits to which their use of reason ought to be contracted. I can only—

CECILIA: Once more, Mr. Censor, I must beg you to leave me. Pardon my impatience, but I cannot converse at present. Ere long, perhaps, indignation may teach me to suppress my sorrow and time and reason may restore my tranquillity.

CENSOR: Time, indeed, may possibly stand your friend, because time

will be regardless of your impetuosity, but faith, madam, I know not what right you have to expect succour from reason, if you are determined not to hear it. Beaufort, I say—

CECILIA: Why will you thus persecute me? Nothing can extenuate the coldness, the neglect, the insensibility of his conduct. Tell him that it admits no palliation, and that henceforth—no, tell him nothing—I will send him no message—I will receive none from him—I will tear his image from my heart! I will forget, if possible, that there I cherished it!

Enter MRS. VOLUBLE.

MRS. VOLUBLE: I hope I don't disturb you, sir? Pray, ma'am, don't let me be any hindrance to you. I only just come to ask if you would not have a bit of fire, for I think it's grown quite cold. What say you, sir? Pray, make free if you like it. I'm sure I would have had one before if I had known of having such company, but really the weather's so changeable at this time of the year that there's no knowing what to do. Why, this morning I declare it was quite hot. We breakfasted with both the windows open. As to Bobby, I verily thought he'd have caught his death, for he would not so much as put his coat on.

CENSOR: Intolerable! The man who could stand this would sing in the stocks and laugh in the pillory! Will you, Miss Stanley, allow me five minutes' conversation to explain—

MRS. VOLUBLE: I beg that my being here may not be any stop to you, for I'll go directly if I'm in the way. I've no notion of prying into other people's affairs—indeed, I quite make it a rule not to do it, for I'm sure I've business enough of my own, without minding other people's. Why now, sir, how many things do you think I've got to do before night? Why, I've got to—

CENSOR: Oh pray, good madam, don't make your complaints to me—I am hard of heart, and shall be apt to hear them without the least compassion. Miss Stanley—

MRS. VOLUBLE: Nay, sir, I was only going—

CENSOR: Do, prithee, good woman, give me leave to speak. Miss Stanley, I say—

MRS. VOLUBLE: Good woman! I assure you, sir, I'm not used to be spoke to in such a way as that.

CENSOR: If I have called you by an appellation opposite to your character, I beg your pardon, but–

MRS. VOLUBLE: I can tell you, sir, whatever you may think of it, I was never called so before. Besides—

CENSOR: Miss Stanley, some other time—

MRS. VOLUBLE: Besides, sir, I say, I think in one's own house it's very hard if—

CENSOR: Intolerable! Surely this woman was sent to satirize the use of speech! Once more–

MRS. VOLUBLE: I say, sir, I think it's very hard if—

CENSOR: Miss Stanley, your most obedient! [*Exit abruptly*]

MRS. VOLUBLE: Well, I must needs say, I think this is the rudest fine gentleman among all my acquaintance. Good woman, indeed! I wonder what he could see in me to make use of such a word as that! I won't so much as go downstairs to open the street door for him—yes, I will too, for I want to ask him about—[*Exit talking*]

CECILIA: Hast thou not, Fortune, exhausted now thy utmost severity? Reduced to poverty, abandoned by the world, betrayed by Beaufort—what more can I fear? Beaufort, on whose constancy I relied! Beaufort, on whose honor, delicacy and worth I founded hopes of sweetest tranquillity, of lasting happiness, of affection unalterable! Oh hopes forever blighted! Oh expectations eternally destroyed! Oh fair and lovely tranquillity, thou hast flown this bosom, never, never more to revisit it!

Re-enter MRS. VOLUBLE.

MRS. VOLUBLE: I could not overtake him all that ever I could do, and yet I went as fast as—Lord, ma'am, sure you ain't a-crying?

CECILIA: Loss of fortune I could have borne with patience—change of situation I could have suffered with fortitude—but such a stroke as this!

MRS. VOLUBLE: Poor young lady! I declare I don't know what to think of to entertain her.

The Witlings

CECILIA: Oh Beaufort! Had our situations been reversed, would such have been my conduct?

MRS. VOLUBLE: Come, dear ma'am, what signifies all this fretting? If you'll take my advice—

Enter BETTY.

BETTY: Do pray, ma'am, speak to master Bobby. He's a-turning the house out of windows, as a body may say.

MRS. VOLUBLE: Well, if I don't believe that boy will be the death of me at last! Only think, ma'am, what a plague he is to me! I'm sure I have my misfortunes as well as other people, so you see, ma'am, you ain't the only person in trouble. Why, ma'am, I say! Did not you hear Betty? She says that Bobby—

CECILIA: Oh for a little repose! Leave me to myself, I beseech you! I can neither speak or listen to you—pray go—pray—alas, I know not what to say! I forget that this house is yours, and that I have no right even to the shelter its roof affords me.

MRS. VOLUBLE: Dear ma'am, pray, take a little comfort—

CECILIA: Have you, madam, any room which for a few hours you can allow me to call my own? Where, unmolested and alone, I may endeavour to calm my mind and settle some plan for my future conduct?

MRS. VOLUBLE: Why, ma'am, the room overhead is just such another as this, and if it's agreeable—

CECILIA: Pray, show it me—I'm sure it will do.

MRS. VOLUBLE: I only wish, ma'am, it was better for your sake; however, I'll make it as comfortable as ever I can, and as soon—[*Exit, talking, with* CECILIA]

BETTY: I'll be hanged now if it is not enough to provoke a stork to live in such a house as this! One may clean and clean forever, and things look never the better for it. As to Master Bobby, he does more mischief than his head's worth; and as to my mississ, if she can but keep talk, talk, talk, she don't care a pin's point for nothing else.

Re-enter MRS. VOLUBLE.

MRS. VOLUBLE: Why, Betty, what do you stand there for? Do you think I keep you to look at?

BETTY: You won't keep me for nothing long. [*Exit* BETTY]

MRS. VOLUBLE: There now, that's the way with all of them! If one does but say the least thing in the world, they're ready to give one warning. I declare servants are the plague of one's lives. I've got a mind to—Lord, I've got so many things to do, I don't know what to set about first! Let me see, [*Seats herself*] now I'll count them over. In the first place, I must see after a porter to carry the lady's message; then I must get the best plates ready against Mrs. Wheedle comes. After that, I must put Mr. Dabler's papers in order, for fear of a surprise—then I must get in a little bit of something nice for supper—then—oh Lord, if I had not forgot that 'scapegrace Bobby! [*Runs off*]

ACT IV

A library at LADY SMATTER'S. LADY SMATTER, MRS. SAPI-ENT, DABLER *and* CODGER, *seated at a round table covered with books.*

LADY SMATTER: Now before we begin our literary subjects, allow me to remind you of the rule established at our last meeting, that everyone is to speak his real sentiments and no flattery is to taint our discussions.

ALL: Agreed.

LADY SMATTER: This is the smallest assembly we have had yet. Some or other of our members fail us every time.

DABLER: But where such luminaries are seen as Lady Smatter and Mrs. Sapient, all other could only appear to be eclipsed.

LADY SMATTER: What have you brought to regale us with tonight, Mr. Dabler?

DABLER: Me? Dear ma'am, nothing!

LADY SMATTER: Oh barbarous!

MRS. SAPIENT: Surely you cannot have been so cruel? For, in *my* opinion, to give pain causelessly is rather disobliging.

The Witlings

DABLER: Dear ladies, you know you may command me, but I protest I don't think I have anything worth your hearing.

LADY SMATTER: Let us judge for ourselves. Bless me, Mr. Codger, how insensible you are! Why do you not join in our entreaties?

CODGER: For what, madam?

LADY SMATTER: For a poem, to be sure.

CODGER: Madam, I understood Mr. Dabler he had nothing worth your hearing.

LADY SMATTER: But surely you did not believe him?

CODGER: I knew no reason, madam, to doubt him.

LADY SMATTER: Oh you Goth! Come, dear Mr. Dabler, produce something at once, if only to shame him.

DABLER: Your ladyship has but to speak. [*Takes a paper from his pocket-book and reads*]

"'ON A CERTAIN PARTY OF *BEAUX ESPRITS*.'

Learning here doth pitch her tent,
Science here her seeds doth scatter;
Learning in form of Sapient,
Science in guise of heav'nly Smatter."

LADY SMATTER: Oh charming! Beautiful lines indeed!

MRS. SAPIENT: Elegant and poignant to a degree!

LADY SMATTER: What do *you* think, Mr. Codger, of this poem? To be sure, [*Whispering to him*] the compliment to Mrs. Sapient is preposterously overstrained, but, otherwise, nothing can be more perfect.

MRS. SAPIENT: Mr. Dabler has, indeed, the happiest turn in the world at easy elegance. Why, Mr. Codger, you don't speak a word? Pray, between friends, [*Whispering to him*] what say you to the notion of making Lady Smatter represent Science? Don't you think he has been rather unskilful in his choice?

CODGER: Why, madam, you give me no time to think at all.

LADY SMATTER: Well, now to other matters. I have a little observation to offer upon a line of Pope. He says,
"Most women have no character at all."
Now I should be glad to know, if this was true in the time of

Pope, why people should complain so much of the depravity of the present age?

DABLER: Your ladyship has asked a question that might perplex a Solomon.

MRS. SAPIENT: It is, indeed, surprisingly ingenious.

DABLER: Yes, and it reminds me of a little foolish thing which I composed some time ago.

LADY SMATTER: Oh pray, let us hear it.

DABLER: Your ladyship's commands—

> The lovely Iris, young and fair,
> Possessed each charm of face and air
> That with the Cyprian might compare.
> So sweet her face, so soft her mind,
> So mild she speaks—she looks so kind—
> To hear—might melt!—To see—might blind!

LADY SMATTER: [*Together*] Oh elegant! Enchanting! Delicious!

MRS. SAPIENT: Oh delightful! Pathetic! Delicate!

LADY SMATTER: Why, Mr. Codger, have you no soul? Is it possible you can be unmoved by such poetry as this?

CODGER: I was considering, madam, what might be the allusion to which Mr. Dabler referred, when he said he was reminded of this little foolish thing, as he was pleased to call it himself.

DABLER: [*Aside*] I should like to toss that old fellow in a blanket!

CODGER: Now, sir, be so good as to gratify me by relating what may be the connection between your song and the foregoing conversation?

DABLER: [*Pettishly*] Sir, I only meant to read it to the ladies.

LADY SMATTER: I'm sure you did us great honor. Mrs. Sapient, the next proposition is yours.

MRS. SAPIENT: Pray, did your ladyship ever read Dryden?

LADY SMATTER: Dryden? Oh yes! But I don't just now recollect him—let's see, what has he writ?

DABLER: "Cymon and Iphigenia."

LADY SMATTER: Oh aye, so he did; and really for the time of day I think it's mighty pretty.

DABLER: Why, yes, it's well enough; but it would not do now.

MRS. SAPIENT: Pray, what does your ladyship think of *The Spectator*?

LADY SMATTER: Oh I like it vastly. I've just read it.

CODGER: [*To* LADY SMATTER] In regard, madam, to those verses of Mr. Dabler, the chief fault I have to find with them is—

DABLER: Why, sir, we are upon another subject now! [*Aside*] What an old curmudgeon! He has been pondering all this time only to find fault!

MRS. SAPIENT: For *my* part, I have always thought that the best papers in *The Spectator* are those of Addison.

LADY SMATTER: Very justly observed!

DABLER: Charmingly said! Exactly my own opinion.

MRS. SAPIENT: Nay, I may be mistaken; I only offer it as my private sentiment.

DABLER: I can but wish, madam, that poor Addison had lived to hear such praise.

LADY SMATTER: Next to Mr. Dabler, my favourite poets are Pope and Swift.

MRS. SAPIENT: Well, after all, I must confess I think there are as many pretty things in old Shakespeare as in anybody.

LADY SMATTER: Yes, but he is too common; *everybody* can speak well of Shakespeare!

DABLER: I vow I am quite sick of his name.

CODGER: Madam, to the best of my apprehension, I can conceive your ladyship hath totally mistaken that line of Pope which says "Most women have no character at all."

LADY SMATTER: Mistaken? How so, sir? This is curious enough! [*Aside to* DABLER] I begin to think the poor creature is superannuated.

DABLER: So do I, ma'am; I have observed it for some time.

CODGER: By *no* character, madam, he only means—

LADY SMATTER: A *bad* character, to be sure!

CODGER: There, madam, lieth your ladyship's mistake; he means, I say—

LADY SMATTER: Oh dear sir, don't trouble yourself to tell *me* his meaning—I dare say I shall be able to make it out.

MRS. SAPIENT: [*Aside to* DABLER] How irritable is her temper!

DABLER: Oh intolerably!

CODGER: Your ladyship, madam, will not hear me. I was going—

LADY SMATTER: If you please, sir, we'll drop the subject, for I rather fancy you will give me no very new information concerning it—do you think he will, Mr. Dabler?

CODGER: Mr. Dabler, madam, is not a competent judge of the case, as—

DABLER: [*Rising*] Not a judge, sir? Not a judge of poetry?

CODGER: Not in the present circumstance, sir, because, as I was going to say—

DABLER: Nay then, sir, I'm sure I'm a judge of nothing!

CODGER: That may be, sir, but is not to the present purpose. I was going—

DABLER: Suppose, sir, we refer to the ladies? Pray, now, ladies, which do *you* think the most adequate judge of poetry, Mr. Codger, or your humble servant? Speak sincerely, for I hate flattery.

MRS. SAPIENT: I would by no means be so ill bred as to determine for Mr. Dabler in the presence of Mr. Codger, because *I* have always thought that a preference of one person implies less approbation of another; yet—

CODGER: Pray, madam, let me speak; the reason, I say—

MRS. SAPIENT: Yet the well-known skill of Mr. Dabler in this delightful art—

CODGER: Madam, this interruption is somewhat injudicious, since it prevents my explaining—

MRS. SAPIENT: [*Rising*] Injudicious, sir? I am sorry indeed if I have merited such an accusation. There is nothing I have more scrupulously endeavoured to avoid, for, in *my* opinion, to be injudicious is no mark of an extraordinary understanding.

LADY SMATTER: [*Aside to* DABLER] How soon she's hurt!

DABLER: Oh most unreasonably!

CODGER: Madam, you will never hear me out; you prevent my

explaining the reason, I say, why Mr. Dabler cannot decide upon Lady Smatter's error in judgement—

LADY SMATTER: [*Rising*] Error in judgement? Really this is very diverting!

CODGER: I say, madam—

LADY SMATTER: Nay, sir, 'tis no great matter; and yet, I must confess, it's rather a hard case that, after so many years of intense study and most laborious reading, I am not allowed to criticise a silly line of Pope.

DABLER: And if I, who, from my infancy, have devoted all my time to the practice of poetry, am now thought to know nothing of the matter, I should be glad to be informed who has a better title.

MRS. SAPIENT: And if I, who, during my whole life, have made propriety my peculiar study, am now found to be deficient in it, I must really take the liberty to observe that I must have thrown away a great deal of time to very little purpose.

LADY SMATTER: And as to this line of Pope—

Enter a SERVANT.

SERVANT: Mr. Censor, my lady, begs to speak to your ladyship for only two minutes upon business of consequence.

DABLER: Censor? Suppose we admit him? [*Aside*] 'Twill be an admirable opportunity to show him my epigram.

LADY SMATTER: Admit him? What, to ask his opinion of Codger's critical annotations?

CODGER: My doubt, madam, is if you will give him time to speak it.

LADY SMATTER: Well, is it agreeable to ye all that Mr. Censor should have admittance? I know it is contrary to rule, yet, as he is one of the wits, and therefore ought to be among us, suppose we indulge him?

CODGER: Madam, I vote against it.

DABLER: [*Aside to* LADY SMATTER] I see he's afraid of him—let's have him by all means.

LADY SMATTER: Without doubt. Pray, Mr. Codger, why are you against it?

CODGER: Because, madam, there are already so many talkers that I cannot be heard myself.

DABLER: [*Aside to* LADY SMATTER] You see how it is?

LADY SMATTER: Yes, and enjoy it of all things. Desire Mr. Censor to walk upstairs. [*Exit* SERVANT] To be sure this is rather a deviation from the maxims of the society, but great minds, as a favourite author of mine observes, are above being governed by common prejudices.

CODGER: I am thinking, madam—

Enter CENSOR.

LADY SMATTER: Mr. Censor, your entrance is most critically fortunate. Give me leave to present you to our society.

CENSOR: I expected to have seen your ladyship alone.

LADY SMATTER: Yes, but I have obtained a dispensation for your admittance to our Esprit Party. But let us not waste our time in common conversation. You must know we are at present discussing a very knotty point, and I should be glad of your opinion upon the merits of the cause.

DABLER: Yes; and as soon as that is decided, I have a little choice piece of literature to communicate to you which I think you will allow to be tolerable.

MRS. SAPIENT: And I, too, sir, must take the liberty to appeal to your judgement concerning—

CENSOR: Aye, aye, speak all at a time, and then one hearing may do.

LADY SMATTER: Mr. Censor, when a point of the last importance is in agitation, such levity as this—

CENSOR: Why, madam, the business which brings me hither.

DABLER: Business? Oh name not the word in this region of fancy and felicity.

MRS. SAPIENT: That's finely said, Mr. Dabler, and corroborates with an opinion of mine which I have long formed, that business and fancy should be regarded as two things.

CENSOR: Aye, madam, and with one of mine which I hold to be equally singular.

MRS. SAPIENT: What is it, sir?

CENSOR: That London and Paris should be regarded as two places.

MRS. SAPIENT: Pshaw!

CODGER: [*To* LADY SMATTER] I say, madam, I am thinking—

CENSOR: Then, sir, you are most worthily employed, and this good company desire nothing less than to impede the progress of your thoughts, by troubling you to relate them.

DABLER: Very true; suppose, therefore, we change the subject. Oh, apropos, have you seen the new verses that run about?

CENSOR: No. [*To* LADY SMATTER] Give me leave, madam, to acquaint you with the motive of my present visit.

LADY SMATTER: You would not be such a Goth as to interrupt our literary discussions? Besides, I must positively have your sentiments upon an argument I have just had with Mr. Codger upon this line of Pope: "Most women—"

CENSOR: Hold, madam. I am no Quixote, and therefore encounter not danger where there is no prospect of reward, nor shall I, till I emulate the fate of Orpheus, ever argue about women—in their presence.

DABLER: Ha, ha! Mighty well said. But I was going to tell you, Mr. Censor, that if you have any desire to look at those verses I was speaking of, I believe I have a copy of them in my pocket. Let's see—yes, here they are. How lucky that I should happen to have them about me! [*Gives them to* CENSOR]. [*Aside*] I think they will surprise him.

CENSOR: [*Reading*] "That passion which we strongest feel
 We all agree to disapprove;
 Yet feebly, feebly we conceal—"

DABLER: [*Pettishly*] Sir, you read without any spirit—
 "Yet feebly—*feebly* we conceal"
You should drop your voice at the second "feebly," or you lose all the effect. [*Aside*] It puts me in a fever to hear such fine lines murdered.

CENSOR: [*Reading*] "We all are bound slaves to self-love."

DABLER: [*Snatching the paper*] Why, you give neither emphasis nor expression! You read as if you were asleep. [*Reading*] "That passion which—"

CENSOR: Oh no more, no more of it. Pray, who is the author?

DABLER: Why, really I—I don't absolutely know—but, by what I have heard, I should take it to be somebody very—very clever.

CENSOR: You should?

DABLER: Yes; and, indeed, to own the truth, I have heard it whispered that it is a posthumous work of—of—oh, of Gay—aye, of Gay.

CENSOR: Of Gay?

DABLER: Yes; found in a little corner of his private bureau.

CENSOR: And pray who has the impudence to make such an assertion?

DABLER: Who? Oh, as to that, really I don't know who in particular—but I assure you not *me*—though, by the way, do you really think it very bad?

CENSOR: Despicable beyond abuse. Are you not of the same opinion?

DABLER: Me? Why, really, as to that—I—I can't exactly say—that is, I have hardly read it. [*Aside*] What a crabbed fellow! There is not an ounce of taste in his whole composition. Curse me, if I was Nature, if I should not blush to have made him. Hold, my tablets! A good thought that! I'll turn it into a lampoon, and drop it at Stapleton's. [*Walks aside and writes in his tablets*]

CENSOR: [*To* LADY SMATTER.] I have seen Miss Stanley, madam, and—

LADY SMATTER: Did you find her at Mrs. Voluble's?

CENSOR: Yes. [*They whisper*]

MRS. SAPIENT: [*Listening. Aside*] So, so, she's at Mrs. Voluble's! There must certainly be some design upon Dabler.

CENSOR: But hear me, madam. I have something to communicate to you which—

LADY SMATTER: Not now, I can attend to nothing now. These evenings, sir, which I devote to the fine arts, must not be contaminated with common affairs.

MRS. SAPIENT: [*Aside*] I shan't rest till I have dived into this matter. [*To* LADY SMATTER.] I am much chagrined, madam, at the disagreeable necessity I am under of breaking abruptly from the learned and ingenious assembly, but I am called hence by an appointment which I cannot give up without extreme rudeness. And I must confess I should be rather sorry to be guilty of that, as I have long been of opinion that a breach of good manners—is no great sign of politeness.

LADY SMATTER: I am quite sorry to lose you so soon. [*Exit* MRS. SAPIENT]. [*Aside*] What a tiresome creature! How glad I am she's gone!

CODGER: Notwithstanding the rebuff I have just met with, madam, I must say I cannot help thinking that—

CENSOR: Do you mean, sir, to satirize the whole company, that you thus repeatedly profess thinking among those who have no other aim than talking?

CODGER: Sir, when a man has been pondering upon a subject for a considerable time, and assorting his ideas in order to explain himself, it is an exceedingly uncivil thing to interrupt him.

LADY SMATTER: Mr. Dabler, what are you writing?

DABLER: Only a little memorandum, ma'am, about business, nothing more.

CODGER: [*Aside*] I find I can never get in two words at a time.

Enter JACK.

JACK: Ma'am, your ladyship's most obedient.

LADY SMATTER: Why did not you come sooner, Jack? We are just broke up.

JACK: I could not help it, upon my word. I came away now just as my tea was poured out at the coffee-house, because I would not stay to drink it.

CODGER: [*Aside*] I'm glad Jack's come. I think at least I shall make him listen to me.

JACK: I have been in such a hurry the whole day that I have never known what I have been about. I believe I have been to sixteen places since dinner. You good folks who sit here talking by the

hour together must lead strange, dull lives. I wonder you don't lose the use of your limbs.

CODGER: Son Jack, when you have finished your speech, please to hear one of mine.

JACK: I hope it won't be a long one, sir.

CODGER: Why do you hope that, son, before you know how well it may entertain you?

JACK: Lord, sir, I never think of being entertained with speeches.

CODGER: What, Jack, not with your own father's?

JACK: Lord, no, sir.

CODGER: No, sir? And pray, sir, why?

JACK: Because I'm always tired before they're half done.

CODGER: Son Jack, 'tis these loose companions that you keep that teach you all this profligacy. Tired of hearing me speak! One would think the poor lad was an idiot.

JACK: So this is your club room, where you all meet to talk?

CENSOR: Yes; and the principal maxim of the learned members is that no one shall listen to what is said by his neighbour.

LADY SMATTER: Fie, Mr. Censor, I'm sure we're all attention—

CENSOR: Yes, to seize the next opportunity of speaking.

LADY SMATTER: Never mind what Mr. Censor says, Jack, for you know he is a professed Stoic.

CENSOR: Stoic? Pray what does your ladyship mean?

LADY SMATTER: Well, well, Cynic, then, if you like it better.

CENSOR: You hold, then, that their signification is the same?

LADY SMATTER: Mercy, Mr. Censor, do you expect me to define the exact meaning of every word I make use of?

CENSOR: No, madam, not unless I could limit your ladyship's language to the contents of a primer.

LADY SMATTER: Oh horrid! Did you every hear anything so splenetic? Mr. Dabler, what are you writing? Suppose, in compliment to our new member, you were to indulge us with a few lines?

DABLER: Does your ladyship mean an extempore?

LADY SMATTER: The thing in the world I should like best.

DABLER: Really, ma'am, I wish for nothing upon earth so much as the honor of your ladyship's commands—but as to an extempore—

the amazing difficulty—the genius requisite—the masterly freedom—the—the—the things of that sort it requires make me half afraid of so bold an undertaking.

CENSOR: Sir, your exordium is of sufficient length.

DABLER: I shall but collect my thoughts, and be ready in a moment. In the meantime, I beg I may not interrupt the conversation. It will be no manner of disturbance to me to hear you all talking; we poets, ma'am, can easily detach ourselves from the company. [*Walks apart*]

CENSOR: I should be glad if your ladyship would inform me what time, according to the established regulations of your society, you allow for the *study* of extempore verses?

LADY SMATTER: I think we have no fixed rule. Some are quick, and some are slow, 'tis just as it happens.

CENSOR: [*Aside*] What unconscious absurdity!

While they are speaking, DABLER *privately looks at a paper, which he accidentally drops instead of putting in his pocket.*

DABLER: [*Advancing*] I hope I have not detained you long?

LADY SMATTER: Is it possible you can be ready so soon?

DABLER: Oh dear yes, ma'am. These little things are done in a moment; they cost *us* nothing. [*Recites*]
In one sole point agree we all,
Both rich and poor, and saint and sinner,
Proud or humble, short or tall,
And that's—a taste for a good dinner.

LADY SMATTER: Oh charming! I never heard anything so satirical in my life.

CENSOR: And so, sir, you composed these lines just now.

DABLER: This very moment.

CENSOR: It seems, then, you can favour your friends whenever they call upon you?

DABLER: Oh yes, sir, with the utmost pleasure.

CENSOR: I should be obliged to you, then, sir, for something more.

DABLER: Sir, you do me honor. I will but take an instant for consid-

eration, and endeavour to obey you. [*Aside*] So, so! I thought I should bring him round at last! [*Walking away*]

CENSOR: Stay, sir. As you make these verses with so much facility, you can have no objection, I presume, to my choosing you a subject?

DABLER: Sir!

CENSOR: And then with firmer courage your friends may counteract the scepticism of the envious, and boldly affirm that they are your own and unstudied.

DABLER: Really, sir, as to that, I can't say I very much mind what those sort of people say. We authors, sir, are so much inured to illiberal attacks that we regard them as nothing—mere marks, sir, of celebrity—and hear them without the least emotion.

CENSOR: You are averse, then, to my proposal?

DABLER: Oh dear, no, sir! Not at all—not in the least, I assure you, sir! [*Aside*] I wish he was in the deserts of Lybia with all my heart!

CENSOR: The readiness of your compliance, sir, proves the promptness of your wit. I shall name a subject which, I believe, you will find no difficulty to dilate upon: self-sufficiency.

DABLER: Sir?

CENSOR: Self-sufficiency—don't you understand me?

DABLER: Really, sir, in regard to that, I don't exactly know whether I do or not, but I assure you if you imagine that *I* am self-sufficient, you are most prodigiously mistaken. I defy anybody to charge me with that, for though I have written so many things that have pleased everybody else, I have always made it a rule to keep my own opinion to myself. Even Mr. Codger must, in this point, do me justice. Will you not, sir?

CODGER: Sir, I shall say nothing. [*Folds his arms and leans upon the table*]

CENSOR: Well, sir, I will give you another subject, then, for of this, I must own, you might long since have been weary. I will not affront you by naming so hackneyed a theme as love, but give us, if you please, a spirited couplet upon war.

DABLER: Upon war? Hum—let's see—upon war—aye—but hold! Don't you think, sir, that war is rather a disagreeable subject where there are ladies? For *myself* I can certainly have no objection, but, I must confess, I am rather in doubt whether it will be quite polite to Lady Smatter.

JACK: Why, Lord, Mr. Dabler, a man might ride ten times round Hyde Park, before you are ready to begin.

DABLER: Sir, you don't know what you talk of. Things of this importance are not to be settled rashly.

CENSOR: Mr. Dabler, I will give you an opportunity of taking your revenge. Let your verses be upon the use and abuse of time, and address them, if you please, to that gentleman.

JACK: Aye, with all my heart. He may address what he will to me, so as he will not keep me long to hear him.

DABLER: Time, did you say? The use and the abuse of time? Aye, very good, a very good subject—time? Yes, a very good idea, indeed! The use and abuse of time—[*Pauses*] But pray, sir, pray, Mr. Censor, let me speak a word to you. Are you not of opinion—now don't imagine this is any objection of *mine*, no, I like the subject of all things, it is just what I wished—but don't you think that poor Mr. Codger here may think it is meant as a sneer at him?

CENSOR: How so, sir?

DABLER: Why, sir, on account of his being so slow. And really, notwithstanding his old-fashioned ways, one would not wish to affront him, poor man, for he means no harm. Besides, sir, his age! Consider that; we ought all to make allowances for the infirmities of age. I'm sure *I* do—poor old soul!

CENSOR: Well, sir, I shall name but one subject more, and to that if you object, you must give me leave to draw my own inference from your backwardness, and to report it accordingly.

DABLER: Sir, I shall be very—I shall be extremely—that is, sir, I shall be quite at your service. [*Aside*] What a malignant fellow!

CENSOR: What say you, sir, to an epigram on slander?

DABLER: On slander?

CENSOR: Yes, sir. What objection can you devise to that?

DABLER: An illiberal subject, sir! A most illiberal subject—I will have nothing to do with it.

CENSOR: The best way to manifest your contempt will be to satirize it.

DABLER: Why, as you say—there's something in that—satirize it? Aye, satirize slander—ha, ha! A good hit enough!

CENSOR: Then, sir, you will favour us without further delay.

DABLER: Sir, I should be extremely happy to obey you—nothing could give me greater pleasure, only that just now I am so particularly pressed for time, that I am obliged to run away. Lady Smatter, I have the honor to wish your ladyship goodnight. [*Going*]

JACK: [*Stopping him*] Fair play, fair play! You shan't go till you have made the verses, or, if you do, I swear I'll run after you.

DABLER: Upon my word, sir—

CENSOR: Prithee, Jack, don't detain him. This anecdote, you know, [*Affecting to whisper*] will *tell* as well without the verses as with them.

DABLER: [*Aside*] That fellow is a mere compound of spite and envy.

LADY SMATTER: Come, Mr. Dabler, I see you relent.

DABLER: Why—hem!—If—if your ladyship insists—pray, Mr. Censor, what is this same subject you have been talking of?

CENSOR: Oh sir, 'tis no matter. If you are so much hurried, why should you stay? We are all pretty well convinced of the alacrity of your wit already.

DABLER: Slander, I think it was? But suppose, sir, for slander we substitute fashion? I have a notion I could do something upon fashion.

CENSOR: Probably, sir, you *have* done something upon fashion. Entertain us, therefore, upon the given subject, or else be a better nomenclator to your verses than to call them extemporary.

DABLER: Well, sir, well! [*Aside and walking away*] A surly fellow!

JACK: Pray, has your ladyship heard the queer story about the Miss Sippets?

LADY SMATTER: No, what is it?

JACK: Why, I heard it just now at Mrs. Gabble's. Sir Harry Frisk, you know, last winter paid his addresses to the eldest sister, but

this winter, to make what variety he could without quitting the family, he deserted to the youngest, and this morning they were to have been married.

LADY SMATTER: Well, and were they not?

JACK: Upon my word, I don't know.

LADY SMATTER: Don't know? What do you mean?

JACK: Why, I had not time to enquire.

LADY SMATTER: Faugh, prithee, Jack, don't be so ridiculous.

DABLER: [*Holding hand before his eyes and walking about*] Not one thought—not one thought to save me from ruin!

CENSOR: Why, Mr. Codger, what are you about? Is it not rather melancholy to sit by yourself at the table, and not join at all in the conversation?

CODGER: [*Raising his head*] Perhaps, sir, I may conceive myself to be somewhat slighted.

LADY SMATTER: Nay, nay, prithee, my good friend, don't be so captious.

CODGER: Madam, I presume at least I have as good a right to be affronted as another man, for which reason—

DABLER: [*Pettishly*] Upon my word, if you all keep talking so incessantly, it is not possible for a man to know what he is about.

CODGER: I have not spoken before for this half-hour, and yet I am as good as bid to hold my tongue! [*Leans again on the table*]

JACK: Oh but, ma'am, I forgot to tell your ladyship the very best part of the story. The poor eldest sister was quite driven to despair, so last night, to avoid at least dancing barefoot at her sister's wedding, she made an appointment with a young haberdasher in the neighbourhood to set off for Scotland.

LADY SMATTER: Well?

JACK: Well, and when she got into the post-chaise, instead of her new lover the young haberdasher, who do you think was waiting to receive her?

LADY SMATTER: Nay, nay, tell me at once.

JACK: But who do you guess?

LADY SMATTER: Faugh, faugh, don't be so tiresome. Who was it?

JACK: Why, that I am not certain myself.

LADY SMATTER: Not certain yourself?

JACK: No, for I had not time to stay till Mrs. Gabble came to the name.

LADY SMATTER: How absurd!

CODGER: [*Again raising his head*] Madam, if I might be allowed—or, rather, to speak more properly, if I could get time to give my opinion of this matter, I should say—

LADY SMATTER: My good friend, we should all be extremely happy to hear you, if you were not so long in coming to the point. That's all the fault we find with you, is it not, Jack?

JACK: To be sure, ma'am. Why, sometimes, do you know, I have made a journey to Bath and back again, while he has been considering whether his next wig should be a bob or a full-bottom.

CODGER: Son Jack, this is very unseemly discourse, and I desire—

LADY SMATTER: Nay, pray don't scold him. Jack, when shall you hear any more of Miss Sippet's adventure?

JACK: Why, ma'am, either tomorrow or Friday, I don't know which.

CODGER: [*Aside and reclining as before*] I verily believe they'd rather hear Jack than me!

JACK: Why, Lord, Mr. Dabler, I believe you are dreaming. Will you never be ready?

DABLER: Sir, this is really unconscionable! I was just upon the point of finishing, and now you have put it all out of my head!

CENSOR: Well, Mr. Dabler, we release you now from all further trouble, since you have sufficiently satisfied us that your extempory verses are upon a new construction.

DABLER: Oh sir, as to that, making verses is no sort of *trouble* to me, I assure you; however, if you don't choose to hear these which I have been composing—

LADY SMATTER: Oh but *I* do, so pray—

JACK: Faugh, faugh, he has not got them ready.

DABLER: You are mistaken, sir, these are quite ready—entirely finished and lodged here, [*Pointing to his head*] but as Mr. Censor—

CENSOR: Nay, if they are ready, you may as well repeat them.

DABLER: No, sir, no, since you declined hearing them at first, I am above compelling you to hear them at all. Lady Smatter, the

next time I have the honor of seeing your ladyship, I shall be proud to have your opinion of them. [*Exit hastily*]

CENSOR: Poor wretch! "Glad of a quarrel straight he shuts the door"—What's this? [*Picks up the paper dropped by* DABLER] So! So! So!

Enter BEAUFORT.

BEAUFORT: [*To* LADY SMATTER] Pardon me, madam, if I interrupt you, I am come but for a moment. [*Apart to* CENSOR] Censor, have you no heart? Are you totally divested of humanity?

CENSOR: Why, what's the matter?

BEAUFORT: The matter? You have kept me on the rack! You have wantonly tortured me with the most intolerable suspense that the mind of man is capable of enduring. Where is Cecilia? Have you given her my message? Have you brought me any answer? Why am I kept in ignorance of everything I wish or desire to know?

CENSOR: Is your harangue finished?

BEAUFORT: No, sir, it is hardly begun! This unfeeling propensity to raillery upon occasions of serious distress, is cruel, is unjustifiable, is insupportable. No man could practise it whose heart was not hardened against pity, friendship, sorrow, and every kind, every endearing tie by which the bonds of society are united.

CENSOR: At least, my good friend, object not to raillery in me, till you learn to check railing in yourself. I would fain know by what law or what title you gentlemen of the sighing tribe assume the exclusive privilege of appropriating all severities of speech to yourselves.

LADY SMATTER: Beaufort, your behaviour involves me in the utmost confusion. After an education such as I have bestowed upon you, this weak anxiety about mere private affairs is unpardonable, especially in the presence of people of learning.

BEAUFORT: I waited, madam, till Mrs. Sapient and Mr. Dabler were gone. Had I waited longer, patience must have degenerated into insensibility. From your ladyship and from Mr. Codger,

my anxiety has some claim to indulgence, since its cause is but too well known to you both.

JACK: [*Aside*] Not a word of me! I'll e'en sneak away before he finds me out. [*Going*]

CODGER: Son Jack, please to stop.

JACK: Sir, I can't; my time's expired.

CODGER: Son, if I conceive a-right, your time, properly speaking, ought to be mine.

JACK: Lord, sir, only look at my watch! It's just eight o'clock, and I promised Billy Skip to call on him before seven to go to the play.

CODGER: Son Jack, it is by no means a dutiful principle you are proceeding upon, to be fonder of the company of Billy Skip than of your own father.

BEAUFORT: For mercy's sake, sir, debate this point some other time. Censor, why will you thus deny me all information?

CODGER: So it is continually! Whenever I speak you are all sure to be in a hurry! Jack, come hither and sit by me. *You* may hear me, I think, if nobody else will. Sit down, I say.

JACK: Lord, sir—

CODGER: Sit down when I bid you, and listen to what I am going to tell you. [*Makes* JACK *seat himself at the table and talks to him*]

LADY SMATTER: Beaufort, let *me* speak to Mr. Censor. What have you done, sir, about this poor girl? Did you give her my message?

CENSOR: She had too much sense, too much spirit, too much dignity to hear it.

LADY SMATTER: Indeed?

CENSOR: Yes; and therefore I should propose—

LADY SMATTER: Sir, I must beg you not to interfere in this transaction. It is not that I mean to doubt either your knowledge or your learning, far from it; but nevertheless I must presume that I am myself as competent a judge of the matter as you can be, since I have reason to believe—you'll excuse me, sir—that I have read as many books as you have.

BEAUFORT: Oh those eternal books! What, madam, in the name of reason, and of common sense, can books have to do in such an affair as this?

LADY SMATTER: How? Do you mean to depreciate books? To doubt their general utility and universal influence? Beaufort, I shall blush to own you for my pupil! Blush to recollect the fruitless efforts with which I have laboured, as Shakespeare finely says, "To teach the young idea how to shoot—"

CENSOR: Shakespeare?—Then what a thief was Thompson!

LADY SMATTER: Thompson? Oh aye, true, now I recollect, so it was.

CENSOR: Nay, madam, it little matters which, since both, you know, were authors.

BEAUFORT: Unfeeling Censor! Is this a time to divert yourself with satirical dryness? Defer, I conjure you, these useless, idle, ludicrous disquisitions, and, for a few moments, suffer affairs of real interest and importance to be heard and understood.

LADY SMATTER: Beaufort, you expose yourself more and more every word you utter. Disquisitions which relate to books and authors ought never to be deferred. Authors, sir, are the noblest of human beings, and books—

BEAUFORT: Would to Heaven there were not one in the world!

LADY SMATTER: Oh monstrous!

BEAUFORT: Once again, madam, I entreat, I conjure—

LADY SMATTER: I will not hear a word more. Wish there was not a book in the world? Monstrous, shocking and horrible! Beaufort, you are a lost wretch! I tremble for your intellects; and if you do not speedily conquer this degenerate passion, I shall abandon you without remorse to that ignorance and depravity to which I see you are plunging. [*Exit*]

BEAUFORT: Hard-hearted, vain, ostentatious woman! Go, then, and leave me to that independence which not all your smiles could make me cease to regret! Censor, I am weary of this contention. What is life, if the present must continually be sacrificed to the future? I will fly to Cecilia, and I will tear myself from

her no more. If, without her, I can receive no happiness, why, with her, should I be apprehensive of misery?

CENSOR: Know you not, Beaufort, that if you sap the foundations of a structure, 'tis madness to expect the sides and the top will stand self-supported? Is not security from want the basis of all happiness? And if you undermine that, do you not lose all possibility of enjoyment? Will the presence of Cecilia soften the hardships of penury? Will her smiles teach you to forget the pangs of famine? Will her society make you insensible to the severities of an houseless winter?

BEAUFORT: Well, well, tell me where I can find her, and she shall direct my future conduct herself.

CENSOR: I have a scheme upon Lady Smatter to communicate to you, which, I think, has some chance of succeeding.

BEAUFORT: Till I have seen Cecilia, I can attend to nothing. Once more, tell me where she is.

CENSOR: Wherever she is, she has more wisdom than her lover, for she charged me to command your absence.

BEAUFORT: My absence?

CENSOR: Nay, nay, I mean not seriously to suppose the girl is wise enough to wish it; however, if she pretends to desire it, you have a sufficient excuse for non-attendance.

BEAUFORT: I don't understand you. Is Cecilia offended?

CENSOR: Yes, and most marvellously, for neither herself nor her neighbours know why.

BEAUFORT: I will not stay another minute! I will find other methods to discover her abode. [*Going*]

CENSOR: Prithee, Beaufort, be less absurd. My scheme upon Lady Smatter—

BEAUFORT: I will not hear it! I disdain Lady Smatter and her future smiles or displeasure shall be equally indifferent to me. Too long already have I been governed by motives and views which level me with her narrow-minded self. It is time to shake off the yoke, assert the freedom to which I was born, and dare to be poor, that I may learn to be happy! [*Exit*]

CENSOR: Shall this noble fellow be suffered to ruin himself? No! The world has too few like him. Jack, a word with you—Jack, I say! Are you asleep, man?

CODGER: Asleep? Surely not.

CENSOR: If you're awake, answer!

JACK: [*Yawning*] Why, what's the matter?

CENSOR: Wake, man, wake and I'll tell you.

CODGER: How, asleep? Pray, son Jack, what's the reason of your going to sleep when I'm talking to you?

JACK: Why, sir, I have so little time for sleep, that I thought I might as well take the opportunity.

CODGER: Son Jack, son Jack, you are verily an ignoramus!

CENSOR: Come hither, Jack. I have something to propose to you—

CODGER: Sir, I have not yet done with him myself. Whereabouts was I, son, when you fell asleep?

JACK: Why, there, sir, where you are now.

CODGER: Son, you are always answering like a blockhead. I mean whereabouts was I in my story?

JACK: What story, sir?

CODGER: How? Did not you hear my story about your aunt Deborah's poultry?

JACK: Lord, no, sir!

CODGER: Not hear it? Why, what were you thinking of?

JACK: Me, sir? Why, how many places I've got to go to tonight.

CODGER: This is the most indecorous behaviour I ever saw. You don't deserve ever to hear me tell a story again. Pray, Mr. Censor, did *you* hear it?

CENSOR: No.

CODGER: Well, then, as it's a very good story, I think I'll e'en take the trouble to tell it once more. You must know, then, my sister Deborah, this silly lad's aunt—

CENSOR: Mr. Codger, I am too much engaged to hear you now. I have business that calls me away.

CODGER: This is always the case! I don't think I ever spoke to three persons in my life that did not make some pretence for leaving me before I had done!

CENSOR: Jack, are you willing to serve your brother?

JACK: That I am! I would ride to York to see what's o'clock for him.

CENSOR: I will put you in a way to assist him with less trouble, though upon a matter of at least equal importance. You, too, Mr. Codger, have, I believe, a good regard for him?

CODGER: Sir, I shall beg leave to decline making any answer.

CENSOR: Why so, sir?

CODGER: Because, sir, I never intend to utter a word more in this room; but, on the contrary, it is my intention to abandon the club from this time forward.

CENSOR: But is that any reason why you should not answer me?

CODGER: Sir, I shall quit the place directly, for I think it an extremely hard thing to be made speak when one has nothing to say, and hold one's tongue when one has got a speech ready. [*Exit*]

JACK: Is he gone? Huzza! I was never so tired in my life. [*Going*]

CENSOR: Hold! I have something to say to you.

JACK: Can't possibly stay to hear you.

CENSOR: Prithee, Jack, how many duels do you fight in a year?

JACK: Me? Lord, not one.

CENSOR: How many times, then, do you beg pardon to escape a caning?

JACK: A caning?

CENSOR: Yes; or do you imagine the very wildness and inattention by which you offend, are competent to make your apology?

JACK: Lord, Mr. Censor, you are never easy but when you are asking some queer question! But I don't much mind you. You odd sort of people, who do nothing all day but *muz* yourselves with thinking, are always coming out with these sort of trimmers; however, I know you so well, that they make no impression on me. [*Exit*]

CENSOR: Through what a multiplicity of channels does folly glide! Its streams, alternately turgid, calm, rapid and lazy, take their several directions from the peculiarities of the minds whence they spring—frequently varying in their courses—but ever similar in their shallowness!

ACT V

A parlour at MRS. VOLUBLE'*s.* MRS. VOLUBLE, MRS. WHEE-
DLE, MISS JENNY *and* BOB *are seated at a round table at supper.*
BETTY *is waiting.*

MRS. VOLUBLE: Well, this is a sad thing, indeed! Betty, give me some
beer. Come, Miss Jenny, here's your love and mine. [*Drinks*]

MRS. WHEEDLE: I do believe there's more misfortunes in our way
of business than in any in the world. The fine ladies have no
more conscience than a Jew. They keep ordering and ordering,
and think no more of paying than if one could live upon a
needle and thread.

MRS. VOLUBLE: Ah, the times are very bad! Very bad, indeed! All
the gentlefolks breaking—why, Betty, the meat i'n't done!
Poor Mr. Mite, the rich cheese-monger at the corner is quite
knocked up.

MRS. WHEEDLE: You don't say so?

MRS. VOLUBLE: Very true, indeed.

MRS. WHEEDLE: Well, who'd have thought of that? Pray, Mrs. Betty,
give me some bread.

MISS JENNY: Why, it is but a week ago that I met him a driving his
own whiskey.

MRS. VOLUBLE: Ah, this is a sad world! A very sad world, indeed!
Nothing but ruination going forward from one end of the
town to the other. My dear Mrs. Wheedle, you don't eat. Pray
let me help you to a little slice more.

MRS. WHEEDLE: Oh, I shall do very well. I only wish you'd take
care of yourself.

MRS. VOLUBLE: There, that little bit can't hurt you, I'm sure. As to
Miss Jenny, she's quite like a crocodile, for she lives upon air.

MRS. WHEEDLE: No, ma'am, the thing is she laces so tight that she
can't eat half her natural victuals.

MRS. VOLUBLE: Aye, aye, that's the way with all the young ladies.
They pinch for fine shapes.

BOB: Mother, I wish you'd help *me*—I'm just starved.

MRS. VOLUBLE: Would you have me help you before I've helped the

company, you greedy fellow, you? Stay till we've done, can't you? And then if there's any left, I'll give you a bit.

MISS JENNY: I'll give Master Bobby a piece of mine, if you please, ma'am.

MRS. VOLUBLE: No, no, he can't be very hungry, I'm sure, for he eat a dinner to frighten a horse. And so, as I was telling you, she has agreed to stay here all night, and, to be sure, poor thing, she does nothing in the world but cry, all as ever I can say to her, and I believe I was talking to her for a matter of an hour before you came, without her making so much as a word of answer. I declare it makes one as melancholy as a cat to see her. I think this is the nicest cold beef I ever tasted. You *must* eat a bit, or I shall take it quite ill.

MRS. WHEEDLE: Well, it must be *leetle* tiny morsel, then.

MRS. VOLUBLE: I shall cut you quite a fox-hall slice.

BOB: Mother, if Mrs. Wheedle's had enough, you'd as good give it me.

MRS. VOLUBLE: I declare I don't believe there's such another fellow in the world for gormondizing! There—take that and be quiet. So, as I was saying—

BOB: Lord, mother, you've given me nothing but fat!

MRS. VOLUBLE: Aye, and too good for you, too. I think, at your age, you've no right to know fat from lean.

MRS. WHEEDLE: Ah, Master Bobby, these are no times to be dainty! One ought to be glad to get bread to eat. I'm sure, for my part, I find it as hard to get my bills paid, as if the fine ladies had no money but what they earned.

MRS. VOLUBLE: If you'll take my advice, Mrs. Wheedle, you'll send in your account directly, and then, if the young lady has any money left, you'll get it at once.

MRS. WHEEDLE: Why, that's just what I thought myself, so I made out the bill and brought it in my pocket.

MRS. VOLUBLE: That's quite right. But, good lack, Mrs. Wheedle, who'd have thought of a young lady's being brought to such a pass? I shall begin soon to think there's no trusting in anybody.

MISS JENNY: For my part, if I was to choose, I should like best to be a lady at once and follow no business at all.

BOB: And for my part, I should like best to be a duke.

MRS. VOLUBLE: A duke? You a duke, indeed! You great numbskull, I wish you'd learn to hold your tongue. I'll tell you what, Mrs. Wheedle, you must know it's my notion this young lady expects something in the money way out of the City, for she gave me a letter, just before you came, to send by a porter; so as I was coming downstairs, I just peeped in at the sides—

Enter CECILIA.

MRS. VOLUBLE: Oh law! I hope she did not me!

CECILIA: I beg your pardon, Mrs. Voluble, for this intrusion, but I rang my bell three times, and I believe nobody heard it.

MRS. VOLUBLE: I'm sure, ma'am, I'm quite sorry you've had such a trouble; but I dare say it was all my son Bobby's fault, for he keeps such a continual jabbering, that there's no hearing anything in the world for him.

BOB: Lord, mother, I'll take my oath I ha'n't spoke three words the whole time! I'm sure I've done nothing but gnaw that nasty fat this whole night.

MRS. VOLUBLE: What, you are beginning again, are you?

CECILIA: I beg I may occasion no disturbance. I merely wished to know if my messenger were returned.

MRS. VOLUBLE: Dear no, ma'am, not yet.

CECILIA: Then he has certainly met with some accident. If you will be so good as to lend me your pen and ink once more, I will send another man after him.

MRS. VOLUBLE: Why, ma'am, he could not have got back so soon, let him never go so fast.

CECILIA: [*Walking apart*] So soon! Oh how unequally are we affected by the progress of time! Winged with the gay plumage of hope, how rapid seems its flight, oppressed with the burden of misery, how tedious its motion, yet it varies not. Insensible to smiles and callous to tears, its acceleration and its tardiness are mere phantasms of our disordered imaginations. How strange that

that which in its course is most steady and uniform should, to our deluded senses, seem most mutable and irregular!

MISS JENNY: I believe she's talking to herself.

MRS. VOLUBLE: Yes, she has a mighty habit of musing. I have a good mind to ask her to eat a bit, for, poor soul, I dare say she's hungry enough. Bobby, get up and let her have your chair.

BOB: What, and then ain't I to have any more?

MRS. VOLUBLE: Do as you're bid, will you, and be quiet. I declare I believe you think of nothing but eating and drinking all day long. Ma'am, will it be agreeable to you to eat a bit of supper with us?

MRS. WHEEDLE: The young lady does not hear you; I'll go to her myself. [*Rises and follows* CECILIA] I hope, Miss Stanley, you're very well? I hope my lady's well? I believe, ma'am, you don't recollect me?

CECILIA: Mrs. Wheedle? Yes, I do.

MRS. WHEEDLE: I'm very sorry, I'm sure, ma'am, to hear of your misfortunes, but I hope things ain't quite so bad as they're reported?

CECILIA: I thank you. Mrs. Voluble, is your pen and ink here?

MRS. VOLUBLE: You shall have it directly; but pray, ma'am, let me persuade you to eat a morsel first.

CECILIA: I am obliged to you, but I cannot.

MRS. VOLUBLE: Why, now here's the nicest little miniken bit you ever saw; it's enough to tempt you to look at it.

BOB: Mother, if the lady don't like it, can't you give it me?

MRS. VOLUBLE: I was just this minute going to help you, but now you're so greedy, you shan't have a bit.

CECILIA: Mrs. Voluble, can I find the pen and ink myself?

MRS. VOLUBLE: I'll fetch it in two minutes. But, dear ma'am, don't fret, for bad things of one sort or other are always coming to pass; and, as to breaking and so forth, why, I think it happens to everybody. I'm sure there's Mr. Grease, the tallow chandler, one of my most particular acquaintance, that's got as genteel a shop as any in all London, is quite upon the very point of ruination. And Miss Moggy Grease, his daughter—

CECILIA: I'll step upstairs, and when you are at leisure, you will be so good as to send me the standish. [*Going*]

MRS. WHEEDLE: [*Stopped her*] Ma'am, as I did not know when I might have the pleasure of seeing you again, I took the liberty just to make out my little account and bring it in my pocket. And I hope, ma'am, that when you make up your affairs, you'll be so good as to let me be the first person that's considered, for I'm a deal out of pocket, and should be very glad to have some of the money as soon as possible.

CECILIA: Dunned already! Good Heaven, what will become of me? [*Bursts into tears*]

MRS. VOLUBLE: Dear ma'am, what signifies fretting? Better eat a bit of supper, and get up your spirits. Betty, go for a clean plate. [*Exit* BETTY]

MRS. WHEEDLE: Won't you please, ma'am, to look at the bill?

CECILIA: Why should I look at it? I cannot pay it—I am a destitute creature—without friend or resource!

MRS. WHEEDLE: But, ma'am, I only mean—

CECILIA: No matter what you mean! All application to *me* is fruitless—I possess nothing. The beggar who sues to you for a penny is not more powerless and wretched. A tortured and insulted heart is all that I can call my own!

MRS. WHEEDLE: But sure, ma'am, when there comes to be a division among your creditors, your debts won't amount to more than—

CECILIA: Forbear, forbear! I am not yet inured to disgrace, and this manner of stating my affairs is insupportable. *Your* debt, assure yourself, is secure, for sooner will I famish with want or perish with cold, faint with the fatigue of labour or consume with unassisted sickness, than appropriate to my own use the smallest part of my shattered fortune, till your—and every other claim upon it—is answered.

MRS. WHEEDLE: Well, ma'am, that's as much as one can expect.

Re-enter BETTY, *with a plate and a letter.*

BETTY: Ma'am, is your name Miss Stanley?

CECILIA: Yes. Is that letter for me? [*Takes it*]

MRS. VOLUBLE: Betty, why did not you bring the letter first to me? Sure I'm the mistress of my own house? Come, Mrs. Wheedle, come and finish your supper.

MRS. WHEEDLE *returns to the table.*

CECILIA: I dread to open it! Does anybody wait?

BETTY: Yes, ma'am, a man in a fine lace livery.

CECILIA: [*Reading*] "Since you would not hear my message from Mr. Censor, I must try if you will read it from myself. I do most earnestly exhort you to go instantly and privately into the country, and you may then depend upon my support and protection. Beaufort now begins to listen to reason—" Oh Heaven! "And therefore, if you do not continue in town with a view to attract his notice, or, by acquainting him with your retirement, seduce him to follow you—" Insolent, injurious woman! "I have no doubt but he will be guided by one whose experience and studies entitle her to direct him. I shall call upon you very soon, to know your determination, and to supply you with cash for your journey, being, with the utmost sorrow for your misfortunes, dear Miss Stanley, Yours &c., Judith Smatter."

What a letter!

BETTY: Ma'am, if you please, is there any answer?

CECILIA: No, none.

BETTY: Then, ma'am, what am I to say to the footman?

CECILIA: Nothing—yes—tell him I have read *this* letter, but if he brings another, it will be returned unopened.

BETTY: Yes, ma'am. [*Aside*] Laws! What a comical answer! [*Exit*]

MRS. VOLUBLE: I wonder who that letter was from!

MISS JENNY: I dare say I can guess. I'll venture something it's from her sweetheart.

MRS. VOLUBLE: That's just my thought! [*They whisper*]

CECILIA: Is then every evil included in poverty? And is the deprivation of wealth what is least to regret? Are contempt, insult and treachery its necessary attendants? Is not the loss of affluence

sufficiently bitter, the ruin of all hope sufficiently severe, but that Reproach too must add her stings, and Scorn her daggers?

MRS. VOLUBLE: When I've eat this, I'll ask her if we guessed right.

CECILIA: "Beaufort begins to listen to reason"—mercenary Beaufort! Interest has taken sole possession of thy heart—weak and credulous that I was to believe I had ever any share in it!

MRS. VOLUBLE: I'm of ten minds whether to speak to her or leave her to her own devices.

CECILIA: "To listen to reason"—is then reason another word for baseness, falsehood and inconstancy?

MRS. WHEEDLE: I only wish my money was once safe in my pocket.

CECILIA: Attract his notice? Seduce him to follow! Am I already so sunk? Already regarded as a designing, interested wretch? I cannot bear the imputation. My swelling heart seems too big for its mansion. Oh that I could quit them all!

MRS. VOLUBLE: [*Rising and approaching* CECILIA] Ma'am, I'm quite sorry to see you in such trouble. I'm afraid that letter did not bring you agreeable news. I'm sure I wish I could serve you with all my heart, and if you're distressed about a lodging, I've just thought of one in Queen Street, that, in a week's time—

CECILIA: In a week's time I hope to be far away from Queen Street— far away from this hated city—far away, if possible, from all to whom I am known!

MRS. VOLUBLE: Dear ma'am, sure you don't think of going beyond seas?

MRS. WHEEDLE: If you should like, ma'am, to go abroad, I believe I can help you to a thing of that sort myself.

CECILIA: How?

MRS. WHEEDLE: Why, ma'am, I know a lady who's upon the very point of going, and the young lady who was to have been her companion all of a sudden married a young gentleman of fortune and left her without any notice.

CECILIA: Who is the lady?

MRS. WHEEDLE: Mrs. Hollis, ma'am; she's a lady of very good fortunes.

CECILIA: I have heard of her.

MRS. WHEEDLE: And she wants a young lady very much. She sets off the beginning of next week. If it's agreeable to you to go to her, I shall be proud to show you the way.

CECILIA: I know not what to do!

MRS. VOLUBLE: Dear ma'am, I would not have you think of such a desperation scheme. Things may be better soon, and who knows but Mr. Beaufort may prove himself a true lover at the last? Lord, if you could but once get the sight of him, I dare say, for all my lady, the day would be your own.

CECILIA: [*Aside*] What odious interpretations! To what insults am I exposed! Yes, I had indeed better quit the kingdom. [*To* MRS. WHEEDLE] Mrs. Wheedle, I am ready to attend you.

MRS. WHEEDLE: Then, Master Bobby, bid Betty call a coach.

CECILIA: No—stay!

MRS. WHEEDLE: What, ma'am, won't you go?

CECILIA: [*Walking apart*] Am I not too rash? Expose myself, like a common servant, to be hired? Submit to be examined and hazard being rejected! No, no, my spirit is not yet so broken.

MRS. VOLUBLE: I hope, ma'am, you are thinking better of it. For my part, if I might be free to advise you, I should say send to the young gentleman and see first what is to be done with *him*.

CECILIA: [*Aside*] What humiliating suggestions! Yes, I see I must be gone. I see I must hide myself from the world, or submit to be suspected of views and designs I disdain to think of. [*To* MRS. WHEEDLE] Mrs. Wheedle, I cannot well accompany you to this lady myself, but if you will go to her in my name, tell her my unhappy situation, as far as your knowledge of it goes—and that, alas, includes but half its misery!—you will much oblige me. When did you say she leaves England?

MRS. WHEEDLE: Next week, ma'am.

CECILIA: I shall have time, then, to arrange my affairs. Tell her I know not yet in what capacity to offer myself, but that, at all events, it is my first wish to quit this country.

MRS. WHEEDLE: Yes, ma'am. I'll get my hat and cloak, and go directly. [*Exit*]

CECILIA: Alas, to what abject dependence may I have exposed myself!

MRS. VOLUBLE: Come, ma'am, let me persuade you to taste my raisin wine. I do believe it's the best that–

CECILIA: I thank you, but I can neither eat nor drink. [*Going*]

Re-enter MRS. WHEEDLE.

MRS. WHEEDLE: I suppose, ma'am, I may tell Mrs. Hollis you will have no objection to doing a little work for the children, and things of that sort, as the last young lady did?

CECILIA: Oh heavy hour! Down, down, proud heart! Tell her what you will! I must submit to my fate, not choose it; and should servility and dependence be my lot, I trust, at least, that I shall not only find them new—not only find them heart-breaking and cruel—but short and expeditious.

MRS. VOLUBLE: But, ma'am, had not you best—

CECILIA: I have no more directions to give, and I can answer no more questions. The sorrows of my situation seem every moment to be aggravated—oh Beaufort! Faithless, unfeeling Beaufort! To have rescued you from distress and mortification such as this would have been my heart's first joy—my life's only pride! [*Exit*]

MRS. VOLUBLE: She's quite in a sad taking, that's the truth of it.

MISS JENNY: Poor young lady! I'm so sorry for her you can't think.

MRS. VOLUBLE: Come, Mrs. Wheedle, you shan't go till you've drunk a glass of wine, so let's sit down a little while and be comfortable. [*They seat themselves at the table*] You need not be afraid of the dark, for Bobby shall go with you.

BOB: Mother, I'd rather behalf not.

MRS. VOLUBLE: Who wants to know whether you'd rather or not? I suppose there's no need to consult all your rathernesses. Well, ma'am, so, as I was going to tell you, poor Miss Moggy Grease—[*A violent knocking at the door*] Lord bless me, who's at the door? Why, they'll knock the house down! Somebody to Mr. Dabler, I suppose; but he won't be home this two hours.

BOB: Mother, may I help myself to a drop of wine? [*Takes the bottle*]

MRS. VOLUBLE: Wine, indeed! No—give me the bottle this minute. [*Snatches and overturns it*] Look here, you nasty fellow, see how you've made me spill it!

Enter BETTY.

BETTY: Laws, ma'am, here's a fine lady all in her coach, and she asks for nobody but you.

MRS. VOLUBLE: For me? Well, was ever the like! Only see, Betty, what a slop Bobby's made! There's no such a thing as having it seen. Come, folks, get up all of you, and let's move away the table. Bob, why don't you stir? One would think you were nailed to your seat.

BOB: Why, I'm making all the haste I can, ain't I?

They all rise, and BOB *overturns the table.*

MRS. VOLUBLE: Well, if this is not enough to drive one mad! I declare I could flee the boy alive! Here's a room to see company! You great, nasty stupid dolt, you, get out of my sight this minute.

BOB: Why, mother, I did not do it for the purpose.

MRS. VOLUBLE: But you did, you great loggerhead, I know you did! Get out of my sight this minute, I say! [*Drives him off the stage*] Well, what's to be done now? Did ever anybody see such a room? I declare I was never in such a pucker in my life. Mrs. Wheedle, do help to put some of the things into the closet. Look here, if my china bowl i'n't broke! I vow I've a great mind to make that looby eat it for his supper. Betty, why don't you get a mop? You're as helpless as a child. No, a broom—get a broom, and sweep them all away at once. Why, you ain't going empty-handed, are you? I declare you have not half the head you was born with.

BETTY: I'm sure I don't know what to do no more than the dog. [*Gets a broom*]

MRS. VOLUBLE: What do you talk so for? Have you a mind to have the company hear you? [*The knocking is repeated*] There, they're knocking like mad! Miss Jenny, what signifies your staring? Can't you make yourself a little useful? I'm sure if you won't at such a time as this—why, Betty, why don't you make haste? Come, poke everything into the closet. I wonder why Bobby could not have took some of the things himself—but as soon as ever he's done the mischief, he thinks of nothing but running away.

They clear the stage, and MISS JENNY *runs to a looking glass.*

MISS JENNY: Dear me, what a figure I've made of myself!

MRS. VOLUBLE: There, now we shall do pretty well. Betty, go and ask the lady in. [*Exit* BETTY] I declare I'm in such a flustration!

MISS JENNY: So am I, I'm sure, for I'm all of a tremble.

MRS. WHEEDLE: Well, if you can spare master Bobby, we'll go to Mrs. Hollis's directly.

MRS. VOLUBLE: Spare him? Aye, I'm sure it would have been good luck for me if you had taken him an hour ago.

MRS. WHEEDLE: Well, goodbye, then. I shall see who the lady is as I go along. [*Exit*]

MISS JENNY: It's very unlucky I did not put on my Irish muslin.

MRS. VOLUBLE: It's prodigious odd what can bring any company at this time of night.

Enter MRS. SAPIENT.

Mrs. Sapient! Dear ma'am, I can hardly believe my eyes!

MRS. SAPIENT: I am afraid my visit is unseasonable, but I beg I may not incommode you.

MRS. VOLUBLE: Incommode me? Dear ma'am, no, not the least in the world. I was doing nothing but just sitting here talking with Miss Jenny, about one thing or another.

MRS. SAPIENT: I have a question to ask you, Mrs. Voluble, which—

MRS. VOLUBLE: I'm sure, ma'am, I shall be very proud to answer it, but if I had but known of the pleasure of seeing you, I should not have been in such a pickle, but it happened so that we've

been a little busy today. You know, ma'am, in all families there will be some busy days, and I've the misfortune of a son, ma'am, who's a little unlucky, so that puts one a little out of sorts, but he's so unmanageable, ma'am, that really—

MRS. SAPIENT: Well, well, I only want to ask if you know anything of Miss Stanley?

MRS. VOLUBLE: Miss Stanley? To be sure I do, ma'am. Why, she's now in my own house here.

MRS. SAPIENT: Indeed? And pray—what, I suppose, she is chiefly with Mr. Dabler?

MRS. VOLUBLE: No, ma'am, no, she keeps prodigiously snug. She bid me not tell anybody she was here, so I make it a rule to keep it secret—unless, indeed, ma'am, to such a lady as you.

MRS. SAPIENT: Oh, it's very safe with me. But, pray, don't you think Mr. Dabler rather admires her?

MRS. VOLUBLE: Oh no, ma'am, not half so much as he admires another lady of your acquaintance. Ha, ha!

MRS. SAPIENT: Fie, Mrs. Voluble! But pray, does not he write a great deal?

MRS. VOLUBLE: Dear ma'am, yes. He's in one continual scribbling from morning to night.

MRS. SAPIENT: Well, and—do you know if he write about any particular person?

MRS. VOLUBLE: Oh yes, ma'am, he writes about Celia, and Daphne, and Cleora, and—

MRS. SAPIENT: You never see his poems, do you?

MRS. VOLUBLE: Oh dear yes, ma'am, I see them all. Why, I have one now in my pocket about Cleora that I happened to pick up this morning. [*Aside to* MISS JENNY] Miss Jenny, do pray put me in mind to put it up before he comes home. [*To* MRS. SAPIENT] Should you like to see it, ma'am?

MRS. SAPIENT: Why—if you have it at hand—

MRS. VOLUBLE: Dear ma'am, if I had not, I'm sure I'd fetch it, for I shall be quite proud to oblige you. As to any common acquaintance, I would not do such a thing upon any account, because I should scorn to do such a baseness to Mr. Dabler,

but to such a lady as you it's quite another thing. For whenever I meet with a lady of quality, I make it a point to behave in the genteelest manner I can. Perhaps, ma'am, you'd like to see Mr. Dabler's study?

MRS. SAPIENT: Oh no, not upon any account.

MRS. VOLUBLE: Because, upon his table, there's a matter of an hundred of his *miniscrips*.

MRS. SAPIENT: Indeed? But when do you expect him home?

MRS. VOLUBLE: Oh not this good while.

MRS. SAPIENT: Well then—if you are certain we shall not be surprised—

MRS. VOLUBLE: Oh, I'm quite certain of that.

MRS. SAPIENT: But then, for fear of accidents, let your maid order my coach to wait in the next street.

MRS. VOLUBLE: Yes, ma'am. Here, Betty! [*Exit*]

MRS. SAPIENT: This is not quite right, but this woman would show them to somebody else if not to me. And now perhaps I may discover whether any of his private papers contain my name. She will not, for her own sake, dare betray me.

Re-enter MRS. VOLUBLE.

MRS. VOLUBLE: Now, ma'am, I'll wait upon you. I assure you, ma'am, I would not do this for everybody, only a lady of your honor I'm sure would be above—

Exit talking, with MRS. SAPIENT.

MISS JENNY: She's said never a word to *me* all the time, and I dare say she knew me as well as could be; but fine ladies seem to think their words are made of gold, they are so afraid of bestowing them.

Re-enter MRS. VOLUBLE.

MRS. VOLUBLE: Oh Miss Jenny, only look here! My apron's all stained with the wine! I never see it till this minute, and now—[*A knocking at the door*] Oh! [*Screams*] That's Mr. Dabler's knock! What shall we all do? Run upstairs and tell the lady this minute.

[*Exit* MISS JENNY] Betty! Betty! Don't go to the door yet. I can't think what brings him home so soon! Here's nothing but ill luck upon ill luck!

Enter MRS. SAPIENT *with* MISS JENNY.

Come, ma'am, come in! Betty! You may go to the door now.

MRS. SAPIENT: But are you sure he will not come in here?

MRS. VOLUBLE: Oh quite, ma'am; he always goes to his own room. Hush! Aye, he's gone up, I heard him pass.

MRS. SAPIENT: I am quite surprised, Mrs. Voluble, you should have deceived me thus. Did not you assure me he would not return this hour? I must tell you, Mrs. Voluble, that, whatever you may think of it, *I* shall always regard a person who is capable of deceit, to be guilty of insincerity.

MRS. VOLUBLE: Indeed, ma'am, I knew no more of his return than you did, for he makes it a sort of rule of a 'Sprit night—

MISS JENNY: Ma'am, ma'am, I hear him on the stairs!

MRS. SAPIENT: Oh hide me—hide me this instant anywhere—and don't say I am here for the universe! [*She runs into the closet*]

MRS. VOLUBLE: No, ma'am, that I won't if it costs me my life! You may always depend upon *me*. [*Shuts her in*]

MISS JENNY: Laws, what a pickle she'll be in! She's got all among the broken things.

Enter DABLER.

DABLER: Mrs. Voluble, you'll please to make out my account, for I shall leave your house directly.

MRS. VOLUBLE: Leave my house? Lord, sir, you quite frighten me!

DABLER: You have used me very ill, Mrs. Voluble, and curse me if I shall put up with it!

MRS. VOLUBLE: Me, sir? I'm sure, sir, I don't so much as know what you mean.

DABLER: You have been rummaging all my papers.

MRS. VOLUBLE: I? No, sir—I'm sorry, sir, you suspect me of such a mean proceeding.

DABLER: 'Tis in vain to deny it. I have often had reason to think

it, but now my doubts are confirmed, for my last new song, which I called "Cleora," is nowhere to be found.

MRS. VOLUBLE: Nowhere to be found? You surprise me! [*Aside*] Good lank, I quite forgot to put it up!

DABLER: I'm certain I left it at the top of my papers.

MRS. VOLUBLE: Did you indeed, sir? Well, I'm sure it's the oddest thing in the world what can become of it!

DABLER: There is something so gross, so scandalous in this usage, that I am determined not to be duped by it. I shall quit my lodgings directly—take your measures accordingly. [*Going*]

MRS. VOLUBLE: Oh pray, sir, stay—and if you won't be so angry, I'll tell you the whole truth of the matter.

DABLER: Be quick, then.

MRS. VOLUBLE: [*In a low voice*] I'm sorry, sir, to betray a lady, but when one's reputation is at stake—

DABLER: What lady? I don't understand you.

MRS. VOLUBLE: Hush, hush, sir! She'll hear you.

DABLER: She? Who?

MRS. VOLUBLE: Why, Mrs. Sapient, sir, [*Whispering*] she's in that closet.

DABLER: What do you mean?

MRS. VOLUBLE: I'll tell you all, sir, by and by, but you must know she came to me, and—and—and begged just to look at your study, sir. So, sir, never supposing such a lady as that would think of looking at your papers, I was persuaded to agree to it; but, sir, as soon as ever we got into the room, she fell to reading them without so much as saying a word! While I, all the time, stood in this manner, staring with stupification. So, sir, when you knocked at the door, she ran down to the closet.

DABLER: And what has induced her to do all this?

MRS. VOLUBLE: Ah, sir, you know well enough! Mrs. Sapient is a lady of prodigious good taste. Everybody knows how she admires Mr. Dabler.

DABLER: Why, yes, I don't think she wants taste.

MRS. VOLUBLE: Well, but, sir, pray don't stay, for she is quite close crammed in the closet.

DABLER: I think I'll speak to her.

MRS. VOLUBLE: Not for the world, sir! If she knows I've betrayed her, she'll go beside herself. And, I'm sure, sir, I would not have told anybody but you upon no account. If you'll wait upstairs till she's gone, I'll come and tell you all about it—but pray, dear sir, make haste.

DABLER: Yes, she's a good agreeable woman, and really has a pretty knowledge of poetry. Poor soul! I begin to be half sorry for her. [*Exit*]

MRS. VOLUBLE: I thought he'd never have gone. How do you now, ma'am? [*Opens the closet door*]

Enter MRS. SAPIENT.

MRS. SAPIENT: Cramped to death! What a strange place have you put me in! Let me be gone this instant—but are you sure, Mrs. Voluble, you have not betrayed me?

MRS. VOLUBLE: I'm surprised, ma'am, you should suspect me! I would not do such a false thing for never so much, for I always—[*A knocking at the door*] Why now, who can that be?

MRS. SAPIENT: How infinitely provoking! Let me go back to this frightful closet till the coast is clear. [*Returns to the closet*]

MRS. VOLUBLE: Well, I think I've managed matters like a Matchwell.

Enter MRS. WHEEDLE.

MRS. WHEEDLE: Oh, I'm quite out of breath—I never walked so fast in my life.

MRS. VOLUBLE: Where have you left Bobby?

MRS. WHEEDLE: He's gone into the kitchen. I must see Miss Stanley directly.

MRS. VOLUBLE: We've been in perilous danger since you went. Do you know [*In a low voice*] Mrs. Sapient is now in the closet? Be sure you don't tell anybody.

MRS. WHEEDLE: No, not for the world. Miss Jenny, pray step up and tell Miss Stanley I'm come back. [*Exit* MISS JENNY]

MRS. VOLUBLE: Well, and while you speak to her, I'll go and talk over Mr. Dabler, and contrive to poke this nasty song under

the table. But first I'll say something to the poor lady in the closet. Ma'am! [*Opens the door*] If you've a mind to keep still, you'll hear all what Miss Stanley says presently, for she's coming down.

MRS. SAPIENT: Are you mad, Mrs. Voluble? What do you hold the door open for? Would you have that woman see me?

MRS. VOLUBLE: Ma'am, I beg your pardon! [*Shuts the door*] I won't help her out this half-hour for that crossness. [*Exit*]

MRS. WHEEDLE: These fine ladies go through anything for the sake of curiosity.

Enter CECILIA.

CECILIA: Well, Mrs. Wheedle, have you seen Mrs. Hollis?

MRS. WHEEDLE: Yes, ma'am, and she's quite agreeable to your proposal; but as she's going very soon and will be glad to be fixed, she says she shall take it as a particular favour if you will go to her house tonight.

CECILIA: Impossible! I must consult some friend ere I go at all.

MRS. WHEEDLE: But, ma'am, she begs you will, for she says she's heard of your misfortunes, and shall be glad to give you her advice what to do.

CECILIA: Then I *will* go to her! For never yet did poor creature more want advice and assistance!

MRS. WHEEDLE: [*Calls at the door*] Betty! Go and get a coach. I'll just go speak to Mrs. Voluble, ma'am, and come again. [*Exit*]

CECILIA: Perhaps I may repent this enterprise. My heart fails me already—and yet how few are those human actions that repentance may not pursue! Error precedes almost every step, and sorrow follows every error. I, who to happiness have bid a long, a last farewell, must content myself with seeking peace in retirement and solitude, and endeavour to contract all my wishes to preserving my own innocence from the contagion of this bad and most deceased world's corruptions.

Enter BETTY.

BETTY: Ma'am, the coach is at the door.

CECILIA: Alas!

BETTY: Mrs. Wheedle, ma'am, is gone upstairs to my mississ, but she says she'll be ready in a few minutes. [*Exit*]

CECILIA: Oh cease, fond, suffering, feeble heart to struggle thus with misery inevitable! Beaufort is no longer the Beaufort he appeared, and since he has lost even the semblance of his worth, why should this sharp regret pursue his image? But alas, that semblance which *he* has lost, *I* must ever retain! Fresh, fair and perfect it is still before me! Oh why must woe weaken all faculties but the memory? I will reason no longer; I will think of him no more. I will offer myself to servitude, for labour itself must be less insupportable than this gloomy indolence of sorrowing reflection. Where is this woman? [*Going*]

Enter BEAUFORT, *who stops her.*

BEAUFORT: My Cecilia!

CECILIA: Oh good Heaven!

BEAUFORT: My loved, lost, injured—my adored Cecilia!

CECILIA: Am I awake?

BEAUFORT: Whence this surprise? My love, my heart's sweet partner—

CECILIA: Oh forbear! These terms are no longer—Mr. Beaufort, let me pass!

BEAUFORT: What do I hear?

CECILIA: Leave me, sir, I cannot talk with you—leave me, I say!

BEAUFORT: Leave you? [*Offering to take her hand*]

CECILIA: Yes, [*Turning from him*] for I cannot bear to look at you!

BEAUFORT: Not look at me? What have I done? How have I offended you? Why are you thus dreadfully changed?

CECILIA: *I* changed? Comes this well from *you*? But I will not recriminate; neither will I converse with you any longer. You see me now perhaps for the last time. I am preparing to quit the kingdom.

BEAUFORT: To quit the kingdom?

CECILIA: Yes. It is a step which your own conduct has compelled me to take.

BEAUFORT: My conduct? Who has belied me to you? What villain—

CECILIA: No one, sir. You have done your work yourself.

BEAUFORT: Cecilia, do you mean to distract me? If not, explain, and instantly, your dark, your cruel meaning.

CECILIA: Can it want explanation to *you*? Have you shocked me in ignorance and irritated me without knowing it?

BEAUFORT: I shocked? I irritated you?

CECILIA: Did you not, in the very first anguish of a calamity which you alone had the power to alleviate, neglect and avoid me? Send me a cold message by a friend? Suffer me to endure indignities without support and sorrows without participation? Leave me defenceless, to be crushed by impending ruin? And abandon my aching heart to all the torture of new-born fears, unprotected, unassured and uncomforted?

BEAUFORT: Can *I* have done all this?

CECILIA: I know not, but I am sure it has seemed so.

BEAUFORT: Oh wretched policy of cold, unfeeling prudence, had I listened to no dictates but those of my heart, I had never been wounded with suspicions and reproaches so cruel.

CECILIA: Rather say, had your heart sooner known its own docility, you might have permitted Lady Smatter to dispose of it ere the deluded Cecilia was known to you.

BEAUFORT: Barbarous Cecilia! Take not such a time as this to depreciate my heart in your opinion, for now—'tis all I have to offer you.

CECILIA: You know too well—'tis all I ever valued.

BEAUFORT: Oh take it then. Receive it once more, and with that confidence in its faith which it never deserved to forfeit! Painfully I submitted to advice I abhorred, but though my judgement has been overpowered, my truth has been inviolate. Turn not from me, Cecilia! If I have temporised, it has been less for my own sake than for yours, but I have seen the vanity of my expectations. I have disobeyed Lady Smatter. I have set all consequences at defiance and flown in the very face of

ruin—and now, will *you*, Cecilia, [*Kneeling*] reject, disdain and spurn me?

CECILIA: Oh Beaufort, is it possible I can have wronged you?

BEAUFORT: Never, my sweetest Cecilia, if now you pardon me.

CECILIA: Pardon you? Too generous Beaufort! Ah, rise!

Enter LADY SMATTER *and* MR. CODGER.

BEAUFORT: [*Rising*] Lady Smatter!

LADY SMATTER: How, Beaufort here? And kneeling, too!

CODGER: Son Beaufort, I cannot deny but I think it is rather an extraordinary thing that you should choose to be seen kneeling to that young lady, knowing, I presume, that your aunt Smatter disaffects your so doing.

LADY SMATTER: Beaufort, I see you are resolved to keep no terms with me. As to Miss Stanley, I renounce her with contempt. I came hither with the most generous views of assisting her, and prevailed with Mr. Codger to conduct her to her friends in the country. But since I find her capable of so much baseness, since I see that all her little arts are at work—

CECILIA: Forbear, madam, these unmerited reproaches. Believe me, I will neither become a burden to you nor a scorn to myself. The measures I have taken I doubt not will meet with your ladyship's approbation, though it is by no means incumbent upon me, thus contemptuously accused, to enter into any defence or explanation. [*Exit*]

BEAUFORT: Stay, my Cecilia—hear me—[*Follows her*]

LADY SMATTER: How, pursue her in defiance of my presence? Had I a pen and ink I should disinherit him incontinently. Who are all these people?

Enter MISS JENNY, MRS. VOLUBLE *and* MRS. WHEEDLE.

MISS JENNY: [*As she enters*] Law, only look! Here's Lady Smatter and an old gentleman!

MRS. VOLUBLE: What, in my parlour? Well, I declare, and so there is! Why, how could they get in?

MRS. WHEEDLE: I suppose the door's open because of the hackney coach. But as to Miss Stanley, I believe she's hid herself.

CODGER: Madam, I can give your ladyship no satisfaction.

LADY SMATTER: About what?

CODGER: About these people, madam, that your ladyship was enquiring after, for, to the best of my knowledge, madam, I apprehend I never saw any of them before.

LADY SMATTER: I see who they are myself now.

MRS. VOLUBLE: [*Advancing to* LADY SMATTER] My lady, I hope your ladyship's well. I am very glad, my lady, to pay my humble duty to your ladyship in my poor house, and I hope—

LADY SMATTER: Pray, is Mr. Dabler at home?

MRS. VOLUBLE: Yes, my lady, and indeed—

LADY SMATTER: Tell him then I shall be glad to see him.

MRS. VOLUBLE: Yes, my lady. [*Aside to* MISS JENNY] I suppose, Miss Jenny, you little thought of my having such a genteel acquaintance among the quality! [*Exit*]

MISS JENNY: [*Aside to* MRS. WHEEDLE] I'm afraid that poor lady in the closet will spoil all her things.

LADY SMATTER: Yes, I'll consult with Mr. Dabler, for as to this old soul, it takes him half an hour to recollect whether two and three makes five or six.

Enter CENSOR.

CENSOR: I have, with some difficulty, traced your ladyship hither.

LADY SMATTER: Then, sir, you have traced me to a most delightful spot; and you will find your friend as self-willed, refractory and opinionated as your amplest instructions can have rendered him.

CENSOR: I would advise your ladyship to think a little less for him and a little more for yourself, lest in your solicitude for his fortune you lose all care for your own fame.

LADY SMATTER: My fame? I don't understand you.

CENSOR: Nay, if you think such lampoons may spread without doing you injury—

LADY SMATTER: Lampoons? What lampoons? Sure nobody has dared—

Enter DABLER *and* MRS. VOLUBLE.

MRS. VOLUBLE: Why, here's Mr. Censor too! I believe there'll be company coming in all night.

LADY SMATTER: Mr. Censor, I say, if there is any lampoon that concerns *me*, I insist upon hearing it directly.

CENSOR: I picked it up just now at a coffee-house:
[*Reads*] "Yes, Smatter is the Muse's friend,
She knows to censure or commend;
And has of faith and truth such store
She'll ne'er desert you—till you're poor."

LADY SMATTER: What insolence impertinence!

DABLER: Poor stuff! Poor stuff, indeed! Your ladyship should regard these little squibs as *I* do, mere impotent efforts of envy.

LADY SMATTER: Oh I do; I'd rather hear them than not.

DABLER: And ill done, too; most contemptibly ill done. I think I'll answer it for your ladyship.

CENSOR: Hark ye, Mr. Dabler, [*Takes him aside*] do you know this paper?

DABLER: That paper?

CENSOR: Yes, sir. It contains the lines which you passed off at Lady Smatter's as made at the moment.

DABLER: Why, sir, that was merely—it happened—

CENSOR: It is too late for equivocation, sir. Your reputation is now wholly in my power, and I can instantly blast it, alike with respect to poetry and to veracity.

DABLER: Surely, sir—

CENSOR: If, therefore, you do not, with your utmost skill, assist me to reconcile Lady Smatter to her nephew and his choice, I will show this original copy of your extemporary abilities to everybody who will take the trouble to read it. Otherwise, I will sink the whole transaction and return you this glaring proof of it.

DABLER: To be sure, sir—as to Mr. Beaufort's choice—it's the thing in the world I most approve—and so—

CENSOR: Well, sir, you know the alternative and must act as you please.

DABLER: [*Aside*] What cursed ill luck!

LADY SMATTER: Mr. Censor, I more than half suspect you are yourself the author of that pretty lampoon.

CENSOR: Nay, madam, you see this is not my writing.

LADY SMATTER: Give it me.

CENSOR: Hold—here's something on the other side which I did not see.

[*Reads*] "Were madness stinted to Moorfields
The world elsewhere would be much thinner;
To time now Smatter's beauty yields—"

LADY SMATTER: How!

CENSOR: [*Reading*] "She fain in wit would be a winner.
At thirty she began to read—"

LADY SMATTER: That's false! Entirely false!

CENSOR: [*Reads*] "At forty, it is said, could spell—"

LADY SMATTER: How's that? At forty? Sir, this is your own putting in.

CENSOR: [*Reads*] "At fifty—"

LADY SMATTER: At fifty? Ha, ha, ha! This is droll enough!

CENSOR: [*Reads*] "At fifty, 'twas by all agreed
A common schoolgirl she'd excel."

LADY SMATTER: What impertinent nonsense!

CENSOR: [*Reads*] "Such wonders did the world presage—"

LADY SMATTER: Mr. Censor, I desire you read no more. 'Tis such rubbish it makes me sick.

CENSOR: [*Reads*] "Such wonders did the world presage
From blossoms which such fruit invited,
When avarice—the vice of age—
Stepped in and all expectance blighted."

LADY SMATTER: Of age! I protest this is the most impudent thing I ever heard in my life! Calculated for no purpose in the world but to insinuate I am growing old.

CENSOR: You have certainly some secret enemy who avails himself of

your disagreement with Miss Stanley to prejudice the world against you.

LADY SMATTER: Oh I'm certain I can tell who it is.

CENSOR: Who?

LADY SMATTER: Mrs. Sapient.

MISS JENNY: [*Aside*] Law, I'm afraid she'll hear them.

LADY SMATTER: Not that I suspect her of the writing—for, miserable stuff as it is, I know her capacity is yet below it—but she was the first to leave my house when the affair was discovered, and I suppose she has been tattling it about the town ever since.

MRS. VOLUBLE: [*Aside*] Ah, poor lady, it's all to fall upon her!

CENSOR: Depend upon it, madam, this will never rest here. Your ladyship is so well known that one satire will but be the prelude to another.

LADY SMATTER: Alas, how dangerous is popularity! Oh Mr. Dabler, that I could but despise these libels as you do! But this last is insufferable—yet you, I suppose, would think it nothing?

DABLER: No, really, ma'am, I can't say that—no, not as *nothing*—that is, not absolutely as nothing—for—for libels of this sort—are rather—

LADY SMATTER: How? I thought you held them all in contempt?

DABLER: So I do, ma'am, only—

CENSOR: You do, sir?

DABLER: No, sir, no, I don't mean to absolutely say that—that is, only in regard to *myself*—for we men do not suffer in the world by lampoons as the poor ladies do—they, indeed, may be quite—quite ruined by them.

LADY SMATTER: Nay, Mr. Dabler, now *you* begin to distress me.

Enter JACK.

JACK: [*Singing*] "She has ta'en such a dose of incongruous matter That Bedlam must soon hold the carcass of Smatter—"

LADY SMATTER: How? What? The carcass of who?

JACK: Ha, ha, ha! Faith, madam, I beg your pardon, but who'd have thought of meeting your ladyship here? Oh Dabler, I have such a thing to tell you! [*Whispers to him and laughs*]

LADY SMATTER: I shall go mad! What were you singing, Jack—what is it you laugh at? Why won't you speak?

JACK: I'm so much hurried I can't stay to answer your ladyship now. Dabler, be sure keep counsel. Ha, ha, ha! I must go and sing it to Billy Skip and Will Scamper, or I shan't sleep a wink all night. [*Going*]

LADY SMATTER: This is intolerable! Stay, Jack, I charge you! Mr. Codger, how unmoved you stand! Why don't you make him stay?

CODGER: Madam, I will. Son Jack, stay.

JACK: Lord, sir—

LADY SMATTER: I am half choked! Mr. Codger, you would provoke a saint! Why don't you make him tell you what he was singing?

CODGER: Madam, he is so giddy-pated he never understands me. Son Jack, you attend to nothing! Don't you perceive that her ladyship seems curious to know what song you were humming?

JACK: Why, sir, it was only a new ballad.

LADY SMATTER: A ballad with *my* name in it? Explain yourself instantly!

JACK: Here it is—shall I sing it or say it?

LADY SMATTER: You shall do neither—give it me!

CENSOR: No, no, sing it first for the good of the company.

JACK: Your ladyship won't take it ill?

LADY SMATTER: Ask me no questions—I don't know what I shall do.

JACK: [*Sings*] "I call not to swains to attend to my song,
Nor call I to damsels, so tender and young;
To critics and pedants and doctors I clatter,
For who else will heed what becomes of poor Smatter?
With a down, down, derry down."

LADY SMATTER: How? Is my name at full length?

JACK: [*Sings*] "This lady with study has muddled her head;
Sans meaning she talked and sans knowledge she read,
And gulped such a dose of incongruous matter
That Bedlam must soon hold the carcass of Smatter.

With a down, down, derry down."

LADY SMATTER: The carcass of Smatter? It can't be—no one would
dare—

JACK: Ma'am, if you stop me so often, I shall be too late to go and
sing it anywhere else tonight.

[*Sings*] "She thought wealth esteemed by the foolish alone,
So, shunning offence, never offered her own;
And when her young friend dire misfortune did batter,
Too wise to relieve her was kind Lady Smatter.
With a down, down, derry down."

LADY SMATTER: I'll hear no more! [*Walks about in disorder*]

CENSOR: Sing on, however, Jack; we'll hear it out.

JACK: [*Sings*] "Her nephew she never corrupted with pelf,
Holding starving a virtue—for all but herself;
Of gold was her goblet, of silver her platter,
To show how such ore was degraded by Smatter.
With a down, down, derry down.
"A Club she supported of witlings and fools,
Who, but for her dinners, had scoffed at her rules;
The reason, if any she had, these did shatter
Of poor empty-headed and little-souled Smatter.
With a down, down, derry down."

LADY SMATTER: Empty-headed? Little-souled? Who has dared write
this? Where did you get it?

JACK: From a man who was carrying it to the printers.

LADY SMATTER: To the printers? Oh insupportable! Are they going
to print it? Mr. Dabler, why don't you assist me? How can I
have it suppressed? Speak quick or I shall die.

DABLER: Really, ma'am, I—I—

CENSOR: There is but one way—make a friend of the writer.

LADY SMATTER: I detest him from my soul—and I believe 'tis
yourself!

CENSOR: Your ladyship is not deceived. I have the honor to be the
identical person. [*Bowing*]

LADY SMATTER: Nay, then, I see your drift—but depend upon it, I
will not be duped by you. [*Going*]

CENSOR: Hear me, madam!

LADY SMATTER: No, not a word!

CENSOR: You must! [*Holds the door*] You have but one moment for reflection, either to establish your fame upon the firmest foundation or to consign yourself for life to irony and contempt.

LADY SMATTER: I will have you prosecuted with the utmost severity of the law.

CENSOR: You will have the thanks of my printer for your reward.

LADY SMATTER: You will not dare—

CENSOR: I dare do anything to repel the injuries of innocence! I have already shown you my power, and you will find my courage undaunted, and my perseverance indefatigable. If you any longer oppose the union of your nephew with Miss Stanley, I will destroy the whole peace of your life.

LADY SMATTER: You cannot! I defy you! [*Walks from him*]

CENSOR: I will drop lampoons in every coffee-house—[*Following her*]

LADY SMATTER: You are welcome, sir.

CENSOR: Compose daily epigrams for all the papers—

LADY SMATTER: With all my heart.

CENSOR: Send libels to every corner of the town—

LADY SMATTER: I care not!

CENSOR: Make all the ballad singers resound your deeds—

LADY SMATTER: You cannot! *Shall* not!

CENSOR: And treat the Patagonian Theatre with a poppet to represent you.

LADY SMATTER: [*Bursting into tears*] This is too much to be born, Mr. Censor, you are a demon!

CENSOR: But, if you relent, I will burn all I have written and forget all I have planned. Lampoons shall give place to panegyric, and libels to songs of triumph. The liberality of your soul and the depth of your knowledge shall be recorded by the Muses and echoed by the whole nation!

LADY SMATTER: I am half distracted! Mr. Dabler, why don't you counsel me? How cruel is your silence!

DABLER: Why, certainly, ma'am, what—what Mr. Censor says—

CENSOR: Speak out, man! Tell Lady Smatter, if she will not be a lost woman to the literary world, should she, in this trial of her magnanimity, disgrace its expectations? Speak boldly!

DABLER: Hem! You—you have said, sir—just what I think.

LADY SMATTER: How? Are *you* against me? Nay then—

CENSOR: Everybody must be against you—even Mr. Codger, as I can discern by his looks. Are you not, sir?

CODGER: Sir, I can by no means decide upon so important a question without maturely pondering upon the several preliminaries.

CENSOR: Come, madam, consider what is expected from the celebrity of your character. Consider the applause that awaits you in the world. You will be another Sacharissa, a second Sappho—a tenth Muse.

LADY SMATTER: I know not what to do! Allow me at least a few days for meditation, and forbear these scandalous libels till—

CENSOR: No, madam, not an hour! There is no time so ill spent as that which is passed in deliberating between meanness and generosity! You may now not only gain the esteem of the living, but—if it is not Mr. Dabler's fault—consign your name with honor to posterity.

LADY SMATTER: To posterity? Why, where is this girl gone? What has Beaufort done with himself?

CENSOR: Now, madam, you have bound me yours forever! Here, Beaufort! Miss Stanley! [*Goes out*]

JACK: Huzza!

CODGER: Madam, to confess the verity, I must acknowledge that I do not rightly comprehend what it is your ladyship has determined upon doing.

LADY SMATTER: No, nor would you, were I to take an hour to tell you.

Re-enter CENSOR *with* BEAUFORT *and* CECILIA.

BEAUFORT: Oh madam, is it indeed true that—

LADY SMATTER: Beaufort, I am so much flurried, I hardly know what is true—save, indeed, that pity, as a certain author says, will ever, in noble minds, conquer prudence. Miss Stanley—

CENSOR: Come, come, no speeches. This whole company bears witness to your consent to their marriage, and your ladyship [*in a low voice*] may depend upon not losing sight of *me* till the ceremony is over.

CECILIA: Lady Smatter's returning favour will once more devote me to her service; but I am happy to find by this letter that my affairs are in a less desperate situation than I had apprehended. [*Gives a letter to* LADY SMATTER] But here, Mr. Censor, is another letter which I do not quite so well understand. It contains an order for £5,000, and is signed with your name?

CENSOR: Faugh, faugh, we will talk of that another time.

CECILIA: Impossible! Liberality so undeserved—

CENSOR: Not a word more, I entreat you!

CECILIA: Indeed I can never accept it.

CENSOR: Part with it as you can! *I* have got rid of it. I merit no thanks, for I mean it not in service to you but in spite to Lady Smatter, that she may not have the pleasure of boasting to her wondering witlings that she received a niece wholly unportioned. Beaufort, but for his own stubbornness, had long since possessed it—from a similar motive.

CECILIA: Dwells benevolence in so rugged a garb? Oh Mr. Censor!

BEAUFORT: Noble, generous Censor! You penetrate my heart—yet I cannot consent—

CENSOR: Faugh, faugh, never praise a man for only gratifying his own humor.

Enter BOB, *running.*

BOB: Mother, mother, I believe there's a cat in the closet!

MRS. VOLUBLE: Hold your tongue, you great oaf!

BOB: Why, mother, as I was in the back parlour, you can't think what a rustling it made.

MISS JENNY: [*Aside*] Dear me! It's the poor lady!

MRS. WHEEDLE: Well, what a thing is this!

MRS. VOLUBLE: Bob, I could beat your brains out!

BOB: Why, Lord, mother, where's the great harm of saying there's a cat in the closet?

JACK: The best way is to look. [*Goes toward the closet*]

DABLER: Not for the world! I won't suffer it!

JACK: You won't suffer it? Pray, sir, does the cat belong to you?

BOB: Mother, I dare say she's eating up all the victuals.

JACK: Come then, my lad, you and I'll hunt her. [*Brushes past* DABLER *and opens the door*]

ALL: Mrs. Sapient!

MRS. SAPIENT: [*Coming forward*] Sir, this impertinent curiosity—

JACK: Lord, ma'am, I beg your pardon! I'm sure I would not have opened the door for the world, only we took you for the cat. If you please, ma'am, I'll shut you in again.

LADY SMATTER: That's a pretty snug retreat you have chosen, Mrs. Sapient.

CENSOR: To which of the Muses, madam, may that temple be dedicated?

JACK: I hope, ma'am, you made use of your time to mend your furbelows?

CODGER: Madam, as I don't understand this quick way of speaking, I should be much obliged if you would take the trouble to make plain to my comprehension the reason of your choosing to be shut up in that dark closet?

CENSOR: Doubtless, sir, for the study of the occult sciences.

LADY SMATTER: Give me leave, madam, to recommend to your perusal this passage of Addison: "Those who conceal themselves to hear the counsel of others, commonly have little reason to be satisfied with what they hear of themselves."

MRS. SAPIENT: And give *me* leave, ma'am, to observe—though I pretend not to assert it positively—that, in my opinion, those who speak ill of people in their absence, give no great proof of a sincere friendship.

CENSOR: [*Aside*] I begin to hope these witlings will demolish their club.

DABLER: [*Aside*] Faith, if they quarrel, I'll not speak till they part.

BEAUFORT: Allow me, ladies, with all humility, to mediate and to entreat that the calm of an evening succeeding a day so agitated with storms may be enjoyed without allay. Terror, my Cecilia,

now ceases to alarm, and sorrow to oppress us. Gratefully let us receive returning happiness, and hope that our example—should any attend to it—may inculcate this most useful of all practical precepts: that self-dependence is the first of earthly blessings, since those who rely solely on others for support and protection are not only liable to the common vicissitudes of human life, but exposed to the partial caprices and infirmities of human nature.

FINIS

Notes on *The Witlings*

DRAMATIS PERSONAE

Father-in-law—Step-father.

ACT I

Megrim—A ladylike headache.

Lappets, tippet, furbelows, pompoons and *falaldrums*—All suggest, with a diminutive air, the intricate components of sewn garments.

Minories—A street in the City of London.

Spenser's Strife—Clayton Delery cites the Book 2, canto 4 of *The Faerie Queen* (1590) by Edmund Spenser, which refers to Occasion, "aged mother" of Furor, and their pursuer Atin. It is mad to seek "*Occasion* to wrath, and cause of strife," according to the poem: "She comes unsought, and shonned followes eke."

Tasted the Pierian Spring—From Alexander Pope's *Essay on Criticism* (1711): "A little learning is a dangerous thing;/ Drink deep or taste not the Pierian Spring."

Monody on a birth—A contradiction, since a monody is a kind of lament.

Rowland for your Oliver—Medieval knights, long proverbial for equally matched opponents.

I to Hercules—An allusion to *Hamlet*, Act 1, scene 2, in which Hamlet says his uncle Claudius is "no more like my father/ Than I to Hercules."

Ranelagh songs—Ranelagh Gardens (1740–1804) in Chelsea was an immensely fashionable and popular venue for assemblies and concerts, with an ornamental lake and a vast rotunda full of people "eating, drinking, staring, or crowding," as Horace Walpole put it in 1742. The music there was much admired and emulated.

ACT II

As a certain author says—The first of many allusions and pseudo-quotations from the mouth of Lady Smatter. As Censor claims, most of them turn out to be spurious. Only those with sources identified by Delery or others are noted below.

Fogrum—Fogey. Cf. Sir Sedley Clarendel in *Camilla*, Bk. 2, Ch. 5: "nobody's civil now, you know; 'tis a fogramity quite out."

Modesty…is the constant attendant upon merit!—Neither Pope nor Swift, but cf. Steele, *The Spectator*, no. 350 (1712): "Modesty is the certain indication of a great spirit."

The memory of a poet should be short, that his works may be original.—Compared by Delery to a passage in section VI of *A Tale of a Tub* (1704) by Swift: "memory, being an employment of the mind upon things past, is a faculty for which the learned in our age, have no manner of occasion…upon which account we think it highly reasonable to produce our great forgetfulness, as an argument for our great wit."

Charade season—Charades, games in which a word has to be deduced

from mimed or cryptic clues to its component syllables, were popularly played in teams. The Austen family were keen charade players, and Jane Austen includes one in her juvenile "History of England."

Scrub-bing—Delery offers the definitions of the word *scrub* from Johnson's *Dictionary*: "(1) A mean fellow, either as he is supposed to scrub himself for an itch, or as he is employed in the mean offices of scouring away dirt. (2) Any thing mean or despicable. (3) A worn out broom."

Fleet Street, Cornhill, Hyde Park, the City—Jack's haste takes him all over London, back and forth, from Hyde Park in the west to Cornhill in the east.

Non compos mentis—Not in a fit state of mind.

French leave—A surreptitious, unannounced departure.

The study of the fine arts…greatly enlarges the mind—Not Pope, but cf. Ovid's *Ex Ponto*, in which "a faithful study of the liberal arts humanizes character."

ACT III, SCENE I

E'en talk a little like folks of this world.—As Censor says, this line is Matthew Prior's, not Thomas Parnell's. It comes from "A Better Answer," which in turn alludes to Shakespeare: "Prithee quit this caprice; and (as old Falstaff says)/ Let us e'en talk a little like folks of this world."

Inamorato—"A male lover" (OED).

Parnassus—The twin-peaked Greek mountain sacred to the Muses and to Apollo, god of poetry.

Tom Thumb and *Lives of the Seven Champions of Christendom*—A popular chapbook, used by Fielding for his burlesque of heroic drama in 1730, and a chivalric romance of the sixteenth century, respectively.

ACT III, SCENE II

The Art of Poetry—Edward Bysshe's *Art of English Poetry* (1702) contained a rhyming dictionary.

By Apollo!—A suitably poetastic exclamation from Dabler.

Nigma—That is, an "enigma," another malapropism.

Lethe—The river beyond which lay the underworld, Hades, in Greek myth.

Abigail—Proverbial for a maid or servant-girl.

Provoke a stork—Storks were proverbially patient birds.

ACT IV

Most women have no character at all—This is the second line of "To a Lady: Argument of the Characters of Women" from Pope's *Moral Essays*. Cf. *Camilla*, Bk. 6, Ch. 2: "'Tis a miserable thing, my dear General, to see the dearth of character in the world. Pope has bewailed it in women; believe me, he might have extended his lamentation."

Cyprian—That is Venus, whose island was Cyprus.

Cymon and Iphigenia—One of Dryden's *Fables Ancient and Modern* (1700). He translated the story from Boccacio, which is set partly Cyprus (it is Dabler who mentions both the poem and the "Cyprian" Venus).

The Spectator—Along with *The Tatler*, one of the seminal Augustan periodicals, produced by Joseph Addison and Richard Steele, first published 1711–12, revived in 1714 and published as a book.

Orpheus—A priest of Apollo torn apart by women he had enraged.

Stapleton's—Delery suggests that this is Burney's invented name for a coffee house.

Stoic and *Cynic*—Lady Smatter confuses two ancient Greek philoso-

phies with slightly similar-sounding names. The former stressed indifference to, while the other implies contempt of, pleasure and pain.

Extempore—Dabler's poetic accomplishments are rather petty, like charades and now "extempore" verses, which were meant to be composed on the spot.

Scotland—Presumably, the eloping couple are heading for Gretna Green, where they might be married without the necessity of parental consent.

Glad of a quarrel, straight he shut the door—A paraphrase of Pope, "An Epistle to Dr Arbuthnot": "Glad of a quarrel, straight I clapped the door."

To teach the young idea how to shoot—Again, Lady Smatter has it completely wrong, and Censor has it right. The line comes from *The Seasons* by James Thomson.

Muz—Delery suggests that this is Jack's corruption of "amuse"; the OED gives one meaning of "muzz" as "make confused" or befuddle, which also seems fitting in this context.

Trimmers—A rebuke or reprimand.

ACT V

Mr. Mite—Mite, according to the OED, was slang for a cheese-monger.

Whiskey—A carriage, also known as a "shay", light enough to be drawn by a single horse.

Like a crocodile…she lives upon air—Chameleons, not crocodiles, were said to live on air.

Melancholy as a cat—Cf. Shakespeare, *I Henry IV* Act I, scene 2: "I am as melancholy as a gib cat or a lugged bear."

Fox-hall—As in Vauxhall ("Fox-Hall") Gardens, where the ham was cut famously thin.

Tallow-chandler—A maker or seller of cheap candles, made from sheep or cattle fat, and said to give less light and a stronger smell than candles made from beeswax.

Standish—Writing stand.

Raisin wine—Cf. the gooseberry wine served to the guests in Jane Austen's skit, "The Visit."

Flee—That is, "flay."

Looby—"An awkward, stupid, clownish person" (OED).

Flustration—Vulgar form of "agitation" or "being flustered" (OED).

Matchwell—That is, a matchmaker.

Patagonian theatre—A fashionable puppet or "poppet" theatre in London, 1776–1781, one of the many enterprises of Charles Dibdin. Cf. *The Belle's Stratagem*, Act 1, scene 1.

Sacharissa, Sappho, tenth Muse—See Introduction. The seventeenth-century poet Edmund Waller addressed love poems to "Sacharissa," Lady Dorothea Sidney. Sappho is one of the only known female poets of ancient Greece; she lived on the island of Lesbos.

Unportioned—Without a dowry or inheritance.

Hannah Cowley:
(1743–1809)

There are two versions of Hannah Cowley. In one, she figures as a difficult woman, who feuds in print with Hannah More, inspires George Colman to denounce her anonymously in the *Monthly Review*, and shuns literary society. To Hester Piozzi she appeared to be "an active woman, whom nobody likes, yet all are forced to esteem." "She and I never met," Mrs. Piozzi confessed to her journal, but "I fancy her vulgar and ill behaved; for no one speaks ill of her, yet she is never in polite circles." What's more, this Cowley was more than once the cause of controversy. In 1786 she adapted *The Lucky Chance* (1686) by Aphra Behn as *The School for Greybeards*, and was forced to rewrite it. *A Day in Turkey* (1791) was condemned as "tainted with politics."

The other Cowley is the kind of woman whom society could approve—a good wife and mother, a writer, yes, but a modest and decent one—which she seems to have cultivated scrupulously when she could. She was born in Tiverton, Devon, in 1743, daughter of a bookseller called Philip Parkhouse. In 1768, she married Thomas Cowley, moved to London, where she would turn to writing drama as a means of improving the family finances. The story goes that her husband teased her into writing *The Runaway*, after she came home

from the theatre one night convinced that she could write a better play than the one they had just seen. After a long hiatus and much revision, David Garrick, who found her charming, produced *The Runaway* in 1776.

It was to be the last new play produced under Garrick's aegis at Drury Lane, an unsolicited manuscript from an unknown writer, chosen on the basis of its artistic merits. It would become a staple piece at the theatre, like several of Cowley's subsequent works. *The Runaway*, she said, "opened a new prospect of advantage to my family, which I have since pursued with alacrity." It earned her some £500. Of a further nine comedies, two tragedies and a farce, *Who's the Dupe?* (1779), the farce, and *The Belle's Stratagem* (1780), which reportedly made her about 1,200 guineas, received over 100 performances each before 1800.

By any standards, this was success, but, according to Cowley, her position came under repeated attack. Criticism of *A Day in Turkey* effectively robbed her of her share of the profits, she claimed. Nor did she make more than £70 from the hugely popular *Who's the Dupe?*, on account of Sheridan's mismanagement. The Cowleys still needed assistance from an influential patron, Lord Harrowby, to stave off their money worries. In 1783, he seems to have secured Thomas a posting in India as an employee of the East India Company, a subject on which little comment from his wife survives, the most important probably being her fulsome dedication of *More Ways than One* (1783) to him. "Fly, comic scenes!" she cries, "Bid him not think, because I gaily write,/ That heavy hours to him, to me, are light"—"Hymen frowns." One of the Cowleys' daughters also emigrated to India, when she married the Revd. David Brown in Calcutta in 1796, but her father died the following year, on the way to see her. (Another daughter had died in her teens in 1790.)

In the meantime, Cowley had attracted a little fame and a lot of ridicule as "Anna Matilda," a name under which she publicly and romantically corresponding, in risibly florid verse, with her "Della Crusca," Robert Merry, for a year, beginning in 1787, in *The World*. William Gifford rightly satirized the whole Della Cruscan school of poetry in *The Baviad* (1791) and *The Maeviad* (1795), by which time

Cowley had already suffered great embarrassment: the much-antici-
pated meeting with Merry revealed her to be over ten years his senior.
In the same year as *The Belle's Stratagem*, she published *The Maid of
Aragon: A Tale*, and followed it with *The Scottish Village* (1786) and
The Siege of Acre: An Epic Poem (1801). A characteristically rapturous
poem, "written on the sea shore" indicates something of her style, and
her attitude to fashionable society, even if it is only "blithe Ramsgate
[that] spreads/ Her haunts alluring":

> There, awakening beauties
> Ponder the victims of the last night's ball,
> And smile at thought of recollected wounds
> They gave insidious midst the lively dance:
> Or future wily stratagems prepare…
> I turn from scenes domestic, feast my thought
> Again upon the view…

Cowley made her farewell to the theatre with *The Town before You*
(1795), prefacing it with a cry of disillusionment: "What mother can
now lead her daughters to the great National School, THE THEATRE,
in the confidence of their receiving either polish or improvement?"
As the theatres became physically larger, they grew correspondingly
friendlier to lavish spectacle and visual humor than to the style of
witty Restoration banter she so admired and could well write, "the
bewitching dialogue of CIBBER and of FARQUHAR." "Should the
luckless Bard stumble on a reflection, or a sentiment, the audience
yawn, and wait for the next tumble from a chair, or a tripping up
of the heels." This complaint about the vulgar demands of English
audiences is consistent with her defense of *The School for Greybeards*
both in its literary allegiances and its dislike of the dictatorship of
popular tastes. She did not retire from London, however, until 1801,
when she returned to Tiverton and a decidedly quiet life. Once there,
she set to work revising her plays, purging them of anything "coarse"
and rendering them, in the words of one editor, Frederick M. Link,
"bland, somewhat overwritten, and conventional." After her death
in 1809, she achieved her canonization as a saint among theatrical

sinners, most conspicuously in the short memoir that was published with her *Works*, collected in three volumes, in 1813. Mrs. Piozzi's gossip about her is hard to ignore, however; Hannah Cowley seems to have been highly idiosyncratic, both as a dramatist of great skill and a determinedly private person.

The Belle's Stratagem

DRAMATIS PERSONAE

MEN

DORICOURT

HARDY

SIR GEORGE TOUCHWOOD

FLUTTER

SAVILLE

VILLERS

COURTALL

SILVERTONGUE

CROWQUILL

FIRST GENTLEMAN

SECOND GENTLEMAN

MOUNTEBANK

FRENCH SERVANT

PORTER

DICK

MASK

FOLLY

WOMEN

LETITIA HARDY

MRS. RACKET

LADY FRANCES TOUCHWOOD

MISS OGLE

KITTY WILLIS

LADY

MRS. FAGG

MASQUERADERS, TRADESMEN, *and* SERVANTS.

The scene is London.

To the Queen

Madam,

In the following comedy, my purpose was to draw a female character, which, with the most lively sensibility, fine understanding, and elegant accomplishments, should unite that beautiful reserve and delicacy which, whilst they veil those charms, render them still more interesting. In delineating such a character, my heart naturally dedicated it to Your Majesty; and nothing remained but permission to lay it at your feet. Your Majesty's graciously allowing me this high honor is the point to which my hopes aspired, and a reward of which, without censure, I may be proud.

Madam,

With the warmest wishes for the continuance of Your Majesty's felicity,

> I am
> > Your Majesty's
> > > Most devoted
> > > > And most dutiful servant,
> > > > > H. Cowley

ACT I, SCENE I

Lincoln's Inn. Enter SAVILLE, *followed by a* SERVANT, *at the top of the stage, looking round as if at a loss.*

SAVILLE: Lincoln's Inn! Well, but where to find him, now I am in Lincoln's Inn? Where did he say his master was?

SERVANT: He only said in Lincoln's Inn, sir.

SAVILLE: That's pretty! And your wisdom never enquired at whose chambers?

SERVANT: Sir, you spoke to the servant yourself.

SAVILLE: If I was too impatient to ask questions, you ought to have taken directions, blockhead!

Enter COURTALL *singing.*

Ha, Courtall! [*To* SERVANT] Bid him keep the horses in motion and then enquire at all the chambers round.

Exit SERVANT.

What the devil brings you to this part of the town? Have any of the long robes handsome wives, sisters or chambermaids?

COURTALL: Perhaps they have, but I came on a different errand, and had thy good fortune brought thee here half an hour sooner, I'd have given thee such a treat, ha, ha, ha!

SAVILLE: I'm sorry I missed it. What was it?

COURTALL: I was informed a few days since that my cousins Fallow were come to town and desired earnestly to see me at their lodgings in Warwick Court, Holborn. Away drove I, painting them all the way as so many Hebes. They came from the farthest part of Northumberland, had never been in town, and in course were made up of rusticity, innocence and beauty.

SAVILLE: Well!

COURTALL: After waiting thirty minutes, during which there was a violent bustle, in bounced five sallow damsels, four of them maypoles; the fifth, Nature, by way of variety, had bent in the Aesop style. But they all opened at once like hounds on a fresh scent: "Oh cousin Courtall! How do you do, cousin Courtall! Lord, cousin, I am glad you are come! We want you to go with us to the Park and the plays and the opera and Almack's and all the fine places!" The devil, thought I, my dears, may attend you, for I am sure I won't. However, I heroically stayed an hour with them, and discovered the virgins were all come to town with the hopes of leaving it wives, their heads full of knight-baronights, fops and adventures.

SAVILLE: Well, how did you get off?

COURTALL: Oh, pleaded a million engagements. However, conscience twitched me, so I breakfasted with them this morning and afterwards squired them to the gardens here, as the most private place in town and then took a sorrowful leave, complaining of my hard, hard fortune that obliged me to set off immediately for Dorsetshire, ha, ha, ha!

SAVILLE: I congratulate your escape! Courtall at Almack's with five awkward country cousins! Ha, ha, ha! Why, your existence as a man of gallantry could never have survived it.

COURTALL: Death and fire! Had they come to town like the rustics of the last age to see Paul's, the Lions and the Waxwork—at their service. But the cousins of our days come up ladies—and, with the knowledge they glean from magazines and pocket books, fine ladies—laugh at the bashfulness of their grandmothers, and boldly demand their *entrées* in the first circles.

SAVILLE: Where can this fellow be!—Come, give me some news. I have been at war with woodcocks and partridges these two months and am a stranger to all that has passed out of their region.

COURTALL: Oh, enough for three gazettes! The ladies are going to petition for a bill that, during the war, every man may be allowed two wives.

SAVILLE: 'Tis impossible they should succeed, for the majority of both Houses know what it is to have one.

COURTALL: Gallantry was blackballed at the *coterie* last Thursday, and prudence and chastity voted in.

SAVILLE: Aye, that may hold till the camps break up. But have ye no elopements? No divorces?

COURTALL: Divorces are absolutely out and the commons-doctors starving, so they are publishing trials of crim. con. with all the separate evidences at large, which they find has always a wonderful effect on their trade, actions tumbling in upon them afterwards like mackerel at Gravesend.

SAVILLE: What more?

COURTALL: Nothing—for weddings, deaths and politics I never talk of but whilst my hair is dressing. But prithee, Saville, how

came you to town, whilst all the qualified gentry are playing at popgun on Coxheath and the country overrun with hares and foxes?

SAVILLE: I came to meet my friend Doricourt, who, you know, is lately arrived from Rome.

COURTALL: Arrived! Yes, faith, and has cut us all out! His carriage, his liveries, his dress, himself are the rage of the day! His first appearance set the whole *ton* in a ferment, and his valet is besieged by *levées* of tailors, habit-makes, and other ministers of fashion to gratify the impatience of their customers for becoming *à la mode de Doricourt*. Nay, the beautiful Lady Frolic t'other night, with two sister countesses, insisted upon his waistcoat for muffs, and their snowy arms now bear it in triumph about town, to the heart-rending affliction of all our *beaux garçons*.

SAVILLE: Indeed! Well, those little gallantries will soon be over; he's on the point of marriage.

COURTALL: Marriage! Doricourt on the point of marriage! 'Tis the happiest tidings you could have given, next to his being hanged. Who is the bride elect?

SAVILLE: I never saw her, but 'tis Miss Hardy, the rich heiress. The match was made by the parents and the courtship begun on their nurses' knees; Master used to crow at Miss, and Miss used to chuckle at Master.

COURTALL: Oh, then by this time they care no more for each other than I do for my country cousins.

SAVILLE: I don't know that; they have never met since thus high and so probably have some regard for each other.

COURTALL: Never met! Odd!

SAVILLE: A whim of Mr. Hardy's. He thought his daughter's charms would make a more forcible impression if her lover remained in ignorance of them till his return from the continent.

Enter SERVANT.

SERVANT: Mr. Doricourt, sir, has been at Counsellor Pleadwell's, and gone about five minutes. [*Exit*]

SAVILLE: Five minutes! Zounds! I have been five minutes too late all my lifetime! Good morrow, Courtall, I must pursue him. [*Going*]

COURTALL: Promise to dine with me today; I have some honest fellows. [*Going off on the opposite side*]

SAVILLE: Can't promise, perhaps I may.—See there! There's a bevy of female Patagonians coming down upon us.

COURTALL: By the Lord, then it must be my strapping cousins. I dare not look behind me—run, man, run.

Exeunt on the same side.

ACT I, SCENE II

A hall at DORICOURT'*s. A gentle knock at the door. Enter the* PORTER.

PORTER: Tap! What sneaking devil art thou? [*Opens the door*]

Enter CROWQUILL.

So! I suppose *you* are one of Monsieur's customers too? He's above stairs now, overhauling all his honor's things to a parcel of 'em.

CROWQUILL: No, sir, it is with you, if you please, that I want to speak.

PORTER: Me! Well, what do you want with me?

CROWQUILL: Sir, you must know that I am—I am the gentleman who writes the *tête- à-têtes* in the magazines.

PORTER: Oh, oh! What, you are the fellow that ties folks together in your sixpenny cuts that never meet anywhere else?

CROWQUILL: Oh, dear sir, excuse me! We always go on *foundation*; and if you can help me to a few anecdotes of your master, such as what marchioness he lost money to in Paris, who is his favourite lady in town, or the name of the girl he first made love to at college, or any incidents that happened to his grandmother or great aunts—a couple will do, by way of sup-

porters—I'll weave a web of intrigues, losses, and gallantries between them that shall fill four pages, procure me a dozen dinners, and you, sir, a bottle of wine for your trouble.

PORTER: Oh, oh! I heard the butler talk of you when I lived at Lord Tinket's. But what the devil do you mean by bottle of wine! You gave him a crown for a retaining fee.

CROWQUILL: Oh sir, that was for a lord's amours; a commoner's are never but half. Why, I have had a baronet's for five shillings, though he was a married man and changed his mistress every six weeks.

PORTER: Don't tell me! What signifies a baronet or a bit of a lord, who maybe was never further than fun and fun round London? *We* have travelled, man! My master has been in Italy and over the whole island of Spain, talked to the Queen of France, and danced with her at a masquerade. Aye, and such folks don't go to masquerades for nothing; but mum—not a word more. Unless you'll rank my master with a lord, I'll not be guilty of blabbing his secrets, I assure you.

CROWQUILL: Well, sir, perhaps you'll throw in a hint or two of other families where you've lived that may be worked up into something, and so, sir, here is one, two, three, four, five shillings.

PORTER: Well, that's honest. [*Pocketing the money*] To tell you the truth, I don't know much of my master's concerns yet, but here comes Monsieur and his gang; I'll pump them. They have trotted after him all round Europe from the Canaries to the Isle of Wight.

Enter several foreign SERVANTS *and two* TRADESMEN. *The* PORTER *takes one of them aside.*

TRADESMAN: Well then, you have showed us all?

FRENCHMAN: All, *en vérité, messieurs!* You avez seen every ting. *Serviteur, serviteur.* [*Exeunt* TRADESMEN]. Ah, here comes one *autre* curious Englishman, and dat's one *autre* guinea *pour moi.*

Enter SAVILLE.

Allons, monsieur, dis way; I will shew you tings, such tings you never see, begar, in England! Velvets by Le Mosse, suits cut by Verdue, trimmings by Grossette, embroidery by Detanville—

SAVILLE: Puppy! Where is your master?

PORTER: Zounds! You chattering, frog-eating dunderhead, can't you see a gentleman? 'Tis Mr. Saville.

FRENCHMAN: Monsieur Saville! *Je suis mort de peur.*—Ten tousand pardons! *Excusez mon erreur,* and permit me you conduct to Monsieur Doricourt; he be too happy *à vous voir.*

Exeunt FRENCHMAN *and* SAVILLE.

PORTER: Step below a bit; we'll make it out somehow! I suppose a slice of sirloin won't make the story go down the worse.

Exeunt.

ACT I, SCENE III

An apartment at DORICOURT*'s. Enter* DORICOURT.

DORICOURT: [*Speaking to a servant behind*] I shall be too late for St. James's; bid him come immediately.

Enter FRENCHMAN *and* SAVILLE.

FRENCHMAN: Monsieur Saville. [*Exit*]

DORICOURT: Most fortunate! My dear Saville, let the warmth of this embrace speak the pleasure of my heart.

SAVILLE: Well, this is some comfort, after the scurvy reception I met with in your hall. I prepared my mind, as I came upstairs, for a *bonjour*, a grimace, and an *adieu*.

DORICOURT: Why so?

SAVILLE: Judging of the master from the rest of the family. What the devil is the meaning of that flock of foreigners below, with their parchment faces and snuffy whiskers? What, can't an Englishman stand behind your carriage, buckle your shoe, or brush your coat?

DORICOURT: Stale, my dear Saville, stale! Englishmen make the best soldiers, citizens, artisans, and philosophers in the world, but the very worst footmen. I keep French fellows and Germans

as the Romans kept slaves, because their own countrymen had minds too enlarged and haughty to descend with a grace to the duties of such a station.

SAVILLE: A good excuse for a bad practice.

DORICOURT: On my honor, experience will convince you of its truth. A Frenchman neither hears, sees, nor breathes but as his master directs, and his whole system of conduct is comprised in one short word, *obedience*! An Englishman reasons, forms opinions, cogitates, and disputes. He is the mere creature of your will, the other, a being conscious of equal importance in the universal scale with yourself, and is therefore your judge, whilst he wears your livery, and decides on your actions with the freedom of a censor.

SAVILLE: And this in defence of a custom I have heard you execrate, together with all the adventitious manners imported by our travelled gentry.

DORICOURT: Aye, but that was at eighteen; we are always *very* wise at eighteen. But consider this point: we go into Italy, where the sole business of the people is to study and improve the powers of music; we yield to the fascination and grow enthusiasts in the charming science. We travel over France and see the whole kingdom composing ornaments and inventing fashions; we condescend to avail ourselves of their industry and adopt their modes. We return to England and find the nation intent on the most important objects: polity, commerce, war, with all the liberal arts, employ her sons. The latent sparks glow afresh within our bosoms; the sweet follies of the continent imperceptibly slide away, whilst senators, statesmen, patriots and heroes emerge from the *virtu* of Italy and the frippery of France.

SAVILLE: I may as well give it up! You had always the art of placing your faults in the best light, and I can't help loving you, faults and all. So, to start a subject which must please you, when do you expect Miss Hardy?

DORICOURT: Oh, the hour of expectation is past. She is arrived, and I this morning had the honor of an interview at Pleadwell's.

The writings were ready, and, in obedience to the will of Mr. Hardy, we met to sign and seal.

SAVILLE: Has the event answered? Did your heart leap or sink when you beheld your mistress?

DORICOURT: Faith, neither one nor t'other. She's a fine girl, as far as mere flesh and blood goes—but—

SAVILLE: But what?

DORICOURT: Why, she's *only* a fine girl—complexion, shape and features—nothing more.

SAVILLE: Is not that enough?

DORICOURT: No! She should have spirit! Fire! *L'air enjoué*! That something, that nothing, which everybody feels and which nobody can describe in the resistless charmers of Italy and France.

SAVILLE: Thanks to the parsimony of my father that kept me from travel! I would not have lost my relish for true, unaffected English beauty to have been quarrelled for by all the belles of Versailles and Florence.

DORICOURT: Faugh! Thou hast no taste. *English* beauty! 'Tis insipidity; it wants the zest, it wants poignancy, Frank! Why, I have known a Frenchwoman, indebted to nature for no one thing but a pair of decent eyes, reckon in her suite as many counts, marquises and *petits maîtres* as would satisfy three dozen of our first-rate toasts. I have known an Italian *marquisina* make ten conquests in stepping from her carriage, and carry her slaves from one city to another, whose real intrinsic beauty would have yielded to half the little *grisettes* that pace your Mall on a Sunday,

SAVILLE: And has Miss Hardy nothing of this?

DORICOURT: If she has, she was pleased to keep it to herself. I was in the room half an hour before I could catch the colour of her eyes, and every attempt to draw her into conversation occasioned so cruel an embarrassment that I was reduced to the necessity of news, French fleets, and Spanish captures with her father.

SAVILLE: So Miss Hardy, with only beauty, modesty and merit, is doomed to the arms of a husband who will despise her.

DORICOURT: You are unjust. Though she has not inspired me with violent passion, my honor secures her felicity.

SAVILLE: Come, come, Doricourt, you know very well that when the honor of a husband is *locum-tenens* for his heart, his wife must be as indifferent as himself, if she is not unhappy.

DORICOURT: Faugh! Never moralise without spectacles. But, as we are upon the tender subject, how did you bear Touchwood's carrying Lady Frances?

SAVILLE: You know I never looked up to her with hope, and Sir George is every way worthy of her.

DORICOURT: *Á la mode Anglaise*, a philosopher even in love.

SAVILLE: Come, I detain you; you seem dressed at all points and of course have an engagement.

DORICOURT: To St. James's. I dine at Hardy's and accompany them to the masquerade in the evening. But breakfast with me tomorrow, and we'll talk of our old companions; for I swear to you, Saville, the air of the continent has not effaced one youthful prejudice or attachment.

SAVILLE: With an exception to the case of ladies and servants.

DORICOURT: True, there I plead guilty—but I have never yet found any man whom I could cordially take to my heart and call friend who was not born beneath a British sky, and whose heart and manners were not truly English.

Exeunt.

ACT I, SCENE IV

An apartment at HARDY's. VILLERS *seated on a sofa, reading.*
Enter FLUTTER.

FLUTTER: Ha, Villers, have you seen Mrs. Racket? Miss Hardy, I find, is out.

VILLERS: I have not seen her yet. I have made a voyage to Lapland since I came in. [*Flinging away the book*] A lady at her toilette is as difficult to be moved as a Quaker. [*Yawning*] What

events have happened in the world since yesterday? Have you heard?

FLUTTER: Oh yes; I stopped at Tattersall's as I came by, and there I found Lord James Jessamy, Sir William Wilding and Mr. —. But now I think on't, you shan't know a syllable of the matter, for I have been informed you never believe above one half of what I say.

VILLERS: My dear fellow, somebody has imposed upon you most egregiously! Half! Why, I never believe one tenth part of what you say, that is, according to the plain and literal expression. But, as I understand you, your intelligence is amusing.

FLUTTER: That's very hard now, very hard. I never related a falsity in my life, unless I stumbled on it by mistake. And if it were otherwise, your dull matter-of-fact people are infinitely obliged to those warm imaginations which soar into fiction to amuse you, for, positively, the common events of this little dirty world are not worth talking about unless you embellish 'em!—Ha! Here comes Mrs. Racket; adieu to weeds, I see! All life!

Enter MRS. RACKET.

Enter, madam, in all your charms! Villers has been abusing your toilette for keeping you so long, but I think we are much obliged to it, and so are you.

MRS. RACKET: How so, pray? Good morning t'ye both. Here, here's a hand a-piece for you. [*They kiss her hands*]

FLUTTER: How so! Because it has given you so many beauties.

MRS. RACKET: Delightful compliment! What do you think of that, Villers?

VILLERS: That he and his compliments are alike: showy, but won't bear examining. So you brought Miss Hardy to town last night?

MRS. RACKET: Yes, I should have brought her before, but I had a fall from my horse that confined me a week. I suppose in her heart she wished me hanged a dozen times an hour.

FLUTTER: Why?

MRS. RACKET: Had she not an expecting lover in town all the time?

She meets him this morning at the lawyer's. I hope she'll charm him; she's the sweetest girl in the world.

VILLERS: Vanity, like murder, will out. You have convinced me you think yourself more charming.

MRS. RACKET: How can that be?

VILLERS: No woman ever praises another unless she thinks herself superior in the very perfections she allows.

FLUTTER: Nor no man ever rails at the sex unless he is conscious he deserves their hatred.

MRS. RACKET: Thank ye, Flutter, I'll owe ye a bouquet for that. I am going to visit the new-married Lady Frances Touchwood. Who knows her husband?

FLUTTER: Everybody.

MRS. RACKET: Is there not something odd in his character?

VILLERS: Nothing but that he is passionately fond of his wife, and so petulant is his love that he opened the cage of a favourite bullfinch and sent it to catch butterflies because she rewarded its song with her kisses.

MRS. RACKET: Intolerable monster! Such a brute deserves—

VILLERS: Nay, nay, nay, nay, this is your sex now. Give a woman but one stroke of character, off she goes like a ball from a racket, sees the whole man, marks him down for an angel or a devil, and so exhibits him to her acquaintance. This "monster," this "brute," is one of the worthiest fellows upon earth—sound sense and a liberal mind—but dotes on his wife to such excess that he quarrels with everything she admires and is jealous of her tippet and nosegay.

MRS. RACKET: Oh, less love for me, kind Cupid! I can see no difference between the torment of such an affection and hatred.

FLUTTER: Oh pardon me, inconceivable difference, inconceivable; I see it as clearly as your bracelet. In the one case the husband would say, as Mr. Snapper said t'other day, "Zounds! Madam, do you suppose that *my* table and *my* house and *my* pictures—" *A propos des bottes*, there was the divinest *Plague of Athens* sold yesterday at Langford's! The dead figures so natural you would

have sworn they had been alive! Lord Primrose bid five hundred. "Six," said Lady Carmine. "A thousand," said Ingot the Nabob. Down went the hammer. "A *rouleau* for your bargain," said Sir Jeremy Jingle. And what answer do you think Ingot made him?

MRS. RACKET: Why, took the offer.

FLUTTER: "Sir, I would oblige you, but I buy this picture to place in the nursery: the children have already got *Whittington and his Cat*; 'tis just this size, and they'll make good companions."

MRS. RACKET: Ha, ha, ha! Well, I protest that's just the way now. The nabobs and their wives outbid one at every sale, and the creatures have no more taste—

VILLERS: There again! You forget this story is told by Flutter, who always remembers everything but the circumstances and the person he talks about. 'Twas Ingot who offered a *rouleau* for the bargain, and Sir Jeremy Jingle who made the reply.

FLUTTER: Egad, I believe you are right. Well, the story is as good one way as t'other, you know. Good morning. I am going to Mrs. Crotchet's concert and in my way back shall make my bow at Sir George's. [*Going*]

VILLERS: I'll venture every figure in your tailor's bill you make some blunder there.

FLUTTER: [*Turning back*] Done! My tailor's bill has not been paid these two years, and I'll open my mouth with as much care as Mrs. Bridget Button, who wears cork plumpers in each cheek and never hazards more than six words for fear of showing them. [*Exit*]

MRS. RACKET: 'Tis a good-natured, insignificant creature! Let in everywhere and cared for nowhere.—There's Miss Hardy returned from Lincoln's Inn. She seems rather chagrined.

VILLERS: Then I leave you to your communications.

Enter LETITIA *followed by her maid.*

Adieu! I am rejoiced to see you so well, madam, but I must tear myself away.

LETITIA: Don't vanish in a moment.

VILLERS: Oh inhuman! You are two of the most dangerous women in town. Staying here to be cannonaded by four such eyes is equal to a *rencontre* with Paul Jones or a midnight march to Omoa! [*Aside*] They'll swallow the nonsense for the sake of the compliment. [*Exit*]

LETITIA: [*Gives her cloak to her maid*] Order DuQuesne never to come again; he shall positively dress my hair no more. [*Exit* MAID]. And this odious silk, how unbecoming it is! I was bewitched to choose it. [*Throwing herself on a sofa and looking in a pocket glass,* MRS. RACKET *staring at her*] Did you ever see such a fright as I am today?

MRS. RACKET: Yes, I have seen you look much worse.

LETITIA: How can you be so provoking? If I do not look this morning worse than ever I looked in my life, I am naturally a fright. You shall have it which way you will.

MRS. RACKET: Just as you please. But pray, what is the meaning of all this?

LETITIA: [*Rising*] Men are all dissemblers! Flatterers! Deceivers! Have I not heard a thousand times of my air, my eyes, my shape—all made for victory! And today, when I bent my whole heart on one poor conquest, I have proved that all those imputed charms amount to nothing—for Doricourt saw them unmoved. A husband of fifteen months could not have examined me with more cutting indifference.

MRS. RACKET: Then you return it like a wife of fifteen months and be as indifferent as he.

LETITIA: Aye, there's the sting! The blooming boy who left his image in my young heart is, at four and twenty, improved in every grace that fixed him there. It is the same face that my memory and my dreams constantly painted to me, but its graces are finished and every beauty heightened. How mortifying to feel myself at the same moment his slave and an object of perfect indifference to him!

MRS. RACKET: How are you certain that was the case? Did you expect him to kneel down before the lawyer, his clerks and your father to make oath of your beauty?

LETITIA: No, but he should have looked as if a sudden ray had pierced him! He should have been breathless! Speechless! For, oh, Caroline, all this was I.

MRS. RACKET: I am sorry you was such a fool. Can you expect a man who has courted and been courted by half the fine women in Europe to feel like a girl from a boarding school? He is the prettiest fellow you have seen and in course bewilders your imagination. But he has seen a million of pretty women, child, before he saw you, and his first feelings have been over long ago.

LETITIA: Your raillery distresses me, but I will touch his heart or never be his wife.

MRS. RACKET: Absurd and romantic! If you have no reason to believe his heart pre-engaged, be satisfied; if he is a man of honor, you'll have nothing to complain of.

LETITIA: Nothing to complain of! Heavens! Shall I marry the man I adore with such an expectation as that?

MRS. RACKET: And when you have fretted yourself pale, my dear, you'll have mended your expectation greatly.

LETITIA: [*Pausing*] Yet I have one hope. If there is any power whose peculiar care is faithful love, that power I invoke to aid me.

Enter MR. HARDY.

HARDY: Well now, wasn't I right? Aye, Letty! Aye, cousin Racket! Wasn't I right? I knew 'twould be so. He was all agog to see her before he went abroad and, if he had, he'd have thought no more of her face, maybe, than his own.

MRS. RACKET: Maybe not half so much.

HARDY: Aye, maybe so, but I see into things; exactly as I foresaw, today he fell desperately in love with the wench! He, he, he!

LETITIA: Indeed, sir! How did you perceive it?

HARDY: That's a pretty question! How do I perceive everything? How did I foresee the fall of corn and the rise of taxes? How did I know that if we quarrelled with America, Norway deals would be dearer? How did I foretell that a war would sink the funds? How did I forewarn Parson Homily that if he didn't some way or other contrive to get more votes than Rubric, he'd lose the

lectureship? How did I—but what the devil makes you so dull, Letitia? I thought to have found you popping about as brisk as the jacks of your harpsichord.

LETITIA: Surely, sir, 'tis a very serious occasion.

HARDY: Faugh, faugh! Girls should never be grave before marriage. How did you feel, cousin, beforehand? Aye!

MRS. RACKET: Feel! Why, exceedingly full of cares.

HARDY: Did you?

MRS. RACKET: I could not sleep for thinking of my coach, my liveries and my chairmen; the taste of clothes I should be presented in distracted me for a week, and whether I should be married in white or lilac gave me the most cruel anxiety.

LETITIA: And is it possible that you felt no other care?

HARDY: And pray, of what sort may your cares be, Mrs. Letitia? I begin to foresee now that you have taken a dislike to Doricourt.

LETITIA: Indeed, sir, I have not.

HARDY: Then what's all this melancholy about? Ain't you going to be married? And, what's more, to a sensible man? And, what's more to a young girl, to a handsome man? And what's all this melancholy for, I say?

MRS. RACKET: Why, because he *is* handsome and sensible, and because she's over head and ears in love with him, all which, it seems, your foreknowledge had not told you a word of.

LETITIA: Fie, Caroline!

HARDY: Well, come, do you tell me what's the matter then. If you don't like him, hang the signing and sealing, he shan't have ye. And yet I can't say that neither, for you know that estate that cost his father and me upwards of fourscore thousand pounds must go all to him if you won't have him; if he won't have you, indeed, 'twill be all yours. All that's clear, engrossed upon parchment, and the poor dear man set his hand to it whilst he was a-dying. "Ah!" said I, "I foresee you'll never live to see 'em come together, but their first son shall be christened Jeremiah after you, that I promise you." But come, I say, what is the matter? Don't you like him?

LETITIA: I fear, sir—if I must speak—I fear I was less agreeable in Mr. Doricourt's eyes than he appeared in mine.

HARDY: There you are mistaken, for I asked him, and he told me he liked you vastly. Don't you think he must have taken a fancy to her?

MRS. RACKET: Why, really I think so, as I was not by.

LETITIA: My dear sir, I am convinced he has not; but if there is spirit or invention in woman, he shall.

HARDY: Right, girl, go to your toilette—

LETITIA: It is not my toilette that can serve me; but a plan has struck me, if you will not oppose it, which flatters me with brilliant success.

HARDY: Oppose it! Not I, indeed! What is it?

LETITIA: Why, sir, it may seem a little paradoxical, but as he does not like me enough, I want him to like me still less, and will, at our next interview, endeavour to heighten his indifference into dislike.

HARDY: Who the devil could have foreseen that?

MRS. RACKET: Heaven and earth! Letitia, are you serious?

LETITIA: As serious as the most important business of my life demands.

MRS. RACKET: Why endeavour to make him dislike you?

LETITIA: Because 'tis much easier to convert a sentiment into its opposite than to transform indifference into tender passion.

MRS. RACKET: That may be good philosophy, but I am afraid you'll find it a bad maxim.

LETITIA: I have the strongest confidence in it. I am inspired with unusual spirits, and on this hazard willingly stake my chance for happiness. I am impatient to begin my measures. [*Exit*]

HARDY: Can you foresee the end of this, cousin?

MRS. RACKET: No, sir, nothing less than your penetration can do that, I am sure, and I can't stay now to consider it. I am going to call on the Ogles, and then to Lady Frances Touchwood's and then to an auction and then—I don't know where—but I shall be at home time enough to witness this extraordinary interview. Goodbye. [*Exit*]

HARDY: Well, 'tis an odd thing—I can't understand it—but I foresee Letty will have her way, and so I shan't give myself the trouble to dispute it. [*Exit*]

ACT II, SCENE I

SIR GEORGE TOUCHWOOD's. *Enter* DORICOURT *and* SIR GEORGE.

DORICOURT: Married, ha, ha, ha! You, whom I heard in Paris say such things of the sex, are in London a married man.

SIR GEORGE: The sex is still what it has ever been since *la petite morale* banished substantial virtues, and rather than have given my name to one of your high-bred fashionable dames, I'd have crossed the line in a fire ship and married a Japanese.

DORICOURT: Yet you have married an English beauty—yea, and a beauty born in high life.

SIR GEORGE: True, but she has a simplicity of heart and manners that would have become the fair Hebrew damsels toasted by the patriarchs.

DORICOURT: Ha, ha! Why, thou are a downright matrimonial Quixote. My life on't, she becomes as mere a town lady in six months as though she had been bred to the trade.

SIR GEORGE: [*Contemptuously*] Common, common. No, sir, Lady Frances despises high life so much from the ideas I have given her that she'll live in it like a salamander in fire.

DORICOURT: Oh, that the circle *dans la Place Victoire* could witness thy extravagance! I'll send thee off to St. Évreux this night, drawn at full length and coloured after nature.

SIR GEORGE: Tell him then, to add to the ridicule, that Touchwood glories in the name of husband, that he has found in one Englishwoman more beauty than Frenchmen ever saw and more goodness than Frenchwomen can conceive.

DORICOURT: Well, enough of description. Introduce me to this phoenix. I came on purpose.

SIR GEORGE: Introduce! Oh, aye, to be sure—I believe Lady Frances

is engaged just now—but another time. [*Aside*] How handsome
the dog looks today!

DORICOURT: Another time! But I have no other time. 'Sdeath! This
is the only hour I can command this fortnight!

SIR GEORGE: [*Aside*] I am glad to hear it, with all my soul. [*To*
DORINCOURT] So then, you can't dine with us today? That's
very unlucky.

DORICOURT: Oh yes—as to dinner—yes, I can, I believe, contrive
to dine with you today.

SIR GEORGE: Psha! I didn't think on what I was saying; I meant sup-
per—you can't sup with us?

DORICOURT: Why, supper will be rather more convenient than dinner.
But you are fortunate; if you had asked me any other night, I
could not have come.

SIR GEORGE: Tonight! Gad, now I recollect, we are particularly
engaged tonight—but tomorrow night–

DORICOURT: Why, look ye, Sir George, 'tis very plain you have no
inclination to let me see your wife at all; so here I sit. [*Throws
himself on a sofa*] There's my hat, and here are my legs. Now I
shan't stir till I have seen her, and I have no engagements: I'll
breakfast, dine, and sup with you every day this week.

SIR GEORGE: Was there ever such a provoking wretch! But, to be
plain with you, Doricourt, I and my house are at your service.
But you are a damned agreeable fellow and ten years younger
than I am, and the women, I observe, always simper when you
appear. For these reasons I had rather, when Lady Frances and
I are together, that you should forget we are acquainted further
than a nod, a smile, or a how-d'ye.

DORICOURT: Very well.

SIR GEORGE: It is not merely yourself *in propria persona* that I
object to, but, if you are intimate here, you'll make my house
still more the fashion than it is, and it is already so much so
that my doors are of no use to me. I married Lady Frances
to engross her to myself, yet such is the blessed freedom of
modern manners that, in spite of me, her eyes, thoughts, and

conversation are continually divided amongst all the flirts and coxcombs of fashion.

DORICOURT: To be sure, I confess that kind of freedom is carried rather too far. 'Tis hard one can't have a jewel in one's cabinet but the whole town must be gratified with its lustre. [*Aside*] He shan't preach me out of seeing his wife, though.

SIR GEORGE: Well now, that's reasonable. When you take time to reflect, Doricourt, I always observe you decide right, and therefore I hope—

Enter SERVANT.

SERVANT: Sir, my lady desires—

SIR GEORGE: I am particularly engaged.

DORICOURT: [*Leaping from the sofa*] Oh Lord, that shall be no excuse in the world. Lead the way, John. I'll attend your lady. [*Exit, following* SERVANT]

SIR GEORGE: What devil possessed me to talk about her? Here, Doricourt! [*Running after him*] Doricourt!

Exit SIR GEORGE. *Enter* MRS. RACKET *and* MISS OGLE, *followed by a* SERVANT.

MRS. RACKET: Acquaint your lady that Mrs. Racket and Miss Ogle are here.

Exit SERVANT.

MISS OGLE: I shall hardly know Lady Frances, 'tis so long since I was in Shropshire.

MRS. RACKET: And I'll be sworn you never saw her *out* of Shropshire. Her father kept her locked up with his caterpillars and shells and loved her beyond anything—but a blue butterfly and a petrified frog!

MISS OGLE: Ha, ha, ha! Well, 'twas a cheap way of breeding her; you know he was very poor, though a lord, and very high-spirited, though a virtuoso. In town, her Pantheons, operas and *robes de cour* would swallowed his seaweeds, moths and monsters in six

weeks! Sir George, I find, thinks his wife a most extraordinary creature: he has taught her to despise everything like fashionable life and boasts that example will have no effect on her.

MRS. RACKET: There's a great degree of impertinence in all that. I'll try to make her a fine lady to humble him.

MISS OGLE: That's just the thing I wish.

Enter LADY FRANCES.

LADY FRANCES: I beg ten thousand pardons, my dear Mrs. Racket. Miss Ogle, I rejoice to see you. I should have come to you sooner, but I was detained in conversation by Mr. Doricourt.

MRS. RACKET: Pray make no apology; I am quite happy that we have your ladyship in town at last. What stay do you make?

LADY FRANCES: A short one! Sir George talks with regret of the scenes we have left and, as the ceremony of presentation is over, will, I believe, soon return.

MISS OGLE: Sure he can't be so cruel! Does your ladyship wish to return so soon?

LADY FRANCES: I have not the habit of consulting my own wishes, but I think, if they decide, we shall not return immediately. I have yet hardly formed an idea of London.

MRS. RACKET: I shall quarrel with your lord and master if he dares think of depriving us of you so soon. How do you dispose of yourself today?

LADY FRANCES: Sir George is going with me this morning to the mercer's to choose a silk, and then—

MRS. RACKET: Choose a silk for you! Ha, ha, ha! Sir George chooses your laces too, I hope, your gloves and your pincushions!

LADY FRANCES: Madam!

MRS. RACKET: I am glad to see you blush, my dear Lady Frances. These are strange, homespun ways! If you do these things, pray keep 'em secret. Lord bless us! If the town should know your husband chooses your gowns!

MISS OGLE: You are very young, my lady, and have been brought up in solitude. The maxims you learnt among the wood nymphs in Shropshire won't pass current here, I assure you.

MRS. RACKET: Why, my dear creature, you look quite frightened! Come, you shall go with us to an exhibition and an auction. Afterwards, we'll take a turn in the Park and then drive to Kensington; so we shall be at home by four to dress, and in the evening I'll attend you to Lady Brilliant's masquerade.

LADY FRANCES: I shall be very happy to be of your party, if Sir George has no engagements.

MRS. RACKET: What! Do you stand so low in your own opinion that you dare not trust yourself without Sir George? If you choose to play Darby and Joan, my dear, you should have stayed in the country; 'tis an exhibition not calculated for London, I assure you!

MISS OGLE: What, I suppose, my lady, you and Sir George will be seen pacing it comfortably round the canal, arm and arm, and then go lovingly into the same carriage, dine *tête-à-tête*, spend the evening at piquet, and so go soberly to bed at eleven! Such a snug plan may do for an attorney and his wife, but for Lady Frances Touchwood, 'tis as unsuitable as linsey-woolsey or a black bonnet at the *festino*!

LADY FRANCES: These are rather new doctrines to me! But, my dear Mrs. Racket, you and Miss Ogle must judge of these things better than I can. As you observe, I am but young and may have caught absurd opinions. Here is Sir George!

Enter SIR GEORGE.

SIR GEORGE: [*Aside*] 'Sdeath! Another room full!

LADY FRANCES: My love! Mrs. Racket and Miss Ogle.

MRS. RACKET: Give you joy, Sir George. We came to rob you of Lady Frances for a few hours.

SIR GEORGE: A few hours!

LADY FRANCES: Oh yes! I am going to an exhibition and an auction and the Park and Kensington and a thousand places! It is quite ridiculous, I find, for married people to be always together. We shall be laughed at!

SIR GEORGE: I am astonished!—Mrs. Racket, what does the dear creature mean?

MRS. RACKET: Mean, Sir George! What she says, I imagine.

MISS OGLE: Why, you know, sir, as Lady Frances had the misfortune to be bred entirely in the country, she cannot be supposed to be versed in fashionable life.

SIR GEORGE: No, Heaven forbid she should! If she had, madam, she would never have been my wife!

MRS. RACKET: Are you serious?

SIR GEORGE: Perfectly so. I should never have had the courage to have married a well-bred, fine lady.

MISS OGLE: [*Sneeringly*] Pray, sir, what do you take a fine lady to be, that you express such fear of her?

SIR GEORGE: A being easily described, madam, as she is seen everywhere but in her own house. She sleeps at home, but she lives all over the town. In her mind, every sentiment gives place to the lust of conquest and the vanity of being particular. The feelings of wife and mother are lost in the whirl of dissipation. If she continues virtuous, 'tis by chance, and if she preserves her husband from ruin, 'tis by her dexterity at the card table! Such a woman I take to be a perfect fine lady!

MRS. RACKET: And you I take to be a slanderous cynic of two-and-thirty. Twenty years hence, one might have forgiven such a libel! Now, sir, hear my definition of a fine lady: she is a creature for whom nature has done much and education more; she has taste, elegance, spirit, understanding. In her manner she is free, in her morals nice. Her behaviour is undistinguishingly polite to her husband and all mankind; her sentiments are for their hours of retirement. In a word, a fine lady is the life of conversation, the spirit of society, the joy of the public! Pleasure follows wherever she appears, and the kindest wishes attend her slumbers.—Make haste, then, my dear Lady Frances, commence fine lady and force your husband to acknowledge the justness of my picture!

LADY FRANCES: I am sure 'tis a delightful one. How can you dislike it, Sir George? You painted fashionable life in colours so disgusting that I thought I hated it, but, on a nearer view, it seems charming. I have hitherto lived in obscurity; 'tis time

that I should be a woman of the world. I long to begin; my heart pants with expectation and delight!

MRS. RACKET: Come then, let us begin directly. I am impatient to introduce you to that society which you were born to ornament and charm.

LADY FRANCES: Adieu, my love! We shall meet again at dinner. [*Going*]

SIR GEORGE: Sure, I am in a dream!—Fanny!

LADY FRANCES: [*Returning*] Sir George?

SIR GEORGE: Will you go without me?

MRS. RACKET: Will you go without me! Ha, ha, ha! What a pathetic address! Why, sure you would not always be seen side by side like two beans upon a stalk? Are you afraid to trust Lady Frances with me, sir?

SIR GEORGE: Heaven and earth! With whom can a man trust his wife in the present state of society? Formerly there were distinctions of character amongst ye: every class of females had its particular description. Grandmothers were pious, aunts discreet, old maids censorious! But now aunts, grandmothers, girls, and maiden gentlewomen are all the same creature; a wrinkle more or less is the sole difference between ye.

MRS. RACKET: That maiden gentlewomen have lost their censoriousness is surely not in your catalogue of grievances.

SIR GEORGE: Indeed it is, and ranked amongst the most serious grievances. Things went well, madam, when the tongues of three of four old virgins kept all the wives and daughters of a parish in awe. They were the dragons that guarded the Hesperian fruit, and I wonder they have not been obliged, by act of Parliament, to resume their function.

MRS. RACKET: Ha, ha, ha! And pensioned, I suppose, for making strict enquiries into the lives and conversations of their neighbours.

SIR GEORGE: With all my heart, and empowered to oblige every woman to conform her conduct to her real situation. You, for instance, are a widow: your air should be sedate, your dress grave, your deportment matronly, and in all things an example

to the young women growing up about you! Instead of which, you are dressed for conquest, think of nothing but ensnaring hearts, are a coquette, a wit and a fine lady.

MRS. RACKET: Bear witness to what he says! A coquette! A wit! And a fine lady! Who would have expected a eulogy from such an ill-natured mortal? Valour to a soldier, wisdom to a judge, or glory to a prince is not more than such a character to a woman.

MISS OGLE: Sir George, I see, languishes for the charming society of a century and a half ago, when a grave squire and a still graver dame, surrounded by a sober family, formed a stiff group in a mouldy old house in the corner of a park.

MRS. RACKET: Delightful serenity! Undisturbed by any noise but the cawing of rooks and the quarterly rumbling of an old family coach on a state visit, with the happy intervention of a friendly call from the parish apothecary or the curate's wife.

SIR GEORGE: And what is the society of which you boast? A mere chaos in which all distinction of rank is lost in a ridiculous affectation of ease and every different order of beings huddled together as they were before the creation. In the same select party, you will often find the wife of a bishop and a sharper, of an earl and a fiddler. In short, 'tis one universal masquerade, all disguised in the same habits and manners.

Enter SERVANT.

SERVANT: Mr. Flutter. [*Exit*]

SIR GEORGE: Here comes an illustration. Now I defy you to tell from his appearance whether Flutter is a privy counsellor or a mercer, a lawyer or a grocer's prentice.

Enter FLUTTER.

FLUTTER: Oh, just which you please, Sir George, so you don't make me a Lord Mayor.—Ah, Mrs. Racket!—Lady Frances, your most obedient, you look—now hang me, if that's not provok-ing—had your gown been of another colour, I should have said the prettiest thing you ever heard in your life.

MISS OGLE: Pray give it us.

FLUTTER: I was yesterday at Mrs. Bloomer's. She was dressed all in green; no other colour to be seen but that of her face and bosom. So says I, "My dear Mrs. Bloomer! You look like a carnation just bursting from its pod."

SIR GEORGE: And what said her husband?

FLUTTER: Her husband! Why, her husband laughed and said a cucumber would have been a happier simile.

SIR GEORGE: But there *are* husbands, sir, who would rather have corrected than amended your comparison. I, for instance, should consider a man's complimenting my wife as an impertinence.

FLUTTER: Why, what harm can there be in compliments? Sure they are not infectious, and, if they were, you, Sir George, of all people breathing, have reason to be satisfied about your lady's attachment. Everybody talks of it: that little bird there that she killed out of jealousy, the most extraordinary instance of affection that ever was given.

LADY FRANCES: I kill a bird through jealousy? Heavens! Mr. Flutter, how can you impute such a cruelty to me?

SIR GEORGE: I could have forgiven you, if you had.

FLUTTER: Oh, what a blundering fool! No, no—now I remember—'twas your bird, Lady Frances—that's it, your bullfinch, which Sir George, in one of the refinements of his passion, sent into the wide world to seek its fortune. He took it for a knight in disguise.

LADY FRANCES: Is it possible! Oh, Sir George, could I have imagined it was you who deprived me of a creature I was so fond of?

SIR GEORGE: Mr. Flutter, you are one of those busy, idle, meddling people who, from mere vacuity of mind are the most dangerous inmates in a family. You have neither feelings nor opinions of your own but, like a glass in a tavern, bear about those of every blockhead who gives you his, and, because you *mean* no harm, think yourselves excused though broken friendships, discords, and murders are the consequences of your indiscretions.

FLUTTER: [*Taking out his tablets*] Vacuity of mind!—What was the next? I'll write down this sermon; 'tis the first I have heard since my grandmother's funeral.

MISS OGLE: Come, Lady Frances, you see what a cruel creature your loving husband can be, so let us leave him.

SIR GEORGE: Madam, Lady Frances shall not go.

LADY FRANCES: *Shall not*, Sir George? [*Weeping*] This is the first time such an expression—

SIR GEORGE: My love! My life!

LADY FRANCES: Don't imagine I'll be treated like a child, denied what I wish and then pacified with sweet words.

MISS OGLE: [*Aside to* LADY FRANCES] The bullfinch! That's an excellent subject; never let it down.

LADY FRANCES: I see plainly you would deprive me of every pleasure, as well as of my sweet bird, out of pure love! Barbarous man!

SIR GEORGE: 'Tis well, madam; your resentment of that circumstance proves to me what I did not before suspect, that you are deficient both in tenderness and understanding. Tremble to think the hour approaches in which you would give worlds for such a proof of my love. Go, madam, give yourself to the public, abandon your heart to dissipation, and see if, in the scenes of gaiety and folly that await you, you can find a recompense for the lost affection of a doting husband. [*Exit*]

FLUTTER: Lord! What a fine thing it is have the gift of speech! I suppose Sir George practises at Coachmakers Hall or the Black Horse in Bond Street.

LADY FRANCES: He is really angry. I cannot go.

MRS. RACKET: Not go! Foolish creature! You are arrived at the moment which some time or other was sure to happen, and everything depends on the use you make of it.

MISS OGLE: Come, Lady Frances! Don't hesitate! The minutes are precious.

LADY FRANCES: I could find in my heart—and yet I won't give up neither. If I should in this instance, he'll expect it forever.

Exeunt LADY FRANCES *and* MRS. RACKET.

MISS OGLE: Now you act like a woman of spirit. [*Exit*]

FLUTTER: A fair tug, by Jupiter—between duty and pleasure! Pleasure beats and off we go, *Iö triumphe*! [*Exit*]

ACT II, SCENE II

An auction room, with busts, pictures, etc. Enter SILVERTONGUE *with three puffers:* MRS. FAGG, MASK *and another.*

SILVERTONGUE: Very well, very well. This morning will be devoted to curiosity; my sale begins tomorrow at eleven. But, Mrs. Fagg, if you do no better than you did in Lord Fillagree's sale, I shall discharge you. You want a knack terribly. And this dress—why, nobody can mistake you for a gentlewoman.

MRS. FAGG: Very true, Mr. Silvertongue, but I can't dress like a lady upon half-a-crown a day, as the saying is. If you want me to dress like a lady, you must double my pay. Double or quits, Mr. Silvertongue.

SILVERTONGUE: *Five shillings* a day! What a demand! Why, woman, there are a thousand parsons in the town who don't make five shillings a day, though they preach, pray, christen, marry, and bury for the good of the community. Five shillings a day! Why, 'tis the pay a lieutenant in a marching regiment, who keeps a servant, a mistress, a horse; fights, dresses, ogles, makes love, and dies upon five shillings a day.

MRS. FAGG: Oh as to that, all that's very right. A soldier should not be too fond of life, and forcing him to do all these things upon five shillings a day is the readiest way to make him tired on't.

SILVERTONGUE: Well, Mask, have you been looking into the antiquaries? Have you got all the terms of art in a string, aye?

MASK: Yes, I have: I know the age of a coin by the taste and can fix the birthday of a medal, *anno mundi* or *anno domini*, though the green rust should have eaten up every character. But you know, the brown suit and the wig I wear when I personate the antiquary are in limbo.

SILVERTONGUE: Those you have on may do.

MASK: These! Why, in these I am a young travelled *cognoscento*. Mr. Glib bought them of Sir Tom Totter's valet, and I am going there directly. You know his picture sale comes on today, and I have got my head full of Parmegiano, Sal Rosa, Metszu, Tarbaek, and Vandermeer. I talk of the relief of Woovermans, the spirit of Teniers, the colouring of the Venetian School, and the correctness of the Roman. I distinguish Claude by his sleep and Ruisdael by his water. The rapidity of Tintoret's pencil strikes me at the first glance, whilst the harmony of Van Dyck and the glow of Correggio point out their masters.

Enter company of LADIES *and* GENTLEMEN.

FIRST LADY: Heyday, Mr. Silvertongue! What, nobody here?

SILVERTONGUE: Oh my lady, we shall have company enough in a trice; if you carriage is seen at my door, no other will pass it, I am sure.

FIRST LADY: [*Aside*] Familiar monster! [*To* SILVERTONGUE] That's a beautiful Diana, Mr. Silvertongue, but in the name of wonder, how came Actaeon to be placed on the top of a house?

SILVERTONGUE: That's David and Bathsheba, ma'am.

FIRST LADY: Oh, I crave their pardon! I remember the names but know nothing of the story.

More company enters COURTALL *among them.*

FIRST GENTLEMAN: Was not that Lady Frances Touchwood coming up with Mrs. Racket?

SECOND GENTLEMAN: I think so—yes, it is, faith. Let us go nearer.

Enter LADY FRANCES, MRS. RACKET, *and* MISS OGLE.

SILVERTONGUE: Yes, sir, this is to be the first lot: the model of a city in wax.

SECOND GENTLEMAN: The model of a city! What city?

SILVERTONGUE: That I have not been able to discover, but call it Rome, Peking, or London, 'tis still a city: you'll find in it the same jarring interests, the same passions, the same virtues and the same vices, whatever the name.

FIRST GENTLEMAN: You may as well present us a map of *terra incognita.*

SILVERTONGUE: Oh pardon me, sir! A lively imagination would convert this waxen city into an endless and interesting amusement. For instance, look into this little house on the right hand; there are four old prudes in it taking care of their neighbours' reputations. This elegant mansion on the left, decorated with Corinthian pillars—who needs to be told that it belongs to a court lord and is the habitation of patriotism, philosophy and virtue? Here's a City Hall: the rich steams that issue from the windows nourish a neighbouring workhouse. Here's a church—we'll pass over that, the doors are shut. The parsonage-house comes next; we'll take a peep here, however. Look at the doctor! He's asleep on a volume of Toland, whilst his lady is putting on rouge for the masquerade. Oh! Oh, this can be no English city; our parsons are all orthodox and their wives the daughters of modesty and meekness.

LADY FRANCES *and* MISS OGLE *come forward, followed by* COURTALL.

LADY FRANCES: I wish Sir George was here. This man follows me about and stares at me in such a way that I am quite uneasy.

MISS OGLE: He has travelled and is heir to an immense estate, so he's impertinent by patent.

COURTALL: You are very cruel, ladies. Miss Ogle, you will not let me speak to you. As to this little scornful beauty, she has frowned me dead fifty times.

LADY FRANCES: [*Confused*] Sir—I am a married woman.

COURTALL: [*Aside*] A married woman! A good hint. [*To* LADY FRANCES] 'Twould be a shame if such a charming woman was not married. But I see you are a Daphne just come from your sheep and your meadows, your crook and your waterfalls. Pray now, who is the happy Damon to whom you have vowed eternal truth and constancy?

MISS OGLE: 'Tis Lady Frances Touchwood, Mr. Courtall, to whom you are speaking.

COURTALL: [*Aside*] Lady Frances! By Heaven, that's Saville's old flame. [*To* LADY FRANCES] I beg your ladyship's pardon. I ought to have believed that such beauty could belong only to your name, a name I have long been enamoured of because I knew it to be that of the finest woman in the world.

MRS. RACKET *comes forward.*

LADY FRANCES: [*Aside to* MRS. RACKET] My dear Mrs. Racket, I am so frightened! Here's a man making love to me, though he knows I am married.

MRS. RACKET: Oh, the sooner for that, my dear; don't mind him.— Was you at the casino last night, Mr. Courtall?

COURTALL: I looked in. 'Twas impossible to stay. Nobody there but antiques. You'll be at Lady Brilliant's tonight, doubtless?

MRS. RACKET: Yes, I go with Lady Frances.

LADY FRANCES: [*To* MISS OGLE] Bless me! I did not know this gentleman was acquainted with Mrs. Racket. I behaved so rude to him!

MRS. RACKET: [*Looking at her watch*] Come ma'am, 'tis past one. I protest, if we don't fly to Kensington we shan't find a soul there.

LADY FRANCES: Won't this gentleman go with us?

COURTALL: [*Looking surprised*] To be sure. You make me happy, madam, beyond description.

MRS. RACKET: Oh, never mind him, he'll follow.

Exeunt LADY FRANCES, MRS. RACKET, *and* MISS OGLE.

COURTALL: Lady *Touchwood* with a vengeance! But 'tis always so; your reserved ladies are like ice, egad! No sooner begin to soften than they melt. [*Exit following*]

ACT III, SCENE I

MR. HARDY'*s. Enter* LETITIA *and* MRS. RACKET.

MRS. RACKET: Come, prepare, prepare; your lover is coming.

LETITIA: My lover! Confess now that my absence at dinner was a severe mortification to him.

MRS. RACKET: I can't absolutely swear it spoilt his appetite; he eat as if he was hungry and drank his wine as though he liked it.

LETITIA: What was the apology?

MRS. RACKET: That you were ill. But I gave him a hint that your extreme bashfulness could not support his eye.

LETITIA: If I comprehend him, awkwardness and bashfulness are the last faults he can pardon in a woman, so expect to see me transformed into the veriest malkin.

MRS. RACKET: You persevere then?

LETITIA: Certainly. I know the design is a rash one and the event important. It either makes Doricourt mine by all the tenderest ties of passion or deprives me of him forever, and never to be his wife will afflict me less than to be his wife and not be beloved.

MRS. RACKET: So you won't trust to the good old maxim, "Marry first, and love will follow"?

LETITIA: As readily as I would venture my last guinea that good fortune might follow. The woman that has not touched the heart of a man before he leads her to the altar has scarcely a chance to charm it when possession and security turn their powerful arms against her.—But here he comes. I'll disappear for a moment. Don't spare me. [*Exit*]

Enter DORICOURT, *not seeing* MRS. RACKET.

DORICOURT: [*Looking at a picture*] So, this is my mistress, I presume. *Ma foi*, the painter has hit her off: the downcast eye, the blushing cheek, timid, apprehensive, bashful. A tear and a prayer book would have made her *La Bella Magdalena*.—
Give *me* a woman in whose touching mien
A mind, a soul, a polished art is seen,
Whose motion speaks, whose poignant air can move.
Such are the darts to wound with endless love.

MRS. RACKET: [*Touching him on the shoulder with her fan*] Is that an impromptu?

DORICOURT: [*Starting*] Madam! [*Aside*] Finely caught! [*To* MRS. RACKET] Not absolutely, it struck me during the dessert as a motto for your picture.

MRS. RACKET: Gallantly turned! I perceive, however, Miss Hardy's charms have made no violent impression on you. And who can wonder? The poor girl's defects are so obvious.

DORICOURT: Defects!

MRS. RACKET: Merely those of education. Her father's indulgence ruined her. *Mauvaise honte*, conceit and ignorance—all unite in the lady you are to marry.

DORICOURT: Marry! I marry such a woman? Your picture, I hope, is overcharged. I marry *mauvaise honte*, pertness and ignorance!

MRS. RACKET: Thank your stars that ugliness and ill temper are not added to the list. You must think her handsome?

DORICOURT: Half her personal beauty would content me, but could the Medicean Venus be animated for me and endowed with a vulgar soul, *I* should become the statue and my heart transformed to marble.

MRS. RACKET: Bless us! We are in a hopeful way then!

DORICOURT: [*Aside*] There must be some envy in this! I see she is a coquette. [*To* MRS. RACKET] Ha, ha, ha! And you imagine I am persuaded of the truth of your character? Ha, ha, ha! Miss Hardy, I have been assured, madam, is elegant and accomplished. But one must allow for a lady's painting.

MRS. RACKET: [*Aside*] I'll be even with him for that. [*To* DORINCOURT] —Ha, ha, ha! And so you have found me out! Well, I protest I meant no harm; 'twas only to increase the *éclat* of her appearance that I threw a veil over her charms.—Here comes the lady; her elegance and accomplishments will announce themselves.

Enter LETITIA, *running.*

LETITIA: La, cousin, do you know that our John—oh, dear heart!—I didn't see you, sir. [*Hanging down her head and dropping behind* MRS. RACKET]

MRS. RACKET: Fie, Letitia! Mr. Doricourt thinks you a woman of elegant manners. Stand forward and confirm his opinion.

LETITIA: No, no, keep before me. He's my sweetheart, and 'tis impudent to look one's sweetheart in the face, you know.

MRS. RACKET: You'll allow in future for a lady's painting, sir. Ha, ha, ha!

DORICOURT: I am astonished!

LETITIA: Well, hang it, I'll take heart. Why, he is but a man, you know, cousin, and I'll let him see I wasn't born in a wood to be scared by an owl. [*Half apart, advances and looks at him through her fingers*] He, he, he! [*Goes up to him and makes a very stiff formal curtsy. He bows*] You have been a great traveller, sir, I hear?

DORICOURT: Yes, madam.

LETITIA: Then I wish you'd tell us about the fine sights you saw when you went oversea. I have read in a book that there are some countries where the men and women are all horses. Did you see any of them?

MRS. RACKET: Mr. Doricourt is not prepared, my dear, for these enquiries. He is reflecting on the importance of the question and will answer you—when he can.

LETITIA: When he can! Why, he's as slow in speech as Aunt Margery when she's reading Thomas Aquinas and stands gaping like mumchance.

MRS. RACKET: Have a little discretion.

LETITIA: Hold your tongue! Sure I may say what I please before I am married, if I can't afterwards. D'ye think a body does not know how to talk to a sweetheart? He is not the first I have had.

DORICOURT: Indeed!

LETITIA: Oh Lud! He speaks!—Why, if you must know—there was the curate at home. When Papa was a-hunting, he used to come a-suitoring and make speeches to me out of books. Nobody knows what a *mort* of fine things he used to say to me—and call me Venis, and Jubah and Dinah!

DORICOURT: And pray, fair lady, how did you answer him?

LETITIA: Why, I used to say: "Look you, Mr. Curate, don't think

to come over me with your flim-flams, for a better man than ever trod in your shoes is coming oversea to marry me." But i'fags! I begin to think I was out. Parson Dobbins was the sprightfuller man of the two.

DORICOURT: Surely this cannot be Miss Hardy!

LETITIA: Laws! Why, don't you know me! You saw me today—but I was daunted before my father and the lawyer and all them, and did not care to speak out, so, maybe, you thought I couldn't. But I can talk as fast as anybody when I know folks a little, and now I have shown my parts, I hope you'll like me better.

Enter HARDY.

HARDY: [*Aside*] I foresee this won't do! [*To* DORICOURT] Mr. Doricourt, maybe you take my daughter for a fool, but you are mistaken. She's a sensible girl as any in England.

DORICOURT: I am convinced she has a very uncommon understanding, sir. [*Aside*] I did not think he had been such an ass.

LETITIA: [*Aside*] My father will undo the whole. [*To* HARDY] Laws, Papa, how can you think he can take me for a fool, when everybody knows I beat the potecary at conundrums last Christmas-time? And didn't I make a string of names, all in riddles, for the Lady's Diary? There was a little river and a great house; that was Newcastle. There was what a lamb says and three letters; that was *Ba*, and *k-e-r*, ker, Baker. There was—

HARDY: Don't stand ba-a-ing there. You'll make me mad in a moment!—I tell you, sir, that for all that, she's devilish sensible.

DORICOURT: Sir, I give all possible credit to your assertions.

LETITIA: Laws, Papa, do come along. If you stand watching, how can my sweetheart break his mind and tell me how he admires me?

DORICOURT: That would be difficult, indeed, madam.

HARDY: I tell you, Letty, I'll have no more of this. I see well enough—

LETITIA: Laws! Don't snub me before my husband-that-is-to-be. You'll teach him to snub me, too, and I believe, by his looks,

he'd like to begin now. So, let us go. Cousin, you may tell the gentleman what a genus I have: how I can cut watch papers and work catgut, make quadrille baskets with pins, and take profiles in shade—aye, as well as the lady at No. 62, South Moulton Street, Grovesnor Square.

Exeunt HARDY *and* LETITIA.

MRS. RACKET: What think you of my painting now?

DORICOURT: Oh, mere watercolours, madam! The lady has caricatured your picture.

MRS. RACKET: And how does she strike you on the whole?

DORICOURT: Like a good design spoilt by the incapacity of the artist. Her faults are evidently the result of her father's weak indulgence. I observed an expression in her eye that seemed to satirize the folly of her lips.

MRS. RACKET: But at her age, when education is fixed, and manner becomes nature, hopes of improvement—

DORICOURT: Would be as rational as hopes of gold from a juggler's crucible. Doricourt's wife must be incapable of improvement, but it must be because she's got beyond it.

MRS. RACKET: I am pleased your misfortune sits no heavier.

DORICOURT: Your pardon, madam, so mercurial was the hour in which I was born that misfortunes always go plump to the bottom of my heart like a pebble in water and leave the surface unruffled. I shall certainly set off for Bath, or the other world, tonight, but whether I shall use a chaise with four swift coursers, or go off in a tangent from the aperture of a pistol, deserves consideration. So I make my adieus. [*Going*]

MRS. RACKET: Oh, but I entreat you, postpone your journey till tomorrow. Determine on which you will—you must be this night at the masquerade.

DORICOURT: Masquerade!

MRS. RACKET: Why not? If you resolve to visit the other world, you may as well take one night's pleasure first in this, you know.

DORICOURT: Faith, that's very true; ladies are the best philosophers, after all. Expect me at the masquerade. [*Exit*]

MRS. RACKET: He's a charming fellow. I think Letitia shan't have him. [*Going*]

Enter HARDY.

HARDY: What's he gone?

MRS. RACKET: Yes, and I am glad he is. You would have ruined us! Now I beg, Mr. Hardy, you won't interfere in this business; it is a little out of your way. [*Exit*]

HARDY: Hang me, if I don't though. I foresee very clearly what will be the end of it if I leave ye to yourselves. So I'll e'en follow him to the masquerade and tell him all about it. Let me see. What shall my dress be? A great mogul? No. A grenadier? No, no, that, I foresee, would make a laugh. Hang me, if I don't send to my favourite little Quick, and borrow his Jew Isaac's dress. I know the dog likes a glass of good wine, so I'll give him a bottle of my forty-eight and he shall teach me. Aye, that's it—I'll be cunning little Isaac! If they complain of my want of wit, I'll tell 'em the cursed Duenna wears the breeches and has spoilt my parts. [*Exit*]

ACT III, SCENE II

COURTALL's. *Enter* COURTALL, SAVILLE *and three others from an apartment in the back scene, the last three tipsy.*

COURTALL: You shan't go yet. Another catch and another bottle!

FIRST GENTLEMAN: May I be a bottle, and an empty bottle, if you catch me at that! Why, I am going to the masquerade. Jack —, you know who I mean, is to meet me, and we are to have a leap at the new lustres.

SECOND GENTLEMAN: And I am going, too—a harlequin—[*Hiccups*] Am I not in a pretty pickle to make harlequinades? And Tony, here—he is going in the disguise—in the disguise—of a gentleman!

FIRST GENTLEMAN: We are all very disguised; so bid them draw up, d'ye hear!

Exeunt the three GENTLEMEN.

SAVILLE: Thy skull, Courtall, is a lady's thimble—no, an eggshell.

COURTALL: Nay, then you are gone too; you never aspire to similes but in your cups.

SAVILLE: No, no, I am steady enough, but the fumes of the wine pass directly through thy eggshell and leave thy brain as cool as—Hey! I am quite sober: my similes fail me.

COURTALL: Then we'll sit down here and have one sober bottle. [*Calling offstage*] Bring a table and glasses.

SAVILLE: I'll not swallow another drop, no, though the juice should be the true Falernian.

COURTALL: By the bright eyes of her you love, you shall drink her health.

SAVILLE: Ah! [*Sitting down*] Her I loved is gone. [*Sighing*] She's married!

COURTALL: Then bless your stars you are not her husband! I would be husband to no woman in Europe who was not devilish rich and devilish ugly.

SAVILLE: Wherefore ugly?

COURTALL: Because she could not have the conscience to exact those attentions that a pretty wife expects. Or, if she should, her resentments would be perfectly easy to me; nobody would undertake to revenge her cause.

SERVANT *brings in table and glasses, then exits.*

SAVILLE: Thou art a most licentious fellow!

COURTALL: I should hate my own wife, that's certain. But I have a warm heart for those of other people, and so here's to the prettiest wife in England—Lady Frances Touchwood.

SAVILLE: Lady Frances Touchwood! I rise to drink her. [*Drinks*] How the devil came Lady Frances in your head? I never knew you give a woman of chastity before.

COURTALL: [*Sneeringly*] That's odd, for you have heard me give half the women of fashion in England. But pray now, what do you take a woman of chastity to be?

SAVILLE: Such a woman as Lady Frances Touchwood, sir.

COURTALL: Oh, you are grave, sir. I remember you was an adorer of hers. Why didn't you marry her?

SAVILLE: I had not the arrogance to look so high. Had my fortune been worthy of her, she should not have been ignorant of my admiration.

COURTALL: Precious fellow! What, I suppose you would not dare tell her now that you admire her?

SAVILLE: No, nor you.

COURTALL: By the Lord, I have told her so.

SAVILLE: Have? Impossible!

COURTALL: Ha, ha, ha! Is it so?

SAVILLE: How did she receive the declaration?

COURTALL: Why, in the old way: blushed and frowned and said she was married.

SAVILLE: What amazing things thou art capable of! I could more easily have taken the Pope by the beard than profaned her ears with such a declaration.

COURTALL: I shall meet her at Lady Brilliant's tonight, where I shall repeat it. And I'll lay my life, under a mask, she'll hear it all without blush or frown.

SAVILLE: [*Rising*] 'Tis false, sir! She won't.

COURTALL: [*Rising*] She will! Nay, I'll venture to lay a round sum that I prevail on her to go out with me—only to taste the fresh air, I mean.

SAVILLE: Preposterous vanity! From this moment I suspect that half the victories you have boasted are false and slanderous as your pretended influence with Lady Frances.

COURTALL: Pretended! How should such a fellow as you, now, who never soared beyond a cherry-cheeked daughter of a ploughman in Norfolk, judge of the influence of a man of my figure and habits? I could show thee a list in which there are names to shake thy faith in the whole sex! And to that list I have no doubt of adding the name of Lady—

SAVILLE: Hold, sir! My ears cannot bear the profanation. You cannot—dare not—approach her! For your soul you dare not

mention love to her! Her look would freeze the word whilst it hovered on thy licentious lips!

COURTALL: Whu! Whu! Well, we shall see. This evening, by Jupiter, the trial shall be made. If I fail, I fail.

SAVILLE: I think thou darest not! But my life, my honor on her purity. [*Exit*]

COURTALL: Hot-headed fool! [*Musing*] But since he has brought it to this point, by Gad I'll try what can be done with her ladyship. [*Rings*] She's frostwork, and the prejudices of education yet strong; ergo, passionate professions will only inflame her pride and put her on her guard. For other arts then!

Enter DICK.

Dick, do you know any of the servants at Sir George Touchwood's?

DICK: Yes, sir, I knows the groom and one of the housemaids; for the matter o'that, she's my own cousin, and it was my mother that holped her to the place.

COURTALL: Do you know Lady Frances's maid?

DICK: I can't say as how I know she.

COURTALL: Do you know Sir George's valet?

DICK: No, sir, but Sally is very thick with Mr. Gibson, Sir George's gentleman.

COURTALL: Then go there directly and employ Sally to discover whether her master goes to Lady Brilliant's this evening; and, if he does, the name of the shop that sold his habit.

DICK: Yes, sir.

COURTALL: Be exact in your intelligence and come to me at Boodle's.

Exit DICK.

If I cannot otherwise succeed, I'll beguile her as Jove did Alcmena, in the shape of her husband. The possession of so fine a woman, the triumph over Saville, are each a sufficient motive—and united they shall be resistless. [*Exit*]

ACT III, SCENE III

The street. Enter SAVILLE.

SAVILLE: The air has recovered me! What have I been doing! Perhaps my petulance may be the cause of *her* ruin, whose honor I asserted. His vanity is piqued, and where women are concerned, Courtall can be a villain.

Enter DICK, *bows and passes hastily.*

Ha! That's his servant!—Dick!

DICK: [*Returning*] Sir.

SAVILLE: Where are you going, Dick?

DICK: Going! I am going, sir, where my master sent me.

SAVILLE: Well answered. But I have a particular reason for my enquiry, and you must tell me.

DICK: Why then, sir, I am going to call upon a cousin of mine that lives at Sir George Touchwood's.

SAVILLE: Very well. [*Gives him money*] There, you must make your cousin drink my health. What are you going about?

DICK: Why, sir, I believe 'tis no harm, or elseways I am sure I would not blab. I am only going to ax if Sir George goes to the masquerade tonight and what dress he wears.

SAVILLE: Enough! Now, Dick, if you will call at my lodgings in your way back and acquaint me with your cousin's intelligence, I'll double the trifle I have given you.

DICK: Bless your honor, I'll call, never fear. [*Exit*]

SAVILLE: Surely the occasion may justify the means; 'tis doubly my duty to be Lady Frances's protector. Courtall, I see, is planning an artful scheme, but Saville shall outplot him. [*Exit*]

ACT III, SCENE IV

SIR GEORGE TOUCHWOOD'S. *Enter* SIR GEORGE *and* VILLERS.

VILLERS: For shame, Sir George! You have left Lady Frances in tears. How can you afflict her?

SIR GEORGE: 'Tis I that am afflicted; my dream of happiness is over. Lady Frances and I are disunited.

VILLERS: The devil! Why, you have been in town but ten days. She can have made no acquaintance for a Commons affairs yet.

SIR GEORGE: Faugh! 'Tis our minds that are disunited. She no longer places her whole delight in me; she has yielded herself up to the world!

VILLERS: Yielded herself up to the world! Why did you not bring her to town in a cage? Then she might have taken a peep at the world! But after all, what has the world done? A twelve-month since you was the gayest fellow in it. If anybody asked, "Who dresses best?"—Sir George Touchwood. "Who is the most gallant man?"—Sir George Touchwood. "Who is the most wedded to amusement and dissipation?"—Sir George Touchwood. And now Sir George is metamorphosed into a sour censor and talks of fashionable life with as much bitterness as the old crabbed fellow in Rome.

SIR GEORGE: The moment I became possessed of such a jewel as Lady Frances, everything wore a different complexion. That society in which I lived with so much *éclat* became the object of my terror, and I think of the manners of polite life as I do of the atmosphere of a pesthouse. My wife is already infected; she was set upon this morning by maids, widows and bachelors, who carried her off in triumph in spite of my displeasure.

VILLERS: Aye, to be sure, there would have been no triumph in the case if you had not opposed it. But I have heard the whole story from Mrs. Racket, and I assure you, Lady Frances didn't enjoy the morning at all. She wished for you fifty times.

SIR GEORGE: Indeed! Are you sure of that?

VILLERS: Perfectly sure.

SIR GEORGE: I wish I had known it. My uneasiness at dinner was occasioned by very different ideas.

VILLERS: Here then she comes to receive your apology. But if she is true woman, her displeasure will rise in proportion to your contrition, and till you grow careless about her pardon, she

won't grant it. However, I'll leave you. Matrimonial duets are seldom set in the style I like. [*Exit*]

Enter LADY FRANCES.

SIR GEORGE: [*Embracing her*] The sweet sorrow that glitters in these eyes, I cannot bear. Look cheerfully, you rogue.

LADY FRANCES: I cannot look otherwise, if you are pleased with me.

SIR GEORGE: Well, Fanny, today you made your *entrée* in the fashionable world. Tell me honestly the impressions you received.

LADY FRANCES: Indeed, Sir George, I was so hurried from place to place that I had not time to find out what my impressions were.

SIR GEORGE: That's the very spirit of the life you have chosen.

LADY FRANCES: Everybody about me seemed happy—but everybody seemed in a hurry to be happy somewhere else.

SIR GEORGE: And you like this?

LADY FRANCES: One must like what the rest of the world likes.

SIR GEORGE: Pernicious maxim!

LADY FRANCES: But my dear Sir George, you have not promised to go with me to the masquerade.

SIR GEORGE: 'Twould be a shocking indecorum to be seen together, you know.

LADY FRANCES: Oh no; I asked Mrs. Racket, and she told me that we might be seen together at the masquerade without being laughed at.

SIR GEORGE: Really?

LADY FRANCES: Indeed, to tell you the truth, I could wish it was the fashion for married people to be inseparable, for I have more heart-felt satisfaction in fifteen minutes with you at my side than fifteen days of amusement could give me without you.

SIR GEORGE: My sweet creature! How that confession charms me! Let us begin the fashion.

LADY FRANCES: Oh impossible! We should not gain a single proselyte, and you can't conceive what spiteful things would be said of us. At Kensington today a lady met us whom we saw at Court

when we were presented. She lifted up her hands in amazement! "Bless me!" said she to her companion, "Here's Lady Francis without Sir Hurlo Thrumbo! My dear Mrs. Racket, consider what an important charge you have! For Heaven's sake, take her home again, or some enchanter on a flying dragon will descend and carry her off." "Oh," said another, "I dare say Lady Frances has a clue at her heel, like the peerless Rosamond; her tender swain would never have trusted her so far without such a precaution."

SIR GEORGE: Heaven and earth! How shall innocence preserve its lustre amidst manners so corrupt? My dear Fanny, I feel a sentiment for thee at this moment tenderer than love, more animated than passion. I could weep over that purity exposed to the sullying breath of fashion and the *ton*, in whose latitudinary vortex Chastity herself can scarcely move unspotted.

Enter GIBSON.

GIBSON: Your honor talked, I thought, something about going to the masquerade?

SIR GEORGE: Well.

GIBSON: Isn't it?—Hasn't you honor?—I thought your honor had forgot to order a dress.

LADY FRANCES: Well considered, Gibson.—Come, will you be Jew, Turk or heretic; a Chinese emperor or a ballad-singer; a rake or a watchman?

SIR GEORGE: Oh neither, my love, I can't take the trouble to support a character.

LADY FRANCES: You'll wear a domino then. I saw a pink domino trimmed with blue at the shop where I bought my habit. Would you like it?

SIR GEORGE: Anything, anything.

LADY FRANCES: Then go about it directly, Gibson. A pink domino trimmed with blue and a hat of the same.—Come, you have not seen my dress yet. It is most beautiful; I long to have it on.

Exeunt SIR GEORGE *and* LADY FRANCES.

GIBSON: A pink domino trimmed with blue and a hat of the same. What the devil can it signify to Sally, now, what his dress is to be? Surely the slut has not made an assignation to meet her master! [*Exit*]

ACT IV, SCENE I

A masquerade. A party dancing cotillions in front—a variety of characters pass and repass. Enter FOLLY *on a hobbyhorse, with cap and bells.*

MASK: Hey! Tom Fool! What business have you here?

FOLLY: What, sir! Affront a prince in his own dominion? [*Struts off*]

MOUNTEBANK: Who'll buy my nostrums? Who'll buy my nostrums?

MASK: What are they?

They all come round him.

MOUNTEBANK: Different sorts and for different customers. Here's a liquor for ladies: it expels the rage of gaming and gallantry. Here's a pill for members of parliament: good to settle consciences. Here's an eye-water for jealous husbands: it thickens the visual membrane through which they see too clearly. Here's a decoction for the clergy: it never sits easy if the patient has more than one living. Here's a draught for lawyers: a great promoter of modesty. Here's a powder for projectors: 'twill rectify the fumes of an empty stomach and dissipate their airy castles.

MASK: Have you a nostrum that can give patience to young heirs whose uncles and fathers are stout and healthy?

MOUNTEBANK: Yes, and I have infusion for creditors: it gives resignation and humility when fine gentlemen break their promises or plead their privilege.

MASK: Come along! I'll find you customers for your whole cargo.

Enter HARDY *in the dress of Isaac Mendoza.*

HARDY: Why, isn't it a shame to see so many stout, well-built young fellows masquerading and cutting *courantas* here at home, instead of making the French cut capers to the tune of your cannon, or sweating the Spaniards with an English *fandango*? I foresee the end of all this.

MASK: Why, thou little testy Israclite! Back to Duke's Place, and preach your tribe into a subscription for the good of the land on whose milk and honey ye fatten. Where are your Joshuas and your Gideons, aye? What, all dwindled into stockbrokers, peddlers, and ragmen?

HARDY: No, not all. Some of us turn Christians and by degrees grow into all the privileges of Englishmen! In the second generation we are patriots, rebels, courtiers and [*Puts his fingers to his forehead*] husbands.

Two other MASKS *advance.*

THIRD MASK: What, my little Isaac! How the devil came you here? Where's your old Margaret?

HARDY: Oh, I have got rid of her.

THIRD MASK: How?

HARDY: Why, I persuaded a young Irishman that she was a blooming, plump beauty of eighteen, so they made an elopement, ha, ha, ha! And she is now the toast of Tipperary. [*Aside*] Ha! There's Cousin Racket and her party; they shan't know me. [*Puts on his mask*]

Enter MRS. RACKET, LADY FRANCES, SIR GEORGE, *and* FLUTTER.

MRS. RACKET: Look at this dumpling Jew; he must be a Levite by his figure. You have surely practised the flesh-hook a long time, friend, to have raised that goodly presence.

HARDY: About as long, my brisk widow, as you have been angling for a second husband, but my hook has been better baited than yours. [*Pointing to* FLUTTER] You have only caught gudgeons, I see.

FLUTTER: Oh! This is one of the geniuses they hire to entertain the

company with their *accidental* sallies.—Let me look at your commonplace book, friend. I want a few good things.

HARDY: I'd oblige you, with all my heart, but you'll spoil them in repeating. Or if you should not, they'll gain you no reputation, for nobody will believe they are your own.

SIR GEORGE: He knows ye, Flutter; the little gentleman fancies himself a wit, I see.

HARDY: There's no depending on what *you* see; the eyes of the jealous are not to be trusted. Look to your lady.

FLUTTER: He knows ye, Sir George.

SIR GEORGE: [*Aside*] What, am I the Town talk?

HARDY: [*Aside*] I can neither see Doricourt nor Letty. I must find them out. [*Exit*]

MRS. RACKET: Well, Lady Frances, is not all this charming? Could you have conceived such a brilliant assemblage of objects?

LADY FRANCES: Delightful! The days of enchantment are restored; the columns glow with sapphires and rubies. Emperors and fairies, beauties and dwarfs, meet me at every step.

SIR GEORGE: How lively are first impressions on sensible minds! In four hours, vapidity and languor will take place of that exquisite sense of joy which flutters your little heart.

MRS. RACKET: What an inhuman creature! Fate has not allowed us these sensations above ten times in our lives, and would you have us shorten them by anticipation?

FLUTTER: Oh Lord! Your wise men are the greatest fools upon earth: they reason about their enjoyments and analyze their pleasures whilst the essence escapes. Look, Lady Frances, do ye see that figure strutting in the dress of an emperor? His father retails oranges in Botolph Lane. That gypsy is a maid of honor, and that ragman a physician.

LADY FRANCES: Why, you know everybody.

FLUTTER: Oh, every creature. A mask is nothing at all to me. I can give you the history of half the people here. In the next apartment there's a whole family who, to my knowledge, have lived on watercress this month to make a figure here tonight—but,

to make up for that, they'll cram their pockets with cold ducks and chickens for a carnival tomorrow.

LADY FRANCES: Oh, I should like to see this provident family.

FLUTTER: Honor me with your arm.

Exeunt FLUTTER *and* LADY FRANCES.

MRS. RACKET: Come Sir George, you shall be *my* beau. We'll make the tour of the rooms and meet them. Oh, your pardon! You must follow Lady Frances or the wit and fine parts of Mr. Flutter may drive you out of her head. Ha, ha, ha! [*Exit*]

SIR GEORGE: I was going to follow her, and now I dare not. How can I be such a fool as to be governed by the fear of that ridicule which I despise! [*Exit*]

Enter DORICOURT, *meeting a* MASK *dressed as a pilgrim.*

DORICOURT: Ha, my lord! I thought you had been engaged at Westminster on this important night.

MASK: So I am. I slipped out as soon as Lord Trope got upon his legs; I can *badiner* here an hour or two and be back again before he is down.

Enter LETITIA.

There's a fine figure! I'll address her.—Charity, fair lady! Charity for a poor pilgrim.

LETITIA: Charity! If you mean my prayers, Heaven grant thee wit, pilgrim.

MASK: That blessing would do from a devotee. From you I ask other charities, such charities as Beauty should bestow: soft looks, sweet words and kind wishes.

LETITIA: Alas! I am bankrupt of these and forced to turn beggar myself. [*Aside*] There he is! How shall I catch his attention?

MASK: Will you grant me no favour?

LETITIA: Yes, one: I'll make you my partner—not for life, but through the soft mazes of a minuet. Dare you dance?

DORICOURT: Some spirit in that.

MASK: I dare do anything you command.

DORICOURT: Do you know her, my lord?

MASK: No, such a woman as that would formerly have been known in any disguise, but beauty is now common. Venus seems to have given her cestus to the whole sex.

A minuet.

DORICOURT: [*During the minuet*] She dances divinely.

When ended exeunt LETITIA *with* MASK.

Somebody must know her! Let us enquire who she is. [*Exit*]

Enter SAVILLE *and* KITTY WILLIS, *habited like* LADY FRANCES.

SAVILLE: I have seen Courtall in Sir George's habit, though he endeavoured to keep himself concealed. Go and seat yourself in the tea-room, and on no account discover your face. Remember too, Kitty, that the woman you are to personate is a woman of virtue.

KITTY: I am afraid I shall find that a difficult character. Indeed, I believe it is seldom kept up through a whole masquerade.

SAVILLE: Of that *you* can be no judge. Follow my directions, and you shall be rewarded.

Exit KITTY. *Enter* DORICOURT.

DORICOURT: Ha! Saville! Did you see a lady dance just now?

SAVILLE: No.

DORICOURT: Very odd. Nobody knows her.

SAVILLE: Where is Miss Hardy?

DORICOURT: Cutting watch papers and making conundrums, I suppose.

SAVILLE: What do you mean?

DORICOURT: Faith, I hardly know. She's not here, however, Mrs. Racket tells me. I asked no further.

SAVILLE: Your indifference seems increased.

DORICOURT: Quite the reverse: 'tis advanced thirty-two degrees towards hatred.

SAVILLE: You are jesting?

DORICOURT: Then it must be with a very ill grace, my dear Saville, for I never felt so seriously. Do you know the creature's almost an idiot?

SAVILLE: What?

DORICOURT: An idiot. What the devil shall I do with her? Egad! I think I'll feign myself mad, and then Hardy will propose to cancel the engagements.

SAVILLE: An excellent expedient. I must leave you; you are mysterious, and I can't stay to unravel ye. I came here to watch over innocence and beauty.

DORICOURT: The guardian of innocence and beauty at three and twenty! Is there not a cloven foot under that black gown, Saville?

SAVILLE: No, faith. Courtall is here on a most detestable design. I found means to get a knowledge of the lady's dress and have brought a girl to personate her whose reputation cannot be hurt. You shall know the result tomorrow. Adieu. [*Exit*]

DORICOURT: [*Musing*] Yes, I think that will do. I'll feign myself mad, see the doctor to pronounce me incurable, and when the parchments are destroyed—

As he stands in a musing posture, LETITIA *enters.*

LETITIA: [*Sings*].

Wake, thou Son of Dullness, wake!
From thy drowsy sense shake
All the spells that Care employs,
Cheating mortals of their joys.

Light-winged spirits, hither haste,
Who prepare for mortal taste
All the gifts that Pleasure sends,
Every bliss that youth attends.

Touch his feelings, rouse his soul,

> *Whilst the sparkling moments roll,*
> *Bid them wake to new delight,*
> *Crown the magic of the night.*

DORICOURT: By Heaven, the same sweet creature!

LETITIA: You have chosen an odd situation for study. Fashion and taste preside in this spot; they throw their spells around you; ten thousand delights spring up at their command, and you, a stoic, a being without senses, are wrapped in reflection.

DORICOURT: And you, the most charming being in the world, awake me to admiration. Did you come from the stars?

LETITIA: Yes, and I shall reascend in a moment.

DORICOURT: Pray show me your face before you go.

LETITIA: Beware of imprudent curiosity; it lost Paradise.

DORICOURT: Eve's curiosity was raised by the Devil; 'tis an angel tempts mine. So you allusion is not in point.

LETITIA: But *why* would you see my face?

DORICOURT: To fall in love with it.

LETITIA: And what then?

DORICOURT: Why then—[*Aside*] Aye, curse it! There's the rub.

LETITIA: Your mistress will be angry—but perhaps, you have no mistress?

DORICOURT: Yes, yes, and a sweet one it is!

LETITIA: What, is she old?

DORICOURT: No.

LETITIA: Ugly?

DORICOURT: No.

LETITIA: What then?

DORICOURT: Faugh! Don't talk about *her*, but show me your face.

LETITIA: My vanity forbids it; 'twould frighten you.

DORICOURT: Impossible! Your shape is graceful, your air bewitching, your bosom transparent, and your chin would tempt me to kiss it, if I did not see a pouting red lip above it that demands—

LETITIA: You grow too free.

DORICOURT: Show me your face then, only half a glance.

LETITIA: Not for worlds.

DORICOURT: What, you will have a little gentle force? [*Attempts to seize her mask*]

LETITIA: I am gone forever! [*Exit*]

DORICOURT: 'Tis false; I'll follow to the end. [*Exit*]

FLUTTER, LADY FRANCES, *and* SAVILLE *advance.*

LADY FRANCES: How can you be thus interested for a stranger?

SAVILLE: Goodness will ever interest; its home is Heaven. On earth 'tis but a wanderer. Imprudent lady! Why have you left the side of your protector? Where is your husband?

FLUTTER: Why, what's that to him?

LADY FRANCES: Surely it can't be merely his habit; there's something in him that awes me.

FLUTTER: Faugh! 'Tis only his grey beard. I know him; he keeps a lottery-office on Cornhill.

SAVILLE: My province as an enchanter lays open every secret to me. Lady! There are dangers abroad—beware! [*Exit*]

LADY FRANCES: 'Tis very odd. His manner has made me tremble. Let us seek Sir George.

FLUTTER: He is coming towards us.

COURTALL *comes forward habited like* SIR GEORGE.

COURTALL: [*Aside*] There she is! If I can but disengage her from that fool Flutter, crown me, ye schemers, with immortal wreaths.

LADY FRANCES: Oh my dear Sir George! I rejoice to meet you. An old conjuror has been frightening me with his prophecies. Where's Mrs. Racket?

COURTALL: In the dancing room. I promised to send you to her, Mr. Flutter.

FLUTTER: Ah! She wants me to dance. With all my heart. [*Exit*]

LADY FRANCES: Why do you keep on your mask? 'Tis too warm.

COURTALL: 'Tis very warm—I want air—let us go.

LADY FRANCES: You seem quite agitated. Shan't we bid our company adieu?

COURTALL: No, no, there's no time for forms. I'll just give directions

to the carriage and be with you in a moment. [*Going, steps back*] Put on your mask. I have a particular reason for it. [*Exit*]

SAVILLE *advances with* KITTY.

SAVILLE: Now, Kitty, you know your lesson. [*Takes off his mask*] Lady Frances, let me lead you to your husband.
LADY FRANCES: Heavens! Is Mr. Saville the conjuror? Sir George is just stepped to the door to give directions. We are going home immediately.
SAVILLE: No, madam, you are deceived: Sir George is this way.
LADY FRANCES: This is astonishing!
SAVILLE: Be not alarmed: you have escaped a snare and shall be in safety in a moment.

Exit SAVILLE *and* LADY FRANCES. *Enter* COURTALL *and seizes* KITTY*'s hand.*

COURTALL: Now!
KITTY: 'Tis pity to go so soon.
COURTALL: Perhaps I may bring you back, my angel, but go now you must.

Exeunt. Music. DORICOURT *and* LETITIA *come forward.*

DORICOURT: By Heavens! I never was charmed till now. English beauty, French vivacity, wit, elegance. Your name, my angel! Tell me your name, though you persist in concealing your face.
LETITIA: My name has a spell in it.
DORICOURT: I thought so; it must be *Charming.*
LETITIA: But if revealed, the charm is broke.
DORICOURT: I'll answer for its force.
LETITIA: Suppose it Harriet or Charlotte or Maria or—
DORICOURT: Hang Harriet and Charlotte and Maria—the name your father gave ye!
LETITIA: That can't be worth knowing, 'tis so transient a thing.
DORICOURT: How transient?
LETITIA: Heaven forbid my name should be *lasting* till I am married.

DORICOURT: Married! The chains of matrimony are too heavy and vulgar for such a spirit as yours. The flowery wreaths of Cupid are the only bands you should wear.

LETITIA: They are the lightest, I believe, but 'tis possible to wear those of marriage gracefully: throw 'em loosely round and twist 'em in a true lover's knot for the bosom.

DORICOURT: An angel! But what will you be when a wife?

LETITIA: A woman. If my husband should prove a churl, a fool, or a tyrant, I'd break his heart, ruin his fortune, elope with the first pretty fellow that asked me—and return the contempt of the world with scorn, whilst my feelings preyed upon my life.

DORICOURT: [*Aside*] Amazing! [*To* LETITIA]—What if you loved him and he were worthy of your love?

LETITIA: Why, then I'd be anything—and all! Grave, gay, capricious, the soul of whim, the spirit of variety; live with him in the eye of fashion or in the shade of retirement; change my country, my sex; feast with him in an Eskimo's hut or a Persian pavilion; join him in the victorious war dance on the borders of Lake Ontario or sleep to the soft breathings of the flute in the cinnamon groves of Ceylon; dig with him in the mines of Golconda or enter the dangerous precincts of the Mogul's seraglio, cheat him of his wishes, and overturn his empire to restore the husband of my heart to the blessings of liberty and love.

DORICOURT: Delightful wildness. Oh, to catch thee and hold thee forever in this little cage! [*Attempting to clasp her*]

LETITIA: Hold, sir! Though Cupid must give the bait that tempts me to the snare, 'tis Hymen must spread the net to catch me.

DORICOURT: 'Tis in vain to assume airs of coldness: Fate has ordained you mine.

LETITIA: How do you know?

DORICOURT: I feel it *here*. I never met a woman so perfectly to my taste, and I won't believe it formed you so on purpose to tantalize me.

LETITIA: [*Aside*] This moment is worth a whole existence.

DORICOURT: Come, show me your face and rivet my chains.

LETITIA: Tomorrow you shall be satisfied.

DORICOURT: Tomorrow! And not tonight?

LETITIA: No.

DORICOURT: Where then shall I wait on you tomorrow? Where see you?

LETITIA: You shall see me in an hour when you least expect me.

DORICOURT: Why all this mystery?

LETITIA: I like to be mysterious. At present, be content to know that I am a woman of family and fortune. Adieu!

Enter HARDY.

HARDY: [*Aside*] Adieu! Then I am come at the fag end.

DORICOURT: Let me see you to your carriage.

LETITIA: As you value knowing me, stir not a step. If I am followed, you never see me more. [*Exit*]

DORICOURT: Barbarous creature! She's gone! What, and is this really serious? Am I in love? Faugh! It can't be.

Enter FLUTTER.

Oh, Flutter! Do you know that charming creature?

FLUTTER: What charming creature? I passed a thousand.

DORICOURT: She went out at that door as you entered.

FLUTTER: Oh yes, I know her very well.

DORICOURT: Do you, my dear fellow? Who?

FLUTTER: She's kept by Lord George Jennet.

HARDY: [*Aside*] Impudent scoundrel!

DORICOURT: Kept!!!

FLUTTER: Yes, Colonel Gorget had her first, then Mr. Loveil—then— I forget exactly how many—and at last she's Lord George's. [*Talks to other* MASKS]

DORICOURT: I'll murder Gorget, poison Lord George, and shoot myself.

HARDY: [*Aside*] Now's the time, I see, to clear up the whole. [*To* DORINCOURT] Mr. Doricourt! I say Flutter was mistaken. I know who you are in love with.

DORICOURT: [*Aside*] A strange *rencontre*! [*To* HARDY] Who?

HARDY: My Letty.

DORICOURT: Oh, I understand your rebuke. 'Tis too soon, sir, to assume the father-in-law.

HARDY: Zounds! What do you mean by that? I tell you that the lady you admire is Letitia Hardy.

DORICOURT: I am glad *you* are so well satisfied with the state of my heart. I wish *I* was. [*Exit*]

HARDY: Stop a moment—stop, I say! What, you won't? Very well, if I don't play you a trick for this, may I never be a grandfather! I'll plot *with* Letty now and not against her, aye, hang me if I don't. There's something in my head that shall tingle in his heart. He shall have a lecture upon impatience that I foresee he'll be the better for as long as he lives. [*Exit*]

SAVILLE *comes forward with other* MASKS.

SAVILLE: Flutter, come with us. We're going to raise a laugh at Courtall's.

FLUTTER: With all my heart. "Live to live" was my father's motto; "live to laugh" is mine.

Exeunt.

ACT IV, SCENE II

COURTALL'S. *Enter* KITTY *and* COURTALL.

KITTY: Where have you brought me, Sir George? This is not our home.

COURTALL: [*Kneels and takes off his mask*] 'Tis *my* home, beautiful Lady Frances! Oh, forgive the ardency of my passion which has compelled me to deceive you!

KITTY: Mr. Courtall! What will become of me?

COURTALL: Oh, say but that you pardon the wretch who adores you. Did you but know the agonizing tortures of my heart since I had the felicity of conversing with you this morning—or the despair that now—

Knock.

KITTY: Oh, I'm undone!

COURTALL: Zounds! My dear Lady Frances. [*Calling offstage*] I am not at home! Rascal! Do you hear? Let nobody in; I am not at home!

SERVANT: [*Without*] Sir, I told the gentlemen so.

COURTALL: Eternal curses! They are coming up. Step into this room, adorable creature! One moment; I'll throw them out of the window if they stay three.

Exit KITTY *through the back scene. Enter* SAVILLE, FLUTTER, *and* MASKS.

FLUTTER: Oh Gemini! Beg the petticoat's pardon. Just saw a corner of it.

FIRST MASK: No wonder admittance was so difficult. I thought you took us for bailliffs.

COURTALL: Upon my soul, I am devilish glad to see you, but you perceive how I am circumstanced. Excuse me at this moment.

SECOND MASK: Tell us who 'tis, then.

COURTALL: Oh, fie!

FLUTTER: We won't blab.

COURTALL: I can't, upon honor. Thus far: she's a woman of the first character and rank. Saville [*Takes him aside*], have I influence, or have I not?

SAVILLE: Why sure, you do not insinuate—

COURTALL: No, not insinuate, but swear that she's now in my bedchamber! By Gad, I don't deceive you. There's generalship, you rogue! Such an humble, distant, sighing fellow as thou art, at the end of a six-months siege, would have *boasted* of a kiss from her glove. I only give the signal and—pop!—she's in my arms!

SAVILLE: What, Lady Fran—

COURTALL: Hush! You shall see her name tomorrow morning in red letters at the end of my list. [*Aloud, to others*] Gentlemen, you

must excuse me now. Come and drink chocolate at twelve, but—

SAVILLE: Aye, let us go, out of respect to the lady—'tis a person of rank.

FLUTTER: Is it? Then I'll have a peep at her. [*Runs to the door in the back scene*]

COURTALL: This is too much, sir. [*Trying to prevent him*]

FIRST MASK: By Jupiter, we'll all have a peep.

COURTALL: Gentlemen, consider—for Heaven's sake—a lady of quality. What will be the consequences?

FLUTTER: The consequences! Why, you'll have your throat cut, that's all. But I'll write your elegy. So, now for the door!

Part open the door, whilst the rest hold COURTALL.

Beg your ladyship's pardon, whoever you are. [*Leads her out*] Emerge from the darkness like the glorious sun, and bless the wond'ring circle with your charms. [*Takes off her mask*]

SAVILLE: Kitty Willis! Ha, ha, ha!

ALL: Kitty Willis! Ha, ha, ha! Kitty Willis!

FIRST MASK: Why, what a fellow you are, Courtall, to attempt imposing on your friends in this manner! A lady of quality! An earl's daughter! Your ladyship's most obedient—ha, ha, ha!

SAVILLE: Courtall, have you influence or have you not?

FLUTTER: The man's moonstruck.

COURTALL: Hell and ten thousand furies seize you all together!

KITTY: What, me too, Mr. Courtall? Me, whom you have knelt to, prayed to, and adored?

FLUTTER: That's right, Kitty, give him a little more.

COURTALL: Disappointed and laughed at!

SAVILLE: Laughed at and despised. I have fulfilled my design, which was to expose your villainy and laugh at your presumption. Adieu, sir; remember how you again boast of your influence with women of rank, and, when you next want amusement, dare not look up to the virtuous and to the noble for a companion. [*Exit, leading* KITTY]

FLUTTER: And Courtall, before you carry a lady into your bedchamber again, look under her mask, d'ye hear? [*Exit*]

COURTALL: There's no bearing this! I'll set off for Paris directly. [*Exit*]

ACT V, SCENE I

HARDY's. *Enter* HARDY *and* VILLERS.

VILLERS: Whimsical enough! Dying for her and hates her! Believes her a fool and a woman of brilliant understanding!

HARDY: As true as you are alive. But when I went up to him last night at the Pantheon, out of downright good nature to explain things, my gentleman whips round upon his heel and snapped me as short as if I had been a beggar woman with six children and he overseer of the parish.

VILLERS: Here comes the wonder-worker.

Enter LETITIA.

Here comes the enchantress who can go to masquerades and sing and dance and talk a man out of his wits! But pray, have we morning masquerades?

LETITIA: Oh no; but I am so enamoured of this all-conquering habit that I could not resist putting it on the moment I had break-fasted. I shall wear it on the day I am married and then lay it by in spices, like the miraculous robes of St. Bridget.

VILLERS: That's as most brides do. The charms that helped to catch the husband are generally *laid by*, one after another till the lady grows a downright wife, and then runs crying to her mother because she has transformed her *lover* into a downright husband.

HARDY: Listen to me. I han't slept tonight for thinking of plots to plague Doricourt; and they drove one another out of my head so quick that I was as giddy as a goose and could make nothing of 'em. I wish to goodness you could contrive something.

VILLERS: Contrive to plague him! Nothing so easy. Don't undeceive

him, madam, till he is your husband. Marry him whilst he possesses the sentiments you laboured to give him of Miss Hardy, and when you are his wife—

LETITIA: Oh Heavens! I see the whole—that's the very thing. My dear Mr. Villers, you are the divinest man.

VILLERS: Don't make love to me, hussy.

Enter MRS. RACKET.

MRS. RACKET: No, pray don't, for I design to have Villers myself in about six years. There's an oddity in him that pleases me. He holds women in contempt, and I should like to have an opportunity of breaking his heart for that.

VILLERS: And when I am heartily tired of life, I know no woman to whom I would with more pleasure make my executioner.

HARDY: It cannot be. I foresee it will be impossible to bring it about. You know the wedding wasn't supposed to take place this week or more, and Letty will never be able to play the fool so long.

VILLERS: The knot shall be tied tonight. I have it all here. [*Pointing to his forehead*] The licence is ready. Feign yourself ill, send for Doricourt, and tell him you can't go out of the world in peace except you see the ceremony performed.

HARDY: I feign myself ill! I could as soon feign myself a Roman ambassador. I was never ill in my life, but with the toothache. When Letty's mother was a-breeding, I had all the qualms.

VILLERS: Oh, I have no fears for *you*. But what says Miss Hardy? Are you willing to make the irrevocable vow before night?

LETITIA: Oh Heavens! I—I—'tis so exceeding sudden, that really—

MRS. RACKET: That really she is frightened out of her wits—lest it should be impossible to bring matters about. But *I* have taken the scheme into my protection, and you shall be Mrs. Doricourt before night. [*To* HARDY] Come, to bed directly. Your room shall be crammed with phials and all the apparatus of death, then—hey presto for Doricourt!

VILLERS: [*To* LETITIA] You go and put off your conquering dress and get all your awkward airs ready, [*To* HARDY] and you practise

a few groans. [*To* MRS. RACKET] And you—if possible—an air of gravity. I'll answer for the plot.

LETITIA: Married in jest! 'Tis an odd idea! Well, I'll venture it.

Exeunt LETITIA *and* MRS. RACKET.

VILLERS: Aye, I'll be sworn! [*Looks at his watch*] 'Tis past three. The budget's to be opened this morning. I'll just step down to the House. Will you go?

HARDY: What! With a mortal sickness?

VILLERS: What a blockhead! I believe if half of us were to stay away with mortal sicknesses, it would be for the health of the nation. Good morning. I'll call and feel your pulse as I come back. [*Exit*]

HARDY: You won't find 'em over-brisk, I fancy. I foresee some ill happening from this making believe to die before one's time. But hang it—ahem! I am a stout man yet, only fifty-six. What's that? In the last yearly bill there were three lived to above a hundred. Fifty-six! Fiddle-de-dee! I am not afraid, not I. [*Exit*]

ACT V, SCENE II

DORICOURT'S *room.*

SAVILLE: Undressed so late?

DORICOURT: I didn't go to bed till late. 'Twas late before I slept, late when I rose. Do you know Lord George Jennet?

SAVILLE: Yes.

DORICOURT: Has he a mistress?

SAVILLE: Yes.

DORICOURT: What sort of a creature is she?

SAVILLE: Why, she spends him three thousand a year with the ease of a duchess, and entertains his friends with the grace of a Ninon. Ergo, she is handsome, spirited and clever.

DORICOURT *walks about disordered.*

In the name of caprice, what ails you?

DORICOURT: You have hit it: *elle est mon caprice*. The mistress of Lord George Jennet is my caprice. Oh, insufferable!

SAVILLE: What, you saw her at the masquerade?

DORICOURT: *Saw* her, *loved* her, *died* for her—without knowing her. And now the curse is, I can't hate her.

SAVILLE: Ridiculous enough! All this distress about a kept woman whom any man may have, I dare swear, in a fortnight. They've been jarring some time.

DORICOURT: Have her! The sentiment I have conceived for the witch is so unaccountable that, in that line, I cannot bear her idea. Was she a woman of honor, for a wife I could adore her. But I really believe, if she should me an assignation, I should hate her.

SAVILLE: Hey-day! This sounds like love. What becomes of poor Miss Hardy?

DORICOURT: Her name has given me an ague! Dear Saville, how shall I contrive to make old Hardy cancel the engagements? The moiety of the estate which he will forfeit shall be his the next moment by deed of gift.

SAVILLE: Let me see… Can't you get it insinuated that you are a devilish wild fellow, that you are an infidel and attached to wenching, gaming, and so forth?

DORICOURT: Aye, such a character might have done some good two centuries back, but who the devil can it frighten now? I believe it must be the mad scheme at last. There, will that do for a grin?

SAVILLE: Ridiculous! But how are you certain that the woman who has so bewildered you belongs to Lord George?

DORICOURT: Flutter told me so.

SAVILLE: Then fifty to one against the intelligence.

DORICOURT: It must be so. There was a mystery in her manner for which nothing else can account.

A violent rap.

Who can this be?

SAVILLE: [*Looking offstage*] The proverb is your answer: 'tis Flut-

ter himself. Tip him a scene of the madman and see how it takes.

DORICOURT: I will—a good way to send it about town. Shall it be of the melancholy kind or the raving?

SAVILLE: Rant! Rant! Here he comes.

DORICOURT: Talk not to me who can pull comets by the beard and overset an island!

Enter FLUTTER.

There! This is he! This is he who hath sent my poor soul, without coat or breeches, to be tossed about in ether like a duck feather!—Villain, give me my soul again!

FLUTTER: [*Exceedingly frightened*] Upon my soul, I haven't got it.

SAVILLE: Oh, Mr. Flutter, what a melancholy sight! I little thought to have seen my poor friend reduced to this.

FLUTTER: Mercy defend me! What, is he mad?

SAVILLE: You see how it is. A cursed Italian lady—Jealousy—gave him a drug, and every full of the moon—

DORICOURT: Moon! Who dares talk of the moon? The patroness of genius—the rectifier of wits—the—Oh! Here she is!—I feel her—she tugs at my brain—she has it—she has it—Oh! [*Exit*]

FLUTTER: Well! This is dreadful! Exceedingly dreadful, I protest. Have you had Monro?

SAVILLE: Not yet. The worthy Miss Hardy—what a misfortune!

FLUTTER: Aye, very true. Do they know it?

SAVILLE: Oh no, the paroxysm seized him but this morning.

FLUTTER: Adieu! I can't stay. [*Going in great haste*]

SAVILLE: [*Holding him*] But you must stay and assist me; perhaps he'll return again in a moment, and when he is in this way, his strength is prodigious.

FLUTTER: Can't, indeed—can't, upon my soul. [*Going*]

SAVILLE: Flutter, don't make a mistake now. Remember, 'tis Doricourt that's mad.

FLUTTER: Yes—you mad.

SAVILLE: No, no; Doricourt.

FLUTTER: Egad, I'll say you are both mad, and then I can't mistake.

Exeunt severally.

ACT V, SCENE III

SIR GEORGE TOUCHWOOD's. *Enter* SIR GEORGE *and* LADY FRANCES.

SIR GEORGE: The bird is escaped: Courtall is gone to France.

LADY FRANCES: Heaven and earth! Have you been to seek him?

SIR GEORGE: Seek him! Aye.

LADY FRANCES: How did you get his name? I should never have told it you.

SIR GEORGE: I learned it at the first coffeehouse I entered. Everybody is full of the story.

LADY FRANCES: Thank Heaven he's gone! But I have a story for you. The Hardy family are forming a plot upon your friend Doricourt, and we are expected in the evening to assist.

SIR GEORGE: With all my heart, my angel, but I can't stay to hear it unfolded. They told me Mr. Saville would be at home in half an hour, and I am impatient to see him. The adventure of last night—

LADY FRANCES: Think of it only with gratitude. The danger I was in has overset a new system of conduct that, perhaps, I was too much inclined to adopt. But henceforward, my dear Sir George, you shall be my constant companion and protector. And when they ridicule the unfashionable monsters, the felicity of our hearts shall make their satire pointless.

SIR GEORGE: Charming angel! You almost reconcile me to Courtall. Hark! Here's company. [*Stepping to the door*] 'Tis your lively widow. I'll step down the backstairs to escape her. [*Exit*]

Enter MRS. RACKET.

MRS. RACKET: Oh Lady Frances! I am shocked to death. Have you received a card from us?

LADY FRANCES: Yes, within these twenty minutes.

MRS. RACKET: Aye, 'tis of no consequence. 'Tis all over. Doricourt is mad.

LADY FRANCES: Mad!

MRS. RACKET: My poor Letitia! Just as we were enjoying ourselves with the prospect of a scheme that was planned for their mutual happiness, in came Flutter, breathless, with the intelligence. I flew here to know if you had heard it.

LADY FRANCES: No indeed, and I hope it is one of Mr. Flutter's dreams.

Enter SAVILLE.

Apropos, now we shall be informed. Mr. Saville, I rejoice to see you, though Sir George will be disappointed: he's gone to your lodgings.

SAVILLE: I should have been happy to have prevented Sir George. I hope your ladyship's adventure last night did not disturb your dreams?

LADY FRANCES: Not at all, for I never slept a moment. My escape, and the importance of my obligations to you, employed my thoughts. But we have just had shocking intelligence. Is it true that Doricourt is mad?

SAVILLE: [*Aside*] So, the business is done. [*To* LADY FRANCES] Madam, I am sorry to say that I have just been a melancholy witness of his ravings; he was in the height of a paroxysm.

MRS. RACKET: Oh, there can be no doubt of it. Flutter told us the whole history. Some Italian princess gave him a drug in a box of sweetmeats, sent to him by her own page, and it renders him lunatic every month. Poor Miss Hardy! I never felt so much on any occasion in my life.

SAVILLE: To soften your concern, I will inform you, madam, that Miss Hardy is less to be pitied than you imagined.

MRS. RACKET: Why so, sir?

SAVILLE: 'Tis rather a delicate subject, but he did not love Miss Hardy.

MRS. RACKET: He did love Miss Hardy, sir, and would have been the happiest of men.

SAVILLE: Pardon me, madam, his heart was not only free from that lady's chains but absolutely captivated by another.

MRS. RACKET: No, sir, no. It was Miss Hardy who captivated him. She met him last night at the masquerade and charmed him in disguise. He professed the most violent passion for her, and a plan was laid this evening to cheat him into happiness.

SAVILLE: Ha, ha, ha! Upon my soul, I must beg your pardon. I have not eaten of the Italian princess's box of sweetmeats sent by her own page, and yet I am as mad as Doricourt, ha, ha, ha!

MRS. RACKET: So it appears. What can all this mean?

SAVILLE: Why, madam, he is at present in his perfect senses, but he'll lose 'em in ten minutes through joy. The madness was only a feint to avoid marrying Miss Hardy, ha, ha, ha! I'll carry him the intelligence directly. [*Going*]

MRS. RACKET: Not for worlds. I owe him revenge now for what he has made us suffer. You must promise not to divulge a syllable I have told you, and when Doricourt is summoned to Mr. Hardy's, prevail on him to come, madness and all.

LADY FRANCES: Pray do. I should like to see him showing off, now I am in the secret.

SAVILLE: You must be obeyed, though 'tis inhuman to conceal his happiness.

MRS. RACKET: I am going home, so I'll set you down at his lodgings and acquaint you, by the way, with our whole scheme. *Allons!*

SAVILLE: I attend you. [*Leading her out*]

MRS. RACKET: You won't fail us?

Exeunt SAVILLE *and* MRS. RACKET.

LADY FRANCES: No; depend on us. [*Exit*]

ACT V, SCENE IV

DORICOURT's. DORICOURT *seated, reading.*

DORICOURT: [*Flings away the book*] What effect can the morals of fourscore have on a mind torn with passion? [*Musing*] Is it possible such a soul as hers can support itself in so humiliating a situation? A kept woman! [*Rising*] Well, well—I am glad it is so—I am glad it is so!

Enter SAVILLE.

SAVILLE: What a happy dog you are, Doricourt! I might have been mad or beggared or pistoled myself without its being mentioned. But you, forsooth, the whole female world is concerned for! I reported the state of your brain to five different women. The lip of the first trembled; the white bosom of the second heaved a sigh; the third ejaculated and turned her eye—to the glass; the fourth blessed herself; and the fifth said, whilst she pinned a curl, "Well, now, perhaps, he'll be an amusing companion. His native dullness was intolerable."

DORICOURT: Envy! Sheer envy, by the smiles of Hebe! There are not less than forty pair of the brightest eyes in town will drop crystals when they hear of my misfortune.

SAVILLE: Well, but I have news for you: poor Hardy is confined to his bed. They say he is going out of the world by the first post, and he wants to give you his blessing.

DORICOURT: Ill? So ill? I am sorry from my soul. He's a worthy little fellow—if he had not the gift of foreseeing so strongly.

SAVILLE: Well, you must go and take leave.

DORICOURT: What! To act the lunatic in the dying man's chamber?

SAVILLE: Exactly the thing, and will bring your business to a short issue: for his last commands must be that you are not to marry his daughter.

DORICOURT: That's true, by Jupiter! And yet, hang it, impose upon a poor fellow at so serious a moment! I can't do it.

SAVILLE: You must, faith. I am answerable for your appearance,

though it should be in a strait waistcoat. He knows your situation and seems the more desirous of an interview.

DORICOURT: I don't like encountering Racket. She's an arch little devil and will discover the cheat.

SAVILLE: There's a fellow! Cheated ninety-nine women and now afraid of the hundredth.

DORICOURT: And with reason—for that hundredth is a widow.

Exeunt.

ACT V, SCENE V

HARDY's. *Enter* MRS. RACKET *and* MISS OGLE.

MISS OGLE: And so Miss Hardy is actually to be married tonight?

MRS. RACKET: If her fate does not deceive her. You are apprised of the scheme, and we hope it will succeed.

MISS OGLE: [*Aside*] Deuce take her! She's six years younger than I am. [*To* MRS. RACKET] Is Mr. Doricourt handsome?

MRS. RACKET: Handsome, generous, young, and rich. There's a husband for ye! Isn't he worth pulling caps for?

MISS OGLE: [*Aside*] I'my conscience, the widow speaks as though she'd give cap, ears, and all for him. [*To* MRS. RACKET] I wonder you didn't try to catch this wonderful man, Mrs. Racket.

MRS. RACKET: Really, Miss Ogle, I had not time. Besides, when I marry, so many stout young fellows will hang themselves that, out of regard to society, in these sad times, I shall postpone it for a few years. [*Aside*] This will cost her a new lace; I heard it crack.

Enter SIR GEORGE *and* LADY FRANCES.

SIR GEORGE: Well, here we are. But where's the Knight of the Woeful Countenance?

MRS. RACKET: Here soon, I hope, for a woeful night it will be without him.

SIR GEORGE: Oh fie! Do you condescend to pun?

MRS. RACKET: Why not? It requires genius to make a good pun. Some men of bright parts can't reach it. I know a lawyer who writes them on the back of his briefs and says they are of great use in a dry cause.

Enter FLUTTER.

FLUTTER: Here they come! Here they come! Their coach stopped as mine drove off.

LADY FRANCES: Then Miss Hardy's fate is at a crisis. She plays a hazardous game, and I tremble for her.

SAVILLE: [*Offstage*] Come, let me guide you! This way, my poor friend! Why are you so furious?

DORICOURT: [*Offstage*] The house of death—to the house of death!

Enter DORICOURT *and* SAVILLE.

Ah! This is the spot!

LADY FRANCES: How wild and fiery he looks!

MISS OGLE: Now, I think, he looks terrified.

FLUTTER: Poor creature, how his eyes work!

MRS. RACKET: I never saw a madman before. Let me examine him. Will he bite?

SAVILLE: Pray keep out of his reach, ladies, you don't know your danger. He's like a wild cat if a sudden thought seizes him.

SIR GEORGE: You talk like a keeper of wild cats. How much do you demand for showing the monster?

DORICOURT: [*Aside*] I don't like this. I must rouse their sensibility. [*Raving*] There! There she darts through the air in liquid flames! Down again! Now I have her—Oh, she burns, she scorches! Oh! She eats into my very heart!

ALL: Ha, ha, ha!

MRS. RACKET: He sees the apparition of the wicked Italian princess.

FLUTTER: Keep her highness fast, Doricourt.

MISS OGLE: Give her a pinch before you let her go.

DORICOURT: I am laughed at!

MRS. RACKET: Laughed at? Aye, to be sure. Why, I could play the madman better than you.—There! There she is! Now I have her! Ha, ha, ha!

DORICOURT: [*Aside*] I knew that devil would discover me. [*Aloud*] I'll leave the house; I'm covered with confusion. [*Going*]

SIR GEORGE: Stay, sir. You must not go. 'Twas poorly done, Mr. Doricourt, to affect madness rather than fulfil your engagements.

DORICOURT: Affect madness! Saville, what can I do?

SAVILLE: Since you are discovered, confess the whole.

MISS OGLE: Aye, turn evidence and save yourself.

DORICOURT: Yes, since my designs have been so unaccountably discovered, I will avow the whole. I cannot love Miss Hardy—and I will never—

SAVILLE: Hold, my dear Doricourt! Be not so rash. What will the world say to such—

DORICOURT: Damn the world! What will the world give me for the loss of happiness? Must I sacrifice my peace to please the world?

SIR GEORGE: Yes, everything, rather than be branded with dishonor.

LADY FRANCES: Though our arguments should fail, there is a pleader whom you surely cannot withstand: the dying Mr. Hardy supplicates you not to forsake his child.

Enter VILLERS.

VILLERS: Mr. Hardy requests you to grant him a moment's conversation, Mr. Doricourt, though you should persist to send him miserable to the grave. Let me conduct you to his chamber.

DORICOURT: Oh, aye, anywhere, to the antipodes, to the moon carry me, do with me what you will.

MRS. RACKET: Mortification and disappointment, then, are specifics in a case of stubbornness. [*Aside to* SIR GEORGE, LADY FRANCES AND SAVILLE] I'll follow, and let you know what passes.

Exeunt VILLERS, DORICOURT, MRS. RACKET, *and* MISS OGLE.

FLUTTER: Ladies, ladies, have the charity to take me with you, that I may make no blunder in repeating the story. [*Exit*]

LADY FRANCES: Sir George, you don't know Mr. Saville? [*Exit*]

SIR GEORGE: Ten thousand pardons, but I will not pardon myself for not observing you. I have been with the utmost impatience at your door twice today.

SAVILLE: I am concerned you had so much trouble, Sir George.

SIR GEORGE: Trouble! What a word! I hardly know how to address you. I am distressed beyond measure, and it is the highest proof of my opinion of your honor and the delicacy of your mind that I open my heart to you.

SAVILLE: What has disturbed you, Sir George?

SIR GEORGE: Your having preserved Lady Frances in so imminent a danger. Start not, Saville. To protect Lady Frances was my right. You have wrested from me my dearest privilege.

SAVILLE: I hardly know how to answer such a reproach. I cannot apologize for what I have done.

SIR GEORGE: I do not mean to reproach you; I hardly know what I mean. There is one method by which you may restore peace to me: I cannot endure that my wife should be so infinitely indebted to any man who is less than my brother.

SAVILLE: Pray explain yourself.

SIR GEORGE: I have a sister, Saville, who is amiable—and you are worthy of her. I shall give her a commission to steal your heart out of revenge for what you have done.

SAVILLE: I am infinitely honored, Sir George, but—

SIR GEORGE: I cannot listen to a sentence which begins with so unpromising a word. You must go with us into Hampshire, and if you see each other with the eyes I do, your felicity will be complete. I know no one to whose heart I would so readily commit the care of my sister's happiness.

SAVILLE: I will attend you to Hampshire with pleasure, but not on the plan of retirement. Society has claims on Lady Frances that forbid it.

SIR GEORGE: Claims, Saville!

SAVILLE: Yes, claims. Lady Frances was born to be the ornament of

courts. She is sufficiently alarmed not to wander beyond the reach of her protector, and, from the British court, the most tenderly anxious husband could not wish to banish his wife. Bid her keep in her eye the bright example who presides there, the splendour of whose rank yields to the superior lustre of her virtue.

SIR GEORGE: I allow the force of your argument. Now for intelligence!

Enter MRS. RACKET, LADY FRANCES, MISS OGLE, *and* FLUTTER.

MRS. RACKET: Oh Heavens! Do you know—

FLUTTER: Let me tell the story—as soon as Doricourt—

MRS. RACKET: I protest you shan't—said Mr. Hardy—

FLUTTER: No, 'twas Doricourt spoke first. Says he—no, 'twas the parson—says he—

MRS. RACKET: Stop his mouth, Sir George, he'll spoil the tale.

SIR GEORGE: Never heed circumstances, the result, the result.

MRS. RACKET: No, no, you shall have it in form. Mr. Hardy performed the sick man like an angel. He sat up in his bed and talked so pathetically that the tears stood in Doricourt's eyes.

FLUTTER: Aye, stood—they did not drop, but stood. I shall, in future, be very exact. The parson seized the moment; you know, they never miss an opportunity.

MRS. RACKET: "Make haste," said Doricourt. "If I have time to reflect, poor Hardy will die unhappy."

FLUTTER: They were got as far as "the Day of Judgment" when we slipped out of the room.

SIR GEORGE: Then by this time they must have reached "amazement" which, everybody knows, is the end of matrimony.

MRS. RACKET: Aye, the reverend fathers ended the service with that word prophetically, to teach the bride what a capricious monster a husband is.

SIR GEORGE: I rather think it was sarcastically to prepare the bridegroom for the unreasonable humors and vagaries of his helpmate.

LADY FRANCES: Here comes the bridegroom of tonight.

Enter DORICOURT *and* VILLERS. VILLERS *whispers to* SAVILLE, *who goes out.*

ALL: Joy! Joy! Joy!

MISS OGLE: If *he's* a sample of bridegrooms, keep me single! A younger brother from the funeral of his father could not carry a more fretful countenance.

FLUTTER: Oh! Now he's melancholy mad, I suppose.

LADY FRANCES: You do not consider the importance of the occasion.

VILLERS: No, nor how shocking a thing it is for a man to be forced to marry one woman whilst his heart is devoted to another.

MRS. RACKET: Well, now 'tis over, I confess to you, Mr. Doricourt, I think 'twas a most ridiculous piece of Quixotism to give up the happiness of a whole life to a man who perhaps has but a few moments to be sensible of the sacrifice.

FLUTTER: So it appeared to me. But thought I, Mr. Doricourt has travelled; he knows best.

DORICOURT: Zounds! Confusion! Did ye not all set upon me! Didn't ye talk to me of honor, compassion, justice?

SIR GEORGE: Very true. You have acted according to their dictates, and I hope the utmost felicity of the married state will reward you.

DORICOURT: Never, Sir George! To felicity I bid adieu, but I will endeavour to be content. Where is my—I must speak it—where is my *wife*?

Enter LETITIA, *masked, led by* SAVILLE.

SAVILLE: Mr. Doricourt, this lady was pressing to be introduced to you.

DORICOURT: [*Starting*] Oh!

LETITIA: I told you last night you should see me at a time when you least expected me, and I have kept my promise.

VILLERS: Whoever you are, madam, you could not have arrived at a happier moment. Mr. Doricourt is just married.

LETITIA: Married! Impossible! 'Tis but a few hours since he swore to me eternal love. I believed him, gave him up my virgin heart—and now! Ungrateful sex!

DORICOURT: Your virgin heart! No, lady, my fate, thank Heaven, yet wants that torture. Nothing but the conviction that you was another's could have made me think one moment of marriage to have saved the lives of half mankind. But this visit, madam, is as barbarous as unexpected. It is now my duty to forget you, which, spite of your situation, I found difficult enough.

LETITIA: My situation! What situation?

DORICOURT: I must apologize for explaining it in this company, but, madam, I am not ignorant that you are the companion of Lord George Jennet, and this is the only circumstance that can give me peace.

LETITIA: I—a companion! Ridiculous pretence! No, sir, know to your confusion that my heart, my honor, my name is unspotted as hers you have married, my birth equal to your own, my fortune large. That, and my person, might have been yours. But, sir, farewell! [*Going*]

DORICOURT: Oh, stay a moment. [*To* FLUTTER] Rascal! Is she not—

FLUTTER: Who, she? Oh, Lard, no! 'Twas quite a different person that I meant. I never saw that lady before.

DORICOURT: Then never shalt thou see her more. [*Shakes* FLUTTER]

MRS. RACKET: Have mercy upon the poor man! Heavens! He'll murder him.

DORICOURT: Murder him! Yes, you, myself and all mankind. Sir George, Saville, Villers, 'twas you who pushed me on this precipice, 'tis you who have snatched from me joy, felicity and life.

MRS. RACKET: There! Now, how well he acts the madman! This is something like! I knew he would do it well enough when the time came.

DORICOURT: Hard-hearted woman! Enjoy my ruin, riot in my wretchedness.

HARDY *bursts in.*

HARDY: This is too much. You are now the husband of my daughter, and how dare you show all this passion about another woman?

DORICOURT: Alive again!

HARDY: Alive! Aye, and merry. Here wipe off the flour from my face. I was never in better health and spirits in my life. I foresaw 'twould do. Why, my illness was only a fetch, man, to make you marry Letty.

DORICOURT: It was! Base and ungenerous! Well, sir, you shall be gratified. The possession of my heart was no object either with you or your daughter. My fortune and name was all you desired, and these—I leave ye. My native England I shall quit, nor ever behold you more. But, lady, that in my exile I may have one consolation, grant me the favour you denied last night: let me behold all that mask conceals, that your whole image may be impressed on my heart and cheer my distant solitary hours.

LETITIA: This is the most awful moment of my life. Oh Doricourt, the slight action of taking off my mask stamps me the most blessed or miserable of women!

DORICOURT: What can this mean? Reveal your face, I conjure you.

LETITIA: Behold it.

DORICOURT: Rapture! Transport! Heaven!

FLUTTER: Now for a touch of the happy madman.

VILLERS: This scheme was mine.

LETITIA: I will not allow that. This little stratagem arose from my disappointment in not having made the impression on you I wished. The timidity of the English character threw a veil over me you could not penetrate. You have forced me to emerge in some measure from my natural reserve and to throw off the veil that hid me.

DORICOURT: I am yet in a state of intoxication. I cannot answer you. Speak on, sweet angel!

LETITIA: You see I *can* be anything. Choose then my character. Your

taste shall fix it. Shall I be an English wife? Or, breaking from the bonds of nature and education, step forth to the world in all the captivating glare of foreign manners?

DORICOURT: You shall be nothing but yourself; nothing can be captivating that you are not. I will not wrong your penetration by pretending that you won my heart at the first interview, but you have now my whole soul. Your person, your face, your mind I would not exchange for those of any other woman breathing.

HARDY: A dog! How well he makes up for past slights! Cousin Racket, I wish you a good husband with all my heart. Mr. Flutter, I'll believe every word you say this fortnight. Mr. Villers, you and I have managed this to a "T." I never was so merry in my life. 'Gad, I believe I can dance! [*Footing*]

DORICOURT: Charming, charming creature!

LETITIA: Congratulate me, my dear friends! Can you conceive my happiness?

HARDY: No, congratulate me, for mine is the greatest.

FLUTTER: No, congratulate me that I have escaped with life, and give me some sticking plaster. This wildcat has torn the skin from my throat.

SIR GEORGE: I expect to be among the first who are congratulated, for I have recovered one angel while Doricourt has gained another.

HARDY: Faugh! Faugh! Don't talk of angels, we shall be happier by half as mortals. Come into the next room! I have ordered out every drop of my forty-eight, and I'll invite the whole parish of St. George's but what we'll drink it out—except one dozen which I shall keep under three double locks for a certain christening that I foresee will happen within this twelvemonth.

DORICOURT: My charming bride! It was a strange perversion of taste that led me to consider the delicate timidity of your deportment as the mark of an uninformed mind or inelegant manners. I feel now it is to that innate modesty English husbands owe a felicity the married men of other nations are strangers to. It

is a sacred veil to your own charms; it is the surest bulwark to your husband's honor. And cursed be the hour, should it ever arrive, in which British ladies shall sacrifice to foreign graces the grace of modesty!

Exeunt.

EPILOGUE

Nay, cease, and hear me; I am come to scold.
Whence this night's plaudits to a thought so old?
To gain a lover hid behind a mask!
What's new in that? Or where's the mighty task?
For instance, now what Lady Bab or Grace
E'er won a lover in her *natural* face?
Mistake me not: French red or blanching creams
I stoop not to, for those are hackneyed themes.
The arts I mean are harder to detect,
Easier put on, and worn to more effect,
As thus:
Do pride and envy, with their horrid lines,
Destroy th'effect of nature's sweet designs?
The mask of softness is at once applied,
And gentlest manners ornament the bride.
Do thoughts too free inform the vestal's eye,
Or point the glance, or warm the struggling sigh?
Not Dian's brows more rigid looks disclose,
And virtue's blush appears where passion glows.
And you, my gentle sirs, wear vizors too—
But here I'll strip you and expose to view
Your hidden features. First I point at—you.
That well-stuffed waistcoat and that ruddy cheek,
That ample forehead and that skin so sleek,
Point out good nature and a generous heart.
Tyrant! Stand forth and, conscious, own thy part:
Thy wife, thy children, tremble in thy eye,
And peace is banished when the father's nigh.
Sure, 'tis enchantment! See, from every side
The masks fall off! In charity, I hide
The monstrous features rushing to my view.
Fear not there, grandpapa—nor you—nor you:
For, should I show your features to each other,
Not one amongst ye'd know his friend or brother.

'Tis plain, then: all the world, from youth to age,
Appear in masks. *Here* only, on the stage,
You see us as we are. Here trust your eyes;
Our wish to please admits of no disguise.

FINIS

Notes on *The Belle's Stratagem*

DEDICATION

The Queen—Queen Charlotte Sophia (1744–1818), consort to George III. A model of "aristocratic...rational domesticity" (Clarissa Campbell Orr, "Queen Charlotte, 'Scientific Queen'" in *Queenship in Britain, 1660–1837*, Manchester: Manchester University Press, 2002, p.236), the Queen was represented as a model mother. She bore her husband fifteen children during their long reign.

ACT I, SCENE I

Lincoln's Inn—One of London's four Inns of Court, the centers of legal activity.

Long robes—Judges.

Warwick-Court, Holborn—Courtall has not had to come far, since Holborn is an area of central London just to the north of the Inns of Court.

Hebes—Hebe was the Greek goddess of youth and spring.

Bent in the Aesop style—According to legend, Aesop was hunch-backed.

Almack's—Highly fashionable assembly rooms on King St., St. James's.

Knight-baronights—Cf. *A Busy Day* by Burney, in which Mrs. Gamp uses the word "baroknight".

Dorsetshire—Courtall claims to be heading south; his cousins live in the north.

Paul's, the Lions and the Waxwork—St. Paul's Cathedral, the lions housed at the Tower of London in the royal menagerie, and the waxworks could be Mrs. Salmon's on Fleet Street.

War—Young men were absent from home fighting the rebels in America and their allies, the French.

Houses—The Houses of Parliament, the Commons and the Lords.

Commons-doctors and *crim. con.*—Lawyers at Doctors Commons specializing in marriage and divorce. "Crim. con." is an abbreviation of "criminal conversation."

Gravesend—A port on the river Thames.

Coxheath—The militia were trained at this Kentish village and George III inspected his troops there while civilians came to admire the warlike scenes. Plays such as *The Camp* (1778) by Sheridan cashed in on Coxheath's popularity.

Ton—The *bon ton*, the fashion or the society that followed it, frequently with derogatory female associations.

Patagonians—Members of a tribe from Argentina, reported to be giants. See also *The Witlings*, Act 5.

ACT I, SCENE II

Sixpenny cuts—cheap newspaper or magazine illustrations.

Je suis mort de peur—I am dead with fear.

ACT I, SCENE III

St. James's—See note on *A Bold Stroke for a Wife*, Act 1, scene 1.

Virtu—Connoisseurship; love and knowledge of the fine arts.

L'air enjoué—A playful demeanor.

Petits maîtres—Lesser gentry.

Marquizina—Marchesina or lesser marchioness.

Locum-tenens—A surrogate placeholder, a representative.

ACT I, SCENE IV

Quaker—Cf. *A Bold Stroke for a Wife*. In Quaker services, members sit in silence until one of them feels "moved" to speak.

Tattersall's—A horse auctioneer's near Hyde Park Corner, established in 1766.

A propos des bottes—French expression which can be roughly translated as "Speaking of which" or "That reminds me."

Plague of Athens—An epidemic of the fifth century BC that is recorded by Thucydides in Book 2 of *The History of the Peloponnesian War*.

Langford's—Another auction house, specializing in art.

Whittington and His Cat—An odd companion piece for the *Plague of Athens*. Richard (or Dick) Whittington was a medieval Mayor of London. His first sign of success was to sell his cat to a king with an infestation of rats.

Cork plumpers—Light balls made out of cork used to pad out hollow cheeks.

A rencontre with Paul Jones or a midnight march to Omoa—Two formidable tasks. A Scot in the service of America, and later Russia against

the Turks, John Paul Jones (1747–92) was a well-known scourge of British ships. The British sustained heavy casualties when they tried to take Omoa, on the Bay of Honduras, in 1780. In conquistador lore, Omoa was the legendary city of fabulously wealth also known as Manoa or El Dorado.

Jacks—Visible, moving parts attached to the harpsichord keys.

ACT II, SCENE I

La petite morale—Minor details of etiquette.

The line—The equator.

Salamander in fire—The amphibian salamander could live in fire and not burn, according to legend, so it became a proverbial metaphor for chastity surrounded by temptation.

Dans la Place Victoire—A square on the right bank in Paris.

St. Évreux—French aristocrat. Presumably, he would have appreciated the gossip about Sir George's change of heart.

Robes de cour—Court gowns.

Ceremony of presentation—Formal introduction at Court.

The Park and *Kensington*—Hyde Park and Kensington are adjacent points on Mrs. Racket's social round. By the latter, suggests Melinda Finberg, she means the royal gardens (*Eighteenth-Century Women Dramatists*, p. 358) that were opened by George I, for respectably dressed people to walk in them, in 1726.

Darby and Joan—Supposedly, a real couple immortalized as "the Happy Couple" in a ballad by Henry Woodfall. It was published in the *Gentleman's Magazine* in March 1735. Cf. Fanny Burney's description of herself and her husband in a letter to her brother James in, written prior to February 22, 1815: "Darby *&* Joan like, therefore, we jog on, *&* only wish Darby *&* Joan like, ultimately together to jog off."

The canal—After the Restoration, several ponds in St. James's Park were converted into a long canal. It was purely decorative, unlike those miles of navigable (and, in places, scenic) water that "canal mania" brought to the country during the eighteenth and nineteenth centuries.

Linsey-woolsey or a black bonnet at the festino—Plain or somber attire at a party.

The dragons that guarded the Hesperian fruit—A Greek myth. One of the labours of Hercules was to fetch the fruit of this tree, golden apples, that were guarded by the serpent Ladon.

Coachmakers Hall or the Black Horse in Bond Street—Cf. *The School of Eloquence* (also 1780), in which Cowley satirizes the new vogue for oratory. Lord George Gordon made the speech that sparked the Gordon Riots at Coachmakers Hall in 1780. The Black Horse suggests a pub, real or not, where oratorical meetings were held.

Iö, triumphe!—An ancient Roman cry: "Hurrah, victory!"

ACT II, SCENE II

Puffers—Silvertongue has hired people to pose as members of the bidding public in order to hype the lots for auction and increase their prices.

Anno mundi or anno domini—The Jewish or Christian ways of dating the year.

Cognoscente—Connoisseur.

Parmegiano…Correggio.—Mask has tripped up a couple of times in trying to cover a lot of artistic ground, mainly Baroque and Renaissance. To begin with, he means Parmigianino, Salvator Rosa, Gabriel Metszu, Gerard Terborch the Younger, and Jan Vermeer. Then he goes on to Philips Wouwerman, David Teniers (the middle of three generations of Teniers artists), and the Venetian and Roman Schools. Then he refers to Claude Lorrain, Jacob van Ruisdael, Jacopo Robusti

Tintoretto, Anthony Van Dyck, and Antonio Allegri Correggio. The list includes specialists in portraiture, landscape, religious scenes and widely varying styles, all ascribed with textbook conventionality.

Diana and *Actaeon, David and Bathsheba*—The lady has mistaken a religious scene for a classical one. The goddess Diana turned the young huntsman Actaeon into a stag after he chanced on her bathing in the woods. His own hounds then tore him to shreds. King David, after glimpsing the beautiful Bathsheba bathing, had her husband, Uriah the Hittite, killed in order to marry her himself.

Toland—The freethinking John Toland caused much controversy, initially with his book *Christianity Not Mysterious* (1696), in which he argued rationally for God's existence. Pope and Swift ridiculed him.

Daphne and *Damon*—Stock pastoral names.

Casino—A public venue not for gambling but for functions and socializing in general.

ACT III, SCENE I

Malkin—"A lower-class, untidy or sluttish woman, esp. a servant, or country girl" (OED).

Ma foi—French exclamation of surprise, literally "my faith."

La Bella Magdalena—After the Renaissance stereotype of the reformed or penitent prostitute.

Mauvaise honte—Extreme bashfulness.

Medicean Venus—The Venus de Medici, a famed classical statue of the nude goddess.

Countries where the men and women are all horses—An allusion to the Houyhnhnms in Part 4 of *Gulliver's Travels* (1726) by Swift.

Thomas Aquinas—A Roman Catholic saint and theologian, Aquinas would be hard going for Aunt Margery.

Mumchance—A game that required dice and silence; a person with nothing to say.

Mort—A large quantity.

Venis, and Jubah, and Dinah—Corruptions of classical and biblical names.

Flimflams—Trifles or tricks.

Potecary—Apothecary.

Watch papers…Grosvenor Square.—Watch papers are circles of paper or cloth used to protect pocket watches from dust. Catgut is coarse material used to stiffen skirts. Profiles in shade are silhouettes. The lady at No. 62 remains unidentified.

Juggler—Alchemist.

My favourite little Quick, his favourite Jew Isaac's dress and *the cursed Duenna*—John Quick, who played Mr. Hardy, would be well known to the audience as Isaac Mendoza, the Jewish dupe, with a "passion for deceit, and tricks of cunning," in *The Duenna*, Sheridan's popular comic opera of 1775. Isaac is tricked into marrying Margaret, the old chaperone to the beautiful young woman he thinks he is marrying.

Forty-eight—A handsome bribe, the German wine of 1748 was a great vintage.

ACT III, SCENE II

Catch—A musical round or perhaps a drinking song.

A leap at the new lustres—An attempt to reach either the new chandeliers or the new beauties.

Harlequin and *Harlequinades*—A colorfully dressed stock pantomime character, whose name is given to horseplay or buffoonery.

The true Falernian—The choicest wine of ancient Rome.

Give—Toast.

Boodle's—A gentleman's club established on Pall Mall in 1764. It moved to St. James's Street in 1783.

As Jove did Alcmene—Jove disguised himself as Amphitryon, Alcmene's husband, in order to seduce her. Plautus Molière and John Dryden are among those who have dramatized the story.

ACT III, SCENE IV

Commons affair—An affair that could be prosecuted by law—by the "Commons doctors," say, mentioned by Courtall in Act 1, scene 1.

Old crabbed fellow in Rome—The Pope.

Sir Hurlo Thrumbo—The hero of a whimsical play of 1729 by Samuel Johnson of Cheshire.

A clue at her heel, like the peerless Rosamond—The subject of an opera by Joseph Addison (1705). King Henry II had kept his mistress, Rosamond Clifford, within a maze of a house. His wife, Eleanor of Aquitaine, found Rosamond with the aid of a thread tied to her heel.

Domino—A hooded masquerade costume to be worn with a mask, but not representative of a particular character.

ACT IV, SCENE I

Nostrums—Quack medicines. Cf. *The Toyshop* (1735) by Robert Dodsley. an afterpiece in which as the satirical exercise does not forward the narrative action at all. "Projectors" are schemers.

Duke's Place...turn Christians—The centre of Jewish life in London, established as such since Cromwell allowed the Jews to settle there in 1650. They had been expelled in the days of medieval Catholicism. Joshua and Gideon are solid Old Testament names, as "milk and honey" derives from the Book of Exodus. Parliament passed a bill for Jewish naturalization in 1753—not the same thing as "turning

Christian," but the means to the "privileges of Englishmen," "second generation" onwards.

Levite, flesh-hook—Mrs. Racket is accusing Hardy of being a fat priest.

Botolph Lane—A lower-class street in Billingsgate.

Westminster—Meaning the Houses of Parliament.

Badiner—Banter or entertain oneself.

Cestus—The love-inspiring girdle of Venus.

Tantalize—Cf. The "fare of Tantalus" in *A Wife To Be Let*, Act 3, scene I.

ACT V, SCENE I

Robes of St. Bridget—Religious relics reputed for their healing powers.

ACT V, SCENE II

Robe de chambre—Dressing gown.

Ninon—Anne de Lenclos, a renowned French courtesan of the seventeenth century.

Elle est mon caprice—She is my whim, my fancy.

A devilish wild fellow…two centuries back.—Cf. *A Wife To Be Let* and *Lovers' Vows*. In both plays, engagements are cancelled on account of the would-be husbands' genuine wildness.

Proverb—That is, "talk of the devil and he is bound to appear."

Monro—Doctor John Monro (1715–91) of Bethlem Hospital was part of a dynasty of famous mad-doctors.

ACT V, SCENE III

Allons—Let's go (French).

ACT V, SCENE IV

Strait waistcoat—Straitjacket.

ACT V, SCENE V

Pulling caps—Slang for a kind of fighting regarded as female.

Lace—Corset lace, probably pulled tight.

Knight of the Woeful Countenance—Another name for Cervantes's Don Quixote.

Bright example—Cf. Cowley's dedication of the play to the same person, Queen Charlotte, consort to George III.

Day of Judgement and *amazement*—The phrase comes near the beginning of the Anglican marriage service, and the word "amazement" comes at the end.

EPILOGUE

Presumably, the actress who played Letitia (in the first production, Elizabeth Younge) spoke this epilogue.

Lady Bab or Grace—As Finberg points out, these are women from well-known afterpieces who win their lovers through disguise, Lady Bab being really the maid in James Townley's *High Life below Stairs* (1759), and Grace dressing as her mistress in Charles Dibdin the Elder's burletta *Poor Vulcan* (1778).

French red or blanching creams—Cosmetics that fix an artificial complexion are as "low" ("I stoop not...") as masks or disguises.

Vestal—Virgin.

Dian—Roman goddess of chastity, among other things.

Vizors—Masks.

'Tis plain, then, all the world…—Cf. Shakespeare's "seven ages of man" in *As You Like It*, Act 2, scene 7.

Elizabeth Inchbald:
(1753–1821)

I t is as if Venus had written books," said Hazlitt, and he was not alone among Inchbald's contemporaries in admiring her as both a beautiful woman and an excellent writer. One periodical editor dubbed her the "Tenth Muse," which became simply "the Muse." More modestly, Mary Shelley described her as "a piquant mixture between a lady and a milkmaid," and a close friend, George Hardinge, called her figure "excellent, and her features pretty," but

> She is very near-sighted and cannot see three inches from her nose without a little round glass, which is a most graceful implement in her hand. She is perfectly modest; but arch, clever, and so interesting, that if she had no genius you would long to be acquainted with her.

With Elizabeth Inchbald (*née* Simpson), this anthology comes back to the figure of the actress-playwright (although one career ended long before the other). She was born in 1753 in Bury St. Edmunds, into the large family of a farmer. Her brother George joined an acting

company in 1770, run by Richard Griffith, described by one colleague as "a perfect old beau of the old school, a Sir Philip Modelove in real life," referring to "the old beau of the old school in *A Bold Stroke for a Wife*, "a man who to the end of his career remained young at heart." It would not be long before Elizabeth followed George, but she would take time to surpass him.

She encountered literature early on, through the encouragement of her mother, and was introduced to the theatre by touring companies that visited Bury St. Edmunds. She had a severe speech impediment, a stutter, and suffered from fragile health, and yet, by the age of twenty, she was an experienced actress, who had must have learned much from her husband, an actor almost twenty years her senior, Joseph Inchbald. She played Cordelia to his Lear, Fanny in *The Clandestine Marriage* by Colman and Garrick, Hermione in *The Winter's Tale*, and Lady Frances Touchwood in *The Belle's Stratagem*, among a "large and diverse" repertoire. She also played Imoinda in *Oroonoko*, the adaptation of Aphra Behn's novella by Thomas Southerne, at Covent Garden.

Joseph Inchbald died in 1779; and within the next years, his widow was able to retire from the stage and establish herself, in the words of her biographer Annibel Jenkins, as "virtually the playwright in residence at Covent Garden in the winter and at the Haymarket in the summer." Her first play, a farce about the topical sensation of hot-air balloons called *A Mogul Tale*, was performed at the Haymarket in 1784. It was to be frequently revived, and was followed by some twenty more plays, half of them originals, the rest adapted loosely from French and German authors. Many, such as *The Midnight Hour*, *Such Things Are* (both 1787) and *Lovers' Vows* (1798), were extremely popular. The 1790s saw the publication of her two novels, *A Simple Story* (1791) and *Nature and Art* (1796). Her final play appeared in 1805, about the time that she consolidated her position as a drama critic with the 125 *Remarks* published in *Bell's British Theatre* (1806–8), and then choosing the plays for *The Modern Theatre* and *A Collection of Farces and other Afterpieces* (both 1809).

All in all, this curriculum vitae suggests a smooth and natural progression of a life, a narrative that excludes the setbacks. She was

only moderately successful as an actress, and several of those many plays failed. Then again, it also belies her determination. It was years before she could persuade a theatre manager to accept one of her plays for production. In the meantime, she was often forced to work and travel hard, take parts she disliked, endure frequent illnesses, and deter unwelcome admirers. She made herself a virtuous reputation by reportedly dampening one theatrical manager's ardour with a bowl of hot water, and pulling another's hair. Otherwise, she seems to have quickly learned the knack of turning disappointed suitors into loyal friends, and shrugging off rumours of an affair with the actor-manager John Philip Kemble, whom she had met along with his sister Sarah Siddons long before they all became theatre celebrities.

Inchbald's longevity as a playwright might also suggest that she was merely an expert at playing to the galleries, but this seems not to be the whole truth, either. Plays such as *The Child of Nature* (1788) and *Everyone Has His Fault* (1793), not to mention her translations from the provocative Kotzebue, raised contemporary social issues that could have easily have been avoided for the sake of pleasing the crowd. In her *Remark* on *Oroonoko*, as Jenkins notes, she makes a point of the unpopularity Southerne's play in Liverpool, since the city had profited from the slave trade. (Hence also her friendship with radicals such as Mary Wollstonecraft, Thomas Holcroft, and William Godwin.) She was also a firm believer in the importance of character, and *Lovers' Vows* is typical of her adaptations in that her alterations to Kotzbue include comic relief in the form of Verdun the Butler and refinements to the forward character of Amelia (see Inchbald's Preface).

Much of Inchbald's daily life is recorded in her pocketbooks, which all together constitute an invaluable record of late eighteenth-century theatre practice. This is fortuitous, since she burned her memoirs on the advice of a Roman Catholic priest, leaving us with James Boaden's valuable but more or less hagiographic *Memoir* of 1833. Since her final years were marred by the death of old friends and withdrawing from her old life, it is a relief to find that Boaden did her some justice and included in his biography the text of her rejected tragedy, *The Massacre*. This politically charged piece about

the St. Bartholomew's Day Massacre had not been reprinted since its first appearance in 1792. The play's closing speech serves as a final, forceful reminder of its author's characteristically humane voice:

> It is not party principles which cause this devastation; 'tis want of sense—'tis guilt—'for the first precept of Christian laws, is charity—the next obligation—to extend that charity, EVEN TO OUR ENEMIES.

Lovers' Vows

DRAMATIS PERSONAE

MEN

BARON WILDENHAIM
COUNT CASSEL
ANHALT
FREDERICK
VERDUN *the butler*
LANDLORD
COTTAGER
FARMER
COUNTRYMAN

HUNTSMEN, SERVANTS, *etc*

WOMEN

AGATHA FRIBURG
AMELIA WILDENHAIM
COTTAGER'S WIFE
COUNTRY GIRL

Scene, Germany—time of representation, one day.

Preface

Lt would appear like affectation to offer an apology for any scenes or passages omitted or added, in this play, different from the original. Its reception has given me confidence to suppose what I have done is right; for Kotzebue's *Child of Love* in Germany was never more attractive than *Lovers' Vows* has been in England.

I could trouble my reader with many pages to disclose the motives which induced me to alter, with the exception of a few commonplace sentences only, the characters of Count Cassel, Amelia, and Verdun the butler. I could explain why the part of the Count, as in the original, would inevitably have condemned the whole play. I could inform my reader why I have portrayed the Baron in many particulars different from the German author, and carefully prepared the audience for the grand effect of the last scene in the fourth act, by totally changing his conduct towards his son as a robber—why I gave sentences of a humorous kind to the parts of the two cottagers—why I was compelled, on many occasions, to compress the matter of a speech of three or four pages into one of three or four lines—and why, in no one instance, I would suffer my respect for Kotzebue to interfere with my profound respect for the judgement of a British

audience. But I flatter myself such a vindication is not requisite to the enlightened reader, who, I trust, on comparing this drama with the original, will at once see all my motives—and the dull admirer of mere verbal translation, it would be vain to endeavour to inspire with taste by instruction.

Wholly unacquainted with the German language, a literal translation of *The Child of Love* was given to me by the manager of Covent Garden Theatre to be fitted, as my opinion should direct, for his stage. This translation, tedious and vapid as most literal translations are, had the peculiar disadvantage of having been put into our language by a German—of course, it came to me in broken English. It was no slight misfortune to have an example of bad grammar, false metaphors and similes, with all the usual errors of feminine diction, placed before a female writer. But if, disdaining the construction of sentences—the precise decorum of the cold grammarian—she has caught the spirit of her author, if, in every altered scene, still adhering to the nice propriety of his meaning, and still keeping in view his great catastrophe, she has agitated her audience with all the various passions he depicted, the rigid criticism of the closet will be but a slender abatement of the pleasure resulting from the sanction of an applauding theatre.

It has not been one of the least gratifications I have received from the success of this play that the original German, from which it is taken, was printed in the year 1791, and yet, that during all the period which has intervened, no person of talents or literary knowledge (though there are in this country many of that description, who profess to search for German dramas) has thought it worth employment to make a translation of the work. I can only account for such an apparent neglect of Kotzebue's *Child of Love* by the consideration of its original unfitness for an English stage, and the difficulty of making it otherwise—a difficulty which once appeared so formidable, that I seriously thought I must have declined it even after I had proceeded some length in the undertaking.

Independently of objections to the character of the Count, the dangerous insignificance of the butler, in the original, embarrassed me much. I found, if he was retained in the *Dramatis Personae*,

something more must be supplied than the author had assigned him. I suggested the verses I have introduced, but, not being blessed with the butler's happy art of rhyming, I am indebted for them, except the seventh and eleventh stanzas in the first of his poetic stories, to the author of the prologue.

The part of Amelia has been a very particular object of my solicitude and alteration. The same situations which the author gave her remain, but almost all the dialogue of the character I have changed. The forward and unequivocal manner in which she announces her affection to her lover, in the original, would have been revolting to an English audience; the passion of love, represented on the stage, is certain to be insipid or disgusting, unless it creates smiles or tears. Amelia's love, by Kotzebue, is indelicately blunt, and yet void of mirth or sadness. I have endeavoured to attach the attention and sympathy of the audience by whimsical insinuations rather than coarse abruptness—the same woman, I conceive, whom the author drew, with the self-same sentiments, but with manners adapted to the English rather than the German taste; and if the favour in which this character is held by the audience, together with every sentence and incident which I have presumed to introduce in the play, may be offered as the criterion of my skill, I am sufficiently rewarded for the task I have performed.

In stating the foregoing circumstances relating to this production, I hope not to be suspected of arrogating to my own exertions only, the popularity which has attended *The Child of Love*, under the title of *Lovers' Vows*. The exertions of every performer engaged in the play deservedly claim a share in its success, and I must sincerely thank them for the high importance of their aid.

PROLOGUE

Poets have oft declared in doleful strain
That o'er dramatic tracks they beat in vain,
Hopeless that novelty will spring to sight,
For life and nature are exhausted quite.
Though plaints like these have rung from age to age,
Too kind are writers to desert the stage,
And if they, fruitless, search for unknown prey,
At least they dress old game a novel way;
But such lamentings should be heard no more,
For modern taste turns Nature out of door,
Who ne'er again her former sway will boast,
Till, to complete her works, she starts a ghost.
If such the mode, what can we hope tonight,
Who rashly dare approach without a sprite?
No dreadful cavern, no midnight scream,
No rosin flames nor e'en one flitting gleam.
Nought of the charms so potent to invite
The monstrous charms of terrible delight.
Our present theme the German Muse supplies,
But rather aims to soften than surprise.
Yet with her woes she strives some smiles to blend,
Intent as well to cheer as to amend:
On her own native soil she knows the art
To charm the fancy, and to touch the heart.
If then she mirth and pathos can express,
Though less engaging in an English dress,
Let her from British hearts no peril fear,
But, as a STRANGER*, find a welcome here.

* *Hamlet.*

ACT I

A high road, a town at a distance; a small inn on one side of the road, a cottage on the other. The LANDLORD *of the inn leads* AGATHA *by the hand out of his house.*

LANDLORD: No, no! No room for you any longer—it is the fair today in the next village, as great a fair as any in the German dominions. The country people with their wives and children take up every corner we have.

AGATHA: You will turn a poor sick woman out of doors who has spent her last farthing in your house.

LANDLORD: For that very reason: because she *has* spent her last farthing.

AGATHA: I can work.

LANDLORD: You can hardly move your hands.

AGATHA: My strength will come again.

LANDLORD: Then *you* may come again.

AGATHA: What am I to do? Where shall I go?

LANDLORD: It is fine weather—you may go anywhere.

AGATHA: Who will give me a morsel of bread to satisfy my hunger?

LANDLORD: Sick people eat but little.

AGATHA: Hard, unfeeling man, have pity.

LANDLORD: When times are hard, pity is too expensive for a poor man. Ask alms of the different people that go by.

AGATHA: Beg! I would rather starve.

LANDLORD: You may beg, and starve too. What a fine lady you are! Many an honest woman has been obliged to beg. Why should not you? [AGATHA *sits down upon on a large stone under a tree*] For instance, here comes somebody; and I will teach you how to begin. [*A* COUNTRYMAN, *with working tools, crosses the road*] Good day, neighbour Nicholas.

COUNTRYMAN: Good day. [*Stops*]

LANDLORD: Won't you give a trifle to this poor woman? [COUNTRY-MAN *takes no notice, but walks off*] That would not do; the poor man has nothing himself but what he gets by hard labour. Here comes a rich farmer; perhaps he will give you something.

Enter FARMER.

LANDLORD: Good morning to you, sir. Under yon tree sits a poor woman in distress who is in need of your charity.

FARMER: Is she not ashamed of herself? Why don't she work?

LANDLORD: She has had a fever. If you would but pay for one dinner—

FARMER: The harvest has been but indifferent, and my cattle and sheep have suffered by a distemper. [*Exit*]

LANDLORD: My fat, smiling face was not made for begging; you'll have more luck with your thin, sour one—so, I'll leave you to yourself.

Exit LANDLORD. AGATHA *rises and comes forward.*

AGATHA: Oh Providence! Thou hast till this hour protected me, and hast given me fortitude not to despair. Receive my humble thanks, and restore me to health, for the sake of my poor son, the innocent cause of my sufferings, and yet my only comfort. [*Kneeling*] Oh, grant that I may see him once more! See him improved in strength of mind and body, and that by thy gracious mercy he may never be visited with afflictions great as mine. [*After a pause*] Protect his father too, merciful Providence, and pardon his crime of perjury to me! Here, in the face of Heaven (supposing my end approaching, and that I can but a few days longer struggle with want and sorrow), here, I solemnly forgive my seducer for all the ills, the accumulated evils which his allurements, his deceit, and cruelty, have for twenty years past drawn upon me.

Enter a COUNTRY GIRL *with a basket.*

AGATHA: [*Near fainting*] My dear child, if you could spare me a trifle—

GIRL: I have not a farthing in the world—But I am going to market to sell my eggs, and as I come back I'll give you three-pence—And I'll be back as soon as ever I can. [*Exit*]

AGATHA: There was a time when I was as happy as this country girl

414

and as willing to assist the poor in distress. [*Retires to the tree and sits down*]

Enter FREDERICK. *He is dressed in a German soldier's uniform, has a knapsack on his shoulders, appears in high spirits, and stops at the door of the inn.*

FREDERICK: Halt! Stand at ease! It is a very hot day; a draught of good wine will not be amiss. But first let me consult my purse. [*Takes out a couple of pieces of money, which he turns about in his hand*] This will do for a breakfast; the other remains for my dinner, and in the evening I shall be at home. [*Calls out*] Ha! Halloo! Landlord! [*Takes notice of* AGATHA, *who is leaning against the tree*] Who is that? A poor sick woman! She don't beg; but her appearance makes me think she is in want. Must one always wait to give till one is asked? Shall I go without my breakfast now, or lose my dinner? The first I think is the best. Aye, I don't want a breakfast, for dinnertime will soon be here. To do good satisfies both hunger and thirst. [*Going towards her with the money in his hand*] Take this, good woman. [*She stretches her hand for the gift, looks steadfastly at him, and cries out with astonishment and joy.*]

AGATHA: Frederick!

FREDERICK: Mother! [*With amazement and grief*] Mother! For God's sake, what is this! How is this! And why do I find my mother thus? Speak!

AGATHA: I cannot speak, dear son! [*Rising and embracing him*] My dear Frederick! The joy is too great—I was not prepared.

FREDERICK: Dear mother, compose yourself; [*Leans her head against his breast*] now, then, be comforted. [*Aside*] How she trembles! She is fainting.

AGATHA: I am so weak, and my head so giddy—I had nothing to eat all yesterday.

FREDERICK: Good Heavens! Here is my little money, take it all! Oh mother! Mother! [*Runs to the inn*] Landlord! Landlord! [*Knocking violently at the door; enter* LANDLORD]

LANDLORD: What is the matter?

FREDERICK: A bottle of wine—quick, quick!

LANDLORD: [*Surprised*] A bottle of wine! For who?

FREDERICK: For me. Why do you ask? Why don't you make haste?

LANDLORD: Well, well, Mr. Soldier: but can you pay for it?

FREDERICK: Here is money—make haste, or I'll break every window in your house.

LANDLORD: Patience! Patience! [*Goes off*]

FREDERICK: [*To* AGATHA] You were hungry yesterday when I sat down to a comfortable dinner. You were hungry when I partook of a good supper. Oh! Why is so much bitter mixed with the joy of my return?

AGATHA: Be patient, my dear Frederick. Since I see you, I am well. But I have been very ill: so ill, that I despaired of ever beholding you again.

FREDERICK: Ill, and I was not with you? I will, now, never leave you more. Look, mother, how tall and strong I am grown. These arms can now afford you support. They can, and shall, procure you subsistence. [LANDLORD *coming out of the house with a small pitcher*]

LANDLORD: Here is wine, a most delicious nectar. [*Aside*] It is only Rhenish, but it will pass for the best old Hock.

FREDERICK: [*Impatiently snatching the pitcher*] Give it me.

LANDLORD: No, no, the money first. One shilling and two-pence, if you please.

FREDERICK *gives him money.*

FREDERICK: This is all I have. Here, here, mother.

While she drinks the LANDLORD *counts the money.*

LANDLORD: Three half-pence too short—however, one must be charitable. [*Exit* LANDLORD]

AGATHA: I thank you, my dear Frederick—Wine revives me—Wine from the hand of my son gives me almost a new life.

FREDERICK: Don't speak too much, mother. Take your time.

AGATHA: Tell me, dear child, how you have passed the five years since you left me.

FREDERICK: Both good and bad, mother. Today plenty, tomorrow not so much—and sometimes nothing at all.

AGATHA: You have not written to me this long while.

FREDERICK: Dear mother, consider the great distance I was from you! And then, in the time of war, how often letters miscarry. Besides—

AGATHA: No matter now I see you. But have you obtained your discharge?

FREDERICK: Oh, no, mother; I have leave of absence only for two months, and that for a particular reason. But I will not quit you so soon, now I find you are in want of my assistance.

AGATHA: No; no, Frederick. Your visit will make me so well, that I shall in a very short time recover strength to work again; and you must return to your regiment when your furlough is expired. But you told me leave of absence was granted you for a particular reason. What reason?

FREDERICK: When I left you five years ago, you gave me every thing you could afford, and all you thought would be necessary for me. But one trifle you forgot, which was, the certificate of my birth from the church-book. You know in this country there is nothing to be done without it. At the time of parting from you, I little thought it could be of that consequence to me which I have since found it would have been. Once I became tired of a soldier's life, and in the hope I should obtain my discharge, offered myself to a master to learn a profession; but his question was, "Where is your certificate from the church-book of the parish in which you were born?" It vexed me that I had not it to produce, for my comrades laughed at my disappointment. My captain behaved kinder, for he gave me leave to come home to fetch it—and you see, mother, here I am. [*During this speech* AGATHA *is confused and agitated*]

AGATHA: So, you are come for the purpose of fetching your certificate from the church-book.

FREDERICK: Yes, mother.

AGATHA: Oh! Oh!

FREDERICK: What is the matter? [*She bursts into tears*] For Heaven's sake, mother, tell me what's the matter?

AGATHA: You have no certificate.

FREDERICK: No!

AGATHA: No. The laws of Germany excluded you from being registered at your birth—for—you are a natural son.

FREDERICK: [*Starts after a pause*] So! And who is my father?

AGATHA: Oh Frederick, your wild looks are daggers to my heart. Another time.

FREDERICK: [*Endeavouring to conceal his emotion*] No, no—I am still your son—and you are still my mother. Only tell me, who is my father?

AGATHA: When we parted five years ago, you were too young to be entrusted with a secret of so much importance. But the time is come when I can, in confidence, open my heart, and unload that burden with which it has been long oppressed. And yet, to reveal my errors to my child and sue for his mild judgment on my conduct—

FREDERICK: You have nothing to sue for; only explain this mystery.

AGATHA: I will, I will. But my tongue is locked with remorse and shame. You must not look at me.

FREDERICK: Not look at you! Cursed be that son who could find his mother guilty, although the world should call her so.

AGATHA: Then listen to me, and take notice of that village, [*Pointing*] of that castle, and of that church. In that village I was born—in that church I was baptized. My parents were poor, but reputable farmers. The lady of that castle and estate requested them to let me live with her, and she would provide for me through life. They resigned me; and at the age of fourteen I went to my patroness. She took pleasure to instruct me in all kinds of female literature and accomplishments, and three happy years had passed under her protection, when her only son, who was an officer in the Saxon service, obtained permission to come home. I had never seen him before. He was a handsome young man—in my eyes a prodigy, for he talked of love, and promised

me marriage. He was the first man who had ever spoken to me on such a subject. His flattery made me vain, and his repeated vows—Don't look at me, dear Frederick! I can say no more. [Frederick *with his eyes cast down, takes her hand, and puts it to his heart*] Oh! Oh! My son! I was intoxicated by the fervent caresses of a young, inexperienced, capricious man, and did not recover from the delirium till it was too late.

FREDERICK: [*After a pause*] Go on. Let me know more of my father.

AGATHA: When the time drew near that I could no longer conceal my guilt and shame, my seducer prevailed on me not to expose him to the resentment of his mother. He renewed his former promises of marriage at her death, on which relying, I gave him my word to be secret—and I have to this hour buried his name deep in my heart.

FREDERICK: Proceed, proceed! Give me full information. I will have courage to hear it all. [*Greatly agitated*]

AGATHA: His leave of absence expired, he returned to his regiment, depending on my promise, and well assured of my esteem. As soon as my situation became known, I was questioned, and received many severe reproaches, but I refused to confess who was my undoer; and for that obstinacy was turned from the castle. I went to my parents, but their door was shut against me. My mother, indeed, wept as she bade me quit her sight forever, but my father wished increased affliction might befall me.

FREDERICK: [*Weeping*] Be quick with your narrative, or you'll break my heart.

AGATHA: I now sought protection from the old clergyman of the parish. He received me with compassion. On my knees I begged forgiveness for the scandal I had caused to his parishioners; promised amendment; and he said he did not doubt me. Through his recommendation I went to town, and hid in humble lodgings, procured the means of subsistence by teaching to the neighbouring children what I had learnt under the tuition of my benefactress. To instruct you, my Frederick, was my care and my delight, and in return for your filial love I would

not thwart your wishes when they led to a soldier's life—but I saw you go from me with an aching heart. Soon after, my health declined, I was compelled to give up my employment, and, by degrees, became the object you now see me. But, let me add, before I close my calamitous story, that, when I left the good old clergyman, taking along with me his kind advice and his blessing, I left him with a firm determination to fulfil the vow I had made of repentance and amendment. I *have* fulfilled it—and now, Frederick, you may look at me again. [*He embraces her*]

FREDERICK: But my father all this time? [*Mournfully*] I apprehend he died.

AGATHA: No. He married.

FREDERICK: Married!

AGATHA: A woman of virtue—of noble birth and immense fortune. Yet, [*Weeps*] I had written to him many times; had described your infant innocence and wants; had glanced obliquely at former promises—

FREDERICK: [*Rapidly*] No answer to these letters?

AGATHA: Not a word. But in the time of war, you know, letters miscarry.

FREDERICK: Nor did he ever return to this estate?

AGATHA: No. Since the death of his mother this castle has only been inhabited by servants, for he settled as far off as Alsace, upon the estate of his wife.

FREDERICK: I will carry you in my arms to Alsace. No—why should I ever know my father, if he is a villain! My heart is satisfied with a mother. No, I will not go to him. I will not disturb his peace; I leave that task to his conscience. What say you, mother, can't we do without him? [*Struggling between his tears and his pride*] We don't want him. I will write directly to my captain. Let the consequence be what it will, leave you again I cannot. Should I be able to get my discharge, I will work all day at the plough, and all the night with my pen. It will do, mother, it will do! Heaven's goodness will assist me; it will prosper the endeavours of a dutiful son for the sake of a helpless mother.

AGATHA: [*Presses him to her breast*] Where could be found such another son?

FREDERICK: But tell me my father's name, that I may know how to shun him.

AGATHA: Baron Wildenhaim.

FREDERICK: Baron Wildenhaim! I shall never forget it.—Oh! You are near fainting. Your eyes are cast down. What's the matter? Speak, mother!

AGATHA: Nothing particular—only fatigued with talking. I wish to take a little rest.

FREDERICK: I did not consider that we have been all this time in the open road. [*Goes to the inn and knocks at the door*] Here, landlord!

LANDLORD *re-enters.*

LANDLORD: Well, what is the matter now?

FREDERICK: Make haste, and get a bed ready for this good woman.

LANDLORD: [*With a sneer*] A bed for this good woman! Ha, ha, ha! She slept last night in that pent-house; so she may tonight. [*Exit, shutting the door*]

FREDERICK: You are an infamous—[*Goes back to his mother*] Oh! My poor mother—[*Runs to the cottage at a little distance, and knocks*] Ha! Halloo! Who is there?

Enter COTTAGER.

COTTAGER: Good day, young soldier. What is it you want?

FREDERICK: Good friend, look at that poor woman. She is perishing in the public road! It is my mother. Will you give her a small corner in your hut? I beg for mercy's sake—Heaven will reward you.

COTTAGER: Can't you speak quietly? I understand you very well. [*Calls at the door of the hut*] Wife, shake up our bed; here's a poor sick woman wants it. [*Enter* WIFE] Why could not you say all this in fewer words? Why such a long preamble? Why for mercy's sake and Heaven's reward? Why talk about reward for such trifles as these? Come, let us lead her in; and

welcome she shall be to a bed as good as I can give her, and
to our homely fare.

FREDERICK: Ten thousand thanks and blessings on you!

WIFE: Thanks and blessings! Here's a piece of work indeed about
nothing! Good sick lady, lean on my shoulder. [*To* FREDER-
ICK] Thanks and reward, indeed! Do you think husband and
I have lived to these years, and don't know our duty? Lean on
my shoulder.

Exeunt into the cottage.

ACT II, SCENE I

A room in the cottage. AGATHA, COTTAGER, *his* WIFE, *and*
FREDERICK *discovered,* AGATHA *reclined upon a wooden bench,*
FREDERICK *leaning over her.*

FREDERICK: Good people have you nothing to give her? Nothing
that's nourishing?

WIFE: Run, husband, run, and fetch a bottle of wine from the land-
lord of the inn.

FREDERICK: No, no; his wine is as bad as his heart: she has drank
some of it, which I am afraid has turned to poison.

COTTAGER: Suppose, wife, you look for a new-laid egg?

WIFE: Or a drop of brandy, husband; that mostly cures me.

FREDERICK: Do you hear, mother—will you, mother? [AGATHA
makes a sign with her hand as if she could not take anything] She
will not. Is there no doctor in this neighbourhood?

WIFE: At the end of the village there lives a horse-doctor. I have never
heard of any other.

FREDERICK: What shall I do? She is dying. My mother is dying. Pray
for her, good people!

AGATHA: Make yourself easy, dear Frederick, I am well, only weak.
Some wholesome nourishment—

FREDERICK: Yes, mother, directly—directly. [*Aside*] Oh where shall
I—no money—not a farthing left.

WIFE: Oh, dear me! Had you not paid the rent yesterday, husband—

COTTAGER: I then, should know what to do. But as I hope for mercy, I have not a penny in my house.

FREDERICK: Then I must—[*Apart, coming forward*] Yes, I will go, and beg. But should I be refused—I will then—I leave my mother in your care, good people. Do all you can for her, I beseech you! I shall soon be with you again. [*Goes off in haste and confusion*]

COTTAGER: If he should go to our parson, I am sure he would give him something.

AGATHA *having revived by degrees during the scene, rises.*

AGATHA: Is that good old man still living, who was minister here some time ago?

WIFE: No. It pleased Providence to take that worthy man to Heaven two years ago. We have lost in him both a friend and a father. We shall never get such another.

COTTAGER: Wife, wife, our present rector is likewise a very good man.

WIFE: Yes! But he is so very young.

COTTAGER: Our late parson was once young too.

WIFE: [*To* AGATHA] This young man being tutor in our Baron's family, he was very much beloved by them all; and so the Baron gave him this living in consequence.

COTTAGER: And well he deserved it, for his pious instructions to our young lady: who is, in consequence, good, and friendly to everybody.

AGATHA: What young lady do you mean?

COTTAGER: Our Baron's daughter.

AGATHA: Is she here?

WIFE: Dear me! Don't you know that? I thought everybody had known that. It is almost five weeks since the Baron and all his family arrived at the castle.

AGATHA: Baron Wildenhaim?

WIFE: Yes, Baron Wildenhaim.

AGATHA: And his lady?

COTTAGER: His lady died in France many miles from hence, and her death, I suppose, was the cause of his coming to this estate, for the Baron has not been here till within these five weeks ever since he was married. We regretted his absence much, and his arrival has caused great joy.

WIFE: [*Addressing her discourse to* AGATHA] By all accounts the Baroness was very haughty and very whimsical.

COTTAGER: Wife, wife, never speak ill of the dead. Say what you please against the living, but not a word against the dead.

WIFE: And yet, husband, I believe the dead care the least what is said against them, and so, if you please, I'll tell my story. The late Baroness was, they say, haughty and proud; and they do say, the Baron was not so happy as he might have been; but he, bless him, our good Baron is still the same as when a boy. Soon after Madam had closed her eyes, he left France, and came to Wildenhaim, his native country.

COTTAGER: Many times has he joined in our village dances. Afterwards, when he became an officer, he was rather wild, as most young men are.

WIFE: Yes, I remember when he fell in love with poor Agatha, Friburg's daughter: what a piece of work that was. It did not do him much credit. That was a wicked thing.

COTTAGER: Have done, no more of this. It is not well to stir up old grievances.

WIFE: Why, you said I might speak ill of the living. 'Tis very hard indeed, if one must not speak ill of one's neighbours, dead nor alive.

COTTAGER: Who knows whether he was the father of Agatha's child? She never said he was.

WIFE: Nobody but him, that I am sure. I would lay a wager—no, no, husband, you must not take his part—it was very wicked! Who knows what is now become of that poor creature? She has not been heard of this many a year. Maybe she is starving for hunger. Her father might have lived longer too, if that misfortune had not happened.

AGATHA *faints.*

COTTAGER: See here! Help! She is fainting—take hold!
WIFE: Oh, poor woman!
COTTAGER: Let us take her into the next room.
WIFE: Oh poor woman! I am afraid she will not live. Come, cheer up, cheer up. You are with those who feel for you.

They lead her off.

ACT II, SCENE II

An apartment in the castle. A table spread for breakfast. Several servants in livery disposing the equipage. BARON WILDENHAIM *enters, attended by a* GENTLEMAN IN WAITING.

BARON: Has not Count Cassel left his chamber yet?
GENTLEMAN: No, my lord, he has but now rung for his valet.
BARON: The whole castle smells of his perfumery. Go, call my daughter hither. [*Exit* GENTLEMAN] And am I after all to have an ape for a son-in-law? No, I shall not be in a hurry; I love my daughter too well. We must be better acquainted before I give her to him. I shall not sacrifice my Amelia to the will of others, as I myself was sacrificed. The poor girl might, in thoughtlessness, say yes, and afterwards be miserable. What a pity she is not a boy! The name of Wildenhaim will die with me. My fine estates, my good peasants, all will fall into the hands of strangers. Oh! Why was not my Amelia a boy?

Enter AMELIA. *She kisses the* BARON's *hand.*

AMELIA: Good morning, dear my lord.
BARON: Good morning, Amelia. Have you slept well?
AMELIA: Oh! Yes, papa. I always sleep well.
BARON: Not a little restless last night?
AMELIA: No.
BARON: Amelia, you know you have a father who loves you, and I

believe you know you have a suitor who is come to ask permission to love you. Tell me candidly how you like Count Cassel?

AMELIA: Very well.

BARON: Do not you blush when I talk of him?

AMELIA: No.

BARON: No. [*Aside*] I am sorry for that. [*To her*] Have you dreamt of him?

AMELIA: No.

BARON: Have you not dreamt at all tonight?

AMELIA: Oh yes. I have dreamt of our chaplain, Mr. Anhalt.

BARON: Aha! As if he stood before you and the Count to ask for the ring.

AMELIA: No, not that. I dreamt we were all still in France, and he, my tutor, just going to take his leave of us forever. I woke with the fright, and found my eyes full of tears.

BARON: Psha! I want to know if you can love the Count. You saw him at the last ball we were at in France: when he capered round you; when he danced minuets; when he—but I cannot say what his conversation was.

AMELIA: Nor I either. I do not remember a syllable of it.

BARON: No? Then I do not think you like him.

AMELIA: I believe not.

BARON: But I think proper to acquaint you he is rich, and of great consequence: rich, and of consequence; do you hear?

AMELIA: Yes, dear papa. But my tutor has always told me that birth and fortune are inconsiderable things, and cannot give happiness.

BARON: There he is right. But if it happens that birth and fortune are joined with sense and virtue—

AMELIA: But is it so with Count Cassel?

BARON: Hem! Hem! I will ask you a few questions on this subject; but be sure to answer me honestly—speak truth.

AMELIA: I never told an untruth in my life.

BARON: Nor ever *conceal* the truth from me, I command you.

AMELIA: [*Earnestly*] Indeed, my lord, I never will.

BARON: I take you at your word. And now reply to me truly. Do you like to hear the Count spoken of?

AMELIA: Good or bad?

BARON: Good. Good.

AMELIA: Oh yes; I like to hear good of everybody.

BARON: But do not you feel a little fluttered when he is talked of?

AMELIA: [*Shaking her head*] No.

BARON: Are not you a little embarrassed?

AMELIA: No.

BARON: Don't you wish sometimes to speak to him, and have not the courage to begin?

AMELIA: No.

BARON: Do not you wish to take his part when his companions laugh at him?

AMELIA: No, I love to laugh at him myself.

BARON: [*Aside*] Provoking! [*To her*] Are not you afraid of him when he comes near you?

AMELIA: No, not at all—oh yes—[*Recollecting herself*] once.

BARON: Ah! Now it comes!

AMELIA: Once at a ball he trod on my foot, and I was so afraid he should tread on me again.

BARON: You put me out of patience. Hear, Amelia! [*Stops short, and speaks softer*] To see you happy is my wish. But matrimony, without concord, is like a duetto badly performed; for that reason, Nature, the great composer of all harmony, has ordained that, when bodies are allied, hearts should be in perfect unison. However, I will send Mr. Anhalt to you—

AMELIA: [*Much pleased*] Do, papa.

BARON: He shall explain to you my sentiments. [*Rings*] A clergyman can do this better than—[*Enter* SERVANT] Go directly to Mr. Anhalt, tell him that I shall be glad to see him for a quarter of an hour if he is not engaged. [*Exit* SERVANT]

AMELIA: [*Calls after him*] Wish him a good morning from me.

BARON: [*Looking at his watch*] The Count is a tedious time dressing.—Have you breakfasted, Amelia?

AMELIA: No, papa. [*They sit down to breakfast*]

427

BARON: How is the weather? Have you walked this morning?

AMELIA: Oh yes, I was in the garden at five o'clock; it is very fine.

BARON: Then I'll go out shooting. I do not know in what other way
to amuse my guest.

Enter COUNT CASSEL.

COUNT: Ah, my dear Colonel! Miss Wildenhaim, I kiss your hand.

BARON: Good morning! Good morning! Though it is late in the day,
Count. In the country we should rise earlier.

AMELIA *offers the* COUNT *a cup of tea.*

COUNT: Is it Hebe herself, or Venus, or—

AMELIA: Ha, ha, ha! Who can help laughing at his nonsense?

BARON: [*Rather angry*] Neither Venus, nor Hebe; but Amelia Wilden-
haim, if you please.

COUNT: [*Sitting down to breakfast*] You are beautiful, Miss Wilden-
haim. Upon my honor, I think so. I have travelled, and seen
much of the world, and yet I can positively admire you.

AMELIA: I am sorry I have not seen the world.

COUNT: Wherefore?

AMELIA: Because I might then perhaps admire you.

COUNT: True; for I am an epitome of the world. In my travels I learnt
delicacy in Italy; hauteur in Spain; in France, enterprise; in
Russia, prudence; in England, sincerity; in Scotland, frugality;
and in the wilds of America, I learnt love.

AMELIA: Is there any country where love is taught?

COUNT: In all barbarous countries. But the whole system is exploded
in places that are civilized.

AMELIA: And what is substituted in its stead?

COUNT: Intrigue.

AMELIA: What a poor, uncomfortable substitute!

COUNT: There are other things: song, dance, the opera and war.

Since the entrance of the COUNT *the* BARON *has removed to a
table at a little distance.*

BARON: What are you talking of there?

428

COUNT: Of war, Colonel.

BARON: [*Rising*] Aye, we like to talk on what we don't understand.

COUNT: [*Rising*] Therefore, to a lady, I always speak of politics; and to her father, on love.

BARON: I believe, Count, notwithstanding your sneer, I am still as much of a proficient in that art as yourself.

COUNT: I do not doubt it, my dear Colonel, for you are a soldier; and, since the days of Alexander, whoever conquers men is certain to overcome women.

BARON: An achievement to animate a poltroon.

COUNT: And, I verily believe, gains more recruits than the king's pay.

BARON: Now we are on the subject of arms, should you like to go out a-shooting with me for an hour before dinner?

COUNT: Bravo, Colonel! A charming thought! This will give me an opportunity to use my elegant gun; the butt is inlaid with mother-of-pearl. You cannot find better work, or better taste. Even my coat of arms is engraved.

BARON: But can you shoot?

COUNT: That I have never tried, except with my eyes, at a fine woman.

BARON: I am not particular what game I pursue. I have an old gun; it does not look fine; but I can always bring down my bird.

Enter SERVANT.

SERVANT: Mr. Anhalt begs leave—

BARON: Tell him to come in. I shall be ready in a moment. [*Exit* SERVANT]

COUNT: Who is Mr. Anhalt?

AMELIA: [*With warmth*] Oh, a very good man.

COUNT: "A good man." In Italy, that means a religious man; in France, it means a cheerful man; in Spain, it means a wise man; and in England, it means a rich man. Which good man of all these is Mr. Anhalt?

AMELIA: A good man in every country, except England.

COUNT: And give me the English good man, before that of any other nation.

BARON: And of what nation would you prefer your good woman to be, Count?

COUNT: [*Bowing to* AMELIA] Of Germany.

AMELIA: In compliment to me?

COUNT: In justice to my own judgement.

BARON: Certainly. For have we not an instance of one German woman, who possesses every virtue that ornaments the whole sex, whether as a woman of illustrious rank, or in the more exalted character of a wife, and a mother?

Enter MR. ANHALT.

ANHALT: I come by your command, Baron—

BARON: Quick, Count, get your elegant gun. I pass your apartments, and will soon call for you.

COUNT: I fly. Beautiful Amelia, it is a sacrifice I make to your father, that I leave for a few hours his amiable daughter. [*Exit*]

BARON: My dear Amelia, I think it scarcely necessary to speak to Mr. Anhalt, or that he should speak to you, on the subject of the Count; but as he is here, leave us alone.

AMELIA: [*As she retires*] Good morning, Mr. Anhalt. I hope you are very well. [*Exit*]

BARON: I'll tell you in a few words why I sent for you. Count Cassel is here, and wishes to marry my daughter.

ANHALT: [*Much concerned*] Really!

BARON: He is—he—in a word I don't like him.

ANHALT: [*With emotion*] And Miss Wildenhaim—

BARON: I shall not command, neither persuade her to the marriage. I know too well the fatal influence of parents on such a subject. Objections to be sure, if they could be removed—but when you find a man's head without brains, and his bosom without a heart, these are important articles to supply. Young as you are, Anhalt, I know no one so able to restore, or to bestow those blessings on his fellow-creatures, as you. [ANHALT *bows*] The Count wants a little of my daughter's simplicity and sensibility. Take him under your care while he is here, and make him something like yourself. You have succeeded to my wish

in the education of my daughter. Form the Count after your own manner. I shall then have what I have sighed for all my life—a son.

ANHALT: With your permission, Baron, I will ask one question. What remains to interest you in favour of a man, whose head and heart are good for nothing?

BARON: Birth and fortune. Yet, if I thought my daughter absolutely disliked him, or that she loved another, I would not thwart a first affection; no, for the world, I would not. [*Sighing*] But that her affections are already bestowed, is not probable.

ANHALT: Are you of opinion that she will never fall in love?

BARON: Oh! No. I am of opinion that no woman ever arrived at the age of twenty without that misfortune. But this is another subject. Go to Amelia, explain to her the duties of a wife and of a mother. If she comprehends them, as she ought, then ask her if she thinks she could fulfil those duties, as the wife of Count Cassel.

ANHALT: I will. But—I—Miss Wildenhaim—[*Confused*] I—I shall—I—I shall obey your commands.

BARON: Do so. [*Gives a deep sigh*] Ah! So far this weight is removed; but there lies still a heavier next my heart. You understand me. How is it, Mr. Anhalt? Have you not yet been able to make any discoveries on that unfortunate subject?

ANHALT: I have taken infinite pains, but in vain. No such person is to be found.

BARON: Believe me, this burden presses on my thoughts so much, that many nights I go without sleep. A man is sometimes tempted to commit such depravity when young. Oh, Anhalt! Had I, in my youth, had you for a tutor; but I had no instructor but my passions; no governor but my own will. [*Exit*]

ANHALT: This commission of the Baron's in respect to his daughter, I am—[*Looks about*] If I should meet her now, I cannot—I must recover myself first, and then prepare. A walk in the fields, and a fervent prayer—After these, I trust, I shall return, as a man whose views are solely placed on a future world; all hopes in this, with fortitude resigned. [*Exit*]

ACT III, SCENE I

An open field. FREDERICK *alone, with a few pieces of money which he turns about in his hands.*

FREDERICK: To return with this trifle for which I have stooped to beg! Return to see my mother dying! I would rather fly to the world's end. [*Looking at the money*] What can I buy with this? It is hardly enough to pay for the nails that will be wanted for her coffin. My great anxiety will drive me to distraction. However, let the consequence of our affliction be what it may, all will fall upon my father's head; and may he pant for Heaven's forgiveness, as my poor mother—

At a distance is heard the firing of a gun, then the cry of "Halloo, Halloo"; gamekeepers and sportsmen run across the stage. FREDERICK *looks about.*

Here they come—a nobleman, I suppose, or a man of fortune. Yes, yes; and I will once more beg for my mother. May Heaven send relief!

Enter the BARON *followed by the* COUNT. *The* BARON *stops.*

BARON: Quick, quick, Count! Aye, aye, that was a blunder indeed. Don't you see the dogs? There they run—they have lost the scent. [*Exit* BARON *looking after the dogs*]

COUNT: So much the better, Colonel, for I must take a little breath.

He leans on his gun. FREDERICK *goes up to him with great modesty.*

FREDERICK: Gentleman, I beg you will bestow from your superfluous wants something to relieve the pain, and nourish the weak frame, of an expiring woman.

The BARON *re-enters.*

COUNT: What police is here, that a nobleman's amusement should be interrupted by the attack of vagrants!

FREDERICK: [*To the* BARON] Have pity, noble sir, and relieve the

distress of an unfortunate son who supplicates for his dying mother.

BARON: [*Taking out his purse*] I think, young soldier, it would be better if you were with your regiment on duty, instead of begging.

FREDERICK: I would with all my heart: but at this present moment my sorrows are too great. [BARON *gives something*] I entreat your pardon. What you have been so good as to give me is not enough.

BARON: [*Surprised*] Not enough!

FREDERICK: No, it is not enough.

COUNT: The most singular beggar I ever met in all my travels.

FREDERICK: If you have a charitable heart, give me one dollar.

BARON: This is the first time I was ever dictated by a beggar what to give him.

FREDERICK: With one dollar you will save a distracted man.

BARON: I don't choose to give any more. Count, go on.

Exit COUNT. *As the* BARON *follows,* FREDERICK *seizes him by the breast and draws his sword.*

FREDERICK: Your purse, or your life.

BARON: [*Calling*] Here! Here! Seize and secure him.

Some of the GAMEKEEPERS *run on, lay hold of* FREDERICK, *and disarm him.*

FREDERICK: What have I done!

BARON: Take him to the castle and confine him in one of the towers. I shall follow you immediately.

FREDERICK: One favour I beg, one favour only. I know that I am guilty, and am ready to receive the punishment my crime deserves. But I have a mother, who is expiring for want—pity her, if you cannot pity me—bestow on her relief. If you will send to yonder hut, you will find that I do not impose on you a falsehood. For her it was I drew my sword; for her I am ready to die.

BARON: Take him away, and imprison him where I told you.

FREDERICK: [*As he is forced off*] Woe to that man to whom I owe my birth! [*Exit*]

BARON: [*Calls another* KEEPER] Here, Frank, run directly to yonder hamlet, inquire in the first, second, and third cottage for a poor sick woman, and if you really find such a person, give her this purse. [*Exit* GAMEKEEPER] A most extraordinary event! And what a well-looking youth! Something in his countenance and address which struck me inconceivably! If it is true that he begged for his mother—but if he did—for the attempt upon my life, he must die. Vice is never half so dangerous, as when it assumes the garb of morality. [*Exit*]

ACT III, SCENE II

A room in the castle.

AMELIA: [*Alone*] Why am I so uneasy; so peevish; who has offended me? I did not mean to come into this room. In the garden I intended to go. [*Going, turns back*] No, I will not—yes, I will—just go, and look if my auriculas are still in blossom, and if the apple tree is grown which Mr. Anhalt planted. I feel very low-spirited; something must be the matter. Why do I cry? Am I not well? [*Enter* MR. ANHALT] Ah! Good morning, my dear sir—Mr. Anhalt, I meant to say—I beg pardon.

ANHALT: Never mind, Miss Wildenhaim. I don't dislike to hear you call me as you did.

AMELIA: In earnest?

ANHALT: Really. You have been crying. May I know the reason? The loss of your mother, still?

AMELIA: No, I have left off crying for her.

ANHALT: I beg pardon if I have come at an improper hour, but I wait upon you by the commands of your father.

AMELIA: You are welcome at all hours. My father has more than once told me that he who forms my mind I should always consider as my greatest benefactor. [*Looking down*] And my heart tells me the same.

ANHALT: I think myself amply rewarded by the good opinion you have of me.

AMELIA: When I remember what trouble I have sometimes given you, I cannot be too grateful.

ANHALT: [*To himself*] Oh Heavens! [*To* AMELIA] I—I come from your father with a commission. If you please, we will sit down. [*He places chairs, and they sit*] Count Cassel is arrived.

AMELIA: Yes, I know.

ANHALT: And do you know for what reason?

AMELIA: He wishes to marry me.

ANHALT: Does he? [*Hastily*] But believe me, the Baron will not persuade you. No, I am sure he will not.

AMELIA: I know that.

ANHALT: He wishes that I should ascertain whether you have an inclination—

AMELIA: For the Count, or for matrimony do you mean?

ANHALT: For matrimony.

AMELIA: All things that I don't know, and don't understand, are quite indifferent to me.

ANHALT: For that very reason I am sent to you to explain the good and the bad of which matrimony is composed.

AMELIA: Then I beg first to be acquainted with the good.

ANHALT: When two sympathetic hearts meet in the marriage state, matrimony may be called a happy life. When such a wedded pair find thorns in their path, each will be eager, for the sake of the other, to tear them from the root. Where they have to mount hills, or wind a labyrinth, the most experienced will lead the way, and be a guide to his companion. Patience and love will accompany them in their journey, while melancholy and discord they leave far behind. Hand in hand they pass on from morning till evening, through their summer's day, till the night of age draws on, and the sleep of death overtakes the one. The other, weeping and mourning, yet looks forward to the bright region where he shall meet his still surviving partner, among trees and flowers which themselves have planted, in fields of eternal verdure.

AMELIA: [*Rises*] Tell my father—I'll marry.

ANHALT: [*Rising*] This picture is pleasing, but I must beg you not

to forget that there is another on the same subject. When convenience, and fair appearance joined to folly and ill humor, forge the fetters of matrimony, they gall with their weight the married pair. Discontented with each other, at variance in opinions, their mutual aversion increases with the years they live together. They contend most, where they should most unite; torment, where they should most soothe. In this rugged way, choked with the weeds of suspicion, jealousy, anger, and hatred, they take their daily journey, till one of these also sleep in death. The other then lifts up his dejected head, and calls out in acclamations of joy, "Oh, liberty! Dear liberty!"

AMELIA: I will not marry.

ANHALT: You mean to say, you will not fall in love.

AMELIA: Oh no! [*Ashamed*] I am in love.

ANHALT: Are in love! [*Starting*] And with the Count?

AMELIA: I wish I was.

ANHALT: Why so?

AMELIA: Because *he* would perhaps love me again.

ANHALT: [*Warmly*] Who is there that would not?

AMELIA: Would you?

ANHALT: I—I—me—I—I am out of the question.

AMELIA: No, you are the very person to whom I have put the question.

ANHALT: What do you mean?

AMELIA: I am glad you don't understand me. [*In confusion*] I was afraid I had spoken too plain.

ANHALT: Understand you! As to that, I am not dull.

AMELIA: I know you are not. And as you have for a long time instructed me, why should not I now begin to teach you?

ANHALT: Teach me what?

AMELIA: Whatever I know, and you don't.

ANHALT: There are some things I had rather never know.

AMELIA: So you may remember I said when you began to teach me mathematics. I said I had rather not know it. But now I have learnt it gives me great deal of pleasure, and—[*Hesitating*]

perhaps, who can tell, but that I might teach something as pleasant to you as resolving a problem is to me.

ANHALT: Woman herself is a problem.

AMELIA: And I'll teach you to make her out.

ANHALT: *You* teach?

AMELIA: Why not? None but a woman can teach the science of herself: and though I own I am very young, a young woman may be as agreeable for a tutoress as an old one. I am sure I always learnt faster from you than from the old clergyman who taught me before you came.

ANHALT: This is nothing to the subject.

AMELIA: What is the subject?

ANHALT: Love.

AMELIA: [*Going up to him*] Come, then, teach it me. Teach it me as you taught me geography, languages and other important things.

ANHALT: [*Turning from her*] Pshaw!

AMELIA: Ah! You won't. You know you have already taught me that, and you won't begin again.

ANHALT: You misconstrue—you misconceive everything I say or do. The subject I came to you upon was marriage.

AMELIA: [*Curtsying*] A very proper subject from the man who has taught me love, and I accept the proposal.

ANHALT: Again you misconceive and confound me.

AMELIA: Aye, I see how it is. You have no inclination to experience with me "the good part of matrimony." I am not the female with whom you would to go "hand in hand up hills, and through labyrinths," with whom you would like to "root up thorns; and with whom you would delight to plant lilies and roses." No, you had rather call "Oh liberty, dear liberty."

ANHALT: Why do you force from me, what it is villainous to own? I love you more than life. Oh, Amelia! Had we lived in those golden times, which the poets picture, no one but you—but as the world is changed, your birth and fortune make our union impossible. To preserve the character, and more the feelings of

an honest man, I would not marry you without the consent of your father. And could I, dare I propose it to him?

AMELIA: He has commanded me never to conceal or disguise the truth. I will propose it to him. The subject of the Count will force me to speak plainly, and this will be the most proper time, while he can compare the merit of you both.

ANHALT: I conjure you not to think of exposing yourself and me to his resentment.

AMELIA: It is my father's will that I should marry. It is my father's wish to see me happy. If then you love me as you say, I will marry; and will be happy—but only with you. I will tell him this. At first he will start; then grow angry; then be in a passion. In his passion he will call me "undutiful," but he will soon recollect himself, and resume his usual smiles, saying "Well, well, if he love you, and you love him, in the name of Heaven, let it be." Then I shall hug him round the neck, kiss his hands, run away from him, and fly to you; it will soon be known that I am your bride, the whole village will come to wish me joy, and Heaven's blessing will follow.

Enter VERDUN, *the* BUTLER.

AMELIA: [*Discontented*] Ah! Is it you?

BUTLER: Without vanity, I have taken the liberty to enter this apartment the moment the good news reached my ears.

AMELIA: What news?

BUTLER: Pardon an old servant, your father's old butler, gracious lady, who has had the honor to carry the Baron in his arms—and afterwards with humble submission to receive many a box o'the ear from you—if he thinks it his duty to make his congratulations with due reverence on this happy day, and to join with the muses in harmonious tunes on the lyre.

AMELIA: Oh! My good butler, I am not in a humor to listen to the muses and your lyre.

BUTLER: There has never been a birthday nor wedding day nor christening day celebrated in your family in which I have not

joined with the muses in full chorus. In forty-six years, three hundred and ninety-seven congratulations on different occasions have dropped from my pen. Today, the three hundred and ninety-eighth is coming forth, for Heaven has protected our noble master, who has been in great danger.

AMELIA: Danger! My father in danger! What do you mean?

BUTLER: One of the gamekeepers has returned to inform the whole castle of a base and knavish trick, of which the world will talk, and my poetry hand down to posterity.

AMELIA: What, what is all this?

BUTLER: The Baron, my lord and master, in company with the strange Count, had not been gone a mile beyond the lawn, when one of them—

AMELIA: What happened? Speak for Heaven's sake.

BUTLER: My verse shall tell you.

AMELIA: No, no, tell us in prose.

ANHALT: Yes, in prose.

BUTLER: Ah, you have neither of you ever been in love, or you would prefer poetry to prose. But excuse [*Pulls out a paper*] the haste in which it was written. I heard the news in the fields—always have paper and pencil about me, and composed the whole forty lines crossing the meadows and the park in my way home.
[*Reads*]
"Oh Muse, ascend the forked mount,
And lofty strains prepare,
About a Baron and a Count,
Who went to hunt the hare.

"The hare she ran with utmost speed,
And sad, and anxious looks,
Because the furious hounds indeed,
Were near to her, gadzooks.

"At length, the Count and Baron bold
Their footsteps homeward bended;

For why, because, as you were told,
The hunting it was ended.

"Before them straight a youth appears,
Who made a piteous pother,
And told a tale with many tears,
About his dying mother.

"The youth was in severe distress,
And seemed as he had spent all,
He looked a soldier by his dress;
For that was regimental.

"The Baron's heart was full of ruth,
While from his eye fell brine-o!
And soon he gave the mournful youth
A little ready rino.

"He gave a shilling as I live,
Which, sure, was mighty well;
But to some people if you give
An inch—they'll take an ell.

"The youth then drew his martial knife,
And seized the Baron's collar,
He swore he'd have the Baron's life,
Or else another dollar.

"Then did the Baron in fume,
Soon raise a mighty din,
Whereon came butler, huntsman, groom,
And eke the whipper-in.

"Maugre this young man's warlike coat,
They bore him off to prison;

And held so strongly by his throat,
They almost stopped his whizzen.

"Soon may a neckcloth, called a rope,
Of robbing cure this elf;
If so I'll write, without a trope,
His dying speech myself.

"And had the Baron chanced to die,
Oh! grief to all the nation,
I must have made an elegy,
And not this fine narration.

"MORAL.
Henceforth let those who all have spent,
And would by begging live,
Take warning here, and be content,
With what folks choose to give."

AMELIA: Your muse, Mr. Butler, is in a very inventive humor this morning.

ANHALT: And your tale too improbable, even for fiction.

BUTLER: Improbable! It's a real fact.

AMELIA: What, a robber in our grounds at noonday? Very likely indeed!

BUTLER: I don't say it was likely, I only say it is true.

ANHALT: No, no, Mr. Verdun, we find no fault with your poetry, but don't attempt to impose it upon us for truth.

AMELIA: Poets are allowed to speak falsehood, and we forgive yours.

BUTLER: I won't be forgiven, for I speak truth—And here the robber comes, in custody, to prove my words. [*Goes off, repeating*] "I'll write his dying speech myself."

AMELIA: Look! As I live, so he does. They come nearer; he's a young man, and has something interesting in his figure. An honest

countenance, with grief and sorrow in his face. No, he is no robber—I pity him! Oh! Look how the keepers drag him unmercifully into the tower. Now they lock it. Oh! How that poor, unfortunate man must feel!

ANHALT: [*Aside*] Hardly worse than I do.

Enter the BARON.

AMELIA: A thousand congratulations, my dear papa.

BARON: For Heaven's sake, spare your congratulations. The old butler, in coming upstairs, has already overwhelmed me with them.

ANHALT: Then it is true, my lord? I could hardly believe the old man.

AMELIA: And the young prisoner, with all his honest looks, is a robber?

BARON: He is; but I verily believe for the first and last time. A most extraordinary event, Mr. Anhalt. This young man begged, then drew his sword upon me; but he trembled so, when he seized me by the breast, a child might have overpowered him. I almost wish he had made his escape. This adventure may cost him his life, and I might have preserved it with one dollar; but now, to save him would set a bad example.

AMELIA: Oh no! My lord, have pity on him! Plead for him, Mr. Anhalt!

BARON: Amelia, have you had any conversation with Mr. Anhalt?

AMELIA: Yes, my lord.

BARON: Respecting matrimony?

AMELIA: Yes, and I have told him—

ANHALT: [*Very hastily*] According to your commands, Baron—

AMELIA: But he has conjured me—

ANHALT: I have endeavoured, my lord, to find out—

AMELIA: Yet I am sure, dear papa, your affection for me—

ANHALT: You wish to say something to me in your closet, my lord?

BARON: What the devil is all this conversation? You will not let one another speak. I don't understand either of you.

AMELIA: Dear father, have you not promised you will not thwart

my affections when I marry, but suffer me to follow their dictates.

BARON: Certainly.

AMELIA: Do you hear, Mr. Anhalt?

ANHALT: I beg pardon—I have a person who is waiting for me—I am obliged to retire. [*Exit in confusion*]

BARON: [*Calls after him*] I shall expect you in my closet. I am going there immediately. [*Retiring towards the opposite door*]

AMELIA: Pray, my lord, stop a few minutes longer. I have something of great importance to say to you.

BARON: Something of importance! To plead for the young man, I suppose! But that's a subject I must not listen to. [*Exit*]

AMELIA: I wish to plead for two young men. For one, that he may be let out of prison; for the other, that he may be made a prisoner for life. [*Looks out*] The tower is still locked. How dismal it must be to be shut up in such a place, and perhaps—[*Calls*] Butler! Butler! Come this way. I wish to speak to you. [*Aside*] This young soldier has risked his life for his mother, and that accounts for the interest I take in his misfortunes. [*Enter the* BUTLER] Pray, have you carried anything to the prisoner to eat?

BUTLER: Yes.

AMELIA: What was it?

BUTLER: Some fine black bread; and water as clear as crystal.

AMELIA: Are you not ashamed! Even my father pities him. Go directly down to the kitchen, and desire the cook to give you something good and comfortable, and then go into the cellar for a bottle of wine.

BUTLER: Good and comfortable indeed!

AMELIA: And carry both to the tower.

BUTLER: I am willing at any time, dear lady, to obey your orders; but, on this occasion, the prisoner's food must remain bread and water. It is the Baron's particular command.

AMELIA: Ah! My father was in the height of passion when he gave it.

BUTLER: Whatsoever his passion might be, it is the duty of a true and honest dependent to obey his lord's mandates. I will not suffer a servant in this house, nor will I, myself, give the young man anything except bread and water. But I'll tell you what I'll do. I'll read my verses to him.

AMELIA: Give me the key of the cellar, I'll go myself.

BUTLER: [*Gives the key*] And there's my verses—[*Taking them from his pocket*] Carry them with you, they may comfort him as much as the wine. [*She throws them down. Exit* AMELIA]

BUTLER: [*In amazement*] Not take them! Refuse to take them—[*He lifts them from the floor with the utmost respect*]
"I must have made an elegy,
And not this fine narration." [*Exit*]

ACT IV, SCENE I

A prison in one of the towers of the castle. FREDERICK *alone.*

FREDERICK: How a few moments destroy the happiness of man! When I, this morning, set out from my inn, and saw the sun rise, I sung with joy. Flattered with the hope of seeing my mother, I formed a scheme how I would with joy surprise her. But, farewell all pleasant prospects; I return to my native country, and the first object I behold, is my dying parent; my first lodging, a prison; and my next walk will perhaps be—oh, merciful Providence! Have I deserved all this?

Enter AMELIA *with a small basket covered with a napkin. She speaks to someone without.*

AMELIA: Wait there, Francis, I shall soon be back.

FREDERICK: [*Hearing the door open, and turning round*] Who's there?

AMELIA: You must be both hungry and thirsty, I fear.

FREDERICK: Oh, no! Neither.

AMELIA: Here is a bottle of wine, and something to eat. [*Places the*

basket on the table] I have often heard my father say, that wine is quite a cordial to the heart.

FREDERICK: A thousand thanks, dear stranger. Ah! Could I prevail on you to have it sent to my mother, who is upon her deathbed, under the roof of an honest peasant, called Hubert! Take it hence, my kind benefactress, and save my mother.

AMELIA: But first assure me that you did not intend to murder my father.

FREDERICK: Your father! Heaven forbid. I meant but to preserve her life, who gave me mine. Murder your father? No, no, I hope not.

AMELIA: And I thought not. Or, if you had murdered anyone, you had better have killed the Count; nobody would have missed him.

FREDERICK: Who, may I enquire, were those gentlemen whom I hoped to frighten into charity?

AMELIA: Aye, if you only intended to frighten them, the Count was the very person for your purpose. But you caught hold of the other gentleman—and could you hope to intimidate Baron Wildenhaim?

FREDERICK: Baron Wildenhaim! Almighty powers!

AMELIA: What's the matter?

FREDERICK: [*Trembling*] The man to whose breast I held my sword—

AMELIA: Was Baron Wildenhaim, the owner of this estate—my father!

FREDERICK: [*With the greatest emotion*] My father!

AMELIA: Good Heaven, how he looks! I am afraid he's mad. Here! Francis, Francis. [*Exit, calling*]

FREDERICK: [*All agitation*] My *father*! Eternal judge! Thou dost not slumber! The man against whom I drew my sword this day was my father! One moment longer, and provoked, I might have been the murderer of my father! My hair stands on end! My eyes are clouded! I cannot see any thing before me. [*Sinks down on a chair*] If Providence had ordained that I should give the fatal blow, who would have been most in fault? I dare not

pronounce—[*After a pause*] That benevolent young female who left me just now, is, then, my sister—and I suppose that fop, who accompanied my father—[*Enter* MR. ANHALT] Welcome, sir! By your dress you are of the church, and consequently a messenger of comfort. You are most welcome, sir.

ANHALT: I wish to bring comfort and avoid upbraidings, for your own conscience will reproach you more than the voice of a preacher. From the sensibility of your countenance, together with a language, and address superior to the vulgar, it appears, young man, you have had an education, which should have preserved you from a state like this.

FREDERICK: My education I owe to my mother. Filial love, in return, has plunged me into the state you see. A civil magistrate will condemn according to the law; a priest, in judgment, is not to consider the act itself, but the impulse which led to the act.

ANHALT: I shall judge with all the lenity my religion dictates; and you are the prisoner of a nobleman, who compassionates you for the affection which you bear towards your mother, for he has sent to the village where you directed him, and has found the account you gave relating to her true. With this impression in your favour, it is my advice, that you endeavour to see and supplicate the Baron for your release from prison, and all the peril of his justice.

FREDERICK: [*Starting*] I—I see the Baron! I! I supplicate for my deliverance! Will you favour me with his name? Is it not Baron—?

ANHALT: Baron Wildenhaim.

FREDERICK: Baron Wildenhaim! He lived formerly in Alsace.

ANHALT: The same. About a year after the death of his wife, he left Alsace; and arrived here a few weeks ago to take possession of this, his paternal estate.

FREDERICK: So! His wife is dead; and that generous young lady who came to my prison just now is his daughter?

ANHALT: Miss Wildenhaim, his daughter.

FREDERICK: And that young gentleman, I saw with him this morning, is his son?

ANHALT: He has no son.

FREDERICK: [*Hastily*] Oh, yes, he has—[*Recollecting himself*] I mean him that was out shooting today.

ANHALT: He is not his son.

FREDERICK: [*To himself*] Thank Heaven!

ANHALT: He is only a visitor.

FREDERICK: I thank you for this information; and if you will undertake to procure me a private interview with Baron Wildenhaim—

ANHALT: Why private? However, I will venture to take you for a short time from this place, and introduce you; depending on your innocence, or your repentance, on his conviction in your favour, or his mercy towards your guilt. Follow me. [*Exit*]

FREDERICK: [*Following*] I have beheld an affectionate parent in deep adversity. Why should I tremble thus? Why doubt my fortitude in the presence of an unnatural parent in prosperity? [*Exit*]

ACT IV, SCENE II

A Room in the Castle. Enter BARON WILDENHAIM *and* AMELIA.

BARON: I hope you judge more favourably of Count Cassel's understanding since the private interview you have had with him. Confess to me the exact effect of the long conference between you.

AMELIA: To make me hate him.

BARON: What has he done?

AMELIA: Oh! Told me of such barbarous deeds he has committed.

BARON: What deeds?

AMELIA: Made vows of love to so many women, that, on his marriage with me, a hundred female hearts will at least be broken.

BARON: Psha! Do you believe him?

AMELIA: Suppose I do not; is it to his honor that I believe he tells a falsehood?

BARON: He is mistaken merely.

AMELIA: Indeed, my lord, in one respect I am sure he speaks truth. For

our old butler told my waiting-maid of a poor young creature who has been deceived, undone; and she, and her whole family, involved in shame and sorrow by his perfidy.

BARON: Are you sure the butler said this?

AMELIA: See him and ask him. He knows the whole story, indeed he does; the names of the persons, and every circumstance.

BARON: Desire he may be sent to me.

AMELIA: [*Goes to the door and calls*] Order old Verdun to come to the Baron directly.

BARON: I know tale-bearers are apt to be erroneous. I'll hear from himself the account you speak of.

AMELIA: I believe it is in verse.

BARON: [*Angry*] In verse!

AMELIA: But then, indeed, it's true.

Enter BUTLER.

AMELIA: Verdun, pray have not you some true poetry?

BUTLER: All my poetry is true and, so far, better than some people's prose.

BARON: But I want prose on this occasion, and command you to give me nothing else. [BUTLER *bows*] Have you heard of an engagement which Count Cassel is under to any other woman than my daughter?

BUTLER: I am to tell your honor in prose?

BARON: Certainly. [BUTLER *appears uneasy and loath to speak*] Amelia, he does not like to divulge what he knows in presence of a third person—leave the room.

Exit AMELIA.

BUTLER: No, no, that did not cause my reluctance to speak.

BARON: What then?

BUTLER: Your not allowing me to speak in verse—for here is the poetic poem. [*Holding up a paper*]

BARON: How dare you presume to contend with my will? Tell in plain language all you know on the subject I have named.

BUTLER: Well then, my lord, if you must have the account in quiet prose, thus it was: Phoebus, one morning, rose in the East, and having handed in the long-expected day, he called up his brother Hymen—

BARON: Have done with your rhapsody.

BUTLER: Aye; I knew you'd like it best in verse—

"There lived a lady in this land,
Whose charms the heart made tingle;
At church she had not given her hand
And therefore still was single."

BARON: Keep to prose.

BUTLER: I will, my lord; but I have repeated it so often in verse, I scarce know how. Count Cassel, influenced by the designs of Cupid in his very worst humor,

"Count Cassel wooed this maid so rare,
And in her eye found grace
And if his purpose was not fair—"

BARON: No verse.

BUTLER: "It probably was base."

I beg your pardon, my lord; but the verse will intrude in spite of my efforts to forget it. 'Tis as difficult for me at times to forget, as 'tis for other men at times to remember. But in plain truth, my lord, the Count was treacherous, cruel, forsworn.

BARON: I am astonished!

BUTLER: And would be more so if you would listen to the whole poem. [*Most earnestly*] Pray, my lord, listen to it.

BARON: You know the family? All the parties?

BUTLER: I will bring the father of the damsel to prove the veracity of my muse. His name is Baden—poor old man!

"The sire consents to bless the pair,
And names the nuptial day,
When, lo! the bridegroom was not there,
Because he was away."

BARON: But tell me, had the father his daughter's innocence to deplore?

BUTLER: Ah! My lord, ah! And you *must* hear that part in rhyme.
Loss of innocence never sounds well except in verse.
"For ah! the very night before,
No prudent guard upon her,
The Count he gave her oaths a score.
And took in change her honor.
"MORAL.
Then you, who now lead single lives,
From this sad tale beware;
And do not act as you were wives,
Before you really are."

Enter COUNT CASSEL

BARON: [*To the* BUTLER] Leave the room instantly.
COUNT: Yes, good Mr. Family Poet, leave the room, and take your
doggerels with you.
BUTLER: Don't affront my poem, your honor; for I am indebted to
you for the plot.
"The Count he gave her oaths a score
And took in change her honor."

Exit BUTLER.

BARON: Count, you see me agitated.
COUNT: What can be the cause?
BARON: I'll not keep you in doubt a moment. You are accused, young
man, of being engaged to another woman while you offer
marriage to my child.
COUNT: To only *one* other woman?
BARON: What do you mean?
COUNT: My meaning is, that when a man is young and rich, has
travelled, and is no personal object of disapprobation, to have
made vows but to one woman, is an absolute slight upon the
rest of the sex.
BARON: Without evasion, sir, do you know the name of Baden? Was
there ever a promise of marriage made by you to his daughter?

Answer me plainly; or must I take a journey to inquire of the father?

COUNT: No; he can tell you no more than, I dare say, you already know, and which I shall not contradict.

BARON: Amazing insensibility! And can you hold your head erect while you acknowledge perfidy?

COUNT: My dear Baron, if every man, who deserves to have a charge such as this brought against him, was not permitted to look up, it is a doubt whom we might not meet crawling on all fours. [*He accidentally taps the* BARON'*s shoulder*]

BARON: [*Starts—recollects himself—then in a faltering voice*] Yet—nevertheless—the act is so atrocious—

COUNT: But nothing new.

BARON: [*Faintly*] Yes—I hope—I hope it is new.

COUNT: What, did you never meet with such a thing before?

BARON: [*Agitated*] If I have—I pronounced the man who so offended—a villain.

COUNT: You are singularly scrupulous. I question if the man thought himself so.

BARON: Yes, he did.

COUNT: How do you know?

BARON: [*Hesitating*] I have heard him say so.

COUNT: But he ate, drank and slept, I suppose?

BARON: [*Confused*] Perhaps he did.

COUNT: And was merry with his friends; and his friends as fond of him as ever?

BARON: Perhaps [*Confused*]—perhaps they were.

COUNT: And perhaps he now and then took upon him to lecture young men for their gallantries?

BARON: Perhaps he did.

COUNT: Why then, after all, Baron, your villain is a mighty good, prudent, honest fellow; and I have no objection to your giving me that name.

BARON: But do you not think of some atonement to the unfortunate girl?

COUNT: Did *your* villain atone?

BARON: No. When his reason was matured, he wished to make some recompense, but his endeavours were too late.

COUNT: I will follow his example, and wait till my reason is matured before I think myself competent to determine what to do.

BARON: And till that time I defer your marriage with my daughter.

COUNT: Would you delay her happiness so long? Why, my dear Baron, considering the fashionable life I lead, it may be these ten years before my judgement arrives to its necessary standard.

BARON: I have the headache, Count. These tidings have discomposed, disordered me. I beg your absence for a few minutes.

COUNT: I obey. And let me assure you, my lord, that although, from the extreme delicacy of your honor, you have ever through life shuddered at seduction, yet there are constitutions and there are circumstances in which it can be palliated.

BARON: [*Violently*] Never.

COUNT: Not in a grave, serious, reflecting man such as *you*, I grant. But in a gay, lively, inconsiderate, flimsy, frivolous coxcomb, such as myself, it is excusable: for me to keep my word to a woman would be deceit: 'tis not expected of me. It is in my character to break oaths in love; as it is in your nature, my lord, never to have spoken any thing but wisdom and truth. [*Exit*]

BARON: Could I have thought a creature so insignificant as that, had power to excite sensations such as I feel at present! I am, indeed, worse than he is, as much as the crimes of a man exceed those of an idiot.

Enter AMELIA.

AMELIA: I heard the Count leave you, my lord, and so I am come to enquire—

BARON: [*Sitting down, and trying to compose himself*] You are not to marry Count Cassel—and now, mention his name to me no more.

AMELIA: I won't—indeed, I won't—for I hate his name. But thank you, my dear father, for this good news [*Draws a chair, and*

sits on the opposite side of the table on which he leans. After a pause] And who am I to marry?

BARON: [*His head on his hand*] I can't tell. [AMELIA *appears to have something on her mind which she wishes to disclose*]

AMELIA: I never liked the Count.

BARON: No more did I.

AMELIA: [*After a pause*] I think love comes just as it pleases, without being asked.

BARON: [*In deep thought*] It does so.

AMELIA: [*After another pause*] And there are instances where, perhaps, the object of love makes the passion meritorious.

BARON: To be sure, there are.

AMELIA: For example, my affection for Mr. Anhalt as my tutor.

BARON: Right.

AMELIA: [*After another pause*] I should like to marry. [*Sighing*]

BARON: So you shall. [*A pause*] It is proper for everybody to marry.

AMELIA: Why, then, does not Mr. Anhalt marry?

BARON: You must ask him that question yourself.

AMELIA: I have.

BARON: And what did he say?

AMELIA: Will you give me leave to tell you what he said?

BARON: Certainly.

AMELIA: And what I said to him?

BARON: Certainly.

AMELIA: And you won't be angry?

BARON: Undoubtedly not.

AMELIA: Why, then—you know you commanded me never to disguise or conceal the truth.

BARON: I did so.

AMELIA: Why then, he said—

BARON: What did he say?

AMELIA: He said he would not marry me without your consent for the world.

BARON: [*Starting from his chair*] And pray, how came this the subject of your conversation?

AMELIA: [*Rising*] I brought it up.

BARON: And what did you say?

AMELIA: I said that birth and fortune were such old-fashioned things to me, I cared nothing about either, and that I had once heard my father declare he should consult my happiness, in marrying me, beyond any other consideration.

BARON: I will once more repeat to you my sentiments. It is the custom in this country for the children of nobility to marry only with their equals; but as my daughter's content is more dear to me than an ancient custom, I would bestow you on the first man I thought calculated to make you happy. By this I do not mean to say that I should not be severely nice in the character of the man to whom I gave you; and Mr. Anhalt, from his obligations to me, and his high sense of honor, thinks too nobly—

AMELIA: Would it not be noble to make the daughter of his benefactor happy?

BARON: But when that daughter is a child, and thinks like a child—

AMELIA: No, indeed, papa, I begin to think very like a woman. Ask *him* if I don't.

BARON: Ask him! You feel gratitude for the instructions you have received from him, and you fancy it love.

AMELIA: Are there two gratitudes?

BARON: What do you mean?

AMELIA: Because I feel gratitude to you; but that is very unlike the gratitude I feel towards him.

BARON: Indeed!

AMELIA: Yes; and then he feels another gratitude towards me. What's that?

BARON: Has he told you so?

AMELIA: Yes.

BARON: That was not right of him.

AMELIA: Oh! If you did but know how I surprised him!

BARON: Surprised him?

AMELIA: He came to me by your command, to examine my heart

respecting Count Cassel. I told him that I would never marry the Count.

BARON: But him?

AMELIA: Yes, him.

BARON: Very fine indeed! And what was his answer?

AMELIA: He talked of my rank in life; of my aunts and cousins; of my grandfather, and great-grandfather; of his duty to you; and endeavoured to persuade me to think no more of him.

BARON: He acted honestly.

AMELIA: But not politely.

BARON: No matter.

AMELIA: Dear father! I shall never be able to love another, never be happy with anyone else! [*Throwing herself on her knees*]

BARON: Rise, I command you.

As she rises, enter ANHALT.

ANHALT: My lord, forgive me! I have ventured, on the privilege of my office, as a minister of holy charity, to bring the poor soldier, whom your justice has arrested, into the adjoining room; and I presume to entreat you will admit him to your presence, and hear his apology or his supplication.

BARON: Anhalt, you have done wrong. I pity the unhappy boy, but you know I cannot, must not, forgive him.

ANHALT: I beseech you then, my lord, to tell him so yourself. From your lips he may receive his doom with resignation.

AMELIA: Oh father! See him and take pity on him; his sorrows have made him frantic.

BARON: Leave the room, Amelia. [*On her attempting to speak, he raises his voice*] Instantly! [*Exit* AMELIA]

ANHALT: He asked a private audience; perhaps he has some confession to make that may relieve his mind, and may be requisite for you to hear.

BARON: Well, bring him in, and do you wait in the adjoining room, till our conference is over. I must then, sir, have a conference with you.

ANHALT: I shall obey your commands.

> ANHALT *goes to the door, and re-enters with* FREDERICK. ANHALT *then retires at the same door.*

BARON: [*Haughtily to* FREDERICK] I know, young man, you plead your mother's wants in excuse for an act of desperation; but powerful as this plea might be in palliation of a fault, it cannot extenuate a crime like yours.

FREDERICK: I have a plea for my conduct even more powerful than a mother's wants.

BARON: What's that?

FREDERICK: My father's cruelty.

BARON: You have a father then?

FREDERICK: I have, and a rich one—nay, one that's reputed virtuous, and honorable. A great man, possessing estates and patronage in abundance; much esteemed at court, and beloved by his tenants; kind, benevolent, honest, generous—

BARON: And with all those great qualities, abandons you?

FREDERICK: He does, with all the qualities I mention.

BARON: Your father may do right. A dissipated, desperate youth, whom kindness cannot draw from vicious habits, severity may.

FREDERICK: You are mistaken. My father does not discard me for my vices. He does not know me, has never seen me. He abandoned me, even before I was born.

BARON: What do you say?

FREDERICK: The tears of my mother are all that I inherit from my father. Never has he protected or supported me, never protected her.

BARON: Why don't you apply to his relations?

FREDERICK: They disown me, too; I am, they say, related to no one. All the world disclaim me, except my mother—and there again, I have to thank my father.

BARON: How so?

FREDERICK: Because I am an illegitimate son. My seduced mother has brought me up in patient misery. Industry enabled her to

give me an education, but the days of my youth commenced with hardship, sorrow and danger. My companions lived happy around me, and had a pleasing prospect in their view, while bread and water only were my food, and no hopes joined to sweeten it. But my father felt not that!

BARON: [*To himself*] He touches my heart.

FREDERICK: After five years' absence from my mother, I returned this very day, and found her dying in the streets for want—not even a hut to shelter her, or a pallet of straw. But my father, he feels not that! He lives in a palace, sleeps on the softest down, enjoys all the luxuries of the great; and when he dies, a funeral sermon will praise his great benevolence, his Christian charities.

BARON: [*Greatly agitated*] What is your father's name?

FREDERICK: He took advantage of an innocent young woman, gained her affection by flattery and false promises; gave life to an unfortunate being, who was on the point of murdering his father.

BARON: [*Shuddering*] Who is he?

FREDERICK: Baron Wildenhaim. [*The* BARON'*s emotion expresses the sense of amazement, guilt, shame, and horror*] In this house did you rob my mother of her honor, and in this house I am a sacrifice for the crime. I am your prisoner—I will not be free—I am a robber—I give myself up. You shall deliver me into the hands of justice; you shall accompany me to the spot of public execution. You shall hear in vain the chaplain's consolation and injunctions. You shall find how I, in despair, will, to the last moment, call for retribution on my father.

BARON: Stop! Be pacified—

FREDERICK: And when you turn your head from my extended corse, you will behold my weeping mother. Need I paint how her eyes will greet you?

BARON: Desist—barbarian, savage, stop!

Enter ANHALT *alarmed.*

ANHALT: What do I hear? What is this? Young man, I hope you have not made a second attempt.

FREDERICK: Yes; I have done what it was your place to do. I have made a sinner tremble [*Points to the* BARON, *and exit*]

ANHALT: What can this mean? I do not comprehend—

BARON: He is my son! He is my son! Go, Anhalt, advise me—help me—Go to the poor woman, his mother—He can show you the way—make haste—speed to protect her—

ANHALT: But what am I to—

BARON: Go! Your heart will tell you how to act. [*Exit* ANHALT. BARON *distractedly*] Who am I? What am I? Mad—raving—no—I have a son—a son! The bravest—I will—I must—oh! [*With tenderness*] Why have I not embraced him yet? [*Increasing his voice*] Why not pressed him to my heart? Ah! See—[*Looking after him*] He flies from the castle. Who's there? Where are my attendants? [*Enter two* SERVANTS] Follow him—bring the prisoner back. But observe my command—treat him with respect—treat him as my son—and your master. [*Exeunt*]

ACT V, SCENE I

Inside of the cottage (as in Act II). AGATHA, COTTAGER, *and his* WIFE *discovered.*

AGATHA: Pray, look and see if he is coming.

COTTAGER: It is of no use. I have been in the road; have looked up and down; but neither see nor hear anything of him.

WIFE: Have a little patience.

AGATHA: I wish you would step out once more. I think he cannot be far off.

COTTAGER: I will; I will go. [*Exit*]

WIFE: If your son knew what Heaven had sent you, he would be here very soon.

AGATHA: I feel so anxious—

WIFE: But why? I should think a purse of gold, such as you have received, would make anybody easy.

AGATHA: Where can he be so long? He has been gone four hours. Some ill must have befallen him.

WIFE: It is still broad daylight; don't think of any danger. This evening we must all be merry. I'll prepare the supper. What a good gentleman our Baron must be! I am sorry I ever spoke a word against him.

AGATHA: How did he know I was here?

WIFE: Heaven only can tell. The servant that brought the money was very secret.

AGATHA: [*To herself*] I am astonished! I wonder! Oh! Surely he has been informed—why else should he have sent so much money?

Re-enter COTTAGER.

AGATHA: Well! Not yet!

COTTAGER: I might look till I am blind for him—but I saw our new rector coming along the road. He calls in sometimes; maybe he will this evening.

WIFE: He is a very good gentleman; pays great attention to his parishioners; and where he can assist the poor, he is always ready.

Enter MR. ANHALT.

ANHALT: Good evening, friends.

BOTH: Thank you, reverend sir. [*They both run to fetch him a chair*]

ANHALT: I thank you, good people. I see you have a stranger here.

COTTAGER: Yes, your Reverence; it is a poor sick woman, whom I took indoors.

ANHALT: You will be rewarded for it. [*To* AGATHA] May I beg leave to ask your name?

AGATHA: Ah! If we were alone—

ANHALT: Good neighbours, will you leave us alone for a few minutes? I have something to say to this poor woman.

COTTAGER: Wife, do you hear? Come along with me. [*Exeunt* COTTAGER *and his* WIFE]

ANHALT: Now—

AGATHA: Before I tell who I am, what I am, and what I was, I must beg to ask—are you of this country?

ANHALT: No, I was born in Alsace.

AGATHA: Did you know the late rector personally, whom you have succeeded?

ANHALT: No.

AGATHA: Then you are not acquainted with my narrative?

ANHALT: Should I find you to be the person whom I have long been in search of, your history is not altogether unknown to me.

AGATHA: "That you have been in search of"! Who gave you such a commission?

ANHALT: A man, who, if it so prove, is much concerned for your misfortunes.

AGATHA: How? Oh, sir! Tell me quickly, whom do you think to find in me?

ANHALT: Agatha Friburg.

AGATHA: Yes, I am that unfortunate woman; and the man who pretends to take concern in my misfortunes is—Baron Wildenhaim—he who betrayed me, abandoned me and my child, and killed my parents. He would now repair our sufferings with this purse of gold. [*Takes out the purse*] Whatever may be your errand, sir, whether to humble or to protect me, it is alike indifferent. I therefore request you to take this money to him who sent it. Tell him, my honor has never been saleable. Tell him, destitute as I am, even indigence will not tempt me to accept charity from my seducer. He despised my heart; I despise his gold. He has trampled on me; I trample on his representative. [*Throws the purse on the ground*]

ANHALT: Be patient. I give you my word, that when the Baron sent this present to an unfortunate woman, for whom her son had supplicated, he did not know that woman was Agatha.

AGATHA: My son? What of my son?

ANHALT: Do not be alarmed. The Baron met with an affectionate son, who begged for his sick mother, and it affected him.

AGATHA: Begged of the Baron! Of his father!

ANHALT: Yes; but they did not know each other; and the mother received the present on the son's account.

AGATHA: Did not know each other? Where is my son?

ANHALT: At the castle.

AGATHA: And still unknown?

ANHALT: Now he is known. An explanation has taken place, and I am sent here by the Baron, not to a stranger, but to Agatha Friburg—not with gold! His commission was—"do what your heart directs you."

AGATHA: How is my Frederick? How did the Baron receive him?

ANHALT: I left him just in the moment the discovery was made. By this time your son is, perhaps, in the arms of his father.

AGATHA: Oh! Is it possible that a man, who has been twenty years deaf to the voice of nature, should change so suddenly?

ANHALT: I do not mean to justify the Baron, but—he has loved you—and fear of his noble kindred alone caused his breach of faith to you.

AGATHA: But to desert me wholly and wed another—

ANHALT: War called him away. Wounded in the field, he was taken to the adjacent seat of a nobleman, whose only daughter, by anxious attention to his recovery, won his gratitude; and, influenced by the will of his worldly friends, he married. But no sooner was I received into the family, and admitted to his confidence, than he related to me your story; and at times would exclaim in anguish, "The proud imperious Baroness avenges the wrongs of my deserted Agatha." Again, when he presented me this living, and I left France to take possession of it, his last words before we parted, were "The moment you arrive at Wildenhaim, make all enquiries to find out my poor Agatha." Every letter I afterwards received from him contained "Still, still, no tidings of my Agatha." And fate ordained it should be so, till this fortunate day.

AGATHA: What you have said has made my heart overflow. Where will this end?

ANHALT: I know not yet the Baron's intentions: but your sufferings demand immediate remedy: and one way only is left. Come with me to the castle. Do not start; you shall be concealed in my apartments till you are called for.

AGATHA: I go to the Baron's? No.

ANHALT: Go for the sake of your son; reflect that his fortunes may depend upon your presence.

AGATHA: And he is the only branch on which my hope still blossoms: the rest are withered. I will forget my wrongs as a woman, if the Baron will atone to the mother. He shall have the woman's pardon, if he will merit the mother's thanks. [*After a struggle*] I *will* go to the castle—for the sake of my Frederick, go even to his father. But where are my good host and hostess, that I may take leave, and thank them for their kindness?

ANHALT: [*Taking up the purse which* AGATHA *had thrown down*] Here, good friend! Good woman!

Enter the COTTAGER *and his* WIFE.

WIFE: Yes, yes, here am I.

ANHALT: Good people, I will take your guest with me. You have acted an honest part, and therefore receive this reward for your trouble. [*He offers the purse to the* COTTAGER, *who puts it by, and turns away. To the* WIFE] Do *you* take it.

WIFE: I always obey my pastor. [*Taking it*]

AGATHA: Goodbye. [*Shaking hands with the* COTTAGERS] For your hospitality to me, may ye enjoy continued happiness.

COTTAGER: Fare you well—fare you well.

WIFE: If you find friends and get health, we won't trouble you to call on us again: but if you should fall sick or be in poverty, we shall take it very unkind if we don't see you.

Exeunt AGATHA *and* ANHALT *on one side,* COTTAGER *and his* WIFE *on the other.*

ACT V, SCENE II

A room in the Castle. BARON *sitting upon a sofa,* FREDERICK *standing near him, with one hand pressed between his—the* Baron *rises.*

BARON: Been in battle too! I am glad to hear it. You have known hard services, but now they are over, and joy and happiness

will succeed. The reproach of your birth shall be removed, for I will acknowledge you my son, and heir to my estate.

FREDERICK: And my mother—

BARON: She shall live in peace and affluence. Do you think I would leave your mother unprovided, unprotected? No! About a mile from this castle I have an estate called Weldendorf. There she shall live, and call her own whatever it produces. There she shall reign, and be sole mistress of the little paradise. There her past sufferings shall be changed to peace and tranquillity. On a summer's morning, we, my son, will ride to visit her; pass a day, a week with her; and in this social intercourse time will glide pleasantly.

FREDERICK: And, pray, my Lord, under what name is my mother to live then?

BARON: [*Confused*] How?

FREDERICK: In what capacity? As your domestic—or as—

BARON: That we will settle afterwards.

FREDERICK: Will you allow me, sir, to leave the room a little while, that you may have leisure to consider *now*?

BARON: I do not know how to explain myself in respect to your mother more than I have done already.

FREDERICK: My fate, whatever it may be, shall never part me from her. This is my firm resolution, upon which I call Heaven to witness! My Lord, it must be Frederick of Wildenhaim, and Agatha of Wildenhaim—or Agatha Friburg, and Frederick Friburg. [*Exit*]

BARON: [*Calling after him*] Young man! Frederick!—Hasty indeed! Would make conditions with his father. No, no, that must not be. I just now thought how well I had arranged my plans—had relieved my heart of every burden, when, a second time he throws a mountain upon it. Stop, friend conscience, why do you take his part? For twenty years thus you have used me, and been my torture. [*Enter* ANHALT] Ah! Anhalt, I am glad you are come. My conscience and myself are at variance.

ANHALT: Your conscience is in the right.

BARON: You don't know yet what the quarrel is.

ANHALT: Conscience is always right, because it never speaks unless it *is* so.

BARON: Aye, a man of your order can more easily attend to its whispers than an old warrior. The sound of cannon has made him hard of hearing. I have found my son again, Mr. Anhalt, a fine, brave young man. I mean to make him my heir. Am I in the right?

ANHALT: Perfectly.

BARON: And his mother shall live in happiness. My estate, Weldendorf, shall be hers; I'll give it to her, and she shall make it her residence. Don't I do right?

ANHALT: No.

BARON: [*Surprised*] No? And what else should I do?

ANHALT: [*Forcibly*] Marry her.

BARON: [*Starting*] I marry her!

ANHALT: Baron Wildenhaim is a man who will not act inconsistently. As this is my opinion, I expect your reasons, if you do not.

BARON: Would you have me marry a beggar?

ANHALT: [*After a pause*] Is that your only objection?

BARON: [*Confused*] I have more—many more.

ANHALT: May I beg to know them likewise?

BARON: My birth!

ANHALT: Go on.

BARON: My relations would despise me.

ANHALT: Go on.

BARON: [*In anger*] 'Sdeath! Are not these reasons enough? I know no other.

ANHALT: Now, then, it is my turn to state mine for the advice I have given you. But first, I presume to ask a few questions. Did Agatha, through artful insinuation, gain your affection? Or did she give you cause to suppose her inconstant?

BARON: Neither; but for me, she was always virtuous and good.

ANHALT: Did it cost you trouble and earnest entreaty to make her otherwise?

BARON: [*Angrily*] Yes.

ANHALT: You pledged your honor?

BARON: [*Confused*] Yes.

ANHALT: Called God to witness?

BARON: [*More confused*] Yes.

ANHALT: The witness you called at that time was the Being who sees you now. What you gave in pledge was your honor, which you must redeem. Therefore thank Heaven that it is in your power to redeem it. By marrying Agatha the ransom's made, and she brings a dower greater than any princess can bestow: peace to your conscience. If you then esteem the value of this portion, you will not hesitate a moment to exclaim "Friends, wish me joy, I will marry Agatha."

> BARON, *in great agitation, walks backwards and forwards, then takes* ANHALT *by the hand.*

BARON: "Friend, wish me joy—I will marry Agatha."

ANHALT: I do wish you joy.

BARON: Where is she?

ANHALT: In the castle, in my apartments here. I conducted her through the garden, to avoid curiosity.

BARON: Well, then, this is the wedding day. This very evening you shall give us your blessing.

ANHALT: Not so soon, not so private. The whole village was witness of Agatha's shame; the whole village must be witness of Agatha's re-established honor. Do you consent to this?

BARON: I do.

ANHALT: Now the quarrel is decided. Now is your conscience quiet?

BARON: As quiet as an infant's. I only wish the first interview was over.

ANHALT: Compose yourself. Agatha's heart is to be your judge.

Enter AMELIA.

BARON: Amelia, you have a brother.

AMELIA: I have just heard so, my lord; and rejoice to find the news confirmed by you.

BARON: I know, my dear Amelia, I can repay you for the loss of Count Cassel; but what return can I make to you for the loss of half your fortune?

AMELIA: My brother's love will be ample recompense.

BARON: I will reward you better. Mr. Anhalt, the battle I have just fought, I owe to myself: the victory I gained, I owe to you. A man of your principles, at once a teacher and an example of virtue, exalts his rank in life to a level with the noblest family and I shall be proud to receive you as my son.

ANHALT: [*Falling on his knees, and taking the* BARON*'s hand*] My lord, you overwhelm me with confusion, as well as with joy.

BARON: My obligations to you are infinite; Amelia shall pay the debt. [*Gives her to him*]

AMELIA: Oh, my dear father! [*Embracing the* BARON] What blessings have you bestowed on me in one day. [*To* ANHALT] I will be your scholar still, and use more diligence than ever to please my master.

ANHALT: His present happiness admits of no addition.

BARON: Nor does mine. And yet there is another task to perform that will require more fortitude, more courage, than this has done! A trial that [*Bursts into tears*] I cannot prevent them—Let me—let me—A few minutes will bring me to myself. Where is Agatha?

ANHALT: I will go, and fetch her. [*Exit* ANHALT *at an upper entrance*]

BARON: Stop! Let me first recover a little. [*Walks up and down, sighing bitterly—looks at the door through which* ANHALT *left the room*] That door she will come from; that was once the dressing room of my mother. From that door I have seen her come many times, have been delighted with her lovely smiles. How shall I now behold her altered looks! Frederick must be my mediator. Where is he? Where is my son? Now I am ready; my heart is prepared to receive her. Haste, haste! Bring her in.

He looks steadfastly at the door. ANHALT *leads on* AGATHA. *The* BARON *runs and clasps her in his arms. Supported by him, she*

sinks on a chair which AMELIA *places in the middle of the stage. The* BARON *kneels by her side, holding her hand.*

BARON: Agatha, Agatha, do you know this voice?

AGATHA: Wildenhaim.

BARON: Can you forgive me?

AGATHA: I forgive you. [*Embracing him*]

FREDERICK: [*As he enters*] I hear the voice of my mother!—Ha! Mother! Father!

> FREDERICK *throws himself on his knees by the other side of his mother. She clasps him in her arms.* AMELIA *is placed on the side of her father attentively viewing* AGATHA. ANHALT *stands on the side of* FREDERICK *with his hands gratefully raised to Heaven. The curtain slowly drops.*

EPILOGUE

Our drama now ended, I'll take up your time
Just a moment or two in defence of my rhyme—
"*Though I hope that among you are *some* who admired
What I've hitherto said, dare I hope none are tired?
But whether ye have or have not heard enough,
Or whether nice critics will think it all stuff,
To myself rhyme has ever appeared, I must own,
In its nature a sort of philosopher's stone;
And if chymists would use it, they'd not make a pother,
And puzzle their brains to find out any other."
Indeed 'tis most strange and surprising to me
That all folks in rhyming their int'rest can't see;
For I'm sure if its use were quite common with men,
The world would roll on just as pleasant again.
"'Tis said, that while Orpheus was striking his lyre,
Trees and brutes danced along to the sound of the wire;
That Amphion to walls soon converted the glebes,
And they rose, as he sung, to a city called Thebes;
I suppose they were butlers (like me) of that time,
And the tale shows our sires knew the wonders of rhyme."
From time immemorial, your lovers, we find,
When their mistresses' hearts have been proud and unkind,
Have resorted to rhyme; and indeed it appears
That a rhyme would do more than a bucket of tears.
Of love, from experience, I speak—odds my life!
I shall never forget how I courted my wife:
She had offers in plenty; but always stood neuter
Till I, with my pen, started forth as a suitor;
Yet made I no mean present of ribband or bonnet,
My present was caught from the stars—'twas a sonnet.
"And now you know this, sure 'tis needless to say,

* The lines between inverted commas are not spoken

That prose was neglected, and rhyme won the day—
But its potent effects you as well may discover
In the husband and wife as in mistress and lover;
There are some of ye here, who, like me, I conjecture,
Have been lulled into sleep by a good curtain lecture.
But that's a mere trifle; you'll ne'er come to blows,
If you'll only avoid that dull enemy, prose.
Adopt, then, my plan, and the very next time,
That in words you fall out, let them fall into rhyme;
Thus your sharpest disputes will conclude very soon,
And from jangling to jingling you'll chime into tune.
If my wife were to call me a 'drunken old sot,'
I should merely just ask her what butler is not?
And bid her take care that she don't go to pot.
So our squabbles continue a very short season:
If she yields to my rhyme, I allow she has reason."
Independent of this, I conceive rhyme has weight
In the higher employments of Church and of State,
And would in my mind such advantages draw,
'Tis a pity that rhyme is not sanctioned by law;
"For 'twould really be serving us all, to impose
A capital fine on a man who spoke prose."
Mark the pleader who clacks, in his client's behalf,
His technical stuff for three hours and a half;
Or the fellow who tells you a long stupid story
And over and over the same lays before ye;
Or the member who raves till the whole house are dosing.
What d'ye say of such men? Why, you say they are prosing.
So, of course, then, if prose is so tedious a crime,
It of consequence follows, there's virtue in rhyme.
The best piece of prose that I've heard a long while,
Is what gallant Nelson has sent from the Nile.
And had he but told us the story in rhyme,
What a thing 'twould be; but perhaps he'd no time.
So I'll do it myself. Oh! 'tis glorious news!
Nine sail of the line! Just a ship for each Muse.

As I live, there's an end of the French and their navy—
Sir John Warren has sent the Brest fleet to Old Davy.
'Tis in the *Gazette*, and that, everyone knows,
Is sure to be truth, though 'tis written in prose.

Notes to Lovers' Vows

PREFACE

See the Introduction for a discussion of Inchbald's Preface.

DRAMATIS PERSONAE

While "Agatha" means "good" in classical Greek, "Frederick" is a resoundingly German name, which the young soldier shares, most obviously, with the greatest Prussian leader of the period, Frederick the Great (1712–86).

See the Introduction for the politics of casting and characters in *Mansfield Park*.

PROLOGUE

The Prologue and Epilogue, as well as all of the poetry, were written by John Tayler, whose own account of contributing to *Lovers' Vows* appears in his *Records of My Life* (London: Edward Bull, 1832), in the first volume, pp. 403–4. He depicts playwrights seeking inspiration as huntsmen who can at least resort to "*old game*" if they fail

to find "novelty" on the well-worn tracks—perhaps being inspired himself by the short hunting scene in Act 3. *Lovers' Vows* goes against the contemporary grain, though, he says, by eschewing fashionable, sensational theatrical effects ("monstrous charms of terrible delight") of Gothic drama. This connects the play with a novel by Jane Austen other than *Mansfield Park*: she started work on *Northanger Abbey* in 1798, the year that *Lovers' Vows* was first performed. As Terry Castle points out in her Introduction to the 1990 Oxford edition, the novel begins with a "resounding no" (p. vii), not unlike Taylor's passage beginning with "No dreadful cavern, no midnight scream." Austen responded to the same popular trend in fiction, begun by *The Mysteries of Udolpho* by Anne Radcliffe (1794), that was pushing drama in the direction of spectacle and special effects. This was also to influence Hannah Cowley's decision to give up writing for the stage.

The footnote to "STRANGER" refers to Shakespeare's *Hamlet*, Act 2, scene 2, in which Hamlet welcomes a traveling troupe of players to Elsinore. He contradicts Polonius's assurance that they will be treated "according to their desert"; they should be treated "much better." *The Stranger* is the title of another highly successful drama adapted from Kotzebue, one that Inchbald acted in many times in 1798. Taylor may be reminding his audience how they welcomed a previous visit from the "German Muse."

The actor who played Baron Wildenhaim, Mr. Murray, spoke the Prologue.

ACT I

German dominions—The seemingly fixed concept of the "German dominions" was in fact a matter of considerable contention in the eighteenth century. See the discussion of *Lovers' Vows* in the Introduction.

Rhenish and Hock—English terms for German dry white wines from the same region, around the river Rhine. The latter is a contraction of the seventeenth-century English "hockamore," from the proper name Hochheimer.

Natural son—That is, a son born outside wedlock, "naturally." The play's German title, *Das Kind der Liebe*, offers yet another euphemism, the "Child of Love."

Oh Frederick, your wild looks are daggers to my heart. Another time.—Cf. Gertrude in *Hamlet*, Act 3, scene 4: "O speak to me no more,/ These Words like Daggers enter in my Ears,/ No more, sweet Hamlet." See note on the Prologue.

Alsace—Frederick's father has removed to what is now a north east region of France.

Pent-house—An outhouse with a sloping roof, a cheaply erected shelter.

ACT II, SCENE II

Hebe, Venus—The Count's hackneyed allusions to the goddesses of youthful spring (Hebe) and love (Venus) ring false in this proudly Gemanic home, as the Baron's irritated response makes clear.

The days of Alexander—Alexander the Great was King of Macedonia, 356–23 BC. He was also the hero of a frequently reprinted, revised and revived tragedy, *The Rival Queens* (1677) by Nathaniel Lee, so English audiences would be well aware of the traditional dual prowess as both lover and soldier to which the Count alludes.

ACT III, SCENE II

Auriculas—Flowers with ear-shaped leaves, as in *Primula auricula*.

Oh Muse, ascend the forked mount—Verdun shows the poetic instincts of a William McGonagall, temperamentally inclined to occasional verse, and deaf to rhyme and rhythm. Like the Count's classical references, his use of archaic terms, such as "pother" (commotion, din, uproar—the word crops up again in the butler's Epilogue), "ruth" (compassion or pity), and "eke" (also), has a bathetic effect on his "fine narration."

ACT IV, SCENE I

Hubert—This is the only time the cottager's name is used.

Compassionates—Feels pity for.

A dissipated, desperate youth, whom kindness cannot draw from vicious habits, severity may.—Punishment may reform a bad character if kindness cannot.

A pleasing prospect in their view—A promising, very likely happy, future.

ACT IV, SCENE II

Phoebus, Hymen, Cupid—In Greek mythology, Phoebus personifies the sun, and Hymen marriage. Cupid, though, is the Roman god of love.

Corse—Medieval form of "corpse."

ACT V, SCENE I

Indigence—Lack of means, poverty.

EPILOGUE

This was a comic vehicle for Mr. Munden as Verdun the butler, and a foil to the melodramatic climax of the drama.

The lines between inverted commas are not spoken.—Original note from the first edition. The quotation marks indicate paasages that were written by Taylor but cut from the performance.

Philosopher's stone—In alchemy (as practiced by "chymists"), this is the crucial element in turning base metal to gold, and even in procuring eternal life.

Orpheus—The mythical Greek poet and musician, said to be able to move animals and inanimate objects with his song.

Amphion—Amphion's music could move the earth itself, so he helped to build the walls of Thebes by playing on his lyre ("glebes" are lumps of soil).

Curtain lecture—"a wife's private reproof to her husband (orig. behind bed-curtains)," according to the OED. Douglas Jerrold wrote a humorous series of such reproofs for *Punch*, *Mrs. Caudle's Curtain Lectures*, in 1845.

Sot—A dolt, often a drunkard.

The Member who raves till the whole House are dosing—Cf. *The Belle's Stratagem*, Act 4, in which "Lord Trope" is certain to speak in Parliament for a couple of hours.

What gallant Nelson has sent from the Nile—Horatio Nelson (1758–1805) became Baron Nelson of the Nile and a national hero after the triumph of his Egyptian campaign in 1798, considered a major victory in the war against Napoleon.

Old Davy—Of unclear origin, "Old Davy" appears to be an eighteenth-century sailors' term for a watery grave. In the form of "Davy Jones's locker," it first saw print in Smollett's novel *Peregrine Pickle* (1751).

Further Reading

Recent editions of plays by eighteenth-century women include:

Finberg, Melinda, ed. *Eighteenth-Century Women Dramatists*. Oxford: Oxford University Press, 2001.

Hughes, Derek, ed. *Eighteenth-Century Women Playwrights*. London: Pickering and Chatto, 2001. A generous selection of plays in six volumes.

Morgan, Fidelis, ed. *The Female Wits: Women Playwrights on the London Stage, 1660–1720*. London: Virago, 1981.

Morgan, Fidelis, and Paddy Lyons, eds. *Female Playwrights of the Restoration*. London: Everyman, 1991.

Rogers, Katharine M., ed. *The Meridian Anthology of Restoration and Eighteenth-Century Plays by Women*. New York: Meridian, 1994.

Kendall, ed. *Love and Thunder: Plays by Women in the Age of Queen Anne*. London: Methuen, 1988.

Thalia Stathas has edited *A Bold Stroke for a Wife* in the Regents Restoration Drama Series (Lincoln: University of Nebraska, 1968), as did Nancy Copeland in 1995 (Peterborough, ONT: Broadview Press).

Editions of Eliza Haywood's plays include Paula Backscheider's

Selected Fiction and Drama of Eliza Haywood (Oxford: Oxford University Press, 1999) and Valerie G. Rudolph's *Plays of Eliza Haywood* (New York: Garland Press, 1983).

The Witlings appears in the *Early English Women Writers 1660–1800* series, edited by Clayton J. Delery (East Lansing, MN: Colleagues Press, 1995). It also appears in Katharine Rogers's *Meridian Anthology* and *The Complete Plays of Frances Burney*, edited by Peter Sabor (Montreal: McGill-Queen's University Press, 1995). The manuscript is held in the Berg Collection, New York Public Library.

The Belle's Stratagem appears in Finberg's anthology and *The "Other" Eighteenth Century: English Women of Letters, 1660–1800*, edited by Robert W. Uphaus and Gretchen M. Foster (East Lansing: Michigan State University Press, 1991). Frederick M. Link has edited a facsimile *Plays of Hannah Cowley* in two volumes (New York: Garland Press, 1979).

More of Elizabeth Inchbald can be found in Roger Manvell's *Selected Comedies* (New York: University Press of America, 1988) and Paula Backscheider's two-volume *Plays of Elizabeth Inchbald* (New York: Garland Press, 1980).

Jane Austen's "Sir Charles Grandison" was transcribed and exhaustively edited by Brian Southam (Oxford: Clarendon, 1980), and a facsimile was published separately by David Astor (Burford: Jubilee Books, 1981). The frail manuscript of "Sir Charles Grandison" has pride of place in the wonderful eighteenth-century collection at Chawton House Library in Hampshire. Margaret Anne Doody and Douglas Murray produced a useful volume of her miscellaneous works, *Catherine and Other Writings*, including the dramatic sketches (Oxford: Oxford University Press, 1993). Austen's early attempts at drama appear in the three "Volumes" of teenage notebooks dating from the 1790s. One is now held in the Bodleian Library in Oxford and the other two at British Library in London. R.W. Chapman edited *Volume the First* for publication by Oxford University Press in 1933, *Volume the Third* 1951, and the *Minor Works* in 1954, which was revised by B.C. Southam in 1969. Southam also edited *Volume the Second* (1963). James Austen's prologues and epilogues appear

in *The Complete Poems of James Austen, Jane Austen's Eldest Brother*, edited by David Selwyn (Chawton: The Jane Austen Society, 2003). See also Further Reading.

The following is a selective list of further reading on the eighteenth century, including female playwrights, the theatre, English culture and history:

Agan, Cami. "Catherine Clive's Media Relations: The Stage as Media and the Page as Performance," *Eighteenth-Century Women* 3 (2003), pp. 47–76.

Austen, Jane, edited by Tony Tanner. *Mansfield Park*. London: Penguin, 1966.

Avery, Emmett L., et al. *The London Stage, 1660–1800*. Carbondale, IL: Southern Illinois University Press, 1960–68.

Baird, Rosemary. *Mistress of the House: Great Ladies and Grand Houses, 1670–1830*. London: Weidenfeld and Nicolson, 2003. Includes a chapter on Elizabeth Montagu, "Bluestocking Bravado," pp. 169–197.

Bernbaum, Ernest. *The Drama of Sensibility*. Boston, MA: Ginn, 1915.

Boaden, James. *Memoirs of Mrs. Inchbald*, London: Bentley, 1833.

Bolton, Betsy. *Women, Nationalism and the Romantic Stage: Theatre and Politics in Britain, 1780–1800*. Cambridge: Cambridge University Press, 2001.

Bowyer, John Wilson. *The Celebrated Mrs. Centlivre*. Durham, NC: Duke University Press, 1952.

Brown, Laura S. "Drama and the novel in eighteenth-century England," *Genre* 13 (1980), pp. 287–304.

Burney, Fanny, edited by Lars E. Troide and Stewart J. Cooke. *The Early Journals and Letters of Fanny Burney, vol. 3: The Streatham Years: Part 1, 1778–1779*. Oxford: Clarendon Press, 1994.

Burney, Fanny, edited by Betty Rizzo. *The Early Journals and Letters of Fanny Burney, vol. 4: The Streatham Years: Part 2, 1780–1781*. Oxford: Clarendon Press, 2003.

Burroughs, Catherine, ed. *Women in British Romantic Theatre: Drama,*

Performance and Society, 1790–1840. Cambridge: Cambridge University Press, 2000.

Butler, E.M. "*Mansfield Park* and Kotzebue's *Lovers' Vows*," *Modern Languages Review* 28 (1933), pp. 326–37.

Byrne, Paula. *Jane Austen and the Theatre*. London: Hambledon and London, 2002.

Castle, Terry. *Masquerade and Civilization*. Stanford: Stanford University Press, 1986.

Chisholm, Kate. *Fanny Burney: Her Life, 1752–1840*. London: Chatto and Windus, 1998. See especially "Good Night Lady Smatter, 1779–80," pp. 82–99.

Clark, Constance. *Three Augustan Women Playwrights*. New York: Peter Lang, 1986.

Clarke, Norma. *The Rise and Fall of the Woman of Letters*. London: Pimlico, 2004.

Colley, Linda. *Britons: Forging the Nation, 1707–1837*. Yale University Press, 1992. See especially "Womanpower," pp. 237–81.

Cotton, Nancy. *Women Playwrights in England, c. 1363–1750*. Lewisburg: Bucknell University Press, 1980.

Darby, Barbara. *Frances Burney, Dramatist: Gender, Performance, and the Late Eighteenth-Century Stage*. Lexington: Kentucky University Press, 1997.

Davenport, Hester. *Faithful Handmaid: Fanny Burney at the Court of King George III*. Stroud: Sutton Publishing, 2000.

Donkin, Ellen. *Getting Into the Act: Women Playwrights in London, 1776–1829*. London: Routledge, 1995.

Doody, Margaret Anne. *Frances Burney: The Life in the Works*. New Brunswick: Rutgers University Press, 1988.

Fernald, Karin. "Fanny Burney and the Witlings," *The New Rambler* Serial No. E 11 (1998–1999), pp. 38–50.

Fisher, Judith W. "The Stage on the Page: Sarah Siddons and Ann Radcliffe," *Eighteenth-Century Women* 2 (2002), pp. 243–63.

Frank, Marcie. *Gender, Theatre, and the Origins of Criticism: From Dryden to Manley*. Cambridge: Cambridge University Press, 2003.

Fraser, Antonia. *The Weaker Vessel: Women's Lot in Seventeenth-Century*

England. London: William Heinemann, 1984. See especially "Petticoat Authors," pp. 407–434, and "Actress as Honey-Pot," pp. 511–36.

Gallagher, Catherine. *Nobody's Story: The Vanishing Acts of Women Writers in the Marketplace, 1670–1820*. Berkeley: California University Press, 1994.

Gay, Penny. *Jane Austen and the Theatre*. Cambridge University Press, 2002.

Greer, Germaine. *Slip-Shod Sibyls: Recognition, Rejection and the Woman Poet*. London: Viking, 1995.

Haywood, Eliza, edited by Gabrielle M. Firmager. *The Female Spectator*. London: Bristol Classical Press, 1993.

Hemlow, Joyce. "Fanny Burney: Playwright," *University of Toronto Quarterly* 19 (1950), pp. 170–90.

Hemlow, Joyce. *The History of Fanny Burney*. Oxford: Clarendon Press, 1958.

Highfill, Philip H., et al, eds. *A Biographical Dictionary of Actors, Actresses, Musicians, Dancers, Managers and Other Stage Personnel in London, 1660–1800*. Carbondale, IL: Southern Illinois University Press, 1973.

Holland, Peter. *The Ornament of Action: Text and Performance in Restoration Comedy*. Cambridge: Cambridge University Press, 1979.

Holland, Peter, and Michael Patterson. "Eighteenth-Century Theatre," in *The Oxford Illustrated History of Theatre*, edited by John Russell Brown, pp. 255–298. Oxford: Oxford University Press, 1995.

Hopkins, Mary Alden. *Hannah More and Her Circle*. New York: Longmans, Green and Co., 1947.

Hume, Robert D., ed. *The London Theatre World, 1660–1800*. Carbondale, IL: Southern Illinois University Press, 1980.

Hume, Robert D. *The Rakish Stage: Studies in English Drama, 1660–1800*. Carbondale, IL: Southern Illinois University Press, 1983.

Jenkins, Annibel. *I'll Tell You What: The Life of Elizabeth Inchbald*. Lexington: Kentucky University Press, 2003.

Jones, Vivien, ed. *Women and Literature in Britain, 1700–1800*. Cam-

bridge: Cambridge University Press, 2000. Includes Angela J. Smallwood, "Women and the Theatre," pp. 238–262.

Justice, George L. Justice. "Suppression and censorship in late manuscript culture: Frances Burney's unperformed *The Witlings*," in *Women's Writing and the Circulation of Ideas: Manuscript publication in England, 1550–1800*, edited by George L. Justice and Nathan Tinker, pp. 201–222. Cambridge: Cambridge University Press, 2002.

Keener, Frederick M., and Susan E. Lorsch, eds *Eighteenth-Century Women and the Arts*. New York: Greenwood Press, 1988.

Langford, Paul. *A Polite and Commercial People: England, 1727–1783*. Oxford: Oxford University Press, 1989.

Laurence, Anne. *Women in England, 1500–1760: A Social History*. London: Weidenfeld and Nicolson, 1994.

Litvak, Joseph. "The Infection of Acting: Theatricals and Theatricality in *Mansfield Park*," *English Literary History* 93.2 (1986), pp. 331–55.

Lock, F. *Susannah Centlivre*. Boston: Twayne, 1979.

Manvell, Roger. *Elizabeth Inchbald: England's Principal Woman Dramatist and Independent Woman of Letters in Eighteenth Century London*. New York: University Press of America, 1988.

McDowell, Paula. "Consuming Women: The Life of the 'Literary Lady' as Popular Culture in Eighteenth-Century England," *Genre* 26 (1993), pp. 219–52.

Nicoll, Allardyce. *A History of English Drama, 1660–1900*. Cambridge: Cambridge University Press, second edition 1952. See especially the second and third volumes.

Nicoll, Allardyce. *The Garrick Stage: Theatres and Audience in the Eighteenth Century*. Manchester: Manchester University Press, 1980.

Pearson, Jacqueline. *The Prostituted Muse: Images of Women and Women Dramatists, 1642–1737*. New York: St. Martin's Press, 1988.

Poovey, Mary. *The Proper Lady and the Woman Writer*. Chicago: Chicago University Press, 1984.

Price, Cecil. *Theatre in the Age of Garrick*. Oxford: Oxford University Press, 1973.

Prior, Mary. *Women in English Society, 1500–1800*. London: Methuen, 1985.

Ranger, Paul. *"Terror and Pity in Every Breast": Gothic Drama in the London Patent Theatres, 1750–1820*. London: Society for Theatre Research, 1991.

Reitzel, William. *"Mansfield Park and Lovers' Vows,"* *Review of English Studies* 9 (1933), pp. 451–56.

Rogers, Katharine M. *Feminism in Eighteenth-Century England*. Urbana: University of Illinois Press, 1982.

Schofield, Mary Anne. *Eliza Haywood*. Boston: Twayne, 1985.

Schofield, Mary Anne, and Cecilia Macheski, eds. *Curtain Calls: British and American Women and the Theater, 1660–1820*. Athens, OH: Ohio University Press, 1991. Includes Douglas R. Butler's "Plot and Politics in Susannah Centlivre's *A Bold Stroke for a Wife*."

Sherbo, Arthur. *English Sentimental Drama*. East Lansing: Michigan State University Press, 1957.

Sherman, Sandra. "'Does Your Ladyship Mean an Extempore?': Wit, Leisure and the Mode of Production in Frances Burney's *The Witlings*," *Centennial Review* 40 (1996), pp. 401–28.

Southam, Brian. *Jane Austen's Literary Manuscripts: A Study of the Novelist's Development Through the Surviving Papers*. London: Athlone Press, 1964; revised edition 2001. See pp. 136–40 for a brief account of "Sir Charles Grandison."

Thomas, David, and Arnold Hare, eds. *Restoration and Georgian England, 1660–1788*. Cambridge: Cambridge University Press, 1989. An invaluable anthology of theatrical documents.

Turner, Cheryl. *Living by the Pen: Women Writers in the Eighteenth Century*. London: Routledge, 1992.

Whicher, George Frisbie. *The Life and Romances of Eliza Haywood*. New York: Columbia University Press, 1915.

Williamson, Marilyn. *Raising Their Voices: British Women Writers, 1650–1750*. Detroit: Wayne State University Press, 1990.

Zelicovici, Dvora. "The Inefficacy of *Lovers' Vows*," *English Literary History* 50 (1983), pp. 531–40.

Appendix:
Jane Austen, dramatist?

I t is no longer tenable, if it ever seriously was, to cite the theatrical episode in *Mansfield Park* as evidence that Jane Austen absolutely disapproved of the theatre. The assumption behind that view is that Fanny Price's uneasiness with the amateur production of Elizabeth Inchbald's sentimental melodrama *Lovers' Vows* (1798), going ahead without her ostensible approval, reflects the author's own sense of right and wrong, uninflected by context or the author's customary irony. Austen's sustained and convincing study of a makeshift theatrical production, from the politics of casting and choosing a play (from a long list of stock pieces) to rehearsing and learning it, seems most unlike the work of a theatre-hating mind.

Austen also shows an intimate knowledge of Inchbald's play, and could reasonably expect many of her readers to see the novel in dialogue with the play, in terms of character, plot and theme. Like Inchbald, she tells a story involving a nobleman, his children, a virtuous priest in a romantic role, and an irresponsible beau with libertine designs, and deals with questions of bloodties, birth, passion and restraint. Fanny and Edmund's attitude to the play recalls Inchbald's preface, with its references to the "indelicately blunt" aspects of the

original. The novel can almost be seen as the cross-generic continu-
ation of a process of domestication initiated by Inchbald, in which
she saw off rival, more literal translations like Anne Plumptre's, by
"Anglicising" Kotzebue's melodrama. *Lovers' Vows* remains a senti-
mental melodrama, however; *Mansfield Park* takes its ideas in the
direction of realism. The novel's themes have been variously described
as ordination, colonialism, and the rise to power of an unspeakable
prude (Kingsley Amis's forthright view of Fanny). *Mansfield Park*
is also a novel that approaches the theme of appearance and reality
through the prism of eighteenth-century drama.

 None of this this is surprising, of course, when we consider a
couple of points about Austen's life. The first is that she attended the
public theater whenever her social and personal situation permitted,
in London, Bath and Southampton, a fact that her afterlife in the
popular imagination as a village-bound spinster rather obscures. The
counter-evidence to the misreading of *Mansfield Park* is to be found
in throwaway lines of her letters—such as a quotation from *The Belle's
Stratagem*, "Mr. Doricourt has travelled; he knows best," January 14,
1801—as well as in her various short dramatic works. It is a pity, for
this reason among many, that so much of Austen's correspondence
was lost or destroyed after her death in 1817. The extant letters show
how she had the concerns of the avid theatergoer at heart—getting a
good seat, for instance, critiquing her favourite actors, being prepared
for all eventualities:

> We were all at the play last night to see Miss O'Neill
> in *Isabella*. I do not think she was quite equal to my
> expectations. I fancy I want something more than can
> be. I took two pocket-handkerchiefs, but had very little
> occasion for either. She is an elegant creature, however,
> and hugs Mr. Young delightfully.[1]

1. A letter to Anna Lefroy, November 28, 1814. The renowned beauty and tragedi-
 enne Eliza O'Neill made her London stage debut earlier that year. She played
 opposite the equally dignified Charles Mayne Young in *Isabella, or the Fatal
 Marriage* (1776) adapted by Garrick from Southerne's *Fatal Marriage* (1694),
 which was, in turn, based on *The History of the Nun* (1689) by Aphra Behn.

The second biographical point is that Austen was well acquainted with amateur theatrical productions from her childhood, mainly at home in her father's rectory in the village of Steventon in Hampshire. Her brother James, to whom "The Visit" (an amusing skit, printed in its entirety below) is dedicated, seems to have been particularly keen on drama, writing the prologues and epilogues for several home productions during the 1780s. These included *The Rivals*, *Tom Thumb* and *The Wonder* by Centlivre.[2] The last of these was performed at Christmas 1787 (as it had been at Drury Lane in January) with a "lady in the character of Violante" (the comedy's heroine) speaking the following lines from the epilogue:

> To crown her sex with well deserved applause,
> (A female champion in a female cause)
> This night's gay Authoress her pen employed,
> Nor is the lively tale of moral void...

That which survives of Austen's own dramatic writing must count as the minor exercises of a major literary voice. It is easy either to exaggerate the importance of these exercises or to overlook them entirely. As Pat Rogers puts it, juvenilia tend to be treated "as the by-products of genius," which is sometimes as much of a curse as a blessing.[3] Such an approach seems to vindicate the reading of a play like *A Wife To Be Let*, say, as a supplement to Haywood's romances or mature novels. Something like it is virtually essential to an appreciation of Austen's thoroughly minor and utterly delightful playlet "Sir Charles Grandison," since it is more dependent on a comprehensive knowledge of Samuel Richardson's novel than *Mansfield Park* relies

2. But not *Lovers' Vows*, it seems. Paula Byrne's *Jane Austen and the Theatre* (London: Hambledon & London, 2003) reproduces on p. 5 a cartoon by James Gillray, "Blowing Up the Pic Nics," which depicts the professionals and the amateurs as rivals. Gillray astutely has Sheridan and company marching under the banners of Shakespeare and Kotzebue, disrupting an amateur performance of *Tom Thumb*. The choice of playwrights would seem to coincide with the impropriety of amateurs performing Kotzebue's *Lovers' Vows* in *Mansfield Park*.
3. In "Richardson in a nutshell," a review of *Jane Austen's "Sir Charles Grandison"* in the TLS, April 3, 1981.

on *Lovers' Vows*.[4] The problem is that Austen's dramatic sketches do not tell us much about the consciously literary artist of the six novels. The form itself gives that curious authorial voice of hers no chance to be heard, and the humor is more jaunty, big-boned burlesque than wry play on generic conventions. They are an opportunity for sharing family jokes, and burlesquing theatrical genres ("The Mystery," "The First Act of a Comedy") and social etiquette ("The Visit"), not honing her sense of narrative structure or character psychology.

"Sir Charles Grandison" is a good illustration of this, although it belongs to Austen's early twenties rather than her childhood. As Paula Byrne observes in *Jane Austen and the Theatre*, *Lovers' Vows* and *Mansfield Park* are both "explorations" of "the difficulties of a prohibited relationship, from a woman's perspective."[5] The theme appeared before either the play or the novel, in Austen's favourite novel by one of her favourite writers, Samuel Richardson: the seven-volume *Sir Charles Grandison* (1753–4). Austen engaged deeply with that book, but not blindly, it seems, since she was able to treat its theme so lightly in "Sir Charles Grandison," a "playlet" written at the very end of the eighteenth century.[6] As recalled in Henry Austen's "Biographical Notice" of his sister, prefixed to the first edition of *Northanger Abbey* and *Persuasion* in 1817, Richardson's epistolary novels were sincerely adored by Austen as they were by many of her contemporaries, but, in Austen's case, this was not an uncritical response:

> Richardson's power of creating, and preserving the consistency of his characters, as particularly exemplified in *Sir Charles Grandison*, gratified the natural discrimination of her mind, whilst her taste secured her from the errors of his prolix style and tedious narrative.

4. "Something like it" meaning "Sir Charles Grandison" is the by-product of somebody else's genius.
5. Paula Byrne, *Jane Austen and the Theatre*, p.158. Inchbald had also explored this theme in *A Simple Story* (1791).
6. In his Introduction, Southam discusses in depth the problems of working out the textual history of "Sir Charles Grandison," the role of Austen's favourite niece,

Elsewhere, Henry Austen remembered that his sister could track the events of the novel through the exact days of the year on which they were supposed to have taken place.[7] Turning such a beast of a book into such a slender drama may well have been part of the joke, especially as Richardson liked to think of himself as a dramatic writer, inserting stage directions and setting elaborate scenes. Austen saw especially that Richardson's dialogue was not a flexible instrument. Byrne imagines Austen's burlesque as a technically unchallenging and critically necessary exorcism.[8]

As Southam warns the reader, "Sir Charles Grandison" is "amusing enough and highly performable, but no masterpiece, not even a minor masterpiece," unpolished if not unfinished, a charmingly unsystematic, "imitative pastiche."[9] The meeting of drama and the novel here is nothing like as sophisticated as that in *Mansfield Park*, with Austen very much off-duty, well away from public scrutiny, indulging in what might be called the "comedy of allusion."[10] In fact, given that a full appreciation of the play requires a verbatim knowledge of Richardson's novel, "Sir Charles Grandison" might be usefully seen as the ultimate word game, closer to the Austen family charades than the published novels. In it, Austen plays the same games of allusion that she plays with *Lovers' Vows* in *Mansfield Park*, but can be all the more elaborate in the presence of a well-known, private audience:

> [The play] part-lampoons, part-imitates a favourite fam-
> ily novel and carries a substratum of Austen jokes and
> references. It was a play for the family to perform.... So
> if we set up "Grandison" for performance in our minds'
> eye, as many readers will do, we should view it with

Anna Lefroy, in its composition and subsequent treatment by the Austen family as more her work than her aunt's. It seems likely that Austen put the play aside and returned to it when a suitable occasion arose for its performance.

7. See Elizabeth Jenkins, *Jane Austen* (London: Orion Publishing Co., 1938) p. 34.
8. *Jane Austen and the Theatre*, pp. 92–3.
9. p. 3 and p. 26.
10. p. 17.

generosity and good humor, just as the family party
would have done in 1800.[11]

Exclamations such as Harriet Byron's in Act 3—"But what he have
though of me in such a dress? Oh! These odious masquerades!"—
might not look like by-products of genius, but they catch both the
hammy tone of Richardson's epistolary females and the distress of
the Austen heroine who sees herself as publicly compromised in the
eyes of her hero. The line is one of many Southam traces to a specific
source in the novel, only there Harriet is able to explain herself to
Sir Charles: "This vile appearance was not my choice. Fie upon me!
I must be thus dressed out for a masquerade. Hated diversion!"[12]

Dashed off though it may be, "Sir Charles Grandison" offers
plenty of lines that are amusing in their own right, in the manner of
"There is something monstrous frightful, my dear Harriet, in mar-
rying a man that one likes." "I am afraid Charlotte is too lively for
matrimony." (Indeed, the prejudice against Charlotte, Sir Charles's
sister, has something of Mrs. Voluble's against her son Bob in *The
Witlings*, with her brother warning her, "Now, Charlotte, hold your
tongue. I am sure some raillery is coming out.") Charlotte gets her
revenge, though, in her portrait of Sir Charles, a ludicrous compres-
sion of Richardson's influential ideal, his "Best of Men," the "Happy
Man" himself:

> My brother is a charming man. I always catch him
> doing some good action. We all wish him to be mar-
> ried but he has no time for love. At least, he appears to
> have none. For he is constantly going about from one
> place to another. But what for, we cannot tell. And we
> have such a high respect for him that we never interfere
> with his affairs.

In the following extract of "Sir Charles Grandison," Act 2, Austen

11. p. 12.
12. *Sir Charles Grandison*, vol. 1, ch. 26.

dramatizes the abduction of the heroine, Harriet Byron, by Sir Hargrave Pollexfen, an episode from Richardson's first volume that requires "only the slightest tilt" from Austen to turn "melodrama" into "broad farce."[13] Pollexfen's pantomime villainy may be less pronounced in the novel, but Richardson's ear for dialogue is particularly woeful in moments of high drama. "Be mine, madam," says Pollexfen at one point. "Be legally mine…or take the consequence…Don't provoke me: don't make me desperate." Mrs. Awberry's argument in his favour, the fainting and the incident with the door are all taken from the novel. The "splendid moment of high comedy…when Harriet flings the prayer-book into the fire" is not:

ACT II

Early the same morning in the home of MRS. AWBERRY *at Paddington. The curtain draws up and discovers* MISS BYRON *and* MRS. AWBERRY. SIR HARGRAVE POLLEXFEN *is visible to the audience, but not to the ladies, at the side of the stage.*

MRS. AWBERRY: But, my dear young lady, think what a large fortune Sir Hargrave has got; and he intends you nothing but marriage.

MISS BYRON: Oh! Mrs. Awberry, do you think I can marry a man whom I always disliked and now hate? Is not this your house? Cannot you favour my escape?

MRS. AWBERRY: My dear madam, that is impossible without detection. You know Sir Hargrave is here and there and everywhere.

MISS BYRON: My dear Mrs. Awberry, you shall have all the money in this purse if you will release me.

SIR HARGRAVE *bursts into the room.*

SIR HARGRAVE: Mrs. Awberry, I see you are not to be trusted with her, you are so tender hearted. And you, madam!

13. Southam, p.24.

He snatches the purse out of her hand and flings it on the ground. He goes to the door and calls.

Mr. —! We are ready.

Enter a CLERGYMAN *and his* CLERK.

Miss Awberry! You will be bridesmaid, if you please.

He takes hold of MISS BYRON's *hand. Enter* DEBORAH AWBERRY.

Now, madam, all your purses will not save you.

The CLERGYMAN *takes a book out of his pocket.* MISS BYRON *screams and faints away.* MISS SALLY AWBERRY *runs in.*

DEBORAH AWBERRY: Sally, Sally, bring a glass of water directly!

MRS. AWBERRY *takes out her salts and applies them to* MISS BYRON's *nose.*

SIR HARGRAVE: I wish women were not quite so delicate, with all their faints and fits!

MISS BYRON *revives.* MISS SALLY *returns with a glass of water and offers it to* MISS BYRON, *who drinks some.*

MRS. AWBERRY: What a long time you have been, child! If she faints again I shall send your sister.

SALLY AWBERRY: [*Aside*] I am glad of it.

SIR HARGRAVE: Come, sir, we will try again.

Takes hold of MISS BYRON's *hand.* DEBORAH AWBERRY *goes behind her.*

CLERGYMAN: [*Reading from a prayer-book*] Dearly beloved—

MISS BYRON: I see no Dearly beloveds here and I will not have any!

MISS BYRON *dashes the prayer-book out of his hand.*

CLERGYMAN: [*Picking it up again*] Oh! My poor book!

SIR HARGRAVE: Begin again, sir, if you please. You shall be well paid for your trouble.

CLERGYMAN: [*Reading again*] Dearly beloved—

MISS BYRON *snatches the book out of his hand and flings it in to the fire, exclaiming*

MISS BYRON: Burn, quick, quick!

The CLERGYMAN *runs to the fire and cries out.*

CLERGYMAN: Oh! Sir Hargrave, you must buy me another.

SIR HARGRAVE: I will, sir, and twenty more, if you will do the business. Is the book burnt?

MRS. AWBERRY: Yes, sir—and we cannot lend you one in its place, for we have lost the key of the closet where we keep our prayer-books.

SIR HARGRAVE: Well, sir, I believe we must put it off for the present. And if we are not married in this house, we shall be in mine, in the Forest.

CLERGYMAN: Then I may go, sir, I suppose. Remember the prayer-book.

SIR HARGRAVE: Yes, sir. Good morning.

Exeunt CLERGYMAN *and* CLERK.

SIR HARGRAVE: I shall be very much obliged to you, Mrs. Awberry, if you and the young ladies will go out of the room for an instant. I will see if I cannot reason with this perverse girl.

Exeunt MRS. AWBERRY *and the* MISSES AWBERRY.

MISS BYRON: Oh! Do not leave me alone with him, let me go out too.

She runs to the door. SIR HARGRAVE *follows her. She gets halfway through the door and he, in shutting it, squeezes her. She screams and faints. He carries her away in his arms to a chair and rings the bell violently. Enter* MRS. AWBERRY, DEBORAH AWBERRY, *and* SALLY.

SIR HARGRAVE: Bring some water directly.

> *Both the daughters go out.* MISS BYRON *revives and exclaims*

MISS BYRON: So, I hope you have killed me at last.

> *Re-enter* DEBORAH *with the water.* SIR HARGRAVE *takes the glass and gives it to* MISS BYRON.

MISS BYRON: No, I thank you. I do not want anything that can give me life.

SIR HARGRAVE: Well, Miss Awberry, you had better get out the cloak. It is four o'clock and she may as well die in my house as in yours.

MRS. AWBERRY: Shall I order the chariot, sir?

SIR HARGRAVE: If you please, ma'am.

> DEBORAH *takes a long cloak out of a closet and attempts to put it round* MISS BYRON. MISS BYRON *struggles.*

SIR HARGRAVE: I will put it on, Miss Awberry, if she will not let you.

> *He puts it on.*

Will you help me lead her downstairs, Miss Awberry?

MRS. AWBERRY: Yes, sir.

> *They both take hold of* MISS BYRON. *Enter* SALLY AWBERRY.

SALLY AWBERRY: Can I be of any service, sir?

SIR HARGRAVE: You may hold the candle.

> SALLY *takes the candle. Exeunt.*

At one point in "Sir Charles Grandison," the humor derives not from sensational action like that of the farcical second act but from absolute banality. "Lucy, were the roads very good?" asks Harriet. "Indeed, they were very good," replies Lucy. "Yes, our ponies went on fast enough," adds Mr. Reeves. Monotonous politeness had inspired Austen already, in "The Visit," a "Comedy in Two Acts," as it would do frequently in the future. Decorum was a topic of debate among educational theorists and would-be makers of manners—not

least because one's rank could be displayed or disguised in a *faux pas* or superior manners. "The Visit," by contrast, has a genteel company behaving appallingly in a lord's house. Although things begin politely enough with the first two scenes, Act Two becomes increasingly ridiculous. Lord Fitzgerald's guests sit on one another's knees (although the chairs are properly "*set round in a row*"), and partake of a range of vile food and drink while Lady Hampton totally overbears her silent husband (bringing Mrs. Voluble and son in *The Witlings* to mind). The question of whether or not we can believe that the playful dedication's reference to "those celebrated comedies called 'The School for Jealousy' and 'The Travelled Man'" refers to real plays depends on the degree to which we think Austen is aping the etiquette of dramatic publication at this point. It seems possible that these are the titles of lost family burlesques. Then again, Austen may be merely mimicking the style of dedications and prefaces that she knew well. Well enough, that is, to catch the tone of tremulous modesty that the playwright had to affect before her patron, not to mention the kind of titles that were commonplace in the eighteenth century. As Penny Gay says in her *Jane Austen and the Theatre*, Austen is "more likely to have encountered the witty young woman as stage heroine in the plays of Hannah Cowley, Elizabeth Inchbald, and Isaac Bickerstaff" than in the Shakespeare plays that might come to our mind at once. It is "plays which have largely disappeared from our map of eighteenth-century drama" that might enhance and refresh our understanding of Austen's progress as an artist.[14]

14. Penny Gay, *Jane Austen and the Theatre*, (Cambridge: Cambridge University Press, 2002), p. 10.

The Visit
A Comedy in Two Acts

Dedication

To the Revd. James Austen

SIR,
The following drama, which I humbly recommend to your protection and patronage, though inferior to those celebrated comedies called "The School for Jealousy" and "The Travelled Man," will I hope afford some amusement to so respectable a *curate* as yourself; which was the end in view when it was first composed by your humble servant, the Author.

DRAMATIS PERSONAE

SIR ARTHUR HAMPTON	LADY HAMPTON
LORD FITZGERALD	MISS FITZGERALD
STANLEY	SOPHIE HAMPTON
WILLOUGHBY, SIR ARTHUR'S NEPHEW	CHLOE WILLOUGHBY

SERVANTS

The scenes are laid in Lord Fitzgerald's house.

The Visit

ACT I, SCENE I

A parlour. Enter LORD FITZGERALD *and* STANLEY.

STANLEY: Cousin, your servant.

FITZGERALD: Stanley, good morning to you. I hope you slept well last night.

STANLEY: Remarkably well, I thank you.

FITZGERALD: I am afraid you found your bed too short. It was bought in my grandmother's time, who was herself a very short woman and made a point of suiting all her beds to her own length, as she never wished to have any company in the house, on account of an unfortunate impediment in her speech, which she was sensible of being very disagreeable to her inmates.

STANLEY: Make no more excuses, dear Fitzgerald.

FITZGERALD: I will not distress you by too much civility—I only beg you will consider yourself as much at home as in your father's house. Remember, "The more free, the more welcome."

Exit FITZGERALD.

STANLEY: Amiable Youth!
"Your virtues, could he imitate
How happy would be Stanley's fate!"

Exit STANLEY.

ACT I, SCENE II

STANLEY *and* MISS FITZGERALD, *discovered.*

STANLEY: What company is it you expect to dine with you today, cousin?

MISS F.: Sir Arthur and Lady Hampton, their daughter, nephew and niece.

STANLEY: Miss Hampton and her cousin are both handsome, are they not?

MISS F.: Miss Willoughby is extremely so. Miss Hampton is a fine
girl, but not equal to her.

STANLEY: Is not your brother attached to the latter?

MISS F.: He admires her, I know, but I believe nothing more. Indeed,
I have heard him say that she was the most beautiful, pleas-
ing and amiable girl in the world, and that of all others he
should prefer her for his wife. But it never went any farther,
I'm certain.

STANLEY: And yet my cousin never says a thing he does not mean.

MISS F.: Never. From his cradle he has always been a strict adherent
to truth.

Exeunt severally. End of the First Act.

ACT II, SCENE I

The Drawing Room. Chairs set round in a row. LORD FIT-
ZGERALD, MISS FITZGERALD *and* STANLEY *seated. Enter a*
SERVANT.

SERVANT: Sir Arthur and Lady Hampton. Miss Hampton, Mr. and
Miss Willoughby.

Exit SERVANT. *Enter the company.*

MISS F.: I hope I have the pleasure of seeing your ladyship well. Sir
Arthur, your servant. Yours, Mr. Willoughby. Dear Sophie,
Dear Chloe—

They pay their compliments alternately.

MISS F.: Pray, be seated.

They sit.

Bless me! There ought to be eight chairs and there are but six.
However, if your ladyship will but take Sir Arthur in your lap, and
Sophie my brother in hers, I believe we shall do pretty well.

LADY H.: Oh! With pleasure....

SOPHIE: I beg his lordship would be seated.

MISS F.: I am really shocked at crowding you in such a manner, but my grandmother (who bought all the furniture of this room), as she had never a very large party, did not think it necessary to buy more chairs than were sufficient for her own family and two of her particular friends.

SOPHIE: I beg you will make no apologies. Your brother is very light.

STANLEY: [*Aside*] What a cherub is Chloe!

CHLOE: [*Aside*] What a seraph is Stanley!

Enter a SERVANT.

SERVANT: Dinner is on table.

They all rise.

MISS F.: Lady Hampton, Miss Hampton, Miss Willoughby.

STANLEY *hands* CHLOE; LORD FITZGERALD, SOPHIE; WILLOUGHBY, MISS FITZGERALD; *and* SIR ARTHUR, LADY HAMPTON. *Exeunt.*

ACT II, SCENE II

The Dining Parlour. MISS FITZGERALD *at top.* LORD FITZGERALD *at bottom. Company ranged on each side. Servants waiting.*

CHLOE: I shall trouble Mr. Stanley for a little of the fried cow-heel and onion.

STANLEY: Oh madam, there is a secret pleasure in helping so amiable a lady.

LADY H.: I assure you, my Lord, Sir Arthur never touches wine; but Sophie will toss off a bumper I am sure, to oblige your lordship.

FITZGERALD: Elder wine or mead, Miss Hampton?

SOPHIE: If it is equal to you, sir, I should prefer some warm ale with a toast and nutmeg.

FITZGERALD: Two glasses of warmed ale with a toast and nutmeg.

MISS F.: I am afraid, Mr. Willoughby, you take no care of yourself. I fear you don't meet with anything to your liking.

WILLOUGHBY: Oh! Madam, I can want for nothing while there are red herrings on table.

FITZGERALD: Sir Arthur, taste that tripe. I think you will not find it amiss.

LADY H.: Sir Arthur never eats tripe; 'tis too savoury for him, you know, my lord.

MISS F.: Take away the liver and crow, and bring in the suet pudding.

A short pause.

MISS F.: Sir Arthur, shan't I send you a bit of pudding?

LADY H.: Sir Arthur never eats suet pudding, ma'am. It is too high a dish for him.

MISS F.: Will no one allow me the honor of helping them? Then John, take away the pudding, and bring the wine.

SERVANTS *take away the things and bring in the bottles and glasses.*

FITZGERALD: I wish we had any dessert to offer you. But my grandmother in her lifetime destroyed the hothouse in order to build a receptacle for the turkeys with its materials; and we have never been able to raise another tolerable one.

LADY H.: I beg you will make no apologies, my Lord.

WILLOUGHBY: Come, girls, let us circulate the bottle.

SOPHIE: A very good notion, cousin; and I will second it with all my heart. Stanley, you don't drink.

STANLEY: Madam, I am drinking draughts of love from Chloe's eyes.

SOPHIE: That's poor nourishment, truly. Come, drink to her better acquaintance.

MISS FITZGERALD *goes to a closet and brings out a bottle.*

MISS F.: This, ladies and gentlemen, is some of my dear grandmother's

own manufacture. She excelled in gooseberry wine. Pray taste it, Lady Hampton.

LADY H.: How refreshing it is!

MISS F.: I should think, with your ladyship's permission, that Sir Arthur might taste a little of it.

LADY H.: Not for worlds. Sir Arthur never drinks anything so high.

FITZGERALD: And now my amiable Sophia, condescend to marry me.

He takes her hand and leads her to the front.

STANLEY: Oh! Chloe, could I but hope you would make me blessed—

CHLOE: I will.

They advance.

MISS F.: Since you, Willoughby, are the only one left, I cannot refuse your earnest solicitations—there is my hand.

LADY H.: And may you all be happy!

FINIS

Notes

ACT I, SCENE I

"*The more free, the more welcome.*"—A quotation from James Townley's farce *High Life below Stairs* (1759), performed at Steventon in 1788–9. This probably dates "The Visit" to the same period. See Paula Byrne, *Jane Austen and the Theatre*, pp. 13–4.

ACT I, SCENE II

Willoughby—A name Austen adopted from Burney's *Evelina* (1778), in which it belongs to Sir Clement Willoughby, and re-used in *Sense and Sensibility* (1811) for the comparably unscrupulous John Willoughby.

ACT II, SCENE II

Toss off a bumper—The unladylike activity of downing a drink.

Hothouse—Cf. *Northanger Abbey*, ch. 22, in which General Tilney proudly boasts of the Abbey's hothouses and its pineapples.

Acknowledgments

No editor is an island. Warm thanks go to all who have assisted in the making of this book, starting with libraries and librarians: staff at the British Library, the Bodleian Library in Oxford, the Theatre Museum Reading Room in London, and Chawton House Library in Hampshire. I have benefited too from correspondence great and small with Paula Byrne, Clayton Delery, Melinda Finberg, Davis McCallum, Jane Milling, Lucie Sutherland, and Linda Troost. Laura and Elizabeth Baggaley, Andrew and John Caines, Jovita Howse, and my colleagues at the TLS have provided invaluable advice and encouragement. My sincere thanks go to the long-suffering and long supportive Matthew Miller, Deborah Meghnagi and Batnadiv Weinberg at *The* Toby Press.

About the Editor

Michael Caines is an editor at the *Times Literary Supplement* and writes regularly for the paper on theater, fiction and literary criticism.

The fonts used in this book are from the Garamond family

The Toby Press publishes fine writing, available at leading bookstores everywhere. For more information, please contact *The* Toby Press at www.tobypress.com